In Plain Sight
Discovering the Furniture of Nathaniel Gould

Gidony King

1761 nay	1762	Dr 1 Silk hand.f 6/8 Sundries pr Day Book 53/c		2		
July	19	To 20 feet of Mehogany a 1/4		1		
		To 7 yd.s of Check a 2/8				
aug.t		To 45½ feet of Meh.y B.d a 1/4		0		
		To ⅜ D.o plank a 2/8		1		
1765 feb.y		To 2j Sugar D.o Ja.s Kuck a 4/				
		To Cash Lent				
mar.h	17	To Cash D.o w.m Kuck 18/ 1 Silk Hankerch 6/8				
66 Jan.y		To 9 lb Beaf a 1/8 old tenor				
ap.l 9		To 86 feet wallnut Bords a 4/6 Old tenor				
June		To 1½ Sugar 6/8				
July 10		To 1½ Ditto				
1767		To 100 feet Wallnut Bord a 3/6 Old Tenor		2		
may		To 2j Sugar 9/ 2 yd.s flanin 6/ 1 Ct.n bais 4/8		1		
June 13		To Cash 2/8 Quater Veal 2/4				
July 4		To 5 pint of Rum at mr Grants				
		To 1½ Bush.l Corn a 3/				
	21	To 7lb Sugar				
	25	To 5 pints Rum Bo.t of Jn.o Ward				
		To 7lb Sugar				
aug.t 5		To 1½ bushels Corn a 3/4				
		To 1 Quater Lamb				
	10	To 7lb Sugar 3/ To 1 Bush.l Corn 3/4				
	27	To 7lb Sugar				
Sep.r		To 7lb Sugar				
oct.r		To 7lb Ditto 3/9 1 Bord Nails 1/3				
Nov.r		To 7lb Ditto				
		To Ditto				
		To 2 Sugar 1/ 1 Nails 1/8 7lb Sugar 2/				
1768 Jan.y		To 7lb Sugar 3/ Stuf for table 2/8				
feb.y ap.l		To 32 feet Clear Bord a				
June 14		To 2 Sugar 1/8 Sundries Mehogany 19/6				
Sep.r 16·26		To 7½ foot Mehogany 6/ Quater Meat 1/8 Burch plank 4/4				
16· 13·16		To Quater meat 1/10 ¼lb Tea 2/ Quater Meat 1/4				
D.o		Carr.d over Leaf				

1765 Contra Cr

 By his ac. in full to March 5 1765 £ 7

June By making Desk 1 4 —

66 Jun By making 1 Cherre Desk 1 4

 By Part of 1 Ceader Di 1 ..

1767
June By making Ceader Ditto . . --- 1 4

Sepr By Makeing 1 Maple Desk 1 .. —

 Carr. over Leaf . — £ 12 12 ..

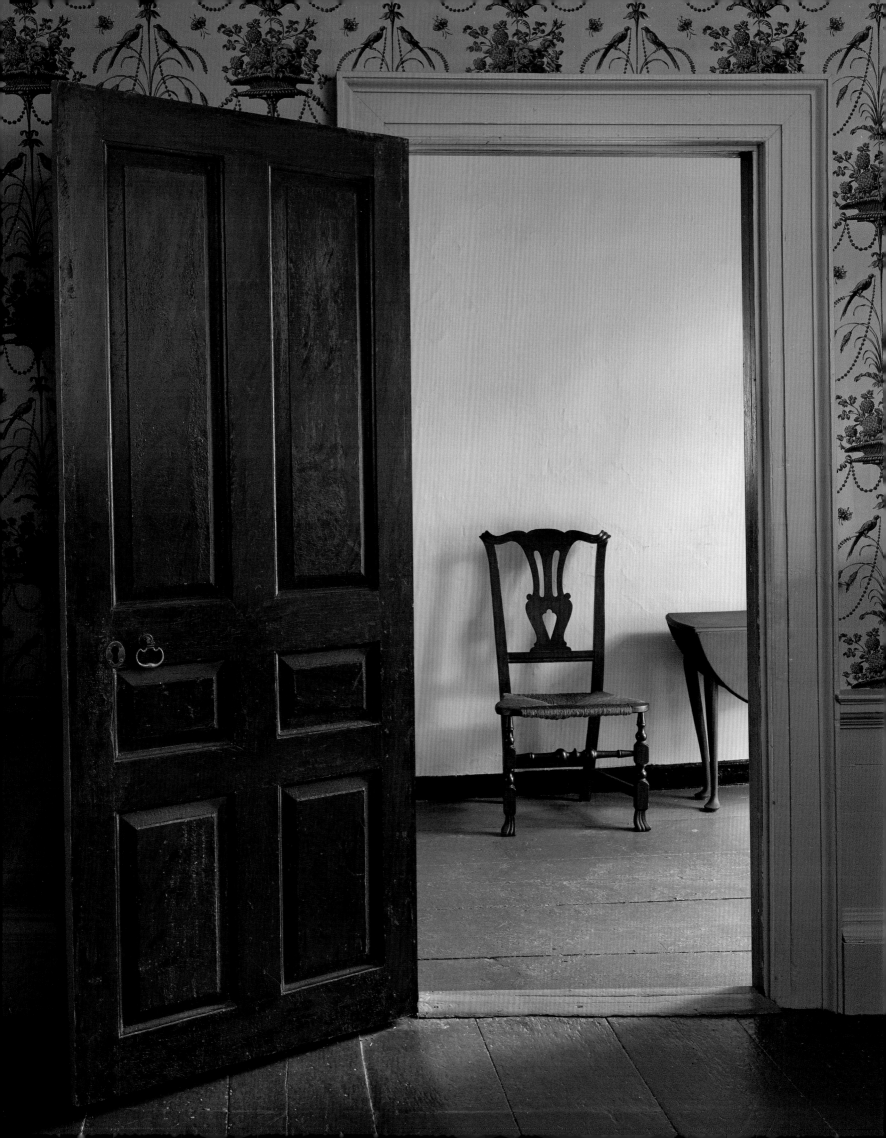

In Plain Sight
Discovering the Furniture of
Nathaniel Gould

KEMBLE WIDMER
and
JOYCE KING

with essays by
GLENN ADAMSON, DANIEL FINAMORE, DEAN THOMAS LAHIKAINEN
and
ELISABETH GARRETT WIDMER

PEABODY ESSEX MUSEUM, SALEM
in association with
D GILES LIMITED, LONDON

In Plain Sight: Discovering the Furniture of Nathaniel Gould accompanies the exhibition organized by the Peabody Essex Museum, Salem, Massachusetts, on view from November 15, 2014 through March 1, 2015.

Peabody Essex Museum
East India Square
Salem, Massachusetts 01970
www.pem.org

Published in association with GILES, London
An imprint of D Giles Limited
4 Crescent Stables, 139 Upper Richmond Road,
London SW15 2TN, UK
www.gilesltd.com

Library of Congress Control Number: 2014003820
ISBN: 978-1-907804-33-5

The exhibition was organized by the Peabody Essex Museum with major support from:
The Americana Foundation
The Henry Luce Foundation
The Lynch Foundation
Nancy and George Putnam
Richard C. von Hess Foundation

Support provided by the East India Marine Associates of the Peabody Essex Museum.

Additional support provided by many individual donors to Four Centuries of Massachusetts Furniture.

Photography Credits

FRONT COVER

Cat. 1 (Chest of Drawers) photographed in the Jeremiah Lee Mansion (ca. 1766–68), 170 Washington Street, Marblehead. Marblehead Museum and Historical Society Historic House Collection. © 2014 Peabody Essex Museum. Photo by Dennis Helmar Photography

BACK COVER

Detail of Nathaniel Gould's Day Book (1768–83), page dated October 1773. Nathan Dane Papers, Massachusetts Historical Society, Boston © 2014 Peabody Essex Museum. Photo by Dennis Helmar Photography

PAGES 2–3

Nathaniel Gould's Account Book, open to Gedney King's debit transactions from May 1761 through December 1768. Nathan Dane Papers, Massachusetts Historical Society, Boston. © 2014 Peabody Essex Museum. Photo by Dennis Helmar Photography

PAGE 4

Cat. 11 (Side Chair). Photographed in Crowninshield-Bentley House (1727–30), 126 Essex Street, Salem, Massachusetts. Peabody Essex Museum Historic House Collection. © 2014 Peabody Essex Museum. Photo by Dennis Helmar Photography

PAGES 182–183

Detail of Nathaniel Gould's Account Book, showing Thomas Collier's order dated January 1767. Nathan Dane Papers, Massachusetts Historical Society, Boston. © 2014 Peabody Essex Museum. Photo by Dennis Helmar Photography

Edited by Terry Ann R. Neff
t. a. neff associates, inc., Tucson, Arizona

Designed by Daphne Geismar,
New Haven, Connecticut

Printed and bound in China

CONTENTS

There is nothing like first-hand evidence.
 —Sherlock Holmes, in *A Study in Scarlet*, 1886

"The Bay State is where the craft [of furniture making] began in America and where it has flourished and endured the longest." So observed Morrison Heckscher, Chairman of the Metropolitan Museum of Art's American Wing, during recent celebrations that have focused on furniture made in Massachusetts over the past four hundred years. From the elegant to the everyday, this legacy of tables, chairs, chests, desks, bedsteads, and other forms is estimated to number in the tens of millions and represents some of our country's finest and most inventive furniture.

The Peabody Essex Museum's American holdings have historically emphasized New England's early portraiture and decorative arts, especially furniture, silver, glass, ceramics, and textiles. The nationally recognized nucleus of the collection is furniture created in Salem's heyday as a significant production center from the late seventeenth to the late nineteenth century. We have been comparably ambitious in supporting and presenting new scholarship on regional furniture through exhibitions and publications, most notably *Luxury and Innovation: The Furniture Masterworks of John and Thomas Seymour* (2003) by the Boston-based furniture conservator Robert D. Mussey Jr., and *Samuel McIntire: Carving an American Style* (2007) by Dean Thomas Lahikainen, PEM's Carolyn and Peter Lynch Curator of American Decorative Art. These comprehensive projects have expanded knowledge and appreciation of the body of works associated with each artist. Most importantly, however, these projects have limned the productivity and creativity of the Seymours and McIntire in ways that illuminate their impact not just on the evolution of furniture-making, style, and taste in a specific locale, but also for an emerging nation forging its distinctive path in the realms of art and culture.

We are therefore proud to present *In Plain Sight: Discovering the Furniture of Nathaniel Gould* as the culmination of a trilogy of monographic studies that celebrate key early figures in the history of American furniture. Successful during their respective lifetimes, the England-to-Boston immigrant Seymours and the Massachusetts-born McIntire and Gould have subsequently experienced varying degrees of appreciation through the vagaries of time, availability of knowledge and examples, and changing trends. The extraordinary number of pieces of furniture made in Massachusetts is matched only by the comparatively low number of surviving examples, and relatively few are tied to known makers. In their midst, Nathaniel Gould has loomed as something of a mystery—believed to have been prolific, handsomely skilled, and exceptionally enterprising, yet considered elusive because of a scarcity of works, lack of documentation, and difficulties of attribution.

Accident—the unexpected discovery of Gould's ledgers in the collection of the Massachusetts Historical Society—and analysis—painstaking and inductive—have produced a uniquely well-documented and multifaceted case study. Unquestionably, Gould emerges as Salem's leading cabinetmaker from around 1758 to his death in 1781, as he made substantial and often expensive furniture, including case pieces of bombé form embellished with carving. Admittedly, the number of works that can be attributed to Gould remains frustratingly small, but the foundation for ongoing research and increasingly assured connoisseurship lies within these pages and those of Gould's archival records.

Even now, however, it is evident that the scale of his workshop, his impressively large, diverse clientele, and his successes in the furniture export trade attest to his achievements as an entrepreneur, especially in a town that during his lifetime gave rise to some of the country's earliest millionaires and global traders. The combination of creativity, ambition, and commerce often has negative connotations for the modern and contemporary art worlds. Yet, these factors have been longstanding, powerful partners in the history of art and culture—the seventeenth century's golden age of Dutch painting spurred by international trade offers a signal example.

Timing is everything, and this project is not just about a particular individual, but also about the period and place in which Gould lived and worked. The Salem/Boston/New England spheres in which he operated during the colonial period and the years of the American Revolution represent a telling confluence. We can view his scrupulously recorded notations as nothing more than the lists and inventories of a methodical mind, or we can read them as precious clues to emerging concepts of style and taste, cultural mores, business

practices, socio-economic circumstances, and familial histories with local, regional, and national relevance.

The depth and breadth of information that this publication encompasses are also testimony to the crucial role that archives and libraries play not just in preserving but in providing access to pieces of the past—names, events, places, objects, or images all holding the promise of relevance and revelation for intrepid researchers. The Peabody Essex Museum's Phillips Library houses invaluable archival resources related to New England's local and global dimensions, and we echo the authors' gratitude for the generous services provided by the archivists and librarians of so many organizations.

A diligent, enterprising researcher is a detective par excellence, whether in the capacity of a curator, writer, or scholar. Kemble Widmer, Joyce King, and Elisabeth Garrett Widmer have unflaggingly devoted themselves to tracking and analyzing a daunting amount of material. To describe their cohesive and compelling study of Gould's career and times as a labor of love is an understatement, and we deeply appreciate the fruits of their dedication and knowledge. In addition to his seminal role in this publication, Kem has served as the consulting curator to the companion exhibition, and Dean Lahikainen, the show's organizing curator, joins us in thanking him for his generous collaboration.

From the outset of the project, Dean envisioned a jewellike exhibition to feature the best of Gould's known furniture through a design and interpretive approach that would invite close looking and contextual exploration. Dean's exceptional understanding of furniture as an expressive form and his deep knowledge of Salem's furniture production shine through in the exhibition, and we warmly congratulate him. Similarly, we join Kem, Dean, Elisabeth, and Joyce in applauding the teamwork and expertise that the museum's staff has brought to bear in realizing the exhibition and publication. We add to their acknowledgments in the introduction these members of the exhibition's planning, design, and interpretive team: Karen Moreau Ceballos, Manager of Exhibition Design Projects; Jacqueline Combs, Graphic Designer; Emily Fry, Lead Interpretation Planner; Annie Lundsten, Exhibition Projects Coordinator; Michelle Moon, Assistant Director for Adult Programs; Ed Rodley, Associate Director of Integrated Media; Dave Seibert, Director of Design; and Walter Silver, Senior Photographer.

The Americana Foundation, Henry Luce Foundation, Lynch Foundation, Richard C. von Hess Foundation, and Nancy and George Putnam have provided major support for *In Plain Sight: Discovering the Furniture of Nathaniel Gould*. Jonathan P. Loring; Robert and Elizabeth Owens; Skinner, Inc.; the East India Marine Associates of the Peabody Essex Museum, and many individual donors to the "Four Centuries of Massachusetts Furniture" initiative have also supported our project. We thank them all for their extraordinary generosity.

We are pleased to have partnered with D Giles Limited to publish this ambitious book. We extend our sincere thanks to Dan Giles and his staff for their stellar production and distribution efforts.

"Data! Data! Data…I can't make bricks without clay," an impatient Sherlock Holmes cries in Sir Arthur Conan Doyle's 1892 short story "The Adventure of the Copper Beeches." At a time when we increasingly take for granted the world of data at our fingertips, this illustrious detective reminds us that the significance of firsthand evidence lies in its transformational power to raise and answer questions and inspire insight.

Dan L. Monroe
The Rose-Marie and Eijk van Otterloo Director and CEO

Lynda Roscoe Hartigan
The James B. and Mary Lou Hawkes Chief Curator

ACKNOWLEDGMENTS

A chance remark by a young research assistant, Brock Jobe, at Boston's Museum of Fine Arts, was the catalyst that led us to focus on Salem furniture of the eighteenth century. While studying a Salem desk in Maine, he offered: "With a little effort, I think we could determine who made this desk." Brock has subsequently been a constant source of knowledge, inspiration, and advice. He has been invaluable in introducing us to major museums and dealers for further study of Salem's furniture.

To have full understanding of eighteenth-century Salem furniture and be able to distinguish it from that of other Essex County towns, we needed a working knowledge of Marblehead and Ipswich as well. All records related to known cabinetmakers or furniture references at the Phillips Library at the Peabody Essex Museum were examined, with the assistance of librarians Irene Axelrod, Kathy Flynn, and Will Lamoy. We are particularly grateful to Jane Ward, whose knowledge of the library collection is unparalleled.

Our study of Essex County objects in local museums was facilitated by Judy Anderson and Karen MacGinnis, Marblehead Historical Society; Dean Thomas Lahikainen and Sarah Chasse, Peabody Essex Museum; Gerald W. R. Ward and Nonie Gadsden, Museum of Fine Arts, Boston; and Darren J. Brown, Beverly Historical Society. Susan Nelson was particularly helpful on Ipswich history, its furniture, and genealogy.

Much of Salem's finest eighteenth-century output has found its way to major museums throughout the country. Our examination of these collections was aided by Wendy Cooper and Bert Denker, Winterthur Museum; Elizabeth Barker, Mead Art Museum; Morrison Heckscher and Peter Kenny, The Metropolitan Museum of Art; Philip Zea and Josh Lane, Historic Deerfield; and Nancy Carlisle and John Childs, Historic New England.

The staff at the Massachusetts Historical Society permitted repeated photography of the ledgers, aided in the reading and interpretation of numerous early documents, and guided us through related manuscript records. Special appreciation is given to Elaine Heavy for coordinating visits and materials. Anne E. Bentley, Anna Clutterbuck-Cook, and Peter Drummey assisted with numerous research tasks. We are particularly grateful for Dennis Fiori's support of the project, including announcing the discovery of Nathaniel Gould's ledgers in major newspapers and periodicals.

The discovery itself necessitated reexamination of some furniture for possible Gould attribution. We are most thankful to the access and documentation provided by the following: Catherine Futter and Joe Rogers, Nelson-Atkins Museum; Kevin Tucker, Dallas Museum of Art; Tara Chicirda and Leroy Graves, Colonial Williamsburg; Emily Pope, Salem Maritime National Historic Site; Jonathan Prown, Chipstone Foundation; Kate Luchini, Lynn Museum and Historical Society; Chris Storb, Philadelphia Museum of Art; Debbie Rebuck, Dietrich American Foundation; Steve Pine and the late Michael Brown, Bayou Bend Collection; and Patricia E. Kane, Yale University Art Gallery.

Gould's ledgers presented a unique opportunity to tie his surviving work to the original customers. Auction houses and antiques dealers lent support in providing family histories, current contacts of consignors, and directing inquiries to present owners. They were generous in sharing what is often sensitive and jealously guarded information. We are indebted to dealers Clarence, Craig, and Todd Prickett for giving us the opportunity to document and research their great desk-and-bookcase and for sharing their extensive photographs and knowledge of Gould's similar work in museums. We also want to recognize the late Harold and Albert Sack, Frank and Dean Levy, Guy Bush, Don Heller, Stephen Score, and Deanne Levison, as well as Ronald Bourgeault of Northeast Auctions, Andrew Holter of Christie's, Leo Legare, Hudson Valley Auctions, and Leslie Keno and Erik Gronning at Sothebys for providing contacts and genealogical information. Their efforts helped obtain access to private collections and further documentation of ownership. Institutional libraries helped fill in missing genealogical information. We are grateful to Winterthur's Jeanne Solinski, Emily Guthrie, and Laurie Perkins; Historic New England's Richard Nylander; staff at the New England Historic and Genealogical Society; Rebecca Troy-Horton at New Hampshire State Archives; and Jessica Gill at Newburyport Public Library. Special recognition goes to Peabody Essex library director Sidney Berger for facilitating access to records during the relocation of the entire Phillips Library.

Gould's large export business created both a problem and an opportunity in writing this book. Elisabeth Garrett Widmer spent months matching account book entries to newspaper records of sailing dates. Joanie and Sam Ingraham took Betsy's compilation and spent additional months searching maritime records at the Phillips Library, adding to and refining the data summarized here in Appendix C. While much of Gould's export business was destined for the West Indies and probably did not survive, a significant amount was shipped to the southern colonies. Sumpter Priddy, Jim Pratt, and Graham Long of the Charleston Museum in South Carolina and Robert Leath of the Museum of Early Southern Decorative Arts (MESDA) helped run down all possible leads. Robert Barker, Anne Rogers Haley, and Adam Bowett gave valuable information concerning colonial export records available in England. Professors Ritchie Garrison at the University of Delaware and Christian Koot at Towson University disclosed pertinent references and their understanding of Britain's trade laws and their application to the colonies. Daniel Finamore's knowledge of the mahogany trade in the West Indies and Central America brought clarity to this intriguing aspect of Gould's business; he was assisted by Barbara Glauber. Our appreciation is extended to the Salem Marine Society for a grant that enabled Dan to study the Naval Office Records of the National Archives, United Kingdom—which helped him to produce his chapter "'Desks took on bord' in Nathaniel Gould's Caribbean Furniture Trade."

Special appreciation for this project is extended to furniture scholars and craftsmen Mark Anderson and Jennifer Mass of Winterthur; Luke Beckerdite; Gretchen Guidess; Al Breed; Alice and the late Tom Kugelman; and William Upton. Clark Pearce, Robert Lionetti, and Robert Mussey have worked with the authors for many years, sharing their knowledge of construction practices, answering questions, and comparing notes. Their support and patience facilitated the documentation of Gould's furniture in this book. In addition, Robert Mussey's offer to photograph every page in the ledgers provided images constantly referred to throughout the writing process. Lynne Paschetag confirmed the projected drop-leaf table price list by independent analysis. Glenn Adamson brought to the project his knowledge of European sources for Gould's furniture in the chapter "Behind the Curve: Putting Nathaniel Gould in Perspective."

We are particularly grateful to the Peabody Essex Museum, especially Lynda Roscoe Hartigan and Dean Thomas Lahikainen, for their support and confidence in our ability to complete this project despite the authors' unexpected health problems. Dean also contributed a chapter, "Grand Houses and Rural Retreats," that sheds great light on Salem during Gould's time. Nicole Pearson, Claire Blechman, Sarah Chasse, and independent designer Daphne Geismar and project editor Terry Ann R. Neff working under the direction of Kathy Fredrickson have coordinated all aspects of bringing this book to print. Gerald W. R. Ward provided invaluable advice and knowledge as reader prior to editing.

Finally, this book would not have been possible without the unwavering support and encouragement of our spouses, the late Fred King and Betsy Widmer, during a very difficult time for both of them personally. Betsy has contributed her knowledge of the eighteenth-century family as reflected through the decorative arts in the chapter "Brides, Housewives, and Hostesses: Acquiring, Using, Caring for, and Enjoying Mr. Gould's Furniture." She also has been unflagging in providing help on resolving many perplexing questions on genealogy and furniture history. We could not have completed the book without her assistance.

Kemble Widmer and Joyce King

NOTE TO THE READER

Nathaniel Gould's ledgers have been presented as faithfully as possible to the originals. Gould notations "Dr" (debit) and "Cr" (credit) generally right after the person's name indicate the type of transaction.

Entries in the first day book are in a Continental currency called "old tenor" (OT) and designated in pounds, shillings, and pence according to the British system (e.g., £2..5..8). Around June 1763, old tenor currency was revalued to "new tenor" (NT) at a ratio of 7.5 OT equal to 1 NT. To avoid confusion and facilitate comparisons, all transactions listed in the body of the text and in the Appendices have been converted to new tenor. The original ledgers would have included old tenor amounts until 1763. After 1776, rampant inflation existed throughout the colonies. English pounds, Spanish dollars, and Continental dollars all appear in the second day book and the account book, so they are listed as written with no attempt to interpret or convert to a common denominator.

In the body of the text, currency is listed as above in pounds, shillings, and pence. If only pounds are given, the form is abbreviated (e.g., £2). Side chairs were normally sold in sets and priced on a per chair basis in the ledgers; orders for multiples of other objects were similarly entered. The price was noted in shillings and pence, with no attempt to convert shillings to pounds (e.g., 25/4, meaning 25 shillings, 4 pence). In the body of the text, if only shillings or pence are given, the form is abbreviated (e.g., 25s. or 4d.).

Appendix A gives customers' names as spelled in the ledgers. In the rest of the book, spelling is based on Massachusetts probate records. In the body of the book, life dates are given for individuals who are not listed in Gould's Client List; all life dates are repeated in the Provenance section in the catalogue entries.

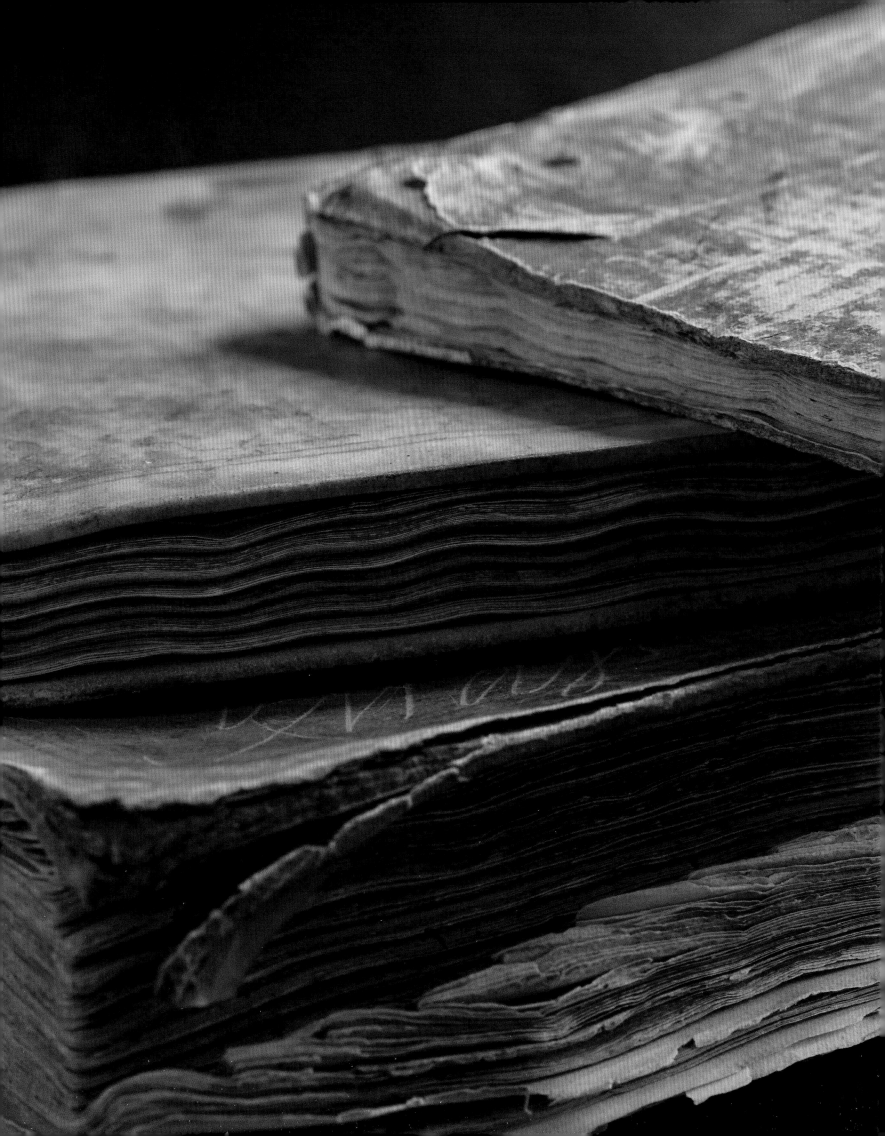

In Plain Sight

KEMBLE WIDMER and JOYCE KING

The recent discovery of the ledgers of cabinetmaker Nathaniel Gould (1734–1781) of Salem, Massachusetts, brings to light the career of one of America's most notable furniture makers and significantly enhances our understanding of business practices and social customs in coastal New England during the critical period of transition from a British colony to an independent nation. The search that led to the discovery began in March 2006 when a call was received from noted antiques dealer C. L. Prickett of Yardley, Pennsylvania, asking for assistance in researching a magnificent and rare bombé desk-and-bookcase recently purchased by the firm (cat. 7). Documentation provided by the seller noted that the piece had always been in the same Boston family and listed owners for the last four generations. Prickett was anxious to determine the original owner of what was clearly one of the supreme examples of eighteenth-century American case furniture.

The request was of particular interest because the desk-and-bookcase was part of a body of work that had been identified as originating in Salem, Massachusetts, based on shared construction details and family histories.[1] The Prickett desk (cat. 7) clearly belonged to this group, as did the much admired desk-and-bookcase given to the Metropolitan Museum of Art in 1909 (fig. 1, also cat. 8). In 1983, curator Morrison Heckscher discovered the signature "Nathaniel Gould" inside this latter desk (cat. 8), but its meaning was questioned because it was followed by the enigmatic notation "not his work" (figs. 2 and 3).[2]

While the ancestral tree for the Prickett desk-and-bookcase included prominent Bostonians dating back to the early 1700s, it was insufficient in establishing a specific original owner and subsequent line of descent. Nonetheless, one could make some assumptions about the information to help narrow the search. Boston was the leading mercantile, political, and cultural center of Massachusetts, with many skilled artisans and a population four times greater than the next largest town, Salem. It seemed highly unlikely that a prominent Boston family would purchase their significant furniture in an outlying town. Knowing that stylistically the desk was likely made in Salem sometime between 1750 and 1780, research was focused on lines of descent that passed through that town.[3] Two lines of inheritance intersected on a common ancestor, Joseph Cabot (1720–1767), a wealthy Salem shipowner and merchant, leading to speculation that he was likely the original owner.

Believing for a variety of reasons that Nathaniel Gould was the best candidate for having made the desk-and-bookcase, an internet search was conducted. His name appeared in the description of the recently catalogued papers of attorney Nathan Dane (1752–1835) of Beverly in the collection of the Massachusetts Historical Society. The end of the description read "and 3 account books of client Nathaniel Gould (1758–81)." Dane had settled Gould's estate in 1781, kept the ledgers, and donated them to the society in 1834. They would ultimately confirm the suppositions, the Prickett desk-and-bookcase had indeed been made by Gould for Joseph and Francis Cabot in 1765. Linking the ledger entries to surviving pieces of furniture allowed reconstruction of the remarkable career of Nathaniel Gould.

Nathaniel was the fifth child and first son of Nathaniel (1697–1746) and Elizabeth (French) Gould (1698–1746). He was born in South Danvers (now Peabody), probably in November 1734, where he was baptized on November 17. His father's occupation is variously listed on deeds as cabinetmaker, housewright, joiner, and yeoman. The family had a long history of being engaged in the wood trades. His

FIG 1
Cat. 8

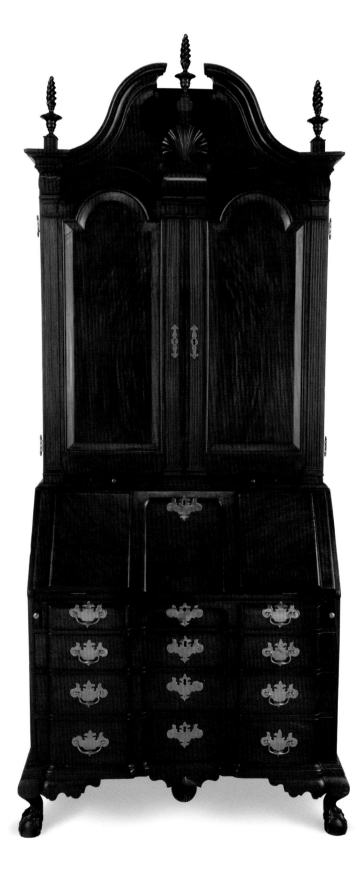

grandfather James (b. 1666), was a wheelwright, as was an uncle. Another uncle and two cousins were housewrights. In February 1746, when he was only twelve, Nathaniel's mother passed away, followed in December by his father, which left him and a younger brother orphans. Nathaniel was placed under the guardianship of his uncle James Gould (1696–1771), a wheelwright, on January 3, 1747.[4]

Although little is known about Gould's life for the next nine years, it must have included an apprenticeship under an excellent master cabinetmaker, probably in Boston or Charlestown, Massachusetts— perhaps even with his future father-in-law, Thomas Wood of Charlestown.[5] One year after coming of age, Gould sold his inherited share of his parents' property. At that time, he was listed as a cabinetmaker living in Charlestown.[6]

With the exception of one 1756 entry, Gould's first day book indicates that his business commenced in Salem in early 1758 when he was twenty-four.[7] He had probably moved and established his shop in Salem sometime in 1757. Late in that year, Gould had contributed £3..12..0 to the fund established for soldiers who had volunteered to defend Fort William Henry during the French and Indian War.[8] Although his gift was the least of any donor, he was probably the youngest contributor and the only cabinetmaker on the list. He may have been motivated by his cousin James Gould, who had volunteered for the expedition. Nathaniel's action served to introduce him to Salem society. More than half of the original donors—including members of the Derby, Cabot, Pickman, Dodge, and Higginson families—would become his clients.

Gould demonstrated his cabinetmaking skills his first year in business by producing a wide range of products, including a mahogany desk sold in March, and his first case of drawers (probably a flat-top high chest) in May to his uncle James. The output from his shop, while modest, included bedsteads, chairs, tables, and stands as well as lesser items such as servers, a knife box, gun stock, coffin, and clothes pins. Captain Samuel Grant accounted for his most significant first-year sale: a riding chair or chaise. Five other riding chairs or portions thereof were produced early in Gould's career, which served as mobile advertisements of his woodworking skills.[9] An important strategic move during this first year was negotiating the sale of desks and tables to ship's captain Crispus Brewer and merchant Robert Shillaber for export. Gould's export business accounted for his greatest profits over the next fifteen years and allowed him semiretirement as a gentleman.[10]

Furniture sales in 1758 totaled £115 and enabled Gould to hire the young cabinetmaker Thomas Brintnal West. Gould's business

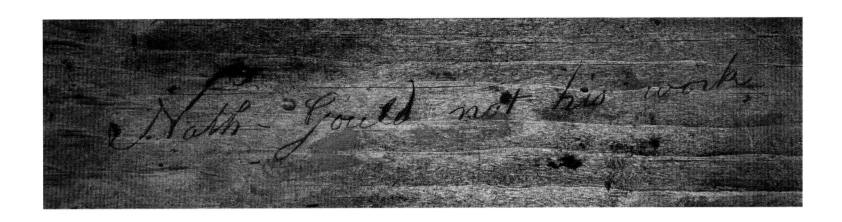

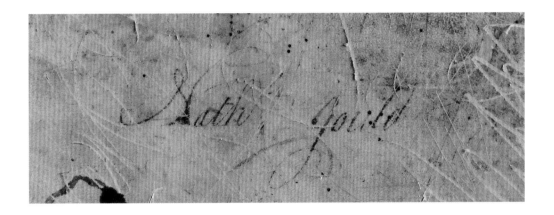

FIG 2
Detail of cat. 8 showing Nathaniel Gould's signature and the inscription "not his work"

FIG 3
Detail of Nathaniel Gould's Account Book showing his signature on the cover
Nathan Dane Papers, Massachusetts Historical Society, Boston

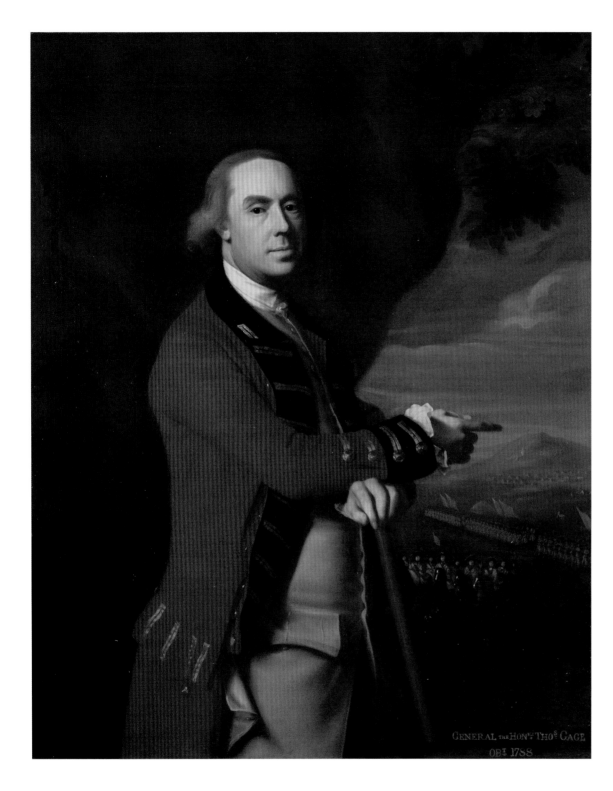

FIG 4
John Singleton Copley (1737–1815)
General Thomas Gage, ca. 1768
Oil on canvas mounted on masonite,
50 × 39 ¾
Paul Mellon Collection, Yale Center for
British Art, New Haven, Connecticut
(B1977.14.45)

increased dramatically in 1759: sales of £293 were 154 percent greater than the first year and a third of them were to ship's captains for export. Three large domestic orders included two for neighboring Marblehead wedding dowries,[11] as Gould had not yet penetrated Salem's elite merchant class. The wedding orders were to be delivered during the summer and his export commitments were tied to sailing dates. To help fulfill his obligations, he turned to John Cogswell of Boston, whom he undoubtedly came to know during his time in Charlestown.[12]

On April 24, 1760, Gould married Rebecca Wood (1739–1807) of Charlestown, daughter of cabinetmaker Thomas Wood. A significant business relationship with his father-in-law and his brother-in-law Thomas Jr. commenced that year. Gould supplied them with mahogany and walnut, furniture hardware, and a variety of commodities in exchange for finished furniture. Ninety-five percent of the furniture produced by the Woods for Gould were cedar desks for export.[13] By November 1761, Gould could afford half of a "mansion house" that he purchased from and shared with peruke maker John Ward (1707–1787). The Gould family would live in this house until April 1773.

The breakthrough in selling to Salem's leading citizens also occurred in 1761: members of the Brown, Crowninshield, and Cabot families made small purchases. Most important was the sale of a table to Hannah Clark Cabot, widow of Dr. John Cabot (1704–1749). That initial order was followed in 1762 by two more tables, a stand (tilt-top) table, side table, bedstead, and case of drawers (probably a bonnet-top high chest). Over twenty-one years, Gould would supply three generations of Cabots with furniture amounting to £660. Sales to the family continued until his death in 1781, and helped to keep his shop open during the challenging business climate of the revolutionary period.

Gould expanded his business during the 1760s and early 1770s; peak years were 1773–74. Export sales continued to be a major factor, but he also supplied most of Salem's noted families with furniture. The most significant event to generate purchase of a wide range of furniture was an upcoming marriage. Moreover, because Gould could produce chairs as well as case pieces in the latest style, he had a distinct advantage over competitors when a large, integrated order was needed. In addition to his prominent clients in Salem, Gould became a key supplier to Jeremiah Lee Esq. of Marblehead (at the time the wealthiest man in Massachusetts), Mark Hunking Wentworth of Portsmouth, New Hampshire, and Dr. William Paine of Worcester, Massachusetts. Less affluent families purchased bedsteads, desks, and chairs that were not constructed of expensive mahogany or walnut.

During the 1770s, Salem, like most other New England seaport towns, resisted the restrictive laws and taxes imposed by England's Parliament and their proxy in Massachusetts, Governor Thomas Hutchinson. Although its politics were less tumultuous than in Boston, the town quickly became divided between Patriots and Tories. Gould was diligent in avoiding association with either side. When forty-eight prominent Tories signed a letter to General Thomas Gage (the replacement for the detested Hutchinson) in support of Salem as the substitute trade port following the closure of Boston's port, two-thirds were Gould clients (fig. 4).[14] Indeed, Gage himself ordered bedsteads, tables, and a paper case from Gould after moving his headquarters from Boston to Danvers in May 1774. These purchases were probably at the recommendation of key crown sympathizers (and Gould customers) in Salem such as comptroller of customs John Mascareen Esq., customs collector Richard Routh, or wealthy merchant George Deblois. The following month, however, 123 people signed a letter to Gage repudiating the idea of Salem's port prospering as a result of Boston's closure, counteracting the Tory letter of support and indicating the town's 5:2 ratio of support for the Patriot cause. The list included the balance of Gould's customers, most of Salem's cabinetmakers, and his cousin James Gould. Nathaniel's name is absent from both lists.[15]

The winds of the impending war did not go unnoticed by Gould. In 1773, he had decided to sell his half of the family's residence. Early in 1774, he purchased two tracts of land that included a barn and farm, but nonetheless opted to rent a home for the rest of his life. The sale of his house was particularly fortuitous because it was destroyed in the great fire of October 1774, which had started in the warehouse of his next-door neighbor, Peter Frye Esq.[16]

The onset of war was devastating to Salem's economy and to most of its craft trades. British laws banning business with non-British colonies in the West Indies severely hampered the free trade that had been practiced by Massachusetts shipowners for one hundred years. Successive attempts by the crown to raise money through taxation of the colonies resulted in the Stamp Act, the Greenwich Hospital tax, and the Coercive Acts. Additional taxes on items such as tea, glass, and other English imports resulted in the colonies uniting to impose a nonimportation agreement, further damaging the economy but increasing the population's resolve to resist. Export furniture, which for Gould had averaged £110 per year between 1770 and 1774, fell by 64 percent in 1775 and was virtually eliminated for the rest of the war.[17] Inflation was an additional challenge. Any consistency of pricing was lost in an

effort to make a profit when costs were increasing at an alarming rate and future expenses were uncertain. There is also some evidence of customers refusing to pay inflated prices.

Gould probably turned over daily operations of the cabinet shop to an unidentified journeyman cabinetmaker around 1776. His thirteen-year-old son Nathaniel Jr. was probably too young to assume the responsibility, although he may have done so later. This assumption is based on a radical change in the ledgers after 1776. Whereas daily entries had meticulously identified each component of an order—its price, often the wood used, and in the case of the tables, overall length—this practice ceased. A number of orders contain no unit or total pricing for the individual items. Table length and the type of wood were seldom noted. Prices listed in the day book were often changed in the account book. This may have been the result of inflation or customers negotiating a different price, but there is also evidence of sloppy record-keeping. Two notable examples are of furniture being sold for less than the price paid to a subcontractor, and another case when a set of chairs was omitted from the overall price of an order. Seeing the degradation of the business he had worked so hard to build must have been difficult. Nathaniel Gould passed away in December 1781 in Rutland, Massachusetts, at the relatively young age of forty-seven.

The Gould ledgers consist of his account book and two day books (1758–63 and 1768–83). There are a host of reasons why they are so valuable to our understanding of eighteenth-century cabinetmaking practices. Principally, they provide two critical pieces of information seldom available to furniture scholars: dates of transactions and specific customer names. Moreover, that data is recorded for nearly his entire working career. The day books (also called waste books) list daily transactions for furniture and commodities. Cash and credit notations are in chronological sequence. The first day book (1758–63) begins in April 1758—probably around the time when Gould arrived in Salem from Charlestown, or at least the date when he established his own shop. Debits are entered on the left pages and credits on the right, with the latter often blank. Entries include the customer's name, a description of the items, the quantity sold, and the price. Bookkeeping was not always rigorous, and sometimes numerous entries for a date appear in the left-hand margin. Varied, sometimes illegible handwriting indicates numerous people made entries. As with most eighteenth-century documents, spelling is inconsistent.

The second day book (1768–83) begins in January 1768 and closes with transactions as late as August 1783. Since Gould died in December 1781, it was probably continued by his son, Nathaniel. Undoubtedly, a

day book documenting work between May 1763 and January 1768 once existed. In the second extant day book, Gould made an effort to conserve expensive paper by posting credits and debits chronologically on the same page, differentiating them by "Dr" (debit) and "Cr" (credit) generally right after the person's name. Additionally, if the first word in the description line is "To," it is a debit transaction; "By" indicates a credit.

The larger account book or ledger (1758–83) begins alphabetically, with a portion of each page devoted to a single client. If the client paid for a purchase in cash and had no outstanding balances, there would be no entry in the account book. Entries record only goods sold on credit or a customer's oustanding credit balance. The left page was for sales (debits) to a customer, whereas the right was for credit transactions, whether cash or goods received as payment. Generally, the entries mirror those in the day books, but they frequently contain additional information. Also, the account book partially documents the gap of 1763–68, for which no day book exists. Although it includes only sales made on credit, determining the ratio of cash sales to credit transactions permits an estimate of Gould's overall production during that five-year period. Furthermore, credit transactions in the account book are accurate and thorough; they served as the basis for settlement of accounts during Gould's life and also for estate purposes. They provide information regarding cabinetmakers working directly for Gould. They also document what he received as payment in Salem's barter economy. The prices at which Gould bought and sold commodities such as molasses or sugar indicate the level and profitability of his business transactions.

Between 1758 and 1776, Gould's pricing was remarkably consistent, which permits the comparison of form and decoration in like items manufactured a decade or more apart.[18] For example, if a table described as a four-foot mahogany table was priced at £2..13..4 in 1760 and the same price was charged in 1774 but the description specified only a four-foot table, it may be assumed to have been mahogany. In addition, this pricing consistency allows the researcher to determine when styles changed, the most prominent example being the switch from bombé to block-front façades in cases of drawers. However, after 1776, with the outbreak of the revolution and the issuance of Continental currency not backed by hard specie, the worst inflationary spiral in American history ensued. The price of Gould's most popular stand table, constant at £2 for seventeen years, increased by 650 percent between 1776 and 1778. Comparison analysis is not possible.

The ledgers also shed considerable light upon the organization and staffing of an urban cabinetmaker's shop. Gould engaged at least

twenty-two journeyman cabinetmakers, either as employees or as sub-contractors working on a per-piece basis. A careful review of the age and working dates of his craftsmen suggests who may have apprenticed with him. Five highly skilled cabinetmakers who did extensive work for Gould have been identified. Only one of the five, Jonathan Ross, has surviving work associated with him. The remaining four were virtually unknown until discovery of the ledgers.[19]

Because only a few individuals who had formal schooling probably made entries in the account book, it was treated as the authority in cases of a discrepancy. Day book entry dates were judged to be sale dates.

The separation of Gould's business with respect to export and domestic sales of furniture was an important element. A significant portion of the shop's output was intended for export, and began much earlier than the generally recognized starting date of about 1790 for Salem's furniture export business. Since the ledgers list the date and purchaser, a search of customs clearances and newspaper listings of sailing departures has made it possible to determine the general destination of many of these sales. Of the more than two hundred orders for furniture that were probably exported, more than half could be connected to a sailing departure date, the name of the ship, its tonnage, and the general, if not specific, destination.

The guidelines for determining whether an order was exported or used domestically was a challenge. Gould noted "cased" for transactions in which he constructed a shipping container. If the sale was made to a known ship's captain or merchant, it was considered an export transaction. However, a sale to someone not engaged primarily in maritime activity entailed identifying where the person lived. Rough roads required crating for shipments traveling more than a few miles from Salem. In addition, wood was a determining factor. Much of Salem's maritime activity was directed to the tropical West Indies, and furniture made from insect-resistant cedar was checked against shipping registers to determine likely export.

The ledgers have helped significantly in linking objects with both maker and original purchaser. At present, there are twenty-seven Gould-attributed items of furniture in major museum collections.[20] Of that total, only two chairs at the Metropolitan Museum of Art in New York had previously been identified with an original owner and probable date of manufacture: a pair of side chairs from a set purchased at the time of the marriage of Sarah Orne (1752–1812) to Clark Gayton Pickman. The Gould ledgers disclosed who bought these chairs and the date they were shipped, as well as other items in Orne's substantial furniture dowry. Since the discovery of the Gould ledgers, an

additional two chairs and three case pieces in museum collections and seven chairs and five case pieces in private hands have been attributed to his shop.

Finally, the ledgers have increased our understanding of eighteenth-century life in Salem. By comparing manufacturing dates with milestones in a customer's life, it was possible to determine the circumstances precipitating an order, be it a ship leaving for the West Indies, a wealthy merchant moving to a new house, or a client providing a dowry for his daughter.

When the young Nathaniel Gould started his shop, he had no known connection to Salem's tightly knit aristocracy. Abraham Watson (1712–1790) had been the town's most prominent cabinetmaker for at least twenty years, and greatly influenced the construction of furniture produced there.[21] His shop had produced the finest Queen Anne–furniture since 1737, but he was easing into retirement and serving as a town selectman and surveyor of boards at the time Gould was opening his shop. The position as Salem's cabinetmaker of first rank was available.

In addition to Watson's retirement, other factors contributed to Gould's success. First and probably most important, Gould was an excellent businessman. Even before arriving in Salem, he laid the groundwork for his business by selling his inherited land in South Danvers, and delayed family life. When he did marry, it was into a furniture-making family. Additionally, his burgeoning relationship with the shipping trades enabled him to purchase bulk commodities such as sugar from the West Indies in exchange for his furniture built for export. He quickly established himself as a supplier of those commodities on favorable terms to other joiners, upholsterers, and chairmakers whose services he needed to rapidly expand his business.

Gould also thrived because he probably was instrumental in introducing the new, fashionable Chippendale style to Salem. His estate inventory listed Thomas Chippendale's *The Gentleman and Cabinet-Maker's Director*, probably the third edition published in 1762.[22] However, he had evidently established important connections to London's furniture design community prior to this time. Strong circumstantial evidence exists that Gould obtained a plate from Robert Manwaring's *The Cabinet and Chair-Maker's Real Friend and Companion* as early as 1762, fully three years before formal publication of the pamphlet in London (1765), and four years before it was offered in Boston by bookseller John Mein.[23] In all likelihood, Gould probably arrived in Salem with a portfolio of Chippendale's designs and was also undoubtedly influenced by the prominent Boston chairmaker James Graham

(1728–1808), whose designs he closely followed. No surviving Queen Anne–style furniture has been attributed to Gould. His production appears to have completely embraced the new style.

Because Gould's ledgers are probably unique in covering virtually the full career of one of the most skilled craftsmen of his time, their discovery is of great significance for the study of not only eighteenth-century cabinetmaking, but also the economic and social life of colonial Massachusetts. The meticulous records include names of both prominent and ordinary citizens, detailed descriptions of the objects sold when a new fashion in furniture was introduced, and reliable and consistent pricing of items. Based on an in-depth analysis of the ledgers from multiple vantage points, this present book lays the groundwork for a broader understanding of the cabinetmaker's work, but the value to scholars of these documents only begins with its publication. The ledgers provide rare opportunities for ongoing comprehensive research exploring multiple aspects of eighteenth-century life in Salem.

1. See Lovell 1974, pp. 120–25 and Vincent, G. 1974, pp. 192–95.

2. Heckscher 1985, pp. 276–79.

3. Known ancestors during the period 1752–90 were checked for birth, marriage, and death dates, and places of residence (to determine probates and wills). Research focused on family lines connected to Salem between 1755 and 1800. Desk-and-bookcases listed in inventories prior to 1755 were discounted. Two separate lines of Paine-Metcalf ancestors originated with very prominent Salem families including the Cabots, Ornes, Higginsons, and Dodges. These families had numerous intermarriages and many had relocated to Boston by the early 1800s, which accounted for this desk-and-bookcase's Boston provenance.

4. Nathaniel Gould is described as a "joiner" in several land transactions. See Ebenezer and Deliverance Marsh to Nathaniel Gould, June 17, 1727, Essex County Deeds (hereafter ECD), vol. 46, p. 202. See also Daniel Cariel and wife, Mary, to Nathaniel Gould, November 6, 1729, ECD, vol. 53, p. 184; for Gould's guardianship, see Probate Records of Essex County, Massachusetts (hereafter PREC), January 1, 1746/47, docket 11415.

5. The simplest assumption is that Gould apprenticed with Thomas Wood and became an example of a live-in apprentice marrying the master's daughter. However, entries in the day book question that hypothesis: Gould must have learned how to make the bombé form when he worked in Charlestown or Boston. There is no evidence that Wood supplied upscale case pieces to Gould, but was assigned relatively straightforward cedar furniture and only rarely delivered mahogany forms. There is also a question of the quality level delivered to Gould by Thomas Wood and his son because of a number of entries for back charges.

6. Nathaniel Gould of Charlestown, cabinetmaker, to John Clemens, December 25, 1756, ECD, vol. 104, p. 61.

7. In the middle of the first day book is a transaction for two tables sold to Moses Paine in September 1756, evidently while Gould still resided in Charlestown. This transaction is not in chronological order and appears to have been posted at a later date.

8. Phillips 1969, pp. 204–10. Gould's donation exceeded three weeks' wages for a journeyman cabinetmaker, reference pay of Thomas West: 22s. 6d., for seven days' work March 1759, The Royal Governor in Massachusetts had earlier authorized enlistment bonuses for militia recruited to defend the fort, which was threatened by the French General Montcalm and a large body of Indians at Fort Ticonderoga. A number of Salem militia were killed or captured when the garrison

capitulated in August. On hearing the news, a great alarm was raised throughout Massachusetts to defend the frontier—from Albany to Springfield. However, Montcalm withdrew his forces to Canada after his decisive victory, and the threat passed for that year. The Massachusetts government reneged on the original promise to enlistees, so local citizens pitched in for the Salem recruits.

9. Components of a riding chair or chaise were sold to John Ives on July 1, 1758, and included a chair body (the wooden portion of a riding chair), the cost of painting the body, a wing, trimming (probably upholstery), brass nails, and a pair of springs. This sale was followed in August by a riding chair to Josiah Cheever for £100. The following month, Samuel Grant purchased a riding chair; Samuel Calley bought a chair body (evidently preferring to complete it himself) on June 17, 1760; Jonathan Cook purchased both a chaise for £215 and a riding chair for £120 on April 3, 1761; the last chaise built by Gould was sold on April 15, 1768, to Nehemiah Clough.

10. In a deed filed March 3, 1761, Gould, called a "cabinetmaker," purchased half a mansion house from John Ward. ECD, vol. 10, p. 126. He sold his portion of the house and a barn on April 18, 1773, when he is also listed as a cabinetmaker. ECD, vol. 133, p. 236. His next purchases were for land owned by John Beckford in 1774 and 1775. The deed transfers for the two properties list his occupation as "gentleman," an indication he was easing into retirement. The term was generally applied to individuals who were no longer dependent on their craft for a living. ECD, vol. 133, p. 191.

11. A large amount of furniture was delivered to John Tasker between April and June 1758 for the wedding of his daughter Deborah to James Freeman in October 1758. The second marriage order was delivered on August 18, 1758, to Tabitha Skinner for her marriage on September 27 to Thomas Gerry of Marblehead.

12. Mussey and Haley 1994, pp. 73–107. Cogswell may have trained in the Charlestown shop of Timothy Gooding. He was entrusted with making a chamber table and matching case of drawers (high chest), at least five tables, a bedstead, four stand tables, and eight desks, one of which was probably bombé. No other joiners who performed occasional subcontract work for Gould were given a furniture order of mahogany of this complexity.

13. Massachusetts Vital Records (hereafter MVR) Charlestown marriages of April 24, 1760. Debit entries for Thomas Wood, January (no date given), June 1 and November 6, 1761.

14. See Phillips 1969, p. 324.

15. Ibid., pp. 325–27.

16. Ibid., pp. 340–42.

17. For the British government's repressive measures leading up to the revolution and their particular impact on Salem residents, see Tagney 1989, pp. 31–109.

18. The best example is the ordinary stand table (tilt-top table with three legs) made of mahogany. The 1758 price of £2 remained constant for seventy tables Gould sold over the next seventeen years. Drop-leaf tables also exhibited consistent pricing. Using data covering the variables that would influence table prices—shape, size, type of wood, type of foot—a matrix was constructed that covered 88 percent of the mahogany and walnut examples sold by the shop between 1758 and 1777 (see Tables, fig. 1). They showed no variation in prices.

19. The four key employees are Philemon Parker, Theophilus Bacheller, William Holman, and John Ropes Jr. See also Tapley 1934.

20. Gould-attributed desk-and-bookcases are in The Metropolitan Museum of Art (cat. 8); Mead Art Museum (acc. no. AC 1945.433.a, b); and Bybee collection at the Dallas Art Museum (acc. no. 1985.B.27.A-B); a chest-on-chest is in the Nelson-Atkins Museum of Art (cat. 3); chests of drawers (four-drawer chests) are in the Marblehead Historical Society (cat. 1); Historic New England (cat. 2); Winterthur Museum (acc. no. 1957.0509, cat. 2, fig. 3); and Museum of Fine Arts, Houston (acc. no. B69.136); chairs using Manwaring-designed splats are in the Peabody Essex Museum (cat. 14); Lynn Historical Society (acc. no. 6358); Historic Deerfield (2) (acc. nos. 59.070.01, 02); The Metropolitan Museum of Art (2) (cat. 15); Museum of Fine Arts, Boston (acc. no. 61.389); Massachusetts Historical Society (acc. no. S32.60); Colonial Williamsburg; and Winterthur Museum (acc. no. 56.52); a pair of chairs with Gothic arch splats are in the Winterthur Museum (cat. 13) and a single chair is in the Museum of Fine Arts, Boston (acc. no. 2004.2062); C-scroll and diamond splat armchairs are in Historic New England (cat. 10); and Museum of Fine Arts, Houston; desks are in the Museum of Fine Arts, Boston (acc. no 41.574); and the

Philadelphia Museum of Art; a drop-leaf table is in the Chipstone Foundation; a side table (single drop-leaf) is in Yale University Art Gallery (cat. 17).

21. This conclusion is based on the study of more than one hundred case pieces originating in Salem during the mid-eighteenth century. Cases of drawers attributed to Watson by the author are in the High Museum, Atlanta, and the Huntington Museum, San Marino, California. A chest-on-chest is in the Peabody Essex Museum.

22. Gould's estate inventory included Chippendale's *Director*. The pair of chairs in the Winterthur collection cited in endnote 20 are copies of a plate that appears only in the 3rd edition (1762).

23. *Boston Evening-Post*, October 13, 1766.

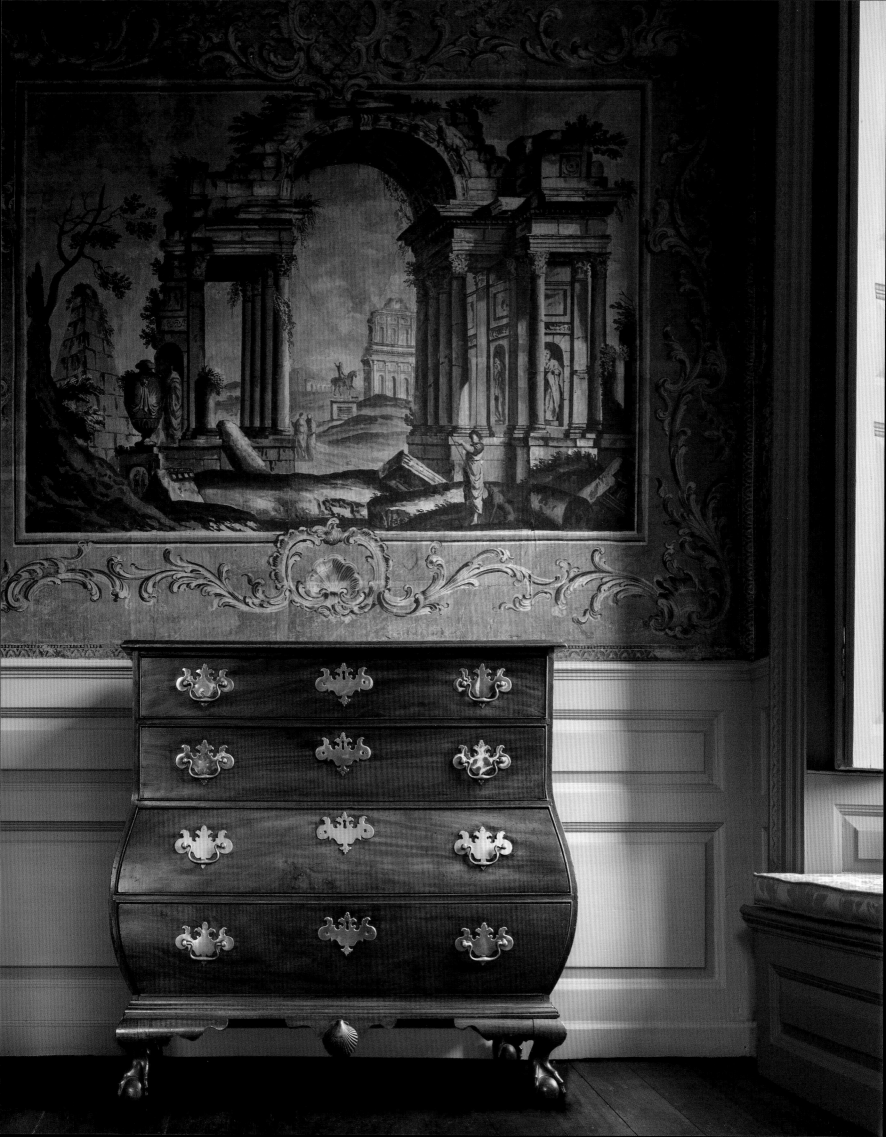

Behind the Curve

Putting Nathaniel Gould in Perspective

GLENN ADAMSON

There is an object in the collection of the Victoria and Albert Museum that hovers somewhere between the conditions of furniture and sculpture (figs. 1 and 2). Conceived by the Dutch designer Jeroen Verhoeven when he was startlingly young (it was his graduation piece from the Design Academy in Eindhoven), it takes advantage of the very latest technology, but also addresses the deep past of furniture. Though visually complex, the premise is simple. Verhoeven took two eighteenth-century furniture forms—a dressing table on cabriole legs, and a serpentine commode—and then charted paths between their profiles, point to point, using digital rendering software. This program was then used to guide an automated router, which carved a blank of stacked plywood into a rough approximation of the digital map. Further handwork by a team of artisans brought this shape into a gorgeously voluminous final form. Verhoeven called his creation *Cinderella Table*, thinking of the transmutation of the pedestrian into the magical. He had shown that "robots, though soulless, can create a thing of beauty."[1]

This extraordinary example of recent design may seem an unexpected portal into the topic of Nathaniel Gould. Yet, this maker from eighteenth-century Salem, Massachusetts, was trying to achieve in his own day something comparable to what Verhoeven has in ours. The parallels are several. First and most obviously, both furniture makers created objects at the very limit of contemporary technique. Gould had no digital modeling tools at his disposal, but he was among the earliest craftsmen in America to interpret the bombé form (cat. 1). This challenging shape requires the maker to fashion curves in thick, solid planks—and to do so with sufficient precision that the finished piece will be perfectly symmetrical. Despite the spectacular quality of Verhoeven's *Cinderella Table*, one could say that Gould's handwork is in fact the more impressive.

A second parallel is that both makers explored the sculptural possibilities of furniture. Viewed from the front, Verhoeven's table refers to historic functional objects, but from the rear it looks almost abstract, or perhaps like the drapery seen on marble statues by the likes of Gianlorenzo Bernini. Gould, too, was a maker with an extraordinary sense of sculptural form. With the exception of decorative features like cabriole legs and scrolling cornices, American case furniture of his date was predominantly rectilinear. The bombé form, by contrast, featured a gentle curve running along its flank, fluid and lyrical in effect. To quote the famous lines of William Hogarth, this "line of beauty" offers pleasurable variation, and "leads the eye in a wanton kind of chase"(fig. 3).[2] This effect is abstract in itself, but just as Verhoeven's billowing table refers to figural sculpture, there is an implicit anthropomorphism in Gould's work. As design historian Ethan Lasser has pointed out, the swelled forms of bombé furniture resemble the silk-garbed, swelling bellies of prosperous New England merchants like Jeremiah Lee Esq., one of Gould's best clients (figs. 4 and 5).[3]

A third and final point of connection between Gould and Verhoeven may be less obvious, but from a furniture history point of view it is perhaps the most intriguing. Both are operating at the site of encounter between the flat and the volumetric. Verhoeven

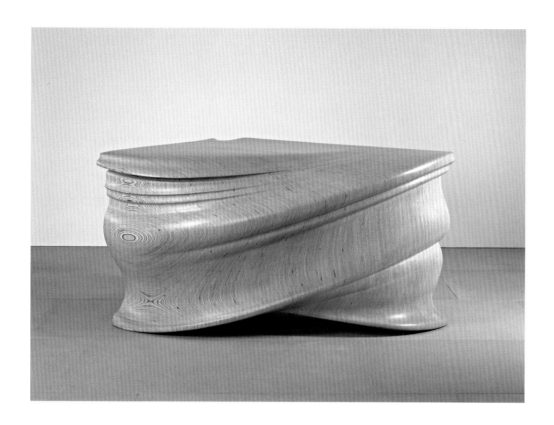

[OVERLEAF, CAT 1]
Photographed in Jeremiah Lee Mansion
(ca. 1766–68), 170 Washington Street,
Marblehead, Massachusetts. Marblehead
Museum and Historical Society Historic
House Collection.

FIG 1
Jeroen Verhoeven (b. 1976)
Cinderella Table, designed 2005
Birch plywood, H 31 ¾; W 51 ¾; D 39 ⅜
Victoria & Albert Museum, London
(W.1-2006)

FIG 2
Fig. 1 rear view

FIG 3 [RIGHT]
William Hogarth, *The Analysis of Beauty*
(Published by J. Reeves, 1753), plate 1
Digital Library for the Decorative Arts and
Material Culture, University of Wisconsin,
Madison, Wisconsin

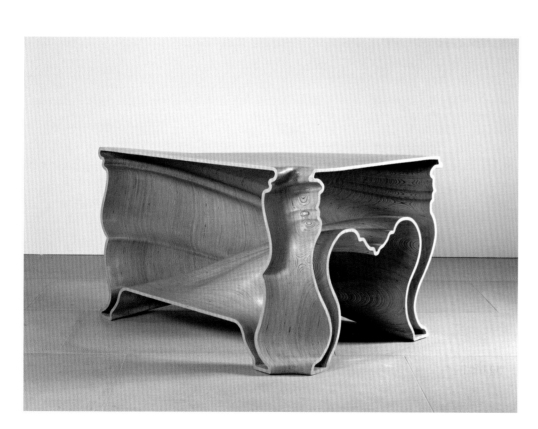

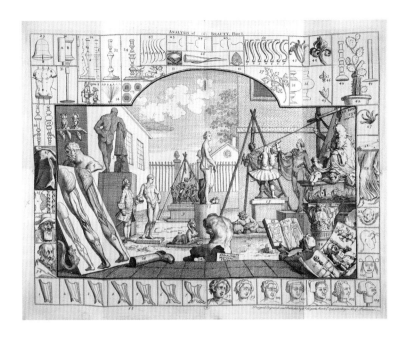

used two-dimensional silhouettes as the groundspring for a fabulously complicated three-dimensional shape. In Gould's case, the two-dimensional anchor was not a simple line drawing, but rather an imported pattern book, which would have provided him with a complete ornamental language. Among New England cabinetmakers, he is notable for the swift processing and deployment of such imported designs from sources like Thomas Chippendale's *The Gentleman and Cabinet-Maker's Director* (London, 1754) and Robert Manwaring's *Cabinet and Chair-Maker's Real Friend and Companion* (London, 1765). In fact, Gould appears to have owned a plate of Manwaring's design by 1762. He is known to have produced chair designs from Manwaring with remarkable fidelity—a practice more common in other American centers, such as Philadelphia and Charlestown, South Carolina. Chippendale pictured in *Director* what he called a "French commode," and it is possible that this image provided Gould the impetus to adopt the form (fig. 6). But, compared to his use of a pattern for a chair back—which is that unusual thing in colonial America, a straight rendition of an imported print source—Gould's case furniture does not emulate Chippendale very faithfully. We should therefore consider other sources, which range from the local to the transatlantic. The pulpit made for the First Church in Ipswich in 1749 is among the first New England examples; the earliest dated example from the Boston area is a desk-and-bookcase made in Charlestown in 1753, only six years before Gould introduced the form to Salem.[4]

The real origins for the bombé form, however, were across the ocean. As Gilbert T. Vincent noted in a pioneering study in 1974,

the earliest European case furniture to have a "swelled" shape were Italian *cassone*, themselves based on Roman sarcophagi, but the proximate sources for New England bombé furniture were more recent: the Baroque movement of the seventeenth and early eighteenth centuries.[5] The leading innovators were German and French cabinetmakers, working in close aesthetic rapport with expressions in architecture, silver, ceramics, and glass. In all these media, full-bodied vessel forms and "ogee" curves (as they were called at the time) became current in the early eighteenth century. This was a departure from the more restrictive Classical orders that dominated design in the previous century, but not yet the wildly exploratory, accretive language of the Rococo.

Bombé shapes presented cabinetmakers with a particular technical challenge. While volumetric curves are comparatively easy to render in plastic media such as clay and glass, it is much more difficult to realize such designs using the board-and-joint logic of furniture. One question concerned the drawers: Should they be straight-sided boxes? Should their profile match the curvilinear sides of the carcass? Or should they be a bit of each—boxes with false fronts that extend to the case edge? American makers largely chose the second option, the most difficult to make, but in the early development of the Baroque bombé form, the typical solution had been to attach a completely separate curved piece to the side of the case, a little like a sculptural fender on a straight-sided automobile. An early example from England or Germany, a desk-and-bookcase from about 1735, which also features modish red japanned decoration, was built in this way, as is clearly evident when seen from the back (figs. 7 and 8).

As the bombé chest entered its height of fashionability in the 1740s, other constructive solutions and compositional ideas proliferated. Cabinetmakers in Dresden fashioned thickly modeled, plastic forms, or set bombé contours in relief against the backdrop of a flat façade of drawers.[6] *Ébenistes* in Paris and in the Low Countries achieved still more sophisticated shapes, which curve simultaneously in a "double serpentine," so that the front and sides of the object curve across two axes simultaneously.[7] These are perhaps the quintessential expression of Baroque design in case furniture, and were made still more remarkable through the addition of marquetry, figured veneers, or even more dramatic decoration. One commode attributed to Bernard Vanrisamburgh II (1697–1767) is decorated not with japanning, but real Japanese lacquer panels taken off an imported box or screen (fig. 9). It is a breathtaking object, both for its technical brilliance and its lack of deference to the original Asian piece. The lacquer panels have been sawn in half (so that both faces could be used in

FIG 4
Detail of cat. 2 showing bombé curve

FIG 5
John Singleton Copley (1738–1815)
Jeremiah Lee, 1769
Oil on canvas, 95 × 59
The Ella Gallup Sumner and Mary Catlin
Sumner Collection Fund, Wadsworth
Atheneum Museum of Art, Hartford,
Connecticut (1945.58)

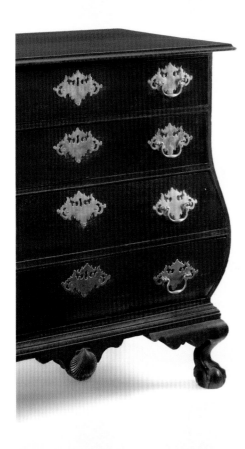

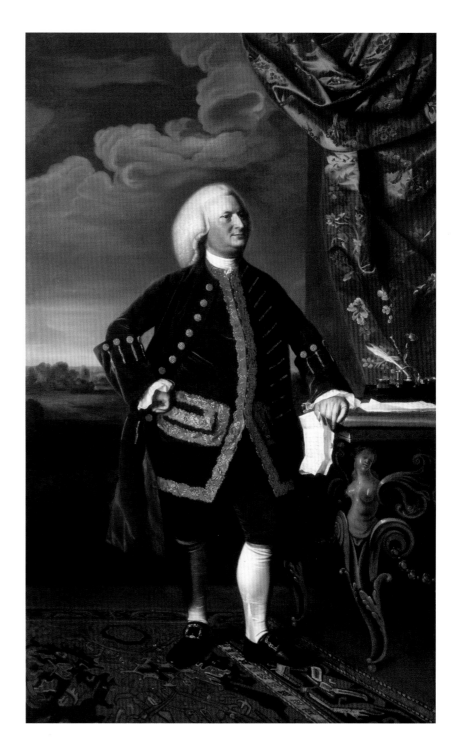

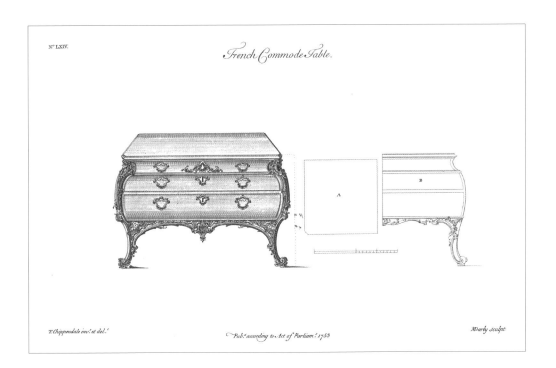

No. LXIV.

French Commode Table.

T. Chippendale inv.t et del.t Pub.d according to Act of Parliam.t 1753 Darly sculpt

FIG 6
Thomas Chippendale, *The Gentleman and Cabinet-Maker's Director,* 3rd edition (Printed for the Author, 1762), plate 43
Phillips Library, Peabody Essex Museum, Salem, Massachusetts

FIG 7
Bureau Cabinet (Desk-and-Bookcase), ca. 1735
England or Germany
Wood, japanned, with engraved brass mounts, H 76 ⅛; W 25 ½; D 10 ¼
Victoria & Albert Museum, London, Bequeathed by Sylvia Maud Cowles in memory of her brother John George Thorn-Drury (W.8:1 to 9-1972)

FIG 8
Fig. 7 rear view

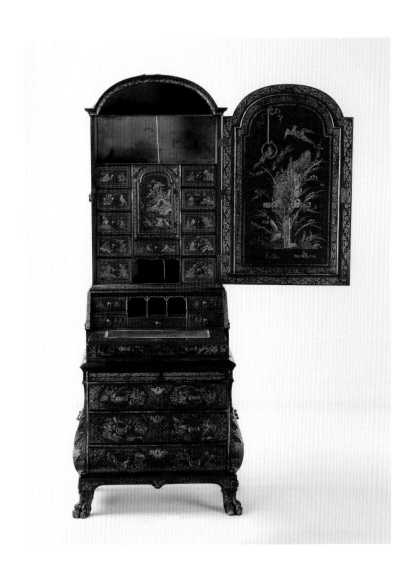

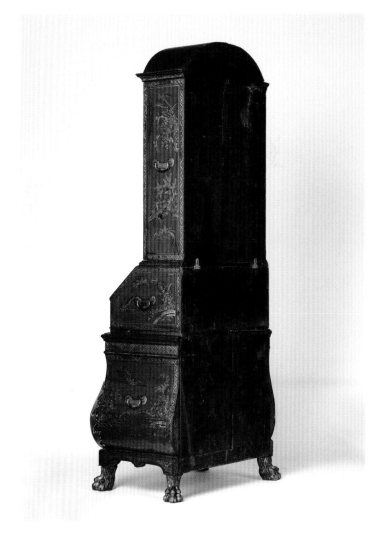

this way) and then planed down, making them thin enough to be cut through and then applied to the façade and sides of the case.

By the middle of the eighteenth century, bombé design had entered the mainstream of continental cabinetmaking technique. One could not call any interpretation of the form straightforward, given the difficulties of manufacture, but heavy-bottomed single-serpentine chests became a typical product across Europe by the 1760s, including in places with relatively independent cabinetmaking traditions such as Spain and Portugal (figs. 10 and 11).[8] Inevitably, the form reached England. As Lucy Wood has shown, commodes with serpentine fronts began to be made there in the 1740s, largely by immigrant makers, and many full bombé objects following French models survive from the period 1750–90.[9] Typically, these were fabricated with straight-sided drawers mounted in a massive frame built up from deal, which was covered with decorative marquetry.

How did this design language migrate to North America? No specific instances of transmission have yet been located, but it seems probable that bombé forms were introduced via imported objects, rather than print sources. As mentioned earlier, the renditions made by Gould and other craftsmen in Massachusetts are notably reductive in comparison to designs such as the one provided in Chippendale. In this respect, they are consistent with most other American interpretations of ambitious European furniture. Colonial craftsmen are often praised for their aesthetic restraint; today, many people find the simple sculptural forms of Gould's work to be preferable to the extravagance of Parisian court *ébenisterie*. This is essentially a prioritization of substance over style. Rather like John Townsend and associated craftsmen in Newport, Rhode Island (whose objects are likewise acknowledged as high points in the history of American furniture), Gould relied on proportion, cleanness of silhouette, and high-quality wood to make his furniture desirable. Instead of elaborate veneered surfaces, he used solid hardwood boards, lending the case pieces a simple, physical presence. As a leading importer of mahogany with access to the best boards for his own use, Gould had a competitive advantage. His reliance on fundamentals extended to his use of decorative embellishment—what little he did use. When Gould placed a single carved scallop shell just so, at the midpoint of the skirt on a chest of drawers, he was distilling a tradition of ornament that began with grand collector's cabinets made in Antwerp, which were festooned with coral, minerals, and shells of all description.[10] These lavish productions materialized a wide-ranging narrative of global exploration, natural history investigation, and courtly collecting. Gould's shell, in contrast, is a single well-judged punctuation mark.

Yet, we should not overstate the case for what scholars have in the past described as "simple city furniture."[11] Partiality for this unadorned style is itself ahistorical, and what we see as clarity of workmanship can just as plausibly be ascribed to a limitation of craft resources. A Parisian cabinet was the work of many different shops—specialists in joinery, carving, brass ormolu, veneering, finishing. This artisanal culture was managed by still other professionals, *marchands merciers* who orchestrated the manufacturing process and coordinated the placement of objects into aristocratic homes.[12] Given a greater concentration of wealth among their clientele, no doubt cabinetmakers in American cities would have tried to follow suit, much as their counterparts in London did through highly capitalized firms such as Seddon or Gillows, early examples of what design historian Pat Kirkham calls "comprehensive manufacturing firms."[13] Indeed, this is exactly what did happen in America after 1800, when leading makers in New York such as Duncan Phyfe scaled up their businesses and worked extensively with subdivided labor.[14]

FIG 9
Bernard Vanrisamburgh II (1697–1767)
Commode, 1760–65
Paris
Oak, lacquer, and gilding,
H 34½; W 56¾; D 24⅜
Victoria & Albert Museum, London,
Bequeathed by John Jones (1105-1882)

FIG 10 [ABOVE RIGHT]
Chest of Drawers, late eighteenth century
Netherlands
Walnut with fruitwood,
H 30½; W 34½; D 20½
Location unknown

FIG 11 [BELOW RIGHT]
Chest of Drawers, late eighteenth century
Portugal
Rosewood, mahogany, and brass fittings,
H 39; W 53⅛; D 25⅝
Museu Nacional de Arte Antiga, Lisbon
(Inv. 646 Mov)

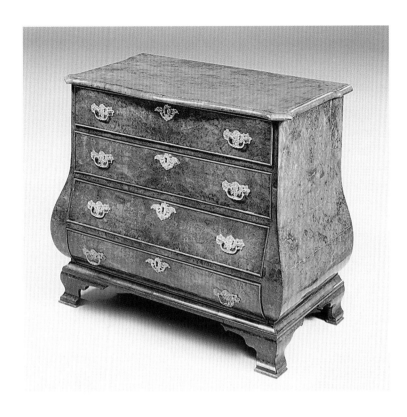

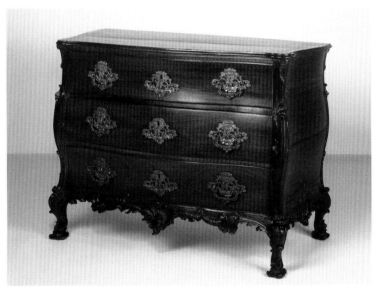

It is equally possible to exaggerate the refined taste of colonial clients.[15] We know that the wealthiest families in Salem, the same class that patronized Gould, were importing luxuries such as British silver and cut glass, as well as European silks, which are displayed prominently in the portraits they commissioned from local painters. One of the great advantages of historical hindsight is that what was considered to be "good, better, or best" in the past has no necessary equivalent to our own preferences. The juxtapositions drawn here—in which one of Salem's finest makers is contrasted with the most complex and ambitious European furniture producers—makes it clear that even though his home town was unusually connected to global circuits of exchange by North American standards, Gould's world was a relatively small one. His work necessarily took shape within circumscribed possibilities of composition, cultural reference, and materiality. Yet, the simplicity and tact of this furniture are a salutary reminder that breadth of vision is not everything. Within his context, Nathaniel Gould was a kind of genius. Recognizing the limitations within which he worked only helps us to realize the fact.

1. Author's interview with Jeroen Verhoeven, April 19, 2013.

2. See Hogarth 1753, ch. 5.

3. See Lasser 2012.

4. See Mussey and Haley 1994.

5. See Vincent, G. 1974. See also Richards and Evans 1997, p. 375.

6. For examples of Dresden bombé workmanship, see Haase 1983, cat. 112, 90a.

7. For examples from the Netherlands, see Baarsen 2000, figs. 6–8.

8. Museu Nacional de Arte Antiga 2000, fig. 57.

9. Wood 1994, pp. 17–18.

10. On the tradition of shell ornament in European furniture, see Adamson 2013; Lovell 2005, p. 69.

11. Morse 1975.

12. Sargentson 1996.

13. Kirkham 1989.

14. Kenny 2011.

15. For an extended discussion on this question, see Bushman 2003.

Grand Houses and Rural Retreats

DEAN THOMAS LAHIKAINEN

There are only two known images of Salem that date to Nathaniel Gould's lifetime; one is a view of School Street (fig. 1) and the other, the farm of Benjamin Pickman Sr. (see fig. 17). Both date to about 1765 and are useful in discussing the townhouses and country estates of the merchant and professional class where so many pieces of Gould's furniture were used and enjoyed. John Adams described the townhouses as "the most elegant and grand I have seen in any of our maritime towns."[1] Like Gould's stately desk-and-bookcases, portraits by John Singleton Copley, and silver by Paul Revere, these domestic structures were a conspicuous statement of the owner's social position and power within the community. They were designed to provide impressive public spaces for entertaining political and business associates, and more intimate private rooms to accommodate the daily needs of the family and household staff; the furniture in each room was appropriate to the room's intended use.

The watercolor of School Street (today Washington Street) was rendered by Dr. Joseph Orne (1749–1786) from the balcony of the 1718 Town House, which stood at the intersection of School and Paved Street (today Essex Street). Orne showed the upper western side looking toward the North River, indicated by a small sailing vessel. The three buildings at the lower left, a shed or stable, boat shop, and house, all belonged to Samuel Field. The next house, owned by Edward Norris, the town clerk and postmaster, was distinguished by the oversized "POST OFFICE" sign awkwardly placed across a second-story window. On October 6, 1774, all four of these structures, along with the only home Gould ever owned, were consumed by one of Salem's largest fires. The next imposing three-story house, built by Benjamin Pickman Sr. in 1763, survived because it was made of brick. Beyond it are four older unpainted wooden buildings: the 1699 William Hunt House with its steep-pitched gables and overhanging second floor (also visible in fig. 13), the modest home of Captain Jonathan Lambert, and, at the end of the street, the seventeenth-century home of dock worker John Cloutman, with a flight of wooden steps leading down to the river.[2]

In the middle of the street is the new brick schoolhouse, built in 1760, which also contained the town's first private subscription library, established that same year by twenty-eight gentlemen, including Benjamin Pickman Sr. and many other Gould clients. In front of the school is the town whipping post. The street is unpaved and the only sidewalk is in front of Pickman's new house edged by a row of posts with chains to keep wagons and the crowds gathered for public whippings at a safe distance. Characteristic of the central part of town, residential and commercial properties were closely intermingled, and the affluent and less so lived comfortably side by side.

Orne no doubt recorded the scene to document these recent changes that were altering this ancient streetscape, which had been evolving since the first English settlers arrived in 1626; by 1764, there were 4,469 inhabitants, including 117 Negroes, both slave and free. The Pickman House replaced an earlier seventeenth-century building and was among the 155 new private dwellings built between 1750 and 1769.[3] While many residents looked with excitement upon this new construction in a classically inspired style (most often called Georgian today), others grew nostalgic. The Reverend William Bentley

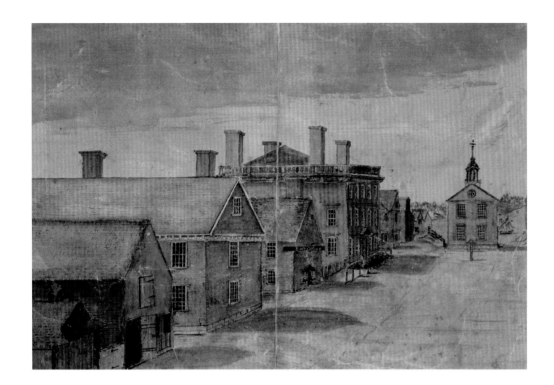

[OVERLEAF]
Front entry hall and staircase, Jeremiah Lee
Mansion (ca. 1766–68), 170 Washington
Street, Marblehead, Massachusetts (fig. 11)

FIG 1
Dr. Joseph Orne (1749–1786)
School Street, Salem, ca. 1765
Watercolor on paper, 12 ½ × 16
Peabody Essex Museum, Salem,
Massachusetts, Gift of Mrs. Joshua Ward,
1852 (1175)

(1759–1819), contemplating the dispersal of one of these seventeenth-century houses and its original furnishings,

grieved to see the connection between the last & present century so entirely lost. There is something agreeable, if not great, in the primitive manners [of that earlier generation]. So much pleasure & peace at home, while the great world is scarcely known. These things charm upon the small scale, & when we see society only in its first stages . . . far away from present fashion.[4]

Salem's sense of fashion did indeed shift during Gould's lifetime, as maritime trade increased the town's wealth and political influence within the colony, and merchants, doctors, and lawyers (often serving in government positions) accelerated the use of fashionable architecture, furniture, and art to define their place in a widening world.

Benjamin Pickman Sr., one of the town's wealthiest cod merchants, built the imposing three-story brick house for his son Benjamin Jr. following his marriage to Mary Toppan (1744–1817) in 1762. He was continuing the longstanding custom of setting up the eldest son in grand style as the heir to the family fortune—a continuation of the British tradition of primogeniture. Benjamin Sr. also paid for the splendid portraits of twenty-two-year-old Benjamin and his young bride painted by John Singleton Copley the year after their marriage (figs. 2 and 3). Elegant clothing and an aristocratic pose were additional ways to express wealth and social position; Benjamin's hand rests on

an expensive gilt-bound book to indicate his recent graduation from Harvard. The couple also received a great deal of silver for entertaining, including pieces by the Boston silversmith John Coburn, and new furniture from the shop of Nathaniel Gould, also paid for by Benjamin Sr. and Mary's father, Dr. Bezaleel Toppan.

Benjamin Sr. retained ownership of the house as a way to control the family and their collective business interests. In his 1773 will, he left the house not to Benjamin Jr., but to his second eldest son, Clark Gayton Pickman, who had married Sarah Orne (1752–1812), daughter of Timothy Orne Sr. (1711–1767), in 1770 (they too received a great deal of Gould furniture). He left Benjamin Jr. the more important family "seat" or mansion on Essex Street, built in 1750 (fig. 4). This bequest was meant to affirm to the community that the family's old money and established patina or status was to continue intact to the next generation. He also gave Benjamin Jr. his farm in South Salem (see fig. 17), another important symbol of their cultural and social prominence.[5]

Architecturally, the two in-town Pickman houses represent the two most popular forms of upper-class domestic structures built in Salem during the eighteenth century: the two-story house with a gambrel roof, and the three-story townhouse with a low-pitched roof. Both forms were provincial variants of houses built in England during the second half of the seventeenth century and reinterpreted in New England by both émigré British-trained artisans and native-born housewrights,

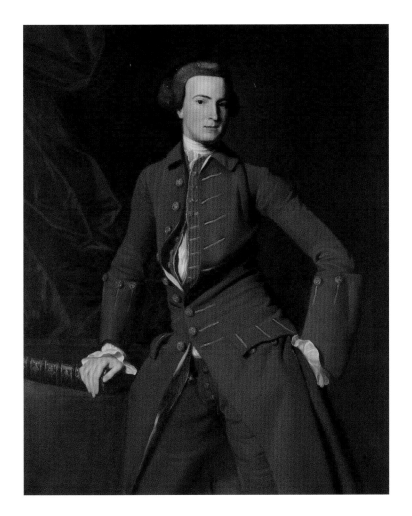
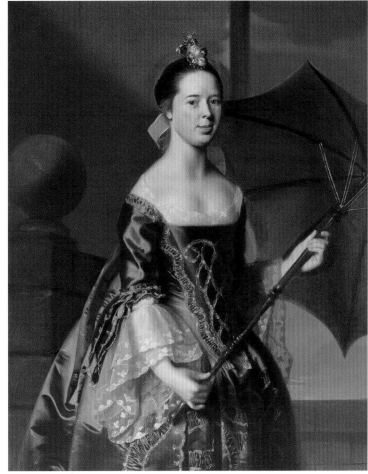

FIG 2
John Singleton Copley (1738–1815)
Benjamin Pickman Jr., 1758–61
Oil on canvas, 50 ³/₈ × 40 ¼
Yale University Art Gallery, New Haven,
Connecticut, Bequest of Edith Malvina
K. Wetmore (1966.79.2)

FIG 3
John Singleton Copley (1738–1815)
Mrs. Benjamin Pickman Jr. (Mary Toppan),
1763
Oil on canvas, 50 × 40
Yale University Art Gallery, New Haven,
Connecticut, Bequest of Edith Malvina
K. Wetmore (1966.79.3)

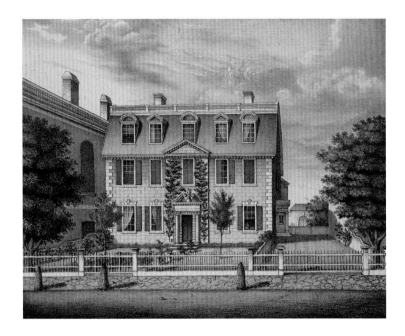

FIG 4
Pendleton's Lithography after J. F. Colman
*Benjamin Pickman House, 165 Essex Street,
Salem*, 1830
Lithograph, 8 ⅜ × 10 ⅜
Peabody Essex Museum, Salem,
Massachusetts (119338)

like Salem's Joseph McIntire (1727–1776). They worked with British and French architectural pattern books to learn the Greco-Roman orders and to see the most fashionable houses designed by prominent architects.[6] But, ultimately, *imitation* played the more important role in spreading a new style or house form once it was developed on this side of the Atlantic. Merchants (and/or often their wives) vied with one another to be the leaders (or close followers) of changing fashion in order to maintain their social position.[7]

Salem's architectural history changed dramatically around 1700 when joiner George Cabot (1678–1717), a native of St. Helier, Jersey, Channel Islands, arrived and built the town's earliest known brick buildings, the first with documented classical ornaments and probably the first with a gambrel roof. His work marked a dramatic shift away from the postmedieval wooden building traditions that had flourished in the town since its founding. The gambrel roof, called a mansard roof in Europe after the sixteenth-century French architect François Mansart, has two slopes per side to provide more headroom in the attic than a simple pitched roof. The lower, steeper slope was generally pierced by dormer windows designed to provide light and air circulation. This type of roof with dormer windows distinguished

most of the upper-class domestic structures built in Salem from 1700 to the early 1760s.

The "elegant" house Cabot built for the wealthy merchant Benjamin Marston around 1707 stood at the corner of what is today Crombie and Essex streets. It was distinguished by carved stone Corinthian capitals, most likely ordered from London, used as caps on brick pilasters; similar ornamentation was used on the façade of the ca. 1690 Foster-Hutchinson House in Boston, considered "the first developed example of provincial Palladianism in New England."[8] The use of brick with stone trim reflects both English and Dutch architectural traditions that saw expression in Britain during the second half of the seventeenth century, including the building of more modest detached houses for members of the prosperous merchant class. These masonry buildings distinguished by the symmetrical arrangement of windows around a central door, served as inspiration for the larger houses built in coastal New England.[9]

While no image of the Marstons' "handsome" house has survived, the general form must have been similar to the house Cabot built for Andrew Faneuil in Boston in 1712, which is visible in a print of Boston published in 1725. It had twin end chimneys with a parapet, a gambrel roof with a balustrade, and five dormer windows on the front slope.[10] The only surviving house of comparable form in New England is the MacPhaedris-Warner House (1718–23) in Portsmouth, New Hampshire. Benjamin Marston Jr. inherited his father's house, but soon after his second marriage in 1729 to Elizabeth Winslow, she "persuaded him to have it pulled down because she supposed it was damp and injurious to health, a circumstance which for several years created a strong prejudice in Salem against brick buildings."[11] The rare carved capitals were salvaged and used for garden ornaments.

Cabot's brick houses must have influenced the design of other important early townhouses in Salem, but none was documented before being destroyed. Many of these were built along Essex Street between what is today Washington Street and Hawthorne Boulevard. The largest, with a 52-foot front and 37 feet deep, was built for the Hon. Samuel Browne prior to his death in 1731 on the site of the present Old Town Hall. It was described as being a "three story mansard roof house" with "17 large and handsome rooms."[12] The house built for the Hon. John Turner in 1743 was of similar form with brick end chimneys, a roof balustrade, and a cupola.[13] Cupolas were a distinguishing feature on many aristocratic Dutch and British houses of the seventeenth century, and they became a status symbol for New England merchants as well. Other local examples included the ca. 1750 George

Crowninshield House (which stood on the site of the present Custom House) and the Jeremiah Lee Mansion in Marblehead (see fig. 11).

One of the most influential mid-century houses in the region was the impressive and costly home built by Thomas Hancock in Boston in 1737. Its stylish rusticated façade was constructed with blocks of Quincy granite with contrasting Braintree stone used for the trim around the doors, windows, and quoins at the corners. Because few could afford such expensive materials, many others used wood to similar effect. Joseph McIntire's 1758 contract to build a wooden house for Jonathan Mansfield in Salem states he is to "Board & finish ye front with Rustick work & each corner in imitation of stone work." The contract also directs that the "the Covings" or cornice was to imitate the one on "Coll Pickman's Mansion House"—just one example of how easily an admired detail was copied.[14]

The rustication on Pickman's wooden façade included the beveled boards to imitate stone ashlar blocks, scored keystone lintels above the first-floor windows, and wooden quoins along the corners. These details were painted in contrasting colors; sand was often mixed with the paint to heighten the sense of real stone. Symmetry was achieved by aligning the five dormer windows with the windows below, and, like the Hancock House, they were given alternating triangular and segmented open-topped caps following British tradition.

In keeping with the Palladian-inspired designs published by James Gibbs and other British pattern book authors at mid-century, Pickman's house was also given a central projecting pavilion with a pediment above the roofline. This feature made the elaborate entrance more prominent. The door surround is similar to one in Campbell's *Vitruvius Britannicus, or The British Architect* (fig. 5), having round engaged columns with Corinthian capitals and an open-topped swan's-neck pediment with a carved bust in the center. A simplified version of this design was used for the entrance to the Captain Thomas Poynton House built in the mid-1750s in the same neighborhood. Instead of a bust as the central ornament, it has a pineapple, a popular western symbol of hospitality (fig. 6). In addition to having similar tastes in architecture, both Pickman and Poynton were patrons of Nathaniel Gould, held strong Loyalist sympathies, and fled Salem together on March 17, 1775, to take refuge in England.[15]

If the Pickman House represented a return to wood as the preferred building material in Salem, it was reversed again in 1761 when Captain Richard Derby, another prosperous merchant and Gould patron, built a brick house for his newly married eldest son, Elias Hasket Derby, and his wife, Elizabeth Crowninshield (1727–1799);

FIG 5
Detail of "The Elevation of Richard Rooth Esq. his house at Epsom in Surrey" from Colen Campbell, *Vitruvius Britannicus, or The British Architect* (London, 1717–25; Dover reprint 2007), plate 49

FIG 6
Frank Cousins (1851–1925)
Detail of *Capt. Thomas Poynton House, 18 Browne Street, Salem (1750)*, ca. 1900
Photograph
Phillips Library, Peabody Essex Museum, Salem, Massachusetts

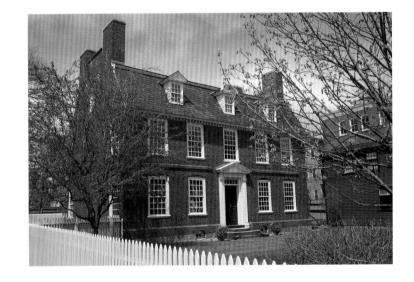

FIG 7
Elias Hasket Derby House (1762), 160 Derby Street, Salem, Massachusetts. National Parks Service Historic House Collection

he also built one for his daughter Martha (1744–1802), after her marriage to Dr. John Prince. Now owned by the National Park Service, the Derby House (fig. 7) is one of the best surviving examples of mid-eighteenth-century Salem architecture because it retains so much of its original interior and exterior fabric.[16] Many of the masonry construction details continue earlier practices: the bricks are laid in Flemish bond and the only attempts at surface ornamentation on the façade are the simple arc of bricks set vertically above each first floor window and the segmented projecting string courses above. A water table of molded bricks on a granite foundation projects out at the base to shed water; twin chimneys are incorporated into each end wall with a straight parapet higher than the roof. The gambrel roof is pierced by dormer windows, the central one having an open-topped segmental pediment. The beautifully proportioned wooden doorframe in the Doric order has fluted pilasters set on rusticated blocks with a triangular pediment with dentils. The five panes of glass provide the only light in the entry hall. Overall, the Derby House façade is the epitome of restraint and simple elegance, pleasing in its symmetry and proportions.

Inside the house, the most spectacular display of craftsmanship appears on the main staircase in the entry hall (fig. 8). Typical of many of the better mid-century houses built in the region, it has an elaborate spiral-carved newel post that anchors the end of the molded railing supported by turned and carved balusters of three different patterns per step, a tradition found in British houses dating from the 1720s.[17] These would have been the work of a master carver-turner who also often provided local cabinetmakers with turned and carved elements for furniture.

The principal rooms off the entry hall reflect the custom of having a fully paneled fireplace wall (fig. 9). The paneling was most often made of inexpensive pine because it was always painted—usually a solid color, but sometimes grained to simulate more expensive materials like cedar, mahogany, or marble. The fireplace opening is framed with a wide bolection molding, but lacks the inner row of decorative British ceramic tiles often found in more costly houses of this period. Another decorative tradition was painting the panel above the fireplace with a landscape to further enhance its role as the focal point of the room. The china cupboard on the right side has shaped shelves for displaying a fine tea set and other ceramic objects. The recessed 12-over-12 light

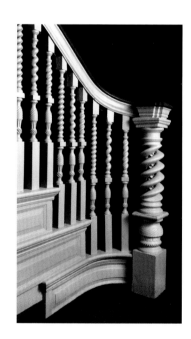

FIG 8
Newel post, main stairway, Derby House (fig. 7)

FIG 9
West wall of first-floor, southwest parlor, Derby House (fig. 7)

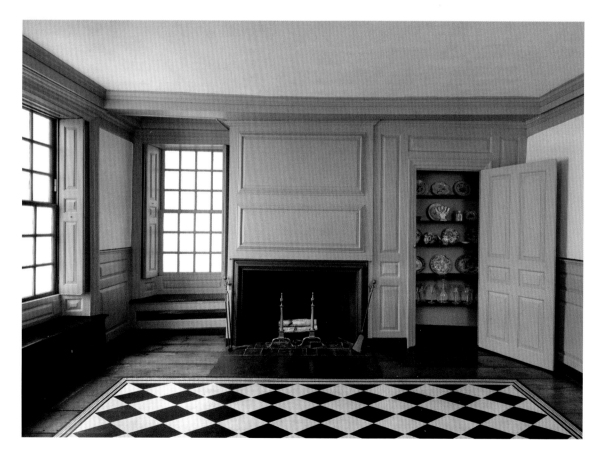

sash windows have full-length folding paneled shutters on each side to control light; there is a built-in seat below. Beveled panels were also used to create the wainscoting below the chair rail and doors, essential for privacy and heat retention during the winter. The plastered walls above the chair rail were often covered with imported wallpaper.

While the Derby House was under construction, another Gould patron, Timothy Orne Sr., was building his new mansion on Essex Street. Three rather than two stories in height, it had a low double-hipped roof embellished with a roof balustrade on the upper deck (fig. 10). Of five bays with a central door, it became the preferred form of townhouse for the merchant class in Salem well into the 1850s; only the detailing changed over time to reflect new interpretations of classical ornament. The Orne House was also among the first to have an open portico with freestanding columns to shelter the front door. This practical and welcoming structure grew in size and decoration during the next century to become another important status symbol for Salem's merchants. The appearance of the Orne House in 1761 may help to explain Benjamin Pickman Sr.'s decision to adopt this new form for the house for his son in 1763 to keep pace, but he chose brick,

rather than wood. Other Gould clients, including Nathaniel Tracy in Newburyport in 1771 and John Cabot of Beverly in 1780, built brick homes of similar form.

The most important surviving expression of all of these British-Palladian–inspired design trends is the townhouse built in Marblehead for one of Gould's most important clients, Jeremiah Lee Esq. (fig. 11). Completed in 1768, the mansion was inspired by plates in Abraham Swan's *A Collection of Designs in Architecture* (London, 1757). Swan showed a similar rusticated elevation for a seven- rather than standard five-bay house with a shallow central pavilion with a broad pediment set above the roof line; Lee further embellished this detail by adding a demilune window. Early images of the mansion document a balustrade originally running along the upper deck. Even though it had disappeared from British design books by this date, the domed cupola remained an important symbol of wealth in the region, in part because it provided a place for a telescope so the owner could monitor the activities of ships in the harbor. The front portico references a pure classical temple form with its four Ionic columns and pediment, set elegantly above a graceful flight of stone steps.

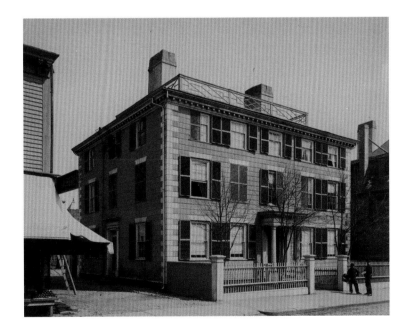

FIG 10
Frank Cousins (1851–1925)
Timothy Orne House (1761), Essex Street, Salem, ca. 1900
Photograph
Phillips Library, Peabody Essex Museum, Salem, Massachusetts

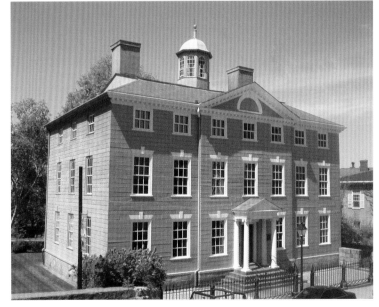

FIG 11
Jeremiah Lee Mansion (ca. 1766–68),
170 Washington Street, Marblehead,
Massachusetts. Marblehead Museum and
Historical Society Historic House Collection

Inside the front door, more than five hundred linear feet of expensive imported mahogany Lee purchased from Gould was used to construct the paneled wainscoting and elaborate broad staircase (see overleaf). Careful coordination of the details is evident on the end block of each step where acanthus leaves have been carved to mimic the Rococo scrolls framing the panels of hand-painted wallpaper featuring classical ruins. Custom ordered from London, the wallpaper installation follows schemes suggested by Swan for decorating the walls in a stair hall.

In the fully paneled best parlor, an unidentified, possibly London-trained, carver created the ornate fireplace surround based on several other Swan designs (fig. 12). The floral and fruit garlands and Rococo acanthus-leaf scrolls are carved in high relief around a central mantel shelf—an innovative feature that was ideal for displaying an expensive garniture set and lighting devices. Though grained to imitate oak in the nineteenth century, the inexpensive pine paneling was originally painted a light yellow to simulate the limestone often used in fashionable British interiors. Of all the surviving houses associated with Gould customers, the Lee Mansion gives the most complete picture of the elegant interiors in vogue when Gould was at the height of his career.[18]

The Revolutionary War stopped or at least slowed new house construction, but in the early 1780s two merchants flush with the proceeds from privateering during the war restarted the building competition. In 1780, Elias Hasket Derby asked a promising young architect named Samuel McIntire (1757–1811), son of housewright Joseph McIntire, to design him a more substantial house on land next to his brick house. The project was abandoned before being completed, in part because McIntire had created a more coherent design for a house for the merchant Jerathmael Peirce at 80 Federal Street. Built in 1782, this house has monumental three-story corner pilasters that give it a sense of solidity and authority that must have rivaled the grandeur of some of the earlier brick and stone buildings in town; it set a new standard for townhouse design.

The Derbys attempted to solve their social slippage by purchasing the 1763 brick Pickman House and hiring McIntire to design a new wooden façade in imitation of the Peirce House; they chose the elegant Ionic rather than plain Doric order for the front pilasters and added the prerequisite portico and cupola (fig. 13). Having regained the upper hand at least architecturally, Elias and Elizabeth Derby were content until the early 1790s when the style changed again: the more lyrical Neoclassical manner of Robert Adam and James Wyatt in England influenced the work of Charles Bulfinch in Boston and in turn McIntire. In 1795, the Derbys demolished the Browne Mansion (which

they had first tried to remodel) and built a new house. The Reverend Bentley noted, "The taking down the largest house of Col. Brown by Mr. Derby is a strange event in this town, it being the first sacrifice of a decent building ever made in the Town to Convenience, or pleasure."[19] The century closed with the Derbys completing the grandest townhouse of them all. Of monumental scale and richly ornamented with a profusion of elegant Neoclassical hand-carved ornaments, the fabled Derby Mansion ushered in a new era of larger townhouse designs that continued into the next century when brick finally won as the most desired building material for the merchant class.[20]

Salem merchants also imitated the British aristocracy by developing country seats outside of the town center; some of these second homes were as grand as the in-town residences. For example, the

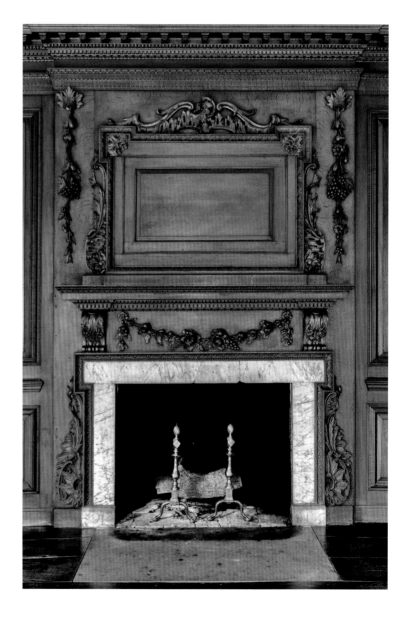

Robert "King" Hooper House, built in Danvers, Massachusetts, in 1754 (fig. 14), housed General Thomas Gage and his staff during the summer of 1774, along with the fourteen pieces of furniture Gage had ordered from Gould. But, most of these country retreats were far less elaborate and would have been simply furnished with less expensive furniture also produced by local cabinetmakers like Gould. Most of these retreats were primarily for the purpose of providing fresh produce, milk, and meat for the family, and thus were called farms, but they also served as the center of the family's summer social life. Many owners took great interest in experimental crops, horticulture, and animal breeding; they enjoyed sharing news of their successes and failures with likeminded gentlemen, thereby fostering pleasurable social intercourse outside the day-to-day realms of commerce and politics.

One of the earliest and most grandiose of these estates was developed by the Hon. William Browne Esq. of Salem on a high windswept hill, today known as Folly Hill in Danvers. Browne started building Browne Hall (named after an ancestral home in England) soon after moving back to Salem in 1738 with his new bride, Mary Burnet, daughter of the Governor of New York. The symmetrical H-plan of the house, consisting of a central block with projecting side wings, took inspiration from British country houses published in Colen Campbell's *Vitruvius Britannicus, or The British Architect* (London, 1725).[21]

A visitor to Browne Hall in 1750 called it a "stately pleasure-house," noting:

The House is built in the form of a long square, with wings at each end, and is about 80 foot long. In the middle is a grand Hall surrounded above by a fine Gallery with neat turned Bannesters, and the Cealing of the Hall Representing a large doom [dome]. Designed for an Assembly or Ball Room, the Gallery for the musicians. &c., the Building has Four Doors Fronting the N.E.S. & W. Standing in the Middle of the Great Hall you have a Full View of the Country from the Four Doors: at the ends of the building is 2 upper and 2 lower Rooms with neat Stair Cases Leading to them. In One of the Lower Rooms is his Library and –Studdy well Stocked with a Noble Collection of Books. . . .[22]

The distinguishing features on the exterior were the portico over the main entrance supported by two-story columns and a cupola on the roof that provided light for the great hall below with its floor painted to simulate Italian mosaics. The house became a place of great social entertainments with conversations on theology, literature, art, and politics. An earthquake in 1755 severely damaged the building, causing Browne to realize his folly in constructing it on such a vulnerable location, so he moved it down the hill in 1761; no trace remains today.

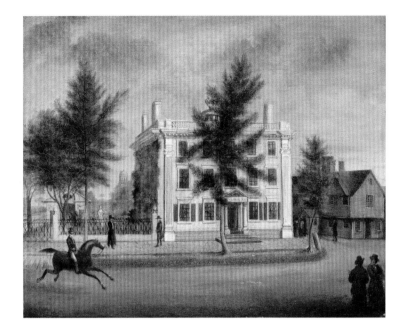

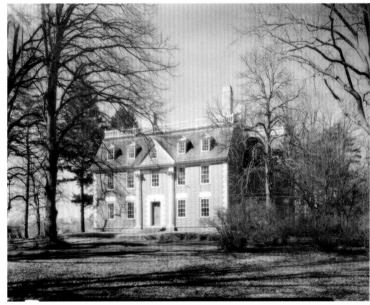

FIG 12 [LEFT]
Fireplace and overmantel in first-floor best parlor, Jeremiah Lee Mansion (fig. 11)

FIG 13 [TOP]
Mary Jane Derby (1807–1892)
Pickman-Derby House (1763, remodeled 1786), 70 Washington Street, Salem, Massachusetts, ca. 1825
Oil on canvas, 12 7/8 × 16
The Detroit Institute of Arts, Founders Society Purchase, Gibbs-Williams Fund
(44. 84)

FIG 14 [BOTTOM]
Robert "King" Hooper House (1754), Danvers, Massachusetts (later moved to Washington, DC), 1934

FIG 15
Anstis Crowninshield (1726–1768)
Pastoral Landscape with Browne Hall,
ca. 1740
Silk on black silk, 9 ¾ × 14 ⅛
Private Collection

The scale of Browne Hall and its Italianate details captured the imagination of the local populace, evidenced by its inclusion in the earliest known silk needlework picture from Salem (fig. 15), wrought about 1740 by Anstis Crowninshield (1726–1768), daughter of Gould patron Captain John Crowninshield Sr., builder of the Crowninshield-Bentley House. While one can speculate whether Anstis intended the young couple in the foreground to represent Mr. and Mrs. Browne, the fact that the man is holding a shepherd's crook ties the figures to the era's fascination with the pastoral theme celebrated in literature and art, and schoolgirl needlework pictures. Some of the finest examples were made by girls from wealthy Salem families while attending finishing schools in Salem or Boston; many of these girls went on to own pieces of Gould's furniture.

A number of these needlework pictures were based on a European print, for example, the elaborate chimneypiece stitched by Sarah Derby, sister of Elias Hasket Derby, about 1763, and based on an engraving by Jean Le Pautre (1617–1682) titled *Women Dancing in an Arcadian Landscape* (seventeenth century). Arcadia was a mythical region of ancient Greece where nymphs and shepherds lived a simple life of rural bliss. However, the inclusion of Browne Hall in the Crowninshield picture, along with other known needleworks delineating Salem landmarks, link this Arcadian pastoral tradition to the real-life experiences of the young ladies visiting or residing in these country estates. A pastoral scene worked by Anna Ward (1744–1832) in 1760–65 shows part of two rusticated houses in the background, one with a dormer window, not unlike the house Joseph McIntire built for her future father-in-law, Jonathan Mansfield, in 1758 (fig. 16).

A visit or frolic at a country estate often involved food brought from the town and provided a range of activities for guests to interact with nature and animals (seen scattered in the foreground of the Ward needlework). Guests picked fruit (the gentleman holds a basket) or just communed with nature, suggested by the gentleman sitting at the lower right smoking his pipe. While one can read these as simple pleasant scenes uniting men and women in happy harmony, Laurel Ulrich has suggested a more complex interpretation, touching upon tensions of courtship, love, and sexual aspirations, which were more easily explored in a country setting than in the formal parlors back in town.[23]

The blending of Arcadian or fantasy themes with real-life experiences is also suggested by comparing the Ward and Crowninshield pictures with the watercolor *A View of the house and part of the Farm of Hon. Benjamin Pickman Esq.*, done about 1765 by an unidentified artist, possibly a schoolgirl (fig. 17). While the intent was to make an accurate record of the farm, the artist also wanted to suggest some of the activities that took place there during a visit. The Pickman Farm was established in 1754 when Colonel Benjamin Pickman purchased eleven acres and built a farmhouse. He and his son continued to acquire

FIG 16
Anna Ward Mansfield Henfield (1744–1832)
Pastoral Canvas-Work Picture, 1760–65
Wool, silk, linen, and paint, 15 ½ × 23 ¾
Peabody Essex Museum, Salem,
Massachusetts, Gift of Ethel Hammond
(126995)

surrounding parcels of land until the estate contained 424 acres on both sides of what today are Loring Avenue and Pickman Road and extending back into the Forest River Conservation Land.

In the watercolor, two women walk arm-in-arm dressed in the fashionable attire of the day. The three men near them are of different professions. One is a farm worker carrying a rake over his shoulder; another appears to be a smartly dressed soldier with a tri-corner hat and a sword jutting out below his coat; the third more portly gentleman may be the owner or farm manager. Two of the men are holding a long staff with a bent end, perhaps a walking stick or shepherd's crook, but one holds his stick with the curved end up, the other with it down as they walk in opposite directions. Are they trying to amuse the ladies? Three more gentlemen in the background are engaged in conversation; one points his walking stick toward the latest farm improvements. Two more figures talk in the distance. The products of the farm are carefully represented: cattle, hay, and vegetables planted in long neat rows running up the hillside. The trees lining the road and those in the distant grove may be fruit trees—the famous "Pickman Pippin," the favorite apple of the region. Lining both sides of the road are walls built of stones cleared from the fields with a single wooden gate to keep the animals from straying. The Reverend Bentley noted on a visit, "Many acres of the great pasture are walled & redeemed from a state of nature. Many new orchards appear on both sides of the road."[24] A simple formal garden likely planted with flowers and herbs has been created in front of the main house with a straight path aligned with the front door; the garden is partly fenced to keep out animals.

Bentley described the buildings on the Pickman Farm as "plain but excellent." We see an ample barn, a small privy or icehouse, and the main dwelling. Benjamin P. Ware, the farm manager in the nineteenth century, recalled the "farm house dating from two periods the massive square chimney stack of the ancient portion of the house, with its great brick oven on one side, three broad fireplace openings into as many rooms and occupying the remaining faces of the chimney and the new house with its generous stud and larger windows and paneled wainscot and well carved balusters and mantelpieces."[25] The central chimney and simplicity of the house in the image suggest the watercolor shows the original house built before 1760 and before the later addition.

Ware also recalled the many holiday frolics that took place there when

family coaches rolled out from town on the Fourth of July always and often on some other festive day with their hampers laden with good cheer, their china-ware and silver and table-linen, their children and guests and all under the watchful care of Abraham True, the good old black butler, whose presence alone was earnest enough of the quality of the feast.[26]

FIG 17
Unidentified Artist
*A View of the house and part of the Farm
of the Hon. Benjamin Pickman,* ca. 1765
Watercolor on paper, 8 ¼ × 11
Private Collection

FIG 18
Michele Felice Cornè (1752–1845)
Ezekiel Hersey Derby Farm, ca. 1800
Oil on canvas, 40 ⅝ × 53 ¼
Historic New England, Boston, Gift of
Bertram K. and Nina Fletcher Little
(1992.170)

A similar scene was captured in a painting of the Ezekiel Hersey Derby Farm (fig. 18), which abutted the Pickman Farm in South Salem and was originally owned by the Browne family, before being confiscated during the American Revolution. Painted by the Neapolitan artist Michele Felice Cornè around 1800, it shows Derby's coach filled with people approaching the large gambrel-roofed farmhouse on a beautiful summer day; lush fields of corn and other vegetables are shown to the right, while the fields to the left are being readied for another crop, perhaps winter rye. A two-story summerhouse in the "Italian style" appears on the hill to the left where guests enjoyed a panoramic view of the entire area, including the Pickman Farm seen in the distant hills. In comparing the two farms, Bentley noted that, "Hearsy Derby has the Browne farm more decorated with gardens & exotics, but Col. Pickman is an excellent example of our best agriculture & pasturage."[27] William Pynchon found a day touring such gardens most agreeable, recording in his diary in 1784:

Dine at Mr. Wickam's with Mrs. Browne and her two daughters. Patty rides out with Dr. Tupper. . . . In the afternoon Mrs. Browne and I, The Captain, Blancy and a number of gentlemen and ladies, ride, some walk out, some to Malbone's garden, some to Redwood's, several of us at both; are entertained very agreeably at each place; tea, coffee, cakes, syllabub, and English beer, etc., [and] punch and wine. We returned in the evening; hear a song of Mrs. Shaw's and are highly entertained; the ride, the road, the prospects, the gardens, the company, in short, everything was most agreeable, most entertaining—was admirable.[28]

In both town and country during the eighteenth century, architecture revealed the social position and interests of the owner and often the size of his purse and ego. Wealth was stated by the structure's dimensions and the number of extra details, particularly carved classical ornaments and columns, which were seen as hallmarks of education and refined taste. Like Gould's furniture, most of these buildings spoke of aesthetic restraint and were marked by symmetry, simplicity, and pleasing proportions. When the design strayed beyond these boundaries of perceived good taste, as in Browne Hall or the great Derby Mansion, it was called folly. As provincial variants of British designs, these buildings helped to define a distinct New England style that even after more than two centuries continues to inspire domestic architecture in America.

1. *Diary of John Adams*, August 6 or 13, 1766. Adams Family Papers, Massachusetts Historical Society, Electronic Archives.

2. Loring 1864, p. 102; Perley 1924, p. 350; Streeter 1896, p. 58.

3. Phillips 1937, p. 272; EIHC 1922, pp. 292–96; Browne 1914, pp. 8–9; Forman 1971, pp. 62–81.

4. Bentley 1962, vol. 2, p. 172.

5. Goodwin 1999, pp. 144–55; Pickman 1928, pp. 13–22.

6. Joseph McIntire's library included William Halfpenny, *The Builder's Pocket Companion* (1747); Francis Price, *The British Carpenter* (1765); Sebastien Le Clerc, *Treatise on Architecture* (1723–24 or a later edition); Isaac Ware, *The Four Books of Andrea Palladio* (1756); and Batty Langley, *The City and Country Builder's, and Workman's Treasury of Designs* (1740 or later). Discussed in Norton 1988.

7. In addition to Goodwin, studies of domestic architecture and social position include Sweeney, K. 1963, pp. 231–55; Kornwolf 2002, pp. 967–78; Murphy 2012, pp. 69–94.

8. Cummings 1964, pp. 52, 65–67; and Cummings 1983, pp. 43–53; Jenison 1976, pp. 21–26.

9. Pierson 1976, pp. 64–98.

10. The print is illustrated in Cummings 1983, p. 44. Cabot immigrated to Salem in 1700 with his brother John and built him a brick house on Essex Street soon after their arrival. After George's marriage to Benjamin Marston's daughter Abigail in 1702, the couple moved to Boston where George died insolvent in 1717. See Cabot 1997, pp. 7–8; and Watson 1873; Loring 1864, pp. 107–108.

11. Felt 1845, vol. 1, pp. 414–15. The Reverend Bentley recorded: "At Mr. Lee's in paved street . . . I saw in his garden one of the stone Corinthian capitals which formerly belonged to the house built upon the spot he possess by Mr. Marston. That house was of brick and was demolished from the prejudice against brick houses & the present house was raised in its stead. . . . The capitals were purchased & some of them removed to a Building possessed by Kitchen . . . at W. corner of Beckford & Essex Street." Bentley in Felt 1845, vol. 2, p. 268.

12. EIHC 1936, pp. 283–84. The house may have resembled the Clark-Frankland House (1712) in Boston, discussed in Carlisle 2003, pp. 112–15.

13. Goodwin gave 1743 as the date of construction (Goodwin 1999, p. 76), while Loring stated 1748 (Loring 1864, p. 37). The cupola and roof of the house are visible in a sketch of Salem by Robert Gilmor reproduced in Kimball 1966, fig. 148.

14. Norton 1988, Document 7.

15. Pickman 1928, p. 56. The Poynton House is discussed in Waters 1879, p. 270, and EIHC 1862, p. 162.

16. Snell 1976; Small 1957, pp. 101–107.

17. Beard 1986, ills. 35, 36.

18. Anderson 2011.

19. Bentley 1962, vol. 2, p. 141; Kimball 1966, p. 80; Felt 1845, vol. 1, p. 414.

20. These two later McIntire houses are discussed in Kimball 1966, pp. 58–59, 77–90; Norton 1988, pp. 31–46; and Lahikainen 2008, pp. 217–58.

21. The only other early American example of the H-plan house was Brinley Place, built in Roxbury, Massachusetts, in 1723, discussed in Lovell 2005, pp. 216–17.

22. Hines 1896, p. 218; Phillips 1937, pp. 186–88; Lovell 2005, p. 218; EIHC 1895, pp. 205–12.

23. Ulrich 2001, pp. 149–52. See also Parmal 2012, pp. 90–91.

24. Bentley 1962, vol. 4, p. 166.

25. EIHC 1903, p. 117; EIHC 1922, p. 292; Thornton 1989, p. 228; Phillips 1937, p. 185.

26. EIHC 1903, p. 117.

27. Bentley 1962, vol. 4, p. 29; Carlisle 2003, p. 77; Little 1972, pp. 226–29.

28. Pynchon 1890, p. 191.

Brides, Housewives, and Hostesses

Acquiring, Using, Caring for, and Enjoying Mr. Gould's Furniture

ELISABETH GARRETT WIDMER

Nathaniel Gould's account books offer a spacious portal through which to explore life at home in eighteenth-century Salem, Massachusetts. His customers, the purchases, the circumstances, and the suggested patterns of consumption help elucidate many details of domestic life in colonial America. Draymen and wharfingers, peruke makers and bakers, sea captains and merchants, all patronized Nathaniel Gould. Some turned to him just once for a single necessary piece of furniture. Long-term customers bought goods and services alike over many years. Other customers were "special occasion" clients, whose purchases signaled important life events. Many patrons were connected by blood or marriage, through business deals and civic positions, religious affiliations and educational bonds, private clubs and professional organizations.

Most lived in Salem—many within walking distance of each other—or in the nearby towns of Beverly, Danvers, Lynn, Marblehead, and Reading. But, marital connections were one significant reason for Gould's furniture being carefully packed and transported to more distant homes in Newburyport and Worcester, Massachusetts; Portsmouth, New Hampshire; and King William, Virginia.[1] Jonathan Jackson (fig. 1), for example, and his friend John Lowell (1743–1802), who both went to Newburyport after graduating from Harvard, had sworn never to marry. But, love is ever capricious, and both, having succumbed to the charms of a pair of Salem girls, pledged their troth on January 3, 1767, and returned to Newburyport with handsome furniture from Gould for two households. A suspicion early on that a number of the larger orders in Gould's account books were connected to a marriage proved correct—indeed, more than 80 percent of those for nonexport domestic purposes (see Appendix D). This percentage is expected to increase with further genealogical study. For many new couples, marriage meant setting up a household. Wedding-associated purchases ranged in scale from small—a single item, such as the mahogany table with carved feet that truckman and cordwainer Jonathan Very purchased on November 30, 1768,

the eve of his daughter Elizabeth's marriage to Benjamin Cox Jr.; to large—as in the sixty-nine pieces of furniture plus thirty-five chair seats covered in fashionable horsehair and the popular woolen fabric harateen, ordered for Rebecca Orne's marriage to Joseph Cabot Jr. in August 1768.[2] Although no two wedding orders are identical—testimony to the active role each couple and their families played in these decisions—patterns do emerge.

For the smaller orders, furniture forms most frequently selected were a table or two and/or single or paired case pieces. When Salem goldsmith William Northey married Rebecca Collins (1740–1826), daughter of Lynn blacksmith Zaccheus Collins, on January 25, 1764, the father of the bride provided a four-foot table, a chamber table, and a case of drawers. When Joseph Southwick's daughter Anne married shoreman Jeremiah Hacker (1725–1781), on April 7, 1765, Southwick purchased "1 Case of Draws with Steps"—a flat-top high chest topped with stepped shelves on which to display treasured pieces of glass or ceramic. A tanner and currier, Southwick paid for this gift in leather. Nine years later, when a younger daughter Tamson married William Frye, Southwick acknowledged the occasion with a four-foot walnut table delivered to "his Son Fry."[3]

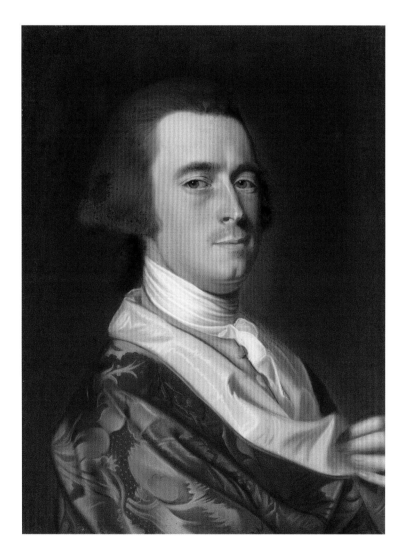

FIG 1

John Singleton Copley (1738–1815)
Jonathan Jackson, late 1760s
Pastel on paper mounted on canvas,
23 ¾ × 17 ¾
Museum of Fine Arts, Boston, Gift of
Mr. Francis W. Peabody in memory of
George C. and Virginia C. Shattuck and
Henry H. and Zoe Oliver Sherman Fund
(1987.295)

Mid-sized wedding orders often included one or more bedsteads; a variety of tables differing in wood, size, and shape; one or two sets of six (sometimes eight) chairs; often an accompanying round or round-about chair; and an array of tea trays, servers, and tea boards, signaling the social aspect of these homes. By the late 1760s, and probably beginning with Rebecca Orne in 1768, a new scale of wedding order emerged that became a model for Salem's elite. These enormous commissions were meant to awe and impress: in the quantity of items, the grand size of individual pieces, and the burgeoning of sets, such as three or four distinct groups of chairs. Soaring case pieces of the finest mahogany and walnut made clear that the expanse of the material was as important as its quality. Obvious expense signaled select status and highlighted family prerogative. There is an added emphasis on the neatness and harmony of pieces ordered en suite: thus, the balanced directive for a mahogany case of drawers, matching chest of drawers, bedstead, and set of chairs for one chamber, in tandem with a similar suite in walnut for another. This hierarchy of woods mirrors the hierarchy of rooms within the eighteenth-century home: the best bedchamber and parlor or drawing room are at the summit and thus deserving of mahogany, while walnut or a mixture of woods might do for secondary rooms.[4] The degree of decoration reinforced the status of the material: mahogany pieces with carved backs, carved knees, and carved toes were intended for the best rooms—rooms to be seen and admired.

Many marriage orders were placed at one time and within a couple of months of the wedding. A mature Lois Gardner (1741–1819), age thirty-one and doubtless familiar with the necessaries to housekeeping, married the Reverend Thomas Barnard Jr. on May 31, 1773. By June 4, they had made their selection: not only such handsome best room furnishings as a mahogany bedstead, six chairs, and a card table, all with carved knees, but homely kitchen items such as a bread trough, folding board (for ironing), a clothes horse, and kitchen chairs. Other wedding orders were placed at one time but months after the wedding, when the couple finally moved into settled quarters. Thus, after Mark Hunking Wentworth had purchased a house on Pleasant Street in Portsmouth, for his daughter Anna (1746–1813) who had married naval officer and customs collector Captain John Fisher in Portsmouth, New Hampshire on June 10, 1763, he followed up in November 1764 with an order of furniture for the house.[5] Others placed their wedding orders over a period of months, perhaps because of payment issues, or because a couple did not go to housekeeping immediately, or because they were novices who had not anticipated all that might be needed, or because a husband was at sea and home only intermittently. When

master mariner Captain John Brooks married Sally Hathorne on the second day of January 1781, it was a noisy, joyous occasion, according to Salem diarist William Pynchon Esq., who recorded the "smart firing" tribute that was "as loud, and the rejoicing near as great, as on the marriage of Robt. Peas, celebrated last year; the fiddling, dancing, etc., about equal in each."[6] Two months later, Captain Brooks placed an initial order, followed by additions in July and September. By November, Sally Brooks seems to have been fully immersed in the quotidian details of housekeeping, for the purchases are for a kitchen table and, finally, in January, a challenging month in which to dry clothes in New England, a clothes horse.

Gould's shop records reveal that a marriage was the single most important moment to furnish a home, although a move, a house fire, and many others circumstances certainly initiated substantial orders. Bridegrooms seem to acknowledge this in the frequency with which a desk is slipped into the wedding order.[7] Gould's account book and day books indicate that the father of the bride or the groom most frequently placed a wedding order (see Appendix D). Sometimes both contributed. In September 1758, the month of daughter Anna's (b. 1738) marriage to mariner Captain Crispus Brewer, Daniel Gardner ordered six maple and six black walnut chairs and one great chair (probably an armchair); Mr. Brewer contributed a stand table. Anna's father died a year later, leaving Anna £6..13..4, "besides what I gave her at her Marriage."[8] Wills are a revealing source of information concerning gifts of movables, real estate, and currency at the time of marriage. Benjamin Lynde

Esq. had placed a relatively small order with Gould for £20..0..6 worth of furniture one month before his daughter Lydia's (1741–1800) marriage to the Reverend William Walter in September 1766. His will of almost a decade later discloses that much more had passed between them at that time, for he bequeathed her "eight thousand pounds Old Tenor, six thousand pounds whereof they had on their marriage."[9]

There were several paths by which a young man in mid-eighteenth-century Salem might improve his prospects for success. Certainly, it helped to be born into a family of means, but good fortune still took cultivation, and family connections could open doors to business and social advancement.[10] Education was another booster up the economic and social ladder, particularly if that education was Harvard College (fig. 2). At least thirty Gould clients were graduates of that facilitating institution.[11] A testimonial to education received and success expected might be broadcast in the bold and handsome guise of an expensive desk-and-bookcase (see cat. 8). Among Gould's Harvard-educated clients, George Cabot, Joshua Dodge, Henry Gardner, and Nathaniel Tracy all acquired a desk-and-bookcase as part of the marriage furnishing plan. In addition to such upscale desks, Gould supplied clients with inexpensive "Riteing desks," some of which were covered as the one shown in the portrait of Robert Hooper (1709–1790) (fig. 3). In July 1771, for example, he charged both Richard Routh and Timothy Orne III for "Lock hinges Screws paper Tape tacks & Covering for writing Desk." Gould also frequently provided the accompanying calculators of the day: "Ruler & Yard Stick." Robert Hooper was not a

FIG 2
Attributed to Mary Leverett Denison Rogers
Embroidered View of Harvard Hall,
early 1700s
Silk, wool, and gilt-silver yarns on open plain-weave linen, 7 11/16 × 9 7/8
Massachusetts Historical Society, Boston

FIG 3

John Singleton Copley (1738–1815)
Robert "King" Hooper, 1767
Oil on canvas, 50 × 39 ¾
Pennsylvania Academy of the Fine Arts,
Philadelphia
The Henry S. McNeil Fund. Given in loving
memory of her husband by Lois F. McNeil
and in honor of their parents by Barbara
and Henry A. Jordan, Marjorie M. Findlay,
and Robert D. McNeil (1984.13)

known client of Gould, but his daughter Alice married client Jacob Fowle Jr. in 1765.

For the distaff side, the colorful samplers and handsome embroideries that hung on the wall, covered a set of chair seats, or ornamented a fire screen, proclaimed that the wives and daughters had also received the finest education available to them and were accomplished and worthy of respect in their own right.[12] Courting scenes were ever popular, as delightfully depicted in Susannah Saunders's 1766 sampler (fig. 4). When Susannah married her schoolmaster, Daniel Hopkins, in March 1771, her father went to Nathaniel Gould to purchase a case of drawers and a chamber table for the couple. Hopkins himself would return to Gould to buy a cherry cradle for their firstborn son and, a year and a half later, a child's coffin. When another Salem daughter, Hannah Batchelder, completed her sampler at Sarah Stivours's School in Salem in 1780, she shared her desiderata for a future mate:

When in Love I Do Commence
May it be a man of sense
Brisk and Arey May He Be
Free From The Spirit of Jelisy.[13]

Indeed, marriage, and especially a financially astute marriage, might be the requisite step to propel one forward. A bride whose deceased father had left her substantially endowed might be particularly attractive. Perhaps before marrying a woman seven years his senior, in 1773, the Reverend Thomas Barnard Jr. had weighed her maturity and notable "sharp temper" against the alluring sweetness of the "two Thousand Pounds lawfull Money" her father had willed to her and "her Heirs & Assigns" in 1766.[14] Even the appropriately named newspaper *The Massachusetts Spy*, in commenting on the marriage, somewhat intrusively observed that Lois Gardner, now Barnard, was "a lady possessed of a fortune of upwards of two thousand pounds lawful money."[15] It was again a newspaper, this time the *Essex Gazette,* that observed that Dr. William Paine of Worcester, Massachusetts (fig. 5), likewise chose wisely in September 1773 when he married Lois Orne (1756–1822) in Salem, "Daughter of Mr. Timothy Orne, late an eminent Merchant of this Place, deceased; a young Lady in Possession of a large Fortune."[16] Indeed, in his 1767 will, Timothy Orne Sr. had bestowed on his daughter a good deal of land and real estate as well as "fifteen Hundred Pounds Lawfull Money"; and on September 8, 1767, guardianship of little Lois, "a Minor under fourteen Years of age" (see fig. 17), was granted to Francis Cabot (1717–1786).[17] It is, therefore, significant that

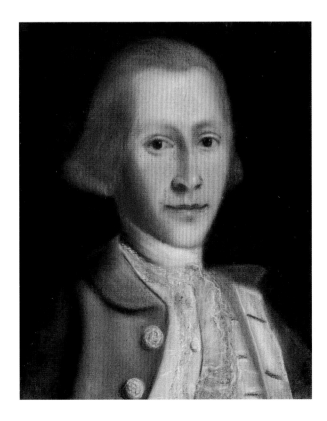

although their handsome wedding order, which included seventeen cases and the screw key and codline to secure them for transport to Worcester, is listed under William Paine, the inscription down the side of the order reads, "Paid by order on Francis Cabot Esq." (fig. 6). Orne money may also have made possible the extensive order Paine left with Boston silversmith Paul Revere, which tallied to another £74 (fig. 7).[18] It appears that Revere's first wife, Sarah Orne (1736–1773), was a distant cousin to Lois, which is significant in an era when kinship bonds were often the clue to professional and social connections. Further, the coat of arms engraved on each piece, together with Lois's emblazoned initials, L.O., indicate that the Orne family was being demonstrably celebrated and perpetuated in this beautiful silver trove.

Two of the extant receipts for Gould furniture are wedding orders.[19] One is addressed to Joseph Cabot Jr. (fig. 8). The day book record for that order (fig. 9), marked X to indicate payment received, is under his bride's name: Rebecca Orne, sister to Lois. It is rare for a female to be the "on paper" initiator of a large order, but two fatherless heiresses, Tabitha Skinner and Rebecca Orne, are cited in Gould's books as commissioning their own outfitting.[20] Tabitha was not quite five years old when her father died and her mother was subsequently appointed guardian. Thomas Gerry succeeded as guardian in May 1759, and four months later was married to his seventeen-year-old charge.[21] At the time of Timothy Orne Sr.'s death, slightly more was put in trust for eldest daughter Rebecca than for her sisters. Francis Cabot (1717–1786), who had been granted guardianship of Rebecca's younger siblings Sarah (1752–1812), Lois, and Esther, was also named a surety in Rebecca's guardianship awarded to William Browne. It is not surprising, therefore, that when this young heiress married, it was to Francis Cabot's nephew Joseph. Despite the receipt, it was undoubtedly not Cabot money that paid for the nuptial outfitting.

Perhaps Timothy Orne Sr., more than any single individual, was the catalyst, albeit a posthumous one, for the large-scale wedding orders of the late 1760s and 1770s.[22] The generous apportionment to his soon-to-be-fatherless daughters would result in three highly visible, very costly, and much emulated orders: for Rebecca Orne and Joseph Cabot Jr. in 1768, for Sarah Orne and Clark Gayton Pickman in 1770, and for Lois Orne and Dr. William Paine in 1773. Ancestral wealth and familial aspirations had combined with Nathaniel Gould's ready access to the best materials and finest craftsmanship to set a new standard in "going to housekeeping." For those at the top of Salem's economic and social scale, family portraits, worked coats of arms (fig. 10), engraved silver, expensive clothing, and multiple pieces from

FIG 6
Detail of Nathaniel Gould's Day Book (1768–83), showing debit entry for Dr. William Paine's order for wedding outfitting, October 1773
Nathan Dane Papers, Massachusetts Historical Society, Boston

FIG 7
Paul Revere (1735–1818)
Selections from the *Paine/Orne Silver Tea and Coffee Service*, 1773
Silver, various dimensions
Worcester Art Museum, Worcester, Massachusetts, Gift of Frances and Eliza Paine, Dr. and Mrs. George C. Lincoln and Richard K. Thorndike (1937.5558, 1959.105, 1963.338a-f, 1965.336, 1967.57)

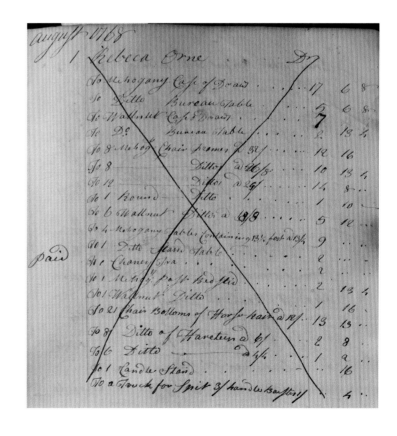

FIG 8
Receipt for Rebecca Orne's Gould order addressed to her husband Captain Joseph Cabot, August 1768
Orne Family Papers, Phillips Library, Peabody Essex Museum, Salem, Massachusetts

FIG 9
Detail of Nathaniel Gould's Day Book (1768–83) showing debit entry for Rebecca Orne's order for her wedding outfitting, August 1768
Nathan Dane Papers, Massachusetts Historical Society, Boston

FIG 10
Lois Gardner (Mrs. Thomas Barnard)
(1741–1819)
Gardner Coat of Arms, n.d.
Silk and metallic threads on black silk,
18 1/8 × 18 1/8
Peabody Essex Museum, Salem,
Massachusetts (135124)

FIG 11
John Appleton (1739–1817)
Imported in the last Ships from London,
1773 (detail and reverse)
Printed by Samuel and Ebenezer Hall,
Salem, Massachusetts
Broadside, 14 5/8 × 7 3/16
William Paine Papers, American
Antiquarian Society, Worcester,
Massachusetts (314030)

the shop of Nathaniel Gould bespoke success, prestige, power, and family prerogative.[23] It is possible to meet a number of these customers today in portraits by the Salem artist Benjamin Blyth, whom Gould supplied with "Straining frames" and "Streching frames," as well as the sign board to advertise his business "of Limning in Crayons."[24] Moreover, at least a dozen Gould customers had themselves recorded for posterity by that most distinguished and sought after artist John Singleton Copley.[25]

Gould's account books only reveal wedding gifts placed through him. However, additional documentary evidence confirms that the brides in Gould's records actively made decisions and purchases in preparation for the happy event. For example, a printed broadside, advertising goods "Imported in the last Ships from London," by merchant John Appleton, who had purchased his own wedding furniture from Gould, has a scribbled receipt on the back made out to seventeen-year-old Lois Orne, two months before her wedding, for the purchase

of linen at Appleton's store in the new brick building above the printing office and nearly opposite the custom house (fig. 11). That printing office was occupied by Samuel and Ebenezer Hall, who printed this broadside and whom Gould supplied with "Sundrie Slips for printing," "Rose wood plank for press," and "smoothing plates for press," on several occasions between April 1770 and September 1777.[26] Another trove of receipts suggests the prewedding bustle and postwedding final details as Dr. Bezaleel Toppan and his daughter Mary visited shops in Salem and Boston in the months before and after her marriage to Benjamin Pickman Jr. on April 22, 1762 (fig. 12).[27] Like Lois Orne, "Miss Polly Toppan" also visited John Appleton early on, purchasing eleven and one-eighth yards of fine linen fabrics on January 13, two months before the young couple would announce their intention to marry. The following month, Dr. Toppan was in Boston acquiring a tablecloth and linens from John and Thomas Stevenson. Also in Boston, on March 31, he made the expensive purchase of seventeen

yards of white satin and one and a quarter yards of linen from William Taylor. Two weeks before the wedding, Dr. Toppan paid for two yards of calicoes delivered to Boston upholsterer Samuel Grant, on the very day that Mary was paying Mary H. Richardson for "Making Suit Cloth[e]s," two negligees, sewing silk, five and a half yards of ribbon, and six yards of ferret [tape/binding]." After the wedding, Bezaleel Toppan concerned himself with supplying additional necessaries for housekeeping. In early July, he went to Salem chairmaker James Cheever (d. 1763) for six simple chairs, then to merchant George Deblois for a dozen knives and forks, and at last, in late August and early September, to Salem blacksmiths Richard and Benjamin Pike for curtain rods and such kitchen essentials as heaters (for irons), a skillet, pot hooks, and getting several kettles bailed. Presumably subsequent to the wedding, Mrs. Pickman purchased a large silver dish, two pairs of dishes, and a pair of canns (mugs) from one Sam Fletcher. And, from the Pickman family silver collection, now at the Museum of Fine Arts, Boston, it is clear that a good deal of additional silver was purchased for the young couple at this time, much of it by Boston silversmith John Coburn, such as the teapot given by Love Rawlins Pickman (1709–1786) to her daughter-in-law Mary Toppan Pickman (fig. 13).[28] One more commemoration of this union was the pair of portraits of Benjamin and Mary Toppan Pickman painted a year after their marriage by Copley (see Grand Houses, figs. 2 and 3). To protect her skin from the sun, Mary holds an umbrella, whose deftly turned shaft is perhaps very close to the "umbrilo" frames Gould supplied to several of his customers.[29] Copley not only signed and dated Mary's picture, but noted her age as well: "1763/ AE. 19." Thus, the portrait had to have been painted between her nineteenth birthday in August and the end of the year. She would have been pregnant or recently delivered of her first child, born September 13.

Mary Vial Holyoke (1737–1802), who kept an invaluable diary of domestic life in Salem, from January 2, 1760, shortly after her marriage to Dr. Edward Augustus Holyoke (fig. 14), until two years before her death in 1802, mentioned that Mr. Pickman was "Published" on March 28, 1762, and took note of his marriage twenty-five days later, on April 22.[30] The public announcement of a proposed marriage was required in Massachusetts, lest there be any objections. Such objections usually occurred privately within the family. Daniel Hathorne was not pleased when his former apprentice, the Irish-born mariner Simon Forrester (fig. 15), won the hand of his daughter Rachel (1757–1823). "With a mind full of superstition, with a temper as boisterous as a tempest & with habits of occasional intemperance like a ship, without a helm,"

FIG 12
Receipts for purchases made by Dr. Bezaleel Toppan and his daughter Mary in connection with her wedding to Benjamin Pickman Esq., April 1762 Pickman Family Papers, Phillips Library, Peabody Essex Museum, Salem, Massachusetts

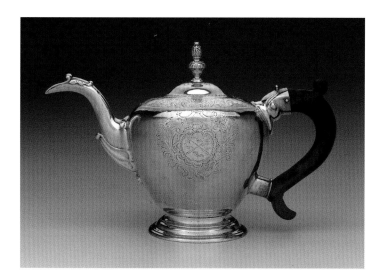

FIG 14 [RIGHT]
Benjamin Blyth (ca. 1740–1787)
Dr. Edward Augustus Holyoke, 1771
Pastel on paper, 14 ¾ × 11 ¼
Private Collection

FIG 15 [FAR RIGHT]
Attributed to Charles Delin (1756–1818)
Simon Forrester, ca. 1780
Oil on canvas, 20 ½ × 16
Peabody Essex Museum, Salem,
Massachusetts, Bequest of Miss Marianne
S. Devereux (103358)

FIG 13
John Coburn (1724–1803)
Teapot engraved with Pickman Coat of
Arms, ca. 1762
Silver, H 6 ¼
Museum of Fine Arts, Boston, Gift of
Mr. and Mrs. Dudley Leavitt Pickman
(31.239)

Forrester seemed a frightening prospect. But, he proved himself a brave and successful privateer, became a merchant and shipowner, and died "the richest man in Salem."[31] Although no furniture was bought from Gould at the time of this marriage, Forrester did purchase a mahogany easy chair frame seven months later, probably in anticipation of the birth of the first of eleven children.

Many parents must have breathed a sigh of relief when their sons married, and married well, for the teenage years were filled with potential pitfalls and dishonoring temptations, as the archives of Harvard College amply demonstrate. Joseph Cabot Jr., who later won the affections of Rebecca Orne, had entered Harvard at age fourteen and a half, which was common, but less than a year later the faculty voted that this freshman "be punished Ten Shillings, make a public Confession and be publicly admonished for his Rude and insolent Behavior to one of the Tutors and that on the Sabbath Day." When his punishment was announced the next morning by no less than Harvard President Edward Holyoke, Cabot "took his Hat and went out of the Chapel without staying to hear the President's Speech out. After Prayers he bulrags the Tutors at a high rate and leaves College." Parental reaction still rings true today: "His mother faints at the News."[32] Joseph Lee Esq., eldest son of Jeremiah Lee Esq. of Marblehead, entered Harvard with the class of 1768. In July 1765, he was fined for "Absence

from his Chamber Twice and for making Tumultuous Noises"; and in April 1767, he was rusticated (suspended) for his part in keeping a woman in a college chamber. He was readmitted to the class of 1769, but in October 1770 was again in trouble when he and John Tracy gave a "riotous party" in the latter's college room.[33] Less than a year later, on September 2, 1771, Ashley Bowen (1728–1813)—seaman, ship rigger, maker of ships' colors, and mender of sails—recorded the bright scene in Marblehead Harbor with "The colors on board all the shipping as Mr. Joseph Lee was published to Mrs. Hannah Hinckley of Barnstable." Five weeks after this respectful, companionate salute to one of their own, the seamen once again hoisted "The color[s] out on board the shipping as Mr. Joseph Lee came to town the last evening with his wife from Barnstable" (fig. 16).[34] One year later, Joseph and Hannah were sufficiently settled for his father to purchase from Gould £81..18..0 worth of handsome furniture for the couple.

Once the banns were published, celebrations began. "Dr. Bernard Published yesterday. His Company Drank Punch here to Day," noted Mary Holyoke on November 20, 1780, as the Holyokes toasted Edward Barnard and Judith Herbert who would marry on January 7.[35] The wedding ceremony itself was most often performed at home before a relatively small group of guests. Thirty, including the Holyokes, were present at Peter Frye's house when daughter Love Pickman Frye

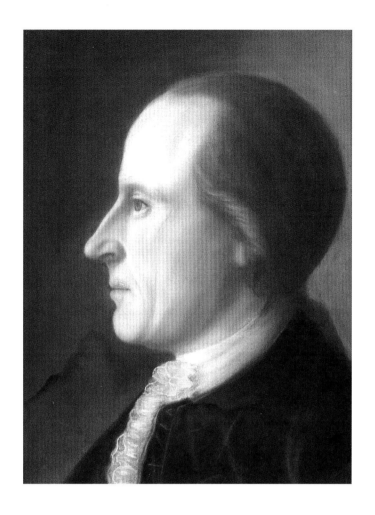

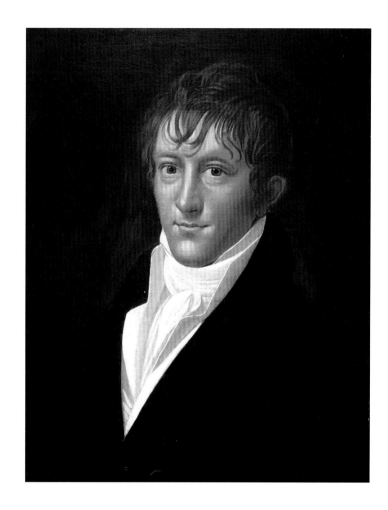

FIG 16
Ashley Bowen (1728–1813)
Marblehead House Flags or "Colors"
Watercolor on paper, H 7 ³/₈; W 12 ½
Marblehead Museum and Historical
Society, Marblehead, Massachusetts

(1754–1839) married Dr. Peter Oliver (dates unknown) on December 4, 1774. The Holyokes had also been among the chosen few when Sarah Orne married Clark Gayton Pickman on July 24, 1770, which Abigail, or Nabby, Eppes considered a small wedding, but "everything very clever."[36] Following a very good dinner, this couple retired at half after ten, and Nabby says that, "After throwing the Stocking and wishing them good night we took our leaves." The custom of throwing one of the bride's stockings was a predecessor to the more demure tossing of the bouquet. On February 10, 1777, John Adams would ask his Abigail to jokingly tell her affianced sister Betsy that he hoped she was married, though he also wished she would wait until he could be there, as, "I want to throw the Stocking."[37] Betsy Smith was married to John Shaw eight months later. If the wedding ceremony itself was rather brief and modest in scale, other rituals threatened to make the occasion costly indeed. Festive meals often featured two of Salem's favorite special event foods: turtle and barbecued meats. Mary Vial Holyoke went to the "turtle at Clarke Pickmans" two weeks after his marriage; and the final charge in Gould's list of wedding furnishings for Rebecca Orne Cabot was for "a Truck for Spit" and a "handle Baister," signifying that the celebrations included a "Magnus Barbecuus" as noted by another Salemite, Harvard-educated, of course (see fig. 9).[38] There was household furniture to select—Clark and Sarah's order with Gould totaled £120..8..0. Then there was the enormous expense of special clothing—for the wedding itself, the subsequent weeks of formal visits, and the four Sundays after the wedding when the bride, accompanied by her husband, brother, or close male relative, was expected to attend services, not so much for religious purposes as for public display. To Nabby Eppes, the couple, on that first Sunday, looked "extremely Pretty," and we can be certain that as many eyes were on the bride as the preacher when she appeared bedecked in a flowered white lutestring (a taffetalike fabric), with " a Rich lace Tucker and tippet and ruffles a blond lace cap & ruff and Stomager [stomacher] and bows." She must have shimmered from head to toe with her glossy dress and paste necklace, sprig, and comb—even the buckles atop her white satin shoes. Not to be outshone, Clark was "Dressed in a suit of White broadcloth with Silver Buttons the wastecoat trim'd with Silver lace ruffles and bosom." The second Sunday, Mrs. Pickman "was dress'd in her Pink and Silver, The Third in her Changeable and the fourth in Straw and White." Meantime, Clark had entertained about twenty-three gentlemen that first Sunday evening while "Sally had company all the Week." Friends and neighbors came to call and congratulate during these obligatory wedding visits. Everyone was on view—the

celebrated and the celebrants. Countless hours were spent before those dressing glasses Gould had framed, and much use made of his dressing boxes, dressing stools, and wig boxes as people sat in his chairs before his chamber tables and toilet tables preparing for such social occasions.[39] On October 2, 1766, when Mary Holyoke made her wedding visit to Benjamin Lynde's daughter Lydia, who had married the Reverend William Walter two days earlier, she did so in concert with "20 ladys."[40] The several sets of chairs and ample "Tea Boards & Servers" were certainly put to use as cake and wine were passed, again and again, to those genteelly seated about the room. Everything as well as everyone was on view. Nabby Eppes could

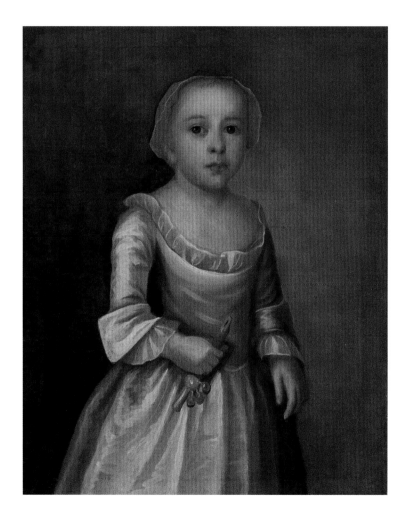

report that the Pickmans' "House is prettily furnish'd," and "there appears a great prospect of happiness."

Within a year, more or less, there might be occasion for another kind of ritual: a "sitting-up" visit when female friends came to call upon a new mother, typically during the third or fourth week after birth (fig. 17). Mary Holyoke was "Brought to bed" of her daughter Peggy on March 4, 1763, and narrated the roster of those who came to visit beginning seventeen days later and continuing through the month: some fifteen friends with names well known to the readers of Gould's account book.[41] These married women could expect to give birth every two years, sometimes over a span of twenty to twenty-five years. Mary Vial Holyoke's first child was born to a twenty-two-year-old bride, her twelfth to a forty-five-year-old matron. Multiplying friends by marriages and births, it is clear that women were charged with a constant round of obligatory visits. To oversee the smooth running of one's own household and care for an ever-more-complicated family, while regularly braving the discomforts, fears, and dangers of pregnancy and childbirth, and at the same time supporting a large circle of friends in like circumstances, must have sometimes seemed overwhelming. Through these wedding and sitting-up visits, humanitarian calls, and social exchanges, these women would have known each others' best parlors and bed chambers as well as their own. Handsomely carved sets of chairs and tables, towering cases of drawers, polished chests of drawers, and exquisitely hung beds were admired not only by family, but by a sizable, frequent, and observant public.

Nathaniel Gould's business records cite twenty-six cradles made over his career: in mahogany, cherry, cedar, walnut, and pine. From the frequent replacement of rockers and other mending—often in preparation for the birth of yet another child—we can infer that they were used regularly. (Gould sold a number of cots, a word sometimes interchangeable with cradle or crib, but more properly a small bed suspended between uprights or a four-legged bedstead with sides to keep a child from falling out, which he also supplied several of his customers.) Three trundle beds appear in the accounts. Little furniture was made specifically for children, suggesting that in the eighteenth century children were adapted to furniture rather than furniture being adapted to children. One of those Salem children was Thomas Mason, portrayed by Joseph Badger (1707/8–1765) at the age of eight (fig. 18)— a boy who would grow up to be a master mariner and merchant and who would order his wedding furnishings from Nathaniel Gould, only a year before being lost at sea. Other than the infant beds, and coffins, the sole pieces of furniture made specifically for children in all Gould's

records are a "chair child's" purchased by Timothy Orne III for use at home, and a "Seat for Child in peu" (pew) commissioned by Aaron Waite for use in church.[42] Nonetheless, childbirth proved the impetus for many purchases from Gould (see Appendix E).

While wives were busy making or mending, washing and ironing infant clothing and lying-in attire, purchasing tea, and assisting in baking "a great batch of plum cake," in readiness for the imminent "Little Stranger," and the subsequent round of visitors, husbands were soliciting Gould for help in getting rooms ready. Some of the tasks were incidental to childbirth, but directly involved in making a chamber look its best—altering and mending looking glasses, polishing a

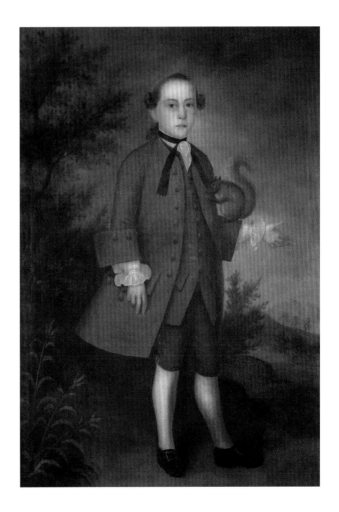

FIG 18
Joseph Badger (1707/8–1765)
Thomas Mason, 1758
Oil on wood, 61 1/8 × 43 7/8
Historic New England, Boston,
Gift of the Stephen Phillips Memorial
Charitable Trust for Historic Preservation
(2006.44.769)

chest of drawers, purchasing a new bed or updating an old one. With the focus on a "lying-in" mother, the bedstead, draped with fifty-some yards of fabric, would also be at the center of attention. Jacob Ashton might have had that in mind when he purchased a mahogany bedstead with fluted foot posts in June 1781 at the time of his daughter Sarah's birth; while Walter Bartlett improved with new bed rails and head posts. Both Bartlett, in 1782, and Dr. Edward Barnard, in 1781, acknowledged the current fad for bed cornices just before the birth of a daughter and son, respectively. Hangings were typically put up each fall to keep out wintry blasts during the cold season. However, they were intentionally hung in the warm weather months if a mother was to deliver and the bed chamber was made into a reception room—for appearance and for a modicum of privacy.[43] Mary Holyoke noted on September 9, 1771, that although she was feeling "Very poorly," she, or, more likely, her help, "Put up bed," three days before giving birth to a daughter.[44] Hanging a bed was a difficult task and Gould often sent one of his "boys" to assist with the job. Thus, Captain Peter Lander paid Gould for putting up two bedsteads, mending a looking glass frame, mending a cradle, and the purchase of six chair frames, before the birth of his daughter Lydia in October 1781. The seats of chamber chairs, like the window seat squabs and curtains, were to accord in color and fabric with the bed hangings.[45] Brig. General John Glover ordered six small chairs and one large chair (probably an easy chair) at the time of the birth of a daughter, and Captain William Lilly purchased an easy chair and six chairs, referred to as "small" by Benjamin Nurse, who upholstered the chairs near the birthdate of Ann Lorn Lilly. Sets of six chairs are often grouped with bedroom furniture in household inventories, and it might be fruitful to explore further the equation between the adjective "small" and chamber chairs. Joseph Churchill purchased rockers for a cradle in August 1760; he also bought two low chairs. Low chairs would be helpful in dressing oneself, but, more significantly, in changing and dressing infants and toddlers close to the floor, where an active baby would be safe, and, in winter, warm. With the chair's seat only twelve to fourteen inches above the ground, a nursing mother would benefit from the greatest warmth and brightest light from the fire, and likewise be more easily able to tend the flame. George Deblois bought a low chair in September 1772, one month before his daughter Betsy was baptized, and shortly before his purchase of rockers for a chair, a crib, and a close-stool. The last, which was a potty chair, would have been an aid in caring for mothers who were confined

FIG 19
Love Pickman (Mrs. Peter Frye) (1732–1809)
Embroidered picture, after 1747
Silk-satin embroidered with silk and metallic threads, 15 7/8 × 21 1/2
Museum of Fine Arts, Boston, The M. and M. Karolik Collection of Eighteenth-Century American Arts (39.241)

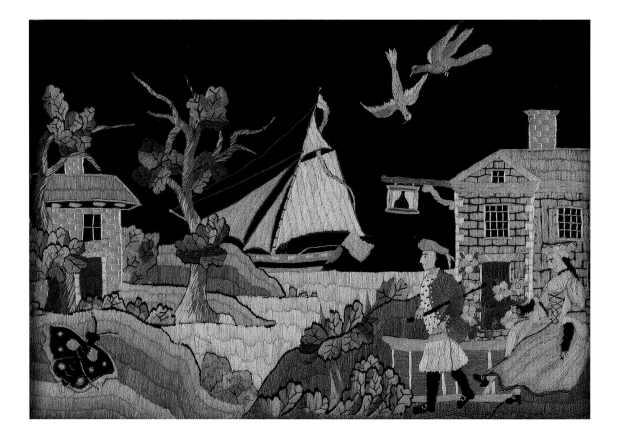

to their chambers, typically for a month after delivery, or in a lengthy convalescence. When Benjamin Lynde Esq.'s wife was delivered of a stillborn child, she herself was so ill that there was little hope of recovery, and "afterward so weak that she was not moved out of her bed but by a sheet, and never put her feet to ground to step" for more than five months.[46] Warm, down-filled, and draft-protected, the easy chair was as appropriate for a convalescent as for the dedicated "watcher" who might spend days and nights nursing a patient back to health.

The purchase of a child's coffin was sometimes the sad sequel to the order for a cradle. Childbirth and childhood were dangerous times in women's lives. Dr. Edward Augustus Holyoke and his wife Mary shared a particularly tragic history. His first wife, Judith, died at age nineteen, followed three weeks later by their newborn daughter. With his second wife, Mary, he had twelve children. Their firstborn, Mary, died at age three from "quinsy," or complications of tonsillitis; a second Mary died at nine months, from a childhood illness that had also threatened an older sister; Elizabeth succumbed to jaundice at eighteen; and six died within days or weeks of birth.[47] Women in Gould's Salem learned early in life that nursing skills were a requisite accomplishment.

There were additional concerns. The sea was all-present and, though these waters were the enabling source of much of the wealth expended with Gould, Neptune could drive a hard bargain. A large number of Gould customers and their sons, including one of his own, were lost at sea. Farewell scenes (fig. 19) and worry were constants. Further, politics complicated life in Nathaniel Gould's Salem. His professional equanimity enabled him to serve both those convinced of the rightfulness of the colonial cause and those steadfastly loyal to British authority, but the American War for Independence and the events leading up to it were highly disruptive to his business, and brought distress, displacement, debt, even death, to his customers. Fires, like the one that broke out in Peter Frye's wood house on the night of October 6, 1774, and ultimately consumed the homes, stores, and meeting house of several Gould customers, were thought to have been set by incendiaries determined to destroy Tory property.[48] By the spring of 1775, Salem citizens had begun to scatter in fear that the British might try to destroy the port town. Some, "on account of the Regulars," went inland—to Ipswich, Haverhill, and Exeter; others, "to avoid ye continual Alarms," to Nantucket; still more sailed for Newfoundland, Nova Scotia, or England, as the "threats and insults of the rabble have been insupportable."[49] For those who stayed, the safety of families and prized possessions was paramount.

The Holyokes spent April 22, 1775, busily packing up goods to be transported the next day to the homes of relatives farther inland, in Boxford. Three days later, Mary was packing for her own departure to Nantucket; she embarked on April 26, leaving her husband in Salem.[50] Uncertainty made decisions difficult; citizens juggled options and struggled to make the right choice. Mary Toppan Pickman, whose husband had departed for England in March, had four children, ages eleven, nine, almost two, and nine months, and big decisions to make. She had secured passage for herself and her children on a vessel bound for Halifax, Nova Scotia, "and part of the furniture was actually shipped therein."[51] But, the ship's departure was delayed, and she decided that her family and estate would probably be safer if she stayed. Dr. Holyoke shared his deliberations with his now distant wife in Nantucket, "I have it in contemplation to send off some necessaries for house keeping, if we should be driven away, but as to expensive furniture, such as looking glasses, chest of drawers, &c., the risk is so great in removing them that I think unless we are in greater jeopardy than I think we are yet, I shall let them abide."[52] By the end of October, that perceived jeopardy was such that Mary Holyoke, who had returned in July to a "very empty" town, now "Moved our Best Chamber furniture to Danvers."[53] Dismantling a bed or securing case pieces was a job for professionals, and Gould's "boys" helped prepare for the move and in making and packing the three boxes that were sent off. Four and a half months later, Mary Holyoke could record with relief the departure of the British from Boston; and soon thereafter she began to reassemble their scattered belongings. On March 29, she went to Danvers, and the following day she "Brought my trunk from there." The goods from Nantucket arrived on May 19—safely, though the ship had been "Chased by a man of war." Once again, Gould's boy was sent to help the Holyokes unpack and set things up. On September 6, 1776, truckman Very brought their things from Danvers, and a month later their "things Came from Boxford." Finally, when Mrs. Holyoke went back to dine in Boxford on September 27, 1777, she retrieved the silver.[54]

Times remained difficult. Mary Holyoke told her uncle on February 27, 1780, that, "We are put to the greatest difficulty to provide for our family, even the commonest necessaries of Provision & Clothing." Inflation was rampant. Cordwood was selling at exorbitant cost, and, "We are obliged to wear now what we should have been ashamed to have given away."[55] In nearby Marblehead, which was literally "buried in the snow," another resident bemoaned the shortage of wood to the point that, "some I know who have burnt Chairs,

TO BE SOLD,

At Public Vendue, on the 19th inft. at the houfe of Mr. Joseph Miller, in Worcefter, near the Court-Houfe in faid town, by the fubfcriber, Agent on the eftate of Dr. William Paine, late of faid Worcefter, Abfentee ; all the perfonal eftate of faid William Paine, now in the hands of faid agent, viz.

A LARGE and Genteel affortment of houfhould furniture, amongft which are two elegant Beds with elegant Curtains, half a dozen of excellent hair bottom mohogany chairs, and half a dozen of black walnut hair bottom chairs, a number of the beft mohogany Tables, looking Glaffes, chefts of Drawers, a quantity of glafs ware, &c. &c. A large quantity of good kitchen furniture of every fort and kind. Alfo, an elegant fall-back chaife.

To be fold, alfo, at the fame time, a very valuable collection of Medical authors, among the number are *Bernardi Siegfried Albini Tabula Skeleti et Mufculorum Corporis Humani*——Alfo a number of valuable Hiftories, making in the whole a library of 122 volumns. WILLIAM DAWES, Agent on faid eftate.

FIG 20
Auction for the Sale of Personal Estate of
William Paine
Massachusetts Spy, Worcester,
Massachusetts, May 13, 1779
American Antiquarian Society, Worcester,
Massachusetts

Hogsheads, Barrels, Chests of Drawers."[56] Among the exiles, a number of Gould customers had had their property confiscated, and much of that furniture had been sold at auction (fig. 20). By 1781, some residents began to return, and again turned to Gould to help replace their losses. When Henry Gardner arrived back in Salem, he soon commenced refurnishing his home with the purchase of bedsteads, tables, chairs, and a chest of drawers. The subsequent order for a pine cradle marked the birth of Sally ten months after her father's return. Benjamin Pickman found that his children had grown and that his wife adeptly had kept his property intact during his decade-long absence. Soon Mary Toppan Pickman was "again as 'women wish to be who love their lords' and as women will be whether they wish it or not."[57] Love Rawlins Pickman was born April 10, 1786, when Mary was four months shy of age forty-two. Her eldest son could later say that not only did his mother's happiness seem "to consist almost exclusively in promoting the happiness and comfort of others," but her "house was the mansion of neatness, of good order, and of hospitality."[58] She was indeed what the eighteenth century would have hailed as a "notable" housewife.

Her family's health and comfort and the care and preservation of tangible goods, in concert with the smooth running of the household, were all within her domain. If a housewife did not perform a specific duty herself, she oversaw those who did. The homes of many of Gould's clients bustled with slaves and servants.[59] Several customers kept a bell to summon their help, while Timothy Orne, in November 1772, had Gould install "Brass wire & Cranks & hanging a Bell,"—a more effective, up-to-date, and fashionable means of command.[60] Should a piece of furniture be damaged by the help or family, Gould might mend it. The frequency and extent of repairs to Richard Routh's furniture suggest that there were troubles at home. A daily concern for all town dwellers was the danger of fire, for even if one was careful, others might not be, and a blaze might have devastating results. William Pynchon Esq. was exasperated on January 30, 1777, when his keeping room chimney was "on fire again"; and Mary Holyoke took note when "Our Little room Chimney Catch'd."[61] Sweeping or burning chimneys to rid them of creosote were preventative measures. Mrs. Holyoke "Burnt 5 Chimnies," on January 30, 1770, and recorded when "Pero swept Kitchen chimney." Still, on April 5, 1775, the beam in their little room again caught fire.[62] A pair of fire buckets for dousing flames, a canvas bag for salvaging valuables, and sometimes a ladder were strategically stored in most of these homes, usually near the front door.

Chief among those domestic fireplaces was the kitchen hearth. The kitchen was the great engine room that enabled the smooth running of

the rest of the house. It was cleaning headquarters: here materials for regular washing, dusting, and polishing would be mixed or gathered. Mary Holyoke's diary portrays the reiterative round of scouring rooms, pewter, and furniture brasses. Gould's furniture was to be rubbed with wax, brush, and soft cloths until one could see one's reflection in the mirrored surface. Silver must be cleaned with rotten stone—a kind of limestone and sweet oil—or with whiting and chalk; and pewter was to be scoured till it shone like the silver; while brass must be cleaned "twice a week" with rotten stone and lamp oil, "which was hard and disagreeable."[63] Clean surfaces and bright polish showed off fine mahogany, silver, or silk; and they bespoke good management, caring concern for the smallest detail, and polite regard for pleasant surroundings. Such sparkle was especially valued because it was so difficult to achieve.[64] Servants were often lazy or worse; cleaning materials were malodorous and wearying to prepare and apply. Seasonal extremes brought additional challenges—in winter when liquids might be frozen throughout the house; in spring, summer, and fall when dust from the streets blew in through every crevice. Floors were held to the same high standards. A clean kitchen floor, and sometimes the sitting room floor, might be decorated with sand in a decorative pattern: "When the sand was first put on, which might be once a fortnight, it was wet & dropped in some pattern, a diamond perhaps, or a square, & after this order was broken, a hemlock broom was gently used, to draw the sand into waves."[65] Gould could supply the broom handle, and Gould client James Barr delivered this sand to tidy Salem housewives.[66]

Those involved in the weekly chore of washing the veritable mountain of sheets and pillowcases, table cloths and napkins, and in the attendant duties of making soap, drawing and heating water, bleaching, and ironing, were grateful for Gould's ironing or folding boards, his "cloas pins" on breezy days, or his clothes horse when weather proved inclement. Material hierarchies extended to the sheets and pillowcases: fine Holland linen for those fluted, tall-post mahogany beds, lowly tow for the "common" oak bedsteads so often cited in wedding orders and intended for use in chambers at the base of the ladder. All these linen and cotton cloths, including table linens, from damask to diaper, were to be snowy white through careful washing and bleaching, and carefully stowed and protected from dampness, rodents, and bugs. Cases of drawers, chests of drawers, trunks, and shelves all obliged. An additional safeguard was to line these drawers with indigo-dyed paper, which provided a splinter-free smoothness and bug-resistant armor (see cat. 1, fig. 1).

It was the custom to take the snow-white cloth off the dining table after the main course, as recalled by a grandchild of William and Lois Paine, reminiscing about life at "Home Farm," where Dr. Paine "always liked to have his meals well served, and the fruit and wine were put on the well-polished mahogany table after the cloth was removed."[67] She remembered that the parlor "was used in winter as a dining-room and sitting-room" combined, referring to the migrational aspect of life at home before the furnace in the basement. Here was the reason for that diversity of table shapes and sizes: in winter, meals were taken at tables set up immediately in front of a fire; in summer, a breezy location was more conducive to long sittings over the wine. "All through the long, severe winter we were cold as a matter of course," confirmed one Salem girl, "excepting the side next to the glowing wood fire, and that was scorched; the entries and sleeping-rooms were probably at freezing point, ice in the water pitchers, unmelting frost on the windows."[68] A standing fire screen from Gould could provide a shield from such one-sided hearth heat and a fireboard might neatly close the opening in summer.[69]

Seasons also determined dining room fare. Gould could supply serving accessories such as sideboards, side tables, dumb Bettys, knife boxes, and bottle stands (always ordered in pairs), but the housewife, and often the husband, too, oversaw the variety and freshness of what went on the table. The diversity of foods enjoyed, as narrated in Salem diaries of the period, attests to local waters and in-town markets, to nearby family farms and backyard kitchen gardens, hotbeds, herb borders, berry patches, and orchards. Mary Holyoke was pleased with the 1,836 stalks of asparagus she picked between May 10 and June 10, 1763; and the first green peas in June and earliest cherries in July were always cause for celebration and competition.[70] Many of these women were accomplished gardeners, and several of the men were acclaimed amateur horticulturists, orchardists, and breeders. Nathaniel Tracy's orchard annually produced 140 bushels of plums, pears, apples, cherries, and peaches, while William Paine took great pride in his as well, and Timothy Orne's cow was a veritable wonder, giving birth to eleven calves in thirty-five months.[71]

The serious commitment and steadfast determination with which so many of these men and women engaged in life mark this period. Everything—from dressing correctly to preparing and serving fresh food graciously, from keeping fine furniture polished to adroitly hanging a bed, from visiting friends to caring for the sick—took a long time, required considerate thought, and demanded effort. They were expected to and did perform these duties of social etiquette. In return, they counted on the same dependability, attention to detail, and concern for work performed well in the best manner with the finest materials. Nathaniel Gould was ready to oblige.

1. William Burnet Browne of Salem married Judith Walker Carter, daughter of Col. Charles Carter of Cleve, King William County, Virginia in 1763. They lived in Salem, but returned in October 1766 to King William County where they lived at Elsing Green. Gould packed "Sundris Household Goods" for them in November, preparatory to shipping. In the summer of 1767, Gould did further work for Browne: he made and cased for shipment two dressing boxes with mirrors, constructed a rabbit cage, and cased two large pictures and a desk-and-bookcase. Brown remained in touch with his Salem friends, and in July 1783 sent William Pynchon a live peacock, which promptly fled the day after arrival but was brought back. See Pynchon 1890, p. 15. For an early view of Elsing Green, see Hardy 1911, p. 84.

2. Vital records, unless noted, are from the database Massachusetts Vital Records to 1850 (hereafter MVR)

3. Tamson Southwick marriage in Perley 1926, vol. 2, p. 56.

4. For more on the hierarchy of rooms, see Garrett 1990.

5. Jobe 1992, pp. 25–26.

6. Pynchon 1890, p. 82.

7. Desks ordered at the time of marriage include Edward Barnard 1781, Crispus Brewer 1758, John Brooks 1781, Henry Brown 1780, Jonathan Cook 1781, George Deblois 1772, John Donaldson 1780, William Goodhue Jr. 1777, James Wood Gould 1782, John Hathorne 1772, Stephen Higginson Jr. 1768, Archelaus McIntire 1761, Ichabod Nichols 1774, Samuel Nichols 1781, John Norris 1778, Abijah Northey 1765, Dr. William Paine 1773, Thomas Palfry 1781, Thomas Smith 1781, Peter Smothers 1779, Alexander Walker 1770. Desk-and-bookcases include Andrew Cabot 1773, George Cabot 1774, Joshua Dodge 1777, Henry Gardner 1769, Clark Gayton Pickman 1770, Richard Routh 1771, Nathaniel Tracy 1775.

8. Will of Daniel Gardner, July 6, 1759, Massachusetts Probate Records of Essex County, 1671–1863 (hereafter PREC), vol. 336, p. 386.

9. Will of Benjamin Lynde Jr., May 10, 1776, quoted in Lynde 1880, pp. 234–35. Richard Derby also purchased furniture from Gould in September 1763 for his daughter Martha, who had married Dr. John Prince. In Derby's will of October 27, 1783, his bequest to Martha included "all Household Furniture & Plate I gave her about time of her marriage." Quoted in Derby 1861, pp. 163–64.

10. For recent scholarship on the Salem elite, see Morris 2000, pp. 603–24.

11. Gould clients who graduated Harvard include Jacob Ashton 1766, Edward Barnard 1774, John Barnard 1762, Thomas Barnard Sr. 1732, Thomas Barnard Jr. 1766, Simon Bradstreet 1728, George Cabot 1770, John Cabot 1763, Joseph Cabot 1764, Samuel Curwen 1735, Joshua Dodge 1771, Asa Dunbar 1767, George Gardner 1762, Henry Gardner 1765, Samuel Gardner 1732, Nathan Goodale 1759, Benjamin Goodhue 1766, William Goodhue Jr. 1769, Edward Augustus Holyoke 1746, Jonathan Jackson 1761, John Lowell 1760, Benjamin Lynde 1718, Timothy Orne 1768, William Paine 1768, Timothy Pickering 1762, Benjamin Pickman Jr. 1759, William Pickman 1766, Nathaniel Sparhawk Jr. 1765, Nathaniel Tracy 1769, William Wetmore 1770.

12. Wives and daughters of Gould clients who worked embroidered pictures or samplers include Hannah Batchelder 1780, Joanna Batchelder 1779, Sally Bott 1784, Anstis Crowninshield ca. 1740, Sarah Derby ca. 1763–66, Elizabeth Herbert 1764, Elizabeth Holyoke ca. 1782, Susanna Holyoke ca. 1790, Betsy Ives 1778, Lois Orne 1766, Nabby Mason Peele 1778, Lucia Pickering 1759, Love Pickman ca. 1745, Ruthy Putnam 1778, Mary Richardson 1783, Susannah Saunders 1766, Abigail White 1765, Rebeckah White 1766.

13. Quoted in Richter 2000, p. 30. See also Ring 1993, pp. 105–106.

14. Will of Samuel Gardner, September 15, 1766, PREC, vol. 345, p. 338. Gardner also left to his daughter Esther who first married Francis Higginson and later married Gould client Daniel Mackey, "Fifteen hundred Pounds lawfull Money which with what I heretofore advanced to & for her viz before her intermarriage with Mr. Daniel Mackay I judge to make at least two Thousand Pounds." At his death, Samuel Gardner was regarded as "the wealthiest citizen of the town." See Briggs 1927, p. 50. See also Morris, p. 611.

15. *Massachusetts Spy* 3, 122 (June 3, 1773), p. 2.

16. *Essex Gazette* 6, 270 (September 21–28, 1773), p. 35.

17. Will of Timothy Orne, May 28, 1767, PREC, vol. 344, p. 156. Guardianships of Timothy, Samuel, Rebecca, Sarah, Lois, and Esther Orne, September 8, 1767, PREC, vol. 344, p. 189.

18. See Buhler 1979, pp. 42–47; Buhler 1936, pp. 38–45; and Kane et al. 1998, pp. 99–100ff.

19. Gould receipt to Captain Joseph Cabot, August 1768, Orne Family Papers, Mss Orne 41 B19 F3, Phillips Library, Peabody Essex Museum. Richard Derby receipt for purchases made for daughter Martha, "Capn Ricd Darby to Nathl Gould," November 21, 1763, Derby Family Papers, Mss 37 B15 F5, Phillips Library, Peabody Essex Museum.

20. For more on women and their role in purchasing, see Styles and Vickery 2006; and Garrett 1990, pp. 249–69.

21. Guardianship of Tabitha Skinner, May 14, 1759, PREC, vol. 336, p. 243. See also New England Historic and Genealogical Register 1900, pp. 419–20.

22. For more on Orne's seminal significance to eighteenth-century Salem, see Hunter 2001.

23. Family portraits, engraved silver, and worked coats of arms have long been recognized as markers of lineal distinction. In recent scholarship, these and other arts of pedigree have been discussed under the descriptor "patina." See McCracken 1990; and Goodwin 1999. See also Garrett 1985, p. 44. Coats of arms relevant to Gould customers include the following identifications: Bradstreet arms worked by Rebecca Bradstreet, daughter of Simon, see Ring 1993, p. 266. Cabot and Fitch arms attributed to Mary Cabot, daughter of Francis Cabot, see Little 1984, p. 137; and Ring 1993, p. 266. Francis Cabot's household inventory, August 22, 1786, lists, "1 Coat of Arms," PREC, vol. 359, p. 158. Curwen coat of arms, Peabody Essex Museum, see Bolton and Coe 1973, p. 403. Lois Gardner, daughter of Samuel and wife of Thomas Barnard, worked the Gardner arms, Peabody Essex Museum, see Ring 1993, p. 269. Samuel Gardner's household inventory, August 4, 1769, lists, "1 Coat of Arms," PREC, vol. 345, p. 458. Listed "In the Middle Room" in Stephen Higginson's household inventory, November 23, 1761, are "2 Family Pictures" and "Arms Framed," PREC, vol. 339, p. 249. Holyoke arms, gouache and gilt on parchment in original frame, ca. 1780, sold at Northeast Auctions, Portsmouth, New Hampshire, "Annual Summer Americana Auction," August 3–5, 2007, lot 1636. The arms of Robert Hale Ives embroidered by his sister Rebecca, see Bolton and Coe 1973, p. 404, pl. 125 (opp.) and p. 406. Jackson arms, see Sweeney, J. and Du Pont 1963, p. 98. Jones arms worked by Mary Jones, later Mrs. Asa Dunbar, see Ring 1993, p. 271; and Benes 1982, p. 160. Lynde arms worked by Benjamin Lynde's daughter Lydia in 1762, see Ring 1993, p. 262. John Norris inventory, April 17, 1809, lists, "Coat of arms," PREC, vol. 377, p. 498. Peirce arms worked by Jerathmael Peirce's daughter Sarah, Peabody Essex Museum, see Ring 1993, p. 272. Pickering arms worked by Timothy Pickering Sr.'s daughter Sarah, 1753, see Ring 1993, pp. 272–73. Pickman arms worked by Elizabeth Delhonde, later Mrs. Samuel Grant, see Little 1984, p. 137. Pickman arms painted by Samuel Blyth, Peabody Essex Museum, see Little 1972a, ill. p. 56. Tracy arms, Peabody Essex Museum, see Ring 1993, p. 277.

24. Gould sold Benjamin Blyth a sign board in October 1769: "Limning in Crayons," from Blyth's advertisement in the *Essex Gazette* 1, 25 (January 10–17, 1769), p. 101. Gould customer portraits in pastel or oil by or attributed to Benjamin Blyth include Elizabeth Higginson Cabot (Mrs. Joseph), George Cabot 1771, Samuel Curwen 1772, Anstis Derby, Elias Hasket Derby ca. 1771–79, Elizabeth Crowninshield Derby, Ezekial Hersey Derby, 1775–76, Richard Derby, ca. 1771–79, George Dodge, ca. 1770, Lydia Herrick Dodge, Eunice Diman ca. 1774, Edward Augustus Holyoke, Mary Vial Holyoke 1771, Thomas Mason, Benjamin Moses, Sarah Carroll Moses, 1781, David Ropes, Priscilla Webb Ropes, date unknown. See Foote 1959, pp. 64–107. Also see Little 1972a, pp. 49–57.

25. Portraits by Copley include Abigail Pickman Eppes ca. 1769, Jacob Fowle Sr. 1761–63, Dr. Sylvester Gardiner Esq. ca. 1772, General Thomas Gage 1768–69, Alice Hooper (later Mrs. Jacob Fowle Jr.) 1763, Lydia Lynde (Benjamin Lynde mentioned in his diary on June 4, 1756, that Lydia "sat for picture" in Boston where he had gone two days earlier "To see Mr. Copeland's [sic] picture," see Lynde 1880, p. 182), Jonathan Jackson 1767–69, Jeremiah Lee Esq., Martha Swett Lee 1769, Benjamin Pickman Jr., Mary Toppan Pickman 1763, Anne Wentworth ca. 1758. Portraits attributed to Copley include William Vans Esq. and his wife, see Prown 1966; and Rebora et al. 1995.

26. Gould supplied Samuel Hall with "Sundrie Slips for printing," April 1770 and September 1771; "Rose wood plank for press," January 1772; and smoothing plates for press, September 1777.

27. "Bills incurred in 1762 by Dr. Bezaleel Toppan, Mary Toppan and Benjamin Pickman for wardrobe & household at time of marriage & going to house keeping," Pickman Family Papers, box 9, folder 11, Phillips Library, Peabody Essex Museum.

28. See Buhler 1931, pp. 43–51; Buhler 1961, pp. 19–29; Buhler 1972. See also Kane et al. 1998.

29. Gould's customers for "umbrilo" frames included such up-scale clients as John Appleton July 1767, Elias Hasket Derby July 1761, William Eppes September 1763, Timothy Orne (bought two) 1764, Jonathan Webb August 1767. Gould billed Thomas Poynton in 1763 and Peter Frye in June 1767 for "mending umbrilo." The fact that umbrellas were often purchased in summer months suggests that they were used more for sun than rain; both men and women used them. Mary Vial Holyoke "Covered umbrella," on May 30, 1769. Holyoke 1911, p. 71.

30. Holyoke 1911, pp. 55–56.

31. Bentley 1962, vol. 4, pp. 462–63.

32. Shipton and Sibley 1972, pp. 33–34.

33. Ibid., pp. 183–84.

34. Bowen 1973, vol. 1, p. 282; "came to town" October 10, 1771, p. 285.

35. Holyoke 1911, p. 105.

36. Ibid., p. 85 (Frye); p. 74 (Pickman): Nabby Eppes, Salem, letter to Mrs. Mary Pickman, Stafford, August 21, 1770, Clark Gayton Pickman Papers 1770–77, in Pickman Family Papers, box 9, folder 2, Phillips Library, Peabody Essex Museum.

37. Butterfield et al. 1963, p. 159.

38. Gardner 1913, p. 9.

39. Gould framed dressing glasses for William Burnet Brown 1767, Stephen Higginson Jr. 1769, and William Pynchon 1770. Jeremiah Lee Esq. purchased two dressing stools in May 1770. Edmund Beckford 1765, Samuel Stone 1757, and Nathaniel Whitaker 1770 bought wig boxes; and in 1768 Alexander Walker purchased a "Draw[er] and Wigg Stand." In Francis Cabot's inventory were "2 wiggs & a Box," in Jeremiah Lee's "2 Wiggs & wigg Boxes," and in Gamaliel Hodges's "1 Wig do [box] & 2 old Wigs." Cabot inventory, p. 162; Jeremiah Lee inventory, June 28 1776, PREC, vol. 353, p. 493. Gamaliel Hodges Inventory, May 1, 1769, PREC, vol. 345, p. 346. For a vivid picture of the laborious process of getting dressed and the details of a gentleman's toilette in Gould's Salem, see the Reverend William Henry Channing's description of the daily morning preparations of his grandfather, Gould client Stephen Higginson, quoted in Higginson 1907, pp. 271–76.

40. Holyoke 1911, pp. 65–66.

41. Ibid., p. 58.

42. Aaron Waite placed this order in the spring of 1772. He had been a member of the First Church in Salem, but in 1771 joined the congregation at Tabernacle. His children were Aaron (b. February 12, 1767); Elizabeth (b. January 4, 1769); Deborah (b. August 20, 1771). Elizabeth and Deborah were baptized at Tabernacle on August 25, 1771. See the databases MVR and Salem Massachusetts Eighteenth-Century Baptisms.

43. For domestic interiors, furnishings, and daily life, and specifically children and bedchambers in early America, see Nylander 1993, pp. 27–31; and Garrett 1990, pp. 120–23, 126–27, 227–32.

44. Holyoke 1911, p. 77.

45. On harmony, see Garrett 1990, pp. 119–20. An entry in Jeremiah Lee's household inventory of June 28, 1776, encapsulates this color accord: "a full suit of yellow silk damask curtains, with bedstead, easy chair, 7 squabs, window curtains," [commas added] at the high value of £79, 3s, 3d. PREC, vol. 353, p. 493.

46. Lynde 1880, p. 165.

47. Holyoke 1911. See also Nichols 1861, pp. 57–61.

48. See Felt 1845, vol. 1, p. 374, where he mentions that Gould client Samuel Field's mother, "while attempting to escape from her residence, struck her head, fell and was burnt to death." See also EIHC 1907, p. 116. Mary Holyoke noted that they had been so alarmed at this encroaching fire that, "We mov'd our furniture." Holyoke 1911, p. 84.

49. "Account of the Regulars," in Lynde 1880, p. 206; "continual Alarms," in EIHC 1907, p. 116, entry for April 28, 1775; "The threats and insults," in William Pynchon letter, April 16, 1775, quoted in Briggs 1927, p. 45.

50. Holyoke 1911, p. 86.

51. Biographical Sketch of Mrs. Mary (Toppan) Pickman by Hon. Benjamin Pickman, in Pickman 1928, p. 81.

52. Edward A. Holyoke, June 20, 1775, quoted in Upham 1876, p. 213.

53. October 30, 1775, Holyoke 1911, p. 92.

54. Ibid., pp. 93, 94; "things came from Boxford," October 10, 1775, p. 94; September 1777, p. 97.

55. Mary Vial Holyoke to Jonathan Simpson, quoted in Upham 1876, p. 236.

56. Samuel Sewall, quoted in Upham 1865, pp. 196–97.

57. Mrs. Abigail Swett to Eliza Wainwright, September 12, [1822], Wainwright Family Papers, Rare Books and Manuscripts Division, The New York Public Library; Astor, Lenox and Tilden Foundations.

58. Pickman 1928, pp. 79–80.

59. Slaves owned by Gould clients are documented in tax records, probate records, and newspaper advertisements. For examples of the trials and tribulations of servant help, see Pynchon 1890, pp. 178, 180, 181.

60. Stephen Higginson had a bell in "the Little front room" of his Salem home when the household inventory was taken on November 23, 1761. Included in the appraisal was "a Negro boy." PREC, vol. 339, pp. 250, 252. Simon Bradstreet kept a bell in the "Parlour" of his Marblehead home where "Negro Woman Phillis" and "Negro Boy Chamie" also lived on December 3, 1771. Ibid., vol. 347, pp. 447, 450.

61. January 30, 1777, in Pynchon 1890, p. 58. December 22, 1786, Holyoke 1911, p. 116.

62. Holyoke 1911, pp. 72, 116, 86.

63. Kelly 2006, p. 60.

64. See Bushman and Bushman 1988, pp. 1213–38; and Garrett 1990.

65. Kelly 2006, p. 52. See also Sturgis 1907, p. 27; and Felt 1845, p. 407.

66. Curwen 1890, pp. 123–24.

67. Sturgis 1907, p. 28.

68. Silsbee 1887, p. 21.

69. Gould's "Screan Stand" and "fyer Scrien" customers included James Cockle, December 1760; George Peele, April 1767; John Saunders, May 1762; and Tabitha Skinner, August 1759. He sold Jeremiah Lee a "Screen frame" in December 1770; and provided Richard Routh with a "Chimney Bord" on May 30, 1772.

70. Holyoke 1991, p. 59.

71. For Tracy, see Brockway and Cavanagh 2004, p. 27. For Paine, see Sturgis 1907, p. 32. For Orne, see Shipton and Sibley 1975, p. 65.

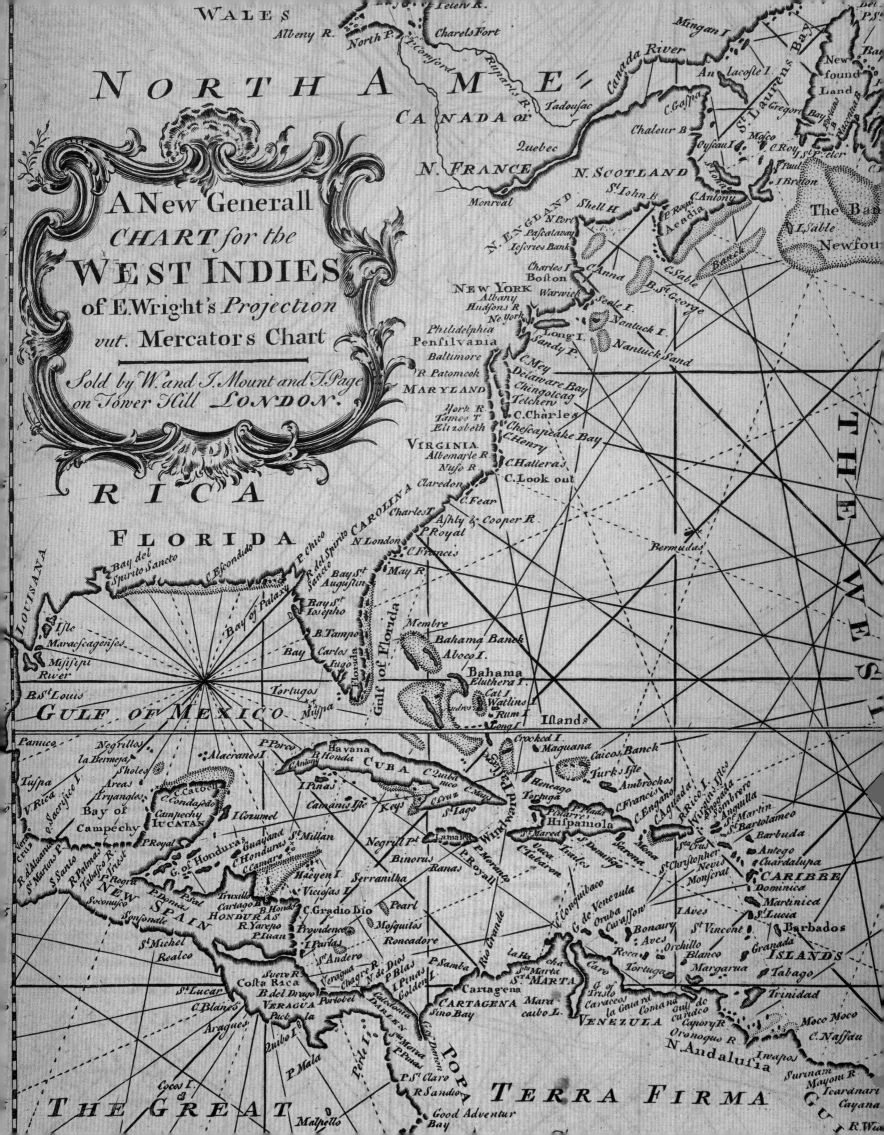

WALES

NORTH AME
RICA

CANADA or
N. FRANCE
Quebec
Monrval
N. SCOTLAND

A New Generall
CHART for the
WEST INDIES
of E. Wright's Projection
vut. Mercators Chart

Sold by W. and I. Mount and T. Page
on Tower Hill LONDON.

Albeny R.
North P.
CharelsFort
Peter R.
Canada River
An Iacoste I.
New found Land
Mingan I.
St Laurens Bay

Tadousac
Chaleur B
Oyseau I.
Mosco
C. Roy
I. St Peter
Gregot
Bay
C. Gossea

N. ENGLAND
St John B.
P. Roya
C. Antony
Acadia
I. Briston
Newfou
Shell H.
N Port
Pascataway
Ieseries Bank
Charles I
Boston
Warwick
C. Anna
Seale I.
C. Sable
B. St George
B. St George
Bank
I. Sable
The Ban

NEW YORK
Albany
Hudsons R.
Ne York
Long I.
Nantuck I.
Sandy P.
Nantuck Sand

Philadelphia
Pensilvania
Baltimore
R. Patomook
MARYLAND
York R.
Tames T.
Elizabeth
VIRGINIA
Albemarle R.
Nuso R.
Claredon
C. Mey
Delaware Bay
Chingotcag
Tetchery
C. Charles
Chesapeake Bay
C. Henry
C. Hatteras
C. Look out
C. Fear

FLORIDA
Bay del
Spirito Sancto
C. Escondido
P. Chico
R del Spirito Sancto
CAROLINA
N. London
Charles T
Ashly & Cooper R.
P. Royal
C. Francis
Bay St
Augustin
May R.
Membre
Bahama Banck
Aboco I.
Bermudas
THE WE

LOUISANA
Isle
Maracscagenses
Misisipi
River
B. St Louis
Bay of Palaxy
Ray St
Iosepho
B. Tampo
Bay
Carlos
Iugo
Florida
Tortugos
Misna
Gulf of Florida
Bahama
Eluthera I.
Cat I
Watlins I.
Rum I.
Long I.
Islands

GULF OF MEXICO

Panuco
Negrillos
la Bermeja
Sholes
Areas
Triangles
Bay of
Campechy
V. Rica
V. Sacrifice I.
C. Catoch
C. Condasedo
Campechy
IUCATAN
P. Royal
I. Cozumel
Alacranes I.
P. Porco
B. Anlony
Havana
B. Honda
CUBA
Keys
I. Pinas
Camanis Isle
C. Quibetnuco
C. Cruz
C. Mayf
St Lago
Crooked I.
Maguana
Caicos Banck
Turks Isle
Ambrochos
Heneago
Tortuga
C. Francis
C. Engano
C. Aguada
R. Rico I.
Virgin Isles
Anbogada
Anguilla
St Martin
St Bartolameo

NEW
SPAIN
Vera
Cruz
S. Martins P.
S. Santo
R. d' Aluaro
S. Lucar
C. Blanes
Aragues
R. Palmas
Tabasco R.
P. Regra
Soconusco
Sonsonde
St Michel
Realco
Truxillo
Cartago
HONDURAS
R. Yarepo
B. del Drago
VERAGUA
Pueb la
Araguez
Cocos I.
P. Mala
Malpello
G. of Honduras
C. Honduras
C. Camaro
Haeyen I.
Viciosas I.
Serranilha
Binorus
Ranas
Negrill Pt
Iamaica
Pearl
Mosquitos
Roncadore
Providence
I. Pailas
St Andero
Veragua
Chagre R.
N de Dio
P. Blas
I. Pinas
Golden I.
Caledonia
Darien
Quibo Iö.
Suere R.
P. Donas
P. Stat
C. Gradio Dio
Costa Rica
Portobel
Sino Bay
P. St Claro
R. Sandio
Perle Iö.
Ia. Meiva
P. Pinas
Good Adventur
Bay
P. Iuan

THE GREAT
TERRA FIRMA

Iama Ilca
Vaca
C. Tubaron
P. Morante
P. Royall
Windward Paas
Hispaniola
S. Maree
S. Domingo
Sarona
Mona
Sta Cruz
St Christopher
Nevis
Monserat
CARIBBE
Dominica
Martinica
St Lucia
Barbuda
Antego
Guardalupa
St Vincent
Granada
Barbados
ISLANDS
Tabago
Trinidad

C. Conquibaco
G. de Venezula
I. Aves
Bonaury
Aves
Oruba
Curasson
Orchillo
Roca
Tortuga
Blanco
Margarua
la Hacha
Caro
Sta Marta
STA MARTA
Cartagena
Mara
caibo L.
G. of
Tristo
Caraccos
la Gaiara
Comana
gulf de
curideo
Capory R.
Oronoquo R.
N. Andalucia
CARTAGENA
VENEZULA
Moco Moco
Inapos
C. Nassau
Surinam
Mayou R.
Icardinari
Cayana
R. Wia

"Desks took on bord"

in Nathaniel Gould's Caribbean Furniture Trade

DANIEL FINAMORE

On June 25, 1767, the topsail schooner *General Wolfe* departed Salem Harbor on a voyage to the West Indies. In command was John Hodges Jr. (1749–1771), the eighteen-year-old son of the shipowner. It was a typical maritime undertaking for Salem merchants of the day, with an outgoing cargo comprising primarily local natural resources such as pine boards, bundles of shingles, and hogsheads of dried and salted fish; all were marked with the initials of various owners who would be credited with the profits, minus the cost of freight, once their cargoes had been sold. Much of the hold was also laden with casks filled with barrel staves and iron hoops that would later be put together by the ship's carpenter for storing molasses purchased at their destination. Containers of bread, corn, water, and other provisions for the crew were stowed where they could be conveniently accessed during the voyage.

In addition to serving as master in charge of sailing the schooner, the younger Hodges was also supercargo, representing the business interests of his father and all who had consigned cargo for the voyage. Charged with these crucial responsibilities that would keep him busy both at sea and in port, he carefully maintained a written log, recording all events and activities of the ship and crew—and himself—that might be considered pertinent when sorting out costs, profits, and performance of the voyage during later accounting. The volume contains accounts of several voyages to the West Indies, as well as those of the schooner *Leopard*.[1]

The younger Hodges had spent the month prior to departure preparing the eighty-ton vessel, replacing worn-out rigging and hardware, caulking and tarring parts of the hull, bringing on board food and supplies for the crew, as well as loading the cargo they intended to sell at their destination. He worked alongside two laborers, one of whom was Primus Manning, a free African-American man whom he paid in tobacco.[2] Their labor included a consignment of three "desks took on bord" twelve days before departure, an order the elder Hodges had placed with cabinetmaker Nathaniel Gould, which he intended to have his son sell for him in the West Indies.[3] The desks were not identical,

since two were priced at £3..14..8 and one at £4..16..0, with 6s. each additional for the "caseing," or crate, which Gould or his workman had constructed to protect them during transport.

After thirty-two days at sea, the vessel arrived off the island of Dominica in the midst of a squall that forced them to stand off shore under a double-reefed foresail until they could come to anchor the following morning. Registering the schooner with the customs agent, they immediately began unloading cargo. More than thirty-six thousand board feet of lumber and countless shingles were divided among several wharves, while two thousand pounds of fish were delivered directly onto different sloops and schooners that had come to Dominica to engage in an inter-island trade. They intended to purchase provisions from vessels such as *General Wolfe* that were arriving from nearer the northern fishing grounds. For two and a half weeks, the crew unloaded cargo, taking in ballast stones to compensate for the change in weight and balance, and once, during a gale, departing the harbor for the safety of open space and deeper water.

By August 13, Hodges had "got rid of all our shingles thank god and our merchant" and had left Dominica for the island of St. Eustatius. He arrived on August 16, "entered and cleared the vessel the same day,"

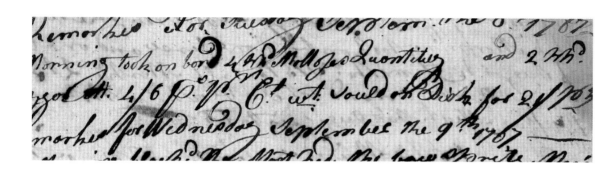

and conducted some unspecified business. On August 17, he "weighd anchor and come to sail with a fine breeze of wind" toward the north coast of Hispaniola.[4] The ship sailed eastward to the north of St. Martin's and other islands, possibly to catch the Gulf Stream, to the small harbor of "Monte Christo" (today's San Fernando de Monte Cristi, Dominican Republic), arriving in five and a half days. Here they set up an awning on the deck to shade the ship's cooper while he put together several hundred hogsheads that had been stored in a collapsed state below. Molasses was delivered to the ship in large containers of varying sizes, called "buckowes," from which it was poured into the hogsheads and stowed. Working with "Monseure Rubey," a local agent, they also took in some sugar, some of which they paid for with turpentine. On September 8, Hodges "Sould one Desk for 21/Pes," and on September 27, he "delivered two Desks . . . out of the vessel to a Spaniard [fig. 1]."[5]

After fifty-three days loading homeward-bound cargo, they were preparing to depart for Salem when Hodges realized that someone had opened his chest and stolen six coins and two buckles and a new silk purse. He suspected one of the Spaniards who had boarded the schooner while loading molasses, which caused Hodges to request that "G_d Damn his sole."[6] Likely riding the Gulf Stream, they arrived home twenty-one days later. Although they had been away 133 days, encounters with at least five other Salem shipmasters during that time

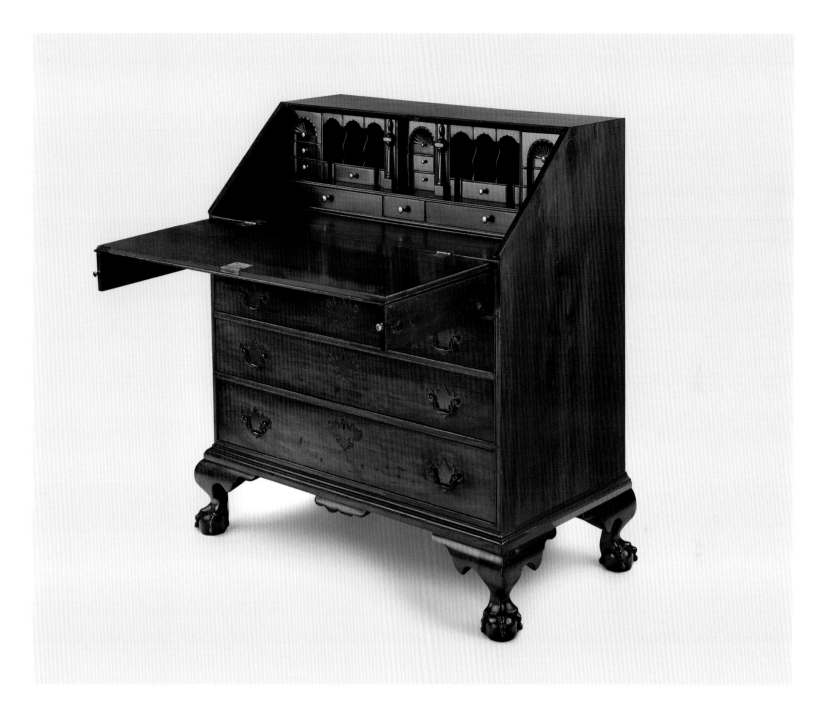

FIG 3
Possibly attributed to Thomas Wood
[whose furniture was exported by
Nathaniel Gould]
Charlestown, Massachusetts
Desk, 1758–79
Cedar, H 44; W 39; D 21 ¾
Private Collection, Massachusetts

FIG 4
Unidentified Artist
This Shews the Schooner Baltick / Coming out of St. Eustatia ye 16th of Nov, 1765, ca. 1765
Watercolor on paper, 13 × 18 ¾
Peabody Essex Museum, Salem, Massachusetts, Gift of the Misses Williams, 1890 (M2367)

FIG 5
Model of an American Merchant Ship with Elaborate Figurehead, mid-eighteenth century
Wood, cordage, and paint,
H 40 ½; W 51; D 23
Peabody Essex Museum, Salem, Massachusetts (M85)

had offered Hodges opportunities for recreation with colleagues and the chance to receive news of home and elsewhere as well as deliver mail and personal items.

Colonial American maritime commerce is characterized by a pervasive resentment caused by a host of British navigation acts that restricted access to goods from Europe and the colonies of other nations to only those that had passed through a British port. Selling to foreign nations was legal, but the acts made return cargoes unprofitable. Although the 1733 Molasses Act permitted a Salem ship to import directly a product from a Spanish colonial West Indian port, it was subject to a per-gallon tax that made it prohibitively expensive. Consequently, these acts were regularly ignored and circumventions were devised. For instance, at St. Eustatius, counterfeit clearance forms were sometimes available to make foreign produce appear as if it had cleared from an English island.[7] An additional motivation for such trade was access to Spanish currency. Recognized to be of high grade internationally, it was soon to become the basis of European and American trade with the Chinese.

One source of foreign produce was the north coast of the island of Hispaniola, which was dotted with Spanish and French settlements. Though only a small town of about one hundred residents, Monte Christo was visited annually by several hundred ships, mostly from British North America and neighboring Caribbean islands (see fig. 2).[8] The port was located conveniently for vessels sailing through the Bahamas or returning northward from the Windward Islands.[9] It was tacitly considered a Spanish port, and cargoes taken off visiting ships were transferred directly to Spanish vessels that then carried them to the neighboring French colony as well as to Caribbean ports of other European colonies. The location, distant from any significant Spanish mercantile center and close to the border of the French colony of Saint-Domingue (today's Haiti), helped residents and visitors alike to engage in lucrative international exchange that circumvented the trade laws of many European nations simultaneously, though Salem ships were regularly harassed upon departure, either at sea by British privateers or back in port by the inspector of customs.[10] Since Hodges referred to his port agent as "Monseure" (not Señor) Rubey, it is likely that the molasses he purchased originated on the French side of the island.

As Salem's export business blossomed during the 1760s, overseas merchant trade became more formally structured with the establishment of a society of shipmasters. Members of the Marine Society at Salem participated in a mutual support network through which they

developed a pool of funds for widows and orphans of deceased members and also shared observations and measurements to improve local navigation. Furthermore, membership introduced a shipmaster into an informal social network involving lucrative business contacts. When ideas for the society were first discussed in 1765, thirty-five merchant vessels were operating from the port (in addition to more than fifty fishing craft).[11] Of the first eighteen masters who formed the society the following year, seven had been or later became involved in Nathaniel Gould's export ventures. Eventually, over 25 percent of Salem Marine Society members became active in Gould's trade until events leading up to the American Revolution ended this aspect of his business in 1775. Approximately one-third of those who received and shipped Gould's export furniture were members of the Marine Society at Salem.

This formal fraternity augmented but did not replace a longstanding structure of Atlantic maritime commerce that relied upon family networks of individuals working in different facets of a business operation. Many of these relationships appear obvious in the records, such as when John Hodges Sr. purchased furniture that was shipped out on a vessel commanded by his son several days later. But, marriage also created less obvious relationships that link furniture orders to ships. Such is the case for Ebenezer Putnam, who made regular purchases from Gould. Though Putnam was a doctor, not a shipmaster, his orders often departed Salem on vessels commanded by his brother-in-law John Scollay.

Vessels carrying Gould's furniture ranged in size from twenty to 115 tons burthen, but most were between sixty-five and eighty tons.[12] A typical eighty-ton vessel of the time was the *Halifax*, built in Boston in 1765.[13] Her dimensions of 58 feet in length on deck and 18 feet wide, with a cargo hold just under 9 feet deep, were no doubt similar to those of the schooner *General Wolfe* commanded by Hodges or the Salem schooner *Baltick* (fig. 4), both of which were also eighty tons. Such small two-masted vessels would have been operated by as few as six crewmen. The schooner rig was a relatively recent invention—none appearing in the Salem registries before 1720—and was well suited to coastwise (including the West Indies) colonial New England commerce, which benefited from small-to-medium-sized cargoes and small crews. Other rigs employed were single-masted sloops and somewhat larger two-masted brigantines, which also would not have called for large complements, thus keeping costs and need for provisions low.

The typical Salem vessel was designed primarily to haul cargo, leaving little space for the comfort of the crew (fig. 5). Cargo was usually hoisted from the wharf by a cable or cord that was attached to a yard and windlass of the vessel or of a bollard mounted to the wharf itself. It would be positioned over the deck hatch and lowered into the hull. The forehold would be loaded first, then the afterhold, leaving the most protected mid-hull area for the last items brought on board, such as Gould's furniture, which frequently arrived just prior to departure. Once the hold was full, additional cargo that needed less protection from weather, such as timber boards, might be carefully stacked on the deck in a manner that maintained the balance of the vessel, but sometimes made sail handling inconvenient.

Gould's furniture was likely never the primary cargo by volume loaded onto a vessel: typical shipments were three desks in cases shipped on the brigantine *Sally* in April 1762, or two desks in cases and three tables shipped in the schooner *General Wolfe* in November 1773. Some shipments consisted of a single article of furniture while one of the largest was two desk-and-bookcases, three desk-and-clothes presses, four plain desks, and four tables, all cased, loaded on board the schooner *Apollo* that was headed for Guadeloupe in March 1761. A conservative estimate of space required for this cargo is four hundred cubic feet. No reliable volumetric comparison can be made with the below-deck area on Salem merchant vessels of the era, but even this volume represented only a minority of the cargo space. The average shipment of furniture probably represented 5 percent or less of the space available, but its value per square foot was considerably higher than that for fish, lumber, and other raw commodities.

Most voyages were to multiple destinations, and documentation of the exact port where furniture was off-loaded appears infrequently. On September 4, 1765, however, master Jonathan Hathorne departed Salem for the "West Indies" in the seventy-eight-ton brigantine *Bradford* carrying six small deck guns for protection and a crew of seven sailors. The vessel carried "6 desks, 2 cases tables here made," of which two cherry desks and two maple tables are likely items that had been delivered in late August by Gould to Benjamin Pickman Esq., who owned a half interest in the *Bradford* with his brother Clark.[14] Arriving at Grenada, Hathorne cleared four desks and two tables for sale there, as well as a wide array of goods, including fish; dry goods; two barrels of whale oil; four barrels of apples; one bag of cheese; staves, hoops, and heads for 195 wooden hogsheads; 8,300 board feet of lumber; twenty-five thousand shingles; 9,340 hoops and staves; and ten oxen. Though Hathorne's voyage from Salem to Grenada was a swift thirty-seven days and he reported a return voyage directly from Grenada back to Salem in thirty-eight days, where else he might have stopped to sell the remaining two desks remains a mystery.[15]

Gould was not the only craftsman exporting furniture from Salem at this time. Of at least 209 voyages that cleared outward at Salem between 1758 and 1765 carrying furniture, only six correlate with Gould's account books as carrying work he sold. Though a small amount might have been produced elsewhere and sold through Salem, much of it, such as the cargo of the sloop *Hannah* that departed in February 1765, carrying "3 desks here made,"[16] indicates that many other craftsmen based in Salem were also actively producing work for export around the Atlantic. In addition, Salem was only one of many ports exporting furniture to the Caribbean. In June 1765, the sloop *Elizabeth* of Bermuda carried two mahogany desks, one mahogany table, and fourteen cedar chairs to the island of Grenada.[17] Other shipments to Grenada that place Salem's role in the Caribbean furniture trade into perspective include six dozen chairs and three desks from Boston on the sloop *Two Brothers* in December 1766; two mahogany desks from New York on the sloop *Margaret* in July 1768; and three desks from Portsmouth on the sloop *Industry* in September of the same year.[18] Newport also contributed large cargoes to the trade, such as in March 1762 when the sloop *Pitt* carried "5 doz chairs, 5 desks, 5 tables" into Kingston, Jamaica, and in April 1766 when the sloop *Dolphin* of the same port brought twelve desks and twelve tables into Grenada.[19]

From 1767 through 1769, eleven desks were exported from Dominica, indicating that those carried inward in vessels from Salem

and elsewhere were being transshipped elsewhere, either within the Caribbean or even beyond.[20] Not all export cargoes were successfully sold in the islands either, since John Ropes Jr. and the brigantine *Britannia* cleared outward from Kingston in November 1766 carrying four desks and six tables.[21] Theirs was a complicated and opportunistic voyage evidently involving multiple stops, since they were ninety-four days out of Salem when they departed Kingston, and they were headed toward Savannah, Georgia, before returning home. Gould had delivered furniture to Ropes for previous voyages of *Britannia* in 1764 and 1765, so Ropes could have been carrying pieces he had purchased earlier from Gould that had failed to sell, or items he had bought from another cabinetmaker. In any event, he placed no subsequent orders with Gould and may have stopped speculating in furniture exports. The increasing presence in Jamaica of furniture imported from London, primarily manufactured by Gillows, could have dampened prospects for Gould's work there as well.[22]

For the most part, Gould filled orders and collected payment from shippers—whether shipowners or others—contenting himself with modest profit from the regular demand. He left the actual export business to others who took on the freight costs and risk, as well as reward, of selling the furniture abroad. In addition to commercial shippers, shipmasters and mates were frequently allotted a limited amount of space as part of their payment for a voyage, allowing

Total Number of Pieces Shipped Each Year

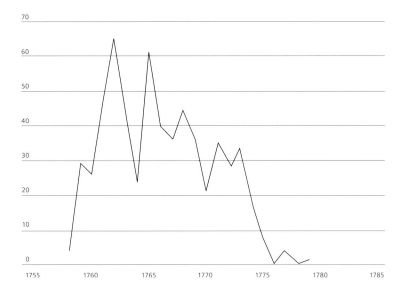

Gould's Domestic, Export, and Total Sales (£) by Year

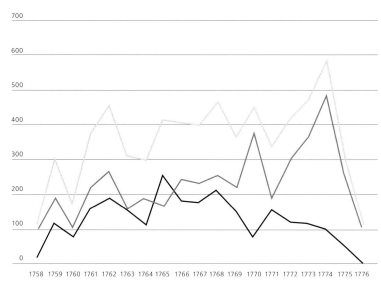

FIG 6
Chart of Nathaniel Gould's Export
Shipments by Year and Nathaniel
Gould's Domestic, Export, and Total
Sales (£) by Year

■ Domestic
■ Export
■ Total

them a small amount of private business. Prior to his departure as mate on the *Leopard* in 1766, John Hodges Jr. purchased a desk—not from Gould—for £3..13..4) presumably selling it at some point along the voyage.[23] Only rarely did Gould himself ship a piece to have it "sold for me in West Indies" as a personal adventure and, unless he was filling a prior order, trusting the shipmaster to sell it at a price high enough to both cover the freight costs and clear him a higher profit than he would receive at home.[24]

Gould provided furniture to maritime exporters over a period of twenty-one years. His first shipment took place in 1758 with four desks and four tables, and was evidently a success, as twenty-nine pieces were exported the following year. Two years later, in 1761, Gould produced forty-eight pieces for export while reaching an all-time high in 1762 with sixty-six articles. This number is misleading, however, since a single shipment of chairs accounted for roughly two-thirds of the total, either fulfilling a special advance order or as an experimental venture that was not repeated in following years.

A graph of Gould's export shipments shows a bell curve with a peak of productivity in 1765 (disregarding the above-mentioned artificial spike in 1762) and then a steady decline to zero in 1776 at the formal outbreak of revolution (fig. 6). Once hostilities began, only five ships carrying furniture departed Salem, and none was to the Caribbean. The curve is punctuated by three periods of sharp decline in output, notably, each occurring around years marked by dramatic events in British colonial trade and diplomacy. In Salem, the effectiveness of Britain's Navigation Acts varied with how zealously they were enforced by customs collectors. The Sugar Act of 1764 increased expectations of enforcement of shipping duties by this officer, specifically requiring duties upon molasses carried, a ban on lumber shipments to the Caribbean, and detailed manifests of all ship cargoes.[25] In addition, the Currency Act of the same year sought to protect merchants by eliminating commerce that relied on colonial currency of depreciated value.[26] Though not affecting furniture exports specifically, these acts had great impact on trade, affecting profits from New England's Atlantic shipping but also increasing the caution with which exporters such as Gould looked at such business ventures.

In January 1766, Captain John Hathorne caused a great disturbance in Salem when he returned from Grenada in the *Bradford* with papers bearing the appropriate stamps—thus having complied with the new regulations. Hathorne was confronted by townsmen who sympathized with the revolutionary Sons of Liberty, who demanded noncompliance. Among the protesters was town selectman Jonathan Gardner Jr.,

who himself had purchased furniture from Gould for an export voyage on the schooner *Industry* the previous May.[27] When Hathorne was lost at sea just a few weeks later, his widow was the first one to receive relief from the Salem Marine Society.[28] Many of Gould's major clients were Tories. Of those who were Marine Society members, at least three became active Loyalists, two of whom, including Pickman, left Salem at least temporarily. Eleven became Patriots, serving either in the Revolutionary War or in the newly formed government.[29]

The divided loyalties among Gould's clients are tied to another dip in his exports in 1766 and 1767 that coincides with imposition of the first Townshend Acts, which taxed a range of imports and gave customs officials additional powers.[30] Gould's exports diminished steadily from then on, with another severe dip to only twenty-four units shipped in 1770, the year of the Boston Massacre. As security of profits declined with anticipation of war, so did Gould's exports. In 1776, the year of revolution when they reached zero, Salem's Loyalists, a group of wealthy merchants, shipowners, and exporters who comprised a large portion of Gould's clients and partners, departed for England or Nantucket. Gould was caught in a colonial merchant's conundrum: many of his major clients and business partners in export activity were Loyalists, but the profitability of export depended largely on trade that violated commercial regulations and taxation.

Beyond the rapid growth in export business during the early 1760s and its more gradual dissolution over the following ten years, the forms of furniture shipped likely reflect Gould's increased understanding of the preferences of Caribbean clients as well as a concentration on pieces that realized the highest profit. The percentage of shipments that were speculative versus those sent to fulfill advance orders is unknown, as is the means by which Gould and his partners anticipated Caribbean market demand, though it was likely via word of mouth from shipmasters returning from the islands. Of Gould's 616 pieces known to have been created for export, 382 were desks, 114 were tables, and 105 were chairs. Bedsteads, cases of drawers, chests, and commodes were exported in such small quantities that they probably reflect very limited opportunities for sale. Occasional listings of clothes-presses and bookcases were likely designed to sit on top of other forms. Desks constituted 62 percent of export forms by number and 74 percent of pieces by value for Gould and his shippers. Between 1766 and 1769 in particular, the peak years of Gould's export business, desks approached the totality of forms exported.

Chairs made up the second largest export by number, but undoubtedly not by cost. Following a single large shipment of forty-two chairs

FIG 7
Agostino Brunias (1728–1796)
Linen Market, Dominica, ca. 1780
Oil on canvas, 19 ⅝ × 27
Paul Mellon Collection, Yale Center for
British Art, New Haven, Connecticut
(B1981.25.76)

in the schooner *Volant* in October 1762, chair exports declined dramatically. Although Salem chairs were in high demand at home, in particular those of mahogany and with decorative carving, the ones exported were of unidentified wood type, suggesting that they were of simple design. Tables offered a consistent secondary export product, particularly before 1765 when desks became overwhelmingly dominant. Even during the 1770s as desk exports declined, some of that loss was made up by a modest number of tables.

Of exported tables where the wood is identified, 70 percent were of mahogany with much smaller representation of the less expensive New England woods maple, cherry, and walnut. Demand for walnut was slow but steady (not more than six pieces in a year) during the 1760s, but production ceased after 1767, no doubt a reflection of the growing vogue for mahogany that occurred throughout the Atlantic world around this time. Mahogany saw fairly consistent demand with up to ten pieces exported annually, except in 1761 and 1765 when larger numbers of tables were shipped. Cherry and maple also exhibit fairly constant but low-level demand.

These four woods reflect general fashion and demand in New England, but when all forms Gould exported are considered, the most notable characteristic of his production is his use of eastern red cedar (*Juniperus virginiana*). This species of juniper, common in eastern North America, possesses aromatic qualities that deter infestation by insects. Hence, a cedar desk was intended to protect both the furniture and its contents. Cedar furniture was particularly attractive for residents of the semitropical Caribbean region where business and personal papers, as well as clothing and other items, were vulnerable to a range of insects, including termites and powder post beetles.

In the home market of Salem, mahogany sold for between 9d. and 1s. per board foot, new tenor. In 1763, Gould purchased two hundred board feet of cedar at 1d. per foot, old tenor.[31] Since the difference in value between the two currencies was seven and a half times, mahogany was at least seven and a half times more expensive than cedar for the craftsman. Many desks constructed of cedar cost the exporter £4..13..4 while those of mahogany could cost over £9. Only a single record of a price received for a Gould cedar desk in the Caribbean survives, when John Hodges Jr. "sould one Desk for 21/Pes" on September 8, 1767. If that record is for payment in the Spanish currency of *pistoles*, also known as doubloons, the selling price was approximately £14 in British currency.[32] Unlike domestic sales in Massachusetts, shipping long distances incurred considerable freight costs on top of craftsmanship and materials—in this case more than twice the wholesale price from the

cabinetmaker. Such a mark-up was possible in a land where large fortunes were being made quickly and highly skilled labor and natural resources—beyond the sugar and molasses—were scarce.

Of all the desks Gould sold for export, 56 percent were of cedar, another 26 percent were maple or cherry, and only 6 percent were mahogany.[33] The demand increased throughout Gould's career: in 1760, Gould's third year exporting furniture, only one of nine desks shipped was of cedar; by 1767, that proportion had become roughly two-thirds (22 of 35); and by 1772, seventeen of eighteen desks shipped were cedar. In Gould's home market, cedar was used for fence posts and shingles, but for the New England cabinetmaker, cedar as a primary wood was a specialized product honed to supply a demand that did not exist at home. Much as raw mahogany flowed outward from the Caribbean to the cabinetmaking centers in North America and Europe, satisfying a taste for lustrous deep red tones and intricately figured grain, so the islands received furniture similarly created from an "exotic" species not native to that region, but which satisfied a local need.[34] Although Gould supplied at least 210 desks for export, none is known to survive today and only a single cedar desk of likely Massachusetts origin has been discovered, curiously, within Massachusetts (see fig. 3).

On a typical West Indies voyage, Salem ships would call at several ports to off-load outgoing cargo and to take on goods bound for home. A ship might visit only one or several islands on any given voyage, and the pattern of visitation was determined by economic, political, and environmental factors. The first port of call, recorded in the summary documents of shipping returns as the destination for ships departing Salem, was usually where local New England goods such as timber and fish were off-loaded, although sometimes a vessel would call first at a center of international trade like St. Eustatius to obtain the most recent market information about prices for goods in the Caribbean.[35] The final port of departure for ships concluding their voyages was also recorded, but inter-island legs of the voyages generally have gone unrecorded. The *General Wolfe*'s voyage is a rare exception, where the master's log has survived, recording all destinations and shipboard activities in detail.

Ships departing Salem carrying Gould's furniture called at sixteen Caribbean ports as well as another seven ports farther north between South Carolina and Newfoundland. With the exception of five voyages during the American Revolution, the Caribbean ports were the primary business ventures for these ships as they navigated winds and currents southward to the islands and back home. Voyages most

frequently called first at the island of Dominica, with its vibrant market in the town of Roseau, while Guadeloupe was the final harbor most visited before returning to Salem (fig. 7). Other British colonial ports visited frequently include Barbados, Grenada, Martinique, Maryland, North Carolina, and St. Christopher.[36] Ports outside British claim included Surinam, St. Croix, and St. Eustatius. Nearly half the destinations recorded in the various sources employ the generic term "West Indies"—whether to obfuscate evidence of illegal trade or to summarize a complex voyage is not clear. Of the other voyages, 20 percent called at Guadeloupe, 15 percent at Dominica, and each of the remaining twenty-one ports was visited less than 10 percent of the time, suggesting a wide network of trade relationships with the potential to bring Gould's furniture to a diverse range of Caribbean island communities.

Most New England cargoes were delivered into the British colonial market for sale and redistribution through the Caribbean, but the example of the *General Wolfe* shows that unlike raw commodities where profits were made by moving cargoes in large volume, individual pieces of high-value craftsmanship such as Gould's furniture could be sold as part of the international trade that brought return cargoes into the colony, much of it in contravention of British law.

Today, historians of the decorative arts pay close attention to the subtle indicators that distinguish the cabinet craft of one city from that of another, as well as the personal decorative style of one craftsman or another within each city. Wealthy residents of these communities could purchase or even commission a piece directly from a lead cabinetmaker and shop owner. But, given the distances and multiple hands involved, furniture shipped to the Caribbean likely lost any associations with its region of manufacture, much less maker. A customer who purchased a desk from a middleman in Dominica or Grenada was undoubtedly satisfying a functional need that was augmented with the air of social status, not satisfying a specific desire for a product bearing the stylistic attributes of the cabinetmakers of Salem, Massachusetts, or the workshop of the master Nathaniel Gould.

1. "A Harbour Journal on bord the schnr. General Woolf kept by Me John Hodges Jun Anno 1767," Hodges, John Jr., Schooner *General Wolfe*, Schooner *Leopard*, Log 1767L, Phillips Library, Peabody Essex Museum. This manuscript sea log and port journal—perhaps the only one to survive for a vessel carrying Gould's furniture—details an array of activities involved in preparing the schooner for her voyage, loading and unloading supplies and cargo, and conducting business at her various destinations along the way.

2. Vickers and Walsh 2005, pp. 62–66. Primus was likely a freed slave of the same Manning family that included Gould clients Thomas and Richard. Poor enough to once have been "warned out" of Salem (a system devised primarily to get rid of indigent vagrants), after his death he was acknowledged by the Reverend William Bentley as having been a "worthy" citizen. See Bentley 1962, vol. 4, p. 594; Ruffin 2007, p. 55.

3. John Hodges Jr., "Log of the *General Wolfe*," 1767, Phillips Library, Peabody Essex Museum, p. 13.

4. Ibid., p. 24.

5. Ibid., pp. 27, 29.

6. Ibid., p. 31.

7. Phillips 1937, pp. 74, 286.

8. Karras 2007, p. 124. Some eighteenth-century charts of the region do not even show a community there, but only a protected anchorage.

9. *The English Pilot* 1765, p. 35.

10. Phillips 1937, pp. 231–32.

11. Smith 1998, p. 9.

12. Tonnage is a volumetric measurement to describe the cargo capacity of a vessel and has nothing to do with weight, which is described as displacement. In the 1760s, tonnage was calculated via a mathematical formula called the Builder's Old Measurement based on a ship's length and maximum beam (width).

13. Chapelle 1935, p. 34.

14. English Shipping Records 1931, p. 1348.

15. "List of ships and vessels which entered inwards between the 5th day of April and the 5th day of July … 1765," National Archives (of the UK), CO106/1 Grenada Shipping Returns, p. 11. This is one of the few instances in which the Salem Custom House records, Grenada Shipping Returns, and Gould's ledgers clearly correlate to trace the movement of furniture and ships.

16. English Shipping Records 1931, p. 1332. Preservation of these records is incomplete so they do not represent all voyages during these years. In addition, the period covered does not include Gould's very productive years of the later 1760s.

17. "List of ships and vessels which entered inwards between the 5th day of April and the 5th day of July … 1765." NA, CO106/1 Grenada Shipping Returns, p. 10.

18. "List of ships and vessels which entered inwards between the 10th day of October, 1765, and the 5th day of January, 1766"; "List of ships and vessels which entered inwards in the Island of Grenadoes in between the 9th day of July and the 9th day of October, 1768," p. 35. NA, CO106/1 Grenada Shipping Returns, p. 17.

19. NA CO142/6 p. 184. "A list of vessels which have cleared inwards at the Port of Kingston between Feby 22, 1762, and 25 June, 1762"; NA CO106/1 Grenada Shipping Returns, p. 21. "List of ships and vessels which entered inwards between the 7th day of Jany and the 4th day of April … 1766."

20. "An account of several species of goods exported from the Island of Dominica from the 1st November 1766 to the 5th of April 1778 in Foreign vessels." NA, CO76/4 Dominica Shipping Returns, pp. 49A.

21. "A list of ships and vessels which entered into Kingston between 5 September and 29 December, 1766," p. 22. CO142/17.

22. Stuart 2008.

23. John Hodges Jr., "Log of the *Leopard*," 1767, Phillips Library, Peabody Essex Museum.

24. Nathaniel Gould, *Account Book*, December 30, 1768.

25. The American Revenue Act of 1764; http://avalon.law.yale.edu/18th_century/sugar_act_1764.asp. Accessed September 9, 2013.

26. http://avalon.law.yale.edu/18th_century/curency_act_1764.asp. Accessed September 9, 2013.

27. Phillips 1937, p. 289.

28. Smith 1998, p. 10.

29. One client, Captain Stephen Mascol, was killed while boarding an English ship on January 1, 1777. He had placed an order with Gould in 1775 that was later sold to John Colston because Mascoll had already left for the war.

30. http://avalon.law.yale.edu/18th_century/townsend_act_1767.asp. Accessed September 9, 2013.

31. See p. 253, Appendix B, Thomas Wood of Charlestown.

32. McCusker 1978. Clarke 1763, p. 279, fixes the value of one *pistole* at 13s., 4d.

33. The remainder being of walnut or unknown wood type.

34. Finamore 2008, pp. 61–87.

35. These records of destinations and cargoes were collected by a naval officer at each port.

36. Claims to several of these islands changed during the period: Guadeloupe, Grenada, Martinique, and St. Eustatius were all British for a time between 1759 and 1763, and Dominica became and remained British.

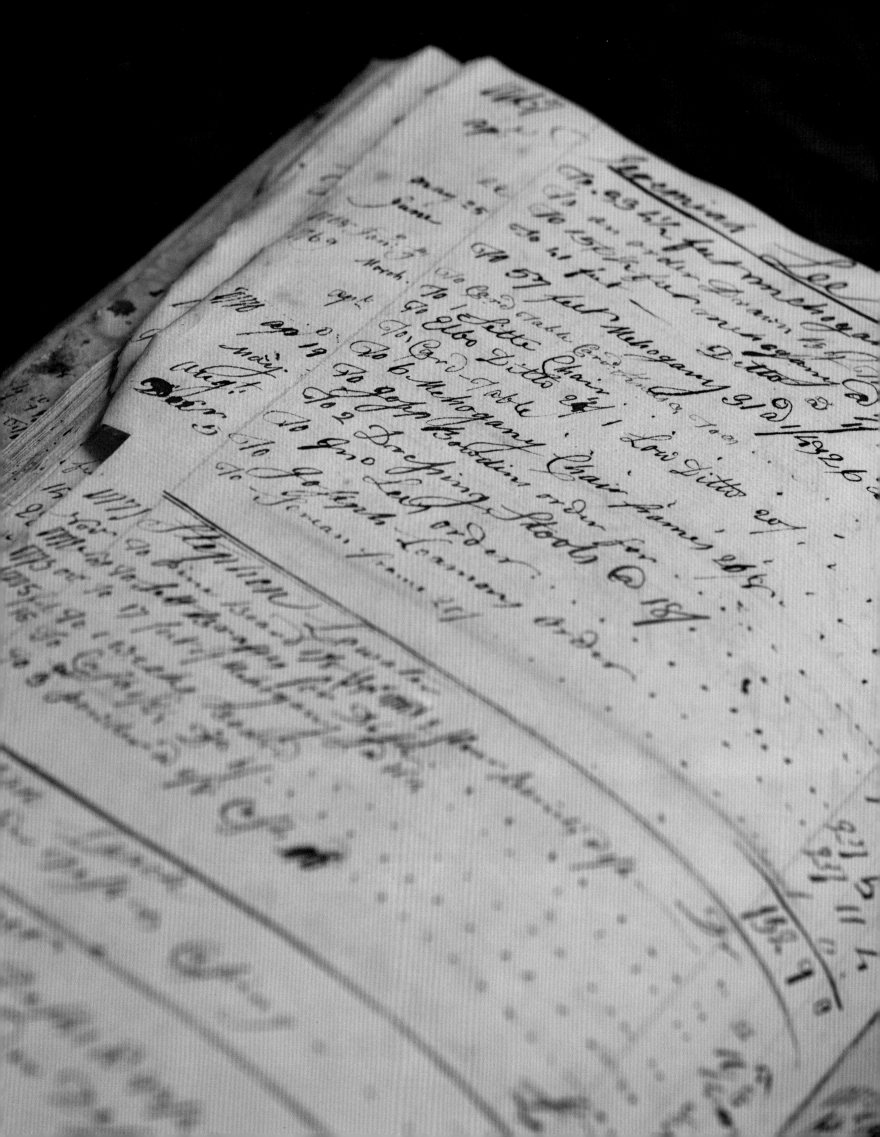

The Business of Cabinetmaking

KEMBLE WIDMER

Sometime between September 1756 and March 1758, Nathaniel Gould embarked on his life's occupation as an independent cabinetmaker. Although new to Salem, he had been well trained in either Boston or Charlestown, and at age twenty-four thought he was ready to establish his own shop. He had a distinct competitive advantage over Salem's existing cadre of cabinet- and chairmakers, for he possessed both the knowledge and skill to produce furniture in the new Chippendale style. Just as important was his realization that his skills and knowledge had to be jealously guarded in order to keep would-be competitors at bay. This approach would govern his business philosophy during his entire career. Family inheritance provided him with that necessary ingredient of any successful business—capital—and he showed every indication of husbanding it carefully. A close review of his transactions, summarized here, reveals insights into his business strategy, his relationship with his employees, the ways he conducted business in general, and the effects of the revolution on his career.

Analysis of Gould's ledgers sheds little light on transactions of apprentices or those associated with the completion of their apprenticeship, such as the presentation of tools or a suit of clothing at the end of training. Surprisingly, the record was largely silent on matters related to apprenticeship itself.[1] Gould certainly had apprentices, yet almost half the joiners listed as making furniture for him were in their early twenties at the time of the first transaction. Whether they apprenticed with Gould or elsewhere could not be determined, but it is likely that many of them trained with Gould, who then hired them for short periods in their late teens or early twenties. A master craftsman often helped a favored apprentice by giving him work until the apprentice found employment or established his own business.[2] Many of the transactions in Appendix B list charges by woodworkers for only a period of time—"by 2 month's work" or "by his account rendered"—which gives some general idea of the amount of work performed for Gould. In some cases, however, where the specific object is mentioned in addition to a price, it is possible to trace that object back to a customer's purchase and thus determine Gould's profit margin. It was assumed in these cases that the individual was working as an employee or subcontractor, and no longer as an apprentice.

Conventional thinking sets completion of an apprenticeship at twenty to twenty-two years of age, which follows the strictly enforced practice of the craft guild system of England. However, Philemon Parker, Gould's most trusted and longest-serving employee, was only eighteen and working as a journeyman when credited with making three desks in January 1763. Thomas Brintnal West was only nineteen when his first invoice was accepted by Gould. Both men are assumed to have trained elsewhere for a relatively short time or ended their apprenticeships at a very early age.

In England, labor was plentiful but materials were scarce and relatively expensive. Enforcement laws governing runaway apprentices enabled the guilds to tightly control the number of people entering a trade, their time of training, and the skill level achieved before being given the right to work as journeyman. The situation in the colonies was the reverse. Skilled labor was not abundant, and there was no organized guild system powerful enough to influence adherence

[OVERLEAF]
Detail of Nathaniel Gould's Account Book
open to Jeremiah Lee's credit transactions
from 1767 through December 1770,
Nathan Dane Papers, Massachusetts
Historical Society, Boston

FIG 1
Detail of Nathaniel Gould's Day Book
(1758–63) showing credit transactions for
John Cogswell, 1759
Nathan Dane Papers, Massachusetts
Historical Society, Boston

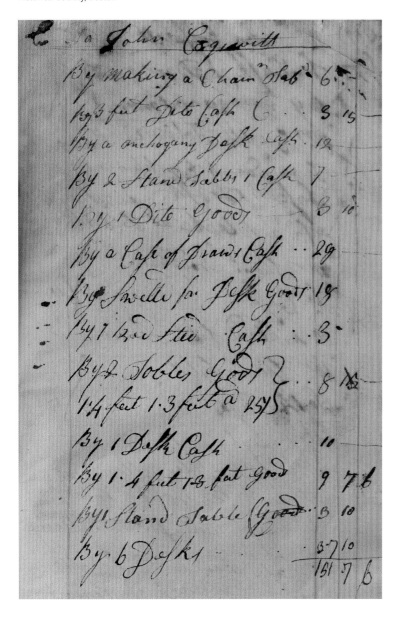

to apprenticeship contracts, if there even was a contract. Runaway apprentices had little to fear outside the immediate colony where their master lived. There was nothing to stop an apprentice from leaving his master and going into business for himself whenever he felt capable. Apprenticeship terms varied greatly. If the apprentice had been orphaned, assignment would be through a court filing and the term would generally extend to age twenty-one, so as to prevent a young, untrained individual from becoming a ward of the state. Apprenticeships requiring the development of a high level of skill, such as was necessary to become a merchant, lasted longer and frequently involved payment to the parents. Less skilled trades had shorter terms and commenced at an earlier age.[3]

Parker was probably trained by his father, cabinetmaker John Parker (dates unknown), while growing up in Malden, Massachusetts, or he may have apprenticed with Gould. Parker was entrusted with making a wider variety of furniture than any other joiner employed by Gould, and except for a brief stint in the army during the revolution, stayed with the shop until the end, receiving his final settlement from Gould's estate.

Gould's first employee was Thomas Brintnal West, who worked briefly from November 1758 until early 1759 and was one of a few people Gould hired who lived in Salem. In March 1759, he was paid 3s. per day for seven days work, a wage considerably above subsequent employees, which may have factored into Gould's decision to stop employing him. No further records could be found of West working as a cabinetmaker. He died prior to 1771, when his widow remarried.

Because of an unfortunate experience with West or to protect his business, Gould recruited long-term employees from outside Salem. When orders to be delivered in 1759 exceeded his capacity to fulfill, he entrusted a substantial order of mahogany furniture to his acquaintance John Cogswell of Boston (fig. 1). Gould undoubtedly knew Cogswell from his time in Charlestown or Boston and was confident in his ability, but Cogswell was also not a threat to Gould's fledgling enterprise in Salem.[4]

The subcontracted orders to West and Cogswell were far more important strategically to Gould's business than their immediate value, for they established a consistent, substantial markup. The stand tables that West made for 9/4 were resold for £2, a 328 percent markup; a chamber table that Cogswell charged 16s was resold at £3..1..4, a 281 percent markup. This pattern continued for most of Gould's career, and as many of the sales were made within a few days of receiving the subcontracted object, they provided a ready source of cash.

Cogswell was a temporary fix, however, and Gould undoubtedly had an apprentice after West's departure. The next most likely candidate was William Holman, who gave his first accounting for independent work in June 1763 when he was twenty-three years old. There are a number of transactions between Gould and Holman's widowed mother.[5] No payments to other joiners are recorded in 1760; Gould and an apprentice could obviously handle the work load. As orders increased in 1761, he again turned for help locally. Thomas Needham, the second generation of a family of cabinetmakers that extended for more than a century, had been purchasing incidental supplies, walnut, and furniture hardware from Gould since 1758. The two had grown up together, were the same age, and Gould placed a few orders with him in early 1761. He was a skilled artisan, perhaps not as skilled a carver as Gould, but nevertheless a potential threat to Gould's business.[6] Gould placed no further business with Needham after 1761, although Needham continued to buy items such as sugar, textiles, and wood for the next fifteen years. Unfortunately more the norm even for skilled cabinetmakers and in contrast to Gould, Needham lived a hand-to-mouth existence for much of his career, particularly after two ill-advised real estate ventures in the early 1760s. He enlisted in the Continental Army at age forty-three to support his family, and alternated between Boston and Salem to eke out a living. When his very promising cabinetmaker son Thomas Needham Jr. died in a storm at age thirty-three, Needham became sole provider for the widow and four grandchildren under the age of seven. Well past retirement age for most joiners, in his mid-sixties he was still working in Boston between 1796 and 1798.[7]

Export orders doubled from an annual £71 in 1760 to £158 in 1761, and Gould diverged from his practice of employing young joiners. He secured the services of John Ropes Jr., a thirty-six-year-old cabinetmaker who had been working in Falmouth, Maine, at the time of his marriage to a bride from Newbury, Massachusetts. Ropes moved back to Salem and had evidently done extensive work prior to May 1762, when he submitted his first rendering of accounts for £29..8..9—a substantial amount considering the average cabinetmaker's wage was approximately £2 per month.[8] He was the second key employee for the shop and continued working through 1773. Unlike for Parker, the records suggest Gould might have entrusted him only with manufacturing desks for export, made of cedar and maple. This may have been due to a lack of skill on Ropes's part, but was more likely based on considerations of competition.

A further increase in exports of 20 percent in 1762 caused Gould to rethink his business plan. He turned to his father-in-law, Thomas Wood of Charlestown, to fulfill a large segment of subcontracted work, primarily cedar desks. Wood submitted a small, unitemized bill in August 1762, which was probably for approval of the first two desks. He was also a source of cedar boards for Gould's use in his own shop. His first three identified cedar desks were delivered in June 1763, each priced at £3. These most closely match orders of Benjamin Pickman Esq. (resold at £3..14..8) and two orders for James Freeman (resold at £4..13..4). The profit margins on those three orders (24 percent and 56 percent) were significantly below Gould's usual profit target and no doubt represented a concession to a family member. During the next decade, Wood supplied a total of forty-seven documented desks of which forty-three were made of cedar. By 1769, Gould was paying Wood the majority of funds received from customers.

Wood's last entry was in June 1775, for purchase of a set of brasses. He claimed losses of £4,000 when his Charlestown shop was burned by the British after the battle of Bunker Hill.

Ebenezer Martin of Marblehead went to work for Gould for three months in September 1763 at 48s. per month. That wage indicates that the twenty-two-year-old Martin was skilled in cabinetmaking and had already completed his apprenticeship, because it was 12 percent higher than the monthly wages Gould paid to Theophilus Bacheller from 1773 to 1775.[9] Martin boarded with Gould for four days and was charged 1/4 per day, which consumed 76 percent of his daily wage. Gould frequently provided room and board for his workmen who did not live in Salem. While Martin's "take home" pay of 24 percent of his total wage was probably adequate, workmen of lesser skill were not as fortunate. Ipswich resident Stephen Lowater sawed timber for Gould in 1763 for 48s. per month (11/5 per week), but he paid Gould 9/8 per week for room and board, or 82 percent of his gross wage. The ledgers provide evidence that there was resistance on Lowater's part to these harsh terms. He boarded with Gould again in June 1766, but the rate was reduced to 8/8 per week, and in a following transaction Gould allowed him board at "half price." In all likelihood, Gould was desperate for sawing help. Although he had previously been paid 48s. per month in 1763, Lowater agreed to work for 40s. per month during the winter of 1767. The lower wage could have been for a lower level of work or the result of hard negotiating on Gould's part, but it indicates Gould's tough and disciplined manner of conducting his business.

Export orders declined briefly in 1764 then surged again in 1765 to close at 66 percent above 1763's record shipments. At this time, Gould

probably had an apprentice in training, eighteen-year-old Jonathan Ross of Ipswich, who would not start invoicing the shop for his work until September 1767, at age twenty. He would be the shop's third key employee, as his first invoice covered twenty-eight months of service. He was assigned chairmaking on a number of occasions, was entrusted with carving ball-and-claw feet, and evidently was working independently from 1771 through 1775, as he purchased a variety of cabinetmaking woods and furniture hardware in addition to fulfilling orders for Gould. By 1776, Ross had moved to Gilmanton, New Hampshire, where he continued cabinetmaking until 1804.[10]

The influx of orders in 1765 again forced Gould to secure temporary local relief. He placed maple and cherry desk orders with Salem housewright Joseph Symonds Jr., and purchased the first of five desks from block maker Gedney King (fig. 2). Undefined work was placed with Daniel Goodhue, possibly of Westford and another possible apprentice.[11] In each case where items were specified in his journals, Gould subcontracted work requiring less skill and made of woods less expensive than mahogany. Symonds and King derived the majority of their income from woodworking trades other than cabinetmaking, but could make acceptable products, particularly for the export market. Gould repeated this strategic outsourcing procedure when he later gave his primary sawyer, Stephen Lowater of Ipswich, an order for four maple desks. Any work subcontracted ran a higher risk of substandard quality because Gould could not control the product as well as in his own shop. He minimized the chance of returns from dissatisfied customers by exporting a large percentage of subcontracted work. By not rapidly expanding his shop to meet current demand, he engaged his skilled employees for the most difficult work and maintained excellence for his most important local clients.

With the exception of desks made by his father-in-law, Gould achieved full profit margin on this subcontracted work. The typical maple desk was purchased for £1 and resold for £3..6..8; cherry and cedar desks purchased for £1..4..0 were resold for £4 or £4..8..0. This extremely lucrative business maintained his profit margins around 233 percent or a 3.33 multiplier of his cost (see Appendix C).[12] These handsome profits were the result of his initial ability to invest capital, and his relationships with several shipowner/merchants that gave him access to West Indies commodities. Sales to woodworkers from 1758 through 1760 were nominal, but fellow cabinetmakers purchased an average of £237 or 55 percent of his nonfurniture sales totals each year in 1761 and 1762. Their purchases included a concentration on sugar and textile products, even shoes.[13] Unlike his furniture, the commodities were

offered at a very low markup and significantly below prevailing market prices in Salem. For example, the price of sugar in Salem in 1775 was 10d. per pound for a loaf; common sugar was 6.5d. per pound. Between 1768 and 1775, however, Gould consistently sold sugar to his supply network at 5.1d. to 5.7d. per pound. These prices were not restricted to people he had subcontracted work with, but appear to cover most of Salem's cabinetmakers. There are examples of other transactions where he made no profit. The result was the establishment of a network of craftsmen who were able to acquire basic commodities at very favorable pricing. Gould also stockpiled the woods used by joiners and sold it in small quantities to this supplier network at a modest markup (see fig. 2), thus ensuring a pool of skilled labor when needed. A typical example of goods purchased from Gould is shown for Stephen Lowater of Ipswich (fig. 3).

The last significant employee was Theophilus Bacheller of Lynn, who began working in the shop in September 1772, probably after completing his apprenticeship with Gould. He worked for months, often boarding with Gould, until the outbreak of war. He served for two years in the Continental Army, rising to the rank of lieutenant before returning to Lynn, where he made a number of case items for Gould in 1781. Little is known of him subsequently, but he was evidently successful because he was listed as "gentleman" at the time of his death in 1833.

As Massachusetts headed for war in 1775, Gould's business in particular, and business in Salem in general, suffered a substantial decline. Relatively constant at £110 per year from 1770 through 1774, his export business declined by 60 percent in 1775 and to zero in 1776; only two export orders were produced during the entire war. Domestic demand also declined substantially. Rampant inflation was the worst in the country's history. In December 1776, a Massachusetts Continental dollar was worth $1.00; only a month later, it had lost 5 percent of its value; by the end of 1777, it was worth 32 cents. One year later, it was worth 16 cents and in December 1779, less than 4 cents.[14] The impact was devastating. By 1780, the Continental Congress declared paper money worthless. During this period, goods were priced at two different levels: lower if paid in silver or Spanish pieces-of-eight; higher if paid in paper currency. The barter system became essential for everyday subsistence. No creditor wanted an outstanding bill settled in depreciated currency. An entry for March 23, 1780, for Philemon Parker, is telling: "by Balance Due on Settlement to be p'd in goods at ye last stated price." Gould's longest serving employee generally settled his accounts once a year. In this entry he was owed £37, but insisted on being paid in merchandise at prewar prices.

With no available work, many joiners entered the army that promised bounties as much as £10, equivalent to four to five months' pay prior to 1777. It appears that Gould lost his core group of suppliers: Parker and Bacheller entered the army, Ross had purchased land and moved his family to Gilmanton, New Hampshire, by 1776, and Wood's business had been destroyed by the British. Fortunately for Gould, some of his most important clients, particularly the Cabots, were prospering through their privateering activities, and the shop was able to limp along between 1776 and 1779. Gould's son Nathaniel Jr. was in his late teens, and with the help of his father probably handled most of the business.[15]

Business resumed a slow recovery after 1779. The number of tables produced suggests an approximation of the level of business.[16] During the first two years of war, table production averaged thirty-three per year, but only ten were produced in 1779 when the furniture market bottomed. The number climbed to twenty-five the following year, and

the thirty-eight tables sold in 1781 slightly exceeded prewar output. However, the shop was a radically different operation compared to earlier years. Chiefly, Gould probably took a reduced role; he was referred to as "gentleman" in property deeds dated 1774 and 1775. Theophilus Bacheller had returned to his home in Lynn after serving in the army, but was the only one of five key joiners to perform any significant work for Gould after 1778.

In the first twenty-one years of the shop's existence (1758–78), Gould recruited, trained, or purchased furniture for resale from twenty-one different joiners. He had developed a high level of competency among at least four skilled cabinetmakers with a broad range of talents including chairmaking. The core competency was nonexistent after 1779. Although Gould died in November 1781, the shop continued to operate until 1783. From 1780 through 1783, eleven new joiners performed work, most of short duration. Chairs, formerly completed by shop employees, were now

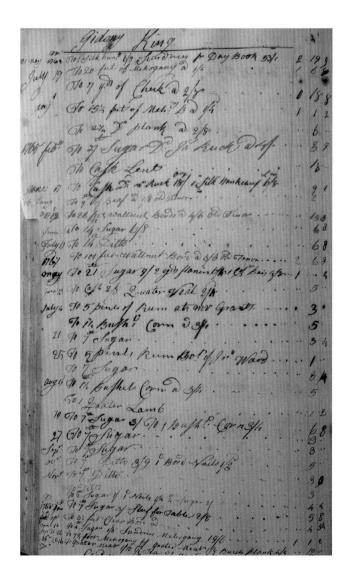

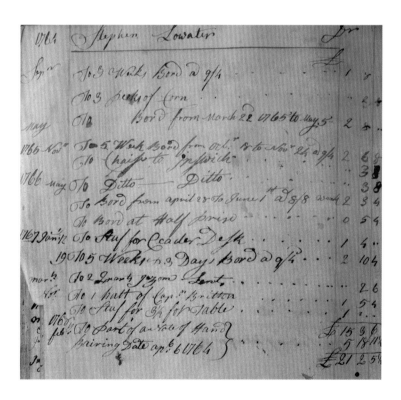

FIG 2
Detail of Nathaniel Gould's Account Book showing debit transactions for Gedney King, May 1761–December 1768
Nathan Dane Papers, Massachusetts Historical Society, Boston

FIG 3
Detail of Nathaniel Gould's Account Book showing debit transactions for Stephen Lowater, September 1764–February 1768
Nathan Dane Papers, Massachusetts Historical Society, Boston

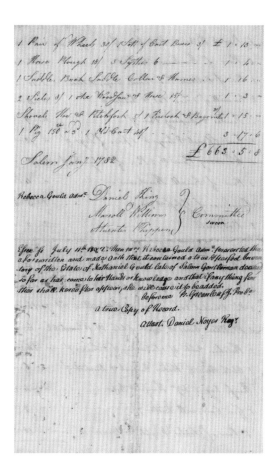

FIG 4
Nathaniel Gould's Estate Inventory, 1782
Nathan Dane Papers, Massachusetts
Historical Society, Boston

purchased from outside. It appears that there was little or no training of staff, as most of the work was done by joiners in their late twenties to early thirties and eight of the eleven had come from other towns. These conditions must have been tumultuous, particularly for Nathaniel Jr., who likely was responsible for managing the business after his father's death. The shop closed in 1783, and responsibility for collecting outstanding receivables was placed with Nathan Dane (1752–1835), a Beverly lawyer. Both Nathaniel Gould's estate inventory and his business ledgers lay dormant among Dane's legal papers until their discovery in 2006.

Although Gould did not leave a will, an extensive inventory taken the month after he died sheds further light on the extent of his operation (fig. 4).[17] As a result of the British blockade of colonial ports, which disrupted his supply of mahogany, the war, and the precipitous decline in business, there was little need to acquire material for future orders. Despite almost six years of these difficult conditions, his inventory of woods used for cabinetmaking was extensive: 1,650 feet of mahogany, 1,000 feet of cedar, 2,000 feet of pine and approximately 10,000 feet of unfinished boards. In addition, he had £44 of partially finished work, almost £10 pounds of brass hardware, and undefined tools in the shop amounting to more than £20. One can only imagine the size of the operation in its heyday of 1774.

It is beyond the scope of this book to review the biographies of so many distinguished clients, but the impact Gould had on one family's purchases is instructive. Many businesses have one or two customers who account for a disproportionate amount of income. For Gould, it was two generations of the extended Cabot family. John Cabot (1680–1743) emigrated from the Channel Island of Jersey to Salem in 1700 and was moderately prosperous in the shipping industry. Two sons, Francis (1717–1786) and Joseph, followed him into the business and developed trade with the West Indies, coastal southern ports, and England (fig. 5).

In that second generation, four of the five surviving children of John Sr., would become early and significant customers of Gould: Hannah Clark Cabot, widow of Dr. John Jr. (1704–1749); Elizabeth, the wife of Stephen Higginson; Francis; and Joseph. Significant sales would be made to seven sons and a daughter of Joseph and Elizabeth Higginson Cabot, the third generation. The family was among Gould's early customers in 1759, and they continued their patronage until he died in 1781; perhaps it is significant that no purchases were made after his death, even though the shop continued for two more years. Over that twenty-three-year span, family members bought 166 chairs, eleven chests of drawers, and five of the fourteen icons of

Gould's shop, the desk-and-bookcase. Total furniture sales to the Cabot family amounted to £660—an amount greater than Gould's total sales each year. Six of the eighteen objects presented in catalogue entries here have been traced to the Cabots.[18]

When Gould arrived in Salem, neither the Cabots nor the Derbys, although prosperous, were among Salem's most elite merchants. That category was reserved for Curwens, Ornes, and Pickmans, but as Massachusetts headed for war, those old line families began to be supplanted by a new group of daring merchant/shipowners who were extending their sphere of trading. The onset of war enhanced their position. Many of the old guard were still in sympathy with the British government, whereas the Cabots had developed strategies that circumvented the restrictive trade laws; they were prepared to convert their fleet of ships to privateers. William Brown (1737–1802), a loyalist, wrote from exile in England on February 10, 1780:

It is a melancholy truth that while some are wallowing in undeserved wealth, that plunder and rapine have thrown into their hand, the wisest, most peaceable and most deserving are now suffering want. . . . The Cabots of Beverly, who, you know, had but five years ago a very moderate share of property, are now said to be by far the most wealthy in New England; Haskett Derby claims the second place in the list.[19]

Privateering could be extraordinarily profitable. Captain George Cabot summed the outcome best: "If the owner could save one out of every three ships he sent out, he made a handsome profit on the lot."[20]

Nine of the Cabots' large orders from Gould were associated with family weddings, commencing with Elizabeth Cabot Higginson's order of dowry furniture for the wedding of her daughter Sarah (1745–1772) to John Lowell (1743–1802) of Newburyport in 1767. Her husband, Stephen Higginson, had made the first purchase of a bookcase in January 1759, followed by a stand table two months later. He died in 1761, but by that time her sister-in-law, Hannah Clark Cabot, widow of John, had made purchases in 1760, 1761, and 1762. The purchases by the two widows of second-generation Cabots evidently set a precedent to be followed by the third generation.

Joseph's eldest son, John (1745–1821), graduated from Harvard at age eighteen and was brought immediately into the family business. His first marriage is somewhat sketchy. After his father's death in 1767, he followed his mother's move to Beverly and resided in her house until his second marriage, to Hannah Dodge (1758–1830), in 1779. The following year, he built a mansion (now the Beverly Historical Society). He was the first of Joseph's seven children to purchase Gould furniture

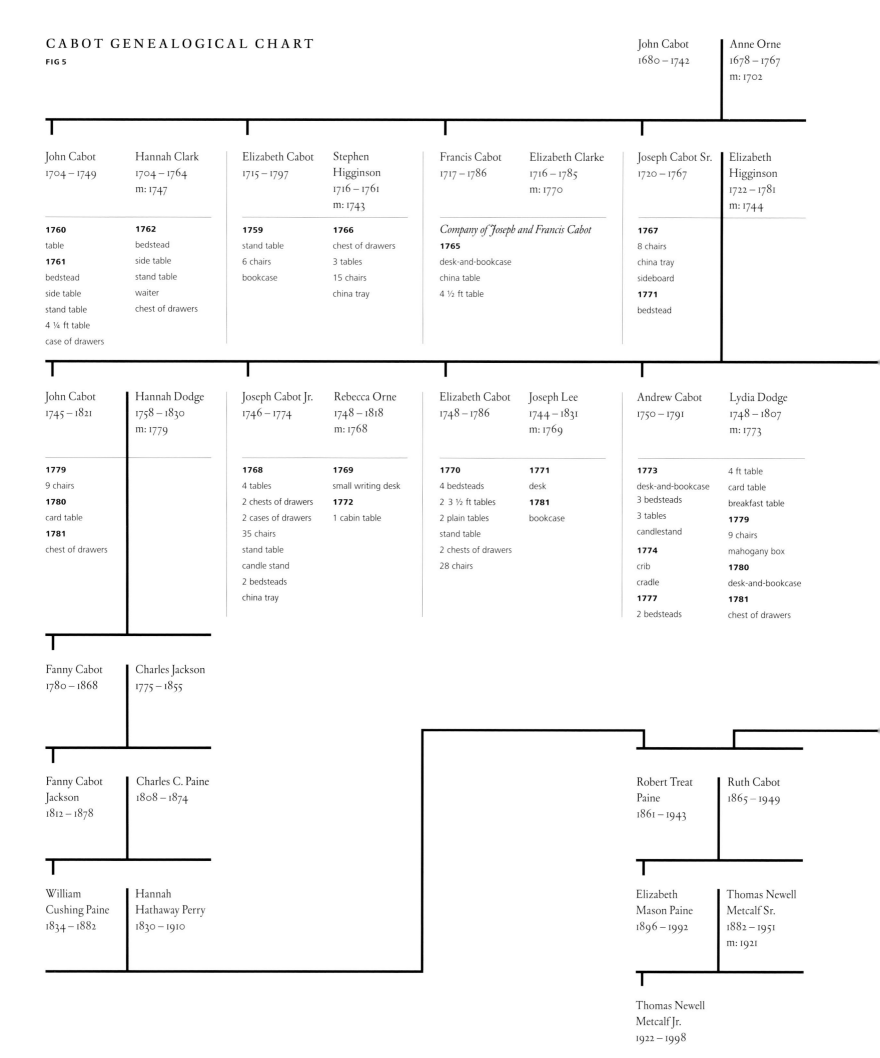

John Cabot
1680 – 1742

Anne Orne
1678 – 1767
m: 1702

John Cabot
1704 – 1749

Hannah Clark
1704 – 1764
m: 1747

1760
table
1761
bedstead
side table
stand table
4 ¼ ft table
case of drawers

1762
bedstead
side table
stand table
waiter
chest of drawers

Elizabeth Cabot
1715 – 1797

Stephen Higginson
1716 – 1761
m: 1743

1759
stand table
6 chairs
bookcase

1766
chest of drawers
3 tables
15 chairs
china tray

Francis Cabot
1717 – 1786

Elizabeth Clarke
1716 – 1785
m: 1770

Company of Joseph and Francis Cabot
1765
desk-and-bookcase
china table
4 ½ ft table

Joseph Cabot Sr.
1720 – 1767

Elizabeth Higginson
1722 – 1781
m: 1744

1767
8 chairs
china tray
sideboard
1771
bedstead

John Cabot
1745 – 1821

Hannah Dodge
1758 – 1830
m: 1779

1779
9 chairs
1780
card table
1781
chest of drawers

Joseph Cabot Jr.
1746 – 1774

Rebecca Orne
1748 – 1818
m: 1768

1768
4 tables
2 chests of drawers
2 cases of drawers
35 chairs
stand table
candle stand
2 bedsteads
china tray

1769
small writing desk
1772
1 cabin table

Elizabeth Cabot
1748 – 1786

Joseph Lee
1744 – 1831
m: 1769

1770
4 bedsteads
2 3 ½ ft tables
2 plain tables
stand table
2 chests of drawers
28 chairs

1771
desk
1781
bookcase

Andrew Cabot
1750 – 1791

Lydia Dodge
1748 – 1807
m: 1773

1773
desk-and-bookcase
3 bedsteads
3 tables
candlestand
1774
crib
cradle
1777
2 bedsteads

4 ft table
card table
breakfast table
1779
9 chairs
mahogany box
1780
desk-and-bookcase
1781
chest of drawers

Fanny Cabot
1780 – 1868

Charles Jackson
1775 – 1855

Fanny Cabot Jackson
1812 – 1878

Charles C. Paine
1808 – 1874

Robert Treat Paine
1861 – 1943

Ruth Cabot
1865 – 1949

William Cushing Paine
1834 – 1882

Hannah Hathaway Perry
1830 – 1910

Elizabeth Mason Paine
1896 – 1992

Thomas Newell Metcalf Sr.
1882 – 1951
m: 1921

Thomas Newell Metcalf Jr.
1922 – 1998

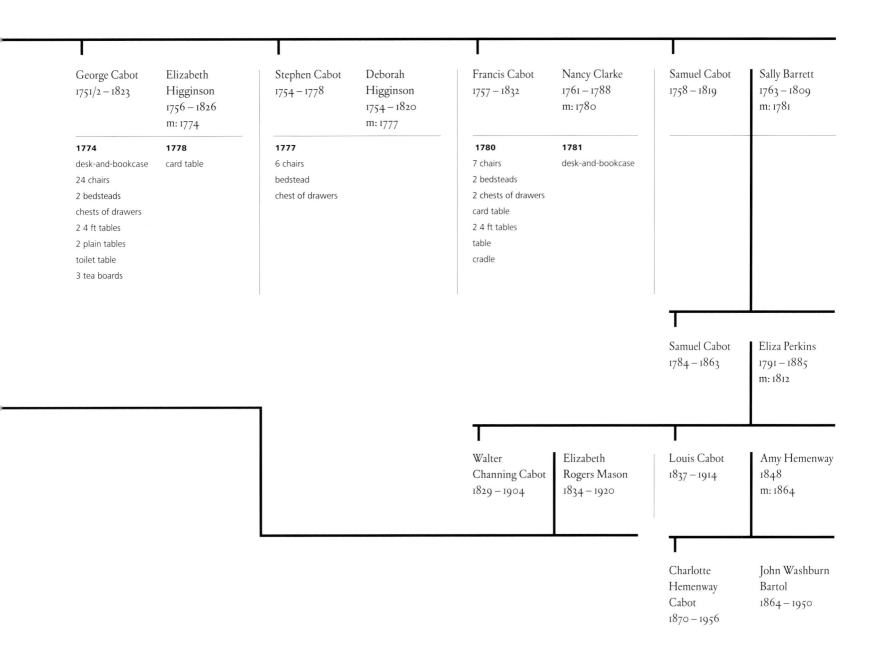

George Cabot
1751/2 – 1823

Elizabeth
Higginson
1756 – 1826
m: 1774

Stephen Cabot
1754 – 1778

Deborah
Higginson
1754 – 1820
m: 1777

Francis Cabot
1757 – 1832

Nancy Clarke
1761 – 1788
m: 1780

Samuel Cabot
1758 – 1819

Sally Barrett
1763 – 1809
m: 1781

1774
desk-and-bookcase
24 chairs
2 bedsteads
chests of drawers
2 4 ft tables
2 plain tables
toilet table
3 tea boards

1778
card table

1777
6 chairs
bedstead
chest of drawers

1780
7 chairs
2 bedsteads
2 chests of drawers
card table
2 4 ft tables
table
cradle

1781
desk-and-bookcase

Samuel Cabot
1784 – 1863

Eliza Perkins
1791 – 1885
m: 1812

Walter
Channing Cabot
1829 – 1904

Elizabeth
Rogers Mason
1834 – 1920

Louis Cabot
1837 – 1914

Amy Hemenway
1848
m: 1864

Charlotte
Hemenway
Cabot
1870 – 1956

John Washburn
Bartol
1864 – 1950

closely connected to his marriage, a set of nine chairs. Like his sister and six of seven brothers, he also purchased a chest of drawers. The popularity of the bombé shape within the family is reflected not only in furniture, but in the interior design of his new house, whose window seats and fireplace moldings are shaped in this manner.[21]

Attending Harvard for less than a year and leaving under somewhat embarrassing circumstances, Joseph Cabot Jr. followed the family custom of going to sea. After the necessary indoctrination period, he was elevated to a supercargo position and later captained the company's ships. By the time his father died, twenty-one-year-old Joseph Jr. had already retired from active sailing duty and was involved in the mercantile end of the business. His marriage to Rebecca Orne united two of Salem's most important families, and their wedding furniture reflected that importance. Joseph Jr. passed away at the young age of twenty-eight.

Next in the progression of Joseph's offspring who received a significant wedding order from Gould was Elizabeth Cabot (1748–1786), on the occasion of her marriage to Captain Joseph Lee. The dowry order consisted of the usual beds, tables, and chairs. One year after their marriage, Joseph Lee ordered a desk, which was the only full-size desk ordered by the extended Cabot family from Gould. Ten years later, he ordered a bookcase for £15, which when added to the cost of the desk at £10, was approximately equal to what his three younger brothers-in-law would pay for their desk-and-bookcases. It is assumed that the bookcase was mounted on the desk purchased earlier, based on the Cabots' tendency to duplicate prior family orders for furniture and the importance they evidently attached to ownership of this form.

Unlike four of his brothers, Andrew Cabot did not go to sea prior to entering a mercantile career. Along with brothers John and George, and brother-in-law Joseph Lee, they started the merchant house of J. & A. Cabot and were partial or full owners of forty-one vessels. Most of the wedding furniture was a gift of the parents of his wife Lydia Dodge (1748–1807), but Andrew acquired the family's second desk-and-bookcase at that time. A third desk-and-bookcase (his second) was purchased when he moved into his new mansion in Beverly. Shortly after his death in 1791, Lydia auctioned a number of household items, including one of the desk-and-bookcases.[22]

The most distinguished Cabot public servant was Joseph's fourth son, George. At the time of his father's death in 1767, he had completed his second year at Harvard at age sixteen. His father had left provisions in his will indicating his hope that George would complete college before joining the family firm. Against the wishes of his mother,

however, he dropped out of college, and signed on as crew with his brother-in-law Captain Joseph Lee. He is reported to have received "the full measure of ships discipline."[23] He evidently learned lessons well, however harsh the instruction, because he was captain of his own ship by age twenty-one. In addition to his partnership with his brothers, he served as a delegate to the Massachusetts Provincial Congress in 1775 and later a United States Senator, holding a number of other important offices in a distinguished career. He also included a desk-and-bookcase and chest of drawers in his wedding furniture when he married Elizabeth Higginson (1756–1826), his first cousin.

George's younger brother, Stephen also married his first cousin, Deborah Higginson (1754–1820), the sister of Elizabeth. By Cabot standards, theirs was a modest dowry consisting of six chairs, a bed, and, of course, a chest of drawers. Stephen died two years after his marriage at age twenty-four. It is often confusing to identify the key people in the second and third generation of the Cabots due to the unusually close ties between the merchant families of Higginsons, Dodges, Clarks, and Lees. After Stephen Cabot's death, his widow, Deborah Higginson Cabot, married widower Joseph Lee, her brother-in-law.

The last of the third generation to purchase a wedding dowry from Gould was Francis Cabot (1757–1832) in 1780, celebrating his marriage to Nancy Clarke (1761–1788). A year later, at age twenty-four, he purchased a desk-and-bookcase. The couple had five children in eight years when Nancy passed away in 1788. Prior to her death, Francis had served in General Lincoln's army suppressing Shays' Rebellion in 1787. He showed a keen affinity for wanderlust and adventure, but avoided responsibility. What is known of Francis's life after his wife's death is obtained mostly from newspapers. His house furniture was sold at public auction in December 1790 and he left five children in the care of their maternal grandparents.[24] He was reported to have been in Philadelphia in 1796, was in the battle of New Orleans in 1815, and died in Natchez, Mississippi, in 1832. There is no evidence that he ever returned to Salem for a visit.

Gould's clients encompassed much of Salem's middle- and upper-class population, from the everyday tradesmen to the wealthiest elements of society. Politically, Gould maintained a neutral stance and was able to avoid being associated with one side or the other leading up to the revolution. He delivered furniture masterpieces outside Salem to other distinguished clients, most of whom had a Salem connection. He owed his success to a keen and disciplined business practice and the foresight in developing the export market. His surviving furniture is a testimony to his interpretation and adaptation to two of England's

prominent furniture design books and the skill with which he trained a workforce. He was a skilled artisan in his craft with a superior sense of proportion and design.

1. Two transactions for Edward Augustus Holyoke, posted in October 1775 "to boys work at his house" and June 1776 "to sundries of work done by boy"; and a charge to John Fisher for "boys work" in June 1766, are the only references to an apprentice in the ledgers.

2. This observation was disclosed to the author by Robert Mussey based on his research into eighteenth-century cabinetmaking and Boston records. It was a determining factor in estimating which journeyman may have apprenticed with Gould.

3. For a thorough review of apprenticeships in the colonial era, see Rorabaugh 1986, pp. 3–7, 16–19, 24–33, 52–53. Charles Hummel of Winterthur was most helpful in citing examples of apprenticeships of shorter duration in the colonies than practiced in England. Edward Stacy of Marblehead, yeoman, apprenticed his son Benjamin Pritchard Stacy at age nine to William Northey, goldsmith of Lynn, only until the age of fourteen. William Northey Papers, MSS 78, box 1, folder 3, Phillips Library, Peabody Essex Museum.

4. For more information on Cogswell, see Mussey and Haley 1994, pp. 73–105.

5. William Holman was the third of ten children of Gabriel and Elizabeth Holman. William's father died in 1756, and sometime afterwards, Gould rented his house from his widow. There are a number of early transactions for cash payments and goods purchased in Gould's ledger to "Mrs. Holman." Gould was also witness to a deed when Mrs. Holman sold part of her inherited property to Joseph Cabot in 1761, Essex County Deeds (hereafter ECD), vol. 137, p. 73.

6. Needham hired Gould in March 1761 "To turning sett Flam's." Called "flams" (flames) in the day book and "blaises" (blazes) in the account book, these were turned and carved finials for a high chest.

7. Needham's birthdate of 1728 as listed in Whitehill 1974, p. 289 is incorrect, and applies to someone else of the same name. His difficulty in making more than a subsistence living as a cabinetmaker was not uncommon, even for highly skilled Salem craftsman such as John Chipman and Elijah Sanderson.

8. The entry for Ropes occurred around the time of old to new tenor currency revaluation. It was assumed to be a new tenor charge in estimating his work for Gould.

9. A signed four-drawer block-front chest by Ebenezer Martin sold at Northeast Auctions, August 11, 2000, lot 738, and is pictured in a C. L. Prickett advertisement in *Antiques* 130, 6 (December 1986), p. 1094. He also was in partnership with Nathan Bowen of Marblehead; see Randall 1965, pp. 52–53.

10. Information on Ross was received from William Upton of Manchester, New Hampshire, who has been a student of New Hampshire furniture makers and attributes a number of case furniture pieces to Ross, based on the Salem characteristics in their construction. Ross and a son had a cabinetmaking shop in Gilmanton from 1780 into the early 1800s. See also New Hampshire Historical Society 1979, p. 150, which notes that Jonathan Ross appears in Strafford County in 1776 as a cabinetmaker from Salem.

11. A 1776 receipt of Daniel Goodhue of Westford for Jonathan Greene is in the Massachusetts Historical Society; Ms. N 2008, Chelsea–Chamberlain Mellon; vol. 3, p. 151.

12. Allocating specific subcontracted work to Gould's customers was subjective, but considered reasonably accurate. If, for example, a cherry desk was delivered around the same time of a shipment, the assignment was straightforward. This decision was confirmed when export sailing dates were generally within a few days of Gould receiving invoices from suppliers. If multiple desks made of the same wood were included on an invoice, allocation to specific customers was more uncertain. It was assumed that the invoice only included furniture made on or before the date of the invoice. If multiple shipments (for example, of maple desks) were recorded, and only a few had been purchased from subcontractors, the assignment of the subcontracted maple desks was made to export sales.

13. Between June 1759 and January 1770, Gould recorded 126 sales of sugar to his supplier network of craftsmen. Market prices for Salem commodities in 1775 are in EIHC 1860, p. 259. Gould purchased sixty-six pounds of sugar from the Cabots on August 1765 for £1..6..8 or 4.85d. per pound; another purchase from Peter Frye Esq. was for fifty-six pounds at £1..6..8 or 5.7d. per pound. Gould was selling sugar at an average price of 5.14d. per pound in 1765, and it appears he absorbed small variations in his purchase price while maintaining stability of the price sold to joiners.

14. See McCusker 1992, pp. 351–55.

15. The birthdate of Nathaniel Gould Jr. could not be accurately determined. Nathaniel's first son, James Wood Gould, was born in 1761. He was followed by another son named John in 1763. No Nathaniel is listed in birth or church baptismal records. When Nathaniel Jr. died in 1799, his listed age corresponded to a birthdate of 1763 and it is assumed that although baptized as John, he assumed the name of Nathaniel throughout his life. See April 30, 1799, Salem Vital Records, N.R. 9.

16. Tables were selected as the basis for comparison due to their broad demand by all walks of life. During this period, sales of large case furniture like desk-and-bookcases and cases of drawers were almost nonexistent.

17. "An Inventory of the Estate of Mr. Nathaniel Gould," January 1782, Nathan Dane Papers, Box 16, Massachusetts Historical Society.

18. Cats. 2, 7, 10, 12, and 16.

19. Curwen 1864, pp. 256–57.

20. Briggs 1927, p. 106, with no reference as to the original source.

21. Elizabeth Cabot on her marriage to Joseph Lee, Rebecca Orne on her marriage to Joseph Cabot, and Francis Cabot on his marriage to Nancy Clarke purchased two chests of drawers. John Cabot's youngest brother, Samuel was the only third-generation of adult not to purchase from Gould. For additional information on the Cabots, see Widmer and King 2010, pp. 166–75.

22. See William Lang's advertisement, *Salem Gazette,* June 12, 1792. In addition to the desk-and-bookcase, a stand table, thirteen leather bottom chairs, and a chest of drawers were auctioned. See also "Minute Book of Settling Estate of Andrew Cabot," Nathan Dane Papers, Box 16, p. 19, Massachusetts Historical Society.

23. Briggs 1927, gives no reference or additional specifics; in all likelihood, it involved whipping.

24. For sale of his household furniture, see *Salem Gazette,* December 14, 1790. His obituary is in *Salem Register,* August 9, 1832.

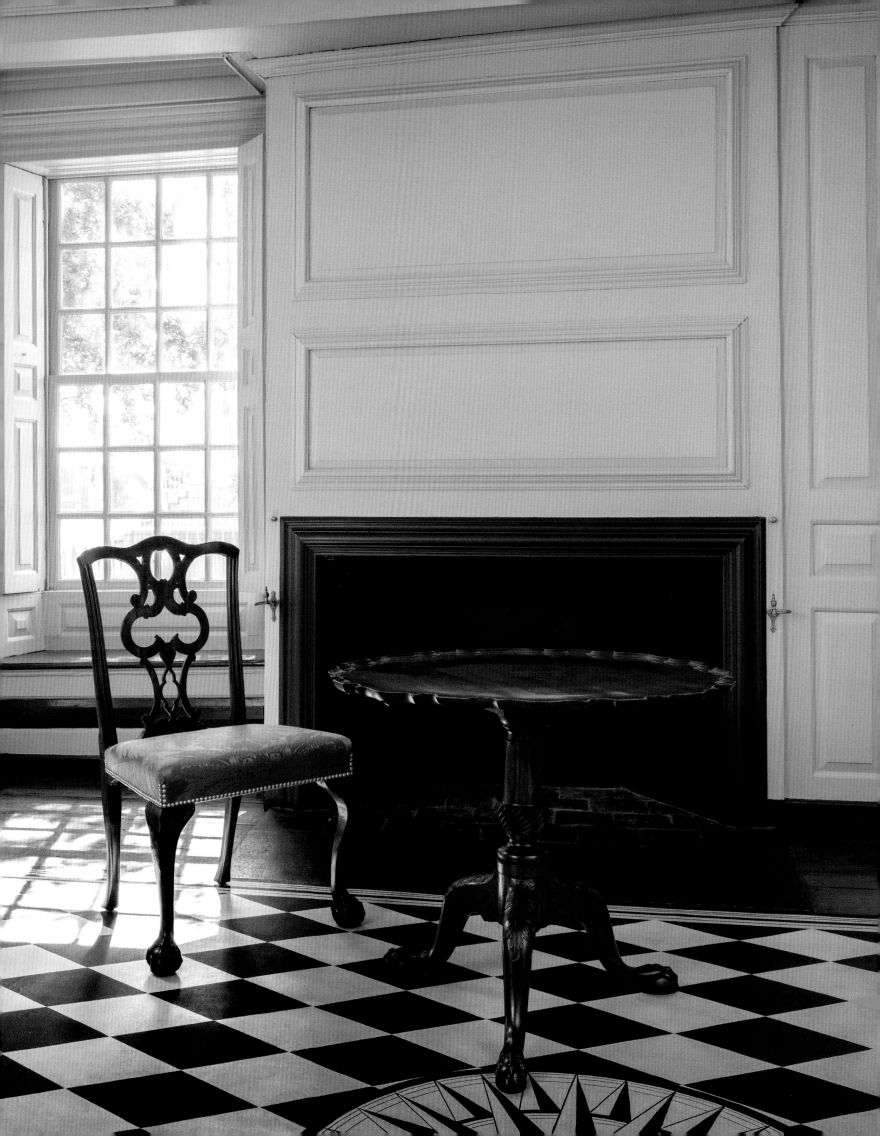

Catalogue
of
Nathaniel Gould's
Furniture Forms

KEMBLE WIDMER
and
JOYCE KING

Case Furniture Construction

Identification of the work of a specific eighteenth-century cabinetmaking shop requires a high level of knowledge of the idiosyncrasies in construction, wood use, and marking systems practiced only in that shop. Such knowledge is derived from an exhaustive examination and tabulation of the object's smallest details, which then become master reference data for a particular shop's standards, techniques, and mannerisms. Comparison to other furniture from the same town will often reveal several construction practices that are consistently different. It may be as obvious as different methods of gluing backboards together or as subtle as noticing that in one shop a particular wood plane had a small nick in its blade whereas another shop used the same type of plane but the cutting edge was undamaged. Once this body of evidence is gathered on a case piece, comparison to other furniture of like form will usually determine whether or not it came from the referenced shop. Following this procedure resolved the conflict surrounding attribution of the magnificent desk-and-bookcase owned by New York's Metropolitan Museum of Art (cat. 8).

Unfortunately, many attributions to a specific cabinet shop or maker are based on only one or a few attributes—a flawed process that often leads to erroneous conclusions. The characteristics of Nathaniel Gould's shop production are consistent and relatively easy to identify. This consistency was sustained despite a working span of more than twenty years, during which Gould produced all types of furniture and employed a number of skilled cabinetmakers. Nonetheless, a reliable attribution to him requires an understanding of many facets of construction, form, and numbering systems. Since some of those characteristics were used by other Salem cabinetmakers, a firm attribution has been made only when the *sum* of the characteristics is considered in comparison to other case pieces. This point cannot be overemphasized.

Large Drawer Construction

STANDARD JOINERY PRACTICE

Assuming he apprenticed in the Boston area, Gould would have been trained to make a drawer incorporating a bottom board nailed into a rabbet at the front and sides (fig. 1). In typical Boston practice, the wood grain of drawer bottoms is perpendicular to the drawer front. The bottom boards usually consist of two to four boards glued together on their edges, forming a butt joint. Both side and bottom boards are planed to approximately 1/4-inch thickness and made of pine. The top edge of the drawer sides is rounded, flat, or finished with a closely spaced double bead. In many cases, drawer backs or bottoms are finished cursorily, leaving a rough surface. Since the pine bottom board was nailed to each drawer side and the grain ran parallel to the sides, when wood shrinkage occurred, the bottom board would split, allowing dust inside. The drawer dividers, or "blades," consisted of a thin strip of primary (usually mahogany or walnut) facing, glued to a pine backing. They were attached to the sides of the case by means of dovetails, but the dovetails were covered by a thin strip of wood running vertically and glued and/or nailed to the sides, hiding the dovetail joint.

Typical drawer construction used in Salem was quite different from Boston's, and Gould quickly adapted. He probably realized the advantages of Salem's design: lower labor cost, a stronger product, and a neater appearance. Drawer sides and backboards typically range between 1/2 to 5/8 inches in thickness, while bottom boards measure 1/4 to 5/16 inches (fig. 2). Wood grain is parallel to the front face. Rather than nailed into a rabbet, the bottom board is tapered at the front and sides and fitted into dados. The additional thickness of drawer elements allowed for a higher capacity load without damage to the drawer or case, and reduced wear. The change in the orientation of the bottom board was labor saving because only one board was used, which eliminated dressing and gluing multiple boards. Moreover, the design allowed the bottom board to shrink without splitting, since it was nailed only at the rear board. In noticeable contrast to Boston work, Salem drawer bottoms and backs are finely finished, giving a smooth, flat surface.

Gould found Boston practice superior in two cases: when cedar was specified by the customer (an option), and when constructing the lower drawers of large case pieces. In both cases, however, the bottom boards were still mounted in dados, which allowed for wood shrinkage without splitting, regardless of the bottom board grain orientation. The drawers are smoothly finished on all surfaces except the underside of the bottom. Hand-forged roseheaded nails are used only to secure the bottom to the backboard. A molding plane in the shape of a wide-spaced double bead was used to shape the top edge of the drawer sides and some backs of

more expensive furniture (fig. 2). The top edge of the backs of less expensive objects was left flat. Drawers slide on the bottom edges of the sides.

Gould's dovetailing of drawers was consistent in its construction of the joint between the front and sides. A half dovetail was used on the top edge, followed by a progression of two, three, and four full dovetails as the drawers increased in height. No half dovetail is used at the bottom, which distinguishes his work from that of some of Salem's other cabinetmakers.[1]

The orientation of Gould's rear dovetails depends on whether the piece is of bombé form (swelled sides) or has straight, flat sides. Drawers from straight-sided case pieces use dovetails with the "pin" exposed on the drawer side. If, however, the drawer side was swelled or inclined, as on a bombé piece, the pin was exposed on the rear board (fig. 3). This prevented the drawer from coming apart when subjected to high load pressures.

DRAWER MARKING

Gould allowed his employees latitude in marking their work. Several case pieces are numbered in chalk on the rear surface of drawer backboards (figs. 3 and 4). When numbered, the top drawer usually starts with an approximation of its height opening in the case. For example, drawer heights between 4 and 5 inches would be assigned "4." Lower drawers are numbered consecutively after the initial number. Other work from the Gould shop shows no signs of numbering.[2]

Case Construction

Chests of drawers (called bureau tables in the ledgers) have top boards 3/4 inches thick and are mounted to 3/4-inch case sides. Gould used a sliding dovetailed joint to attach the top to the side boards, a procedure carried over from his time in Boston. However, the top is also secured with glue blocks inside the case sides, the usual Salem practice. On all case pieces studied, the pine backboards are nailed in a rabbet in the case sides. A lapped joint between the backboards kept dust and dirt out of the interior.

Drawer runners are face-nailed to the sideboards with three or four rosehead nails. Gould retained the usual Boston method of having the

FIG 1
Typical Boston drawer construction

FIG 2
Typical Salem drawer construction

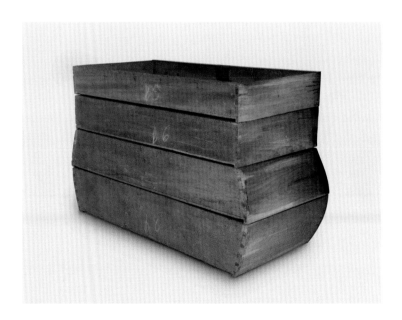

FIG 3
Detail of cat. 1 showing rear dovetail on bombé drawers

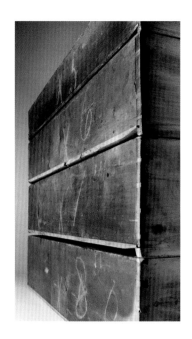

FIG 4 [LEFT]
Detail of cat. 4 showing numbered drawer markings

FIG 5
Detail of cat. 1 showing typical case piece bottom construction

FIG 6
Detail of cat. 4 showing distinctive shaping of knee returns and center shell backing

FIG 7
Detail of cat. 5 showing ogee curves and half-circles repeated on inside edge of straight bracket feet

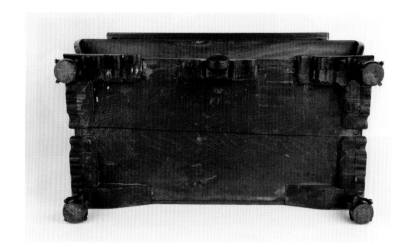

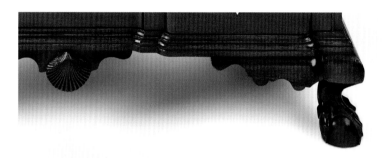

bottom drawer slide on strips of wood rather than directly on the bottom board, the typical Salem design (see Chests of Drawers, fig. 1). Unlike Boston pieces, there is no "giant dovetail" securing the base molding to the pine base board. The same base molding profile is present on all pieces studied. Clearly, Gould carefully evaluated the strengths and weaknesses of Salem and Boston construction techniques and used whichever method he felt was superior.

Examination of the underside of a Gould case piece is necessary to fully understand and appreciate the workmanship of Salem's cabinetmakers. Glue blocks supporting the feet and center drop are substantial and finely finished, even though not normally in view (fig. 5). They are generally 2 to 3 inches thick and mirror the profile of the mahogany facings. Gould's rear foot glue blocks are triangular in shape, 7 to 9 inches long, and the edges are chamfered.

The case bottom is generally in the same plane as the bottom of the base molding, and the feet and supporting blocking are glued directly to the base.[3] Approximately half the pieces studied have one nail in the thinnest section of each block. Gould was neither the first nor the only Salem cabinetmaker to construct the furniture base in this manner: Abraham Watson (1712–1790), working before him, and most makers after him, adhered to the same standards, which are a Salem characteristic.[4]

One additional key element of construction on smaller case pieces like four-drawer chests and desks is indicative of Gould's work. Most of the drawer dividers (blades) are made from solid mahogany as opposed to a thin piece of mahogany glued to a pine backing. This characteristic is atypical of most other Massachusetts North Shore

cabinetmakers. Gould evidently thought it more economical to use a small piece of solid mahogany, rather than incur the cost of fitting two pieces together. The blades are fastened to the case sides by means of an exposed dovetail joint, a standard Salem practice.

EXTERIOR APPEARANCE

For the majority of case work that has survived, Gould's customers specified ball-and-claw feet and a center drop with an applied scallop shell. His shop's knee returns and the backing piece for the shell are greater in length than on most furniture of the period, and consist of a series of ogee curves. They have very distinctive profiles and thus are diagnostic to his shop (fig. 6). Similar ogee curves are used for the straight bracket feet and the diamond cut-out center drops used on less expensive objects (fig. 7).

Another hallmark is Gould's use of select close-grained mahogany. Highly figured mahogany was chosen for the most expensive work, such as the broad surfaces of desk lids and cupboard doors. As the importer of substantial amounts of mahogany from the West Indies, Gould was in a position to select and save the best wood for his clients.

A SURPRISING OBSERVATION

Well trained in multiple aspects of his craft, Gould obviously planned the design and purpose of his furniture carefully, while always considering the economies possible in its manufacture. Given those parameters, one would assume that knee returns and scallop shells would be made from templates and thus be the same dimensions when used on similar sized case pieces. The fact that this was not the case is one of the more surprising results of this study. The length of the mahogany backing for the center drop varies from piece to piece in Gould's output, regardless of case size. The half circles are individually laid out with a compass rather than being traced from a template. If the furniture has not been overly refinished, the center points of the compass are visible (fig. 8). This method was also used in laying out knee returns. In addition, the rays carved in the scallop shell vary in number from twenty-one to thirty, again indicating a high degree of individual attention to each piece. All of these embellishments are executed in the same fashion with the same degree of skill; their chief consistency is their inconsistency in manufacture.

The characteristics cited above will identify the standards of work that Nathaniel Gould insisted upon in his shop's output, while giving leeway to the individual joinery customs of his employees. All of the standard practices described here are present in the catalogue entries that follow, unless otherwise noted. The most striking example of standard shop practice and divergent employee construction within the Gould shop occurs in chair construction and is discussed in that chapter.

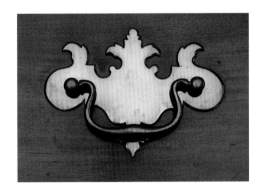

FIG 8
Detail of cat. 2 showing compass center point

FIG 9
Detail of cat. 4 showing Gould's most popular drawer brasses

FIG 10
Detail of cat. 1 showing typical case furniture ball-and-claw foot carving

1. John Chipman, one of Salem's most highly skilled cabinetmakers, used half dovetails at the top and bottom of drawer sides.

2. The most common marking was a "B" followed by the drawer number (see fig. 3). Other markings included an "X" toward the bottom of the rear board and double chalk lines at each end of the rear board. If two drawers adjacent to each other were mounted in openings within the same inch range, for example, 5 1/16 and 5 7/8 inches, the first would be numbered "5" and the second "6," as seen on the Cabot chest of drawers at Historic New England (cat. 2).

3. The chests of drawers at Historic New England (cat. 2) and Winterthur (see cat. 2, fig. 3) and the desks at the Museum of Fine Arts (Boston) and Philadelphia Museum of Art have cleats mounted to the base at the front and sides.

4. Based on the author's analysis of more than one hundred case pieces from Salem cabinetmakers.

Chests of Drawers (Bureau Tables)

Nathaniel Gould described four-drawer chests in his accounts as "bureau tables"—a somewhat surprising and confusing use of that term. Many references in the literature assume that this term refers to what is today called a "kneehole desk," but this is not the case for Gould. In his ledgers, a chest of drawers can be identified by one of two names: "bureau table" or "case of drawers." A review of known furniture attributed to the Gould shop, when compared to his total output, reveals that survival rates vary from less than 1 percent to a high of 30 percent for larger case pieces. Five of the fifty-six chests of drawers produced in his shop survive. The four that were closely examined are virtually identical except in minor dimensions, indicating that they must have been sold for the same price prior to the inflationary spiral during the American Revolution. The five chests of drawers were among the eighteen that were sold at £6 each, since no other model accounted for more than five sales, and all five were bombé in shape.[1]

The only other possibility within the classification identified as "case of drawers" that could account for five survivors are the fourteen *walnut* objects sold for £7..6..8 each. However, the five bombé chests of drawers are mahogany, hence they must have been the objects Gould and his workmen referred to as "bureau tables." This hypothesis was confirmed when two of the five existing chests of drawers were tied to specific customer purchases in Gould's ledgers.[2]

As highly prized today as they were popular when first introduced in Boston in the 1750s, case pieces incorporating the bombé shape included desks, desk-and-bookcases, chest-on-chests, and chests of drawers. Appreciation for the form in Boston was undoubtedly influenced by local silversmiths, who incorporated it in their work as early as the mid-seventeenth century, and by imported English furniture owned by wealthy Bostonians.

Although the bombé style had been available from highly skilled cabinetmakers in Boston as early as the 1750s, it appears that Gould introduced it to Salem shortly after his arrival.[3] His first sale of this form, on June 4, 1759, to John Tasker Esq. of Marblehead, is of particular interest. In September of the prior year, Tasker's daughter Deborah married James Freeman, and received a chamber table made by Gould from her parents as part of her dowry. Nine months later, her parents ordered both the first chest of drawers sold by Gould and a case of drawers priced at £12. The case of drawers was probably a bonnet-top high chest of mahogany. It was at first thought that this order was for her parents, rather than Deborah. However, James Freeman died in 1763 and his extensive estate inventory lists a "barr table" valued at £4..16..0 and, in the next entry, a "case of draws" at £10. The valuation of the "barr table" is much higher than other tables, and it and the case of drawers are considered to be the set purchased four years earlier by Tasker for his daughter and son-in-law.[4]

Seventeen months later, Tasker ordered a chest of drawers and case of drawers. This order was undoubtedly for his daughter Anne (1739–ca. 1802), on the occasion of her wedding to Thomas Wentworth (1739/40–1768) of Portsmouth. Priced at £6..13..4, it was the second most expensive chest of drawers delivered by the Gould shop. The case of drawers was probably a chest-on-chest, but not of bombé shape, considering its cost of £16.

Six months later, John Tasker's widow, Deborah, ordered a third chest of drawers also coupled with a case of drawers. The chest of drawers was the same form and decoration as that given to her daughter Ann, but the case of drawers price of £17..6..8 identifies it as a bombé chest-on-chest identical to cat. 4. These orders established a pattern that was to be repeated over and over: the ordering of chests of drawers for wedding dowries often coupled with cases of drawers. The increase in the popularity of both the chest of drawers and the coincidental orders for chest-on-chests signaled the decline of chamber tables being ordered with high chests (highboys).

Given that the sales of thirty-four of the fifty-six chests of drawers produced by Gould's shop were associated with weddings, the item was clearly considered a necessity for the well-to-do bride. The wealthiest families often ordered two chests, one mahogany and one of less expensive walnut or cherry. Cases of drawers, most often chest-on-chests, accompanied twenty-two of the chests of drawers orders before the outbreak of war in 1776. Gould's ledgers demonstrate the continued vogue for the bombé form in chests of drawers throughout the period of the shop's production, whereas the block-front style eclipsed it in popularity for cases of drawers, desks, and desk-and-bookcases as early as 1770.

FIG 1
Detail of cat. 1 showing typical case
furniture interior construction: strips of
wood support the bottom drawer, drawer
slides are nailed to case sides, drawer
dividers are solid mahogany

Although it is possible to identify the most popular model of chest of drawers (the £6 version), their relative pricing gives a clue to the form of other types, in addition to identifying several made of woods other than mahogany. One of the two chests of drawers ordered by Francis Cabot (1757–1832) in 1780 is listed as a "plain Bureau table" and priced at £5. This sale took place in the middle of the war when pricing was extremely unstable. However, the facts that the chest was sold for the standard £6 for the most popular model, and sold to the Cabots, who could exert pressure to maintain prerevolutionary prices, and that three others were sold at the same price in prior years, indicate that this model was significantly less costly to make, despite being mahogany. The form's specific appearance is open to debate until a four-drawer chest can be attributed to Gould, but it could have been straight sided. The chests of drawers priced at £5..6..8 were also mahogany, probably of bombé form, and might have had ogee bracket feet, rather than ball-and-claw feet. Five chests of drawers were listed as walnut and priced at £2..13..4. All were coupled with a more expensive mahogany piece and formed part of a substantial dowry order. The price difference is too great to be accounted for only by the change from mahogany to walnut (walnut or cherry was usually 70 percent of the price of mahogany),[5] implying that the second chest of drawers for each order was a much less expensive form than the bombé.

The five examples are remarkably consistent, with small variations in construction, inscriptions, and dimensions. The chest of drawers was the only surviving type of case furniture with enough examples to illustrate the variations in construction and dimension that can occur in a large shop operating over twenty years. Bombé chests are rare—a circumstance often attributed to the labor and material costs involved in shaping their swelled sides. The early chests in Boston were fashioned from mahogany as much as 3 inches thick. Drawer sides were left vertical and did not match the curve of the case sides.[6] The interior of a typical Gould chest, however, indicates he curved the drawer sides and thus achieved a more pleasing façade (fig. 1). This approach required greater skill and increased the cost of the object. Gould learned the technique prior to his arrival in Salem, but his introduction to the city of this entirely new fashion of furniture made a dramatic impact, particularly among the socially conscious new brides of Marblehead and Salem.

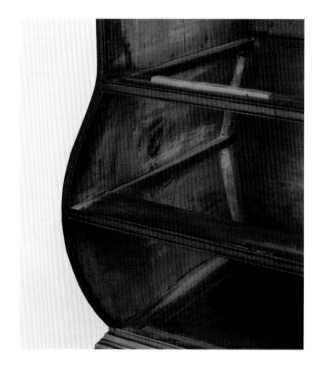

1. For a thorough review of the development of the bombé form in Boston and vicinity, see Vincent, G. 1974, pp. 137–96.

2. Chests of drawers sold to Mrs. Elizabeth Cabot Higginson in November 1766 and Andrew Cabot in 1781 were identified through family provenance and are two of the four documented survivors. A chest of drawers at the Museum of Fine Arts, Houston (B69.136), appears to be from the Gould shop; closer examination is needed.

3. The earliest documented example of the bombé shape in Boston is a desk-and-bookcase signed by Benjamin Frothingham in 1753. See Vincent, G. 1974, p. 140. A bombé pulpit was built for the First Church of Ipswich by cabinetmaker Abraham Knowlton in 1749. See Nelson 2000, pp. 42–59.

4. James Freeman Inventory, November 22, 1764, Massachusetts Essex County Probate Records, vol. 341, pp. 462–67.

5. The five orders that included two chests of drawers are as follows: Rebecca Orne, 1768, mahogany £5..6..8 and walnut £2..13..4; Joseph Lee, 1770, mahogany £5..6..8 and cherry £2..13..4; Clark Gayton Pickman, 1770, mahogany £5..6..8 and walnut £2..13..4; Jeremiah Lee Esq., 1772, mahogany £5..6..8 and walnut £2..13..4; Dr. William Paine, 1773, mahogany £6 and walnut £2..13..4. To determine the price difference between mahogany and walnut or cherry, the cherry stand tables ordered by Benjamin Mouton in 1766; walnut ordered by Josiah Gould in 1768; and cherry ordered by Rowland Savage in 1774, all priced at £1..8..0, were compared to the basic mahogany stand table of £2. The same form in a lesser wood was priced at 70 percent of mahogany. This ratio was confirmed for two sets of the chairs of walnut versus mahogany ordered by John Appleton in 1767 and two sets ordered by Josiah Orne the same year. The difference prices were 69 percent and 71 percent respectively.

6. See Vincent, G. 1974, p. 170, pl. 119.

Chest of Drawers

1758–66

Attributed to the shop of Nathaniel Gould

Dense mahogany; secondary wood: eastern white pine

H 38 3/8; W 41 5/16; D 20 5/16

Marblehead Historical Society, Marblehead, Massachusetts, Gift of Mrs. Francis B. Crowninshield (1945.62)

PROVENANCE: Elizabeth Mansfield Rust (1791–1891); her daughter Elizabeth Hathorne Proctor (1824–1909); her daughter Anna Maria Rust Osgood (1854–1928); her son Osgood Packard (b. 1881);[1] Marblehead Historical Society, 1945

Although it lacks the symmetry and balance of later examples, this extremely important object represents an early effort by Gould to design and construct the bombé style, and offers a starting reference point for the form's development in all his later case furniture. If not the first, it is certainly one of the earliest examples produced by Gould, and, based on its proportions, predates the one sold to Mrs. Elizabeth Cabot Higginson in November 1766 (see cat. 2, fig. 2). Its overall height of 38 3/8 inches is 2 inches greater than any other example studied. The shaping of the sides begins *after* the second drawer. This, coupled with the chest of drawers' maximum width of 41 5/16 inches (almost 3 inches greater than other examples), and wider than the top board, makes the chest distinctly pot-bellied. It is evident that Gould was familiar with the form, but had not yet worked out the relationship of dimensions to provide an aesthetically pleasing product. The overall appearance is additionally compromised by the minimal overhang of the top in relation to the width of the case below.

Despite the different dimensions, it is assumed that this example was sold for £6, the same price as chests of drawers for Mrs. Elizabeth Cabot Higginson (see cat. 2, fig. 2) and Andrew Cabot (cat. 2). There are no significant variations in design or hardware. If this assumption is correct, there are four possibilities as to its original purchaser and subsequent ownership: Mrs. Hannah Cabot, January 1762; Dr.

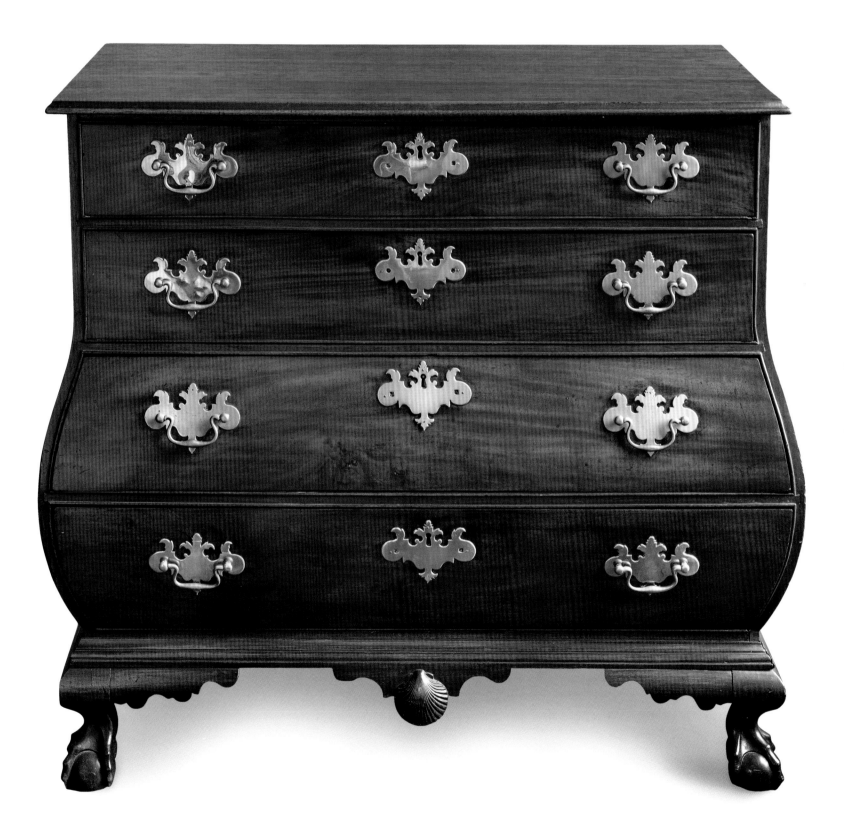

FIG 1
Detail of cat. 1 showing drawer with blue
paper liner

[RIGHT, CAT 1]
Photographed in Jeremiah Lee Mansion
(ca. 1766–68), 170 Washington Street,
Marblehead, Massachusetts. Marblehead
Museum and Historical Society Historic
House Collection

Bezaleel Toppan, June 1762; Richard Derby, September 1763;[2] Mark
Hunking Wentworth (2 chests), November 1764.[3]

 This example may be considered the prototype for Gould's bombé
chests of drawers. The case interior exhibits most of Gould's standard
construction practices and elements for chests of drawers (see Chests
of Drawers, fig. 1). Of particular note is the shaping of drawer sides to
conform to the case's bombé curve. All these features were retained on
chests of drawers spanning twenty years of production. The chest is in
excellent condition. Especially noteworthy is the blue paper, frequently
used as lining material in the eighteenth century, which is still present
in all four drawers (fig. 1).

1. As per a letter from Israel Sack, Inc., New York, to Mrs. Francis B. Crowninshield, stating that
the firm had been told by Packard's great-grandmother (Elizabeth M. Rust) that the chest had
been in her father's house in Salem.

2. Richard Derby probably purchased the chest of drawers for his daughter Martha, who married
Dr. John Prince in September 1762. Her dowry furniture was delayed for approximately a year,
however, until the couple moved into the house—also a gift from her father—that he purchased
from Elizabeth Cabot Higginson in May 1763. See Murphy 2008.

3. This example is probably not one of Wentworth's two chests of drawers that were delivered to
Portsmouth, New Hampshire, to his daughter and her husband Captain John Fisher, naval officer
and collector of customs for Portsmouth and Salem. Much of Fisher's property was confiscated
during the revolution and sold at auction, but the chests of drawers are not among the items he
claimed as losses, indicating he had transferred or sold them prior to leaving Portsmouth. See
Fisher 1783–90, vol. 2, pp. 549–655.

Chest of Drawers
1781

Attributed to the shop of Nathaniel Gould

Dense mahogany; secondary wood: eastern white pine

H 36 ¹⁄₈; W 39; D 21 ³⁄₈

Historic New England, Boston (1984.21)

PROVENANCE: Andrew Cabot (1750–1791), February 24, 1781; his wife Lydia Dodge Cabot (1748–1807); their fourth daughter Catherine (1789–1862) and her husband Charles Chauncey Foster (1785–1875); their daughter Susan (1823–1900) and her husband Francis Lowell Batchelder (1825–1858); their son Charles (1856–1954) and his wife Laura Poor Stone (1863–1956); their son Charles Jr. (1898–1973) and his wife Martha Lee (1906–1984); by bequest from Martha Lee Batchelder to Historic New England, 1984.[1]

Andrew Cabot purchased this chest of drawers shortly after he and his wife moved to Beverly in the early 1780s. He joined four brothers who had followed their mother, Elizabeth Higginson Cabot, in relocating from Salem. Around the time of the move, Andrew Cabot built the mansion house that is now Beverly City Hall (fig. 1). This chest of drawers and a second of his two desk-and-bookcase purchases from Gould were probably intended for his new residence.

Another chest of drawers, sold to Mrs. Elizabeth Cabot Higginson (fig. 2), illustrates the importance of provenance in determining attribution to Gould. It bears a chalk inscription reading "John Chipman Gray," the name of a later owner. Gray had many ancestors in Salem who might have purchased this piece from Gould, but none is listed as a customer. However, furniture purchases were often occasioned by a marriage, and those made by the bride's family would have carried her maiden name. However, again no client match could be found. Discovery of a sad but frequent event in the eighteenth century—the death of a young bride—helped solve the problem. The standard family genealogy only recorded the marriage of one of Gray's ancestors, John Lowell (1743–1802), to his *third* wife, Rebecca Russell (1747–1816). However, Lowell was first married to Sarah Higginson (1745–1772), and that marriage provided the essential clue in tracing this chest of drawers.

Sarah's mother, Elizabeth Cabot Higginson, purchased this chest of drawers in 1766 in addition to other dowry furniture for the young couple. Confirmation that the order was for her daughter is given in the account book where the items are described as "cased" for shipment. Lowell lived in Newburyport and the furniture was probably shipped by sea to avoid damage over rough colonial roads. Sadly, Sarah died only six years after her marriage. Two years later, Lowell married Susanna Cabot (1754–1777), Sarah Higginson's cousin. Her wedding dowry was also purchased from Nathaniel Gould by her father, Francis Cabot (1717–1786) Susanna also passed away at an early age, after which John Lowell married Rebecca Russell, John Chipman Gray's great-grandmother on his mother's side, and the chest began its descent in the family.

Despite a twenty-year span, there are no significant construction differences in Gould's early and late chests of drawers—only slight dimensional changes to improve overall appearance. The shop was continually experimenting with the relative proportions of the bombé design. This example, the Higginson chest (fig. 2), and a chest of drawers at Winterthur (fig. 3) illustrate the best balance of form. The example for Mrs. Elizabeth Cabot Higginson demonstrates that only four years after his very early bombé chest of drawers (cat. 1), Gould had developed the design from an awkward blend of two straight-sided drawers on top of two widely bulging drawers into a case piece of great beauty. Two significant changes account for the transformation: Gould increased the width and depth of the top, resulting in the top being

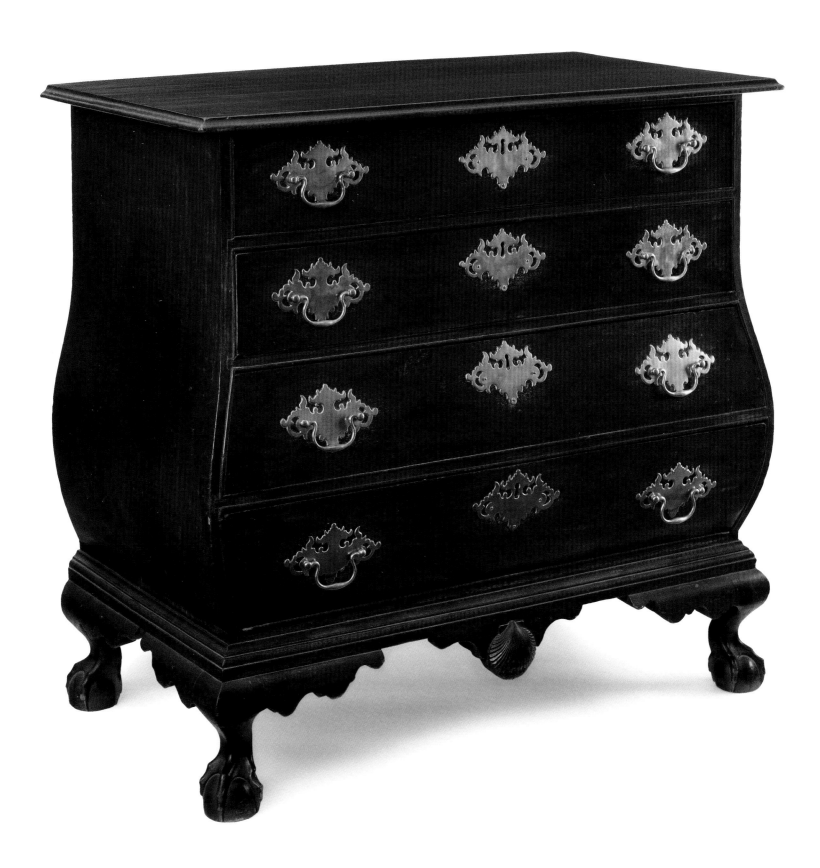

FIG 1
Andrew Cabot House (1763),
191 Cabot Street, Beverly, Massachusetts,
(now Beverly City Hall), 1830s. Photograph
Historic New England, Boston

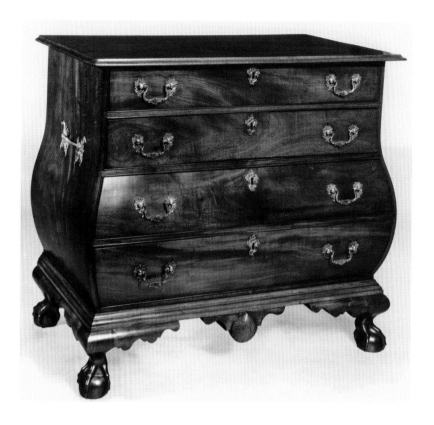

FIG 2
Attributed to the shop of Nathaniel Gould
Chest of Drawers, November 1766
Mahogany and white pine,
H 33 ¼; W 36 ½; D 20
Bernard & S. Dean Levy, Inc., New York

FIG 3
Attributed to the shop of Nathaniel Gould
Chest of Drawers, 1765–82
Mahogany and white pine,
H 35 ¼; W 37 ⅛; D 22 ½
Winterthur Museum, Wilmington,
Delaware, Bequest of Henry Francis
du Pont (1957.0509)

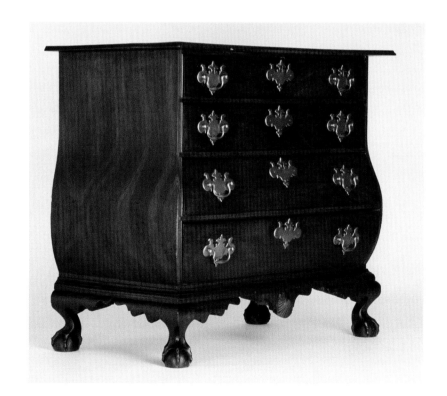

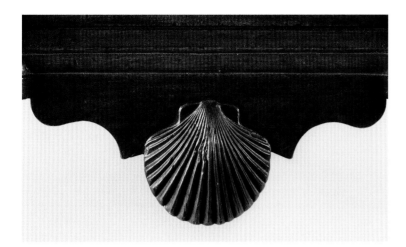

FIG 4
Detail of cat. 2 showing carved
scallop shell

at least as wide as the maximum width of the bombé section, and he extended the curvature of the sides into the second drawer, thus eliminating the sharp transition from a straight vertical to a wide bulge. There was little need for change going forward.

Drawer heights here are more evenly proportioned than in any other chest, which minimizes the contrast between the bulge of the lower two drawers compared to the height of the top two. It also provides evidence that each leg bracket and the backing of the scallop shell drop were individually laid out with a compass (see Case Furniture, fig. 8). This scallop shell is the most delicately carved of any Gould case piece studied, with thirty rather than the usual twenty-two to twenty-six rays (fig. 4). Unlike in earlier work, the table's feet and their supporting brackets are glued to cleats rather than to the case bottom. Dovetails at the rear of the bottom two drawers follow the standard Gould practice of pins exposed toward the rear of the drawer. The chest is in excellent condition and retains an old finish. The brasses are replaced.

1. With gratitude to Richard C. Nylander, curator emeritus at Historic New England, for providing the well-documented line of descent on this chest of drawers.

Cases of Drawers

Nathaniel Gould's ledger descriptions generally can be translated into today's vernacular of furniture terms, with the notable exception of those items called "cases of drawers." Gould used that term, perplexingly, as an all-inclusive name for flat-top high chests, bonnet-top high chests, chest-on-chests, and possibly other forms. Of the seventy-seven objects listed in the ledgers, which Gould sold at twenty-eight different prices, only two surviving cases of drawers have been attributed to the shop: a bombé chest-on-chest (cat. 3) and a block-front chest-on-chest (cat. 4). Fortunately, there are clues that indicate their possible original owners. Their prices of £17..6..8 and £18..13..4, respectively, defined the "case of drawers" as a chest-on-chest for eleven other entries, leaving sixty-four "cases of drawers" undefined as to type, although it was possible to determine the wood most likely used in 85 percent of the entries. Efforts to assess the specific form of those "cases of drawers" involved an evaluation of three principal factors: identification of the wood, consideration as to whether a chamber table was sold with the case of drawers, and the statistical significance of the price.

Unfortunately, the specific type of case of drawers can be reasonably inferred from the ledgers on only one other occasion in addition to the listings for the two surviving examples. An April 15, 1765, order for Joseph Southwick lists "1 case of draws with steps," which indicates a flat-top high chest, fitted with "steps" (shelves mounted on the top of the upper case designed for the display of small articles).[1] Southwick was a tanner of modest means and purchased this high chest as the sole piece of furniture for his daughter's marriage to shoreman Jeremiah Hacker (1725–1781). Another particularly important entry was made in October 1767 documenting the sale to John Appleton of "1 case of draw of mahogany sweld ends" (fig. 1). The term "swelled" describes multiple curved shapes in eighteenth-century account books and estate inventories, including the block-front, bombé, serpentine, or oxbow shape. However, "swelled *ends*" could refer only to the bombé form. Appleton's price of £17..6..8 was the exact price charged to five other customers, thus identifying their very expensive purchases also as bombé chest-on-chests.[2] Confirmation of this analysis was the discovery of the date "1773"

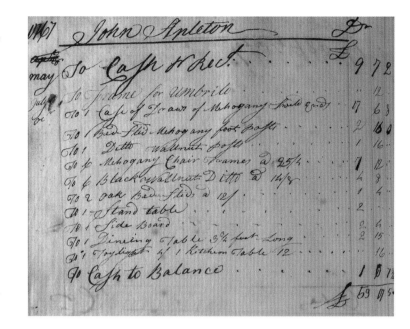

in cat. 4. Only one of the five cases of drawers built that year could account for a price of £18..13..4, which was the cost of the block-front chest-on-chest shown.

Walnut case pieces were generally priced at 70 percent of a comparable mahogany piece.[3] Maple or cherry items were generally 50 percent less than those made of mahogany. Objects of the same wood therefore tended to be clustered in groups in a price list. The ledgers specifically identify the wood used for seventeen cases of drawers. An unidentified object priced exactly the same as one with a specified wood is assumed to have been the same form, made of the same material, and with identical embellishment. Thus, the wood identified on seventeen objects confirmed the wood on twenty-seven additional cases of drawers. A review of customer inventories disclosed the wood for three more objects, which led to identifying the material used for an additional three case pieces with identical prices.[4]

Many of Gould's cases of drawers would be known today as high chests of drawers. These consist of a top section of drawers, mounted on a lower section also containing drawers and supported by cabriole legs. Several design and ornament options were offered to the customer. The most significant impact on cost was the choice of a flat or bonnet top. A flat-top surface could be equipped with steps. The feet could be a plain pad or carved ball-and-claw. The type of brass hardware also affected the price, as would special carving for the drawer fronts or legs. The second major subgroup or classification of Gould's cases of drawers are known today as chest-on-chests. The options available for high chests applied to this group as well.

Using these parameters, a price between £4 and £4..16..0 probably indicated a walnut flat-top high chest. Walnut cases of drawers priced at £7..6..8 accounted for eleven sales, or 14 percent of the total. Two of the sales were coupled with chamber tables, indicating that these were high chests rather than chest-on-chests.[5] Priced £3 above the flat-top high chest, their higher cost indicates a bonnet-top high chest, which required more material and labor. In addition, three mahogany chamber tables are documented as being sold with mahogany cases of drawers priced at £10 and £10..13..4, which in all probability were mahogany bonnet-top high chests.[6]

These imposing double-case pieces were among the most ambitious and impressive objects produced in Gould's shop. High chests, although very costly, were a most desirable furniture item, particularly for wedding gifts (two-thirds of the wedding orders included one). They were used for storage of valuable textiles in the bedroom, where their many drawers provided organized space and gave protection from light, insects, and dust. More affluent families often ordered a chamber table or chest of drawers to accompany the case of drawers, providing additional storage and serving as a dressing table for the lady of the house. Two of Essex County's wealthiest families ordered dual chest-on-chests, one mahogany and one walnut, to celebrate the union of prominent families: Rebecca Orne received hers on her marriage to Joseph Cabot Jr. in 1768, and Mary Lee (1753–1819), daughter of Jeremiah Lee Esq., when she married Nathaniel Tracy of Newburyport in 1775. Lee also ordered a pair for his eldest son, Joseph Esq., when Joseph married in 1772.

An analysis of all cases of drawers in chronological sequence, including the wood used, price, year made, and estimated form, illustrates several dramatic changes in customer preference. Delivery of bombé chest-on-chests ceased in 1768, about fifteen years after they were introduced, although they continued to be made in Boston. Clark Gayton Pickman's order of 1770 marks the introduction by Gould in Salem of the block-front design for this type of furniture. The demise of mahogany bonnet- and flat-top high chests appears to have occurred at the same time. This change in style for large case pieces was embraced by Gould's wealthiest customers, who were assumed to be more fashion-conscious clients, whereas the walnut high chest remained popular among less affluent tradesmen.[7]

Construction

Because no high chests are known that can be attributed to Gould today, this discussion is based on an analysis of the bonnet-top chest-on-chest form. Given the consistency of craftsmanship normally encountered in the shop's output, it can be inferred that both forms were made in roughly the same manner.

FIG 2
Detail of cat. 3 showing indentation of rear
bonnet section

FIG 3
Detail of cat. 4 interior showing bonnet
construction

LOWER CASE

All full-width drawers and base elements followed Gould's standard characteristics. The top of the lower case was made of pine, approximately 3/4 inches thick and dovetailed to the sides. Strips of molding using a concave curve, filet, and convex curve are nailed at the front and sides of the case, concealing the exposed dovetail of the pine top and acting as a locator for the upper case. Feet and knee blocks are mounted directly to the case bottom. Drawer dividers consist of a half-inch mahogany strip glued to a pine board, generally 2 1/2 to 3 inches in depth, and are dovetailed to the case sides with an exposed joint.

UPPER CASE

The 11/16-inch pine bottom is dovetailed to the case sides with pins exposed on the bottom board. The upper case drawers followed Gould's standard construction practice, but the joint attaching the drawer dividers to the case sides is covered by fluted pilasters capped by a bolection block. The swan's-neck pediment is topped by a complex ogee molding that traces the pediment profile. The same molding caps both sides of the upper case. Due to the pilaster width, upper case drawers are narrower than those in the lower case. Drawer slides are tenoned into the top drawer divider at the front and nailed to the

case sides at the rear. A full-depth dustboard supports the top tier of three small drawers. The drawers are restrained from lateral movement by small strips running front to rear and are nailed to the dustboard. Drawer stops consisting of small blocks are glued to the top surface of the drawer dividers. Thin pine slats cover the bonnet-top opening and are nailed to front, side, and rear boards with small rosehead nails. The pine backboards are lap jointed between boards and nailed in a rabbet on the 3/4-inch thick mahogany sides. The top backboard extends to the top of the bonnet and effectively covers the opening at the rear. This extension of the backboard is a Salem characteristic that differentiates this furniture from bonnet-top case pieces made in Ipswich and Boston, where the backboard is open at the top. Both chest-on-chests have backboards cut at the rear for clearance with a room crown molding when installed (fig. 2). The tympanum or sounding board has openings for the top tier of drawers capped by a plinth supporting the center finial. The plinth is flanked by two circular openings. Small pinwheel-carved volutes are appended from the top of the tympanum board. The bonnet is structurally supported at the top by one horizontal and two vertical boards surrounding the opening—a method of support called a "hanging box construction" (fig. 3), which was not a typical Salem practice, but reflects Gould's training in Boston.

Page (Danvers brickmaker), 1775. The last one was sold to John Lee Esq. as part of his daughter's dowry in 1777. Three block-front chest-on-chests were delivered to customers who ordered bombé-shaped chest of drawers: Dr. William Paine, 1773; William Vans, 1775; and Edward Allen ordered a chest-on-chest in January 1774, after ordering a bombé chest of drawers in November 1773.

1. In the ledger entry, "steps" refers to shelves constructed on top of the high chest. This was not possible on forms using the bonnet top and the price was too low for the piece to have been a chest-on-chest. The shelves were used to display small objects.

2. These two transactions could not have been high chests with legs, which never use the bombé form. Chests of drawers of the bombé shape accounted for objects now known as four-drawer chests and were priced at £6. Only a chest-on-chest could account for a price almost triple that of the chest of drawers.

3. For a comparison of the prices of mahogany and walnut, see Chests of Drawers, pp. 96–97..

4. The Jacob Fowle Inventory, taken January 27, 1779, Massachusetts Probate Records of Essex County (hereafter PREC), 10026, vol. 353, pp. 371–73 lists the case of drawers he purchased in April 1763 for £10 as mahogany. The Josiah Orne Inventory (see PREC 20086, vol. 360, pp. 486–90) lists a mahogany case of drawers, which is assumed to be the item sold to him November 5, 1767, for £10..13..4. This assumption was confirmed by a case of drawers sold to John Crowninshield for his daughter Elizabeth's marriage to Elias Hasket Derby on May 7, 1761, for the identical amount. In a memorandum of Elias Hasket Derby of household furniture given to her by her father, the case of drawers is listed as mahogany (Elias Hasket Derby legal documents, MSS37, box 18, folder 9, Phillips Library, Peabody Essex Museum). All three cases of drawers were sold with chamber tables.

5. No chest-on-chests were documented as being sold with an accompanying chamber table.

6. The test of reasonableness was made by comparing prices of walnut bonnet-top high chests (£7..6..8) to assumed mahogany equivalents (£10). Walnut high chests were 73 percent of the corresponding mahogany pieces, putting them in line with other forms tested.

7. Bonnet-top high chests of walnut sold after 1770 were to tradesmen Benjamin Coates (cordwainer and stagecoach operator), 1770; Jonathan P. Saunders (surveyor and town clerk), 1771; Edmund Whitemore Jr. (joiner), and Jonathan Ireland (Charlestown blacksmith), 1774; Jeremiah

Chest-on-Chest

1761–68

Attributed to the shop of Nathaniel Gould

Dense mahogany; secondary wood: eastern white pine

H 94 ½; W 43 ¾; D 23 ¼; bonnet-top clearance for crown molding when installed: top cutout 13 ⅜ (horizontal), ¾ (vertical); second cutout: 3 (horizontal), 3 ⅜ (vertical from top of bonnet)

Inscribed on top of top pine board of lower case in chalk: *Salem*

Nelson-Atkins Museum of Art, Kansas City, Missouri, William Rockhill Nelson Trust (34.123)

PROVENANCE: Dr. Gideon L. Soule (1796–1879); his son Judge Augustus L. Soule (1827–1887);[1] (Flayderman sale, auctioneer Frederic H. Wandell, lot 580, January 27, 1934); (Ginsburg & Levy); Nelson-Atkins Museum of Art, 1934

This chest is one of only six objects sold by Gould at a price of £17..6..8. Two clues provide an indication as to the probable first purchaser. The chalk inscription "Salem" is unusual and not seen on any other Gould work. It might be an indication that this piece was shipped elsewhere. The second clue is provided by the provenance: the earliest documented owner, Dr. Gideon Soule (1796–1879), was born and worked in Exeter, New Hampshire, not far from Portsmouth.[1]

Armed with these facts, speculation about the original owner suggests that the client was probably Mark Hunking Wentworth of Portsmouth, a wealthy member of a prominent local family and the father of John Wentworth (1737–1820), New Hampshire's last Royal Governor. Mark Hunking Wentworth purchased a chest-on-chest on November 22, 1764, for the wedding of his daughter Anna (1746–1813) to Captain John Fisher Esq.[2] Fisher was a naval officer and customs collector for the ports of Portsmouth and Salem. As hostilities began that would lead up to the revolution, Fisher was forced to abandon his posts for England in late 1775. He was declared an enemy of the United States, his property was confiscated, and his wife's inheritance forfeited. An inventory of his personal possessions, which were probably sold at auction on October 24, 1778, included a case of drawers—possibly this chest—that was the second most valuable piece of furniture in the account.[3]

Case pieces this large generally were not shipped great distances. It is possible that the Wentworth/Fisher family's chest-on-chest traveled after the sale only as far as Exeter, twenty miles from Portsmouth, where it was later owned by the Soule family.

This chest-on-chest exhibits a few exceptions to Gould's standard construction practices. The backs of drawers are not numbered in chalk, and a mixture of rosehead and hand-forged sprig finishing nails are used throughout. Pin locations face the rear of the lower case on the bottom three drawers. Although the finials are not original, their configuration can be taken from the carved pinwheel volutes. The curvature of the pinwheel blades is opposite one another, whereas on cat. 4, they curve in the same direction. This is not inconsistent carving, but an example of Gould's attention to detail in balancing the symmetry of his major work: the opposing volute blades indicate the type and carving of the finials. The center finial would have been a ball and steeple, but corkscrew finials with opposing threads would have been mounted at the sides.[4]

1. As per the genealogy accompanying the chest when it was sold at the Flayderman sale on January 27, 1934.

2. Anna Wentworth and Captain John Fisher were married on June 10, 1763. The case of drawers was not delivered until November 22, 1764, upon completion of the house her father had purchased for them.

3. For Fisher's travels and Loyalist claims, see Fisher 1783–90, vol. 2, pp. 549–655, n.d.

4. Gould was following the practice of Salem's most prominent earlier cabinetmaker, Abraham Watson. Carved volutes with opposing blades are appended to the tympanum board of a high chest in the Huntington Museum, San Marino, California, that retains its original opposing thread side finials and ball-and-steeple center finial.

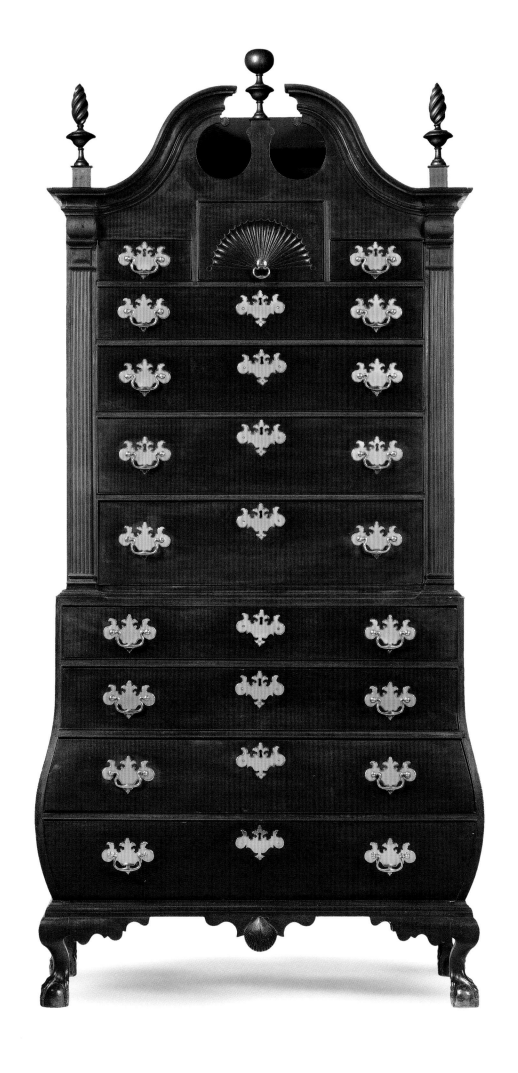

Chest-on-Chest

1773

Attributed to the shop of Nathaniel Gould

Dense and medium grade mahogany; secondary wood: eastern white pine

H 93 ³/₈; W 44 ⁷/₈; D 23 ½; bonnet-top clearance for crown molding when installed: top cutout 10 (horizontal), ¾ (vertical); second cutout 3 (horizontal), 4 ½ (vertical from top of bonnet)

Inscribed on upper case in chalk: top tier short drawers: *xR* and *xL*; top tier center drawer: *xJ*; long drawers from top to bottom: *x 5 x, x 6 x, x 7 x, x 8 x*; on inside of lower board of upper case in ink: *1773*. Inscribed on lower case drawers from top to bottom in chalk: *x 4 x, x 5 x, x 6 x, x 7 x*

Private Collection

PROVENANCE: Carolyn Clendenin Ryan Foulke; gift to Stratford Hall Plantation, 1982; (Christie's, New York, "Important American Furniture, Folk Art and Prints," sale no. 1387, October 8, 2004, lot 41); present owners

A magnificent, rare survivor of the tumultuous period of the American Revolution, this chest-on-chest is also the only known survivor of the block-front form of "case of drawers" from the Gould shop. Probably purchased originally by Dr. William Paine of Worcester, it is the third of seven delivered. It is ironic that four of the seven were sold to clients outside Salem, but it is indicative of Gould's significant reputation.

This particular case piece is the only known example from the Gould shop with a complete date: the barely legible inscription "1773" (fig. 1).[1] This likely pinpoints the year it was purchased by Paine, just two weeks after his marriage to Lois Orne (1756–1822). Gould sold only one expensive chest-on-chest that year. At the time of his marriage, Paine was studying medicine under Dr. Edward Augustus Holyoke of Salem, but Paine was a staunch Loyalist and, with his wife, went to England in 1774 for further study. Subsequently, he was appointed apothecary and surgeon for the British forces in North America. These actions resulted in his assets in Worcester being condemned and sold at auction in 1779.[2] His father's family purchased many of his most cherished possessions, but it is uncertain whether the case of drawers was included. Many of Paine's personal effects were auctioned in 1893, sixty years after his death, at which time the chest-on-chest may have left the family.

Although its construction closely follows the bombé chest-on-chest (cat. 3), there are notable differences. The grain direction of all four bottom drawer boards in the lower case is perpendicular, rather than parallel, to the front—a variation of Gould's usual practice. This probably indicates that Paine, intending to use the drawers for especially heavy loads, may have requested this stronger method of construction, which reduces any deflection of the bottom board.

When the chest was sold at auction in 2004, the catalogue stated: "long drawer facings of upper case replaced." The top tier of small drawers in the upper case had mahogany drawer fronts from the same grain pattern as the lower case drawers, but the long drawers were of a different grade of mahogany. The tool marks, dovetailing, and construction indicate, however, that the upper case drawer fronts are original. Perhaps there simply was not enough select mahogany available to make all the drawer fronts from the same flitch of wood.

The most important facet of construction and condition is the survival of all three original finials. Each has a right-hand threaded corkscrew, but the center finial is significantly larger than the two flanking it (fig. 2). The visual impact is dramatic—the eye is drawn to the curve of the swan's-neck pediment above and the finely carved fan drawer immediately below (fig. 3). The carved pinwheel volutes at the top of the aperture opening incorporate both fan blades with clockwise rotation, as opposed to the bombé example with opposite pinwheel rotation (one clockwise, one counter-clockwise). This was likely no accident, but an indication of the use of three corkscrew finials with right threads

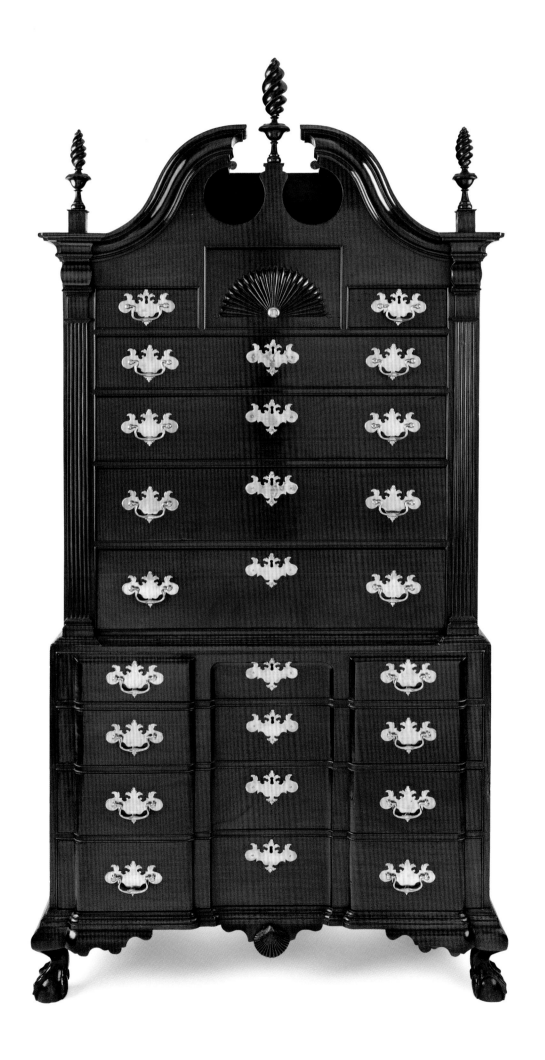

FIG 1
Detail of cat. 4 showing date inscription

FIG 2
Cat. 4 finials

(see cat. 3). The center top drawer is skillfully carved in the usual Gould manner: a radiating fan ending with a thumbnail gouge cut. Here, as on many of Gould's case pieces, a circle cut at the ends of the fan whimsically suggests that the fan has a mustache (fig. 4). It is not seen on any other cabinetmaker's work and, although not always present, appears to be a hallmark of Gould.

1. With appreciation to Robert Mussey and the staff at Robert Mussey Associates for sharing this discovery.

2. For the advertisement of Paine's condemned assets, see *Massachusetts Spy* (Worcester) 9, 419 (May 13, 1779), p. 4: "A LARGE and Genteel assortment Of household furniture, amongst which …, a number of the best … chests of Drawers …" (see Brides, Housewives, and Hostesses, fig. 20). For a detailed history of Paine's life, see Shipton and Sibley 1975, p. 68.

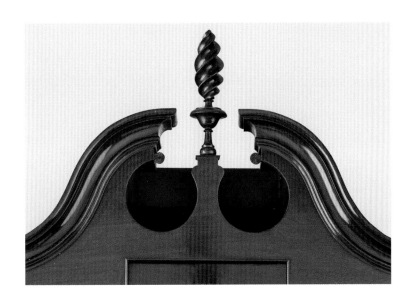

FIG 3
Detail of cat. 4 showing bonnet, carved volutes, and large center finial

FIG 4
Detail of cat. 4 showing fan carving on top center drawer

Desks and Desk-and-Bookcases

If one type of case furniture could define Nathaniel Gould's legacy, it would be the desk and its illustrious, larger cousin, the desk-and-bookcase. Introduced in Boston about 1720, the desk, with its small compartments in the upper portion and three or four large drawers below the writing surface, remained largely unchanged until the end of the eighteenth century, reaching its highest development in the bombé and block-front designs popular during Gould's working dates. The addition of an upper case containing shelves and compartments for ledgers and books, pigeonholes for papers, and other compartments, created the tall, stately desk-and-bookcase, one of the signature forms of eighteenth-century American cabinetmaking.[1]

A desk was a necessity for anyone in business. In colonial Salem's barter economy, invoices and ledgers had to be meticulously maintained and safely stored. Accounts were often not settled for years, and frequently had to be reconciled by court-appointed lawyers after the death of an individual. Travel and communication were uncertain during this period, so multiple copies of correspondence were sent to overseas factors. The tightly composed spaces in desks and desk-and-bookcases helped businessmen keep their affairs organized and accessible.

Whereas other types of furniture were usually ordered in only one or two woods, desks were selected in maple, cherry, walnut, cedar, and mahogany, depending on the customer's financial circumstances or the desk's destination.[2] A significant portion of Gould's wealth came from the sale of desks, especially cedar desks, for export. Those export sales in turn established relationships with many of Salem's merchants and shipowners, providing him with ready access to marketable goods and mahogany of superior grade. For these merchants, the most conspicuous sign of their wealth and success in business was a desk-and-bookcase. By the early 1760s, Gould had become Salem's preeminent supplier of these imposing and stylish objects.

Desks for Domestic Sale

Gould sold approximately 110 desks to the domestic market; twenty were to customers whose only purchase from him was a single desk. As confirmation of Gould's reputation, sixteen desks were delivered outside Salem, to customers in Newburyport, Boston, Middleton,

Kingston, Reading, and towns in the more immediate vicinity such as Danvers, Lynn, Marblehead, and Beverly. Many of these clients chose to incur additional transportation costs, despite having perfectly capable cabinetmakers in their own town. The price Gould charged for walnut, maple, and cherry desks evidently allowed sufficient margin for wholesalers to resell at a profit, accounting for an additional eleven sales.[3] Unlike other types of furniture that were closely tied to weddings, fewer than 11 percent of desk sales were included with wedding orders. However, 40 percent of the desk-and-bookcases sales were made as part of a dowry.

Gould's desks for domestic consumption fall into three major categories: straight or flat-front desks made of maple, cherry, walnut, and mahogany with bracket feet and a basic interior design; bombé-shaped mahogany desks usually with ball-and-claw feet and a complex interior; block-front mahogany desks with ball-and-claw feet, a complex interior, and blocked lid.

Gould's ledgers state or imply the wood used in 94 percent of the domestic desks. The least expensive were twelve maple desks invoiced between £2 and £3..13..4. Typical customers included Danvers cabinetmaker Thomas Giles, yeoman (farmer) Archelaus McIntire of Reading, and sailmaker Benjamin Beckford Jr.

Reflecting a step-up in price and accounting for nearly the same number of sales were the thirteen cherry desks priced between £3..9..4 and £4. It appears that cherry was not particularly popular in Salem, as the majority were shipped outside the town or sold to merchant/traders.[4]

Walnut was the choice for desks and many other furniture forms for Salem's middle class, although the least expensive walnut desks overlapped the most expensive cherry prices. Prices range from £3..14..8 to £5, with two models priced at £4 and £4..13..4 accounting for two-thirds of the total production of twenty-one.[5] Customers who ordered walnut desks included silversmith William Northey, chairmaker John Larkin, fisherman Edmund Beckford, and baker Billings Bradish. Seventeen walnut desks were sold between 1758 and 1769, whereas only four could be documented between 1770 and 1781, reflecting the decline of walnut in favor of mahogany, even for those of relatively modest means.

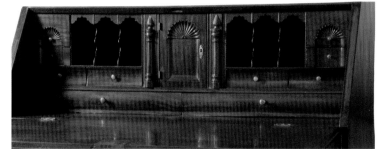

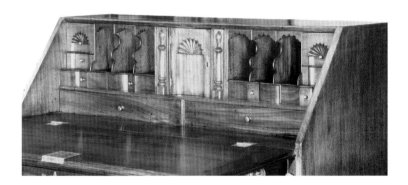

The majority of domestic desks sold were made of mahogany and covered all three major categories of design. Analysis of Gould's ledgers reveals that the flat-front desk priced at £7..6..8 accounted for 20 percent of Gould's total mahogany production and was his most popular model (excluding desks for export). The three attributable survivors are this model.

The surviving desks and desk-and-bookcases attributed to Gould suggest that he used a standard template for the interior elements. Four tiers of drawers were incorporated, with the top row containing drawers with carved fans. On the flat-front model, priced at £7..6..8, only one central drawer is located in this row and there is no prospect door. The second row also contains only one drawer, which in the three survivors was blocked. The single drawers of the first and second tier are flanked by removable document slides, which in turn are flanked by four letter openings (fig. 1). The third row contains five drawers. On

the plain mahogany desk, these drawers had a plain flat-front, but on the other three mahogany examples they are blocked and serpentine in shape. The bottom fourth row contains two wide drawers meeting at the middle of the desk. Typical customers were ship's master Ichabod Nichols, who purchased a desk around the time of his wedding, fisherman David Beckford Jr., mariner Captain Crispus Brewer, and housewright James Andrews.

Connecting a surviving bombé chest-on-chest (cat. 3) and a block-front (cat. 4) to the original purchasers defined the relationship of prices paid for the two forms: the block-front was more costly.[6] Analysis of the two upscale designs for desks confirmed that relationship. There appear to be three prices charged for bombé desks and only five were sold, the last one in 1768, the same year the last bombé case of drawers was delivered. Three of the five are known to survive—the highest percentage of any Gould case piece—and they offer a good example of the options available to a customer. The example at the Museum of Fine Arts, Boston (fig. 2), is the only highly priced desk to use the central drop design of the less expensive walnut and mahogany examples. Its unusual document-slide facing resembles a belaying pin, indicating its original owner may have been a mariner. Unlike other bombé and all the block-front desks, the third and fourth tier drawers also follow the inexpensive mahogany design.[7] The most expensive surviving bombé desk is in the collection of the Philadelphia Museum of Art (fig. 3). Its document slides use gilded and carved flame finials and the third and fourth tiers of drawers are concave and convex in front shaping, echoing the curvature in the bombé sides. The interior of the third survivor is unique and would have been the least expensive.[8] Its third tier of drawers consists of three blocked and two flat drawers rather than five blocked and serpentine drawers. The fourth tier uses two flat-faced drawers. A blocked and fan carved prospect door was standard on the bombé desk and opened to reveal three blocked doors.

The slightly more expensive block-front desk was the successor to the bombé. All appear to be made of mahogany and were priced between £10 and £12. By far the most popular was the £10 version first introduced by Gould in 1761. Nine sales of this model and five of more expensive options were made prior to 1777.[9] Based on their interior design and external features, possibly as many as eight Gould block-front desks have survived.[10] Their design elements also occur on the three surviving block-front desk-and-bookcases. The top two tiers of drawers are identical to those on the earlier bombé desks. Third tier drawers are blocked and serpentine on all examples. Additional expense was added for the fourth tier, however, as every one of these desks used three blocked and serpentine drawers. Whereas bombé desks were designed with a fan carved blocked prospect door, the block-front used a tombstone design (fig. 4).

Both these beautiful and expensive desk styles were functional status symbols, as desirable then as they are today. They were particularly sought after by three professions: master mariner/ship captains, merchants, and doctors. Together, they accounted for 79 percent (19 of 24 of identifiable bombé and block-front desks produced.[11]

Two desks deserve special mention. One has been suggested as possibly the product of Salem cabinetmaker William King (b. 1761), based on the fluted carving of its knees and returns, but close examination resulted in definitive attribution to the Gould shop.[12] In addition to the optional knee carving, the customer added the additional expense of cedar—rather than pine-lined drawers. It was probably one of the two desks priced at £10..6..8 or £10..13..4. The second desk appears to share trademarks of the Gould shop (fig. 5), but the lid blocking is rounded at the top corner rather than squared. The two interior drawers of the third tier flanking the prospect door follow the standard profile of Boston cabinetmakers and are not indicative of Salem practice (fig. 6). The main case drawer bottoms have grain perpendicular to the front—the usual Boston practice. While it may have been sold by Gould, it was probably fabricated by a Boston cabinetmaker.[13]

Two inexpensive options were offered on desks: a flat center drop with two volutes topped by a pierced diamond cutout (see Case Furniture Construction, fig. 7), or a more expensive scallop shell; one could also opt for straight bracket feet or ball-and-claw feet. Other distinctive characteristics include desk lopers made from solid primary wood and equipped with a peg inserted on the inside surface behind a scribed locating line that acts as a stop; the top drawer of bombé and block-front desks overlaps the divider between the drawer and the loper, exposing only a thin bead on the external surface (fig. 7); valance headers for the letter compartments are of thick (3/8 to 1/2 inch) primary wood and glued in place without small glue blocks; small notches cut on the inside top surface of the header are used as numbers for position identification (fig. 8);[14] original prospect doors are carved from solid mahogany; large clock-style brass hinges are mortised into the back of the door (fig. 9); document slides are designed with a variety of facings, with the dolphin head the earliest; pine sides are glued and tenoned to the front block and glued to the base and rear blocks (fig. 10); no nails are used on document slides; brass or steel locks are mortised to the lid and contain two to four tumblers; when any case piece was designed with external blocking, the top corners are squared.

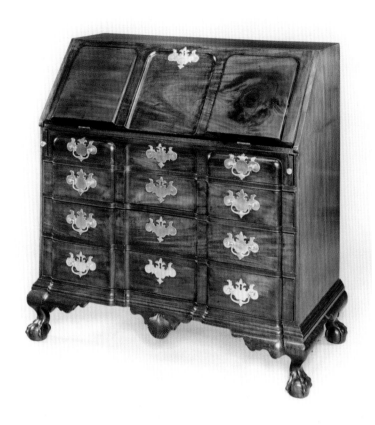

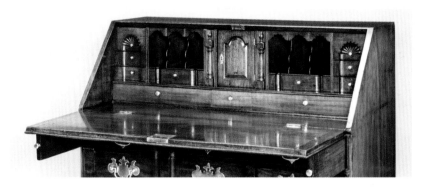

FIG 5
School of Nathaniel Gould
Desk, 1761–82
Massachusetts
Mahogany and white pine,
H 43 ¼; W 42; D 20 ½
C. L. Prickett, Yardley, Pennsylvania (88-29)

FIG 6
Detail of fig. 5 showing desk interior

FIG 7
Detail of cat. 8 showing lapping of top
drawer to vertical divider and loper

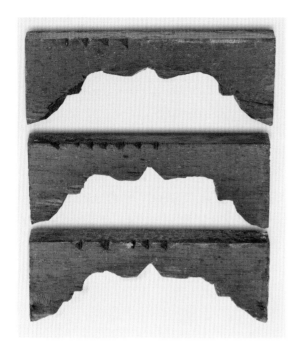

FIG 8
Detail of cat. 5 showing numbering system
on back of desk valances

FIG 9 [TOP RIGHT]
Detail of cat. 8 showing late uncarved
frame on document slide

FIG 10 [BOTTOM RIGHT]
Cat. 5 document slide

Desks for Export

Seventy-four percent of Gould's export business consisted of desks (see Appendix C). The four primary woods used for local consumption were also shipped abroad, although more walnut desks were sold for export than locally, and nearly four times as many cherry and maple desks were exported compared to local sales. Those numbers pale in comparison to shipments of cedar desks: 212 with one model priced at £4..13..4 accounting for almost half the total.[15] Virtually all of Gould's cedar desks were destined for the West Indies. Gould's father-in-law, Thomas Wood of Charlestown, was a principal supplier of cedar desks; thirty-eight sales are documented in the account book (see "Desks took on bord," fig. 3). Boston-area makers employed a number of construction features not used in Salem: gluing drawer bottoms on the interior desk compartment into rabbets of the front, side, and rear drawer boards; making the front profile of the third tier drawers located under valance openings flat with a concave-convex curve shaped at either end; and covering the drawer blade dovetails that attach the blade to the desk sides with a strip of wood, as opposed to Salem's method of leaving the dovetails exposed. The ball-and-claw feet are sculptured with thick claws, and support for the feet deviates from the Salem practice of expending fine workmanship on blocking. Although Gould purchased many desks from outside cabinetmakers, only five other cedar desks are documented as to their maker: one by Gedney King of Salem and four by Gould employees William Holman and Philemon Parker. The shop itself undoubtedly built some cedar desks, particularly during slow business periods, but in all likelihood those desks and the five not built by Wood probably featured Salem construction characteristics.

The price range for any given material was wider than for desks sold locally, indicating broader options. There does not appear to have been any premium charged other than crating costs, as domestic and export prices match on many basic models. Most of the desks did not have ball-and-claw feet and there appears to be a significant charge for this feature.[16] Cedar desks could be ordered with maple ends, with drawers of cedar rather than pine, and it appears that some type of bookcase top, with paneled or glazed doors, could be added. An order for Charles Worthen in January 1770 specified "cherrytre desk with paneled doors" and Nathan Leach ordered a "small Cedar desk with claw feet glass door." The price of £6..13..4 was the highest price charged of any cedar desk and matched that of the large cedar desks equipped with "colt feet." The outbreak of war ruined the export business for Gould and his many suppliers; only two orders were shipped after 1775.

Desk-and-Bookcases

Among Salem's elite, there was no more desirable household furnishing than a desk-and-bookcase. The epitome of this class of furniture in Salem during the eighteenth century in terms of style, workmanship, and selection of wood was achieved in the Nathaniel Gould shop. His product was unparalleled in Massachusetts and rivaled the finest of Newport's Townsend-Goddard cabinetmakers. Gould's patrons were Essex County's wealthiest citizens, including Clark Gayton Pickman, Edward

FIG 11
Detail of cat. 8 showing elongated arches, bookcase doors, and shell

Allen, and Joshua Dodge. An astounding five examples were made for members of the wealthy and increasingly powerful Cabot family.

Although Gould owned the 1762 edition of Thomas Chippendale's *The Gentleman and Cabinet-Maker's Director,* which illustrates six variations of the form, Gould's design for desk-and-bookcases was his own creation and represents the highest level of his art and skill. No furniture from his shop displays the creativity of design, balance of proportions, and quality of wood selection and carving better than the bookcase portion of these masterpieces. They feature fluted pilasters, a bolection molding, and a scallop shell with undulating rays that is tilted forward to better display its superior carving (fig. 11). Carved volutes appended from openings in the bonnet draw attention to the characteristic Salem central finial. The fall lids of the desk-and-bookcases appear to be cut from the same flitch of mahogany (figs. 12 and 13). The striped grain falls in a swag pattern on the lid, which further complements the upper bookcase. Gould's ledgers reveal that this particular mahogany log was cherished, saved for at least eleven years, and used only for his most important commissions.[17]

The interiors of both the desk-and-bookcase portions are masterpieces on their own and in perfect harmony with the design and workmanship of the exterior. Gould produced fifteen desk-and-bookcases.[18] Three were comparably priced to chest-on-chests and are probably not among the four survivors that share the common characteristics.[19] All have tombstone paneled doors with fluted pilasters and two candle slides are pocketed below the doors. Inside the bookcase are two more beautifully executed shell fan carvings surmounting shelves and dividers laid out according to the customer's preference (fig. 14). All four interiors are different, but three share the approach Gould used for designing desk letter openings: an accentuated cupid's bow shape to the valance header and ogee curved compartment dividers. A horizontal row of five drawers is mounted at the base on the three block-front examples.

The bonnet section is constructed in the same manner as outlined for cases of drawers, with a pocket at the rear of the top to facilitate maintaining the optimum clearance of the room's crown molding despite variations in ceiling heights (see Cases of Drawers, fig. 2). Rather than laboriously working out individual proportions for many construction elements, Gould solved the problem by making the top arch of the doors nonconcentric circles and thereby varying the height of the covered doors (see fig. 11).[20]

FIG 12
Detail of cat. 7 showing secretary fall front

FIG 13
Detail of cat. 8 showing secretary fall front

FIG 14
Detail of cat. 8 showing bookcase interior

FIG 15
Detail of cat. 7 showing lid lock

1. For desks and their development, see Ward 1988, pp. 289–350.

2. Ninety percent of stand tables were mahogany and the remainder walnut. From 1756 until 1777, the Gould shop produced 197 drop leaf tables for domestic customers of which only seven (3.5 percent) were made of woods other than walnut or mahogany.

3. The number of desks sold for resale domestically is actually higher but could not be documented. For example, Benjamin Daland, a truck man, purchased two maple desks in 1759, obviously for resale, and a mahogany desk in 1763. Without proof that it was for his personal use, it has been considered as purchased for resale. Similarly, master mariner Stephen Higginson purchased a walnut desk for £4..13..4 in November 1768. The price is much less than the typical purchase, considering his occupation, and it was one of the simplest of walnut desks Gould made; however, no sailing date of Higginson's could be placed in proximity to the purchase, hence it was assumed to be for his personal use (unlikely as it may seem).

4. Jonathan Webb, Jobe Whipple, Daniel Jacobs (2), Moses Yell, and Elijah Osborne, all of Danvers, ordered cherry desks. Desks ordered by George Deblois, Stephen Mascol, and Benjamin Williams were probably for resale. Only two cherry desk sales could be identified with Salem residents: those to harness maker James Bott and coaster Jonathan Webb.

5. Three mahogany examples of straight-front desks share design elements and were probably desks priced at £7..6..8, the only category large enough to have left three survivors. Another mahogany desk is similar in all respects except for the third tier of drawers, which have a flat-front surface instead of the serpentine and blocked tier on the mahogany examples. These with flat third tier drawers would have been less expensive, and were probably priced between £6..13..4 and £7. For illustrations of three mahogany desks attributed to the Gould shop, see Sack 1981, p. 335, no. 834; Skinner, Bolton, Massachusetts, "Americana," 1274, October 27–28, 1989, lot. 334; Northeast Auctions, Manchester, New Hampshire, "Important Americana & Folk Art," November 6–7, 1993, lot 549 and sold again in Skinner, Boston, Massachusetts, "American Furniture & Decorative Arts", 2412, June 8, 2008, lot 35.

6. This statement that the block-front form is more expensive than the bombé design of case furniture is counter to prevailing literature. It was first suggested to the author by museum conservators Chris Storb of the Philadelphia Museum of Art and Mark Anderson of Winterthur, both skilled cabinetmakers with extensive knowledge of eighteenth-century tools and shop practices. They pointed out that block-front design is much more difficult to make than the bombé, because of the difficulty of maintaining the blocked relationship of the drawer fronts and the base molding and possibly the feet. Although the bombé form may use more material (and even that is open for discussion), additional labor costs for the block-front offset any savings. The Gould ledgers and identification of specific sales with surviving examples confirmed that the block-front was more expensive.

7. See Hipkiss 1941, cat. no. 27 (acc. no. 41.574), and supp. ill. 27 for a view of the interior.

8. The desk is shown in an Israel Sack advertisement in *Antiques* 96, 3 (September 1969), inside front cover. Although it is reported to have descended through the Derby family, no connection could be made to any of the five family purchasers. Despite its economical interior, the desk is equipped with more expensive ball-and-claw feet and a scallop shell drop.

9. At least six more block-front desks were made between 1777 and 1782, but inflationary pricing makes it impossible to be more specific as to their wood or design. They are identified as "swell'd" or "swell'd front" or were invoiced at comparable prices to prerevolutionary block-front desks, but the block-front total produced during that period is probably greater. For a history of desks, see Richards and Evans 1997, pp. 409–12.

10. Attributed Gould desks examined by the author include: (1) Sotheby's, New York, "Important American Furniture, Folk Art, Folk Paintings and Silver," 5622, October 24, 1987, lot 525; also in Sack 1957–91, vol. 6, p. 1488, no. P4507, and advertised in *Antiques* 92, 4 (October 1977): inside front cover. (2) G.K.S. Bush advertisement in *Antiques* 138, 1 (July 1990), p. 12; also Cinnamon Hill advertisement in *Antiques* 141, 1 (January 1992), p. 52; also Northeast Auctions, Portsmouth, New Hampshire, "Important Americana and Folk Art," April 17, 1994, lot 628. (3) Northeast Auctions, Portsmouth, New Hampshire, "New Hampshire Auction", August 1–3, 2003, lot 797. (4) Walton advertisement in *Antiques* 77, 2 (August 1985), p. 156; also C. L. Prickett advertisement in *Antiques* 134, 1 (July 1988), p. 19. (5) Sack 1957–91, vol. 2, p. 393, no. 990, and advertised in *Antiques* 91, 2 (February 1967), inside front cover. Examples possibly by Gould but not personally

examined include: (6) Sack advertisement in *Antiques* 55, 6 (June 1949), p. 399. (7) Baumstone advertisement in *Antiques* 115, 3 (March 1979), p. 399. (8) Ginsburg advertisement in *Antiques* 3, 5 (May 1977), p. 845.

11. Desks sold to master mariners/ship captains with their probable shape include Samuel William (bombé), 1759; Thomas Aden (block-front), 1761; Jonathan Mason (block-front), 1764; James Grant (bombé), 1764; Henry Williams (block-front), 1766; Captain John Archer Jr. (block-front), 1767; naval officer Samuel Ward (bombé), 1768; Joseph Skilling (block-front), 1768; Israel Dodge (block-front), 1770; Joseph Lee (block-front), 1771; Samuel Grant (block-front), 1771; John Donaldson (assumed block-front), 1780. Merchants include William West (bombé), 1759; John Gooll (block-front), 1772; Colonel John Hathorne (block-front), 1772; Mary Hathorne (block-front), 1773. Doctors include William Paine (block-front), 1773; William Goodhue (block-front), 1777; Edward Barnard (assumed block-front), 1781.

12. The desk, in a private collection, incorporates all the standard Gould interior and case construction elements. Its extremely dense mahogany is typical of most of Gould's most expensive production. William King Jr. was active after the American Revolution and had no business with Gould. The reference to a possible King attribution was made in Sack 1957–91, vol. 6, p. 1488, no. P4507.

13. Gould purchased nine mahogany desks from suppliers. Most of these could be connected to export shipments, but none could be tied directly to this desk, which probably came from a Boston-trained cabinetmaker working in the Gould shop, perhaps during 1777–82 when shop turnover was high.

14. Only one desk was observed that retained small glue blocks behind the valance header. Without glue blocks, valance headers frequently became dislodged. Glue blocks could have been added at a later date. When the number of letter openings exceeded six, Gould sometimes used Roman numerals to mark positions seven and eight.

15. Twenty-five walnut desks were exported, versus twenty-one sold locally; fifty-four cherry exports versus thirteen; forty-six maple exports versus thirteen; and twenty-two mahogany exports versus a minimum of fifty-eight local sales. Export shipments are well documented as to material and price, because this business was concluded prior to the revolution, whereas desks sold in Salem continued during the war, but with inconsistent pricing and a lack of identification during the last years of the shop's production. Eight exports could not be identified as to material. Total export sales of desks were 361.

16. The most common cedar model was priced at £4..13..4 and is frequently described as a "large" cedar desk. The first entry for a "large Cedar desk with colt claw feet" was placed by Josiah Bachelder Jr. in February 1773, when he paid £6..13..4. The price is exactly £2 higher or 10s per foot additional cost versus a routine charge for ball-and-claw feet sold domestically of 4s per foot. It appears that the premium for providing all cedar drawers was £1..6..8.

17. The two desk lids cut from the flitch were for the Francis and Joseph Cabot desk-and-bookcase made in 1765 and the desk-and-bookcase sold to Jeremiah Lee Esq. in 1775.

18. Thomas Mason, Richard Routh, and Peletiah Webster ordered desk-and-bookcases priced between £13..6..8 and £17..6..8, less than 75 percent of the cost of the remaining orders, and thus considered to be of less expensive wood or much simpler design. In addition, one order from Samuel Waters for half a desk-and-bookcase might have indicated the purchase of only the bookcase, which was being added to an existing desk. The desk-and-bookcase ordered by Benjamin Goodhue Jr. is not priced in the ledger.

19. For the third desk, in the Dallas Museum of Art, see Venable 1989, pp. 58–63. For the fourth, in the Mead Art Museum, University of Massachusetts at Amherst, see Shepard 1978, p. 245. The Dallas and Mead examples have undergone restoration.

20. Robert Mussey noted this characteristic in Gould's desk-and-bookcases, and kindly shared his observation with the authors.

Desk

1756–65

Attributed to the shop of Nathaniel Gould

True mahogany group (*Swietenia* spp.); secondary wood: eastern white pine

H 42 ¼; W 41 ¼; D 21 ¾

Inscribed on outside back of top tier drawer in chalk: *X*; on outside back of second tier drawer in chalk: *X2*; on outside back of third tier drawers in chalk, left to right: *1X, X2, X, X4, X5*; on outside back of fourth tier drawers in chalk: *X1, X2*; on outside left surface at bottom rear of proper left hand document slide in pencil: *Samuel Gyle[s], Danvers*; on outside rear board of all main case drawers in chalk, top to bottom: *B3, B4, B5, B6*; on outside bottom board in chalk: *B*

Collection of Kevin and Janet Twomey

PROVENANCE: By descent in the family of Mrs. Beatrice Gibbs, Guilford, New Hampshire; (antiques dealers Edward and Donna Lanigan, Rome, New York, 1993); the present owners, 1993.

This straight-front mahogany desk is classic Gould construction in all aspects. It is a very early, if not the earliest, example of Gould furniture to survive. The dolphin-head carving of the document slides, for example, indicates his early manner. The desk also incorporates all the features of his most economical model except for the choice of wood. It has straight bracket feet rather than the more expensive ball-and-claw foot, the center drop ornament lacks the carved scallop shell, and the interior is functional but has no interior embellishments except the fan carved center drawer. The desk was probably sold in the lower price range for mahogany desks, between £5..6..8 and £6.

The signature "Samuel Gyle[s], Danvers" (fig. 1) has been a perplexing problem. The Salem cabinetmaker Samuel Gyles would seem to be a logical choice to have signed the desk either as an employee or a customer of Gould. However, no sale of a desk to him is recorded in the Gould ledgers. Gould did, however, purchase two maple desks from his son, Thomas Giles, also a cabinetmaker, in 1759, shortly after Gould settled in Salem, and he sold maple to Samuel the same year. Both transactions established an early business relationship with the family. They also had a personal relationship as the Gyles family and Gould's parents lived in close proximity in Danvers and belonged to the same church.[1]

This desk was probably produced in a fairly narrow time period, between 1754, the date Samuel Gyles moved from Salem to Danvers,

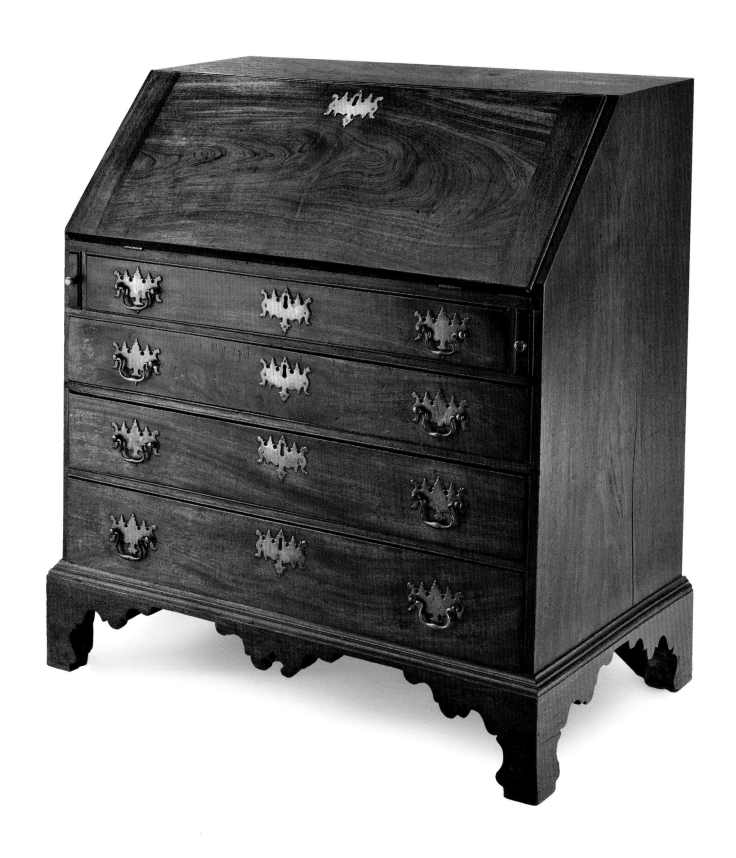

FIG 1
Detail of cat. 5 showing signature of
Samuel Gyle(s) and Danvers

FIG 2
Detail of cat. 5 showing original drawer
brasses

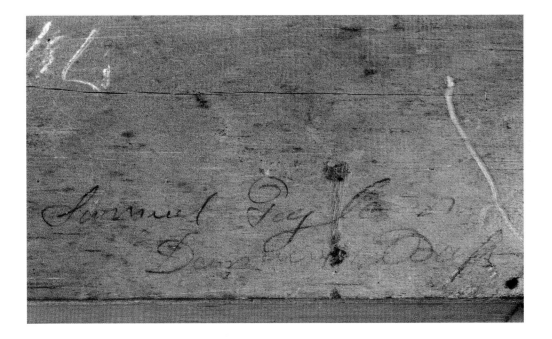

and 1758, the date of the first transactions in the Gould day book. It shows all the classic Gould characteristics of his early construction, from drawer numbering, fine attention to detail and finishing of the base, solid mahogany valance headers, interior layout of drawers in the desk section, solid mahogany lopers and drawer dividers, to case and large drawer construction.

But the question as to how, and under what circumstances, this prime example of Gould's handiwork of a less expensive furniture piece received Samuel Gyles's signature shall remain a mystery for the time being.

This desk is in outstanding original condition, the best of any Gould case piece examined. The pine tree brasses for the large drawers are original (fig. 2), which is particularly surprising inasmuch as the threaded posts were never equipped with nuts. The drawer slides have never been repositioned, and the desk lid hinges and pulls of the interior drawers are also original. The only repairs are to a short section of the lipped edge of the desk lid and one volute of the center drop. It serves as an excellent base object for the study of all of Gould's subsequent case furniture.

1. Vincent, J. A. 1864. For Samuel Gyles, see pp. 16–20; Another possible owner was Samuel Giles, see pp. 55–62, son of Thomas. He joined the Continental Army in 1775, served for five years, and moved to Vermont after the war. Too young to have purchased the desk earlier, his name in all records is spelled Giles as opposed to Gyles for his grandfather. No record could be found of the younger Samuel residing in Danvers as an adult. For a list of church members, see Massachusetts Archives Collections (1629–1799), vol. 2, p. 337. Sometime in the late eighteenth century, the family changed the spelling of their name from Gyles to Giles.

Desk

1770–81

Attributed to the shop of Nathaniel Gould

Dense mahogany; secondary wood: eastern white pine

H 43 ¾; W 41 ¾; D 21 ½

Inscribed on the interior of the rear boards of the first tier drawers in chalk, proper right: *I*; middle and proper left: large looping *R*; rear boards of the second tier drawers in chalk, middle: illegible marks; rear boards of the third tier drawers in chalk, proper right: *X*; second drawer from right in chalk: *X2* and calculation on the underside bottom; third drawer from right: *2*; fourth drawer from right: *X4*; far left drawer: *5*; rear boards of

the fourth-tier drawers in chalk: proper right: *XI*; middle: *M*; proper left: *3*. Inscribed on the proper left document slide in chalk, on left: calculations, and on right side: numbers, and in ink, *William*; on the proper right slide in ink, on left: *Agnes G Munsey; William T Munsey*, and on right side: *Brackett T Munsey; Agnes G Munsey; Jane Hill Munsey; Jane B* [illegible]

Private Collection

PROVENANCE: (Antiques dealer Israel Sack); the present owners, 1971

This desk reflects Nathaniel Gould's highest level as an artisan cabinetmaker, and it is among the finest desks made in New England, if not the entire colonies. The wood was carefully selected and comparable to his great desk-and-bookcases. The interiors of all known block-front desks follow the template established for the desk-and-bookcases.

Slight variations from Gould's standard construction practice possibly indicate a manufacture date of 1770–81. The turned column topped by a slender carved flame on the face of each document slide is a later design than the earlier dolphin-head. The top edge of the drawer backs in the main case is not dressed with a molding plane.[1] The center drop with its twenty-seven segments is more finely carved than any other desk. The desk is missing its prospect door.

Early ink inscriptions on furniture objects are treasured by researchers. To have not one but four distinct signatures is highly unusual and they were met with great anticipation. Unfortunately, no direct link to any of Gould's customers could be established. It appears that Brackett Munsey (1813–1894) and his wife Jane Hill Munsey (1814–1867) owned the desk sometime in the mid-nineteenth century. Their children William T. Munsey (b. 1843), Agnes G. Munsey (b. 1841), and Jane B. Munsey (1834–1877) followed their parents' lead of signing this heirloom in due course. Since so many master mariners were the original owners of these block-front desks, there is a possibility that it came into the Munsey family through an ancestor who followed that career.[2]

This desk is probably the model priced at £10 in the ledgers based on the number of survivors and the lack of additional cost refinements such as cedar-lined drawers or knee carving. Eight of the eleven desks sold at this price before 1777 were purchased by master mariners, two of whom were closely tied to the Cabots and lived in Beverly: Israel Dodge and Joseph Lee Esq.

1. The dolphin-head motif appears on two of the three surviving bombé desks and the earliest documented desk-and-bookcase (see cat. 7), which has been identified as being made in 1765. The bombé design preceded the block-front, and both flat-front desks are considered early because of the use of the dolphin-head decoration on document slides. The slender flame appears on all three surviving block-front desk-and-bookcases and one other desk. The unfinished top edge of the rear board in main case drawers only appears on this example of the block-fronts. The valance headers are not numbered by notches but appear to be original. These last two points may indicate a different joiner's work, but all three facts taken together indicate production sometime in the 1770s.

2. Jane Hill Munsey was born in Beverly and resided there for a time after her marriage to Brackett Munsey in 1834, as per information compiled from the Massachusetts Vital Records by Joyce King.

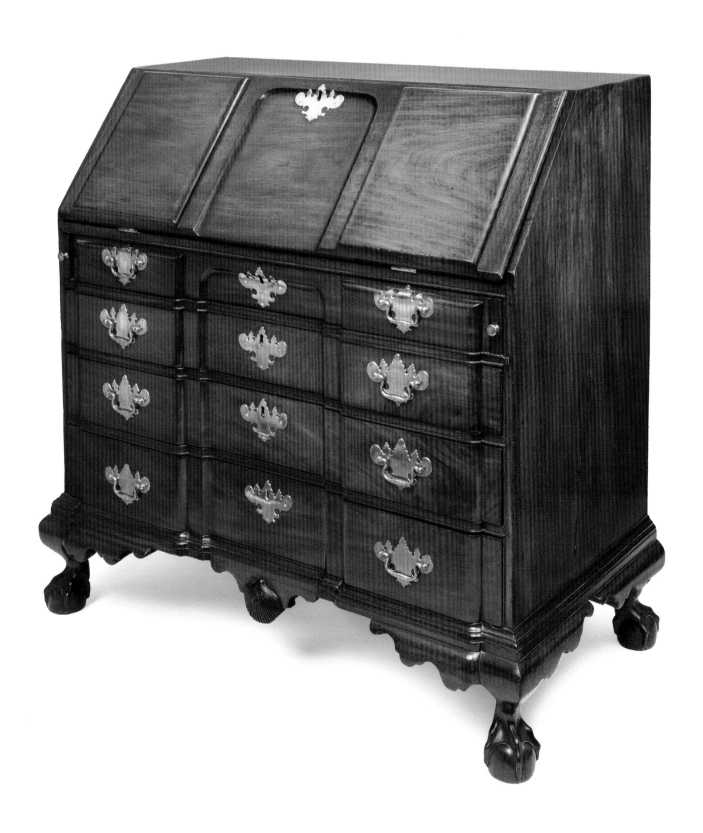

Desk-and-Bookcase

ca. 1765

Attributed to the shop of Nathaniel Gould

Dense mahogany; secondary woods: eastern white pine

H 96 ⅛; W 44 ⅛; D 22 ¾; bonnet-top clearance for crown molding when installed: top cutout 13 (horizontal), 3 ¾ (vertical)

Inscribed on lower portion of backboard of desk section drawers in chalk: *x*

Private Collection

PROVENANCE: By descent in the family to Elizabeth Rogers Mason Cabot (1834–1920); her daughter Ruth Cabot Paine (1865–1949); her daughter Elizabeth Mason Paine Metcalf (1896–1992); her son Thomas Newell Metcalf Jr. (1922–1998); anonymous family member; (antiques dealer C. L. Prickett, 2006); the present owners, 2009

It was the purchase of this magnificent piece by the antiques dealer C. L. Prickett that led eventually to the discovery of the Nathaniel Gould ledgers at the Massachusetts Historical Society. Although the family that owned it had two centuries of history principally in Boston, original genealogical research as given by the family indicated that the initial purchaser probably lived in Salem. The ancestors of Elizabeth Mason Paine Metcalf diverged through two lines with a shared common ancestor of Joseph Cabot Sr. (see Business of Cabinetmaking, fig. 5). Her father, Robert Treat Paine (1861–1943), was the fourth generation descendant of John Cabot (1745–1821), Joseph's eldest son. Her mother, Ruth Cabot (1865–1949), was a third-generation descendant of Samuel Cabot Sr., the seventh and youngest son of Joseph Sr. Unfortunately, there is no record in the ledgers of a desk-and-bookcase being sold to John or Samuel Cabot. However, four of these great objects were sold to John and Samuel's three brothers.[1] Joseph's third son, Andrew, purchased his first desk-and-bookcase in 1773 for £24, a month after his wedding to Lydia Dodge (1748–1807). Seven years later, he purchased a second desk-and-bookcase, approximately at the time he moved to a new house in Beverly (see cat. 2, fig. 1), paying Gould £45 in inflated colonial currency.[2] Joseph's fourth son, George, purchased his desk-and-bookcase a month after his wedding to Elizabeth Higginson (1756–1826), paying a more modest £20. Unfortunately, Joseph's

fifth son, Stephen, passed away shortly after his wedding to Deborah Higginson (1754–1820), before he had a chance to establish himself. The sixth son, Francis Cabot (1757–1832), upheld family tradition when he purchased a desk-and-bookcase from Gould in 1781, for the same price paid by his brother Andrew the previous year.

There was one other purchase: the firm of Francis (1717–1786) and Joseph Cabot Sr. (1720–1767) was responsible for the first recorded domestic sale of a Gould desk-and-bookcase in 1765. Two clues point to this ledger entry being for the object under discussion here. The desk-and-bookcase was reported as never having left the family, which is confirmed if the line of descent went from John Cabot to Elizabeth Metcalf. As the eldest son, John would have had a preferential claim on assets of his father, Joseph, who passed away in 1767. Joseph's share of the business assets was left to his wife Elizabeth; Joseph's brother and partner, Francis, was named guardian of the minor children. The desk-and-bookcase was probably inherited by John sometime after 1767.[3]

The second clue comes from the fact that the bombé style had seemingly been supplanted by the block-front design in Salem by 1770. Only three desk-and-bookcases were built prior to 1770, one of which was probably of a simpler design than the example under discussion here. Gould's shop probably made only two bombé desk-and-bookcases. The two candidates for a bombé case piece of this magnitude were sold to the Cabot firm and Henry Gardner. Gardner's purchase

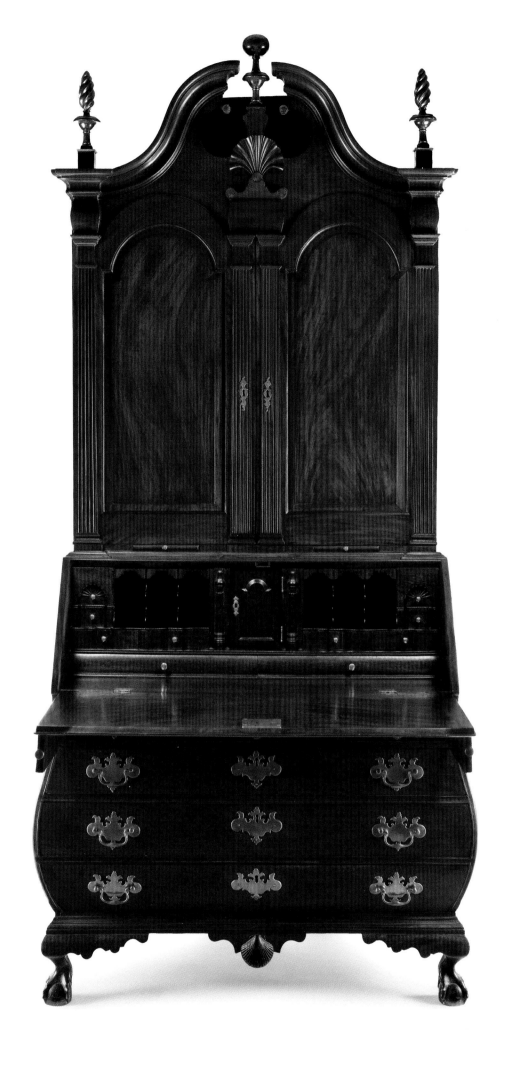

was 13 percent less expensive and cannot be considered to be a candidate from a provenance or cost standpoint.[4]

Additional information received from the Metcalf family shortly before publication solidified the most probable descent. The thesis that John Cabot probably inherited the desk and bookcase from his father's firm does not change. The new information, however, placed ownership one generation earlier, with Elizabeth Rogers Mason Cabot (1834–1920), and by inference to her husband, Walter Channing Cabot (1829–1904), who predeceased her by sixteen years, squarely placing the line of descent in the Samuel Cabot Sr. (1758–1819) rather than John Cabot line. Samuel would not have been the original purchaser, as he was only seven years old when the desk-and-bookcase was made. After its assumed inheritance by John Cabot, it crossed family lines and became the property of his son Samuel Jr. (1784–1863).[5] Confirming this sequence of events are the set of four chairs (cat. 12) with Cabot history that follow the same line of descent until dispersal of the younger Samuel Cabot's estate.[6]

Construction adheres to the standard Gould characteristics with two exceptions. Drawer blades (dividers) are comprised of a 1/2-inch facing strip of mahogany backed by 3-inch pine, as opposed to the shop's usual practice of constructing blades of solid primary wood. The dovetail pins of all four main case drawers are exposed on the rear board. The upper case is original and has not been altered in height. Brasses are original with some restoration to the tips of escutcheons; they are a pattern usually used by Gould on large case pieces. The proper right and center finials are replacements. The missing half of the scallop shell carving between the bookcase doors was restored by taking a mold from cat. 8.

1. For the Cabots and their residences and Beverly, see Widmer and King 2010, pp. 166–75.

2. Both desk-and-bookcases are listed in Andrew Cabot's Inventory, at £7..10..0 and 90s [£4..10..0] respectively , Massachusetts Probate Records of Essex County 4431 (hereafter PREC). Only one is listed in his wife Lydia's inventory of September 21, 1807, valued at four dollars, Massachusetts Probate Records of Suffolk County, docket 22925, vol. 105, p. 419 (hereafter PRSC). Lydia sold one desk-and-bookcase on June 15, 1792, after she moved to Boston. See "Minute Book of Settling Estate of Andrew Cabot," Nathan Dane Papers, box 16, p. 19, Massachusetts Historical Society.

3. PREC, vol. 44, p. 144.

4. It appears that both desks and cases of drawers transitioned to block-front design by 1770, according to prices charged. Supporting this thesis is the fact that Clark Gayton Pickman ordered a desk-and-bookcase at the same time he ordered a case of drawers. The latter was priced at £18..13..4, the first of the block-front designs sold by Gould. It is highly unlikely that that desk-and-bookcase was the "old style" bombé form.

5. The inventory of Samuel Cabot Sr. does not contain a desk-and-bookcase. PRSC, docket 25841, vol. 117, p. 193. In addition, he predeceased his oldest brother John by two years and would not have inherited the desk-and-bookcase.

6. The younger Samuel Cabot Jr. had two sons: Walter Channing Cabot and Louis Cabot. Walter Channing's wife was Elizabeth Rogers Mason Cabot, the first identified family member to own the desk-and-bookcase. Their daughter, Ruth Cabot Paine, was the second owner. Louis Cabot's daughter, Charlotte Hemenway Cabot Bartol, was the first identified owner of the four chairs (cat. 12). It is most likely that Samuel Jr. received the desk-and-bookcase and the set of chairs at the same time, either as inheritance or purchase from a family member.

Staircase, Jeremiah Lee Mansion (ca. 1766–68), 170 Washington Street, Marblehead, Massachusetts. Marblehead Museum and Historical Society Historic House Collection

Desk-and-Bookcase

1775

Shop of Nathaniel Gould

Dense mahogany; secondary wood: eastern white pine

H 105; W 45; D 24; bonnet-top clearance for crown molding when installed[1]

Inscribed on lower case: on top board in ink: *Nath Gould not his work* and *Joseph Gould 177*[?]; on first tier middle drawer behind the prospect door in pencil: *Oliver Putnam / Hampstead N. H. / Oct.17-1888 / this desk was bought by my grandfather / at an auction in Derry before / I can remember*; on second tier proper left drawer in chalk: *Mrs. T G* [illegible]; on third tier proper left drawer in pencil: *Oliver Putnam / Hampstead Jan 29 1888*. Inscribed on upper case: on proper right side of second drawer in chalk: arrow pointed down and *X*; on proper right side of third drawer in chalk: *3*; on bottom board of fourth drawer in chalk: arrow pointed down and *X*; fifth drawer in chalk: illegible

The Metropolitan Museum of Art, New York, Gift of Mrs. Russell Sage (10.125.81)

PROVENANCE: Purchased at auction by Thorndike Putnam (1787–1858);[2] his son Henry Putnam (1817–1878); his son Oliver Putnam (1844–1897); (unidentified Boston dealer); H. Eugene Bolles; Mrs. Russell Sage before 1909; The Metropolitan Museum of Art, 1909

Considered by American furniture scholar Morrison Heckscher to be "one of the supreme manifestations of the characteristic Massachusetts block-front desk with scroll-pediment bookcase," this desk-and-bookcase is the finest surviving example from Nathaniel Gould's illustrious career. Fortunately, it came to the Metropolitan Museum accompanied by documented provenance that helped make possible an attribution to Gould.[3]

In April 1775, Jeremiah Lee Esq., Marblehead's wealthiest shipowner and merchant, was invoiced for a large order of furniture as part of the dowry for his daughter Mary (1753–1819) (fig. 1). Her marriage to Newburyport's Nathaniel Tracy less than two months prior to its shipment united their respective towns' most prominent merchant families. Gould's account book clarifies that Lee's purchase was "for his daughter" (fig. 2). Coupled with the fact that the order was "cased" (crated for shipment, probably by sea), there is little doubt that it was intended for their new home in Newburyport (fig. 3).

Unfortunately, Tracy's venture into privateering during the revolution was disastrous.[4] Efforts to renegotiate his substantial debts after the war proved fruitless. Bankrupt by 1786, he removed his family to the Spencer-Pierce-Little House in Newbury. In the inventory of 1797 following his death, which included most of the dowry furniture received from his wife's family, the desk-and-bookcase was the most valuable piece. His widow had few tangible assets to support the family and was compelled to sell furniture during the ensuing years.[5] It was probably between 1797 and 1812 that Thorndike Putnam acquired this piece. His father, Oliver Putnam (1753–1798), lived in Newburyport and would have been familiar with the desk-and-bookcase, as well as the circumstances of the Tracy family. This desk-and-bookcase was the second most expensive item of furniture sold by the Gould firm, priced just below the one sold to Sarah Orne (1752–1812) as part of her dowry when she wed Clark Gayton Pickman.

The intriguing inscription "Nath Gould not his work" (see Hidden in Plain Sight, fig. 2) was the basis for an earlier attribution of the desk to Henry Rust (1737–1812) of Salem. However, Rust's signature desk (fig. 4) does not compare favorably to documented Gould work in design or construction.[6] The unusual sentiment expressed in the notation nevertheless offers clues to the nature of a workshop and the relationships therein. The first two words are in Gould's hand and match his signature on other documents. The three words "not his work" are in a different hand and, as Heckscher proposed, were most probably added by a discontented employee. Indeed, it is hard to conceive of a more outstanding example of Gould's work. Its construction adheres to the standard characteristics and its condition is the best of the four survivors of the form—and a worthy legacy of the best of Nathaniel Gould.

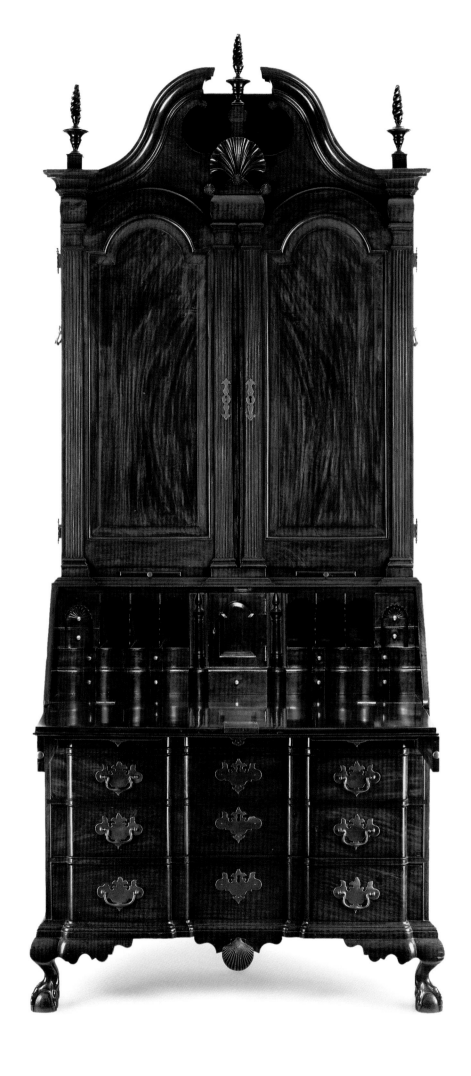

FIG 1
Detail of Nathaniel Gould's Day Book
(1768–83) showing Jeremiah Lee Esq.'s
order for his daughter Mary's wedding
dowry, April 9, 1775
Nathan Dane Papers, Massachusetts
Historical Society, Boston

FIG 2
Detail of Nathaniel Gould's Account Book
showing Jeremiah Lee Esq.'s order for his
daughter Mary's wedding dowry,
April 9, 1775
Nathan Dane Papers, Massachusetts
Historical Society, Boston

FIG 3
Nathaniel Tracy House (ca. 1771),
Newburyport, Massachusetts
Photograph
Phillips Library, Peabody Essex Museum,
Salem, Massachusetts

1. This area of cutout for a crown molding was restored, so the original dimensions could not be determined.

2. As per inscriptions dated 1888 in the desk section drawer.

3. For a complete description and history, see Heckscher 1985, pp. 276–79.

4. At one time, Tracy was principal owner or had an interest in 110 vessels of which twenty-four were engaged in privateering. By the end of the war, all but thirteen had been captured or destroyed. Nathaniel and Mary Lee Tracy moved to a mansion house that was built and owned by his father, Patrick, who eventually left it to Nathaniel's children so that it could not be seized in Nathaniel's bankruptcy. See Currier 1896, pp. 551–64.

5. The final sale of household furniture occurred in 1820, but Mary Tracy had probably disposed of the desk-and-bookcase earlier. It is not listed in her inventory (Massachusetts Essex County Probate Records, docket 27962, vol. 395, p. 443). She sold her church pew at auction as early as December 1797. See *Newburyport Herald,* February 29, 1820, for the final sale of the house and furniture.

6. The proposal that Henry Rust, cabinetmaker of Salem, was responsible for this object, plus the body of work attributed to one Salem shop, is in Venable 1989, pp. 58–63. A detailed analysis of why Henry Rust was not responsible for this desk-and-bookcase and the associated work is in Widmer and King 2008, pp. 1–25.

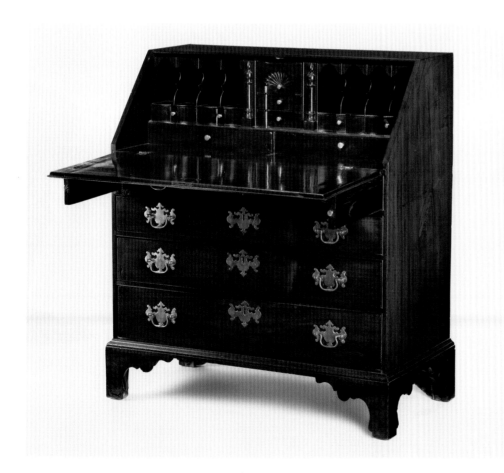

Seating Furniture

Among the most significant discoveries in the Gould ledgers was the extent of his chairmaking activity. The research on transactions related to chairs and the study of his surviving chairs have yielded important information regarding Gould's training prior to arriving in Salem, the division of labor in his shop, and particularly, the disclosure of when English chair patterns were actually available in colonial America.

There were at least seven well-established chairmakers in Salem when Nathaniel arrived in or before 1758. Probably the most prominent were William Lander and his son, William Lander Jr. Also in business were William Gray (1727–1805), Benjamin Symonds (1714–1779), Ichabod Glover, and James Cheever (d. 1763).[1] Salem's most accomplished cabinetmaker prior to Gould's arrival, Abraham Watson (1712–1790), also produced seating furniture. However, chairmaking tended to be a specialized arm of the joinery trade, particularly in larger towns that could support the activity, so why did Gould not use local experienced talent in satisfying his customer's orders? The answer is probably twofold.

He was introducing a new furniture style based on Thomas Chippendale's designs in *The Gentleman and Cabinet-Maker's Director* (London, 1765). Many of the other furniture forms that have a distinctive Chippendale Rococo design influence, such as chests of drawers, desks, desk-and-bookcases, chest-on-chests, and tables, had been evolving from the Queen Anne–style in the major cabinetmaking centers, including Boston, since the 1740s. The Rococo influence may or may not have been prevalent in Salem furniture in the mid-1750s, but it was certainly a key part of Gould's offering when he arrived. His introduction of the Chippendale-style chair was a radical departure from Salem's standard chair design. With their squared-end crest rail, pierced and sometimes carved splat, and cabriole legs that were not joined by stretchers, his chairs were completely different from the Queen Anne–style examples prevalent before his arrival.

The second point is conjecture, but supported by his general use of subcontractors and apprentices from outside Salem. In introducing this new style of furniture, Gould was careful not to encourage competition for his work. When Lander, Doak, and Glover were asked to produce chairs for Gould, they were always assigned the simplest

maple and birch "kitchen" chairs that had not changed substantially in design for thirty years.

Until its closure in 1783, the Gould shop produced a surprising 1,399 pieces of seating furniture. Side chairs, usually sold in sets of six and ordered at the time of a wedding, accounted for 93 percent. He also produced the other popular forms of eighteenth-century seating furniture, including easy (large) chairs (37), round chairs (29), close stool or convenient chairs (10), low (slipper) chairs (7), child's chairs (1), elbow (arm) chairs (8), Windsor chairs (4), and two settees.[2] His first elbow (arm) chair was not sold until 1765, long after the form had been introduced. There is an interesting entry in January 1771 for Nathaniel Sparhawk Jr., who paid Gould for retrofitting arms to his conventional side chair.[3]

With the possible exception of foot carving, chairs possess none of the attributes of Gould case furniture, hence, attributing chairs to his shop required a different approach. Fortunately, a set of four overupholstered "owl's-eye" Chippendale-style chairs that were purported to have descended from the Cabot family was located (see cat. 12). Just as fortuitously, they had been stripped in preparation for new fabric, which allowed a close examination of the chairs, including the base of the splat and the shoe (fig. 1). Among the construction characteristics noted were a series of punch marks (as seen, for example, in fig. 1) on

FIG 1
Detail of bottom of splat of cat. 13 (with shoe removed) showing punch dot numbering system

FIG 2
Robert Manwaring, *The Cabinet and
Chair-Maker's Real Friend and Companion*
(Printed for Henry Webley, 1765),
detail of plate 9
Phillips Library, Peabody Essex Museum,
Salem, Massachusetts

FIG 3
Attributed to the shop of Nathaniel Gould
Detail of Pair of Side Chairs showing
ball-and-claw feet and acanthus-leaf
knee carving Type A (left), Type B (right),
ca. 1762–74
Mahogany, H 37; W 20¾; D 16½ (with
slight variations)
Historic Deerfield, Deerfield,
Massachusetts (right: 59.070.01;
left: 59.070.02)

the inside of the shoe and at the base of the crest rail, which indicated the chair number within the set. Also noteworthy were their deviations from standard New England chairmaking practice: they lack stretchers and have squared rear legs that flare at the feet.

A similar leg and foot structure was noted on other Massachusetts chairs in the literature, especially on a number of chairs featuring a splat design derived from plate 9 in Robert Manwaring's *The Cabinet and Chair-Maker's Real Friend and Companion*, published in London in 1765 and available as early as October 1766 in Boston (fig. 2).[4] Manwaring also suggested a less expensive option: "Should the ornamented parts be left out, there would still remain Grandeur and Magnificence behind, and the Design will appear open and genteel." Gould took Manwaring at his word and offered both designs.

Parlour

That the Manwaring splat design was used in Gould's shop was confirmed by the provenance of a pair of chairs in the Metropolitan Museum of Art. The family history indicated that they had been part of the dowry of Sarah Orne (1752–1812) upon her marriage to Clark Gayton Pickman in 1770 (see cat. 15). In the Gould account books, the entry reads "6 Chair frames Carvd Backs @36/." The words "Carvd Backs" appear on only one other entry: a set of chairs also priced at 36s. and sold to Francis Cabot (1757–1832) in July 1774.

Gould made a total of fifty-six mahogany chairs at this price of 36s. commencing in 1764. Further confirmation that the Manwaring design was initially popular in the Gould shop was determined by a side chair at the Lynn Historical Society with an old (but not contemporaneous) painted inscription on the rear rail: "Parson Thomas Barnard Salem 1750."[5] The entry for June 4, 1773, for Thomas Barnard Jr., reads "6 Mehogany Chair frames With Carvd Knees @ 30/." Five surviving Manwaring-design chairs are fully carved on the crest rail and splat; eight others are not carved above the seat. All thirteen chairs, however, have ball-and-claw feet and acanthus-leaf knee carving. The uncarved version (see cat. 14) was probably first produced in 1762; Gould produced a total of forty-two examples of this type.

There was one significant hurdle yet to overcome if the Manwaring-design chairs were to be firmly attributed to the Gould shop. The first examples in the accounts, sold at an estimated price of 32s. for an

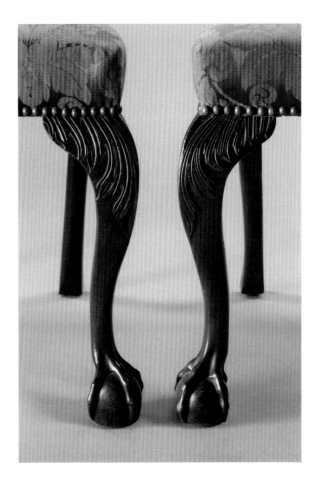

FIG 4
Type A and Type B Chairs Comparison Chart

FIG 4
Type A and Type B Chairs Comparison Chart

	TYPE A	TYPE B
knee carving	descending acanthus leaf	swept-back acanthus leaf
stippled background	yes	none
width of rear rail at top	15 7/8 – 16 9/16	17 1/8 – 17 1/4
width between rear legs at floor	10 – 11 1/16	12 1/4 – 13 15/16
number nails per corner block	4	2
number of pins, rear rail to rear stile	2	1
ball-and-claw carving	space between claws: inverted V	space between claws: open semicircle

uncarved version, were a set of six purchased in 1762 by James Cockle Esq., collector of customs for the port of Salem from 1760 to 1765. Carved versions, priced at 36s., were introduced by Gould in 1764. But, Manwaring's book was not printed in London until 1765 and was first advertised in Boston in late 1766, three years *after* Gould's presumed production began.[7]

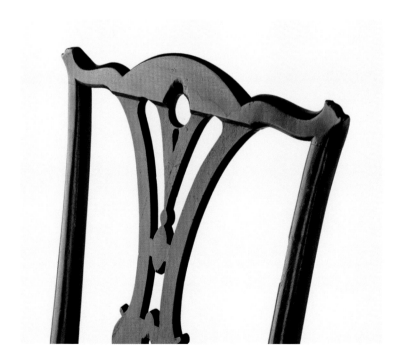

FIG 5
Detail of cat. 9 showing rear of crest rail

Sometime in the early 1800s, a string-bound copy of Manwaring's book was donated to the Phillips Library (now part of the Peabody Essex Museum). On the reverse of plate 9, and only on this page, is an ink inscription: "from London 1762" (fig. 7). It is entirely possible that this was Gould's copy, and he acquired plate 9 prior to publication of the full portfolio. (Individual plates were offered by cabinetmakers prior to assembling a folio of engravings into a book.)[8] Perhaps it is purely coincidental that the first chair sale of the design was to Cockle, or perhaps Cockle obtained the plate for Gould and received the prototypes.

Close examination of two Manwaring-splat chairs at Historic Deerfield revealed the hands of two carvers, as the ball-and-claw foot and the acanthus-leaf knee carving were different (fig. 3). Moreover, neither foot carving matched the typical ball-and-claw foot from case pieces attributed to Gould (see fig. 4). In addition, whereas the chairs could have been assigned to two different carvers, inside or outside the Gould shop, their dimensions are slightly different as well.

Twelve of the thirteen estimated surviving chairs with Manwaring-splat design that were studied could be divided into two major groups with the Type A and Type B significant differences listed above.[6]

All the Manwaring-design chairs are attributed to Gould. No other American chairs of this design are known to exist. Despite their minor differences, they are basically the same design: all have front molded stiles, flaring rear feet, no stretchers, rear rails usually made of birch, and a numbering system located on both the shoe and base of the splat (although the method of marking takes three different forms), rear bracket responds, and, with the exception of the spacing of the rear legs and crest rails, virtually identical overall dimensions (see fig. 4). All of the splats on the surviving examples were made from the same template.

Identifying characteristics of construction for Gould's chairs in general, including other splat designs, include a relatively thin stock used for crest rails that has a flat rear surface (fig. 5). The bottom edge of that surface was chamfered on less expensive chairs and rounded on higher value models. The splat is seated directly in the rear rail. If the chair is equipped with pad feet, the bottom edge of the toe blends into a ring at the rear of the foot. The foot is mounted on a circular 3/4-inch-high pad (fig. 6). If the chair has a slip seat, the rear rail and shoe are frequently combined as one piece of primary wood. The frame rail is numbered with a series of notches, similar to Gould's manner of marking valance headers on desks, and the bottom of splat and shoe are not numbered.

When two hundred-year-old objects are offered for sale, broken or repaired elements will often affect their value significantly. In the case

of this style of chair, a broken splat is a positive sign of originality. The vertical grain of the wood at the extreme left and right sides of the splat has little structural support laterally, and is easily broken. An indication as to whether the splat or shoe is original can be determined by the presence of Roman numerals or dots at the base of the splat.[9] The shoe was removed on eleven chairs. Splats were numbered at the base on seven of the eleven chairs, but only one (in Winterthur) showed no signs of breakage, indicating probable replacement of four splats.[10]

Three other splat designs can be attributed to Gould by similar analysis: the "C-scroll and diamond" (cat. 10), a "Gothic arch" splat (cat. 13), and a "pierced lancet and keyhole" splat (cat. 9). A fourth splat, the "C-scroll," is probable, but none could be located for positive identification.[11]

The ledgers list forty-eight different prices for side chairs. Determining specific models for each price is impossible without a larger population of survivors with a firm family provenance. The broad range of prices resulted from the wide variety of available woods and splat designs. A customer could also choose ball-and-claw or pad feet, plain or carved knees, and a frame designed for a slip seat or over-upholstered rails.

"Kitchen" or "common" birch or maple chairs with flag or straw seats (cat. 11) were the least expensive. Typically, they were subcontracted to other Salem chairmakers, particularly when the shop was handling a large order. Birch, walnut, or cherry chairs were generally priced between 10s and 22s, whereas the cheapest mahogany chair cost 16s. The price of a specific splat design is more difficult to determine, because Gould sold both mahogany and walnut chairs at the same price in seven different cases. Mahogany chairs priced at 26/8 per chair

were identified as having slip seats in a number of entries. Based on 133 chairs sold at this price, they were probably the "owl's-eye" splat design and had plain (uncarved) knees and pad feet.

Manwaring splats without carving of the crest rail cost 32s. and 36s. if carved. All of the surviving models of this design were upholstered over the seat rails. The over-upholstered models used a greater amount of expensive fabric, but the chair frame was less expensive to make: the front and side rails were birch or maple and did not have to be finished by the cabinetmaker with a molded edge. It appears that Gould may have priced his chairs with slip seats at 1s. 4d. more than over-upholstered versions.

The chair entries provided interesting information on the fabrics used. Gould's primary upholsterer from 1762 to 1771 was Benjamin Nurse. Between Gould's entries and the detail in Nurse's charges to Gould, fifty-six chairs were listed as being covered in harateen, forty-seven in leather, twenty in calf, twenty-three in horsehair, sixteen in the more expensive hair cloth, and eight had worked bottoms. One of Nurse's transactions was for covering six chairs with seal skin, but it could not be connected to a specific customer sale. One chair, a rare survivor, retains its original seat stuffing and under fabric.[12]

Many of Gould's chairs show damage or repairs on the sides of the rear legs at the seat rail (figs. 8 and 9). In all these cases, the imprint of an upholstery nail head was evident, and in one case the impression of knife cuts could be seen. Chairs bottomed in either calf or leather had the material secured by nailing into the rear leg rather than terminating at the junction of side rail and rear leg. Nailing in this location, coupled

FIG 6
Detail of cat. 9 showing typical pad foot

FIG 8 [FAR LEFT]
Detail of cat. 9 showing nailhead impressions on sides of rear legs at seat rail, indicating original covering was hide

FIG 9 [LEFT]
Detail of cat. 14 showing absence of nailhead impressions on sides of rear rails, indicating original cover was woven

FIG 10 [TOP RIGHT]
Detail of cat. 10 showing base of splat and shoe

FIG 11 [BOTTOM RIGHT]
Detail from an "owl's-eye" splat chair from a set of six attributed to the shop of Nathaniel Gould, now in a private collection, showing numbering system on slip-seat chairs

with pins connecting the side rail to rear legs, created a weak joint that led to breakage. Chairs bottomed with a woven fabric, however, were nailed in the conventional manner: by folding the fabric under and nailing at the end of the side rail. It is thus possible to determine whether leather or a woven fabric was the original chair covering.

Although Gould may have had access to Manwaring's designs as early as 1762, and owned a 1762 edition of Chippendale's *Director*, he had been making chairs in the Chippendale manner upon his arrival in Salem in 1758.[13] His chairs bear a striking resemblance to those attributed to James Graham (1726–1808), an immigrant Scottish chairmaker who arrived in Boston in August 1754 and may have introduced the Chippendale style there.[14] Three of Gould's splat designs—the "owl's eye," "C-scroll and diamond," and the "C-scroll"—were Graham's most popular designs. Both men produced chairs with well-formed cabriole legs and rear legs flaring out at the base but without stretchers. Both also used an ogee-shaped bracket that is nailed under the side rail and tenoned to the rear leg. Close physical examination is needed to determine the maker. The guidelines are clear: Graham's pad feet are decorated with incised vertical lines on the face of the foot; Gould's are plain. In over-upholstered chairs, Graham supported the seat with four diagonal braces in addition to using triangular corner blocks; the braces form a diamond and are face nailed to the inside of chair rails;

Gould used only triangular blocks. Workmanship on Graham's corner blocks and braces is fastidious, with all corners chamfered and sanded; Gould usually did not chamfer corners. Graham counter-bored the nail hole for knee returns, corner blocks, and rear brackets, so that the nail heads are below the surface; Gould left the nail heads flush with the wood surface and did not counter-bore nail holes. The rear rail of Graham's mahogany chairs is usually veneered over an oak, maple, or birch secondary wood; rear rails of Gould's over-upholstered mahogany chairs are usually birch and not veneered, often resulting in a distinct color difference between the rear rail and the leg on older finishes. For over-upholstered chairs, Graham did not number either the splat or the shoe; Gould numbered both, primarily by one of two marking systems: chiseled Roman numerals or punched dots (see figs. 1 and 10). For slip seat chairs, Graham used a 5/8-inch chisel to mark the center of the rear rail and seat frame; Gould cut notches into the inside corner of the front seat rail (fig. 11), and the seat rail and shoe are often one piece.

There is little doubt that Gould was influenced by Graham's work during his years in Boston. Both men were probably instrumental in introducing Chippendale-style chairs to their respective towns. The similarity ended there: Graham was in debt for most of his life and died a pauper, whereas Gould prospered and left a sizable estate.

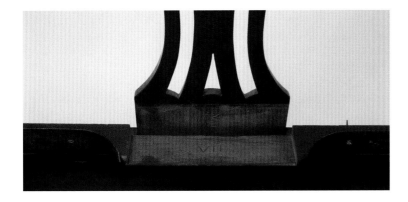

1. For seating furniture in the eighteenth century, see Richards and Evans 1997, pp. 1–6. Cheever sold six inexpensive chairs to Dr. Bezaleel Toppan for his daughter's wedding in July 1762, at approximately the same time that Gould delivered a large order that included *no* chairs (see Cheever to Toppan receipt, July 9, 1762, Pickman Family Papers, MSS 5, box 9, f 11, Phillips Library, Peabody Essex Museum).

2. Round and easy chairs could also serve the function of a convenience chair. The description of the item sold was used in assigning chairs to each category. Two chairs for export, sold to Mason and Williams in October 1762, and described as "yeller chairs," were assumed to have been painted Windsor chairs. A number of perplexing entries in the ledgers denote "small chairs," although many were priced at the same level as larger chairs. They could have been the same form but smaller in size. These were not considered child's chairs unless the quantity sold was one or two.

3. The entry concerning retrofitting elbows to existing side chairs is noteworthy. If an armchair appears on the market today with overall dimensions smaller than usual and comparable to side chairs of the form, it usually is categorized as having been restored at a later time and is substantially depreciated in value. Gould's entry indicates that the alteration sometimes may have been nearly contemporary with the chair's production.

4. Manwaring 1765, plate 9. Manwaring's book was first offered in England in an advertisement in London's *Lloyd's Evening Post* 1340 (February 7, 1766). Boston bookseller John Mein listed it in an advertisement for books, *Boston Evening Post*, October 27, 1766. For a full discussion of English furniture pattern books and their influence on American cabinetmakers, see Heckscher 1994, pp. 172–205.

5. The inscription on the chair at the Lynn Historical Society in Massachusetts was probably painted at a later date and erroneously refers to Barnard's father Thomas Sr.. A chair at Colonial Williamsburg carries a provenance in the Dane family. Nathan Dane was the lawyer for Nathaniel Gould's estate and the Gould ledgers were discovered among his papers, but there is no record of Gould selling any furniture to Dane. Dane may have acquired the chairs after Gould's death, possibly from a member of the Cabot family, who were also clients.

6. Type A chairs (without carving on crest rail or splat) include: (1) a chair at Historic Deerfield (acc. no. 59.070.01, .02); see Fales 1976, p. 50. (2) a chair at Colonial Williamsburg that descended in the Dane family; see Greenlaw 1974, p. 64. (3) a chair at the Lynn Historical Society (acc. no. 6358). Type A chairs with carved crest rail and splat include: (4) a pair of chairs at The Metropolitan Museum of Art; see cat. 14 (5) a chair at the Massachusetts Historical Society (acc. no. S32.60). (6) a chair (not studied in detail) sold by antiques dealer Leigh Keno, now in a private collection. Type B chairs without carving on crest rail or splat include: (7) a chair at the Peabody Essex Museum; see cat. 15 (8) a second chair at Historic Deerfield (acc. no. 59.70.1). (9) a chair at the Museum of Fine Arts, Boston (acc. no. 61.389); see Randall 1965, pp. 182–83, cat. no. 144. (10) a chair at Winterthur Museum (acc. no. 56.52); see Richards and Evans 1997, pp. 102–104. Type B chairs with carved crest rail and splat include: (11) a pair of chairs sold by antiques dealer C. L. Prickett and now in a private collection. Type A chairs: one of the chairs at Historic Deerfield, and the Colonial Williamsburg examples are dimensionally compatible and their numbers stamped on the chair rails could be from the same set. The Barnard chair at the Lynn Historical Society appears to be from a different set based on dimensions. Type B chairs: the Winterthur chair is the best preserved of any Manwaring-splat chair and a small piece of leather was found in the rear rail. Chairs at the Museum of Fine Arts, Boston, and the Peabody Essex Museum were covered in fabric, hence were a different set than the example at Winterthur; it is uncertain whether they were from the same set. Examination of a chair in a private collection was insufficient to enable any conclusions.

7. In September 1761, sea captain Jonathan Cook ordered twelve chairs from Gould, along with a cherry desk. Converting old tenor to new tenor gave a unit price of 36s. for the chairs. The order is estimated as destined for export and the chair price may have included casing. Cook ordered only one item for his own use and was not a likely candidate for chairs of this design or cost.

8. For factors that led to cabinetmakers publishing design books, see Puetz 1999, pp. 217–39.

9. Information on seven uncarved Manwaring-style backs, including many of the examples cited above, is contained in a letter from Harold Sack to Charles L. Montgomery, July 12, 1956, folder 56.52, registration office, Winterthur Museum. In a conversation with the author on April 23, 2011, Albert Sack stated that the six chairs not sold to Winterthur were "badly broken." See Richards and Evans 1997, p. 104.

10. One of the two chairs at the Metropolitan Museum (cat. 15) was not numbered on the splat and also had no breaks. The splat was probably a very old replacement, as its color, wear, and carving were consistent with other elements. Four chairs in the group lacked numbering at the base of the splat, and those splats are deemed to be replacements.

11. See *Antiques* 79, 3 (March 1961), p. 238.

12. The chair at Winterthur is inscribed: "Bottomed June 1773 / by WVE Salem." Numerous attempts have failed to identify this individual. No Salem residents with these initials could be found around this time, and Gould made his last set of this model in 1773, for the Reverend Thomas Barnard, but the Winterthur chair and Barnard chair are types B and A respectively. The initials are probably those of an itinerant upholster. See Richards and Evans 1997, pp. 102–103.

13. A set of six chairs sold to Stephen Higginson on April 23, 1759, at a cost of 25/4 each, were probably mahogany "owl's-eye" splat chairs with pad feet. No Queen Anne-style chairs with Gould characteristics are known.

14. Gould was significantly influenced by designs of Graham. See Widmer 2013.

Side Chair

1758–81

Attributed to the shop of Nathaniel Gould

Lancet and keyhole splat

Walnut; secondary woods: maple (front and one side rail), birch (rear rail and one side rail), eastern white pine (corner blocks)

H 37⁹⁄₁₆ (overall), H 16¹⁵⁄₁₆ (seat); W 21¹⁵⁄₁₆; D 20½

Inscribed on base of splat by chiseling: *IIIII;* on underside of shoe by chiseling: *V*

Private Collection

PROVENANCE: Possibly William Northey (1735–1804) of Salem; his son Ezra Northey (1779–1855); definitely William Northey (1829–1900); his son William E. Northey (1869–?); his daughter Cynthia W. S. Martin (1916–2009); anonymous family member; (Hudson Valley Auctioneers, Beacon, New York, September 21, 2009); the present owners, 2009

This chair, probably part of an original set of six, descended in the same family as a drop-leaf table (cat. 16). As in the case of the table, there is no record of the Northey family's purchase from Gould.[1]

The "lancet and keyhole" splat is loosely derived from plate 14 in Chippendale's 1762 edition of the *Director*. However, the more probable source for Gould's design was the "V-shaped with double lancet and keyhole" splat, of Boston chairmaker James Graham (1726–1808).[2] This chair, with its flat, uncarved, narrow splat, was available in mahogany and walnut, and probably priced from 16s to 24s per chair.[3] A splat simpler than this example may have originated in the Gould shop. It was even narrower than the Northey chair splat with only three piercings.[4]

This Type A (see Seating Furniture, fig. 4) chair follows Gould's construction pattern except that only two rosehead nails are used in the corner blocks. The splat is seated directly in the rear rail. The presence of bracket responds is an unexpected feature on this relatively inexpensive chair, considering that both sets of the more expensive "owl's-eye" splat chairs lacked the bracket. The chair was initially covered in leather and decorated with brass upholstery nails. It was originally webbed using 2-by-2-inch material mounted over the side rails and nailed underneath; this was then covered with sacking cloth and lastly with stuffing. The chair has probably been reupholstered three times.[5]

1. Family history indicated that this set of three chairs had never left the family prior to being auctioned. In 1767, William Northey purchased perukemaker John Ward's half of the dwelling Ward shared with Nathaniel Gould. See William Northey manuscript papers, MSS 78, box 1, folder 3, Phillips Library, Peabody Essex Museum. For biographical information on Northey, see the entry by Gerald W.R. Ward in Kane et al. 1998, pp. 733–35.

2. Gould was significantly influenced by Graham's designs. See Widmer 2013. Three of Gould's designs were close copies: the "owl's eye," "C-scroll and diamond," and "C-scroll." This design is a simplified version of a fourth splat used by Graham.

3. For a mahogany pair with this splat design, pad feet, and over-upholstered rails, see Christie's, New York, "Important American Furniture," 7924, June 22, 1994, lot 223. A chair possibly from the same set as this example is illustrated in Chamberlain 1950, p. 85.

4. Simpler splats are illustrated in an advertisement by Lynn & Monahan for a pair of mahogany chairs in *Antiques* 131, 2 (February 1987), p. 376. A pair of birch chairs (listed as walnut), was offered at Skinner, Bolton, Massachusetts, "American Furniture & Decorative Arts," 2011, August 12, 2000, lot. 95.

5. Mark Anderson of Winterthur's conservation department found a piece of degraded leather in the rear rail. Gretchen Guidess of Historic New England's conservation department determined the original undercovering.

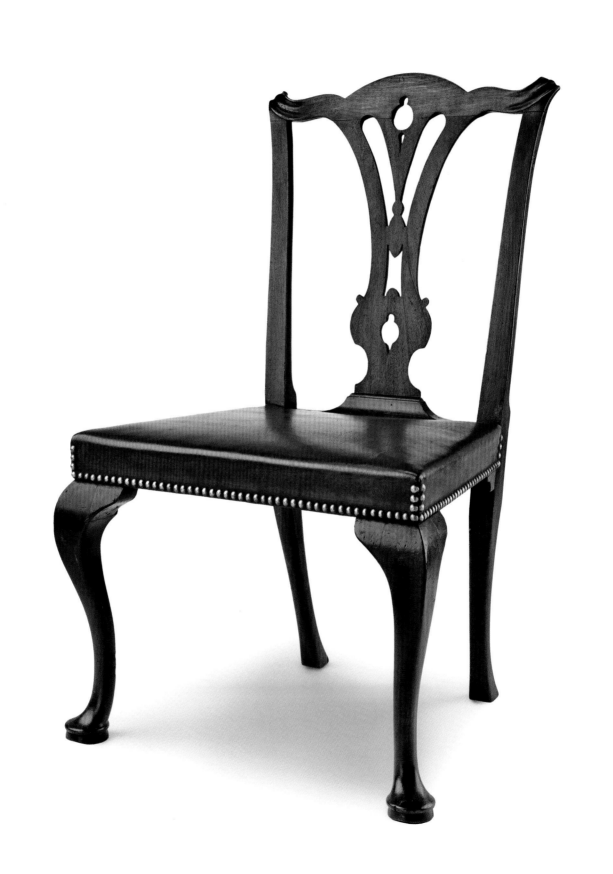

Armchair

1758–81

Attributed to the shop of Nathaniel Gould

C-scroll and diamond splat

Mahogany; secondary woods: maple (front and side rails), birch (rear rail), eastern white pine (corner blocks)

H 36 9/16 (overall), H 16 1/2 (seat); W 22 5/8; D 23 1/32

Inscribed on inside of rear rail in ink: *Bought about 1804 Lord Fairfax Sale in Virginia* and *In the year 1849 I will be married*; on base of splat by chiseling: *VII*; on shoe by chiseling: *VII*

Historic New England, Boston, Bequest of Julia G. Crocker, 1933 (1933.6041)

PROVENANCE: Julia G. Crocker; by bequest to the Society for the Preservation of New England Antiquities (now Historic New England), 1933

The "C-scroll and diamond" splat chairs were never as popular in Salem as they were in Boston. As one of only two known surviving armchairs of this type attributed to Gould, this example is extremely important in documenting his construction techniques, and the dispersal of colonial furniture. The inscription on the rear rail refers to Bryan, the eighth Lord Fairfax, whose possessions were auctioned in Alexandria, Virginia, in 1803. His father's second wife, Bryan's mother, was Deborah Clark (1707–1747) of Salem, daughter of Deborah and Francis Clarke.[1] She married Sir William Fairfax of Belvoir (1691–1757), son of Henry Fairfax of Tolston and Anne Harrison, on October 28, 1731. Deborah's wedding and death are too early to have allowed for a purchase from Gould, and his ledgers do not record any sales to the Fairfax family in Virginia, although this chair has all the characteristics of his chair production.

Deborah Clark's sister Hannah Clark Cabot was the wife of Dr. John Cabot (1704–1749). She was the first of the Cabot family to make significant purchases of furniture from Gould, and an influence on the popularity of many of his newly introduced styles. Hannah's will reads in part: "I give and bequeath all my house hold furniture, house linen, plate and wearing apparel (except what is already disposed of) to my nieces Hanna Clark and Deborah Fairfax Clark, daughters of my late brother John Clark Esqr dec. to be equally divided between them to be sold for their use or to be kept till they are of age or married…."[2]

The chairs probably made their way to Virginia after Hannah's nieces inherited them. There is no record of Hannah purchasing chairs, but they were probably the set of eight valued in her inventory at 36s each and located in the best room.[3] That valuation, made within a few years of purchase, was much higher than a standard side chair would have received, and it could be accounted for by the chair's large size.

The armchair is constructed in Gould's usual manner, but its dimensions are greater; the corner blocks are particularly large. Unlike most side chairs, rear brackets are shaped from the side rail and are one piece. Foot carving is Type A style (see Seating Furniture, fig. 4). The arms are attached to the stiles by being inserted in a pocket and screwed in place from the back side. A wood plug covers the screw head. The shaping of the serpentine arm is minimal. Two small pins secure the mortise-and-tenon joint of the arm support to the arm. The arm support is mortised over the side rail and secured with screws, capped with wood plugs. The leaf carving at the center of the crest rail is shallow and not of the usual Gould quality.

1. For another chair possibly from the same set, see Warren et al. 1998, pp. 53–54, cat. no. F91. The staff at Historic New England connected the Lord Fairfax sale to Salem. See Jobe and Kaye 1984, pp. 396–97, cat. no. 116.

2. See abstract of Hannah Cabot Will, September 27, 1764, Massachusetts Probate Records of Essex County (hereafter PREC), docket 4436, book 341.

3. Hannah Cabot Inventory, November 21, 1764, PREC, book 342, p. 451.

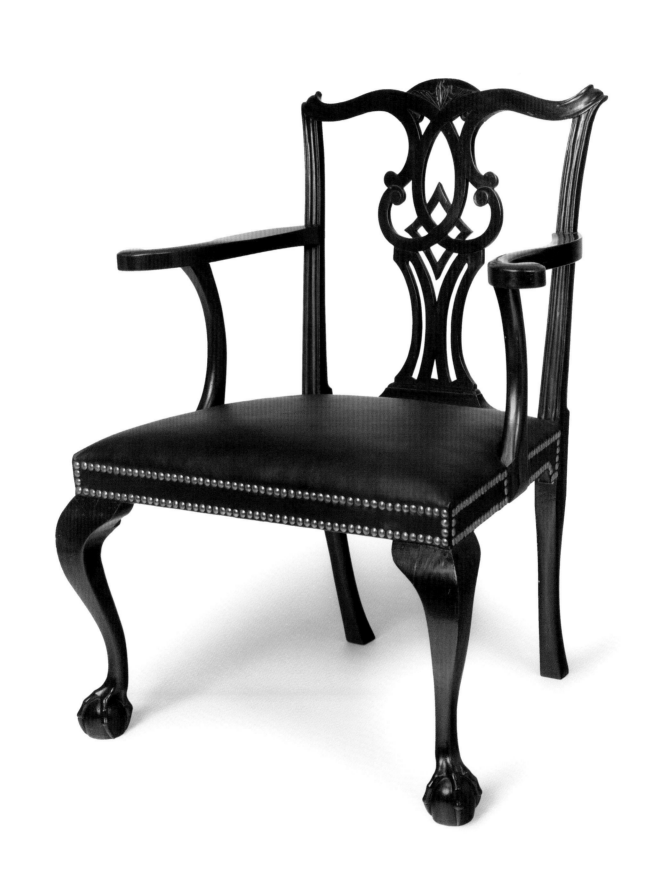

Kitchen Side Chair and Armchair

1758–95

Possibly from the shop of Nathaniel Gould

Lancet and plumb-bob splat

Birch; rush (flag) bottomed seats

Side Chair: H 37 5/8 (overall), H 16 5/8 (seat); W 19 13/16; D 17 7/8

Armchair: H 39 3/8 (overall), H 15 1/2 (seat); W 22 11/16; D 18 3/4

Peabody Essex Museum, Salem, Massachusetts, Gift of the Estate of Miss Ellie F. Ward, 1920 (112041, 112042)

PROVENANCE: Miss Ellie F. Ward; Essex Institute (now the Peabody Essex Museum), 1920

The "lancet and plumb-bob" splat design has long been associated with chairs made in Essex County.[1] Subtle variations in their turnings, shape of the seat, and splat design suggest that these chairs were made by a large number of makers. Only a few share enough common elements to indicate that they were made in one shop. Without a family history or other documentation, it is impossible to assign any chairs of this type to the Gould shop with any certainty.

However, this related side chair and armchair, although not part of the same set, are among the possibilities. Gould's influence appears most evident in their splat design, a simplified version of his "lancet and keyhole splat" (see cat. 9). Above the seat the design is typically Chippendale style, elements below are a carryover from the William and Mary style, incorporating on the better examples a turned front stretcher and legs, and rectangular side and rear stretchers sometimes with a molded edge. The most inexpensive models had straight front legs that were not turned.

Although such chairs were subcontracted, Gould offered customers a wide selection, described variously as "common," "kitchen," and "black" in two woods: maple and birch. Some of the least expensive may have been pine and painted. Twelve different prices covered his production of 181 examples of these vernacular chairs, usually sold in sets of six, seven, or twelve. Wedding orders frequently included a set, and round or corner chairs with similar legs and splats are also known.[2]

1. For a discussion of two Essex County chairs of this type, see Jobe and Kaye 1984, pp. 412–16.

2. For a pair with square seats, see Skinner, Bolton, Massachusetts, "American Furniture and Decorative Art," 1923, June 6, 1999, lot 299. For round or corner chairs, see Skinner, Bolton, Massachusetts, "American Furniture and Decorative Arts," 2128, February 24, 2002, lot 429; Northeast Auctions, Portsmouth, New Hampshire, "Fall New Hampshire Weekend Auction," October 28–29, 2006, lot 915; and Northeast Auctions, Portsmouth, New Hampshire, "American and European Furniture and Decorations," May 30, 1993, lot 112.

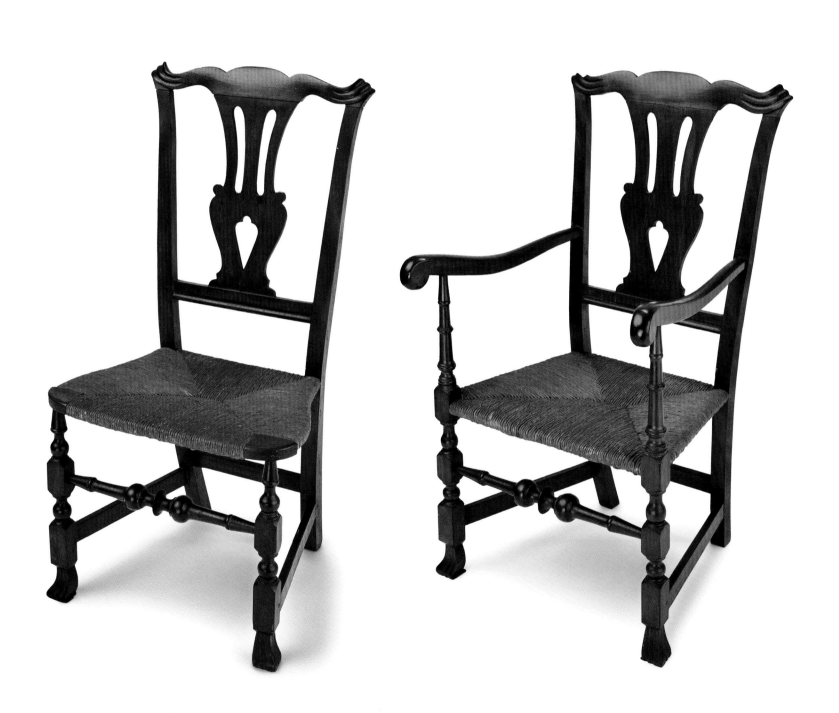

Side Chair

1759–81

Attributed to the shop of Nathaniel Gould

Owl's-eye splat

Mahogany; secondary woods: birch (front and side rails), eastern white pine (corner blocks)

H 36 ⁷⁄₈ (overall), H 17 ³⁄₁₆ (seat); W 21 ⁵⁄₈; D 20 ¼

Inscribed on base of splat and on shoe by chiseling: *II* with two punched dots

Private Collection

PROVENANCE: By inheritance to Charlotte H. Cabot (1870–1956), who married John Washburn Bartol (1864–1950); anonymous Bartol family member; (Northeast Auctions, May 1988, lot 333); (antiques dealer C. L. Prickett); (Christie's, New York, "Important American Furniture, Silver, Prints, Scrimshaw, & Decorative Arts," sale 1189, January 16–17, 2003, lot 342); (Christie's, New York, "Important American Furniture, Silver, Prints, Folk Art, & Decorative Arts," sale 1279, January 14, 2004, lot 440); anonymous private collector; the present owners, 2007

Representative of Nathaniel Gould's most popular Chippendale-style chair, this example exhibits an "owl's-eye" splat with plain cabriole legs on pad feet. Between 1759 and 1770, Gould sold five sets totaling thirty chairs of the over-upholstered version with this splat design. The even more popular slip-seat model, although introduced seven years later, accounted for 133 chairs in fourteen sets sold between 1766 and 1777—a total that was undoubtedly higher, but could not be tracked accurately during the war years. The slip-seat version was priced at 26/8 and, using the same logic for determining Manwaring-style chairs, it is assumed that the over-upholstered chair sold for slightly less at 25/4. These slip-seat models were either the most expensive or second most expensive chairs in large wedding orders.

Unlike most other identified Gould chairs, mahogany rather than birch was used for the rear rails and rear leg brackets are absent. The shoes are marked twice with the shop's numbering system of punched dots and chiseled Roman numerals, whereas the splats are marked only with Roman numerals. Their construction follows Gould's standard practice for Type A chairs (see Seating Furniture, fig. 4). The chair was originally decorated with brass upholstered nails.[1]

When the provenance listed above was first examined, it was determined that the line of descent from the second generation of Cabot purchasers went through Samuel Cabot Sr. (1758–1819), youngest son of Joseph and Elizabeth Higginson Cabot. Since Samuel was only

thirteen years old when Gould died, it was assumed that these four chairs were a stray inheritance from one of Samuel's older brothers. However, the line of descent of cat. 7, was determined to have gone through the same line from Samuel Cabot. Both the chairs and the desk-and-bookcase shared three generations of ownership in the Cabot family prior to being separated when Eliza Perkins Cabot (1791–1885) died.[2]

1. A set of six mahogany chairs with slip seats and pad feet is in a private collection. See Sotheby Parke Bernet, New York, "Important Americana," 7865, January 19, 2003, lot 546. Not examined, but possibly from the Gould shop, are a set of six walnut chairs with slip seats and pad feet illustrated in Sack 1988, p. 609, no. 1386; a single chair with ball-and-claw feet and slip seat illustrated in Sotheby Parke Bernet, New York, "Important American Furniture and Related Decorative Arts," 4478Y, November 21–22, 1980, lot 1391; a single chair with over-upholstered seat rails and ball-and-claw feet illustrated in Christie's New York, "Contents of Benjamin Ginsburg, Antiquary including the Property of Cora Ginsburg," 5412, October 14–15, 1983, lot 713; and a single chair with slip seat and pad feet illustrated in Christie's New York, "Important American Furniture, Silver & Folk Art," 1003, January 18–19, 2002, lot 415.

2. Samuel Cabot might have received these chairs, possibly from his oldest brother, John, before passing away in 1819. But it is more likely that his son Samuel Cabot Jr. either inherited or purchased these chairs from a family member, at the same time as their acquisition of the desk-and-bookcase (cat. 7). After Samuel died, the chairs passed to his wife, Eliza Perkins Cabot, then to her son Louis, who passed the chairs to his daughter, Charlotte H. Cabot, the first of the known provenance listed above (see Business of Cabinetmaking, fig. 5).

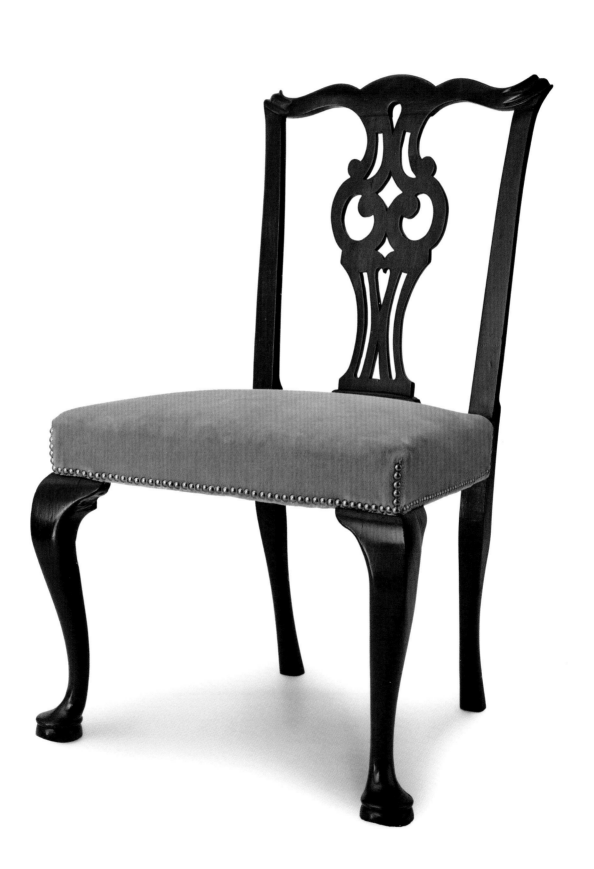

Side Chair

1762–81

Attributed to the shop of Nathaniel Gould

Gothic arch splat

Dense mahogany; secondary woods: maple (side and front seat rails), birch (rear seat rail), eastern white pine (corner blocks)

H 36¾ (overall), H 16½ (seat); W 21 9/16; D 20⅞

Inscribed at base of splat: two punched dots

Winterthur Museum, Winterthur, Delaware, Bequest of Henry Francis du Pont, 1969 (1965.1624.1)

PROVENANCE: (Antiques dealer John S. Walton); Henry Francis du Pont, 1952; by bequest to the Winterthur Museum, 1969

This chair, one of three known to survive, represents a rare instance of an American cabinetmaker faithfully copying a design from an English pattern book, in this case, plate 14 from Thomas Chippendale's *Director* (fig. 1). Finally, these chairs are an extremely rare use of this specific Gothic splat design.[1]

The lack of stretchers, flared rear feet, and a rear rail made of birch suggested the origin as Gould's shop—which was confirmed by finding punched dots at the base of the splats. The engraving of plate 14 (see fig. 1) appears only in Chippendale's third edition, published in 1762, which thus confirms the edition Gould probably owned.[2]

Construction and dimensions follow the Type A characteristics for Gould's chairs (see Seating Furniture, fig. 4). This fragile splat, like the Manwaring copies, has sustained damage over time. The crest rail is restored at both ends, and a patch added. There is a split in one rear leg and the shoe is a replacement. The chairs were probably covered originally with either leather or calf, judging by the telltale nail holes on the outside face of the rear legs, adjacent to the side rails. Surprisingly, the second chair from the set lacks stippling surrounding the acanthus-leaf carving on the knees, which is present on all other Type A chairs and is a defining characteristic for the group. The detail must have been overlooked by the maker. The added embellishments of acanthus-leaf carved knees, ball-and-claw feet, and the carved splat comparable to his best Manwaring-splat chairs place this set in

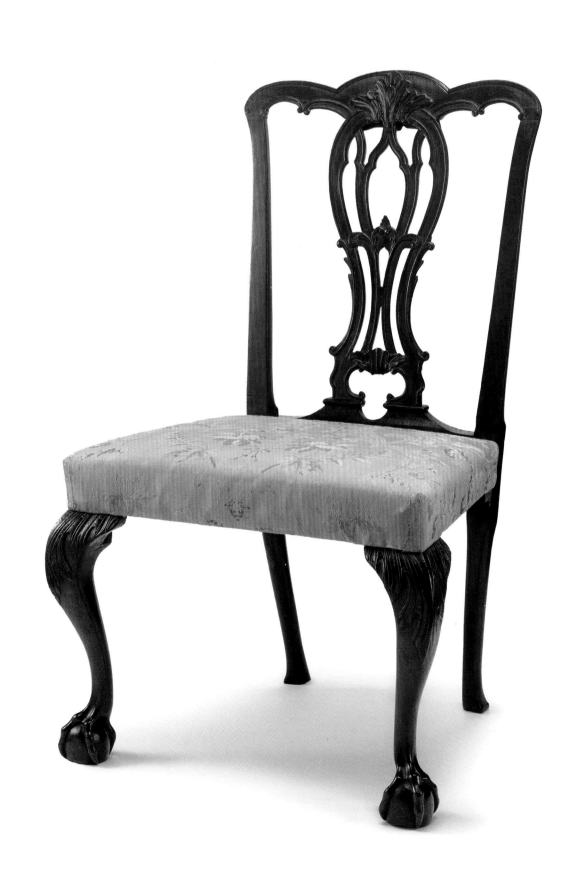

FIG 1
Thomas Chippendale, *The Gentleman and Cabinet-Maker's Director*, 3rd edition (Printed for the Author, 1762), detail of plate 14
Phillips Library, Peabody Essex Museum, Salem, Massachusetts

[RIGHT, CAT 14]
Photographed in Derby House (1762), 168 Derby Street, Salem, Massachusetts.
National Park Service Historic House Collection

the upper echelon of Gould's offerings. There are four prices that may have indicated this level of workmanship.[3] A likely candidate was a set of six chairs sold to Dr. William Paine in October 1773 on the occasion of his marriage to Lois Orne (1756–1822). The chairs, priced at 38/8, were slightly higher than the most expensive Manwaring version. The entry in the second day book reads "to 6 do [chair frames] carv'd @ 38/8." The use of the word "carv'd" occurs in only two other chair entries, both for Manwaring patterns. Three strips of wood added to the second chair of the set appear to document genealogical information about the owners during the nineteenth century. Unfortunately, all efforts to identify the three persons whose initials are present on the second chair have been unsuccessful.

1. For further information on this chair, see Richards and Evans 1997, pp. 100–101. For another example, see Ward et al. 2008, p. 77 (acc. no. 2004.2062). This chair has the stippled background adjacent to leaf carving on the knee.

2. Chippendale's *Director* is listed in Gould's estate inventory, Massachusetts Historical Society, Boston.

3. Other costly chairs were priced at 36/8, for a set sold to Benjamin Pickman in 1765; a set of six sold to Richard Derby for 39s in 1763; and a set of six sold in 1764 to John Dean at 42/8. Dean's set were called "small chairs," which is confusing since one would not usually associate this price level with a small chair. All four sets at these prices were the only examples sold.

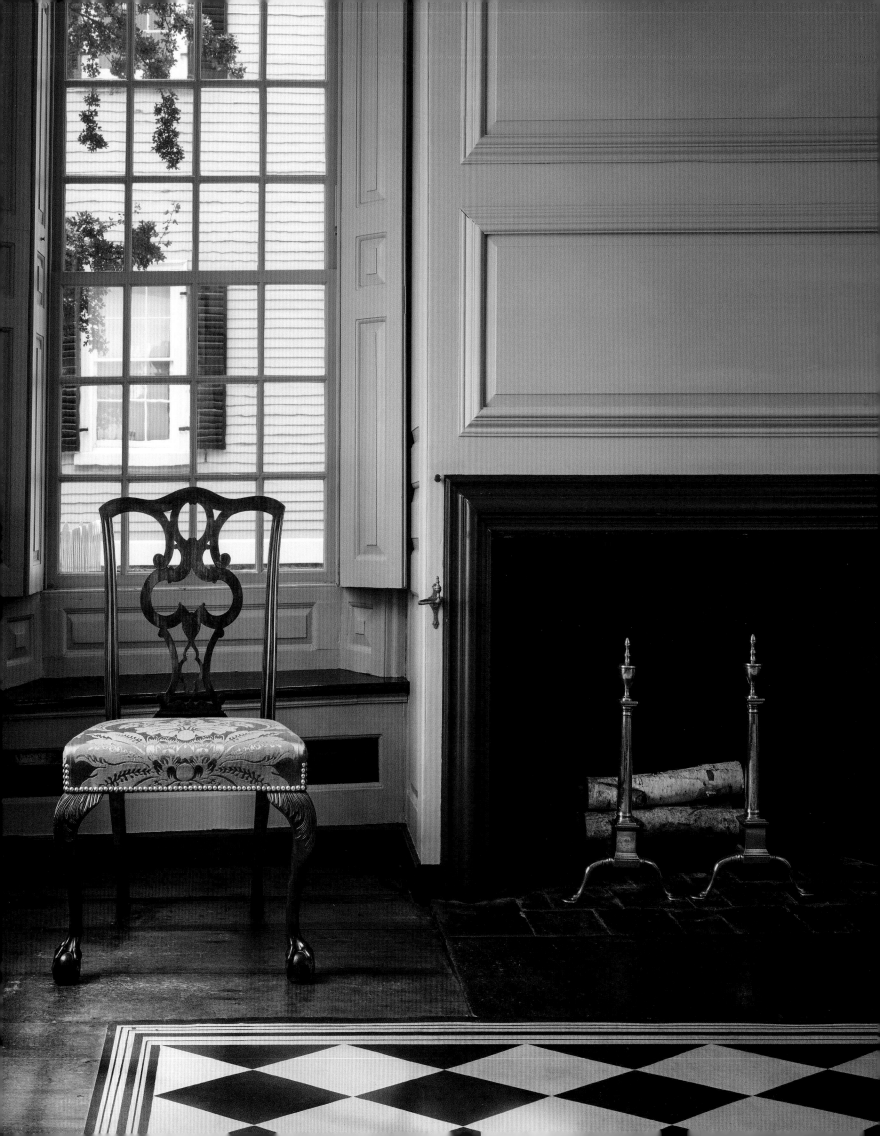

Side Chair

1763–68

Attributed to the shop of Nathaniel Gould

Manwaring-style splat and plain crest rail

Mahogany; secondary woods: maple (front and side rails), birch (rear rail), eastern white pine (corner blocks)

H 37 ½ (overall), H 16 ¾ (seat); W 21 ⁹/₁₆; D 20 ½

Inscribed on underside of shoe by scratching: *III* or *IIII*; at the base of the splat by scratching: *III*

Peabody Essex Museum, Salem, Massachusetts, Gift of John H. Rickertson, 1961 (130002)

PROVENANCE: John H. Rickertson; Peabody Essex Museum, 1961

Eight chairs similar to this example have survived; seven of them are in museums. Chairs in general, and this Manwaring style in particular, are more susceptible to serious damage than case pieces. The number of existing uncarved Manwaring-style chairs should indicate an original production of seventy to two hundred chairs,[1] yet Gould's account book lists only five orders for a total of just forty-two chairs.[2]

Three of the eight extant chairs are of Type A construction and five are of Type B (see Seating Furniture, fig. 4). Based on dimensions, the former are from two distinct sets. The Type B chairs represent at least two and possibly three different sets.[3] This would mean that at least one chair had survived from each of the five sets Gould sold, which seems unlikely. It may instead be that Gould made more chairs of this type, but because their peak popularity occurred during 1763–67, the period for which we have only the account book, documentation may simply be lacking.

This Type B chair features swept-back acanthus-knee carving, lacks stippling surrounding the knee carving, and has only two rosehead nails securing the corner blocks and a single pin securing the rear rail to the leg. The lack of nail impressions on the rear leg indicates the chair was probably upholstered with fabric (see Seating Furniture, fig. 9).

Although it was introduced in 1762, the uncarved Manwaring-style chair does not appear to have had sustained popularity, as only one set was sold after 1768, to the Reverend Thomas Barnard Jr. in 1773. Five

years had elapsed since the previous set sold, which may account for the reduction in price if Gould had components available. By comparison, eleven sets of carved Manwaring chairs were sold, including possibly two sets with slip seats. Seventy-four carved chairs are documented; almost double the production of uncarved chairs. Both designs had a relatively short life, probably because of the tendency of the splats to break. As style-conscious as they may have been, Gould's customers would not have persisted in purchasing furniture requiring frequent repairs.

1. Based on survival percentages of chests of drawers (5 of 56), tables (estimated 10 out of 195), and other forms less fragile than chairs.

2. The Thomas Barnard set of six at 30s. per chair was included with four other sets, totaling thirty-six chairs at 32s. each. Barnard's price was not the price charged for this particular design to other customers, and no other chair or any type was listed at that price. The most likely price charged for the same design is 32s. per chair—the only price level produced in sufficient quantity to account for eight survivors. No apparent difference between the Barnard chair and others of this type explained the 2s. difference.

3. Criteria for determining whether chairs were from the same set included: key dimensions within 1/8 inch; numbers on splat and shoe different between chairs but the same type of marking; signs indicating fabric versus a hide covering the same between chairs.

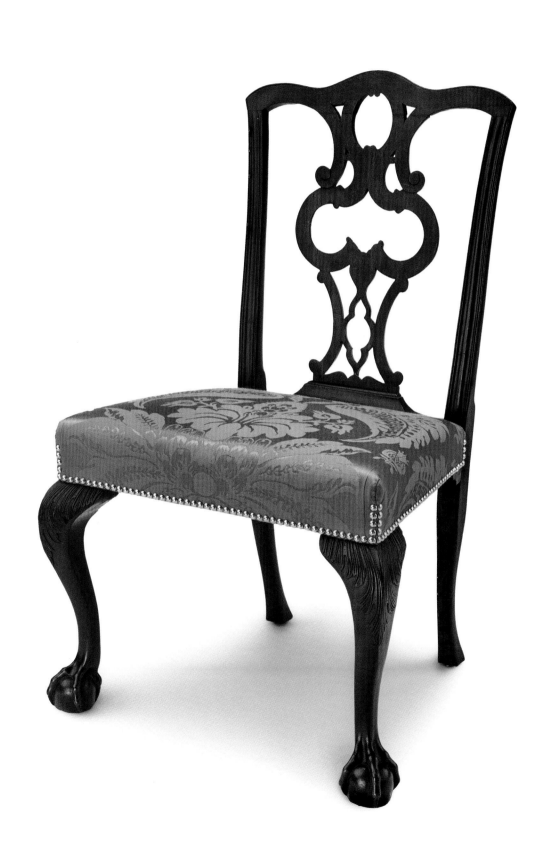

Side Chair

1770

Attributed to the shop of Nathaniel Gould

Manwaring-style splat and carved crest rail

Mahogany; secondary woods: maple (front and side rails), birch (rear rail), eastern white pine (corner blocks)

H 38 ¹¹⁄₁₆ (overall), H 16½ (seat); W 21½; D 21

Inscribed on underside of shoe in chalk: *II*; at base of splat: *II,* and two punched dots

The Metropolitan Museum of Art, New York, Gift of Mrs. Paul Moore, 1939 (39.88.2)

PROVENANCE: Clark Gayton Pickman (1746–1781), August 24, 1770, before his marriage to Sarah Orne (1752–1812); their daughter Sarah Orne Osgood (1771–1791); her sister Rebecca Taylor Osgood (1772–1801); her daughter Sally Osgood (1796–1835), who married the Reverend Bailey Loring (1786–1860); Osgood Loring (1819–1867); John O. Loring (1860–?); John Alden Loring (1895–1947); (antiques dealer Mrs. Francis Nichols, The Antiques Galleries, Boston); Mrs. Paul Moore; The Metropolitan Museum of Art, 1939

With expensive fabric upholstered over the chair rails, finely carved splat and crest rail, and a very stylish design that had never been seen before 1764 locally (Manwaring's book would not be available in Boston until two years later), these chairs must have made quite an initial impression on Salem society, including the Pickman family. The first set of this type was sold in March 1764 to the captain and merchant Jonathan Peele Jr., a year after Gould produced his first examples of the uncarved Manwaring style. The most important early transaction was probably a set of twelve delivered to Mark Hunking Wentworth in November of the same year on the occasion of his daughter's wedding to Captain John Fisher Esq., naval officer and customs collector for Salem and Portsmouth.[1] Over the ensuing ten years, Gould delivered a total of fifty-six chairs with over-upholstered seats and probably an additional eighteen with slip seats. Five chairs, including this pair, are known to survive of the former, but none of the slip-seat version.[2]

The total production of seventy-four Manwaring-carved splat chairs was covered by only ten orders, only one of which occurred after 1770. The form never received widespread popularity within Salem, probably due to the splat's tendency to crack or break outright. Three orders were delivered to Marblehead, in addition to Wentworth's large order destined for Portsmouth, New Hampshire.

1. Although the Pickman sale determines the unit price of these chairs at 36s., no definite sale could be found to indicate a price for slip-seat verions. However, Wentworth's transaction specifically states "movable bottoms" and the difference in price of 1/4 is in the same range as less expensive chairs distinguished by movable bottoms versus over-upholstered.

2. In addition to the one discussed here, a chair is in the collection of the Massachusetts Historical Society, and a pair of chairs was purchased at a Pook and Pook auction by antiques dealer C. L. Prickett and then sold to a private collector in 2010. There may be a third set of two that has survived, whereabouts unknown. The first recorded sale of a pair was offered at auction on January 26, 1945, by Parke Bernet in the sale of Blinn W. Page of Skowhegan, Maine. No connection to any of Gould's original customers could be made to Page. A set of two in the collection of Mr. and Mrs. Harry A. Carlson of Cincinnati was published in *Antiques* 49, 1 (January 1946), pp. 48–49, and the firm of Israel Sack advertised a pair from the collection of Roland V. Vaughn in *Antiques* 66, 4 (October 1954), inside front cover.

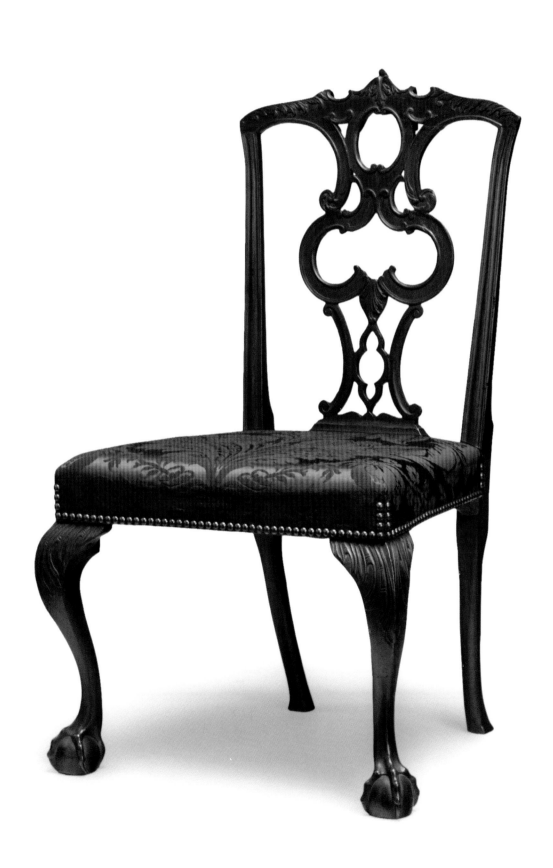

Tables

The transformation from tables primarily for work or dining to more specialized purposes peaked in the middle of the eighteenth century when wealthier people had increased leisure time available for social functions. Many English design books supported this transformation. For example, Robert Sayer's *Household Furniture in the Genteel Taste* (1760) lists china, breakfast, card, claw, dressing, library, night, sideboard, slab, toilet, and writing tables.[1]

Gould's customers ordered many of these types, although differences between English and American terminology sometimes make it difficult to equate names with surviving forms. Gould often used more traditional New England names, such as "chamber table" for Sayer's "dressing table." One of Gould's most popular forms was a chest of drawers he referred to as a "bureau table." The task of identifying specific forms from eighteenth-century inventories has proven difficult for furniture scholars because there is usually insufficient identification as to the type of table listed.

Gould's ledgers are particularly valuable in determining when a specific type was introduced and their price ranges. They document "bureau" (chests of drawers), cabin (used on ships), card, chamber, kitchen, side, sideboard, stand, tea, toilet, and writing tables, but the most popular were conventional drop-leaf tables that could be efficiently stored against a wall when not in use. Options included type of wood, length, shape, feet, and additional decorative carving. Length was the specification most often listed, with 3 1/2- and 4-foot tables accounting for the 77 percent that could be classified. The shop also sold a significant number of smaller tables, most likely with rectangular or square tops, four fixed legs, and perhaps a drawer.

Analysis of the entries enabled the construction of a basic price list for drop-leaf tables (see fig. 1). The drop-leaf tables are the only form made by Gould with sufficient data to reach such conclusions.

Drop-Leaf Tables and Side Tables

By the time Gould commenced business in Salem in 1758, the design of tables with falling leaves (known today as drop-leaf tables) had transitioned from round tables with auxiliary pivoting turned legs, popular in the William and Mary period of about 1690–1730, to round- or

rectangular-topped tables utilizing hinged frame rails. Frame construction was significantly altered in the new style. Four stationary legs were reduced to two, making the table more stable on uneven early flooring. A drawer inside the frame was usually eliminated. Tops were attached to frames by glue blocks sometimes augmented with screws, rather than by a series of vertical pins. Stretchers between the legs were eliminated around 1740. The resulting table was lighter, less expensive to make, and accommodated more seating because there were no stretchers.

Unfortunately, when making entries for an order, Gould's workmen were not always consistent or thorough in the description of what they were making. Determining Gould's prices for specific types of tables was critical to this study. Without analysis to develop the price matrix given here, the ledger entries are a random and unconnected series of data points. This price matrix permitted the tabulation of the number of each table type produced, changes in customer preferences over time, and a sense of ordering patterns.[2]

If two tables were listed at £2..13..4 and one specified mahogany and the second listed length as 4 feet, then others priced at £2..13..4 were considered to be 4-foot mahogany tables. A similar process was used to determine the foot style, based on Gould's surcharge of 1s. extra per carved foot: a difference of 4s. signified four carved feet. The shape of the top had to be the other variable that accounted for two different prices for mahogany tables of equal size and type of foot. Analysis suggests that he charged 13/4 per linear foot for square tops, and 14/8 per foot for round tops.[3]

Of the 183 domestic walnut or mahogany drop-leaf tables Gould sold between 1758 and 1777, 141 gave exact specifications. An additional seventeen tables were defined by price, but data was insufficient to determine their full specifications. The matrix defined a total of 158 tables for 86 percent coverage. Only eight tables had prices that fell outside the matrix. Data was insufficient for eight tables made of other materials, and seventeen entries bore obvious transcription errors.[4] Some characteristics could reasonably be estimated: two tables ordered together were likely made of the same wood unless otherwise specified. Currency fluctuations and rampant inflation prevented analysis

of sixty-three tables shipped after 1777. The shop also produced a minimum of sixty-seven tables destined for export, however, many prices include charges for crating but were not itemized. Transactions that list only the total feet for a shipment were impossible to break down. Thus, drop-leaf tables sold between 1777 and 1782 and all export shipments were excluded from the database for the price list.

The price matrix provides a great deal of information about Gould's trade in particular and cabinetmaking practices as a whole, perhaps most notably the link between furniture purchase and weddings, underscoring the importance of these threshold events and the commissions they generated for the cabinetmaking trade. It also reveals fashion trends, such as the preference for square-top tables. Of the twenty-two walnut drop-leaf tables in the price list, 64 percent were 4-foot tables, and the majority had square tops. Walnut was used infrequently as a table wood after 1768, supplanted by mahogany. Of

the 119 mahogany examples in the price list, only fifty-six (47 percent) were 4-foot tables, as preferences shifted toward a variety of sizes; fifteen were specified with ball-and-claw feet, and round or oval tops were ordered 27 percent of the time.

Only one drop-leaf and no side tables could be tied directly to Gould, although two tables share a long history of family ownership in Salem.[5] Attribution was based on similarity of foot carving and the quality of mahogany used.

Since side and conventional drop-leaf tables share construction characteristics, if one table type could be put in Gould's shop, the other would follow. Both have an apron or end board in the shape of a cupid's bow. The knee returns are a typical Salem design of sharp corner to the radius ending in a raised volute (fig. 2). The legs incorporate a well-formed cabriole terminating in ball-and-claw feet with thin claws descending vertically (see fig. 6). Most of the tables have an external

FIG 1

Reconstructed Price List for Mahogany and Walnut Drop-Leaf Tables, 1758–76

LENGTH	FOOT CARVING	WALNUT SQUARE	WALNUT ROUND	MAHOGANY SQUARE	MAHOGANY ROUND
		(0..10..8 / FT.)	(0..12..0 / FT.)	(0..13..4 / FT.)	(0..14..8 / FT.)
2' 9"	Pad	1..9..4	1..13..0	1..16..8	2..0..4
	B&C	1..13..4	1..17..0	1..20..8	2..4..4
3'	Pad	1..12..0	1..16..0	2..0..0	2..4..0
	B&C	1..16..0	2..0..0	2..4..0	2..8..0
3' 6"	Pad	1..17..4	2..2..0	2..6..8	2..11..4
	B&C	1..21..4	2..6..0	2..10..8	2..15..4
3' 8"	Pad			2..8..10	2..13..9 $\frac{1}{3}$
	B&C			2..12..10	2..17..9 $\frac{1}{3}$
3' 9"	Pad			2..10..0	2..15..0
	B&C			2..14..0	2..19..0
4'	Pad	2..2..8	2..8..0	2..13..4	2..18..8
	B&C	2..6..8	2..12..0	2..17..4	3..2..8
4' 6"	Pad	2..8..0	2..14..0	3..0..0	3..6..0
	B&C	2..12..0	2..18...0	3..4..0	3..10..0
4' × 5' (oval)	Pad				3..0..0
	B&C				3..4..0
4' 9"	Pad				3..9..2
5'	Pad	2..13..4	3..0..0	3..6..8	3..13..4
	B&C	2..17..4	3..4..0	3..10..8	3..17..4

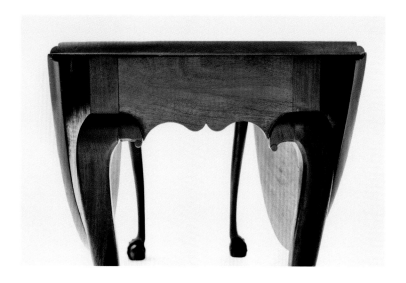

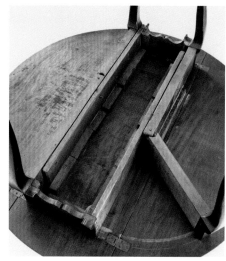

glue block mounted on the outside of the frame adjacent to the outer fixed rail (fig. 3). Horizontal glue blocks inside the frame attach it to the fixed top. The underside of the top is extensively tooth-planed to aid in setting a strong glue joint. Two rows of three or four rosehead nails attach the inner rail to the fixed outer rail. The end rails are tenoned and pinned at one end and dovetailed to the inner stationary rail at the other end. A vertical glue block reinforces the dovetailed joint. Iron butt hinges, often of unequal length, are usually positioned with one edge in line with the end rail of the frame and attached the folding leaf to the fixed top of the table. Very thin filler blocks are usually placed between the fixed outer rail and stationary inner rail. The dovetailed format of the inner rail to the end rail usually consists of a half dovetail at top and bottom, and three full dovetails between. The hinged joint of the fly-leg incorporates a five knuckle joint, three on the fixed rail, two on the fly-rail. A semicircular relief cut is made on the fixed rail at the hinged joint when viewed from the bottom. The ends of the knuckles are vertically chiseled for clearance.

Side Tables

Among the many table types documented as being produced in Gould's shop was one not commonly referred to today, the "side table." The Gould references to a side table were at first a mystery. Those ledger entries include no further description—the wood used, the table's shape, or dimensions. Their price, with two exceptions, indicates the use of mahogany. The tables were approximately 3 feet in dimension,

as prices are very close to those charged for 3-foot conventional drop-leaf mahogany tables. The term "side table" is descriptive of the table's actual use, for it was intended to be placed permanently against the wall, whereas conventional drop-leaf tables were frequently moved to accommodate more than three people. The logical identification is a single drop-leaf table. Such tables were not intended to replace the conventional drop-leaf, but rather act as a useful supplement to the household when serving only one to three sitters. Inventories during the period made no distinction between the single and double drop-leaf table, hence identifying them is difficult. Existing examples are extremely scarce and the majority of them are attributed to artisans working in the Salem area.

The Gould shop produced twenty-seven examples of this very rare form.[6] Because no existing side table has any history of ownership to Gould customers, their attribution is more difficult. Despite the lack of comparative data to other forms, three clues indicate that some surviving tables, including cat. 17, probably originated in the Gould shop.[7]

The first involves numbers. Fewer than twenty-five Massachusetts single drop-leaf tables survive, but four of them undoubtedly originated in the same shop and are made of extremely dense mahogany.[8] None of the remaining eleven tables appears to share characteristics with any other, and thus were made in different cabinet shops. Construction features common to the four are shared by a number of conventional drop-leaf tables of various sizes. Gould was the dominant

cabinetmaker in Salem during the 1760–81 period. His shop produced 260 conventional drop-leaf tables in addition to the twenty-two side tables. It is highly unlikely that any of the lesser-known cabinet shops in Salem produced this number of surviving side tables.

The second indication is the choice mahogany. Gould imported significant quantities of mahogany from the West Indies and acted as a supplier to many of Salem's cabinetmakers, but he saved the most select woods for his own use. The four surviving side tables that are probably from Gould incorporate the finest grade of mahogany available.

The third clue to possible attribution involves the secondary wood. Cat. 17 has a fixed outer frame and swing rail made of mahogany, rather than the customary birch or pine. This choice was highly unusual, and the use of a wood double the price of other woods indicates a shop where mahogany was readily available. Mahogany was used for secondary surfaces in other Gould furniture, for example, in desk-and-bookcases.

Breakfast Tables

Thomas Chippendale's *Director* (1762) illustrates two types of drop-leaf breakfast tables in plate 53 (fig. 4). The first has a mid-shelf for storage of condiments or food, and the second has a drawer but no mid-shelf; the latter became known as a Pembroke table as early as 1780.

However, in inventories and price books of the period, the term "breakfast table" also encompassed other forms.

Although no such object has been identified and thus details are unknown, Gould's ledgers list six breakfast tables prior to 1774, all priced between 7/4 and £1, which places them squarely in the middle of other tables described as "small." However, the entries do not necessarily describe the form being produced, as terminology was inconsistent, and some "small" tables may have been breakfast tables.[9] Based on their prices, they were probably made of less expensive wood such as maple or cherry and devoid of carved decoration. Some may even have been made of pine and painted.

The sale on July 6, 1774, to Francis Cabot (1757–1832), delineates the introduction of a Pembroke table. Described as a breakfast table, but priced at £3—triple any previously listed breakfast table—it was clearly a different type. The table was part of an expensive dowry for the wedding of Cabot's daughter Susanna (1754–1777) to John Lowell (1743–1802) of Newburyport. Its form was clarified three years later when Cabot's son Andrew ordered "1 breakfast table with 2 draw & leave" (fig. 5). Although its market was limited, Francis Cabot, Henry Brown, and William Pickering, three of Salem's most affluent citizens, also ordered the expensive model. Gould sold five more of the ordinary breakfast tables between 1777 and the shop's closure in 1783.

Card Tables

Originating in Europe in the mid-to-late seventeenth century, card tables are listed in American probate inventories as early as 1720. By the time Gould arrived in Salem in 1758, they had achieved widespread popularity; his first sale of this table type occurred in October of that year. Gould's card tables would have followed the general Chippendale style, consisting of a rectangular top, a hinged fly-leaf that opens to provide the full playing surface, and four cabriole legs with one rear leg (the fly-leg) swiveling to support the leaf when opened. Based on price comparisons, thirteen of the fifteen card tables he sold prior to the revolution were mahogany and two likely were walnut. Sales to the Reverend Thomas Barnard Jr. and Judge William Pynchon Esq. describe the decoration of the mahogany tables: they had "carved knees

& border" and sold for £4. Conversely, one for Jeremiah Lee Esq. of Marblehead had "carved knees and toes" and sold for £4..8..0. Since ball-and-claw feet carried a standard charge of 1s per foot, there must have been additional embellishment worth 4—perhaps a more elaborate interior with pockets for chips or possibly a drawer. A year later, Lee ordered the most expensive card table sold by Gould, priced at £5. A 1775 order for William Vans Esq. specified an interior "lined with green cloth." Since the price was less than the £4 charged for the majority of mahogany card tables, it is assumed that it did not have any carved decoration. It also might imply that most tables were lined with green cloth, assumed to be baize.

Gould's shop produced a total of twenty-nine card tables during the period 1758–81; three of them were destined for export. Of the twenty-six

FIG 5
Detail of Nathaniel Gould's Account Book showing Andrew Cabot's order,
April 5, 1777
Nathan Dane Papers, Massachusetts Historical Society, Boston

FIG 6
Detail of cat. 16 showing typical ball-and-claw foot on a table

sold in Salem, eight were sold in pairs—a trend started in 1775 when Jeremiah Lee included a pair in the dowry furniture for his daughter Mary (1753–1819) for her wedding to Nathaniel Tracy of Newburyport.

Chamber Tables

Nathaniel Gould referred to what today is called a lowboy or dressing table as a chamber table. His first sale of this form was in 1756 to Moses Paine, predating his first day book entry and possibly made while Gould was still living in Charlestown.

No surviving chamber table can be attributed to Gould. He produced only nineteen examples—fourteen prior to 1770 and none after 1775. Ten of the sales were made in conjunction with the purchase of a case of drawers, which, based on prices, was probably a high chest (highboy).

The ledgers do not specify the wood used for any chamber tables, but some assumptions are possible. When sold with a companion piece, the woods were assumed to match. Further, if either a case of drawers or a chamber table was identified as to wood, then all other furniture selling at the same price was assumed to be of the same material. Finally, if the probate inventory of a customer identified the wood of their case of drawers, and a chamber table was listed as a companion, the two were assumed to be of the same wood.[10]

Likewise, it is possible to speculate on the typical form of his chamber tables. If made of mahogany, its wood would be superior to most grades commonly encountered. Gould controlled most of the select mahogany arriving in Salem, acting as wholesaler to other joiners and probably reserving the best wood for his own use. Pad or ball-and-claw feet were options (fig. 6). The skirt would be shaped with opposing ogee curves interrupted with a short straight section. Between the two curves, there might be a diamond-shaped cutout. The lower center drawer might have a fan carving similar to those used on chest-on-chests (see cat. 4) or desks. Knee returns would be designed with a sharp corner in the radius that ended with a raised volute (see fig. 2).

The decline in use of the chamber table appears to match the decline of its companion case of drawers, the highboy. The latter was supplanted by the chest-on-chest, and it appears that bureau and toilet tables served the function formerly reserved for chamber tables.

Sideboard Tables

Intended as a serving aid in the dining room, this table was also used to display the accouterments of formal dining, such as silver services, wine decanters, and knife boxes. Of the eight tables described in the

FIG 7
Stand Table, 1750–75
Massachusetts
Mahogany, H 23 ⅛; W 31¾
Salem Maritime National Historic Site,
Salem, Massachusetts (SAMA 2280)

ledgers as "side board," probably no more than three are candidates for the classic type. The identification problems are illustrated by the August 3, 1779, entry for Dr. Isaac Spafford of Beverly. In the day book, it is called a "side table," but the account book lists the transaction as a "side board table." Inflation at this time makes identification by price impossible. The first five sales are called side board tables and fall in the range of prices charged for conventional side tables—whether by coincidence or misnaming.

Gould's sideboard tables were probably larger than the single drop-leaf side table and supported on straight rather than the cabriole legs as illustrated in Chippendale's *Director* (1762), plates 56–57. Gould's form should not be confused with the later large Neoclassical-style sideboards.

Stand Tables and Stands

Round tilt-top tables were known by various names in the eighteenth century. Throughout Gould's ledgers and in many Salem inventories of the period, they were called "stand tables." This table had a hinged mechanism that enabled the top to be placed upright, thus allowing for easier movement in a room. It offered more flexibility than any other

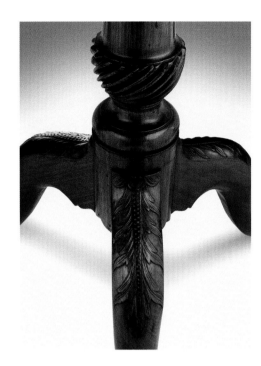

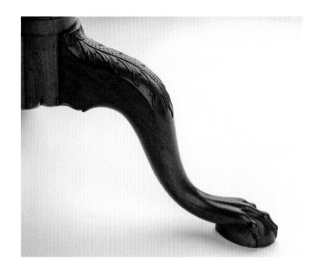

FIG 8
Diagram of a typical Essex County stand table column

FIG 9
Detail of cat. 18 showing typical urn carving

FIG 10
Detail of cat. 18 showing typical knee and foot carving

furniture form, as it could be placed in a corner or against a wall when not in use, located near a window during the summer, and, probably most important, moved near a fireplace in winter. It served multiple functions as a worktable, a dining table, or for taking tea.[11]

Starting as early as 1758 and continuing until it closed in 1783, Gould's shop produced a total of 138 stand tables, including nine for export. Of the ninety-three manufactured prior to 1777, only nine were walnut or cherry; the balance were mahogany. The most popular model, which accounted for sixty-four objects or 77 percent of the total mahogany production, was priced at £2, had a plain knee, a plain urn, and "snake" feet. [12]

Although a number of Massachusetts North Shore stand tables survive, very few have a family provenance[13] and none could be firmly attributed to Gould. Part of the difficulty is that the table's idiosyncratic construction shares few elements with documented Gould case furniture or other objects. The best indications of possible attribution are select mahogany, superior carving, and attention to detail in design—all characteristics of other Gould furniture.

For Gould's basic model, priced at £2, customers could choose a top that was round, square, or square with serpentine edges (fig. 7). The single-board top is attached to the columnar three-legged base by two rectangular cleats with beveled edges. It is hinged to a square block and attached to the top of the column, which for Gould and

FIG 11
Detail of stand table attributed to the shop
of Nathaniel Gould, now in a private
collection, showing original leather disk
caster

other Essex County cabinetmakers took a typical form (fig. 8). A brass latch secures the top when lowered. Three cabriole legs dovetailed to the bottom of the base usually have a wrought iron or tin reinforcing plate (spider) nailed to the underside of the column and legs. Notches in the exposed sides of the base cylinder and leg give the appearance of a scalloped edge. Cabriole legs terminate in snake feet on elliptical shaped pads. Three customers desiring rat-claw feet paid one shilling per foot more than the standard, or £2..3..0. An additional three people, including Richard Derby and Mark Hunking Wentworth, paid 1s. more, or £2..4..0, for an undetermined embellishment believed to have been carved spiral flutes in the urn or possibly added acanthus-leaf carving to the knees (figs. 9 and 10).[14]

The second most popular model, priced at £2..8..0, accounted for fourteen sales and remained in vogue through the revolution. Buyers were from the upper echelons of Salem society. Trend-setting Hannah Cabot, widow of Dr. John Cabot (1704–1749), ordered the first with this decoration in 1761.[15] Orders from Jacob Fowle Jr., Richard Derby, and Samuel Curwen Esq. followed. A clue to its top shape is given by the entry for Ichabod Glover on December 21, 1770: "Stand Do [table] Carved Feet Holo Top" (Holo or "hollow" indicating a dished top). These tables were probably circular with a so-called "pie-crust" carved edge (see cat. 18).[16] Three tables sold at higher

prices might have included casters mounted to the feet (fig. 11), or carved flutes in the tapered cylinder of the column.[17]

Stands

Gould's account book entries that make reference solely to a "stand" may be considered as notations for a smaller version of the stand table. But, whereas a stand table served many purposes, a stand was usually designed for one specific function. The ledgers give eight uses: screen (pole or fire) stands (3 were sold), bottle stands (10 sold in pairs), candle stands and "light stands" (34), glass stands (1), reading (sloped surface for holding manuscripts) stands (2), kettle stands (2), "stand for a clock" (1), and urn stand (1). The functions of nine stands were not specified. Most were priced from a few shillings to £1, and like their bigger cousins, probably had three legs, a column, and a top. Whereas stand tables, larger and intended to be moved, incorporated a tilt-top and latch mechanism, most stands probably had tops screwed to a cleat that was firmly attached to the column and hence fixed in position.

No surviving stands could be firmly attributed to the Gould shop, but two candle stands are possible candidates. The first (fig. 12) incorporates all the features appearing in the most expensive stand tables, including the fluted column. A simpler candle stand of extremely dense mahogany and with well-defined rat-claw feet is in the Chipstone Foundation collection (fig. 13).

Tea Tables and China Tables

No new social custom had more impact on eighteenth-century American furniture design than the ritual of drinking tea. Introduced in Holland in the early seventeenth century by traders traveling from China, and first used for medicinal purposes, tea became a regular part of the morning meal and the centerpiece for afternoon gatherings. It inspired the creation of specialized furniture.

Tea tables were made primarily in two styles: with a rectangular top and four legs, and with a round tilt-top supported by a pillar with three legs. The Gould ledgers and other New England account books referred to the former as a tea table; Gould called the latter a stand table. Conversely, in the Middle Atlantic states, these round tables on a pillar were called tea tables.

Gould's tea tables were probably rectangular with square corners and a raised rim; they were sometimes called square tables because of the corners. The molding around the edge would have protected delicate china and also discouraged the use of the tea table for other activities. Generally, tea tables averaged 26 to 26 7/8 inches in height—somewhat shorter than tables intended for eating. Whereas Gould's

stand tables were purchased by many Salem residents, only his wealthiest clients bought tea tables. The form was particularly favored in Marblehead—the destination for five of the nine sold domestically between 1759 and the mid-1760s, when they seem to have lost their appeal. Two more were exported. Among the purchasers were Elias Hasket Derby and Benjamin Pickman Esq. As for the eleven tea tables, ten appear to have been made of mahogany. The last tea table was sold in 1764 to Jonathan Peele Jr. and the first object referred to as a "China table" was sold the following year, possibly indicating a new preference for this more expensive furniture form used for the same purpose. Prices for mahogany tea tables ranged between £2 and £2..8..0, the same range as for a 3-foot mahogany drop-leaf table. Pad or ball-and-claw feet and acanthus leaves carved on the knees were probable options. There was one exception, however: a tea table sold to Benjamin Pickman Esq. in December 1762 priced at £5..6..8. It may have been a turret-top tea table popular in Boston, or perhaps it was simply misnamed.

China tables, a specialized version of the tea table, were introduced to New England during the 1750s. Their primary purpose was

FIG 12
Candle Stand, 1760–80
Massachusetts Mahogany,
H 27 7/8; W 14
Location unknown

FIG 13
Candle Stand, 1780–90
Salem, Massachusetts
Mahogany, H 27; W 16 3/4; D 16 3/4
Chipstone Foundation (1978008)

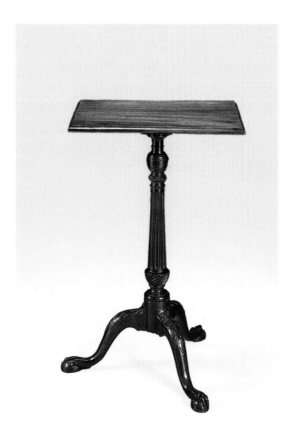

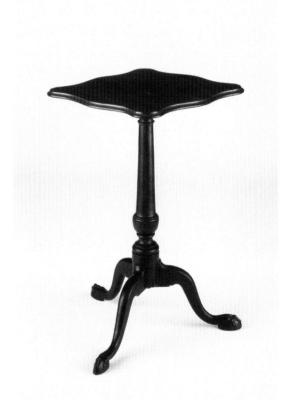

to display the accouterments of tea service. The table is depicted in the first edition of Chippendale's *Director* (1754) as well as in the third edition (1762), which Gould owned (fig. 14). Its rectangular top usually incorporated a raised gallery around the perimeter. Unfortunately, no Gould survivors of this table type are known. Of his four listings for China tables, only three match the description, the one sold to Sylvester Gardiner Esq. in 1774 for £2—half the price of the others, was probably a misnamed tea table. The most expensive example by far, at £6..13..4, was sold to the firm of Francis and Joseph Cabot in June 1765. It was almost double the price of the other two China tables sold in 1775 to Peter Frye Esq. and to Jonathan Payson. Comparison to Gould's price of £6 for a typical bureau table hints at the assumed ornamentation of the Cabot China table.

Another object associated with serving tea or other treats, the server, is listed in the miscellaneous category in the appendices. It is a smaller version of the rimmed or scalloped table tops of stand tables (fig. 15).

Miscellaneous Tables

Some tables could not be placed in a major subdivision category. Most are described simply as "small," but for others, the description indicates nothing more than the type of wood used, generally cherry, maple, or pine. Five table types included here deserve comment.

Cabin Tables. A number of shipowner/captains ordered cabin tables from Gould's shop. Prices varied widely and probably depended on the size of the ship's cabin and whether the tables were to be built in.

Kitchen Tables. Eleven entries from 1758 until 1781 are priced mostly in the range of 12s. to 16s., although a December 1767 for Captain Josiah Orne is priced at £1..3..4. Four of the eleven are included in wedding orders. These tables probably were ruggedly constructed in maple or pine and had straight legs. One for John Gardner Jr. in July 1759 identified as being "colard" was probably pine and painted.

Toilet Tables. Four of the ten objects identified as" toilet" tables were also connected to wedding orders. First appearing in 1763, this table form was generally priced between 4s. and 8s., and was most likely pine. Inventories of the period describe them as placed in a bedchamber;

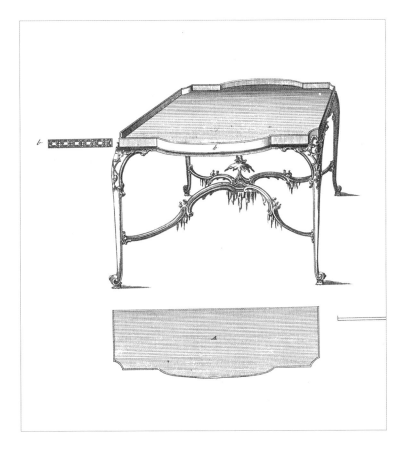

FIG 14
Thomas Chippendale, *The Gentleman and Cabinet-Maker's Director*, 3rd edition (Printed for the Author, 1762), detail of plate 51
Phillips Library, Peabody Essex Museum, Salem, Massachusetts

they were probably covered with a fabric and used by the lady of the house and appeared about the time that chamber tables were going out of favor. Many of the tables described in the ledgers as "small" may have been toilet tables.[18]

Writing Tables. Chippendale's *Director* devotes six plates to his "writing table," ranging from simple to very ornate. Gould identified three entries as writing tables between 1773 and 1778. These were probably of substantial, yet simple, construction and similar in form to the sideboard tables. Sales of this type were probably influenced by the intriguing order in June 1774 from General Thomas Gage, commander of British forces in North America, which included "a large table and form," four tables made of deal, and two small tables.

Frames for Slab Tables. Two and possibly three table frames were ordered for use as "slab" (marble-topped) serving tables; the tops evidently came from a different supplier. The two identified frames for Captain John Fisher Esq. and Samuel Flagg both cost £1..16..0..4. Another frame possibly for this purpose, but identified only as "a frame for a larg squair table," was sold to John Tasker Esq. in June 1758 for £2.

1. For social customs and their impact on table design and use, see Barquist 1992, pp. 14–25. For eighteenth-century tables, see Richards and Evans 1997, pp. 213–19.

2. Tables made of cherry or maple were considered fixed-leg unless length was given; tables priced less than a 2 1/2-foot walnut table were considered fixed-leg.

3. Cabinetmaker Robert Lionetti helped determine which top shape was more expensive. The conclusion is also supported by the fact that of eleven pairs of tables ordered mostly for wedding dowries, only one pair called for round tops. Square tables could be abutted to form a large dining table.

4. Most prices outside the matrix were higher than the description indicated and were for objects sold to affluent Salem residents: (1) John Crowninshield, (2) Elias Hasket Derby, (2) Dr. Bezaleel Toppan, (1) George Dodge, (1) Samuel Grant, (2) Deborah Tasker, (1) Daniel Cheever, (1) John Fisher Esq., (1) Nathaniel Leach, (1) John Jenks. This suggests there were added embellishments or a more expensive wood was used. The price of £3 describes a 4 1/2-foot mahogany table with a round top as indicated by all parameters used in establishing the price list. However, eleven orders at this price are described as a 4-foot table. An order for Dr. Sylvester Gardiner Esq. in December 1774, for two tables priced at £6 was a key: they were described as 5' × 4' tables and this terminology was used in defining the other ten orders. Although no description exists, it is most likely that this was an oval-shaped top 4 feet in length and 5 feet wide when opened. When compiling data for the price matrix, the Samuel Holman, Thomas Elkins, and John Tasker orders were determined to be mahogany, 3 1/2-foot, square tables with pad feet. However, two orders in December 1770 for Ichabod Glover and Billings Bradish were both priced at £2..6..8, but listed as "3 1/2 foot tables with claw or carved feet." Based on prices per linear foot according to the price matrix, it was concluded that these entries and other outliers contain errors. Most errors involved incorrect conversion from old to new tenor pricing, or pricing from the list indicating a specification different from the ledger description—perhaps as a result of a change in the order.

5. A 4 1/2-foot round mahogany drop-leaf table with ball-and-claw feet descended in the family of William Northey until sold at auction in 2009. Northey purchased half of the house that Nathaniel Gould lived in (see cat. 16).

6. Two customers listed as purchasing two side tables are separated by two years between the entry in the day book and the account book. These have been counted as separate transactions, however, they could have been for the same transaction and the posting to the account book occurred at a late time. See the Daniel Mackey entry for a side table priced at £2..4..0, February 7, 1762, and an entry in the account book for April 1764 at the same price.

7. See cat. 17. This table is also discussed in Barquist 1992, cat. 54.

8. In addition to cat. 20, one sold at Sotheby's New York, "Important Americana: Furniture and Folk Art," 6957, January 17, 1997, lot 975, and again at Northeast Auctions, Manchester, New Hampshire, "Americana Auction," August 4–6, 2006, lot 1798, and is now in a private collection. Another, not examined by the writer, was published in *Antiques* 102, 3 (September 1972), p. 289, and again in *Antiques* 90, 2 (August 1966), p. 141. A fourth, examined, example sold at Legare Auctions, Byfield, Massachusetts, February 3, 1993, had descended from William Augustus Horton of Salem; it is now in a private collection. Results of a comprehensive survey of single drop-leaf tables by furniture scholar Betsy Davidson have identified over twenty existing side tables, most from eastern Massachusetts.

9. The account book entry for John Donaldson in 1780 records a sale of "1 small do [table] 24/," but the day book reads: "1 break't [breakfast] table."

10. Walnut cases of drawers were sold to Edmund Whitemore Jr. and Jonathan Ireland at £7..6..8. Although they did not buy accompanying chamber tables, John Saunders and Zaccheus Collins did when they purchased their cases of drawers at the same £7..6..8, hence, walnut. Their chamber tables are assumed to be of the same wood. Likewise, Susannah Hathorne paid £8..13..4 for a case of drawers identified as walnut, the same price Roland Savage paid for his high chest. Two years later, he ordered a chamber table. The wood was identified on three more chamber tables, sold at £2..8..0, the price paid by Savage and Collins, which matches the chamber tables purchased by Moses Paine, John Tasker Esq., and Dr. James Bradish. The John Hodges Inventory identified the chamber table as mahogany. See Massachusetts Probate Records of Essex County (hereafter PREC), vol. 367, p. 355. The Jacob Fowle Inventory of January 27, 1779, identified a case of drawers and "one chamber mahogany table with drawers." See PREC, vol. 363, p. 373. Their price of £3..6..8 identified the chamber tables of Timothy Pickering, Captain Josiah Orne, Henry Williams, and Jonathan Payson also as mahogany. Identification of the wood for the remaining tables is probable, based on the proximity of prices to the identified examples.

11. For the names for tilt-top tables and their evolution, see Barquist 1992, pp. 232–33. For their usage, see Garrett 1990, pp. 62–66. The basic characteristics of the form are discussed in Sack 1987, pp. 248–52.

12. Almost 80 percent of Gould's mahogany stand tables had snake feet, a plain urn, and undecorated knees. The number of surviving Essex County tables *without* embelishment is much less than those that were originally produced. Unfortunately, many plain stand tables were recarved later (on knees, feet, and/or urn) in an effort to increase their price.

13. For an Essex County round-top stand table that descended in a Newburyport, Massachusetts, family and is one of very few examples with a provenance, see Jobe and Kaye 1984, pp. 29–98.

14. A plain stand table with a square, serpentine-edged top, rat-claw feet, and no later embellishment is pictured in an advertisement for Donna Brown Antiques, in *Antiques* 123, 6 (June 1983), p. 1138; see also Northeast Auctions, Portsmouth, New Hampshire, "New Hampshire Three–Day Auction," May 18–20, 2001, lot 746. A stand table with a square serpentine top, rat-claw feet, and a carved spiral fluted urn was offered in Northeast Auctions, Portsmouth, New Hampshire, "Collection of Cora and Benjamin Ginsberg," August 3, 2003, lot 1817.

15. Hannah Clark Cabot was also the first Salem resident to order a single-leaf side table, and she probably ordered the second bonnet-top chest-on-chest.

16. In addition to the catalogue entry, two other possible examples are featured in Parke Bernet, New York, "Important Americana," January 26–27, 1945, lot 247; and an advertisement for John Walton, Inc., in *Antiques* 123, 2 (February 1983), p. 272.

17. A square-top stand table with carved fluted urn and column, carved knees, and possibly recarved feet is illustrated in an advertisement for Linda D. Peters, Inc., in *Antiques* 130, 1 (July 1986), p. 50.

18. For the use and form of toilet tables in Boston, see Richards and Evans 1997, p. 296.

Drop-Leaf Table
1759–70

Probably shop of Nathaniel Gould

True mahogany group (*Swietenia* spp.) and Cuban mahogany (*Swietenia mahogani*); secondary woods: eastern white pine and birch

Dimensions: H 27 7/16; L 54 3/8; W 18 7/16 (leaves closed); W 53 3/4 (leaves open)

Private Collection

PROVENANCE: Possibly William Northey (1735–1804) of Salem; his son Ezra Northey (1779–1855); definitely William Northey (1829–1900); his son William E. Northey (1869–?); his daughter Cynthia W. S. Martin (1916–2009); anonymous family member; (Hudson Valley Auctioneers, Beacon, New York, September 21, 2009); the present owners, 2009

This table and a side chair (cat. 9) are claimed by the family to have always remained in their possession, however, in both cases, no such sale to William Northey is recorded in Gould's ledgers.[1] Nonetheless, there are clues that suggest a strong possibility for the original purchaser. Fortunately, Gould left enough information to compile price lists for mahogany and walnut drop-leaf tables (see Tables, fig. 1). This table measures 4 1/2 feet in diameter, a very rare size. Between 1758 and 1777, Gould documented sales of only seven mahogany tables of this size, of which six had square tops. The one round table sold also had ball-and-claw feet. No round mahogany tables in any size were sold after 1769.[2]

In March 1765, an account book records the sale of "1 mehogony table 4 1/2 foot long" to the firm of Francis and Joseph Cabot for £3..10..0 (fig. 1). The price list further defined the table as being round with ball-and-claw feet. In the same transaction, the Cabots ordered a bombé desk-and-bookcase (see cat. 7). Whether this is the table sold to the Cabot firm and then subsequently purchased by the Northey family, or whether two tables of this model were made, will probably never be known. It survives in excellent original condition as an example of a rare model of Gould's drop-leaf table portfolio.[3] Construction follows his standard shop practice for the form, and the finish appears to be an old shellac.

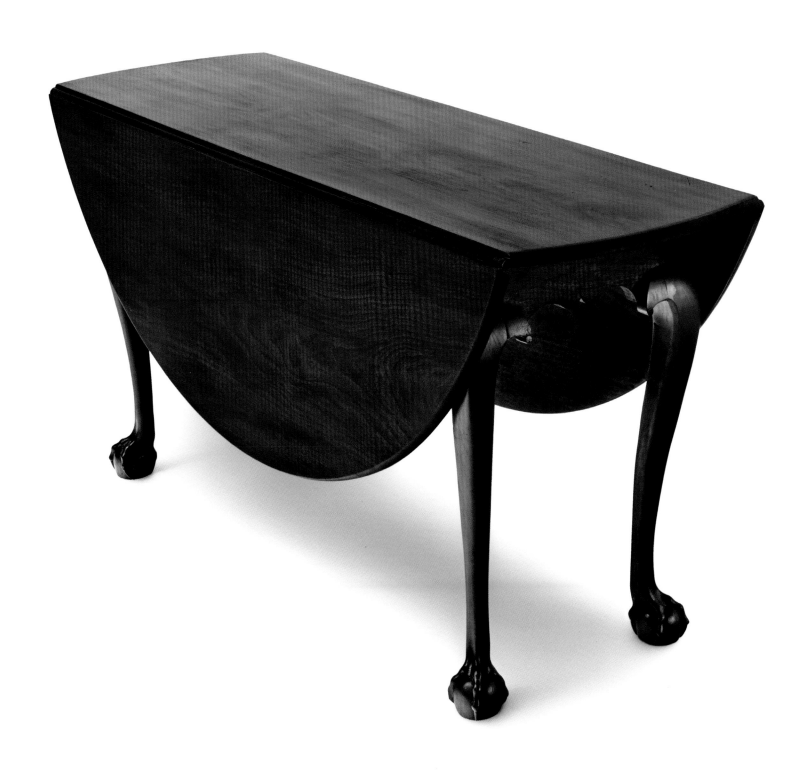

1. See entry on cat. 9.

2. Although there is no record of a round mahogany table sold after 1769, there were six tables described only as 5-by-4 feet and assumed to be oval in shape during the 1770s. Pricing after 1776 was too erratic to determine table size, shape, or foot type.

3. Microscopic analysis performed by Alden Identification Service, May 6, 2013, revealed two different types of mahogany.

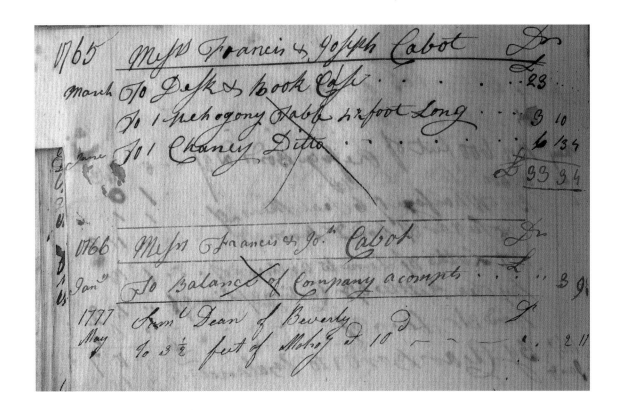

[RIGHT, CAT 18]
Photographed in Derby House (1762),
160 Derby Street, Salem, Massachusetts.
National Park Service Historic House
Collection

FIG 1
Detail of Nathaniel Gould's Account Book
showing Francis & Joseph Cabot's order,
1765
Nathan Dane Papers, Massachusetts
Historical Society, Boston

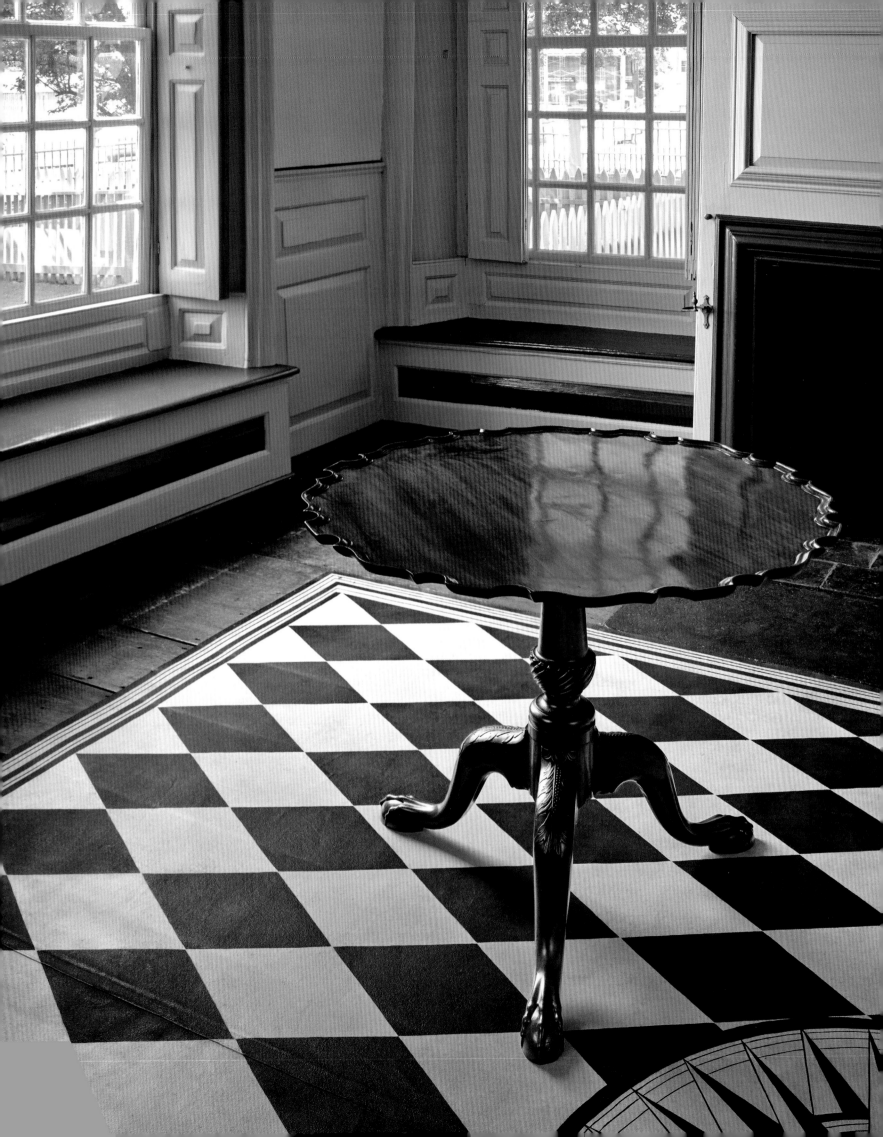

Side Table

1760–80

Probably the shop of Nathaniel Gould

Dense mahogany; secondary woods: mahogany (rear frame rail, fixed and swing portions of outer rail) and white pine (inner stationary rail, glue and filler blocks)

H 27 ¹³⁄₁₆; L 35 ¾; W 18 ¾ (leaves closed), W 35 ¾ (leaves open); Distance of fly-leaf to floor when leaf is down: 9 ¼

Inscribed on underside of fly-leaf in chalk: *I* or *J Wilder*

Yale University Art Gallery, New Haven, Connecticut, Mabel Brady Garvan Collection (1930.2224)

PROVENANCE: (Antiques dealer Charles Woolsey Lyon); Francis P. Garvan, April 25, 1929; Yale University Art Gallery

The eighteen customers for Gould's unusual "side tables" were among Salem's elite. The widow Hannah Clark Cabot ordered the first table in August 1761, and was evidently so pleased that a second was ordered five months later. The first appears to have had plain pad feet priced at £2. The second table, priced at £2..8..0, probably was embellished with ball-and-claw feet and additional carving.[1]

Wedding gifts accounted for nine of the tables; Richard Derby gave two to his daughter Martha (1744–1802), when she wed Dr. John Prince; Jeremiah Lee Esq. of Marblehead gave one to his son Joseph (1748–1785); one was included in the dowry of Lois Orne (1756–1822) on her wedding to Dr. William Paine; Dr. Bezaleel Toppan purchased one when his daughter married Benjamin Pickman Esq.; and Jonathan Turner Esq. purchased one on the occasion of his daughter's wedding to Captain Henry Gardner. All of these were large furniture orders and included conventional drop-leaf tables in addition to the side table, with the exception of Derby's order for two side tables.

In this table, the outside edge of each top board is shaped with an ogee molding plane and each corner is notched, an unusual embellishment not seen on the other examples. The inscription "Wilder" has not been identified with any Salem residents of the period.[2]

1. Gould charged 1s. per foot for carving ball-and-claw feet.

2. This table is discussed in Barquist 1992, pp. 136–38, cat. 54.

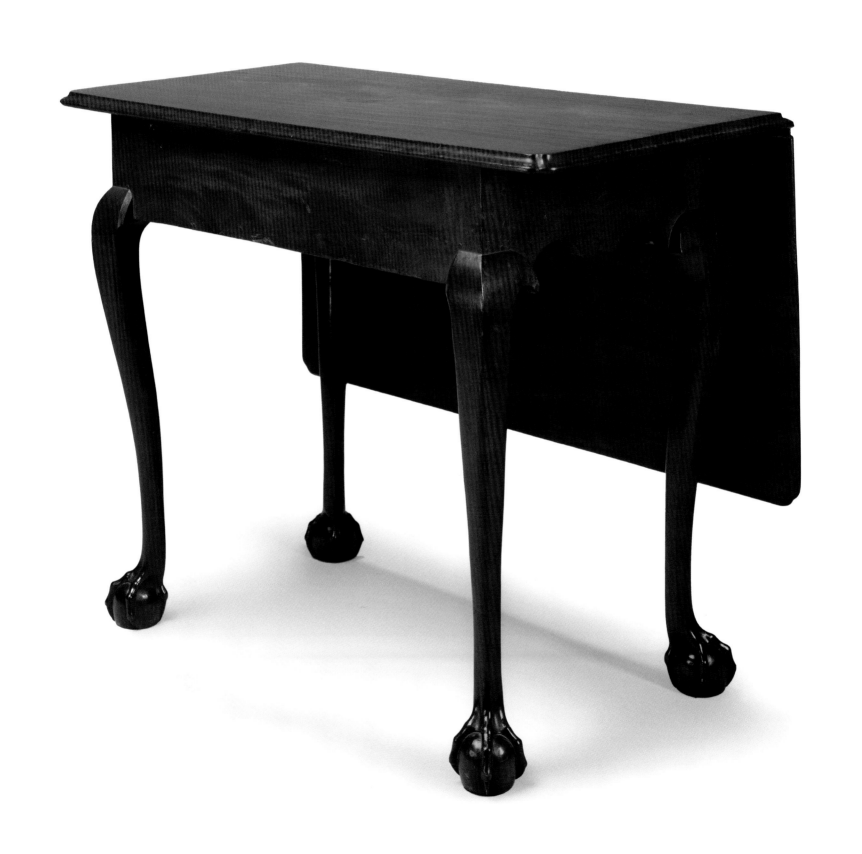

Stand Table

1761–81

Probably the shop of Nathaniel Gould

Dense mahogany; secondary wood: birch

Dimensions: H 27 ⅝; W 33 ¼ (across grain), W 33 ¹³⁄₁₆ (parallel to grain)

Private Collection

PROVENANCE: (Antiques dealer Israel Sack); the present owners

Although no stand tables have a provenance that can be positively tied to the Gould shop, this example embodies all the features typical of his output: the use of select close-grained mahogany, superior carving in crispness and design, and a surviving population that indicates they were made by a large, well-established shop operating over a number of years. Together, these factors likely eliminate other Salem cabinetmakers as the likely source of origin.

The top's crisp "pie-crust" scalloped edge is reminiscent of the Rococo design of silver salvers, and these Gould-style tables are the only examples of New England origin with this stylish feature. The table also incorporates the added carved embellishments of a fluted urn at the base of the column, and descending acanthus leaves centered on a star-punched central stem and capped by three swags that are characteristic of Gould carving on this type of table. The table legs terminate in finely carved rat-claw feet grasping an elongated ball. The defining characteristic of this table, however, is its superior grade of mahogany; it equals the wood used in his iconic desk-and-bookcases (see cat. 8).

Construction of this table is in line with Gould's standard practice. The column is through-tenoned into a 1 15/16-inch-thick birch block and has turned elements.

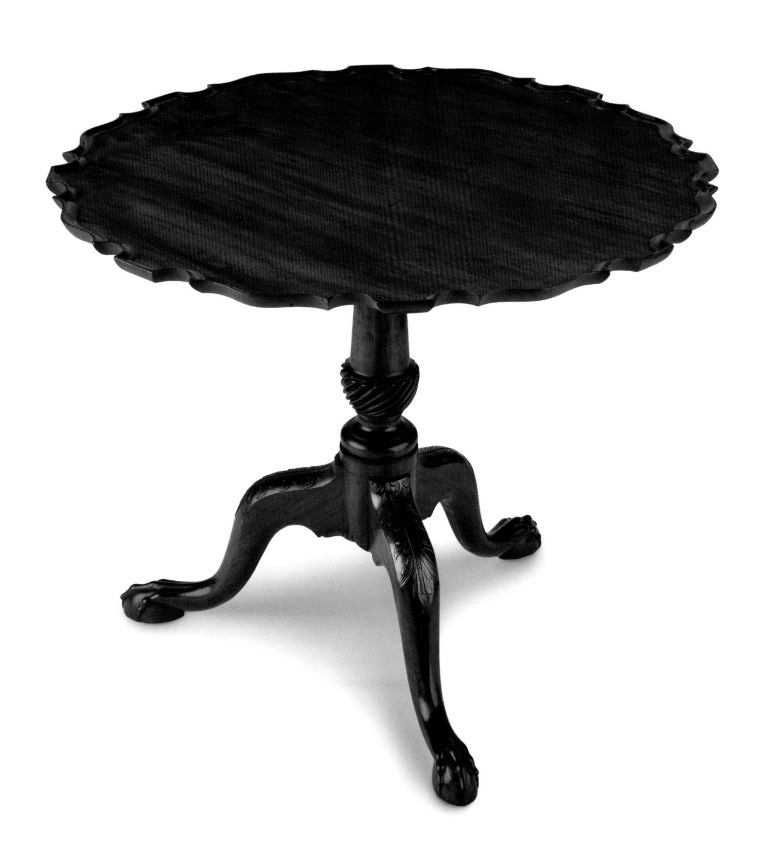

Bedsteads

Gould made 224 "bedstid" or bedsteads during his career; he used this generic term to describe any number of different forms of furniture used for sleeping. During his time, the term "bed" generally referred to the mattress used on top of the bedstead, while "bed furniture" described all of the other textiles used to create a fully dressed bedstead. While none of Gould's bedsteads has been located or identified to date, the ledger entries provide a wealth of information on the variety of forms he produced, the materials he used, and the prices he charged. But, unlike other consistently recorded furniture forms found in the account books, Gould's bedstead entries are inconsistent and leave room for speculation as to what an individual item may have been.

Many entries simply list "bedstid," occasionally with a qualifying word such as "plain" or "common." Other entries identify the type of bedstead, using the specific terms—cot, field, press, camp, high post, low post, trundle, and small bed (probably for a child). Gould charged thirty-three different prices for these various entries, according to the form, wood used, and extra details, such as carving or supports for the mattress. But, a price is not necessarily an indication of the form.

For example, a number of "maple" bedsteads were sold for 16s., the same price charged for a "press" and "trundle" bedstead and one oak bedstead.

Despite these ambiguities, several observations can be made about Gould's production. The simplest bedsteads were made of oak and cost between 12s. and 13/4; these included "common," "cord" (probably referring to simple rope supports for the bedding), "trundle" (a low form made with wheels to slide under a larger bed), and "press" (with hinged rails so the frame could fold up against a wall). Bedsteads made of maple accounted for the highest number of sales (32) and many of these were likely similar in form to one from New England in the Colonial Williamsburg collection (fig. 1).

Gould made "high post" bedsteads using either walnut or mahogany for the front posts and less expensive woods such as maple for the rails, rear posts, and headboard. His walnut bedsteads generally cost £1..16..0 to £2, while the mahogany ones started around £4. The four posts were designed to accommodate the installation of bed hangings, consisting of a tester (a wooden frame covered with fabric to

FIG 1
Low Bedstead, 1740 –70
Maple with white pine headboard,
H 24 ¾; W 74 ¾; D 51
Colonial Williamsburg, Williamsburg,
Virginia, Museum purchase (1966-225)

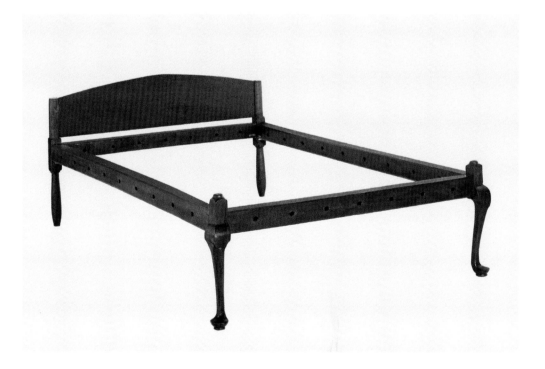

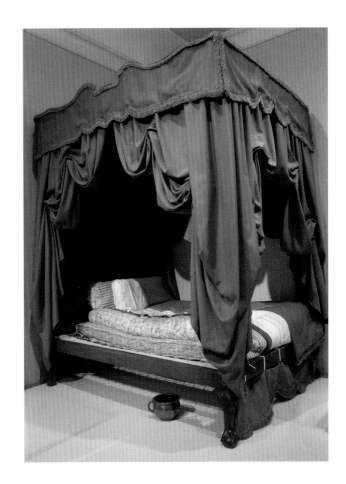

FIG 2

High Post Bedstead, 1760–95
Maple (head posts and rails), white pine
(headboard), and mahogany (foot posts),
H 90¾; W 78½; D 58
Winterthur Museum, Wilmington,
Delaware, Gift of Henry Francis du Pont
(1955.0792)

form a protective ceiling over the entire bed), valance, and floor-length curtains to enclose the bed for warmth and privacy. A full set of bed hangings made from costly fabric generally exceeded the cost of the bedstead itself, sometimes by a substantial amount.[1]

Gould's first mahogany bedsteads were sold in 1762, including one to Dr. Bezaleel Toppan, six weeks after his daughter Mary's wedding to Benjamin Pickman Esq. Gould charged £4, and subsequent orders at the same price indicate that the bed had "carved toes and knees," referring to the use of ball-and-claw feet on cabriole legs with acanthus-leaf carving on the knees.[2] A few entries noted that the upper posts were plain or fluted. Eight more mahogany bedsteads were ordered by other clients over the next ten years with none exceeding that price. While no surviving example has been tied to Gould, all of these were likely similar in form to a Salem bedstead made by an unidentified maker in the Winterthur collection (fig. 2).

A notable increase in the cost of mahogany bedsteads in the 1770s suggests a rising interest in additional ornamental carving on posts and legs as a status symbol for members of the merchant class. In 1774, Francis Cabot (1757–1832) paid a substantially higher sum of £5..6..8 for a mahogany bedstead for his daughter following her marriage to John Lowell (1743–1802) of Newburyport. Not to be outdone by this conspicuous consumption, Dr. Sylvester Gardiner ordered one for £6 in December 1774, quickly followed by an order from Jeremiah Lee for a bedstead at the same price for his daughter Mary at the time of her marriage to Nathaniel Tracy of Newburyport.

Several entries mention a "canvas bottom" or "sack bottom," referring to the fabric panel that was laced to the rails to create the support for the mattresses and other bedding; several different techniques were used for the attachments. While some entries for "bottoms" were included as part of the bedstead order, others were clearly made as replacements for older beds.

Gould also made cornices as an optional item, the first in 1776. Only one entry specified the material: mahogany was used to make a cornice for Francis Cabot in 1780, suggesting it was finished to match the front posts. Other cornices may have been made of less expensive woods because they were intended to be painted or covered with the same fabric used to make the bed hangings. Fabric-covered cornices were often sculptural in form, creating a highly ornamental effect. Of the twelve cornices Gould made, some were part of the original bedstead order while others were retrofitted to an older bed. Surprisingly, half of the cornices were ordered in 1781, suggesting that despite the hardships clients were experiencing during the revolutionary war, this ornamental extra had become another competitive status symbol for the merchant class.

1. For an excellent account of the development of the bedstead and its furnishings, see Richards and Evans 1997, pp. 195–98.

2. Orders for Clark Gayton Pickman, August 25, 1770; Thomas Barnard, June 4, 1773; and Edward Allen, August 29, 1773, were all priced at £4 and specified carved toes and/or knees.

To Balance of Com[...]

1777
Sam.l Dean of Bever[...]
May To 3 ½ feet of Mahog[any...]

1767 Thomas Collier

[...]y 17 To 1 Coffee Draws 9[...]
 To 2 Mahogany Ta[bles...]
 To 6 Chairs @ 6/8

Introduction to Gould's Client List and the Appendices

The discovery of the ledgers of Nathaniel Gould provides us with an unprecedented record of the day-to-day work of a eighteenth-century cabinet shop. Two key pieces of information, the names of clients and the dates of transactions, have been critical to framing our understanding of Gould's business. His Client List, reconstructed here with additional genealogical information from the Massachusetts probate records and resources at the Phillips Library, demonstrates that Gould's customers came from all levels of society. Copied directly from the ledgers, Appendices A and B allow a close examination of Gould's output and his employees. His involvement in export trade is explored in Appendix C, which ties orders to specific voyages. Finally, Appendices D and E offer a glimpse into the life events that prompted some of Gould's clients to purchase his furniture.

Key to the Appendices

APPENDIX A: Furniture Orders by Form

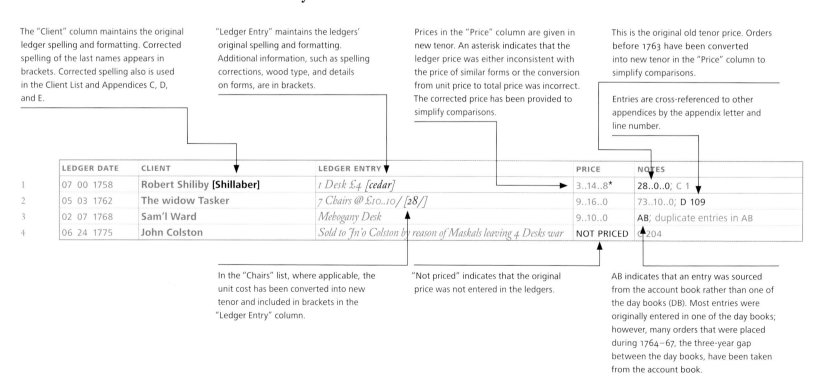

The "Client" column maintains the original ledger spelling and formatting. Corrected spelling of the last names appears in brackets. Corrected spelling also is used in the Client List and Appendices C, D, and E.

"Ledger Entry" maintains the ledgers' original spelling and formatting. Additional information, such as spelling corrections, wood type, and details on forms, are in brackets.

Prices in the "Price" column are given in new tenor. An asterisk indicates that the ledger price was either inconsistent with the price of similar forms or the conversion from unit price to total price was incorrect. The corrected price has been provided to simplify comparisons.

This is the original old tenor price. Orders before 1763 have been converted into new tenor in the "Price" column to simplify comparisons.

Entries are cross-referenced to other appendices by the appendix letter and line number.

	LEDGER DATE	CLIENT	LEDGER ENTRY	PRICE	NOTES
1	07 00 1758	Robert Shiliby [Shillaber]	*1 Desk £4 [cedar]*	3..14..8*	28..0..0; C 1
2	05 03 1762	The widow Tasker	*7 Chairs @ £10..10/ [28/]*	9..16..0	73..10..0; D 109
3	02 07 1768	Sam'l Ward	*Mehogany Desk*	9..10..0	AB; duplicate entries in AB
4	06 24 1775	John Colston	*Sold to Jn'o Colston by reason of Maskals leaving 4 Desks war*	NOT PRICED	C 204

In the "Chairs" list, where applicable, the unit cost has been converted into new tenor and included in brackets in the "Ledger Entry" column.

"Not priced" indicates that the original price was not entered in the ledgers.

AB indicates that an entry was sourced from the account book rather than one of the day books (DB). Most entries were originally entered in one of the day books; however, many orders that were placed during 1764–67, the three-year gap between the day books, have been taken from the account book.

APPENDIX B: Journeymen and Apprentices

"By" indicates a credit transaction.

LEDGER DATE	LEDGER ENTRY	PRICE	NOTES
09 07 1773	*By 12 month's work @ 42/8*	25..12..0	AB
10 00 1773	*To board while sick of Measels*	0..8..0	AB
11 12 1781	*[By] 1 Sideboard do [table]*	NOT PRICED	For Henry Gardner; called side table but crossed out

"To" indicates a debit transaction.

Possible clients to whom these pieces were sold were determined by comparing ledger date and price.

APPENDIX C: Furniture Orders Associated with Export

"Date of Departure" indicates the date that the vessel set sail from Salem. This list is organized chronologically by date of departure.

"Client" names are in the corrected spelling, also used in the Client List and Appendices D and E.

Vessel types are listed as follows:
Sch. = Schooner
Slp. = Sloop
Bgnte. = Brigantine
Brig = Brig

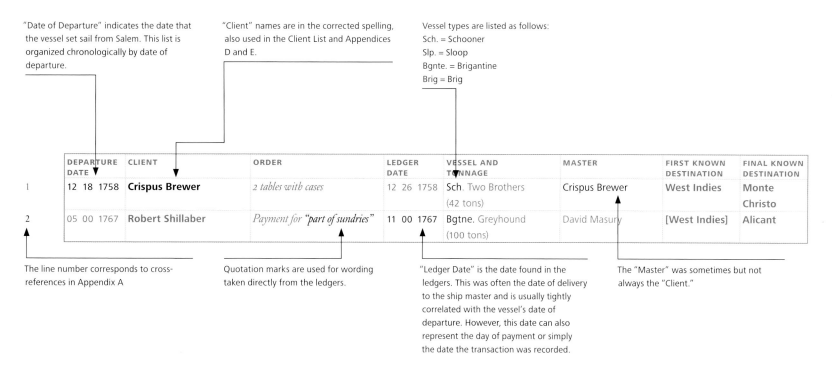

	DEPARTURE DATE	CLIENT	ORDER	LEDGER DATE	VESSEL AND TONNAGE	MASTER	FIRST KNOWN DESTINATION	FINAL KNOWN DESTINATION
1	12 18 1758	**Crispus Brewer**	*2 tables with cases*	12 26 1758	Sch. Two Brothers (42 tons)	Crispus Brewer	West Indies	Monte Christo
2	05 00 1767	**Robert Shillaber**	*Payment for "part of sundries"*	11 00 1767	Bgtne. Greyhound (100 tons)	David Masury	[West Indies]	Alicant

The line number corresponds to cross-references in Appendix A

Quotation marks are used for wording taken directly from the ledgers.

"Ledger Date" is the date found in the ledgers. This was often the date of delivery to the ship master and is usually tightly correlated with the vessel's date of departure. However, this date can also represent the day of payment or simply the date the transaction was recorded.

The "Master" was sometimes but not always the "Client."

APPENDIX D: Furniture Orders Associated with Weddings
APPENDIX E: Furniture Orders Associated with Children and Childbirth

int. = date of a couple's intention to marry
cert. = date on marriage certificate
bp. = date on baptismal record
* = pricing for comparative purposes invalid due to inflation

Client List

CLIENT	LIFE DATES	RESIDENCE	OCCUPATION
Adams, Daniel	ca. 1742 – ca. 1789	Salem; Beverly	*Intelligence officer*
Aden, Thomas			*Mariner*
Adkins, Nathaniel			
Alcock, Captain Robert	1743 – 1830	Salem	*Mariner, shopkeeper, innholder, senator, judge*
Allcock, Jonathan		Boston	*Chairmaker*
Allen, Captain Edward	1735 – 1803	Salem	*Mariner, merchant*
Andrews, James	ca. 1732 – 1820	North Danvers	*Housewright*
Appleton, John	1738/9 – 1817	Salem; Haverhill	*Merchant (English goods)*
Archer, Captain John Jr.	1732 – 1819	Salem	*Mariner, shipowner*
Archer, Jonathan Jr.	1747 – 1800	Salem	*Innholder, teacher, assessor*
Archer, Jonathan Sr.	ca. 1732 – 1797	Salem	*Barber, peruke maker*
Archer, Samuel Jr.	1742 – 1825	Salem	*Hardware dealer*
Ashby, David	1757 – 1822	Salem	*Shipwright*
Ashton, Jacob	1744 – 1829	Salem	*Merchant, gentleman*
Austin, Josiah	ca. 1745 – 1825	Charlestown; Salem	*Joiner*
Bacheller, Theophilus	1751 – 1833	Lynn	*Cabinetmaker, gentleman*
Barbour, Nathaniel		Salem	
Barnard, Dr. Edward	1755 – 1822	Haverhill; Salem	*Physician, apothecary*
Barnard, John	1745 – 1785	Newbury; Salem	*Merchant*
Barnard, Reverend Thomas	1716 – 1776	Newbury; Salem	*Pastor (First Church)*
Barnard, Reverend Thomas Jr.	1748 – 1814	Salem	*Pastor (North Church)*
Barnes, Major Thomas	1752 – 1821	Salem	*Cabinetmaker, store owner (drygoods), served in the Revolution*
Barr, Captain James	1721 – 1803	Salem	*Sand business, wharfinger*
Bartlett, Captain Nicholas	1716 – 1785	Marblehead	*Mariner, shipowner*
Bartlett, Captain William	d. 1794	Beverly	*Mariner, shipowner, privateer*
Bartlett, Walter Price	1743 – 1824	Salem	*Auctioneer*
Batchelder, Josiah Jr.	1737 – 1809	Beverly	*Justice of the peace, mariner, merchant*
Beckford, Benjamin Jr.	1732 – 1799	Salem; Beverly	*Shoreman, sailmaker*
Beckford, David Jr.	1740 – before 1783	Salem	*Mariner, housewright*
Beckford, Ebenezer	1737 – 1816	Salem; Danvers	*Merchant*
Beckford, Edmund	b. 1727	Salem; Lyndeborough, NH	*Fisherman, yeoman*
Beckford, Samuel	1730 – ca. 1783	Salem	*Mariner, cooper*
Beckford, Samuel Jr.	b. ca. 1755	Salem	*Mariner*
Bell, Elizabeth (Peele)	b. 1749	Salem	*Innkeeper, wife of Daniel Bell*
Berry, John	ca. 1730 – 1804	Salem	*Shipowner*
Blyth, Benjamin	1746 – ca. 1786	Salem	*Artist*
Blyth, Samuel	ca. 1721 – 1774	Salem	*Sailmaker*
Blyth, Samuel Jr.	ca. 1744 – 1795	Salem	*Painter*
Blyth, Verin	ca. 1748 – 1804	Salem	*Sailmaker, served in revolution*
Boden, William	ca. 1746 – 1807	Salem	*Mariner*
Bott, James	ca. 1745 – 1829	Salem	*Chaisemaker, harnessmaker*
Bowditch, Captain Ebenezer	1702 – 1768	Salem	*Mariner, shopkeeper, gentleman*
Bowen, William	d. ca. 1821	Marblehead	*Mariner*
Bowman, Jonathan			
Boynton, Thomas	1746 – 1833	Newbury; Andover	*House joiner*
Bradish, Billings	1741 – 1791	Salem; Danvers	*Baker, innholder*
Bradish, Dr. James	1752 – 1818	Harwick; Floyd, NY	*Physician, assistant surgeon's mate in revolution*
Bradstreet, Reverend Simon	1709 – 1771	Marblehead	*Minister*
Brewer, Captain Crispus	1734 – before 1765	Salem; Danvers	*Mariner*
Brewer, William	1750 – 1795	Salem	*Mariner*
Britton, Captain David	ca. 1706 – 1786		*Mariner, hatmaker*
Brooks, Captain John	1750 – 1788	Salem; Boston	*Mariner, privateer*
Brown, Henry		Halifax; Salem	*Mariner*
Brown, Captain Nathan	1742 – 1787	Newburyport; Salem	*Mariner, privateer*
Brown, Nickolas		Salem; Hartford, CT	*Chaisemaker, chairmaker*

CLIENT	LIFE DATES	RESIDENCE	OCCUPATION
Brown, William		Salem	*Tailor*
Browne, William Burnet Esq.	1738 – 1784	Salem; Virginia	*Merchant*
Buffington, Captain John	ca. 1743 – 1827	Salem	*Mariner, merchant, privateer, served in revolution*
Buffington, Joseph			*Shoemaker*
Buffinton, Captain Nehemiah	1745 – 1832	Salem	*Mariner, merchant, yeoman, privateer*
Bullard, Adam	d. before 1800		*Trader*
Cabot, Andrew	1750 – 1791	Salem; Beverly	*Merchant, shipowner*
Cabot, Elizabeth (Higginson)	1722 – 1781	Salem; Beverly	*Wife of Joseph Cabot Sr.*
Cabot, Francis	1717 – 1786	Salem	*Merchant*
Cabot, Francis Jr.	1757 – 1832	Salem	*Soldier*
Cabot, Captain George	1752 – 1823	Salem; Beverly; Boston	*Mariner, statesman, merchant*
Cabot, Hannah (Clark)	1704 – 1764	Salem	*Widow of Dr. John Cabot*
Cabot, John	1745 – 1821	Salem; Beverly; Boston	*Merchant, shipowner*
Cabot, Joseph Sr.	1720 – 1767	Salem	*Merchant*
Cabot, Captain Joseph Jr.	1746 – 1774	Salem	*Mariner, merchant*
Cabot, Stephen	1754 – 1778	Salem; Beverly	*Merchant*
Caldwell, John	1741 – 1771	Ipswich; Salem	*Yeoman*
Caldwell, Stephen	1749 – 1836	Ipswich	*Yeoman*
Calley, Captain Samuel		Salem	*Mariner, gentleman*
Calley, Francis		Salem	*Cordwainer*
Chandler, John	1752 – 1821	Salem	*Ship carpenter, housewright, gentleman*
Chase, Abner	1740 – 1784	Salem	*Painter, glazier, shoemaker*
Cheever, Benjamin	1746 – 1832	Salem	*Shoemaker, tanner*
Cheever, Daniel	1735 – 1787	Salem	*Cordwainer, shoemaker*
Cheever, Josiah	d. ca. 1758	Beverly; Gloucester	*Merchant*
Chipman, Joseph	1738 – 1817	Salem; Beverly	*Pumpmaker, blockmaker*
Churchill, Joseph	1745 – 1807	Salem	*Tailor, innholder*
Churchill, Mr. [Joseph]	1722 – 1780	Plymouth; Boston; Salem	
Clark, Samuel		Danvers	*Joiner, retailer*
Clarke, Captain Jacob	d. 1786		*Mariner*
Clemons, Samuel	1730 – 1803	Haverhill	*Cooper*
Cleveland, Captain Stephen	ca. 1741 – 1801	Salem	*Mariner, privateer*
Clough, Benjamin	1744 – ca. 1794	Salem; Boscawen, NH	*Blacksmith*
Clough, Nehemiah	1741 – 1825	Salem; Canterbury, NH	*Joiner*
Coates, Benjamin	1736 – 1774	Lynn; Salem; Boston	*Cordwainer, owned ship tavern, ran stage coach*
Cockle, James		Salem; Danvers	*Customs collector (1760 – 64)*
Cogswell, John	1738 – 1818	Boston; Salem	*Cabinetmaker, board surveyor*
Collier, Thomas II	b. 1743	Marblehead; Newburyport	*Mariner, privateer*
Collins, Enoch	1735 – 1773	Lynn; Salem	*Hatter*
Collins, Zaccheus	1698 – 1770	Lynn	*Blacksmith, maltster, farmer*
Colston, John		Gloucester	
Cook, Francis		Salem	*Teacher*
Cook, Captain Jonathan	1731 – after 1780	Salem	*Mariner, shoreman*
Cook, Jonathan Jr.	1757 – 1803	Salem	*Shoreman*
Cook, Joseph	1748/9 – before 1810	Salem	*Mariner*
Cook, Stephen	1752 – 1803	Salem	*Saddler, chaisemaker*
Cross, Joshua	1752 – 1837	Salem	*Served in revolution, joiner*
Crowel, Captain Samuel	1755 – 1810	Salem	*Mariner*
Crowninshield, Anstis (Williams)	1700 – 1774	Salem	*Widow of John Crowninshield*
Crowninshield, Jacob	1732 – 1774	Salem	*Shipowner*
Crowninshield, Captain John	1696 – 1761	Salem	*Mariner*
Crowninshield, Captain John Jr.	1728 – 1766	Salem	*Mariner*
Cumming, Samuel	1731/2 – 1796	Topsfield	*Gentleman*
Curwen, Samuel Esq.	1715 – 1802	Salem	*Judge (Court of Admiralty), merchant*

CLIENT	LIFE DATES	RESIDENCE	OCCUPATION
Daland, Benjamin	ca. 1729 – 1810	Salem	*Truckman, yeoman*
Dean, John	1737 – 1803	Salem; Boston	*Privateer*
Dean, Joseph	1708 – 1778	Salem	*Hatter*
Dean, Samuel		Beverly	*Joiner*
Deblois, George	1740 – 1799	Salem; Newburyport	*Merchant, shopkeeper (drygoods and hardware)*
Deering, Josiah			
Derby, Elias Hasket	1739 – 1799	Salem	*Merchant*
Derby, Captain Richard	1712 – 1783	Salem	*Mariner, merchant*
Derby, John	1741 – 1812	Salem; Boston	*Mariner, privateer*
Doak, William	d. 1827	Marblehead; Salem	*Chairmaker*
Dodge, Captain George	1726 – 1808	Salem; Beverly	*Mariner, merchant*
Dodge, George Jr.	1750 – 1821	Salem	*Merchant*
Dodge, Israel	1739 – 1822	Beverly; Salem	*Shipowner, merchant*
Dodge, Joshua	1752 – 1814	Beverly	*Tanner, merchant*
Dodge, Larkin	1747 – 1775	Salem	
Donaldson, Captain John	1750 – 1784	Salem	*Mariner*
Dowse, Joseph Esq.	ca. 1709 – 1785	Boston; Salem	*Merchant, surveyor (port of Salem)*
Drowne, Thomas	1715 – 1795	Boston; Epping, NH	*Copper, metalsmith*
Dunbar, Reverend Asa	1745 – 1787	Salem	*Minister (First Congregationalist Church)*
Elkins, Captain Henry	d. 1772	Salem	*Mariner*
Elkins, Captain Thomas	1737 – 1764	Salem	*Mariner*
Emerson, Richard	b. 1739	Haverhill	*Maltster, husbandman*
Eppes, Abigail (Pickman)	1733 – 1780	Salem	*Wife of William Eppes Esq.*
Eppes, William Esq.	1727 – 1765	Salem	*Merchant*
Estes, Abijah	1707 – 1790	Salem	*Shoreman*
Estes, Ahijah	1733 – 1783	Salem	*Hatter*
Felt, Benjamin	ca. 1705 – 1769	Salem	*Coaster, gentleman*
Field, Samuel	1732 – 1786	Salem	*Boatbuilder, merchant*
Fisher, Captain John	d. 1805	Salem; Portsmouth, NH	*Mariner, customs collector*
Flagg, Samuel	b. 1737	Worcester; Salem	*Merchant, dealer (English and Indian goods)*
Flint, Amos	1718 – 1797	Reading; Danvers	*Yeoman*
Flint, Elisha	1715 – 1773	Salem; South Danvers	*Farmer*
Flint, Jonathan [too many to identify]			
Flint, Joseph		Salem; Marblehead	*Joiner, housewright, sawmill operator*
Flint, Joseph Jr. [too many to identify]			
Forrester, Captain Simon	1748 – 1817	Salem	*Mariner, privateer, merchant*
Foster, Caleb		Salem	*Blacksmith*
Foster, Captain [too many to identify]		Kingstown	
Foster, Gideon Jr.	1749 – 1845	South Danvers	*Farmer, merchant*
Foster, John Jr.	1713 – ca. 1766	Manchester	*Shoreman, mariner, yeoman*
Foster, Jonathan		Tewksbury	
Foster, Joshua		Marblehead	*Tailor*
Foster, Robert	1742 – 1814	Salem	*Blacksmith, fisherman*
Fowle, Jacob Jr.	1740 – 1778	Marblehead; Newburyport	*Merchant*
Fowle, Jacob Sr. Esq.	1704 – 1771	Marblehead; Newburyport	*Merchant*
Fowler, Ezekiel & Co			*Blacksmith*
Francis, Captain Ebenezer	ca. 1743 – 1777	Beverly	*Colonel, mariner, merchant*
Francis, Mr. [too many to identify]			
Freeman, Deborah (Tasker)	ca. 1732 – 1810	Marblehead	*Wife of James Freeman*
Freeman, James	1728 – 1763	Fairfield, CT; Marblehead	*Distiller, merchant, shipowner*
Frost, Benjamin	d. ca. 1813	Beverly; Salem	*Mariner, shipowner*
Frothingham, Jonathan	ca. 1732 – 1802	Charlestown; Salem; Danvers	*Chaisemaker*
Frye, Peter Esq.	1723 – 1820	Salem	*Register of Probate, teacher, shipowner, merchant*
Frye, Thomas	d. 1777	Salem	*Mariner, shipowner*
Gage, General Thomas	1719 – 1787	England; Danvers	*British general, commander of North American forces*

CLIENT	LIFE DATES	RESIDENCE	OCCUPATION
Gardiner, Dr. Sylvester Esq.	1707 – 1786	Boston; Salem	Physician, drug importer
Gardner, Daniel	1709 – 1759	Salem; Danvers	Surveyor of highways, representative to General Court, gentleman
Gardner, George	ca. 1743 – 1773	Salem	Merchant
Gardner, Henry	ca. 1747 – 1817	Salem; Malden	Shipowner, merchant
Gardner, Captain John Jr.	1731 – 1805	Salem	Mariner, shipowner, juryman
Gardner, John	1736 – 1816		Shopkeeper
Gardner, Captain Jonathan Jr.	1728 – 1791	Salem	Mariner, merchant
Gardner, Samuel	ca. 1713 – 1769	Danvers	Merchant, representative to General Court
Gavett, Jonathan	1731 – 1806	Salem	Joiner, cabinetmaker, turner
Gavett, Joseph	1699 – 1765	Salem	Joiner
Giles, Thomas	ca. 1731 – 1775	South Danvers; Salem	Cabinetmaker
Glover, Ichabod	ca. 1747 – 1801	Salem	Chairmaker
Glover, Brig. General John	1732 – 1797	Salem; Marblehead	American general in revolution, shipowner, merchant
Goodale, Nathan	1740 – 1806	Salem; Newton	Merchant, first clerk (District Court of Massachusetts)
Goodale, Nathaniel	b. 1731	Danvers	Cordwainer
Goodhue, Benjamin Jr.	1748 – 1814	Salem	Merchant, representative and senator (US Congress)
Goodhue, Daniel	1747 – 1809	Ipswich; Westford	Cabinetmaker
Goodhue, William Sr.	1715 – 1799	Danvers	Tavernkeeper, gentleman
Goodhue, Dr. William Jr.	1747 – 1782	Salem	Physician
Goodwin, Joseph Phillips			
Gooll, John	ca. 1742 – 1776	Salem	Shopkeeper, merchant
Gould, James	ca. 1736 – 1810	South Danvers; Salem	Blockmaster, housewright, joiner, lumber dealer
Gould, James Wood	1761 – 1799	Salem	Mariner
Gould, John	1738 – 1802	Gloucester; Salem	Blacksmith
Gould, Josiah	1740 – 1801	South Danvers; Salem	Housewright
Gould, Nathaniel Jr.	ca. 1763 – ca. 1804	Salem	Cabinetmaker, joiner
Gowen, Lydia		Salem	
Grafton, Joseph	d. before 1786	Salem	Coaster
Grafton, Joseph Jr.	1726 – 1817	Salem	Mariner
Grant, Daniel		Exeter	Shopkeeper
Grant, Francis [2 possibles]		Salem	Barber, peruke maker, at ferry or shopkeeper
Grant, Lieutenant James		Salem; Halifax, Nova Scotia	British lieutenant in 45th Regiment
Grant, Captain Samuel	1739 – 1794	Salem	Mariner, shipowner
Graves, Jonathan		Ipswich	
Gray, Abraham	1715 – 1791	Lynn; Salem	Shoemaker, shoe dealer
Gray, William	1750 – 1825	Lynn; Salem; Boston	Lieutenant Governor, merchant
Greenwood, Miles	1736 – 1814	Salem; Boston	Merchant
Gyles, Samuel	1694 – after 1758	South Danvers; Salem	Joiner, cabinetmaker
Hall, Samuel	1740 – 1807	Newport, RI; Salem; Boston	Printer
Hamilton, Alex	1727 – 1798	Scotland; Salem	
Harraden, Captain Jonathan	1744 – 1803	Gloucester; Salem	Mariner, privateer, ropemaker
Hartwell, John		Lunenburg	Served in the revolution as a mechanic
Hastie, James		Salem; Newport, RI	Merchant, trader, shopkeeper
Hathorne, Colonel John	ca. 1749 – 1834	Salem	Merchant
Hathorne, Mary	d. 1802	Salem	Shopkeeper
Hathorne, Susannah [mother or daughter]		Salem	
Hathorne, William Jr.	1743 – 1815	Salem	Mariner, merchant
Hayward, Josiah		Salem	Cordwainer
Hicks, Mary	1733 – 1792	Salem	Spinster
Higginson, Lieutenant Colonel John Esq.	1720 – 1774	Boston; Salem	Register of Deeds
Higginson, Elizabeth (Cabot)	1715 – 1797	Salem; Beverly	Widow of Stephen Higginson Sr.
Higginson, Captain Henry	1747 – 1790	Salem; Boston	Mariner, privateer

CLIENT	LIFE DATES	RESIDENCE	OCCUPATION
Higginson, Hon. Stephen Sr.	1716 – 1761	Salem	*Merchant, representative to General Court, judge (Essex County)*
Higginson, Captain Stephen Jr.	1743 – 1828	Boston; Salem	*Mariner, merchant, Continental Congress, served in Navy*
Hilliard, Joseph	1737 – 1774	Salem	
Hitchens, William	1747 – 1833	Lynn; Salem; Dorchester	
Hodges, Captain Gamaliel	1716 – 1768	Salem	*Mariner, shipowner*
Hodges, Captain John	1723/4 – 1799	Salem	*Mariner, merchant*
Hodges, Priscilla (Webb)	1715 – 1807	Salem	*Landlady, wife of Gamaliel Hodges*
Holman, Samuel	1737 – 1825	Salem	*Hatmaker*
Holman, William	1740 – 1827	Salem	*Joiner, cabinetmaker, retailer*
Holyoke, Dr. Edward Augustus	1728 – 1829	Salem	*Physician*
Hood, Joseph	ca. 1738 – 1769	Salem	*Hatter*
Hopkins, Reverend Daniel	1734 – 1814	Waterbury, CT; Salem	*Minister (South Church), schoolmaster*
Hopkins, Joseph	b. 1742	Salem; Schenectady, NY	*Leather dresser*
Horton, Jonathan	d. 1808	Salem	
Hutchinson, Ebenezer	ca. 1730 – before 1768	Danvers	*Yeoman*
Hutchinson, Captain Israel	d. 1811	Danversport	*Housewright, mill owner*
Hutchinson, Thomas	ca. 1740 – 1786	Salem	*Blacksmith*
Ingalls, Ephraim	ca. 1739 – 1815	Lynn	*Tailor, minister*
Ingersoll, Jonathan	1751 – 1840	Salem; Windsor, VT	*Mariner, merchant*
Ingersoll, Captain Samuel	1744 – 1804	Salem	*Mariner*
Ireland, Jonathan	ca. 1746 – 1823	Charlestown; Salem	*Blacksmith*
Ives, John	ca. 1732 – 1801	Salem	*Tanner*
Ives, Captain Robert	1744 – 1773	Beverly	*Mariner*
Jackson, Jonathan	1743 – 1810	Newburyport; Boston	*Merchant*
Jacobs, Daniel	ca. 1711 – 1809	Danvers	*Shoemaker, farmer*
Jacobs, Daniel Jr.		Danvers	*Mariner*
Jeffrey, Arthur	ca. 1735 – 1790	Salem	*Cooper*
Jenkins, John	1761 – ca. 1824	Salem	*Tailor*
Jenks, John	1751 – 1817	Salem	*Merchant (dry goods)*
Johnson, Captain Holton	1745 – after 1790	Lynn	*Mariner, representative to General Court*
Johnson, Jonathan		Rowley; Kittery, ME	*Yeoman*
Jones, Captain Samuel	d. before 1798	Salem	*Mariner*
Kast, Phillip Godfried	ca. 1739 – 1791	Salem; Hopkinton, NH	*Apothecary (Sign of the Lion & Mortar)*
King, Gedney	1740 – 1814	Salem	*Cabinetmaker, joiner, blockmaker*
King, James Jr.	1752 – 1831	Salem	*Cashier (Essex Bank), blockmaker, joiner*
King, Major Samuel	ca. 1747 – 1781	Salem	*Aide-de-camp to Major General DeKalb*
Knight & Cumin			*Company*
Knight, Enos	1729 – 1788	Middleton; Topsfield	*Yeoman*
Knight, John	b. 1755	Middleton	
Knight, Captain Nathaniel	1754 – 1839	Middleton; Salem	*Mariner, wharfinger (Derby Wharf)*
Lafitte, Mark		France; Salem	*Merchant, shipowner, embezzler*
Lamson, William			
Lander, Benjamin	d. ca. 1816	Salem	*Mariner*
Lander, Captain Peter	1743 – 1834	Salem	*Mariner, merchant*
Lander, William	d. ca. 1778	Salem	*Chairmaker, turner*
Lander, William Jr.	d. ca. 1782	Salem	*Chairmaker*
Lang, Nathaniel	b. 1736	Salem	*Goldsmith, silversmith*
Lang, William	1750 – 1827	Salem	*Auctioneer*
Larkin, John	1724 – 1798	Boston	*Chairmaker*
Lawless, Menitable (Bacon)	b. 1755	Salem	
Leach, John Jr.	1747 – 1804	Ipswich; Salem	*Sawyer*
Leach, Captain John	1738 – ca. 1791	Salem; Boston	*Mariner, ship carpenter*
Leach, Captain Nathan	1733 – 1813	Beverly	*Mariner, merchant*
Leach, Nathaniel	ca. 1741 – 1776	Marblehead	*Mariner*

CLIENT	LIFE DATES	RESIDENCE	OCCUPATION
Lee, Elizabeth (Ives)	b. 172?	Salem	*Widow of Richard Lee*
Lee, Jeremiah Esq.	1721 – 1775	Marblehead	*Merchant, shipowner, served in revolution*
Lee, John Esq.	1715/6 – 1789	Manchester; Marblehead	*Merchant, shipowner, served in revolution*
Lee, Captain Joseph	1744 – 1831	Beverly	*Mariner, merchant*
Lee, Joseph Esq.	1748 – 1785	Marblehead	*Merchant, shipowner*
Lilly, Captain William	1747 – after 1805	Salem; Guilford, CT; Canada	*Mariner, merchant (English goods)*
Lovett, Captain Benjamin		Beverly	*Yeoman, mariner (for Cabot family)*
Lovett, Israel		Beverly	*Mariner*
Lowater, Stephen	ca. 1733 – 1800	Ipswich; Salem	*Carpenter, cabinetmaker*
Luscomb, Samuel Jr.	1722 – 1781	Salem	*Housewright, whitesmith, clockmaker, gunsmith*
Luscomb, William	1716/7 – 1783	Salem	*Housewright*
Lynde, Benjamin Esq.	1700 – 1781	Salem	*Judge of Probate Court, loyalist, addresser of General Gage*
Mackey, Captain Daniel	1720 – 1796	Salem	*Mariner*
Manning, Richard	1731 – 1811	Salem	*Gunsmith*
Manning, Thomas		Portsmouth, NH; Charleston, SC	*Mariner, privateer*
Mansfield, Jonathan	1717 – 1791	Salem	*Trader*
Martin, Ebenezer	1741 – 1800	Salem; Marblehead	*Cabinetmaker*
Mascareen, John Esq.	d. 1779	Boston; Salem	*Comptroller of the King's customs at Salem*
Mascol, Captain Stephen	ca. 1740 – 1777	Salem	*Mariner, privateer*
Mason, [Thomas] & Williams, [George]		Salem	*Company (shipping merchants)*
Mason, David	1726 – 1794	Salem; Boston	*Painter, "Wizard of 1771"*
Mason, Captain Jonathan	ca. 1733 – 1799	Salem	*Mariner, privateer*
Mason, Captain Thomas	1723 – 1801	Salem	*Mariner, merchant*
Mason, Thomas Jr.	1750 – 1779	Salem	*Mariner*
Masury, Captain David	d. 1789	Salem	*Mariner, taverner*
Masury, Captain Richard	ca. 1728 – 1786	Salem	*Mariner, privateer*
Masury, Captain Samuel	1729 – 1781	Marblehead; Salem	*Mariner*
McComb, Joseph		Salem	*Shopkeeper*
McIntire, Archelaus	1729 – 1791	Reading	*Yeoman, town councilman*
Millen, Robert	b. 1736	Framingham	
Morgan, Israel	ca. 1757 – 1812	Salem; Manchester	
Morgan, William	ca. 1741 – 1810	Beverly	*Mariner, distiller*
Moses, Captain Benjamin	1737 – 1803	Salem	*Mariner, privateer*
Moses, Eleazer	1734/5 – 1791	Salem	*Sailmaker*
Moses, Joseph	b. ca. 1745	Salem	*Sailmaker, merchant*
Moulton, Benjamin	b. 1776	Danvers	*Yeoman*
Mugford, [probably James]		Marblehead	*Privateer*
Neal, Jonathan	ca. 1726 – 1790	Salem	*Mariner, soldier, privateer, merchant*
Needham, Edmund	d. 1819	Salem	*Mariner*
Needham, Isaac	1746 – 1830	Salem	*Merchant, baker*
Needham, Thomas	1734 – 1804	Salem	*Joiner, cabinetmaker*
Needham, Thomas Jr.	1755 – 1787	Salem	*Cabinetmaker*
Newhall, Jeremiah	1737 – 1780	Lynn	*Housewright, yeoman*
Nichols, David			
Nichols, Captain Ichabod	1749 – 1839	Salem; Portsmouth, NH	*Mariner, merchant*
Nichols, James	1742 – 1810	Salem; Reading	*Baker*
Nichols, Jonathan		Salem	*Chaisemaker*
Nichols, Captain Nathan		Salem; Portsmouth, NH	*Mariner, privateer*
Nichols, Richard			
Nichols, Samuel	b. ca. 1761	Salem	
Nichols, William	1721 – 1786	Reading; Salem	*Mason*
Norris, Edward	1745 – 1803	Salem	*Schoolmaster, merchant, postmaster, town clerk*
Norris, John	1748 – 1808	Salem	*Merchant, senator*
Northey, Abijah	1741 – 1816	Salem	*Silversmith*
Northey, William	1735 – 1804	Lynn	*Silversmith, goldsmith, maritime trade*

CLIENT	LIFE DATES	RESIDENCE	OCCUPATION
Nurse, Benjamin	1720 – 1798	South Danvers; Salem	Saddler, upholsterer, chair bottom maker, shoreman
Nutting, John Jr.	1733 – 1773	Salem	Teacher (grammar school)
Nutting, John Sr. Esq.	ca. 1693 – 1790	Salem	Collector for the port of Salem
Ober, Captain Benjamin	1725 – 1788	Beverly; Salem	Mariner, shoreman
Odell, James	1731 – 1762	Salem	Mariner
Oliver, Dr. Benjamin L.	1760 – 1835	Salem	Physician
Orne, Captain Josiah	ca. 1745 – 1789	Salem	Mariner
Orne, Rebecca	1748 – 1818	Salem	Wife of Joseph Cabot Jr.
Orne, Timothy III	1750 – 1789	Salem	Merchant
Osborn, Elijah		Danvers	
Osborn, George	ca. 1738 – 1808	Salem	Mariner
Osborn, Stephen		Salem; Danvers	Shoreman
Page, Jeremiah	1722 – 1806	Medford; Danvers	Brickmaker
Paine, Moses	b. 1732	Braintree; Middletown, CT	
Paine, Dr. William	1750 – 1833	Worcester; Salem	Surgeon
Palfry, Captain Thomas	1751 – 1802	Salem	Mariner, trader
Parker, Philemon	b. 1745	Malden; Salem	Joiner, cabinetmaker
Parrot, Captain George			Mariner
Patterson, Captain William		Salem	Mariner
Payson, Jonathan	1752 – 1826	Boston; Salem	Upholsterer, hotel owner, postmaster
Peabody, Captain William	1724 – 1787	Middleton	Mariner, yeoman, gentleman
Peele, George	ca. 1730 – 1801	Salem	Housewright, carpenter, mariner, trader
Peele, Captain Jonathan Jr.	1731 – 1809	Salem	Mariner, merchant
Peirce, Jerathmael	ca. 1746/7 – 1827	Charlestown; Salem	Leather dresser, merchant
Peirce, Nathan	1749 – 1812	Newbury; Salem	Tobacconist, merchant
Phippen, Atwater	1726 – 1806	Salem	Cabinetmaker, joiner, gentleman
Phippen, David	1715 – 1782	Salem	Joiner
Pickering, John	1738 – 1823	Salem; Richmond, NH	Mariner
Pickering, Timothy Sr.	1702/3 – 1778	Salem	Yeoman
Pickering, William	1737 – 1802	Salem	Fisherman, mariner
Pickman, Colonel Benjamin Sr.	1707/8 – 1773	Boston; Salem	Colonel, merchant, representative to General Court, judge
Pickman, Benjamin Esq. Jr.	1740 – 1819	Salem	Merchant
Pickman, Clark Gayton	1746 – 1781	Salem	Merchant
Pickman, William	1748 – 1815	Salem	Naval officer (port of Salem), merchant
Piemont, John	ca. 1717 – 1802	Boston; Danvers; Ipswich	Peruke maker, tavernkeeper
Pike, Richard	ca. 1727 – 1792	Salem	General shipwork, blacksmith, gentleman
Powell, William		Boston	Merchant, shipowner, Overseer of the Poor (Boston)
Poynton, Thomas	1712 – 1781	Salem; England	Merchant, shipowner
Prince, Dr. John	1733 – 1816	Salem; Halifax, Nova Scotia	Physician, apothecary, merchant
Procter, Thorndike Sr.	1700 – 1774	Salem	Senior blacksmith, gentleman
Punchard, James	b. 1738	Salem	Merchant (West Indies and South Carolina goods and seeds)
Purington, Amos	d. 1815	Danvers	Blacksmith
Putnam, Bartholomew	1738 – 1815	Salem	Shipowner, surveyor, collector for the port of Salem
Putnam, Dr. Ebenezer	1717 – 1788	Salem	Physician
Putnam, Edmund	1724 – 1810	Topsfield; Danvers	Tailor, farmer
Putnam, William	d. 1800	Danvers	Yeoman
Pynchon, William Esq.	1723 – 1789	Salem	Lawyer, judge
Ramsdall, Amos	d. ca. 1780	Salem; Boston; Walpole	General shipwork
Reyke, Antony			
Richards, Joel	1758 – 1837	Roxbury; Salem; Claremont, NH	Artificer, housewright
Richards, Richard		Lynn; Salem	Shipwright
Richardson, Captain Addison	1739 – 1811	Woburn; Cambridge; Salem	Soldier, carpenter, housewright, selectman
Rollings, Joseph		Salem	Cooper
Ropes, Daniel	1737 – 1821	Salem	Cordwainer
Ropes, David Jr.	1738 – 1793	Salem	Innholder, cooper, yeoman, trader, merchant
Ropes, John Jr.	ca. 1725 – ca. 1782	Salem; Falmouth	Joiner, carpenter, housewright, cabinetmaker

CLIENT	LIFE DATES	RESIDENCE	OCCUPATION
Ropes, Captain John III	d. ca. 1789	Salem	*Mariner*
Ropes, Jonathan		Marblehead	*Caulker, coaster*
Ropes, Jonathan Jr.	1718 – 1799	Newbury; Salem	*Merchant, shipowner*
Ropes, William	ca. 1758 – 1828	Salem	*Privateer*
Ross, Jonathan	b. 1747	Salem; Gilmanton, NH	*Joiner, carpenter*
Routh, Richard	1749 – 1801	Salem; Halifax, Nova Scotia; NY	*Customs collector, store owner (English goods)*
Roxwaiter, Thomas			
Rust, Henry	1737 – 1812	Ipswich; Salem; Maine	*Cabinetmaker, merchant, shipowner (privateer)*
Safford, Abraham	1735 – 1829	Andover; Salem, NH	*Cabinetmaker, innholder*
Safford, William		Salem	*Baker, associated in privateering*
Sargent, Captain Dudley	1752 – 1818	Newburyport	*Mariner*
Sargent, Paul Dudley	1745 – 1827	Gloucester; Boston	*Privateer*
Saunders, John	b. 1724/5	Salem	*Shopkeeper*
Saunders, Jonathan P.		Salem	*Surveyor, town clerk (Salem)*
Saunders, Philip	1692/3 – 1768	Salem	*Baker*
Saunders, Captain Philip Jr.	1732 – 1830	Salem	*Mariner*
Saunders, Captain Samuel	1736 – 1772	Virginia or Philadelphia	*Mariner*
Savage, M or N [too many to identify]			
Savage, Rowland		Surrey, England; Salem	*Gentleman*
Scollay, Captain John Jr.		Salem	*Mariner, porter*
Seaford, William			
Shepard, Jeremiah	1751 – 1817	Salem	*Hatter, feltmaker*
Shillaber, Robert	1736 – 1808	Danvers	*Merchant, importer, mill owner (Trask's)*
Shillaber, Samuel	b. 1738	Danvers	*Housewright*
Skillin, Captain Joseph	ca. 1737 – 1773	Marblehead	*Mariner*
Skinner, Tabitha	1742 – 1791	Marblehead	*Wife of Thomas Gerry*
Smith, Anne			
Smith, George [too many to identify]			*Mariner*
Smith, Jonathan			
Smith, Thomas		South Carolina	*Commander, privateer*
Smothers, Peter	ca. 1757 – 1821	Salem	
Southwick, Joseph	1716 – 1791	Danvers	*Tanner*
Spafford, Dr. Isaac	1752 – 1786	Beverly	*Physician*
Sparhawk, Nathaniel Jr.	1744 – 1814	Salem	*Merchant*
Sprague, Major Joseph	1739 – 1808	Salem	*Major, distiller*
Stacey, Benjamin		Marblehead	
Stacey, Richard	1732 – 1792	Marblehead	*Mariner*
Stephens [too many to identify]		Townsend	
Stimson, Thomas	1735 – 1805	Salem; Reading	*Mason*
Summerville, Thomas		Salem	*Innholder*
Swan, Ebenezer	ca. 1728 – 1789	Boston; Salem	*Merchant, clothier, tailor*
Symonds, Captain John	1725 – 1807	Salem	*Mariner, shoreman, gentleman*
Symonds, Captain Jonathan III		Salem	*Mariner, shoreman*
Symonds, Joseph	1721 – 1769	Salem	*Cabinetmaker, joiner, housewright*
Symonds, Joseph Jr.	d. 1809	Salem	*Housewright, yeoman*
Tasker, Deborah (Skinner) (Pitts)	1702 – 1768	Marblehead	*Widow of John Tasker Esq.*
Tasker, John Esq.	1707 – 1761	Marblehead	*Justice Inferior Essex County Court, merchant*
Thaxter, Jonathan	1741/2 – 1831	Hingham	*Carpenter, artificer*
Thorndike, Captain Israel	1755 – 1832	Beverly	*Mariner, merchant, philanthropist, state legislator*
Thorndike, Nicholas [too many to identify]		Beverly	
Toppan, Dr. Bezaleel	1704/5 – 1762	Salem	*Physician*
Touzel, John	ca. 1727 – 1785	Salem	*Goldsmith, jeweler*
Tower, Israel			
Tracy, Nathaniel	1751 – 1796	Newburyport; Newbury	*Privateer, financier of revolution, merchant*
Trask, Joseph	1745 – before 1783	Plymouth	*Mariner, wheelwright*

CLIENT	LIFE DATES	RESIDENCE	OCCUPATION
Tucker, John		Gloucester	*Merchant*
Tucker, Jonathan		Salem	*Commander, privateer*
Tucker, Lewis			
Turner, John Esq.	1709 – 1786	Salem	
Turner, John Jr.	ca. 1744 – 1785		*Commander, privateer*
Vans, William	ca. 1730 – 1797	Boston; Salem	*Merchant, tea seller for Hannah Clark Cabot*
Very, Jonathan	1721 – 1803/4	Salem	*Truckman, cordwainer*
Vinning, Mary		Lynn; Marblehead	*Widow of Thomas Vinning*
Wadsworth, Samuel	b. 1750	Milton; Salem	*Cordwainer, singing teacher*
Waite, Aaron	1742 – 1830	Malden; Salem	*Tanner, leather merchant, shipowner (privateer)*
Walker, Alexander		Salem	
Ward, John	1738 – 1789	Salem	*Cabinetmaker, joiner*
Ward, John III	1707 – 1787	Salem	*Peruke maker*
Ward, John Jr.	b. 1729	Salem	*Cabinetmaker, joiner*
Ward, Joshua	1752 – 1825	Salem	*Shipping merchant, distillery owner*
Ward, Miles	1733 – 1796	Salem	*Cabinetmaker, glazier, joiner*
Ward, Samuel	1740 – 1812	Salem	*Naval officer, distiller*
Wardin, John		Salem	
Wardin, John Jr.		Salem	*Joiner*
Waters, Benjamin	1721 – 1784	Charlestown; Salem	*Baker, innholder, ferry operator*
Waters, Samuel	d. 1785	Salem	*Mariner*
Watson, Jonathan	b. 1732	Medford; South Hampton, NH	*Cooper*
Webb, Captain Jonathan	ca. 1716 – 1792	Salem	*Mariner, coaster*
Webb, Jonathan		Salem	*Shoemaker*
Webb, Mr. [too many to identify]		Danvers	
Webb, Nathaniel	1745 – 1831	Danvers	*Yeoman*
Webster, Reverend Peletiah	1726 – 1795	Philadelphia	*Minister, teacher, merchant*
Wentworth, Governor Mark Hunking	1709 – 1785	Portsmouth, NH; Nova Scotia	*Governor of New Hampshire*
West, Captain Benjamin	1739 – 1809	Salem	*Mariner, merchant*
West, Captain Samuel Jr.	1722 – 1774	Salem	*Mariner*
West, Thomas Brintnal	1739 – ca. 1771	Salem	*Cabinetmaker*
West, William	ca. 1728 – 1813	Salem	*Merchant*
Whipple, Jobe	b. 1739	Danvers	*Housewright, gentleman*
Whitaker, Reverend Nathaniel	1730 – 1795	Salem	*Minister (Tabernacle)*
White, Isaac	1753 – 1780	Charlestown; Salem	*Tallow chandler, merchant*
White, Captain John Jr.	1722 – 1792	Salem	*Mariner*
White, John	d. ca. 1773	Marblehead	*Housewright*
White, Mrs. [too many to identify]			
White, Samuel Jr.		Danvers	*Wheelwright*
Whitemore, Edmund Jr.	ca. 1750 – 1816	Salem	*Joiner, housewright*
Whitridge, Richard	1731 – 1774	Danvers	*Housewright*
Williams, Benjamin	1727/8 – 1775	Salem	*Trader*
Williams, Captain George	1731 – 1797	Salem	*Mariner, merchant*
Williams, Captain Henry	1744 – 1814	Salem	*Mariner*
Williams, Samuel	ca. 1733 – 1801	Salem	*Mariner, merchant, shipowner (privateer)*
Wilson, Charles		Salem	
Winship, Ebenezer Esq.	1735 – 1799	Arlington; Salem	
Wood & Waters			*Company*
Wood, Joseph	b. 1743	Rutland, VT	*Innholder*
Wood, Thomas	1708 – 1800	Charlestown; Rutland, VT	*Joiner, cabinetmaker*
Wood, Thomas Jr.	1740 – 1814	Charlestown	*Joiner*
Worthen, Captain Charles	1739 – 1773	Amesbury; Salem	*Mariner, shipowner*
Wyer & Turner			*Company*
Wyer, Russell	b. 1743	Danvers; Salem; Falmouth	*Merchant*
Yell, Moses	1747 – 1817	Salem; Newburyport	*Cordwainer, mariner*
Young, Nathaniel	d. after 1773	Salem	

Bedsteads

	LEDGER DATE	CLIENT	LEDGER ENTRY	PRICE	NOTES
1	08 28 1758	Isral Touer [Tower]	*a Bedstid [oak]*	0..12..0	4..10..0
2	11 07 1758	Thomas Elkins	*a Bed Stid [maple]*	0..16..0	6..0..0; D 28
3	07 02 1760	Joseph Dean	*1 Bedstid with double rails*	1..2..0	8..5..0
4	09 24 1760	Robert Millen	*1 Bedstid with Sack'n Bott'm*	1..18..0	14..5..0; D 64
5	12 00 1760	David Ropes [Jr.]	*1 Bedstid*	1..1..4	8..0..0; D 92
6	07 23 1761	Joseph Dean	*1 Bedstid [maple]*	0..16..0	6..0..0
7	07 25 1761	Henry Elkens [Elkins]	*a Bedstid [prob. oak]*	0..13..4	5..0..0; duplicate entries in DB; E 39
8	09 08 1761	Bemamin Nurse	*1 Bed Stid [oak]*	0..12..0	4..10..0
9	11 00 1761	M'rs Han'h Cabot	*1 Wallnut Bed Stid 36/*	1..16..0	13..10..0
10	01 15 1762	M'rs Han'h Cabot	*Meb'y Bed Stid [mahogany]*	3..9..4	26..0..0
11	07 00 1762	Bez'l Toppen [Toppan]	*Mehogany Bedstid*	4..0..0	30..0..0; D 85
12	07 00 1762	Bez'l Toppen [Toppan]	*Walnut dito [bedstead]*	2..0..0	15..0..0; D 85
13	07 00 1762	Bez'l Toppen [Toppan]	*2 Oak Bedstid @ 100/*	1..6..8	10..0..0; D 85
14	01 25 1763	Sam'l Grant	*1 Bedstid [oak]*	0..12..0	4..10..0; D 41
15	09 00 1763	Richard Darby [Derby]	*1 Bed stid [mahogany]*	3..9..4	AB; D 88
16	12 05 1763	John Prince	*Mehogany Bedstid*	3..5..4	AB
17	10 00 1764	Thomas Somervil [Somerville]	*1 Bedstid 12/ [oak]*	0..12..0	AB
18	11 00 1764	Ben'n Nurse	*1 Bedstid 12/ posts & rails 4/ [prob. oak]*	0..16..0	AB
19	01 00 1765	Eleazer Moses	*1 Bedstid [maple]*	0..16..0	AB
20	07 00 1765	Benjamin Pickman Jr.	*Oak Bedstid*	0..12..0	AB
21	07 00 1765	William Pinchon Esq [Pynchon]	*1 Bedstid Wallnut*	1..16..0	AB; prob. for new house built in 1765
22	08 00 1765	Eleazer Moses	*1 Ditto [bedstead, oak]*	0..12..0	AB
23	01 29 1766	Sam'l Grant	*1 Mehogany Bedstid*	4..10..0	C 76
24	06 00 1766	Thomas Stimson	*1 Bedstid [oak]*	0..12..0	AB; D 99
25	08 00 1766	Ben'n Lynde Esq	*1 ditto Bedstid [cherry]*	1..4..8	AB; D 108
26	09 15 1766	Jonathon Mason	*1 Bedstid [oak]*	0..12..0	AB
27	12 00 1766	Timothy Pickering	*1 Bedstid*	1..5..4	AB; D 24
28	01 17 1767	Thomas Colyer 2'd [Collier II]	*1 Bedstid 20/*	1..0..0	AB; D 18
29	02 18 1767	Thomas Poynton	*1 Bedstid 16 False posts & rails 4/ [maple]*	1..0..0	AB
30	05 00 1767	Robert Foster	*1 Bedstid [oak]*	0..12..0	AB
31	07 00 1767	Robert Foster	*Ditto [bedstead, oak]*	0..12..0	AB
32	10 00 1767	John Apleton [Appleton]	*1 Bedstid Mehogany foot posts*	2..16..0	AB; D 1
33	10 00 1767	John Apleton [Appleton]	*1 ditto [bedstead] Wallnut posts*	1..16..0	AB; D 1
34	10 00 1767	John Apleton [Appleton]	*2 Oak Bedstids @ 12/*	1..4..0	AB; D 1
35	11 05 1767	Josiah Orne	*1 Maple Bedstid 16/*	0..16..0	AB; D 78
36	11 05 1767	Josiah Orne	*1 Oak ditto 12/ [bedstead]*	0..12..0	AB; D 78
37	11 05 1767	Josiah Orne	*1 Bed bottom 22/*	1..2..0	AB; D 78
38	11 05 1767	Josiah Orne	*1 p'r [pair] Bed rails 2/*	0..2..0	AB; D 78
39	02 07 1768	Joshua Foster of Marblehead	*Bed stid & rails [oak]*	0..16..0	
40	08 01 1768	Rebeca Orne	*1 Mehog'y post Bedstid*	2..13..4	D 16
41	08 01 1768	Rebeca Orne	*Wallnut ditto [bedstead]*	1..16..0	AB; D 16
42	09 26 1768	Ebenezer Swan	*4 sides for Bedstid d'ld [delivered] T Neadham*	0..3..4	Delivered to Thomas Needham
43	09 26 1768	John Symonds	*Bedstid 16/ [maple]*	0..16..0	
44	11 11 1768	Step'n Higgenson [Higginson]	*1 Bedstid Walnut posts*	1..16..0	
45	11 11 1768	Step'n Higgenson [Higginson]	*1 Ditto Common Sort plain 16/ [bedstead, maple]*	0..16..0	
46	12 23 1768	Joseph Skilen [Skillin]	*1 Bedstid 24/*	1..4..0	
47	04 07 1769	Rev Thomas Barnard	*Making Bedstid*	0..8..0	
48	04 07 1769	Step'n Cook	*1 Bed-Stid [oak]*	0..12..0	
49	04 07 1769	Jonathan Mason	*Bedstid & False posts & rails*	1..0..0	
50	11 00 1769	Jn'o Turner, Esq	*Mehogany Post Bedstid*	3..13..4	D 36
51	11 00 1769	Jn'o Turner, Esq	*2 Maple Ditto @ 14/8 [bedstead]*	1..9..4	D 36
52	01 01 1770	Abner Chase	*Oak Bedstid*	0..12..0	
53	01 11 1770	Joseph Lee [Esq. of Beverly]	*1 Bed Stid High Posts [walnut]*	1..16..0	D 57
54	01 11 1770	Joseph Lee [Esq. of Beverly]	*1 Mapple ditto [bedstead]*	0..16..0	D 57
55	01 11 1770	Joseph Lee [Esq. of Beverly]	*2 Oak ditto @ 12/ [bedstead]*	1..4..0	D 57
56	01 11 1770	Joseph Lee [Esq. of Beverly]	*False posts & Doble Rails*	0..6..0	D 57

Bedsteads

	LEDGER DATE	CLIENT	LEDGER ENTRY	PRICE	NOTES
57	01 11 1770	Joseph Lee [Esq. of Beverly]	*4 Sack bottoms @ 20/*	4..0..0	D 57
58	03 09 1770	Jonathan Haridon [Harraden]	*Oak Bedstid*	0..12..0	AB
59	08 24 1770	Clark Gat'n Pickman	*1 Mehogany Bed Stid with carv'd toe & knee*	4..0..0	D 86
60	08 24 1770	Clark Gat'n Pickman	*1 Wall't ditto [bedstead, walnut]*	1..16..0	D 86
61	08 24 1770	Clark Gat'n Pickman	*Small Bed stid 10/*	0..10..0	D 86
62	08 24 1770	Clark Gat'n Pickman	*Brass caps for Bed stids*	0..5..5	D 86
63	08 24 1770	Clark Gat'n Pickman	*4 sack bottoms for b stids [bedsteads]*	4..0..0	
64	09 05 1770	Nath'l Adkins	*Bedstid [maple]*	0..16..0	
65	10 04 1770	Ben'n Moses	*Bed Stid [maple]*	0..16..0	
66	11 00 1770	Thomas Wood of Charlestown	*Bedstid False posts & Dob'l rails 20/*	1..0..0	
67	11 00 1770	Henry Williams	*2 Bedstids @ 16/ [maple]*	1..12..0	D 115
68	11 00 1770	Henry Williams	*False posts & doble rails*	0..6..0	D 115
69	11 00 1770	Alexander Walker	*False posts and rails for Bed*	0..4..0	D 107
70	01 17 1771	W'm Goodhue	*Set Bed Rails with False posts*	0..4..0	
71	01 24 1771	Jn'o Webb—Coaster	*Bedstid [oak]*	0..12..0	
72	02 02 1771	Israel Dodge	*1 Bedstid with Sack botom*	1..16..0	C 156
73	04 06 1771	Mr _____ Staid	*Bed stid*	0..10..0	
74	05 03 1771	Elizabeth Cabot	*1 Bed-Stid, Sack Bottom [maple]*	1..16..0	
75	06 00 1771	W'm Goodhue	*Bedstid 28/*	1..8..0	
76	08 00 1771	Nath'l Sparhawk [Jr.]	*Bedstid with Wallnut posts*	1..16..0	
77	09 28 1771	Joseph Sprague	*1 Bedstid Mehogany posts*	3..12..0	E 102
78	12 14 1771	William Pinchon Esq [Pynchon]	*Bedstid with Wall't posts with Sack Bottom*	2..16..0	AB; D 79
79	12 14 1771	George Deblois	*1 Bedstid Ash posts 36/*	1..16..0	D 22
80	12 14 1771	George Deblois	*1 Comon do [bedstead] 16/ 2 Bottoms 40/*	0..16..0	AB; D 22
81	02 05 1772	Phllip God'y Cast [Kast]	*Bedstid*	1..0..0	E 63
82	04 00 1772	Joseph Lee [of Beverly]	*1 Bedstid 20/*	1..0..0	
83	06 16 1772	George Deblois	*1 Bedstid [maple]*	0..16..0	Duplicate entries in DB
84	08 20 1772	Jer'h Lee [Esq.]	*Bed-stid Mehog'y posts*	3..14..8	D 58
85	08 20 1772	Jer'h Lee [Esq.]	*2 do post Bed-Stids @ 36/ [walnut]*	3..12..0	D 58
86	08 20 1772	Jer'h Lee [Esq.]	*Cash paid for makeing 3 Bed bottoms*	1..4..0	D 58
87	08 20 1772	Jer'h Lee [Esq.]	*2 Setts Bed rails*	0..6..0	D 58
88	08 20 1772	Jn'o Symonds—Shoreman	*Bedstid 13/4 [oak]*	0..13..4	D 58
89	09 17 1772	Nathan Goodale	*Maple Bed-Stid*	0..16..0	E 50
90	09 17 1772	Nathan Goodale	*Paid Joseph Moses for Making Bed bottom*	0..8..8	
91	10 00 1772	Samuel Flagg	*Bedstid w'h [with] w't posts [walnut]*	1..16..0	D 32
92	10 10 1772	George Deblois	*5 Bedstid 14/8*	3..13..4	For resale
93	10 10 1772	George Deblois	*Camp Bedstid*	1..0..0	For resale
94	10 10 1772	Bart'y Putnam	*Maple Bedstid*	0..16..0	
95	11 00 1772	Su'anh Harthorne [Hathorne]	*Bedstid*	1..8..0	D 46 or 50
96	11 20 1772	Sam'l Waters	*1 Bedstid 13/4 [oak]*	0..13..4	
97	12 02 1772	Stephan Maskall [Mascol]	*Trundle Bedstid*	0..13..4	E 76
98	03 00 1773	Clark G Pickman	*1 Bedstid Wal't posts [walnut]*	1..16..0	AB
99	05 00 1773	George Dodge	*1 Bed-Stid Mehogony posts 72/*	3..12..0	D 12
100	05 00 1773	George Dodge	*1 Do Bedstid Wall't posts [walnut]*	1..16..0	D 12
101	06 04 1773	Thomas Barnard Jun.	*Bed stid Mehogony posts carv'd knes [knees]*	4..0..0	D 4
102	06 04 1773	Thomas Barnard Jun.	*1 Do with Wall't posts [bedstead, walnut]*	1..16..0	D 4
103	06 04 1773	Thomas Barnard Jun.	*2 Do Common @ 16/ [bedstead, maple]*	1..12..0	D 4
104	06 04 1773	Thomas Barnard Jun.	*1 Small Do 10/ [bedstead]*	0..10..0	D 4
105	06 04 1773	Thomas Barnard Jun.	*4 Canves bottoms @ 20/*	4..0..0	D 4
106	07 00 1773	Ben'n Coates	*1 Bedstid Mehogany posts & claw feet*	4..6..8	
107	07 17 1773	Enoch Colins [Collins]	*Trundle Bedstid [oak]*	0..12..0	E 26
108	08 15 1773	John Piemont	*[2] Press Bedstids @ 36*	2..12..0	Total does not reflect unit price
109	08 29 1773	Edward Allin [Allen]	*1 BedStid Mehogany posts Carvd Toes & knees*	4..0..0	
110	09 00 1773	Jn'o Appleton	*1 Paled Bedstid [pallet]*	1..0..0	E 2
111	10 00 1773	William Paine	*Bedstid Mehog'y posts Carvd*	4..0..0	Shipped in cases; D 81

Bedsteads

	LEDGER DATE	CLIENT	LEDGER ENTRY	PRICE	NOTES
112	10 00 1773	**William Paine**	*1 Do Wall't [bedstead with carved posts, walnut]*	1..16..0	Shipped in cases; D 81
113	10 00 1773	**William Paine**	*2 Canvas Bottoms for Do @ 20/ [bedsteads]*	2..0..0	Shipped in cases; D 81
114	10 20 1773	**Jonathon Payson**	*Camp Bedstid with bottom*	2..8..0	
115	11 24 1773	**Andrew Cabot**	*1 Bedstid with Sack'n bottom [maple]*	1..16..0	
116	01 14 1774	**Anne Smith**	*Press Bed Stid*	0..16..0	
117	02 16 1774	**Nathan Goodale**	*1 Trundle Bedstid*	0..16..0	E 50
118	03 16 1774	**George Cabot**	*1 Bed Stid Wall't posts /36 [walnut]*	1..16..0	D 14
119	03 16 1774	**George Cabot**	*1 Do Comon 16/ [maple, bedstead]*	0..16..0	D 14
120	03 16 1774	**George Cabot**	*2 Bed Bottoms @ 20/*	2..0..0	D 14
121	03 17 1774	**Clark G Pickman**	*1 Bedstid Wall't posts [walnut]*	1..16..0	
122	05 02 1774	**Tho's Mason jun**	*1 Bed Stid Meh'y posts [mahogany]*	4..4..0	D 63
123	05 02 1774	**Tho's Mason jun**	*Bed rails & seting up Bed*	0..6..0	D 63
124	06 08 1774	**Edward Allin [Allen]**	*1 Bedstid 80/ [mahogany]*	4..0..0	
125	06 18 1774	**Tho's Gage**	*1 Bedstid*	0..12..0	
126	06 25 1774	**Tho's Gage Esq'r**	*3 Oak Bed Stid @ 12/*	1..16..0	
127	06 25 1774	**Tho's Gage Esq'r**	*1 field Do [bedstead]*	1..16..0	
128	06 25 1774	**Tho's Gage Esq'r**	*Sack Bottom*	0..14..8	
129	06 27 1774	**George Dodge**	*Bed Stid w't posts [walnut]*	1..16..0	
130	07 06 1774	**Francis Cabot**	*1 Bedstid W't posts [walnut]*	1..16..0	D 60
131	07 06 1774	**Francis Cabot**	*1 Mehogony post Bedstid*	5..6..8	D 60
132	08 13 1774	**Eph'm Ingalls**	*Press Bedstid with jer'n Hinges 20/*	1..0..0	
133	10 15 1774	**Rich'd Routh**	*a Wal't high post Bed-Stid [walnut]*	1..16..0	Delivered after his house fire on 10/06/1774
134	10 15 1774	**Rich'd Routh**	*2 Common Do @ 16/ [bedsteads, maple]*	1..12..0	Delivered after his house fire on 10/06/1774
135	10 15 1774	**Peter Frye [Esq.]**	*Bed-Stid w't posts 36/ [walnut]*	1..16..0	
136	10 15 1774	**George Deblois**	*Bed-Stid*	0..10..8	
137	10 29 1774	**Rich'd Routh**	*1 Wall't post Bed-Stid 36 [walnut]*	1..16..0	Delivered after his house fire on 10/06/1774
138	11 08 1774	**W'm Doak**	*Bedstid [maple]*	0..16..0	
139	12 02 1774	**Sylveter Gardner Esq [Gardiner]**	*Bedstid Mehogony posts*	6..0..0	
140	12 02 1774	**Sylveter Gardner Esq [Gardiner]**	*1 do Wall't do [bedstead with walnut posts]*	1..16..0	
141	12 02 1774	**Sylveter Gardner Esq [Gardiner]**	*1 do low posts [bedstead, maple]*	0..16..0	
142	12 02 1774	**Sylveter Gardner Esq [Gardiner]**	*3 Bed bottoms @ 20/*	3..0..0	
143	12 02 1774	**Jonathon Symonds [III]**	*1 Bedstid & rails 16/ [maple]*	0..16..0	D 102
144	12 10 1774	**William Bodin [Boden]**	*Bedstid w posts and rails [maple]*	0..16..0	D 6
145	12 24 1774	**Peter Frye esq**	*2 Common Bedstids [maple]*	1..12..0	D 76
146	02 15 1775	**Jon'n Ireland**	*Bedstid [maple]*	0..16..0	
147	04 09 1775	**Jeremiah Lee [Esq.]**	*1 Bed Stid [mahogany]*	6..0..0	D 104
148	05 23 1775	**Louis Tucker**	*1 Bedstid with cavis bottom*	1..18..0	
149	06 24 1775	**Jon'n Payson**	*1 Bedstid @ 36/ [walnut]*	1..16..0	
150	06 24 1775	**Jon'n Payson**	*1 do 40/ [bedstead]*	2..0..0	
151	06 24 1775	**Jon'n Payson**	*2 bottoms @ 20*	2..0..0	
152	08 00 1775	**William Vans Esq'r**	*Mehogony post Bed-Stid with Canves Bottom*	5..0..0	D 105
153	08 23 1775	**George Dodge**	*1 Bedstid 16/ [maple]*	0..16..0	
154	12 00 1775	**W'm Powel [Powell]**	*1 Bedstid with Sack bottom*	1..10..8	
155	01 13 1776	**James Hastie**	*1 High post Bed Stid with wal't posts [walnut]*	2..0..0	
156	01 13 1776	**James Hastie**	*Sack Bottom*	1..4..0	
157	02 26 1776	**Joseph Lee [of Beverly]**	*Cott*	1..4..0	E 72
158	04 06 1776	**Mrs Hodges**	*1 Bedstid high posts [pair]*	2..0..0	
159	04 06 1776	**Mrs Hodges**	*Set Bed rails*	0..4..0	
160	04 06 1776	**Mrs Hodges**	*Canves bottom for do [bedstead]*	1..2..0	Duplicate entries in AB
161	07 00 1776	**Isaac White**	*1 Bedstid 100/ [mahogany]*	5..0..0	Duplicate entries in AB
162	07 00 1776	**Jn'o Jinkens [Jenkins]**	*Bedstid [oak]*	0..13..4	Mistakenly omitted from the AB and not invoiced until 01/1781

Bedsteads

	LEDGER DATE	CLIENT	LEDGER ENTRY	PRICE	NOTES
163	10 00 1776	**Will'm Pickman**	*Two Mahogony Bed posts 48/ set of Bed posts*	2..8..0	D 87
164	10 09 1776	**Jon'n Ross**	*Sett of Cornices for Bed*	1..0..0	
165	10 09 1776	**Jon'n Payson**	*Sett Cornices for Bed*	0..18..0	
166	11 00 1776	**Will'm Pickman**	*1 Bedstid*	1..4..0	D 87
167	11 11 1776	**Jon'n Payson**	*Sett Cornices for Bed*	0..18..0	
168	11 16 1776	**Jon'n Payson**	*Sett Bed Cornices*	0..18..0	
169	01 00 1777	**W'm Pickman**	*Bedstid with Meh'y posts [mahogany]*	5..0..0	
170	01 00 1777	**W'm Pickman**	*Sack bottom*	2..8..0	
171	03 15 1777	**Nathan Nickals [Nichols]**	*Bedstid with Wall't posts [walnut]*	2..8..0	D 69
172	03 15 1777	**Nathan Nickals [Nichols]**	*Canvas bottom for do [bedstead]*	2..0..0	D 69
173	04 05 1777	**Andrew Cabot**	*2 Bed Stid @ 20/*	2..0..0	
174	04 05 1777	**Andrew Cabot**	*2 Canvas Bottoms @ 40/*	4..0..0	
175	05 00 1777	**Joshua Dogue [Dodge]**	*1 Bed Stid Wall't posts [walnut]*	2..8..0	D 25
176	05 00 1777	**Joshua Dogue [Dodge]**	*1 Do Do Common [bedstead, walnut]*	1..0..0	D 25
177	05 00 1777	**Joshua Dogue [Dodge]**	*2 Canvas Bottoms @ 40/*	4..0..0	D 25
178	05 06 1777	**Stephen Cabot**	*1 Bedstid Meh'y posts [mahogany]*	3..0..0	D 17
179	05 06 1777	**Stephen Cabot**	*Can's bottom [canvas]*	2..8..0	D 17
180	08 00 1777	**William Goodhue, Jn'r.**	*1 Bedstid*	3..6..8	D 39
181	08 00 1777	**William Goodhue, Jn'r.**	*Canvas bottom for do [bedstead]*	2..8..0	Duplicate entries in AB; D 39
182	08 00 1777	**Isaac White**	*1 Bedstid*	5..0..0	E 112
183	08 00 1777	**Isaac White**	*Cash p'd [paid] for making bottom*	0..15..0	E 112
184	08 00 1777	**Isaac White**	*Twine & line*	0..5..0	
185	09 23 1777	**W'm West**	*1 Bedstid Meh'g Posts [mehogany]*	5..0..0	
186	10 24 1777	**Israel Thorndike**	*1 Bedstid [mahogany]*	5..0..0	D 103
187	10 24 1777	**Israel Thorndike**	*Making bottom*	0..18..0	D 103
188	02 00 1778	**Ben'n Goodhue Ju'r**	*1 Bed-stid high posts*	12..0..0	D 38
189	02 00 1778	**Ben'n Goodhue Ju'r**	*1 do Common [bedstead]*	3..4..0	D 38
190	09 08 1778	**Joshua Ward Ju'r.**	*High posts for Bed*	18..0..0	
191	09 08 1778	**Joshua Ward Ju'r.**	*1 Bedstid flut'd posts*	30..0..0	
192	09 18 1778	**Sam'l Ward**	*High posts for Bed stid [walnut]*	1..16..0	
193	09 22 1778	**Peter Lander**	*Sets Bed rails & puting up Bed*	0..12..0	4..0..0
194	11 09 1778	**Sam'l Ward**	*1 Bedstid fluted posts [mahogany]*	5..0..0	30..0..0
195	11 09 1778	**Sam'l Ward**	*High posts for Bedstid*	2..16..0	18..0..0
196	11 09 1778	**Sam'l Ward**	*2 Sets of Bed rails*	0..12..0	4..0..0; E 65
197	12 00 1778	**Jn'o Neal**	*Bed stid*	6..0..0	
198	05 00 1779	**George Dodge Jn'r.**	*1 Bedstid Meh'g Posts [mahogany]*	60..0..0	D 15
199	05 00 1779	**George Dodge Jn'r.**	*1 do do corded [bedstead, mahogany]*	9..0..0	D 15
200	05 00 1779	**George Dodge Jn'r.**	*1 Bedstid with Sack bot'm*	12..0..0	D 15
201	05 00 1779	**W'm Goodhue**	*Bedstid*	6..0..0	
202	06 16 1779	**Nath Nickals [Nichols]**	*Bedstid*	30..0..0	
203	11 00 1779	**Peter Sm'otherst [Smothers]**	*1 Bedstid*	1..10..0	D 96
204	11 11 1779	**Elias Hasket Derby**	*Maple Bedstid*	1..10..0	
205	01 27 1780	**Francis Cabot Jn'r**	*Meh'y Post Bedstid with Meh'y cornice [mahogany]*	6..0..0	D 13
206	01 27 1780	**Francis Cabot Jr**	*Bedstid high posts 80/*	4..0..0	E 21
207	04 06 1780	**Jon'n Aridon [Harraden]**	*1 Bedstid*	NOT PRICED	
208	04 06 1780	**Nath'l Whitaker**	*Bedstid with carv'd posts*	8..0..0	
209	06 00 1780	**Bartholemew Putnam**	*1 Bedstid*	NOT PRICED	
210	08 00 1780	**Henry Brown**	*1 Bed Stid*	100..0..0	D 10
211	08 00 1780	**John Danielson [Donaldson]**	*1 Bedstid @ 30/*	1..10..0	D 26
212	08 22 1780	**Joseph McComb**	*1 Bed Stid 30/*	0..30..0	Duplicate entries in AB
213	11 00 1780	**Josiah Orne**	*Cot Bedstid*	0..18..0	AB; E 83
214	11 00 1780	**Joshua Dodge**	*Cot Bedstid*	0..10..0	E 34
215	11 00 1780	**Peter Laundor [Lander]**	*Bedstid high posts fluted*	5..0..0	
216	12 16 1780	**Jn'o Norice [Norris]**	*Cornice for Bed*	NOT PRICED	
217	01 00 1781	**Joshua Dodge**	*Bedstid with High posts*	6..0..0	AB; E 36

	LEDGER DATE	CLIENT	LEDGER ENTRY	PRICE	NOTES
218	02 00 1781	Doc. Edward Barnard	*Bedstid Mahogy posts plain*	NOT PRICED	D 3
219	02 00 1781	Doc. Edward Barnard	*1 plain common Maple do [bedstead]*	NOT PRICED	D 3
220	02 00 1781	Doc. Edward Barnard	*1 do Oak [bedstead]*	NOT PRICED	AB; D 3
221	02 00 1781	James King Jr	*1 Bedstid Mahog posts*	NOT PRICED	E 64
222	02 00 1781	Jn'o Cook Jun'r	*Bedstid*	NOT PRICED	D 19
223	02 24 1781	W'm Lang	*Bedstid Mehog posts fluted*	NOT PRICED	
224	03 00 1781	Sam'l Nichols	*1 Bedstid £150*	1..7..0	150; D 70
225	03 00 1781	J'on Brooks	*1 Bedstid £600*	600..0..0	D 9
226	05 00 1781	Barth'w Putnam	*High Post Bedstid*	NOT PRICED	D 82
227	05 00 1781	Barth'w Putnam	*Common do [bedstead]*	NOT PRICED	
228	05 00 1781	Thomas Smith	*1 Bedstid 1-6-8*	1..6..8	AB
229	05 05 1781	Sam'l Ingersol [Ingersoll]	*Maple Bedstid*	1..16..0	
230	05 20 1781	John Tucker	*Bedstid with fluted posts [mahogany]*	10..0..0	
231	06 00 1781	Joe'b Ashton	*Bedstid with fluted posts [mahogany]*	10..0..0	E 5
232	06 00 1781	Joe'b Ashton	*1 set of Bed rails*	0..12..0	AB; E 7
233	06 00 1781	Jar'l Peirce	*1 Mahogany Bedstid with fluted posts*	10..0..0	AB
234	06 00 1781	Step'n Cook	*Bedstid w'h [with] plain posts*	4..0..0	
235	07 13 1781	Jn'o Brooks	*1 Bedstid @ 24/*	1..4..0	D 9
236	08 00 1781	Jar'l Peirce	*1 Bed cornice*	2..0..0	AB
238	08 27 1781	Henry Gardner	*Bedstid*	2..0..0	
239	08 27 1781	Bar't Putnam	*High post Bed Stid*	1..0..0	
240	09 00 1781	Doc. Edward Barnard	*1 Bed Cornice*	NOT PRICED	AB; E 9
241	09 00 1781	John Brooks	*1 Bed cornice 40/*	2..0..0	D 9
242	09 17 1781	Doc't Bernard [Barnard]	*1 Bed cornice*	2..0..0	E 9
243	09 17 1781	Jar'l Peirce	*1 Bed cornice*	2..0..0	
244	11 12 1781	Jn'o Danielson [Donaldson]	*1 Bedsted 30/*	1..16..0	AB
245	11 12 1781	Henry Gardner	*1 High Post Bedstid*	NOT PRICED	Ordered after his return from exile
246	11 12 1781	Henry Gardner	*1 Bedstid*	NOT PRICED	Ordered after his return from exile
247	02 00 1782	Ben'n West	*1 Bedstid £4*	4..0..0	AB
248	09 00 1782	W'm Nichols	*1 Bedstid*	1..7..0	AB
249	10 10 1782	Shep'n Cleveland	*1 Maple Bedstid*	1..10..0	
250	11 00 1782	William Ropes	*High post Bedsted with cornice*	10..13..0	AB
251	11 09 1782	William Safford	*1 Bedstid*	1..10..0	
252	11 09 1782	Walter P. Bartlett	*Cot Bedstid*	0..18..0	E 12
253	11 09 1782	Walter P. Bartlett	*1 Bed cornice*	1..16..0	E 11
254	05 00 1783	Nathan Peirce	*1 High post Bedsted*	8..0..0	E 87

Cases of Drawers

	LEDGER DATE	CLIENT	LEDGER ENTRY	PRICE	NOTES
1	00 00 1758	Thomas Elkins	*Case Drawers [walnut]*		Entry from a credit to journeyman Thomas West where customer is mentioned
2	05 21 1758	James Gould	*a Case of Draws 86/8 [prob. walnut]*	4..6..8	Price listed as 4..13..4 in DB
3	07 00 1758	David Nickals [Nichols]	*a Case of Draws [prob. walnut]*	4..5..4	32..0..0
4	08 18 1758	John Leach, Ju'r	*a Case of Draws [prob. walnut]*	4..5..4	32..0..0; D 56
5	06 04 1759	John Tasker [Esq.]	*Case of Draws [mahogany]*	12..0..0	90..0..0; D 34
6	08 18 1759	Tabytha Skyner [Skinner]	*1 Case of Draws [walnut]*	14..13..4	110..0..0; sold w/ chamber table; D 37
7	03 08 1760	Sam Clamons [Clemons]	*a Case of Draws [prob. flat-top high chest, walnut]*	4..0..0	30..0..0
8	04 08 1760	Sam'l White Jn'r.	*a Case of Draws [prob. flat-top high chest, walnut]*	4..0..0	30..0..0
9	09 24 1760	Robert Millen	*1 Case of Draws*	6..13..4	50..0..0; D 64
10	01 00 1761	Arcl's McIntire	*1 Case of Draws [prob. flat-top highboy, walnut]*	4..0..0	30..0..0; D 62

Cases of Drawers

	LEDGER DATE	CLIENT	LEDGER ENTRY	PRICE	NOTES
11	04 10 1761	Jerem'h Newhall	*1 Case of Draw [walnut]*	7..6..8	55..0..0; not listed in AB until 08/1763; D 67
12	05 07 1761	John Crowningshell [Crowninshield]	*1 Case of Draws [mahogany]*	10..13..4	80..0..0; D 23
13	11 00 1761	Mrs Han'h Cabot	*1 Case of Draws [prob. mahogany]*	16..0..0	120..0..0
14	11 01 1761	Dan'l Ropes	*1 Case of Draws [walnut]*	7..6..8	55..0..0; D 91
15	11 03 1761	John Tasker Esq	*1 Case of Draws [prob. mahogany]*	16..0..0	120..0..0; D 110
16	01 26 1762	Wl'm Luscomb	*Case of Draws [prob. flat-top highboy]*	4..2..0*	30..15..0
17	04 00 1762	George Dodge	*1 Case of Draws [mahogany chest-on-chest]*	17..6..8	130..0..0
18	05 03 1762	Widow Tasker	*1 Case of Draws [mahogany chest-on-chest]*	17..6..8	130..0..0; D 110
19	06 00 1762	Be'l Topen [Toppan]	*Case of Draws [mahogany chest-on-chest]*	17..6..8	130..0..0; D 85
20	06 00 1762	John Bery [Berry]	*Case of Draws [prob. walnut]*	4..13..4	35..0..0
21	06 00 1762	Enos Night [Knight]	*Case of Drawers*	6..0..0	45..0..0
22	04 00 1763	Jacob Fowle	*1 Case of Draws [mahogany]*	10..0..0	75..0..0; sold w/ chamber table
23	09 03 1763	John Pickering	*1 Case of Draws [walnut]*	7..6..8	AB; D 83
24	03 00 1764	Zacheus Collins	*1 Case of Draws [walnut]*	7..6..8	AB; sold w/ chamber table; D 73
25	06 00 1764	Joseph Churchwell [Churchill]	*Case of Draws*	6..5..0	AB
26	11 01 1764	Abraham Gray	*1 Case of Draws*	6..13..4	AB; D 43
27	11 22 1764	Mark Hu'n Wintworth of Ports'th New Ham'r [Wentworth]	*1 Mahogany Case of Draws [chest-on-chest]*	17..6..8	AB; shipped in cases; D 31
28	01 00 1765	Josiah Gould	*1 Case of Draws without brasses [prob. walnut]*	4..6..8	AB
29	04 00 1765	James Bradish, Jn'r.	*1 Case of Draws [walnut]*	6..13..4	AB; sold w/ chamber table
30	04 15 1765	Joseph Southwick	*1 Case of Draws with steps [prob. flat-top high chest, walnut]*	4..4..0	AB; D 44
31	12 26 1765	Jere'h Page of Danvers	*Case of Draws del'd [delivered] Francis [walnut]*	4..16..0	AB
32	01 29 1766	Sam'l Grant	*1 half of Case of Draws*	7..13..4	AB; C 76
33	05 00 1766	Simon Broadstreet [Bradstreet]	*Case of Draws & Table [prob. mahogany]*	13..6..8	AB; order not itemized
34	08 09 1766	Benjamin Molton [Moulton]	*1 Case Draws*	6..0..0	AB
35	01 17 1767	Thomas Colyer 2'd [Collier II]	*1 Case Draws 93/4 [walnut]*	4..13..4	AB; D 18
36	10 00 1767	John Apleton [Appleton]	*1 Case of Draw of Mehogany sweld ends*	17..6..8	AB; D 1
37	11 05 1767	Josiah Orne	*1 Case of Draws [mahogany]*	10..13..4	D 78
38	01 14 1768	Gama'l Hoges [Hodges]	*Case of Draws £10..13..4 [mahogany]*	10..13..4	D 109
39	01 21 1768	Amos Flint	*Case drawers 60/ [prob. maple]*	3..0..0	D 47
40	08 01 1768	Rebeca Orne	*Mehogany Case of draw [chest-on-chest]*	17..6..8	D 16
41	08 01 1768	Rebeca Orne	*Wallnut Case Drawers*	7..0..0	D 16
42	09 03 1768	William Launder [Lander]	*Wall't Case of Draws [walnut]*	7..0..0	D 55
43	12 30 1768	Sam'l Grant	*Half Case Draws sold for me in West Indies*	7..5..6	C 131
44	02 18 1769	Isaic Neadham [Needham Jr.]	*Case of Draws £7/6/8 [walnut]*	7..6..8	D 66
45	02 23 1769	Roland Savage	*1 Case of Draws [walnut chest-on-chest]*	8..13..4	
46	03 16 1769	W'm Launder [Lander Jr.]	*Case of Draws dl'd [delivered] young [walnut]*	4..13..4	Delivered to Nathaniel Young
47	08 12 1769	Amos Flint	*Case of draw & table*	3..13..4*	Order not itemized, total was 4..8..0
48	11 00 1769	Jn'o Turner Esq	*1 Mehogany Case of Draws £15/6/8*	15..6..8	D 36
49	01 22 1770	John Gooll	*Case of Draws for shop 16/*	0..16..0	
50	06 09 1770	Ben'n Coates	*Case of Draws [walnut]*	7..6..8	
51	07 18 1770	Joseph Dean	*Making Case of Draws of Rosewood, Exclusive of Brasses*	13..6..8	Paid in cash
52	08 24 1770	Clark Gat'n Pickman	*Case Draws [mahogany chest-on-chest]*	18..13..4	D 86
53	11 00 1770	Henry Williams	*1 Case of Draws [mahogany]*	10..13..4*	Sold w/ chamber table; order not itemized in AB, total was 37..6..4; D 114
54	05 03 1771	Jn'o Saunders	*Case of drawers [walnut]*	7..6..8	Sold w/ chamber table; D 49
55	08 01 1771	Gideon Foster of Danvers	*1 Case of Draws 96/ [prob. walnut]*	4..16..0	D 33
56	08 20 1772	Jeremiah Lee Esq	*Mehog'y Case Draws [chest-on-chest]*	18..13..4	Called chest-on-chest in inventory of 1785, valued @ 14..0..0; D 58
57	08 20 1772	Jeremiah Lee Esq	*Wall't Case of Draws [chest-on-chest, walnut]*	8..13..4	Called chest-on-chest in inventory of 1785, valued @ 9..0..0; D 58
58	09 14 1771	Nath.l Sparhawk [Jr.]	*Case of Draws for shop [prob. pine]*	0..12..0	

	LEDGER DATE	CLIENT	LEDGER ENTRY	PRICE	NOTES
59	11 00 1772	Suanh Hathorne	*Wall't Case Draws [chest-on-chest, walnut]*	8..13..4	D 46 or 50
60	05 00 1773	Joseph Cook	*Case of Draws del'd [delivered to] brother [walnut]*	4..13..4	
61	06 09 1773	Paletiah Webster of Philadelphia	*Mehogany Case Drawes*	12..0..0	
62	07 20 1773	William Launder [Lander]	*Mehogany Case Draws*	12..0..0	Price listed as 13..6..8 in AB
63	07 30 1773	Jere'h Lee Esq	*Mehogany Low Case of Draws*	8..0..0	
64	10 00 1773	William Paine	*1 Case of drawers [mahogany chest-on-chest]*	18..13..4	Shipped in cases; D 81
65	01 11 1774	Mr Nathaniell Webb of Danv's	*Case of Draws @ 96/2 [walnut]*	4..16..0	
66	01 13 1774	Eben'r Francis	*Case of Draws [walnut]*	4..16..0	
67	01 13 1774	Edward Allen	*Case of Draws Mehogany*	18..13..4	
68	01 17 1774	Tho's Mason Ju'r.	*Case Draws [mahogany block-front chest-on-chest]*	18..13..4	D 63
69	01 18 1774	Edmun Whitmore Jun	*Black Wall't Case Draws [walnut]*	7..6..8	D 112
70	06 27 1774	Jon'n Ireland	*Wall't Case Draws [walnut]*	7..6..8	
71	10 01 1774	Nehemiah Buffinton [Buffington]	*1 Case Draws [walnut]*	4..13..4	D 11
72	12 02 1774	Jonathon Symonds [III]	*Wl't Cas of Draws [walnut]*	4..16..0	D 102
73	02 04 1775	Jeremiah Page	*Case Draws [walnut]*	7..6..8	D 90
74	04 09 1775	Jeremiah Lee Esq	*1 Case of Draws [mahogany block-front chest-on-chest]*	18..13..4	D 104
75	04 09 1775	Jeremiah Lee Esq	*1 Do [Case of Draws, prob. mahogany]*	16..0..0	D 104
76	06 24 1775	Jon'n Payson	*Case Draws*	9..1..4	Shipped in 2 cases; sold w/ chamber table
77	06 24 1775	Jon'n Payson	*2 Cases for Case of Draws*	0..16..0	
78	08 00 1775	William Vans, Esq'r	*1 Case Draws [mahogany chest-on-chest]*	18..13..4	D 105
79	02 00 1776	Jn'o Lee Esq	*1 Case Draws Del/d his Daughter [walnut]*	7..6..8	D 48
80	12 04 1776	John Lee, Esq	*1 Case of Draws [walnut chest-on-chest]*	8..13..4	D 48
81	09 23 1777	Jn'o Lee Esq	*1 Case Draws*	15..0..0	D 77
82	11 07 1777	Edmund Putnam	*W't Case drawers [walnut]*	$50.00	D 29

Chairs

	LEDGER DATE	CLIENT	LEDGER ENTRY	PRICE	NOTES
1	01 16 1758	Robert Shileby [Shillaber]	*6 Chairs @ 55/ @ 7/4 [maple]*	2..4..0	16..10..0; price listed as 7/4 in AB
2	09 23 1758	Daniel Gardenor [Gardner]	*6 Black Walnut Chairs @ £8..10/ [22/8]*	6..16..0	51..0..0; D 8
3	09 23 1758	Daniel Gardenor [Gardner]	*a Great Chair*	14..0..0	D 8
4	09 23 1758	Daniel Gardenor [Gardner]	*6 Maple Chairs @ 55/ [7/4]*	2..6..8	17..10..0; D 8
5	10 04 1758	Chrispus Brewer	*Seven Chairs @ 30/ [4/]*	1..8..0	10..10..0; D 8
6	11 07 1758	Thomas Elkins	*[6] Chairs @ 125/ [16/8]*	4..4..0	31..10..0; D 28
7	11 07 1758	Thomas Elkins	*6 small Chairs*	NOT PRICED	Order not itemized, total for 6 small and 1 large chair was 20..0..0; D 28
8	11 07 1758	Thomas Elkins	*1 large dito [chair]*	NOT PRICED	Order not itemized, total for 6 small and 1 large chair was 20..0..0; D 28
9	12 26 1758	Chris Brewer	*a Round back Chair*	1..9..4	11..0..0
10	01 16 1759	Ben'n Stacy [Stacey]	*12 Chairs £8..10 @ 22/8 [walnut or cherry]*	13..12..0	102..0..0; D 97
11	01 16 1759	Ben'n Stacy [Stacey]	*1 Round Ditto 37/4 [chair]*	1..17..4	14..0..0; D 97
12	04 23 1759	Stephen Higingson [Higginson]	*6 Chairs @ £9..10/ [25/4]*	7..12..0	57..0..0
13	07 23 1759	Richard Stacy [Stacey]	*6 Chairs @ £8..10/ [walnut or cherry, 22/8]*	6..16..0	51..0..0; D 98
14	07 23 1759	Richard Stacy [Stacey]	*1 Round Dito [chair, walnut]*	2..0..0	15..0..0; D 98
15	08 18 1759	Muckford [Mugford]	*6 Black Walnut Chairs @ £9..10 [25/4]*	7..12..0*	59..0..0; old tenor price listed in DB incorrect, should be 57..0..0
16	08 18 1759	Tabytha Skyner [Skinner]	*6 Chair frames @ £8..10 [walnut or cherry, 22/8]*	6..16..0	51..0..0; D 37
17	08 18 1759	Tabytha Skyner [Skinner]	*7 Black Wt Dito @ £8..10 [chairs, walnut, 22/8]*	7..18..8	59..10..0; D 37
18	08 18 1759	Tabytha Skyner [Skinner]	*1 Round Dito [chair, walnut]*	2..0..0	15..0..0; D 37
19	10 29 1759	John Gardnor [Gardner]	*2 Chairs @ 110/*	1..9..4	11..0..0
20	11 20 1759	Jose'h Grafton	*1 Close Stool Great Chair 48/*	2..8..0	18..0..0; C 11
21	04 24 1760	Jacob Fowle Esq	*6 Chairs @ £8..5..0 [22/]*	6..12..0	49..10..0

Chairs

	LEDGER DATE	CLIENT	LEDGER ENTRY	PRICE	NOTES
22	04 24 1760	Jacob Fowle Esq	*Large Ditto [chair]*	1..17..4	14..0..0
23	07 03 1760	Mr Churchwell [Churchill]	*6 Chairs @ 30/ [4/]*	1..4..0	9..0..0
24	07 11 1760	Mary Hix [Hicks]	*1 doz [12] of Chairs @ 50/ [6/8]*	4..0..0	30..0..0
25	08 16 1760	Sam West	*a Close Stool Convenant [convenience] Chair*	1..0..0	7..10..0
26	08 16 1760	John Growningsheld [Crowninshield Sr.]	*a Close Stool Chair*	1..8..0	10..10..0
27	08 16 1760	Joseph Churchwell [Churchill]	*2 low Chairs @ 25/*	0..6..8	2..10..0; E 24
28	10 15 1760	John Dean	*6 small Chairs @ £10..0/*	8..0..0	60..0..0; C 17
29	10 15 1760	John Dean	*2 large dito @ £16 [chairs]*	4..5..4	32..0..0; C 17
30	12 12 1760	John Nuting [Nutting]	*a Round Chair*	1..0..0	7..10..0
31	01 08 1761	John Growningsheld [Crowninshield Sr.]	*6 Chairs @ 7..10..0 [20/]*	6..0..0	45..0..0; D 23
32	04 03 1761	Jon'n Cook	*1 Chair*	16..0..0	120..0..0; C 20
33	09 01 1761	Ben'n Stacy [Stacey]	*8 Chairs @ £7..10/*	8..0..0	60..0..0
34	09 01 1761	Joshua Foster	*6 Chairs @ 22/8 [walnut or cherry]*	6..16..0	
35	09 01 1761	Jon'n Cook	*12 Chairs @ £13..10/ [mahogany, 36/]*	21..12..0	162..0..0; duplicate entries in AB; C 23
36	02 07 1762	James Cockel [Cockle]	*8 Chairs @ £12 [mahogany, 32/]*	12..16..0	96..0..0
37	05 03 1762	The widow Tasker	*7 Chairs @ £10..10/ [28/]*	9..16..0	73..10..0; D 110
38	08 00 1762	Elias Hask't Darby [Derby]	*6 Meh'y Chair frames @ £9 [mahogany, 24/]*	7..4..0	54..0..0; D 23
39	08 00 1762	Elias Hask't Darby [Derby]	*12 Burch Ditto @ 80/ [chairs, 10/8]*	6..8..0	48..0..0; D 23
40	08 00 1762	Elias Hask't Darby [Derby]	*12 Leather Bottoms for Dito @ 85/ [chairs, 11/4]*	6..16..0	51..0..0; D 23
41	08 00 1762	Elias Hask't Darby [Derby]	*6 Hariteen Ditto @ 60/ [bottoms for chairs]*	2..8..0	18..0..0; D 23
42	08 00 1762	Elias Hask't Darby [Derby]	*4 Burch Chairs flag bottoms @ 58/ [7/8 / 1/2]*	1..10..11 1/4	11..12..0; D 23
43	10 23 1762	Messrs Mason & William	*36 Small Chairs @ £14/*	68..8..0	504..0..0; C 28
44	10 23 1762	Messrs Mason & William	*6 Round Dittos @ £25*	20..0..0	150..0..0; C 28
45	10 23 1762	Messrs Mason & William	*3 Convenant Dittos @ £27 [convenience chairs]*	10..16..0	81..0..0; C 28
46	10 23 1762	Messrs Mason & William	*2 Settee Dittos @ £75 [chairs]*	20..0..0	150..0..0; C 28
47	11 00 1762	John White Junr	*6 Chairs @ £9..10 @ 25/4*	7..12..0	57..0..0
48	01 25 1763	Sam'l Grant	*6 Chairs @ 70/ [birch, straw bottoms, 9/4]*	2..16..0	21..0..0; D 41
49	01 25 1763	W'm West	*6 Mehog'y Chairs @ 150/ [mahogany, 20/]*	6..0..0	45..0..0
50	02 07 1763	Thom's Mason	*6 Chairs @ 32/0 [mahogany]*	8..2..0	AB
51	04 00 1763	Jacob Fowle	*6 Wal't Chairs @ £9 @ 26/ [walnut]*	7..16..0	54..0..0; AB; unit price in AB incorrect, should be 24/; chairs carved per Mason's inventory
52	05 00 1763	James Freeman	*[12] Chairs @ £14..10/*	23..4..0	174..0..0; C 33
53	05 00 1763	James Freeman	*2 Round do @ 400/ [chairs]*	5..6..8	40..0..0; C 33
54	09 00 1763	Richard Darby [Derby]	*6 Mehogany Chairs @ 39/*	11..14..0	AB; D 88
55	09 00 1763	Richard Darby [Derby]	*6 Do Wallnut @ 26/ [chairs]*	7..16..0	AB; D 88
56	09 00 1763	Richard Darby [Derby]	*4 Do Locust @ 20/8 [chairs]*	4..2..8	AB; D 88
57	09 00 1763	Richard Darby [Derby]	*1 large Meh'y Chair [mahogany]*	2..8..0	AB; D 88
58	09 00 1763	Richard Darby [Derby]	*1 Round Do Locost [chair]*	1..4..0	AB; D 88
59	12 00 1763	Jacob Fowle	*1 do [chair, walnut]*	1..10..0	AB
60	03 26 1764	Jon'n Peale Jr [Peele]	*6 Chairs @ 36/ [mahogany]*	10..16..0	AB
61	04 27 1764	Jacob Fowle	*6 Wallnut Chairs as p'r [per] day book [24/]*		AB; not a sale, correcting entry from 04/1763
62	08 00 1764	John Dean	*6 small Chairs @ 42/8 [walnut or cherry]*	12..16..0	AB; order not itemized in AB
63	08 00 1764	John Dean	*2 large D'o @ 60/ [chairs]*	6..0..0	AB; order not itemized in AB
64	08 07 1764	James Grant	*8 Chairs @ 22/8 [walnut or cherry]*	9..1..4	AB; duplicate entries in AB
65	11 00 1764	Sam'l Curwin [Curwen]	*6 Mehogany Chairs @ 20/*	6..0..0	AB
66	11 22 1764	Mark Hu'n Wintworth of Ports'th New Ham'r [Wentworth]	*6 Meh'g Chairs bottom'd with calf @ 28/ [mahogany]*	8..8..0	AB; D 31
67	11 22 1764	Mark Hu'n Wintworth of Ports'th New Ham'r [Wentworth]	*12 ditto with moveable bottoms @ 37/4 [chairs, mahogany]*	22..8..0	AB; D 31
68	01 01 1765	Benjamin Pickman Esq	*6 Mehogany Chairs @ 36/8*	11..4..0	AB; overcharged by 4..0..0

Chairs

	LEDGER DATE	CLIENT	LEDGER ENTRY	PRICE	NOTES
69	02 00 1765	**Thomas Poynton**	*Black Wal't Chair [walnut]*	1..4..0	AB
70	02 00 1765	**Thomas Poynton**	*Elbow do [for chair, black walnut]*	1..10..0	AB
71	03 00 1765	**Benjamin Pickman Esq**	*Ditto [chair, mahogany]*	1..16..8	AB; additional chair for set ordered in 01/1765
72	03 00 1765	**Sam'l West Jr.**	*1 Close Stool Chair*	1..0..0	AB
73	04 10 1765	**Josiah Bachelder Jr [Batchelder]**	*6 Mehogany Chairs @ 28/*	8..8..0	AB; D 5
74	09 24 1765	**Nicholas Bartlet Marblehead [Bartlett]**	*[6] Chairs @ 37/4 per*	11..4..0	AB; C 67
75	12 00 1765	**John Glover**	*6 small Mehogany Chairs @ 23/8*	8..8..0	AB; E 48
76	12 00 1765	**John Glover**	*1 large ditto [chair]*	1..17..4	AB; E 48
77	06 00 1766	**Simon Broadstreet [Bradstreet]**	*6 Chairs @ 22/*	6..12..0	AB
78	06 00 1766	**Simon Broadstreet [Bradstreet]**	*1 Round Chair*	1..6..8	AB
79	07 00 1766	**Joshua Foster**	*6 Mehogany Chairs @ 270/ old tenor [36/]*	9..0..0	AB; undercharged by 1..16..0; D 18
80	08 00 1766	**Simon Broadstreet [Bradstreet]**	*6 Chairs @ 18/*	5..8..0	AB
81	08 00 1766	**Simon Broadstreet [Bradstreet]**	*Hareteen for Chair bottom*	0..8..0	AB
82	08 02 1766	**Ben'n Lynde Esq**	*6 Cheretre Chairs @ 95/ old tenor [cherry, 12/4]*	3..14..0	AB; price incorrect in DB; D 107
83	08 02 1766	**Ben'n Lynde Esq**	*6 Chairs ditto @ ditto [95/ old tenor, cherry, 11/8]*	3..10..0	AB; D 108
84	08 02 1766	**Ben'n Lynde Esq**	*8 Mehogany Chairs @ 26/8 [slip seat]*	10..13..4	AB; D 108
85	08 02 1766	**Ben'n Lynde Esq**	*2 ditto ditto [chairs, mahogany] @ 22/*	2..2..8	AB; D 108
86	08 02 1766	**Ben'n Lynde Esq**	*1 Round Chair*	0..15..10	AB; D 108
87	08 09 1766	**Benj'n Molton [Moulton]**	*6 small Chairs @ 6/8 [maple]*	2..0..0	AB
88	08 09 1766	**Benj'n Molton [Moulton]**	*1 larg 13/4 [chair]*	0..13..4	AB
89	10 00 1766	**John White Of Marblehead**	*6 Mehogany Chairs @ 33/4*	10..9..0	AB
90	10 15 1766	**Deborah Freeman**	*6 Mahogany Chairs @ 37/4*	11..4..0	AB
91	10 25 1766	**William Liley [Lilly]**	*6 Mehogany Chairs @ 36/*	10..16..0	AB; E 73
92	10 25 1766	**William Liley [Lilly]**	*1 Easy Chair*	2..16..0	AB; E 74
93	11 00 1766	**Mrs Higingson [Higginson]**	*6 Mehogany Chairs @ 24/*	7..4..0	AB; D 59
94	11 00 1766	**Mrs Higingson [Higginson]**	*8 Wallnut do @ 15/ [chairs]*	6..0..0	AB; D 59
95	11 00 1766	**Mrs Higingson [Higginson]**	*1 Round do [chair]*	1..2..6	AB; D 59
96	11 00 1766	**Mrs Higingson [Higginson]**	*Bottoming 9 Chairs @ 10/*	4..10..0	AB; D 59
97	11 00 1766	**Mrs Higingson [Higginson]**	*Bottoming 6 ditto @ 6/ [chairs]*	1..16..0	AB; D 59
98	11 00 1766	**Jonathan Jackson**	*[6] Chairs*	NOT PRICED	AB; order not itemized, quantity determined from upholstery order for Benjamin Nurse; D 51
99	12 30 1766	**Jacob Ashton**	*6 Mehogany Chairs @ 36/*	10..16..0	AB
100	12 30 1766	**Jacob Ashton**	*1 Round ditto [chair]*	2..9..4	AB; ordered same year as his graduation from Harvard
101	01 17 1767	**Thomas Colyer 2'd [Collier II]**	*6 Chairs @ 6/8*	2..0..0	AB; D 18
102	02 12 1767	**John Fisher Esq**	*2 Windsor Chairs @ 18/*	1..16..0	AB
103	02 18 1767	**Thomas Poynton**	*6 Wallnut Chairs @ 28/*	8..8..0	AB
104	06 00 1767	**John Mauskereen [Mascareen Esq.]**	*8 Chairs exclusive of hair covers @ 22/8*	9..1..4	AB; ordered 1 month after moving into his house in Salem
105	08 00 1767	**Joseph Cabot**	*8 Chairs @ 32/ [mahogany]*	12..16..0	AB
106	10 00 1767	**John Apleton [Appleton]**	*6 Mehogany Chair frames @ 25/4*	7..12..0	AB; D 1
107	10 00 1767	**John Apleton [Appleton]**	*6 Black wallnut ditto @ 14/8 [chairs]*	4..8..0	AB; D 1
108	11 05 1767	**Josiah Orne**	*6 Mehog'y Chairs @ 32/*	9..12..0	AB; D 78
109	11 05 1767	**Josiah Orne**	*6 Cheretree Chairs @ 22/8 [cherry]*	6..16..0	AB; D 78
110	12 00 1767	**Josiah Orne**	*1 low Chair*	1..1..4	AB; D 78
111	12 00 1767	**Josiah Orne**	*Round ditto 26/ [chair]*	1..6..0	AB; D 78
112	05 15 1768	**Wood & Waters**	*8 Chairs @ 8/8 [birch, with straw bottoms]*	3..9..4	
113	08 01 1768	**Rebeca Orne**	*8 Maho'y Chair Frames @ 32/ [mahogany, horse hair upholstery]*	12..16..0	D 16
114	08 01 1768	**Rebeca Orne**	*8 ditto [mahogany chair frames] @ 26/8 [slip seat-barateen]*	10..13..4	D 16
115	08 01 1768	**Rebeca Orne**	*12 ditto [chair frames] @ 24 [horse hair]*	14..8..0	D 16
116	08 01 1768	**Rebeca Orne**	*1 Round ditto [chair, horse hair)*	1..10..0	D 16

Chairs

	LEDGER DATE	CLIENT	LEDGER ENTRY	PRICE	NOTES
117	08 01 1768	**Rebeca Orne**	*6 Walnutt ditto @ 18/8 [chair, barateen]*	5..12..0	D 16
118	08 01 1768	**Rebeca Orne**	*21 Chair bottoms of horse hair @ 12/*	13..13..0	D 16
119	08 01 1768	**Rebeca Orne**	*8 Ditto of Hareteen @ 6/ [chair bottoms]*	2..8..0	D 16
120	08 01 1768	**Rebeca Orne**	*6 do @ 4/4 [chair bottoms, hariteen]*	1..2..0	D 16
121	11 11 1768	**Step'n Higgenson [Higginson]**	*6 Burch Chair frames @ 10/8*	3..4..0	
122	12 23 1768	**Joseph Skilen [Skillin]**	*6 Chairs @ 37/8 [mahogany]*	10..16..0	Price corrected to 36/ in AB
123	02 18 1769	**Isaic Neadham [Needham Jr.]**	*7 Joyners Chairs @ 7/4 [maple]*	2..11..4	D 66
124	02 18 1769	**Isaic Neadham [Needham Jr.]**	*1 Round do 14/8 [chair]*	0..14..8	D 66
125	02 18 1769	**Isaic Neadham [Needham Jr.]**	*4 Common do @ 3/8 [chairs]*	0..14..8	Unit price in AB incorrect; D 66
126	03 16 1769	**Jere'h Lee, Esq**	*1 Sette Chair [settee]*	1..13..4	Delivered 1 year after his house was completed
127	03 16 1769	**Jere'h Lee, Esq**	*Elbow Ditto 24/ [chair]*	1..4..0	Delivered 1 year after his house was completed
128	03 16 1769	**Jere'h Lee, Esq**	*1 Low Ditto 20/ [chair]*	1..0..0	Delivered 1 year after his house was completed
129	03 24 1769	**Joseph H [Hood]**	*Frame for Easy Chair*	1..6..8	E 55
130	03 24 1769	**Roland Savage**	*6 Wallnut Chairs @ 28/8*	8..8..0	Undercharged by 0..4..0
131	04 07 1769	**Jeremiah Lee, Esq mar'h [of Marblehead]**	*6 Mehogany Chair frames @ 26/8*	8..0..0	Delivered 1 year after his house was completed
132	11 00 1769	**Jn'o Turner Esq**	*8 Mehogany Chair frames @ 26/8 [slip seat]*	10..13..4	D 36
133	11 00 1769	**Jn'o Turner Esq**	*6 ditto @ 36/ [chair frames, mahogany]*	10..16..0	D 36
134	11 00 1769	**Jn'o Turner Esq**	*6 Wall't ditto @ 13/4 [chair frames, walnut]*	4..0..1	D 36
135	11 00 1769	**Jn'o Turner Esq**	*14 Leather bottoms @ 10/8*	7..9..4	D 36
136	11 00 1769	**Jn'o Turner Esq**	*6 Hareteen ditto @ 6/ [bottoms]*	1..16..0	D 36
137	12 00 1769	**George Gardner**	*6 Mehogony Chairs @ 28/*	8..8..0	AB
138	01 11 1770	**Joseph Lee [Esq. of Beverly]**	*8 Mehogony Chair frames @ 16*	6..8..0	D 57
139	01 11 1770	**Joseph Lee [Esq. of Beverly]**	*6 Birch ditto @ 10/8 [chair frames]*	3..4..0	D 57
140	01 11 1770	**Joseph Lee [Esq. of Beverly]**	*7 Birch Chair straw bottoms @ 9/4*	3..5..4	D 57
141	01 11 1770	**Joseph Lee [Esq. of Beverly]**	*7 Kitchen ditto @ 3/9 [chairs, staw bottoms]*	1..6..3	D 57
142	01 11 1770	**Joseph Lee [Esq. of Beverly]**	*Bottoming 8 Chairs with calf @ 10/8*	4..5..4	D 57
143	01 11 1770	**Joseph Lee [Esq. of Beverly]**	*ditto 6 Hareteen @ 6/0 [bottoming chairs]*	1..16..0	D 57
144	03 31 1770	**Nath'l Whitekar [Whitaker]**	*6 Chair frames @ 16/*	4..16..0	
145	03 31 1770	**Nath'l Whitekar [Whitaker]**	*1 Elbo ditto 20/ [chair, mahogany]*	1..0..0	
146	03 31 1770	**Nath'l Whitekar [Whitaker]**	*Hair seating for 2 Chairs 12/*	0..12..0	
147	03 31 1770	**Nath'l Whitekar [Whitaker]**	*Bottoming 7 Chairs @ 6/*	2..2..0	
148	04 09 1770	**George Gardner**	*Round Chair*	1..16..0	
149	05 09 1770	**Roland Savage**	*Easy Chair frame & covering*	1..4..0	E 99
150	05 09 1770	**Roland Savage**	*Upholsters Bill*	1..10..8	Overcharged by 0..8..0
151	05 09 1770	**Joseph Sprague**	*6 Chairs with calf bottoms @ 36/ [mahogany]*	10..16..0	
152	08 24 1770	**Clark Gat'n Pickman**	*6 Chair frames Carvd Backs @ 36/ [mahogany]*	10..16..0	D 86
153	08 24 1770	**Clark Gat'n Pickman**	*6 Ditto @ 28/ [chair frames, mahogany]*	8..8..0	D 86
154	08 24 1770	**Clark Gat'n Pickman**	*6 Ditto @ 22/ [chair frames, mahogany]*	6..12..0	D 86
155	08 24 1770	**Clark Gat'n Pickman**	*6 Wall't ditto @ 16/ [chair frames, walnut]*	4..16..0	D 86
156	08 24 1770	**Clark Gat'n Pickman**	*Round Chair*	1..13..4	D 86
157	08 24 1770	**Clark Gat'n Pickman**	*8 Maple chairs Black @ 4/4*	1..14..8	D 86
158	08 24 1770	**Clark Gat'n Pickman**	*7 Birch do Straw Bottoms @ 8/8 [chairs]*	3..0..8	D 86
159	10 24 1770	**Robert H Ives**	*Easy Chair frame*	3..0..0	E 60
160	11 00 1770	**Henry Williams**	*14 Birch Chairs @ 14/8*	10..5..0	D 114
161	11 00 1770	**Henry Williams**	*1 Round ditto [chairs, birch]*	1..1..4	D 114
162	11 00 1770	**Henry Williams**	*8 Black ditto @ 4/4 [chairs]*	1..14..8	D 114
163	11 00 1770	**Jn'o Archer Jn'r.**	*6 Mehogany Chairs leather seats @ 25/4 per*	7..12..0*	Price corrected, was 7..10..0
164	11 00 1770	**Jn'o Archer Jn'r.**	*1 Round Chair*	1..14..0	AB
165	01 07 1771	**Nath'l Sparhawk [Jr.]**	*Making elbows for Chairs*	0..6..8	
166	03 00 1771	**Ebenezer Swan**	*6 Chair frames @ 28/*	8..8..0	

Chairs

	LEDGER DATE	CLIENT	LEDGER ENTRY	PRICE	NOTES
167	04 00 1771	**Thomas Stimson**	*Chairs of Wm Launder omitted [maple]*	2..0..0	
168	04 28 1771	**Phil'n Parker**	*6 Chairs of Wm Launder 40/ [maple, 6/8]*	2..0..0	
169	05 03 1771	**Rich'd Maning [Manning]**	*An easey Chair frame*	1..6..0	
170	05 03 1771	**Benj'n Nurse**	*6 Wall't Chairs @ 14/8 [walnut]*	4..8..0	
171	06 01 1771	**Nathan Goodale**	*Chair frame*	0..14..8	
172	07 00 1771	**Abgial Eppes**	*6 Chair frames @ 28/*	8..8..0	D 93
173	07 00 1771	**Abgial Eppes**	*6 ditto @ 20/ [chair frames]*	6..0..0	D 93
174	09 28 1771	**Joseph Sprague**	*Easy Chair frame*	1..10..0	E 103
175	10 12 1771	**W'm Pinchon Esq [Pynchon]**	*6 Wall't Chairs frames @ 18/ [walnut]*	5..8..0	AB
176	12 10 1771	**W'm Pinchon Esq [Pynchon]**	*6 Mehogany do @ 22/ [chair frames]*	6..12..0	AB; D 79
177	01 03 1772	**Tho's Poynton**	*Chair frame*	1..6..8	
178	01 27 1772	**Jere'h Lee Esq**	*1 Elbo Chair frame*	1..0..0	Price listed as 1..5..0 in AB
179	03 00 1772	**Roland Savage**	*Close Stool Chair*	1..8..0	E 100
180	04 00 1772	**Timothy Orne [III]**	*2 straw bottom Chairs [birch, 10/8]*	1..1..4	
181	05 04 1772	**Daniel Mackey**	*2 Elbow Chair frames*	NOT PRICED	
182	07 28 1772	**Edward Allen**	*Easy Chair frame mahogany*	1..10..0	
183	07 28 1772	**Edward Allen**	*Cash paid the upholster*	2..16..0	AB
184	08 20 1772	**Jer'h Lee [Esq.]**	*12 Chair frames @ 18/*	10..16..0	D 58
185	08 20 1772	**Jer'h Lee [Esq.]**	*6 Chair frames @ 22/*	6..12..0	D 58
186	08 20 1772	**Jer'h Lee [Esq.]**	*12 Do Chair frames @ 14/ [walnut]*	8..8..0	D 58
187	08 20 1772	**Jer'h Lee [Esq.]**	*6 Do Chair frames @ 14/ [walnut]*	4..4..0	D 58
188	09 11 1772	**Jeremiah Lee [Esq.]**	*Easy Chair frame*	1..10..0	
189	09 11 1772	**W'm Putnam**	*Easy Chair frame*	1..10..0	
190	09 17 1772	**George Deblois**	*Low Chair*	0..12..0	E 30
191	10 10 1772	**George Deblois**	*1 Round Chair 60/ [close stool]*	3..0..0	Listed as "close stool" @ 60/ in AB; E 32
192	10 10 1772	**George Deblois**	*12 Chairs @ 10/*	6..0..0	
193	10 10 1772	**George Deblois**	*6 do @ 7/ [chairs]*	2..2..0	
194	10 10 1772	**George Deblois**	*6 do @ 3/4 [kitchen chairs]*	1..0..0	
195	10 10 1772	**Thomas Drowne**	*8 Chair frames @ 26/8 [mahogany]*	10..13..4	D 32
196	02 07 1773	**Nathan Leach**	*12 Chairs @ 21/4*	12..16..0	C 180
197	02 07 1773	**Nathan Leach**	*3 Large do @ 28/ [chairs]*	4..4..0	C 180
198	05 00 1773	**Edward Allen**	*Close Stool Chair frame*	1..8..0	AB
199	05 03 1773	**Edward Allen**	*Cash paid for bottoming & pan for do [close stool chair frame]*	0..15..4	AB
200	06 04 1773	**Thomas Barnard Jun.**	*6 Mehogany Chair frames With Carvd Knees @ 30/*	9..0..0	D 4
201	06 04 1773	**Thomas Barnard Jun.**	*6 D plain Knees @ 26/8 [chair frames, mahogany]*	8..0..0	D 4
202	06 04 1773	**Thomas Barnard Jun.**	*2 Elbo Do @ 33/4 [chair frames, mahogany]*	3..6..8	D 4
203	06 04 1773	**Thomas Barnard Jun.**	*12 Wallnut do @ 20/ [chair frames]*	12..0..0	D 4
204	06 04 1773	**Thomas Barnard Jun.**	*6 Kitchen Chairs 20/9*	1..6..0	When he paid, the price was changed to 20/6; D 4
205	06 26 1773	**Wil'm Morgan**	*6 Chairs for your daughter @ 8/*	2..8..0	
206	07 00 1773	**Ben'n Coates**	*6 Chair frames @ 28/*	8..8..0	
207	07 17 1773	**Timothy Orne [III]**	*Child's Chair*	0..4..8	E 86
208	09 11 1733	**Nathan Leach**	*6 Chair frames @ 21/4*	6..8..0	
209	09 11 1773	**Nathan Leach**	*2 Large Do @ 28/ [chair frames]*	2..16..0	
210	10 00 1773	**William Paine**	*6 Chair frames Meh'y @ 26/8 [mahogany]*	8..0..0	Shipped in cases; D 81
211	10 00 1773	**William Paine**	*6 Do Carved @ 38/8 [chair frames]*	11..12..0	Shipped in cases; D 81
212	10 00 1773	**William Paine**	*6 Do Wall't @ 16/ [chair frames, walnut]*	4..16..0	Shipped in cases; D 81
213	10 00 1773	**William Paine**	*6 Do Do @ 20/ [chair frames, walnut]*	6..0..0	Shipped in cases; D 81
214	03 26 1774	**George Cabot**	*9 Wal't Chair frames @ 20/ [walnut]*	9..0..0	D 14
215	03 26 1774	**George Cabot**	*8 Mahog'y Do Do @ 26/8 [chair frames]*	10..13..4	D 14
216	03 26 1774	**George Cabot**	*Easey Chair frame 36/*	1..16..0	D 14
217	03 26 1774	**George Cabot**	*6 Kichin Chairs @ 22/*	1..2..0	Price is total for all 6 chairs; D 14
218	05 00 1774	**Tho's Mason Jun**	*12 Mehogany Chair frames @ 26/8*	16..0..0	D 63

Chairs

	LEDGER DATE	CLIENT	LEDGER ENTRY	PRICE	NOTES
219	05 00 1774	**Tho's Mason Jun**	*6 Wall't do do @ 20/ [chair frames, walnut]*	6..0..0	D 63
220	06 08 1774	**Edward Allin [Allen]**	*12 Chair frames @ 26/8 [mahogany]*	16..0..0	Paid for by delivering large quanity of mahogany
221	07 06 1774	**Francis Cabot**	*8 Chair frames @ 26/8 loos seats [mahogany]*	10..13..4	D 60
222	07 06 1774	**Francis Cabot**	*8 Chair frames carved backs @ 36 [mahogany]*	14..8..0	D 60
223	07 06 1774	**Francis Cabot**	*Settee Chair [mahogany]*	4..0..0	D 60
224	09 00 1774	**Israel Morgan**	*6 Chairs on account of W'm Morgan [@ 8/]*	2..8..0	AB
225	10 01 1774	**Nehemiah Buffinton [Buffington]**	*6 Birch Chairs @ 8/8*	2..12..0	D 11
226	10 01 1774	**Nehemiah Buffinton [Buffington]**	*6 Black do @ 3/4 [chairs]*	1..0..0	D 11
227	12 02 1774	**Sylveter Gardner Esq [Gardiner]**	*14 Mehogany Chair frames @ 24/*	16..16..0	
228	12 24 1774	**Peter Frye esq**	*6 Wall't Chair frames [walnut, 20/]*	6..0..0	D 76
229	12 24 1774	**Peter Frye esq**	*6 Mehog'y do do [chair frames, 26/8]*	8..0..0	D 76
230	01 00 1775	**Peter Frye [Esq.]**	*Easy Chair frame*	1..8..0	D 76
231	01 09 1775	**Peter Frye [Esq.]**	*6 Chair frames wall't @ 22/ [walnut]*	6..12..0	D 76
232	04 09 1775	**Jeremiah Lee [Esq.]**	*1 Dozn Chairs @ 26/8 [mahogany]*	15..16..0	Undercharged by 0..4..0; D 104
233	04 09 1775	**Jeremiah Lee [Esq.]**	*6 Chair frames @ 28/*	8..8..0	D 104
234	04 09 1775	**Jeremiah Lee [Esq.]**	*12 Chair frames @ 26/8 [mahogany]*	15..16..0	Undercharged by 0..4..0; D 104
235	04 09 1775	**Jeremiah Lee [Esq.]**	*7 cases @ 6/*	2..2..0	D 104
236	04 09 1775	**Jeremiah Lee [Esq.]**	*Easy Chair frame*	1..16..0	
237	06 24 1775	**Jon'n Payson**	*6 Wall't Chair frames @ 22/8 [walnut]*	6..4..0*	Price corrected, was 6..16..0
238	12 00 1775	**Nath'l Tracy-NBPT**	*Easy Chair Frame*	1..16..0	E 106
239	03 13 1776	**Cap Curtis**	*3 Chairs*	NOT PRICED	
240	04 06 1776	**Mrs Hodges**	*8 Birch Chair frames @ 15/4*	6..2..8	
241	04 06 1776	**Mrs Hodges**	*6 Straw bottom Chairs @ 8/8*	2..12..0	
242	07 00 1776	**Isaac White**	*6 Chairs frames @ 24/*	7..4..0	Duplicate entries in AB; D 112
243	11 25 1776	**Isaac White**	*2 Mehogony Chair frames @ 24*	2..8..0	Duplicate entries in AB
244	11 25 1776	**John Jinks [Jenks]**	*6 Chairs @ 8/*	2..8..0	D 53
245	05 00 1777	**Joshua Dogue [Dodge]**	*14 Black Wl't Chair frames @ 24/ [walnut]*	16..16..1	D 25
246	05 00 1777	**Joshua Dogue [Dodge]**	*Cash D'd [delivered] W'm Launder for Bottoms*	1..4..0	D 25
247	05 06 1777	**Stephen Cabot**	*6 Chair frames @ 20/*	6..0..0	D 17
248	05 06 1777	**Stephen Cabot**	*Cash p'd [paid] for bottoming*	1..4..0	D 17
249	07 10 1777	**Simon Forister [Forrester]**	*1 Mehog'y Easy Chair frame*	2..8..0	
250	09 23 1777	**Jn'o Lee Esq**	*12 Chair frames @ 26.8 [mahogany]*	16..0..0	D 77
251	09 23 1777	**Jn'o Lee Esq**	*12 Bottoms*	3..12..0	D 77
252	09 23 1777	**W'm West**	*12 Chair frames @ 24/*	14..8..0	Duplicate entries in AB; D 114
253	10 00 1777	**Jn'o Derby**	*Easy Chair frame*	3..0..0	
254	10 00 1777	**Jn'o Derby**	*Close Stool do [chair frame]*	4..10..0	
255	10 24 1777	**Israel Thorndike**	*[6] Chairs @ 48/*	14..8..0	D 103
256	10 24 1777	**Israel Thorndike**	*P'd [paid] for bottoming*	3..12..0	D 103
257	02 00 1778	**William West**	*1 Walnut Chair*	1..4..0	AB
258	04 08 1778	**William West**	*Chair frame*	4..16..0	AB
259	07 13 1778	**W'm West**	*Easy Chair frame*	8..0..0	E 110
260	03 19 1779	**Dudly Sergant Esq'r [Sargent]**	*4 Chair frames @ 10£*	40..0..0	Price corrected in AB, was 20..0..0; E 97
261	03 19 1779	**Dudly Sergant Esq'r [Sargent]**	*1 do do [chair frame]*	15..0..0	E 97
262	09 00 1779	**Joshua Doge [Dodge]**	*6 Chair frames @ 26/8 [mahogany]*	8..0..0	
263	09 00 1779	**Joshua Doge [Dodge]**	*6 do do @ 24/ [chair frames]*	7..4..0	
264	10 09 1779	**Jn'o Cabot**	*9 Chair frames @ 26..13..4*	240..0..0	D 15
265	10 09 1779	**Andrew Cabot**	*9 Chair frames @ 26..13..4 @ 56/*	25..4..0	AB
266	01 27 1780	**Francis Cabot Jn'r**	*6 Meh'y Chair frames [mahogany, 28/]*	8..8..0	D 13
267	01 27 1780	**Francis Cabot Jn'r**	*1 Easy do do [chair frames]*	1..8..0	D 13
268	06 00 1780	**Bartholemew Putnam**	*6 Chairs*	NOT PRICED	
269	08 00 1780	**Henry Brown**	*6 Chairs @*	414..0..0	D 10
270	08 22 1780	**Joseph McComb**	*6 Mah'y Chairs [mahogany]*	NOT PRICED	
271	08 22 1780	**Joseph McComb**	*1 Round do [chair]*	NOT PRICED	

	LEDGER DATE	CLIENT	LEDGER ENTRY	PRICE	NOTES
272	11 00 1780	W'm Pickering	*6 Chairs*	414..0..0	D 84
273	01 00 1781	Saml Flagg	*1 Easey Chair frame*	4..0..0	
274	01 06 1781	Jn'o Jinkins [Jenkins]	*1 Easey Chair frame*	1..8..0	Price corrected in AB, was 1..16..0
275	02 24 1781	Jn'o Cook Jun'r	*6 joiners Chairs*	NOT PRICED	Total for all chairs was 612; D 19
276	02 24 1781	Jn'o Cook Jun'r	*1 Round do [chair]*	NOT PRICED	D 19
277	02 24 1781	Jn'o Cook Jun'r	*2 Black do [chair]*	NOT PRICED	D 19
278	03 00 1781	Jn'o John Brooks	*2 Chair frames 2520£*	2520..0..0	D 09
279	05 00 1781	Barth'w Putnam	*12 Chair frames*	NOT PRICED	D 82
280	05 05 1781	Thomas Smith	*6 Chairs*	[4..0..0]	Order not itemized in DB, price derviced by subtracting other items from the total
281	06 00 1781	Jacob Ashton	*1 Chair frame [easy chair]*	4..0..0	AB; E 6
282	09 20 1781	Peter Lander	*6 Chair frames @ 56/ [mahogany]*	16..16..0	E 69
283	10 01 1781	Jona'n Ingersol [Ingersoll]	*6 Chair frames @ 56 [mahogany]*	16..16..0	
284	11 12 1781	John Danielson [Donaldson]	*6 Black Chairs 9/*	2..14..0	
285	11 12 1781	John Danielson [Donaldson]	*Round Chair*	2..5..0	
286	11 12 1781	Henry Gardner	*8 Chair frames @ 56/ ea [mahogany]*	NOT PRICED	Ordered after his return from exile
287	02 00 1782	Ben'n West	*6 Mehogany Chair frames @ 28/*	8..8..0	AB
288	02 00 1782	Ben'n West	*1 Easy Chair frame*	2..0..0	AB
289	04 00 1782	James Wood Gould	*1 Sett Chairs*	6..0..0	D 40
290	05 18 1782	W'm Gray	*6 Chair frames @ 28/ [mahogany]*	8..8..0	D 42
291	09 00 1782	Abner Chase	*Round Chair*	1..10..0	AB
292	10 15 1782	Walter P Bartlett	*1 Easy Chair frame [mahogany]*	2..8..0	E 10
293	03 00 1783	James Wood Gould	*2 Lowe Chairs*	0..14..0	1..8..0
294	03 01 1783	Nathan Pierce	*6 Mahog Chair frames @ 56/*	16..16..0	
295	03 20 1783	Benj'n West	*6 Mehogany Chair frames*	16..16..0	
296	06 07 1783	Jonathon Mansfield	*1 Easy Chair Frame*	3..0..0	
297	06 07 1783	Samuel Bickford [Beckford]	*a litel chir [chair]*	NOT PRICED	

Chests of Drawers (Bureau Tables)

	LEDGER DATE	CLIENT	LEDGER ENTRY	PRICE	NOTES
1	06 04 1759	John Tasker [Esq.]	*a Buro Table [bureau table, mahogany]*	5..6..8	40..0..0; sold w/ case of drawers; D 34
2	11 03 1761	John Tasker, Esq	*1 Bureau Table [prob. mahogany]*	6..13..4	50..0..0; sold w/ case of drawers; D 110
3	01 15 1762	Han'h Cabot	*1 Bureau Table [mahogany]*	6..0..0	45..0..0
4	05 03 1762	The widow Tasker	*1 Bureau Table 50£ [prob. mahogany]*	6..13..4	50..0..0; sold w/ bombé chest-on-chest; D 110
5	06 00 1762	Be'l Topen [Toppan]	*Bureau Table [mahogany]*	6..0..0	45..0..0; sold w/ bombé chest-on-chest; D 85
6	09 00 1763	Richard Darby [Derby]	*1 Bureau Table [mahogany]*	6..0..0	AB; D 88
7	11 22 1764	Mark Hu'n Wintworth of Ports'th New Ham'r [Wentworth]	*2 Bureau Tables @ 6£ [mahogany]*	12..0..0	Sold w/ bombé chest-on-chest; AB; D 31
8	11 22 1764	Mark Hu'n Wintworth of Ports'th New Ham'r [Wentworth]	*4 Cases for Draws & Tables @ 8/ [mahogany]*	1..12..0	AB; D 31
9	09 24 1765	Nicholas Bartlet Marblehead [Bartlett]	*1 Bureau Table*	5..6..8	AB; C 67
10	09 24 1765	Nicholas Bartlet Marblehead [Bartlett]	*1 Case for ditto [bureau table]*	0..6..8	AB; C 67
11	11 00 1766	Mrs Higingson [Higginson]	*1 Bureau Table [mahogany]*	6..0..0	AB; shipped in 3 cases; D 59
12	02 07 1768	Samuel Curwin, Esq [Curwen]	*Bureau Table*	3..0..0	
13	08 01 1768	Rebeca Orne	*Ditto Bureau Table [mahogany]*	5..6..8	Sold w/ bombé chest-on-chest; D 16

Chests of Drawers (Bureau Tables)

	LEDGER DATE	CLIENT	LEDGER ENTRY	PRICE	NOTES
14	08 01 1768	**Rebeca Orne**	*Do Bureau Table [walnut]*	2..13..4	Sold w/ bombé chest-on-chest; D 16
15	11 00 1769	**Jn'o Turner, Esq**	*Bureau Table 93/4 [mahogany]*	5..6..8	4..13..4; sold w/ less expensive chest; D 36
16	01 11 1770	**Joseph Lee [Esq. of Beverly]**	*1 Mehog'y Bureau Table*	5..6..8	D 57
17	01 11 1770	**Joseph Lee [Esq. of Beverly]**	*1 Cheretree Ditto [bureau table, cherry]*	2..13..4	D 57
18	05 00 1770	**Sam'l West jn'r**	*Bureau Table [mahogany]*	5..0..0	
19	08 24 1770	**Clark Gat'n Pickman**	*Bureau Table [mahogany]*	5..6..5	Sold w/ block-front chest-on-chest; D 86
20	08 24 1770	**Clark Gat'n Pickman**	*Ditto Wall't [bureau table, walnut]*	2..13..4	D 86
21	12 22 1770	**Biling Bradish**	*1 Bureau Table*	4..0..0	
22	03 00 1771	**Haskett Derby**	*Bureau table [mahogany]*	6..0..0	
23	04 00 1772	**Timothy Orne**	*Bureau Table*	NOT PRICED	
24	08 20 1772	**Jer'h Lee [Esq.]**	*1 Bureau Table [mahogany]*	5..6..8	Sold w/ walnut block-front chest-on-chest; D 58
25	08 20 1772	**Jer'h Lee [Esq.]**	*Do Bureau Table [walnut]*	2..13..4	D 58
26	06 04 1773	**Thomas Barnard Jun.**	*1 Bureau Table [mahogany]*	6..0..0	D 4
27	07 30 1773	**Jn'o Appleton**	*Bureau Table*	3..6..8	
28	08 24 1773	**Peletiah Webster of Philadelphia**	*1 Bureau Table Ship'd [shipped] by Goodhue*	3..6..8	Sold w/ case of drawers
29	10 07 1773	**William Paine**	*1 Bureau Table [mahogany]*	6..0..0	Sold w/ block-front chest-on-chest; shipped in cases; D 81
30	10 07 1773	**William Paine**	*1 Wall't Do [bureau table, walnut]*	2..13..4	Shipped in cases; D 81
31	11 20 1773	**Edw'd Allen**	*1 Bureau Table [mahogany]*	6..0..0	
32	01 17 1774	**Tho's Mason Ju'r.**	*Bureau Table [mahogany]*	6..0..0	Sold w/ block-front chest-on-chest; D 63
33	03 26 1774	**George Cabot**	*1 Bureau Table £6 [mahogany]*	6..0..0	D 14
34	12 02 1774	**Sylveter Gardnor Esq [Gardiner]**	*1 Bureau Table [mahogany]*	6..0..0	
35	12 24 1774	**Peter Frye esq**	*Bureau Table [mahogany]*	6..0..0	D 76
36	12 24 1774	**Peter Frye esq**	*1 do do [bureau table, walnut]*	3..0..0	D 76
37	04 09 1775	**Jeremiah Lee [Esq.]**	*1 Bureau Table [mahogany]*	9..0..0	Price far exceeds all others for this form; D 104
38	06 24 1775	**Jon'n Payson**	*1 Bureau Table [prob. mahogany]*	5..0..0	Sold w/ case of drawers
39	08 00 1775	**William Vans Esq'r**	*1 Bureau Table [mahogany]*	6..0..0	Sold w/ block-front chest-on-chest; D 105
40	12 21 1776	**Isaac White**	*Bureau table [mahogany]*	6..0..0	7..6..8; duplicate entries in AB
41	02 25 1777	**Step'n Cabot**	*Bureau Table [mahogany]*	5..0..0	D 17
42	04 08 1777	**Peter Launder [Lander]**	*Bureau Table*	6..10..0	
43	10 24 1777	**Israel Thorndike**	*1 Bureau Table*	12..0..0	D 103
44	11 07 1777	**W'm Pickman**	*Bureau Table*	8..0..0	
45	02 04 1778	**Ben'n Goodhue**	*Bureau Table [prob. mahogany]*	6..0..0	16..0..0; D 38
46	04 23 1778	**John Hartwell**	*1 Bureau Table*	NOT PRICED	Order not itemized, total was 70..0..0
47	05 00 1779	**Joshua Dodge**	*Bureau table*	75..0..0	
48	01 27 1780	**Francis Cabot jn'r**	*1 Bureau Table [mahogany]*	6..0..0	D 13
49	01 27 1780	**Francis Cabot jn'r**	*1 do do plain [bureau table]*	5..0..0	D 13
50	06 00 1780	**Bartholemew Putnam**	*1 Bureau Table*	5..0..0	
51	02 24 1781	**John Cabot**	*1 Bureau Table*	900..0..0	
52	02 24 1781	**Andrew Cabot**	*a Bureau Table*	12..0..0	AB
53	03 00 1781	**John Brooks**	*Bureau Table 700£*	700..0..0	D 9
54	05 16 1781	**Barth'w Putnam**	*1 Bureau Table swel'd*	NOT PRICED	D 82
55	11 12 1781	**Henry Gardner**	*1 Bureau table*	NOT PRICED	
56	01 00 1782	**Henry Gardner**	*Bureau table*	NOT PRICED	
57	02 00 1782	**Ben'n West**	*1 Bureau Table £4..10*	4..10..0	AB
58	05 00 1782	**Sam'l Blyth**	*Bureau Table [mahogany]*	6..0..0	

Desk-and-Bookcases

	LEDGER DATE	CLIENT	LEDGER ENTRY	PRICE	NOTES
1	03 13 1761	Joseph Grafton [Jr.]	*2 Desks & Bookcases @ £100 13£ 6/8*	26..13..4	200..0..0; C 19
2	03 13 1761	Joseph Grafton [Jr.]	*Casing of Dito 26/8 [for desk-and-bookcases]*	1..6..8	20..0..0; C 19
3	03 00 1765	Messrs Francis & Joseph Cabot	*Desk & Bookcase [mahogany]*	23..0..0	AB; prob. installed in their office building at 299 Essex St., Salem
4	09 24 1765	Nicholas Bartlet Marblehead [Bartlett]	*1 Desk & Bookcase*	16..0..0	AB; C 65
5	05 02 1766	Josiah Bachelder [Batchelder]	*1 Mehogany Desk & Bookcase*	14..13..4	AB; partial payment in walnut @ 4P/FT, casing was 0..16..0 extra; C 81
6	05 02 1766	Josiah Bachelder [Batchelder]	*2 Cases for dito 2 [unreadable]*	NOT PRICED	AB; C 81
7	04 00 1767	Thomas Mason	*Desk & Bookcase*	17..6..8	
8	10 00 1769	Henry Gardner	*Desk & Bookcase of Mahogany*	20..0..0	Fled as a Loyalist, returned in 1781; desk not in his inventory when he died; D 36
9	04 30 1770	Sam'l Waters	*Half of Desk & Bookcase*	8..13..4	
10	08 24 1770	Clark G Pickman	*Mehogany Desk & Book Case*	28..10..0	In his inventory of 12/07/1783, valued @ 18..0..0; D 86
11	06 00 1771	Rich'd Roulth [Routh]	*Desk & Bookcase*	16..0..0	Prob. destroyed in house fire in October 1774; D 93
12	01 03 1772	George Deblois	*Mehogany Desk & Book Case*	21..6..8	Loyalist, fled to Nova Scotia; D 22
13	05 18 1773	Andrew Cabot	*1 Desk & Bookcase [mahogany]*	24..0..0	D 12
14	03 26 1774	George Cabot	*Mehogany Desk & Book Case*	20..0..0	D 14
15	06 13 1774	Edward Allin [Allen]	*Desk & Book-Case [mahogany]*	24..0..0	Paid for by delivering large quantity of mahogany; charge may have been reduced to 22..0..0
16	07 00 1774	Peletiah Webster of Philadelphia	*Desk & Bookcase*	13..6..8	AB
17	04 09 1775	Jeremiah Lee [Esq.]	*1 Desk & Bookcase [mahogany]*	26..13..4	D 104
18	05 00 1777	Joshua Dogue [Dodge]	*1 Desk & Book Case [mahogany]*	21..6..8	D 25
19	09 16 1777	Benjamin Goodhue, Jr.	*Desk & Bokcase [mahogany]*	NOT PRICED	
20	04 06 1780	Andrew Cabot	*1 Desk & Book Case 45£ [mahogany]*	40..0..0	Duplicate entries in DB
21	08 00 1781	Francis Cabot Jr	*Desk & Bookcase [mahogany]*	45..0..0	

Desks

	LEDGER DATE	CLIENT	LEDGER ENTRY	PRICE	NOTES
1	03 23 1758	John Wardin Jr	*a Mahogany Desk 106/8*	5..6..8	40..0..0
2	07 00 1758	Robert Shiliby [Shillaber]	*1 Desk £4 [cedar]*	3..14..8*	28..0..0; C 1
3	07 00 1758	Robert Shiliby [Shillaber]	*do £4..13..2 [desk, cedar]*	4..13..0	C 1
4	07 01 1758	Wiliam Lamson	*a Desk [walnut]*	4..0..0*	30..0..0; Price corrected in AB, was 3..14..8
5	10 04 1758	Chrispus Brewer	*a Desk [mahogany]*	7..6..8	55..0..0; D 8
6	00 00 1759	Joseph Trask	*1 Desk [walnut]*	4..0..0	30..0..0; C 3
7	01 02 1759	John Nutting jn 'r	*3 Desks @ £30 [maple]*	12..0..0	90..0..0; C 5
8	01 02 1759	John Nutting jn 'r	*Dito second hand Sundries of joiners work*	3..4..0	24..0..0
9	01 12 1759	Samuel Wiliam [Williams]	*a Desk [mahogany]*	9..6..8	70..0..0
10	02 24 1759	Chris's Brewer	*a Desk [mahogany]*	9..6..8	70..0..0; C 4
11	06 04 1759	Sam'l West, Ju'r	*a Desk [cherry]*	3..12..0	27..0..0
12	06 29 1759	Joseph Trask	*a Maple Desk*	3..6..8	25..0..0; C 6
13	07 01 1759	Eben'r Bickford [Beckford]	*a Desk [mahogany]*	6..13..4	50..0..0
14	08 00 1759	Chrispus Brewer	*a Desk [mahogany]*	9..1..4	68..0..0; C 8
15	08 10 1759	William West	*a Desk Mehogany*	9..6..8	70..0..0
16	11 20 1759	Benjamin Doland [Daland]	*2 Maple Desks @ £25/ @ 66/8*	6..13..4	50..0..0
17	11 20 1759	Jose'h Grafton [Jr.]	*1 Walnut Desk @ 80/*	4..13..4*	35..0..0; C 11

Desks

	LEDGER DATE	CLIENT	LEDGER ENTRY	PRICE	NOTES
18	11 20 1759	Jose'h Grafton [Jr.]	*Casing dito 6/8*	0..6..8	2..10..0; C 11
19	11 20 1759	Jose'h Grafton [Jr.]	*2 Maple Desk @ 25£*	6..13..4	50..0..0; C 11
20	11 20 1759	Jose'h Grafton [Jr.]	*Casing ye above [for desks]*	0..10..8	4..0..0; C 11
21	11 26 1759	Anto'y Lab'm Reyke	*1 Meh'ny Desk [mahogany]*	6..13..4	50..0..0; C 9
22	11 26 1759	Anto'y Lab'm Reyke	*Casing Dito [for desk]*	0..6..8	2..10..0; C 9
23	11 26 1759	Anto'y Lab'm Reyke	*1 Maple dito [desk]*	3..0..0	22..10..0; C 9
24	11 26 1759	Anto'y Lab'm Reyke	*Casing Dito [desk]*	0..6..8	2..10..0; C 9
25	12 18 1759	Samuel Magry [Masury]	*1 Maple Desk*	3..0..0	22..10..0; C 12
26	12 18 1759	Samuel Magry [Masury]	*Case dito [desk]*	0..6..8	2..10..0; C 12
27	01 01 1760	John Larkin	*1 Black Walnut Desk*	4..0..0	30..0..0
28	01 23 1760	John Gardnor jn'r. [Gardner]	*1 Desk [mahogany]*	9..12..0	72..0..0; C 14
29	01 23 1760	John Gardnor jn'r. [Gardner]	*Casing of Desk & Table*	0..13..4	5..0..0; C 14
30	02 26 1760	Tho's Mason	*1 Maple Desk*	3..0..0	22..10..0; C 13
31	05 10 1760	Richard Emerson	*1 Black Walnut Desk*	4..0..0	30..0..0; duplicate entries in DB
32	05 13 1760	Thomas Gyles [Giles]	*1 Map'l Desk [maple]*	2..0..0	15..0..0
33	06 03 1760	Jose'h Grafton [Jr.]	*1 Seder Desk & Close cas [cedar]*	7..6..8	55..0..0; C 15
34	06 03 1760	Jose'h Grafton [Jr.]	*2 Cheretree Desks £25 @ 66/8 [cherry]*	6..13..4	50..0..0; C 15
35	06 03 1760	Jose'h Grafton [Jr.]	*6 Cases for y'e above 36/*	1..16..0	13..10..0 C 15
36	07 02 1760	Wiliam Northey	*1 Black Walnut Desk*	4..2..8	31..0..0
37	09 20 1760	James Andros [Andrews]	*a Mehogany Desk*	7..6..8	55..0..0; partially paid for by 3 days work @ 4/8
38	10 15 1760	John Dean	*4 Cheretree Desks @ £25 [cherry]*	13..6..8	100..0..0; C 17
39	10 15 1760	John Dean	*Casing of dito 50/ [desks]*	1..6..8	10..0..0; C 17
40	01 23 1761	Ebn'r Bickford [Beckford]	*2 Small Desk[s]*	2..13..4	20..0..0; C 18
41	02 24 1761	Arcleus McIntire	*1 Maple Desk*	2..0..0	15..0..0; C 62
42	03 13 1761	Jose'h Grafton [Jr.]	*4 Seder Desks-plain @ £28 @ 74/8 [cedar]*	14..18..8	112..0..0; C 19
43	03 13 1761	Jose'h Grafton [Jr.]	*Casing of Dito 26/8 [desks]*	1..6..8	10..0..0; C 19
44	04 03 1761	Jon'n Cook	*2 Cheretree Desks @ £25 [cherry]*	6..13..4	50..0..0; C 20
45	04 03 1761	Jon'n Cook	*1 Walnut dito [desk]*	3..17..4	29..0..0; C 20
46	05 07 1761	John Pickring [Pickering]	*Mehogany Desk*	7..6..8	55..0..0
47	05 07 1761	Eben'r Bickford [Beckford]	*1 Desk £28/10 [@] 82/8 [walnut]*	3..16..10	28..10..0; C 21
48	05 07 1761	Eben'r Bickford [Beckford]	*Casing 2.10/ [for desk]*	0..6..8	2..10..0; C 21
49	07 23 1761	Joseph Dean	*1 Desk Cheretre [cherry]*	3..12..0	27..0..0; C 24
50	09 00 1761	Joseph Dean	*1 Black Walnut Desk*	5..0..0	37..10..0; C 24
51	09 00 1761	Sam'l Grant	*2 Cheretree Desks @ £27 [cherry]*	7..4..0	54..0..0; C 22
52	09 01 1761	Jon'n Cook	*1 Cheretree Desk [cherry]*	3..12..0	27..0..0; C 23
53	11 06 1761	Thomas Ading [Aden]	*1 Meh'y Desk [mahogany]*	10..0..0	75..0..0
54	11 06 1761	James Punchard	*1 Small Desk*	1..0..0	7..10..0
55	00 00 1762	Samuel Grant	*1 Mehog'ny Desk*	7..0..0	52..10..0
56	01 26 1762	John Gardnor Jn'r [Gardner]	*1 Venee'd Desk [veneered]*	5..6..8	40..0..0; C 25
57	01 26 1762	John Gardnor Jn'r [Gardner]	*1 Blak Dito [desk]*	4..13..4	35..0..0; C 25
58	01 26 1762	John Gardnor Jn'r [Gardner]	*1 Seder dito @ 60/ [cedar desk]*	4..0..0	30..0..0; C 25
59	01 26 1762	John Gardnor Jn'r [Gardner]	*Casing Ditos @ 60/ [for desks]*	1..4..0	9..0..0; C 25
60	04 01 1762	David Masury	*Mahh'y Desk [mahogany]*	9..6..8	70..0..0; C 26
61	04 01 1762	David Masury	*Seder dito [cedar desk]*	NOT PRICED	C 26
62	04 01 1762	David Masury	*1 Maple dito [desk]*	4..6..8	32..10..0; C 26
63	04 01 1762	David Masury	*Cassing ditos @ 3 [desk]*	0..16..0	6..0..0; C 26
64	06 00 1762	Nath'l Lang	*1 Desk of Mehogy*	7..6..8	55..0..0
65	07 00 1762	Nick Brown	*Black Waln't Desk*	4..5..4	32..0..0
66	08 00 1762	Edmond Bickford [Beckford]	*1 Desk [walnut]*	4..0..0	30..0..0
67	08 00 1762	Jon'n Neall	*Walnut Desk*	4..0..0	30..0..0
68	08 00 1762	John Symonds	*1 Walnut Desk*	4..0..0	30..0..0
69	10 12 1762	Jon'n Cook	*Meh'n Desk & Case [mahogany]*	7..14..8	58..0..0; C 27
70	11 00 1762	John Garnor Jr [Gardner]	*2 Blackwalnut Desks @ £37..10/*	10..0..0	75..0..0; C 29
71	11 00 1762	John Garnor Jr [Gardner]	*1 Mapel ditto [desk]*	3..0..0	22..10..0; C 29

Desks

	LEDGER DATE	CLIENT	LEDGER ENTRY	PRICE	NOTES
72	11 00 1762	**Phillip Sandors jn'r [Saunders]**	*1 Maple Desk*	3..0..0	22..10..0; C 30
73	11 00 1762	**Phillip Sandors jn'r [Saunders]**	*Casing do [for desk]*	0..6..8	2..10..0; C 30
74	12 12 1762	**John Ropes ye 3 [III]**	*1 Black Walnut Desk*	3..12..0	27..0..0; C 31
75	12 12 1762	**John Ropes ye 3 [III]**	*1 Maple do [desk]*	3..0..0	22..10..0; C 31
76	12 23 1762	**Benjamin Waters**	*1 Black walnut Desk*	4..13..4	35..0..0; AB
77	00 00 1763	**Billings Bradish**	*1 Walnut Desk*	4..13..4	AB; poss. for his new house built in 1764
78	00 00 1763	**Jonathon Weib [Webb]**	*1 Cheretree Desk & Casing [cherry]*	5..0..0	AB
79	00 00 1763	**Jonathon Weib [Webb]**	*1 Small Desk*	1..12..0	AB
80	03 00 1763	**Benjamin Pickman Jr. [Esq.]**	*1 Seder Desk [cedar]*	3..14..8	28..0..0; C 32
81	03 00 1763	**Benjamin Pickman Jr. [Esq.]**	*2 d'o of Maple @ 450/ [desks]*	6..0..0	45..0..0; C 32
82	03 00 1763	**Benjamin Pickman Jr. [Esq.]**	*3 Cases for D'o @ 50/ [desks]*	1..0..0	7..10..0; C 32
83	05 00 1763	**James Freeman**	*2 Meb'y Desks @ £75 [mahogany]*	20..0..0	150..0..0; C 33
84	05 00 1763	**James Freeman**	*1 plain [mahogany] d'o [desks]*	8..0..0	60..0..0; C 33
85	05 00 1763	**James Freeman**	*2 Seder d'o @ £35 [desks, cedar]*	9..6..8	70..0..0; C 33
86	05 00 1763	**James Freeman**	*5 Cases @ 70/*	2..6..8	17..10..0; C 33
87	06 00 1763	**Amos Ramsdall**	*1 Maple Desk*	3..6..8	AB
88	07 00 1763	**John Gardner [Jr.]**	*1 Maple Desk*	3..6..8	AB; C 34
89	10 00 1763	**William Epes Esq [Eppes]**	*Wallnut Desk @ 74/8 Casing @ 6/8*	4..1..4	AB
90	11 00 1763	**Mssrs Mason & Williams**	*3 Seder Desks @ 84/ [cedar]*	12..12..0	AB; entry in A/B "for his part for 6 desks del'd on ac\'t Mason & Williams"…11..0..0 entry dated Nov 1763; C 38
91	11 00 1763	**Mssrs Mason & Williams**	*3 do of Maple @ 62/8 [desks]*	9..8..0	AB; C 38
92	11 05 1763	**Ebenezer Bickford [Beckford]**	*half of 4 Desks £8..12*	8..12..0	AB; his share of venture cargo; C 36
93	11 20 1763	**Benjamin Doland [Daland]**	*1 Mehogany Desk*	6..0..0	AB
94	12 00 1763	**Jonathon Mason**	*1 Desk 81..4 [walnut]*	4..1..4	AB; C 39
95	12 00 1763	**Jonathon Mason**	*1 do 66/8 [desk, maple]*	3..6..8	AB; C 39
96	12 00 1763	**William West**	*1 Seder Desk [cedar]*	5..0..0	AB; C 37
97	12 00 1763	**William West**	*3 Cheretree do [desks, cherry] @ 81/4*	12..4..0	AB; C 37
98	00 00 1764	**Stephan Cook**	*1 Maple Desk*	3..6..8	AB; C 40
99	03 00 1764	**Jonathon Mason**	*1 Mehogany do [desk]*	10..0..0	AB
100	04 10 1764	**John Gardner [Jr.]**	*1 Meb'y Desk 126/8 [mahogany]*	6..6..8	AB; C 41
101	04 10 1764	**John Gardner [Jr.]**	*1 Wallnut do 138/4 [desk]*	6..13..4	AB; C 41
102	04 10 1764	**John Gardner [Jr.]**	*1 Seder do 80/ [desk, cedar]*	4..3..0	AB; C 41
103	04 10 1764	**John Gardner [Jr.]**	*3 Cases for do @ 8/ [desk]*	1..4..0	AB; C 41
104	05 27 1764	**William Peabody**	*Wallnut Desk*	3..14..8	AB
105	06 00 1764	**Thomas Fry [Frye]**	*1 Wallnutt Desk & Casing*	4..1..4	AB; C 42
106	06 00 1764	**Josiah Orne**	*1 Sedar Desk & Casing [cedar]*	5..0..0	AB; C 43
107	06 00 1764	**Thomas Ading [Aden]**	*3 Sedar Desks @ 84/ [cedar]*	12..12..0	AB; C 44
108	06 00 1764	**Thomas Ading [Aden]**	*1 Wallnut do 81/4 [desk]*	4..1..4	AB; C 44
109	06 16 1764	**Joseph Flint**	*1 Desk De'd [delivered] Thomas Adin p't [per] order [maple]*	3..6..8	AB; C 45
110	07 00 1764	**Philip Saunders Jr.**	*Maple Desk taken from Day Book*	3..6..8	AB
111	07 00 1764	**Is'l Dodge**	*2 Seder Desks 93/4 [cedar]*	9..6..8	AB; C 46
112	07 00 1764	**Is'l Dodge**	*2 do @ 84/ [cedar desks]*	8..8..0	AB; C 46
113	07 07 1764	**Phillip Saunders Jr**	*Meb'y do [mahogany desk]*	10..0..0	AB
114	08 00 1764	**Nath'l Young**	*Wall't Desk [walnut]*	3..14..8	AB
115	08 00 1764	**Phillip Saunders Jr**	*1 Maple Desk*	3..6..8	AB; C 47
116	08 07 1764	**James Grant**	*1 Meb'y Desk [mahogany]*	9..13..4	AB
117	11 00 1764	**Peter Frye [Esq.]**	*Desk & Casing [cherry]*	4..0..0	AB; C 48
118	11 16 1764	**John Ropes 3rd [III]**	*1 Walnut Desk @ 80/ Casing 6/*	4..6..0	AB; C 49
119	11 30 1764	**Sam'l Grant**	*1 Wallnut Desk & Casing*	5..0..0	AB; C 50
120	00 00 1765	**Nehemiah Clough**	*1 Maple Desk*	3..13..4	AB
121	01 00 1765	**David Bickford, fisherman [Beckford]**	*1 Mehogany Desk w/o brasses*	6..0..0	AB

Desks

	LEDGER DATE	CLIENT	LEDGER ENTRY	PRICE	NOTES
122	01 00 1765	**John Dean**	*1 Mehogany Desk*	7..6..8	AB
123	01 01 1765	**Benjamin Pickman Esq**	*Wallnut Desk*	3..14..8	AB; C 52
124	03 07 1765	**William Padison [Patterson]**	*2 Seder Desks @ 80/ [cedar]*	8..0..0	AB; C 53
125	03 07 1765	**William Padison [Patterson]**	*2 Cases for do @ 6/8 [desks]*	0..13..4	AB; C 53
126	04 01 1765	**Jonathon Mason**	*1 Seder Desk 93/4 [cedar]*	4..13..4	AB; C 54
127	04 01 1765	**Jonathon Mason**	*2 do @ 84/ [desks, cedar]*	8..8..0	AB; C 54
128	05 00 1765	**Ebenezer Putnam**	*His part for 4 Desks & 3 tables del'd [delivered] of bord y'e schooner---J Scalley mast'r*	16..13..4	AB; C 60
129	05 00 1765	**Phillip Saunders Jr**	*1 Wallnut Desk 80/*	4..0..0	AB; C 56
130	05 00 1765	**Phillip Saunders Jr**	*1 Maple do 66/8 [desk]*	3..6..8	AB; C 56
131	05 00 1765	**Is'l Dodge**	*2 Seder Desks @ 93/4 [cedar]*	9..6..8	AB; C 55
132	05 00 1765	**Sam'l Grant**	*Sedar Desk [cedar]*	4..10..0	AB; C 59
133	05 00 1765	**John Gardner [Jr.]**	*1 Seder Desk [cedar]*	4..13..4	AB; C 57
134	05 00 1765	**John Gardner [Jr.]**	*2 do Desks @ 80/ [cedar]*	8..0..0	AB; C 57
135	05 00 1765	**Bartelmy Putnam**	*1/4 part for 4 Desks de'd [delivered] in Company*	4..4..0	AB; C 60
136	05 00 1765	**Bartelmy Putnam**	*1 large Sedar Desk seprate ac't [cedar, account]*	4..13..4	AB; C 60
137	06 00 1765	**Benjamin Pickman Esq**	*2 Mehogany Desks @ 173/3*	17..6..8	AB; C 58
138	06 00 1765	**Benjamin Pickman Esq**	*2 ditto @ 133/4 [desks, mahogany]*	13..6..8	AB; C 58
139	08 00 1765	**John Hodges**	*1/4 part for 4 Sedar Desks del'd [delivered] on bord y'e schooner--to mast'r B. Putnam [cedar]*	4..3..8	AB; C 64
140	08 00 1765	**Gamabiel Hogges [Hodges]**	*1/2 for 4 Seder Desks Del'd [delivered] on bord ye schooner ---B to Master Putnam [cedar]*	8..17..4	AB; C 63
141	08 26 1765	**Benjamin Pickman Esq**	*1 Cheretree Desk 88/ [cherry]*	4..8..0	AB; C 65
142	08 26 1765	**Benjamin Pickman Esq**	*1 ditto 80/ [desk, cherry]*	4..0..0	AB; C 65
143	08 26 1765	**Benjamin Pickman Esq**	*Casing ditto @ 6/8 [desk]*	0..13..4	AB; C 65
144	09 00 1765	**Abjiah Northey**	*1 Mehogany Desk*	7..0..0	AB; D 72
145	09 05 1765	**Henry Williams**	*1 Sedar Desk @ 80/ Casing do [cedar, 6/8]*	4..6..8	AB; C 73
146	09 11 1765	**John Ropes 3rd [III]**	*2 Cheretree Desks @ 66/8 [cherry]*	6..13..4	AB; C 66
147	09 11 1765	**John Ropes 3rd [III]**	*Casing Do @ 6/8 [desk]*	0..13..4	AB; C 66
148	09 24 1765	**Nicholas Bartlet Marblehead [Bartlett]**	*1 Desk [mahogany]*	10..13..4	AB; C 67
149	09 24 1765	**Nicholas Bartlet Marblehead [Bartlett]**	*1 Case for ditto [desk]*	0..8..0	AB; C 67
150	10 00 1765	**John Gardner [Jr.]**	*1 Sedar Desk [cedar]*	4..0..0	AB; C 71
151	11 00 1765	**Stephan Cook**	*1 Wallnut Desk*	4..13..4	AB; C 74
152	11 02 1765	**Samuel Shillerby [Shillaber]**	*1 Cheretree Desk [cherry]*	3..14..8	AB; C 70
153	11 20 1765	**Is'l Dodge**	*1 Seder ditto 80/ [desk, cedar]*	4..0..0	AB; C 72
154	11 20 1765	**Is'l Dodge**	*1 Cheretree ditto 80/ [desk, cherry]*	4..0..0	AB; C 72
155	11 29 1765	**Phillip Saunders [Jr.]**	*Cheretree Desk [cherry]*	3..14..8	AB; C 75
156	00 00 1766	**Joshua Foster of Marblehhead**	*1 Mehogany Desk*	9..6..8	AB
157	00 00 1766	**Joseph Hopkins**	*1 Wallnut Desk*	4..1..0	AB
158	03 00 1766	**Richard Manning**	*1 Ceader Desk @ 93/4 Casing do 6/*	4..19..4	AB; C 78
159	03 00 1766	**Richard Manning**	*1 ditto 80/ Casing @ 6/ [desk]*	4..6..0	AB; C 78
160	03 04 1766	**Larkin Dodge**	*2 Seder Desks, 3 feet 4 in long @ 98/*	9..16..0*	AB; C 77
161	03 04 1766	**Larkin Dodge**	*1 Cheretree ditto 74/8 [3' 4" long desk, cherry]*	3..14..8	AB; C 77
162	04 00 1766	**Bartelmy Putnam**	*2 Maple Desks @ 60/*	6..0..0	AB; C 79
163	04 00 1766	**Bartelmy Putnam**	*Casing ditto @ 6/ [desk]*	0..12..0	AB; C 79
164	04 16 1766	**Israel Lovett**	*1 Ceader Desk @ 88/*	4..8..0	AB; C 80
165	04 16 1766	**Israel Lovett**	*1 Cheretree do 80/ [desk, cherry]*	4..0..0	AB; C 80
166	05 00 1766	**Henry Williams**	*1 Cheretree do @ 74/8 Casing do 5/ [desk, cherry]*	3..19..8	AB; C 83
167	05 02 1766	**Josiah Bachelder [Batchelder Jr.]**	*1 cedar Desk 100/ Casing 8/*	5..8..0	AB; C 81
168	05 31 1766	**Henry Williams**	*4 Desks & Casing [prob. cherry]*	15..12..0	AB; C 83
169	06 00 1766	**Is'l Dodge**	*1 Maple ditto [desk]*	3..4..0	AB; C 84
170	06 00 1766	**Is'l Dodge**	*2 Ceader Desks @ 90/ cas'd [cased]*	9..0..0	AB; C 86
171	07 03 1766	**John Gardner [Jr.]**	*1 Cheretree do 80/ [desk, cherry]*	4..0..0	AB; C 86

Desks

	LEDGER DATE	CLIENT	LEDGER ENTRY	PRICE	NOTES
172	07 03 1766	**John Gardner [Jr.]**	*1 Ceader do 84/ [desk]*	4..4..0	AB; C 86
173	07 03 1766	**Jonathon Mason**	*5 Ceader To Desks @ 80/*	20..0..0	AB; C 85
174	07 03 1766	**Jonathon Mason**	*1 Cheretree ditto [desk, cherry]*	3..14..8	AB; C 85
175	07 03 1766	**Jonathon Mason**	*1/4 m [thousand] bord nails for Casing*	0..5..0	AB; C 85
176	08 01 1766	**Josiah Orne**	*2 Ceader Desks @ 80/*	8..0..0	AB; C 88
177	08 01 1766	**Josiah Orne**	*2 cases for Do @ 6/ [desk]*	0..12..0	AB; C 88
178	08 07 1766	**Josiah Orne**	*1 Ceader Desk @ 86 Casing*	4..6..0	AB; C 88
179	10 15 1766	**Ebenezer Bowditch**	*1 Ceader Desk @ 83/4 Casing 6/*	4..19..4	AB
180	10 25 1766	**Henry Williams**	*1 Mehogany Desk*	10..0..0	AB
181	11 29 1766	**William Launder [Lander]**	*Ceader Desk 93/4 Casing 6/*	4..13..4	AB; C 91
182	12 00 1766	**Benjamin Bickford [Beckford]**	*Maple Desk 60/ Casing 6/*	3..6..0	AB
183	12 00 1766	**John Archer Jr.**	*Cheretree Desk [cherry]*	4..0..0	AB; C 90
184	12 00 1766	**John Archer Jr.**	*Casing ditto [desk]*	0..6..0	AB; C 90
185	01 00 1767	**Jonathon Neal**	*1 Maple Desk d'ld [delivered] Ezekiel Newhall*	3..6..8	
186	01 00 1767	**Ben'n Lovett**	*1 Ceader Desk and Casing 100/*	5..0..0	AB; C 93
187	01 00 1767	**Ben'n Lovett**	*1 ditto 84/ [desk]*	4..4..0	AB; C 93
188	02 00 1767	**Is'l Dodge**	*1 Cheretree ditto 88; Casing 5/4 [desk, cherry]*	4..13..4	AB; C 94
189	02 20 1767	**Is'l Dodge**	*1 Ceader Desk @ 74/8 Casing 5/4'd*	4..0..0	AB; C 94
190	03 04 1767	**John Gardner [Jr.]**	*2 Ceader Desks @ 80/*	8..0..0	AB; C 95
191	05 11 1767	**Jonathon Mason**	*5 Cheretree Desks @ 72/ [cherry]*	18..0..0	AB; C 97
192	05 28 1767	**George Smith**	*1 Mahogany Desk & Casing*	8..13..4	AB; C 98
193	05 28 1767	**George Smith**	*1 Large Ceader ditto [desk]*	4..13..4	AB; C 98
194	05 28 1767	**George Smith**	*1 Black Walnut ditto [desk]*	4..13..4	AB; C 98
195	05 28 1767	**George Smith**	*1 Small Ceader ditto [desk]*	4..4..0	AB; C 98
196	05 28 1767	**George Smith**	*1 Maple ends ditto [desk]*	3..11..0	AB; C 98
197	05 28 1767	**George Smith**	*1 Cheretree ditto [desk, cherry]*	3..16..0	AB; C 98
198	06 00 1767	**Eben'r Hutchinson**	*1 Maple Desk d'd [delivered] Dan'o Jacobs*	3..5..4	AB
199	06 00 1767	**Thomas Fry [Frye]**	*Large Ceader Desk sold for me in West Indies*	4..13..4	AB; C 92
200	06 16 1767	**John Hodges**	*1 Ceader Desk*	4..16..0	AB; C 101
201	06 16 1767	**John Hodges**	*1 ditto [desk, cedar]*	3..14..8	AB; C 101
202	06 16 1767	**John Hodges**	*ditto [desk, cedar]*	3..14..8	AB; C 101
203	06 16 1767	**John Hodges**	*Casing ditto @ 6/ [for desk]*	0..18..0	AB; C 101
204	06 17 1767	**Sam'l Masury**	*1 Maple Desk @ 60/*	3..0..0	AB; C 100
205	06 25 1767	**Josiah Bachelder [Jr.]**	*1 Ceader Desk*	5..6..8	AB; C 102
206	06 25 1767	**Josiah Bachelder [Jr.]**	*1 ditto do [cedar desk] pine draws*	4..0..0	AB; C 102
207	06 25 1767	**Josiah Bachelder [Jr.]**	*2 cases for the above @ 5/4*	0..10..8	AB; C 102
208	06 25 1767	**David Britton**	*Cedar Desk*	5..13..4	AB; C 100
209	06 25 1767	**David Britton**	*Casing ditto*	0..6..8	AB; C 100
210	08 00 1767	**Ebenezer Bowditch**	*1 Maple Desk 60/ Casing 5/4*	3..5..4	AB; C 103
211	09 06 1767	**Larkin Dodge**	*1 Ceader Desk*	4..13..4	AB; C 104
212	09 06 1767	**Larkin Dodge**	*Casing Do [for desk]*	0..6..0	AB; C 104
213	09 06 1767	**Larkin Dodge**	*1 Ceader Desk*	4..0..0	AB; C 104
214	09 06 1767	**Larkin Dodge**	*Casing do [for desk]*	0..4..0	AB; C 104
215	10 00 1767	**Is'l Dodge**	*Desk [prob. maple]*	3..1..2	AB; C 106
216	10 00 1767	**John Gardner Jr.**	*3 Large Ceader Desks @ 93/4*	14..0..0	AB; C 105
217	10 00 1767	**John Gardner Jr.**	*3 Small ditto @ 80/ [desk]*	12..0..0	AB; C 105
218	11 00 1767	**John Archer Jn'r.**	*Mahogany sweld frt Desk [swelled front]*	10..0..0	AB
219	11 00 1767	**Joseph Chipman**	*1 Maple Desk*	3..2..0	AB
220	11 00 1767	**Daniel Chever [Cheever]**	*1 Maple Desk*	2..18..8	AB; C 107
221	12 00 1767	**William Nickals [Nichols]**	*Mehogany Desk*	7..6..8	AB
222	12 24 1767	**Samuel Shillerby [Shillaber]**	*Desk Cheretree & Casing [cherry]*	4..0..0	Price listed as 3..14..8 in AB; C 108
223	01 28 1768	**Josiah Orne**	*5 Ceader Desks & Casing @ 84/*	21..0..0	C 109
224	02 07 1768	**Sam'l Ward**	*Mehogany Desk*	9..10..0	AB; duplicate entries in AB
225	02 25 1768	**Same'l Grant**	*2 Ceader Desks and Casing @ 84/*	8..8..0	C 111
226	02 25 1768	**Israel Lovett**	*Larg Ceader Desk 93/4 Casing 6/8*	5..0..0	C 110

Desks

	LEDGER DATE	CLIENT	LEDGER ENTRY	PRICE	NOTES
227	04 13 1768	Phillip Sanders Jr [Saunders]	*2 Chere Desks & Casing @ 80/ [cherry]*	8..0..0	C 111
228	04 16 1768	Cap'n Foster of Kingstown	*Walnut Desk*	4..0..0	
229	06 02 1768	John Gardner, Jr.	*1 Large Ceader Desk & Casing*	4..13..4	AB; C 113
230	06 06 1768	Is'l Dodge	*1 Ceader Desk 93/4*	4..13..4	AB; C 115
231	06 06 1768	Is'l Dodge	*1 ditto 84/ with Casing [cedar desk]*	4..4..0	C 115
232	06 23 1768	Josiah Bachelder [Batchelder Jr.]	*2 Ceader Desks @ 106/8*	10..13..4	C 116
233	06 23 1768	Josiah Bachelder [Batchelder Jr.]	*2 cases @ 5/4*	0..10..8	C 116
234	06 23 1768	Nathan Leach	*One Ceader Desk*	4..0..0	C 117
235	06 23 1768	Nathan Leach	*Casing*	0..5..4	C 117
236	07 07 1768	Charles Warrin [Worthen]	*2 Cedar Desks @ 80*	8..0..0	C 118
237	07 07 1768	Charles Warrin [Worthen]	*2 Cases @ 6/*	0..12..0	C 118
238	07 08 1768	Sam'l Shilerby [Shillaber]	*Ceader Desk & Casing*	4..4..0*	Price corrected in AB; C 140
239	07 15 1768	Woods & Waters	*1 Ceader Desk*	4..0..0	C 119
240	07 23 1768	Mr. Savage	*Chere desk [cherry]*	3..15..0	
241	09 26 1768	Israel Lovet [Lovett]	*2 Ceader Desks @ 93/4*	9..6..8	C 120
242	10 05 1768	Josiah Bachelder [Batchelder Jr.]	*1 Cedar Desk*	5..6..8	AB; C 121
243	10 14 1768	Samuel Saunders	*4 Ceadar Desks @ 80/*	16..0..0	C 122
244	10 14 1768	Samuel Saunders	*4 Cases for do @ 6/ [desks]*	0..1..4	C 122
245	10 22 1768	Jn'o Gardner Jn'r	*1 Ceader Desk 84/*	4..4..0	C 123
246	10 22 1768	Jn'o Gardner Jn'r	*1 Cheretree do 72/ [desk, cherry]*	3..12..0	C 123
247	11 11 1768	Step'n Higgenson [Higginson]	*Wall't Desk @ 93/4 [walnut]*	4..13..4	Price listed as 4..13..0 in AB
248	11 11 1768	George Parrot	*2 Cheretree Desks @ 73/4 [cherry]*	7..6..8	AB
249	12 00 1768	Thorndike Procter	*His part of 4 Desks del'd [delivered] ye schor Speedwell*	4..18..8	AB; C 126
250	12 00 1768	Robert Shilerby [Shillaber]	*His part of 4 [cedar] Desks del'd [delivered] on bord the schooner Speedwell*	4..14..8	AB; C 124
251	12 23 1768	Cap'n Joseph Skiling [Skillin]	*Mehogany Desk*	10..13..4	
252	12 23 1768	Charles Warin [Worthen]	*1 Large Desk for his Adventure*	4..13..4	AB; C 125
253	12 30 1768	Sam'l Grant	*1 Large Ceader Desk*	4..13..0	C 131
254	12 30 1768	Ezekel Fowler & Com'y	*2 Ceader Desks @ 96/*	9..12..0	C 127
255	12 30 1768	Ezekel Fowler & Com'y	*His part of 4 desks del'd [delivered] ye schooner Speedwell*	4..14..8	C 127
256	12 30 1768	Charles Worthen	*His part of 4 ditto in Com'y [company] dl'd [delivered] schooner Speedwell*	4..14..8	AB; C 130
257	01 12 1769	Tho's Poynton	*Riting Desk [writing]*	1..4..0	
258	01 12 1769	Henry Higinson [Higginson]	*1 Ceader Desk*	4..4..0	C 128
259	02 02 1769	Mess'rs Wyer & Turner	*1 Ceader Desk & casing*	4..13..4	C 133
260	02 02 1769	Mess'rs Wyer & Turner	*1 do [cedar desk and case]*	4..4..0	C 133
261	02 02 1769	Mess'rs Wyer & Turner	*2 do Maple ends @ 78/ [cedar desks and cases]*	7..17..4	C 133
262	02 02 1769	Dan'l Cheever	*1 Meh'g'y Desk & Casing [mahogany]*	6..6..0	C 132
263	02 02 1769	Dan'l Cheever	*1 Ceader ditto [desk]*	4..6..0	C 132
264	02 02 1769	Dan'l Cheever	*1 Cheretre ditto [desk, cherry]*	4..0..8	C 132
265	03 09 1769	Henry Williams	*1 Ceader Desk 93/4*	4..13..0	C 135
266	03 09 1769	Henry Williams	*1 do 80/ [cedar desk]*	4..0..0	C 135
267	03 17 1769	George Osborn	*2 Ceader Desks @ 93/4*	9..7..0	C 134
268	05 16 1769	John Gardner Jn'r	*2 Large Ceader Desks @ 93/4*	9..6..8	C 137
269	05 16 1769	John Gardner Jn'r	*2 small chere do @ 20 [cherry desks]*	2..0..0	C 137
270	05 18 1769	Step'n Higgenson [Higginson]	*1 Cheretree Desk & Cas [cherry]*	4..0..0	C 136
271	06 00 1769	Israel Lover [Lovett]	*1 Large Ceader Desk @ 93/4*	4..13..4	AB; C 138
272	06 14 1769	Joseph Moses	*Wall't Desk [walnut]*	4..13..4	
273	06 14 1769	Tho's Frye	*Large Ceader Desk sold for me in West Indies*	4..13..4	C 129
274	06 20 1769	W'm West	*1 Ceader Desk Map'l ends 74/8 [maple]*	3..14..8	
275	06 20 1769	W'm West	*1 Cheretree do 80/ [desk, cherry]*	4..0..0	
276	06 20 1769	W'm West	*2 Cases for y'e above @ 6/ [cherry desks]*	0..12..0	
277	06 20 1769	Jn'o Archer Jn'r.	*1 Ceader Desk & case*	4..0..0*	Price corrected in AB, was 4..4..0; C 139
278	07 00 1769	Sam'l Grant	*1 Ceader Desk*	4..13..4	C 141

Desks

	LEDGER DATE	CLIENT	LEDGER ENTRY	PRICE	NOTES
279	07 09 1769	**Daniel Jacobs**	*Cheretree Desk [cherry]*	3..14..8	AB
280	08 00 1769	**Israel Dodge**	*1 Large Ceader Desk 93/4*	4..13..4	C 142
281	08 00 1769	**Israel Dodge**	*1 Cheretree do 64/ [desk, cherry]*	3..4..0	C 142
282	08 00 1769	**Israel Dodge**	*1 Maple ditto 60 [desk]*	3..0..0	C 142
283	08 12 1769	**Charles Worthen**	*Large Ceader Desk*	4..13..4	C 143
284	08 12 1769	**Charles Worthen**	*Small Desk sold for me in Adventure*	1..10..0	AB; C 143
285	10 00 1769	**Josiah Bachelder [Batchelder Jr.]**	*1 Large Ceader Desk*	4..13..4	C 146
286	10 00 1769	**Josiah Bachelder [Batchelder Jr.]**	*Casing*	0..4..8	C 146
287	10 00 1769	**John Gardner Jr**	*1 Ceader Desk*	4..4..0	
288	10 00 1769	**Jn'o Turner jr**	*2 Maple Desks & Casing @ 64/*	6..8..0	C 144
289	10 21 1769	**Nathe'n Leach**	*1 Large Ceader Desk*	4..13..4	C 145
290	11 04 1769	**Ben'n Williams**	*1 Cheretree Desk & Casing without brasses [cherry]*	3..5..4	Price listed as 3..5..8 in AB
291	12 00 1769	**Joseph Cabot**	*Righting Desk*	1..10..0	
292	12 11 1769	**Joseph Cabot**	*Righting Desk*	1..8..0	Price listed as 1..4..0 in AB
293	01 17 1770	**James Bott**	*1 Cheretree Desk & Casing [cherry]*	4..0..0	Duplicate entries in AB
294	01 17 1770	**Charles Worthen**	*Cheretre Desk with paneel doors 69/4 [cherry]*	3..9..4	C 147
295	02 03 1770	**Henry Gardner**	*Wrighting Desk*	1..4..0	
296	02 08 1770	**Is'l Dodge**	*1 Mahogany Desk 200/*	10..0..0	
297	02 26 1770	**Isarael Dodge**	*1 Large Ceader Desk*	4..13..4	C 148
298	04 06 1770	**Alxo'r Walker**	*Mahogeny Desk*	7..6..8	D 106
299	05 09 1770	**Job Whipple**	*Cheretree Desk [cherry]*	3..9..4	
300	05 09 1770	**Henry Williams**	*Cheretre Desk and Case [cherry]*	3..14..8	Price listed as 3..15..4 in AB; C 149
301	06 30 1770	**Charles Worthen**	*1 Maple Desk & Casing*	3..0..0	C 150
302	08 05 1770	**Isl Dodge**	*1 Maple Desk*	3..0..0	C 151
303	08 18 1770	**Tho's Barnard, Jn'r**	*Righting Desk*	1..4..0	
304	08 18 1770	**Rob't Allcock**	*4 Maple Desks & Casing @ 60/*	12..0..0	C 152
305	10 04 1770	**Jn'o Gardner Jr**	*2 larg Ceader Desks @ 93/4*	9..6..8	C 154
306	12 12 1770	**Sam'l Flagg**	*Mehogany Desk*	7..6..8	
307	01 10 1771	**David Masury**	*3 Maple Desks @ 60/*	9..0..0	C 155
308	01 24 1771	**Joseph Lee**	*Mehogany Desk*	10..0..0	
309	02 02 1771	**Israel Dodge**	*Maple Desk & Casing*	3..0..0	C 156
310	02 08 1771	**Israel Dodge**	*Mehogany Desk*	10..0..0	
311	03 00 1771	**Jn'o Barnard**	*Wrighting Desk*	1..8..0	
312	04 00 1771	**Sam'l Grant**	*Swel'd front Desk*	10..6..8	
313	04 06 1771	**Jn'o Gardner Jn'r.**	*2 Cheretree Desks @ 69/4 [cherry]*	6..18..8	C 157
314	04 06 1771	**Jn'o Gardner Jn'r.**	*1 Maple ditto [desk]*	3..0..0	C 157
315	04 15 1771	**Joseph Moses**	*Map'l Desk [maple]*	3..0..0	Prob. venture cargo since he already purchased a walnut desk in 1769
316	04 28 1771	**Jn'o Buffinton [Buffington]**	*mak [making] Maple Desk*	3..0..0	
317	05 01 1771	**Jn'o Tucker**	*1 Mehogany Desk*	6..13..4	
318	06 00 1771	**Charles Worthen**	*Small Desk 24/*	1..4..0	C 158
319	06 00 1771	**Josiah Orne**	*3 Ceader Desks @ 93/4*	14..0..0	C 160
320	06 00 1771	**Larkin Dodge**	*4 Large Ceader Desks @ 93/4*	18..13..4	C 161
321	06 00 1771	**Peter Frye [Esq.]**	*Cheretree Desk & Casing 74/8 [cherry]*	3..14..8	C 159
322	08 00 1771	**W'm Launder Jr. [Lander]**	*1 Cheretree Desk and Casing [cherry]*	3..14..8	C 163
323	08 00 1771	**Israel Dodge**	*3 Large Ceader Desks @ 93/4*	14..8..0	C 162
324	09 14 1771	**Jn'o Tucker**	*Large Ceader Desk and Casing*	4..13..4	C 167
325	09 28 1771	**Jn'o Gardner Jr.**	*1 Ceader Desk with Ceadar draws £6*	6..0..0	AB; C 164
326	09 28 1771	**Jn'o Gardner Jr.**	*2 ditto @ 93/4 Del'd [delivered] in Sep'r 1771 [desks]*	9..6..8	AB; C 164
327	10 12 1771	**Josiah Batchelder [Jr.]**	*Large Ceader Desk @ 93/4 per*	4..13..4	C 165
328	10 12 1771	**Henry Higinson [Higginson]**	*Large Ceader Desk @ 93/4 per*	4..13..4	C 166
329	11 18 1771	**Moses Yell [Danvers]**	*Cheretree Desk 69/4 Casing 6/ [cherry]*	3..15..4	
330	11 18 1771	**Peter Fry esq [Frye]**	*Cheretree Desk 69/4 Casing 6/ [cherry]*	3..15..4	C 169
331	11 25 1771	**Larkin Dodge**	*Large Ceader Desk*	4..13..4	C 171
332	12 02 1771	**Nathan Leach**	*2 Large Desks with Cedar drawers cased*	12..0..0	C 170

Desks

	LEDGER DATE	CLIENT	LEDGER ENTRY	PRICE	NOTES
333	12 02 1771	**Nathan Leach**	*Small Desk*	3..6..8	C 170
334	02 00 1772	**John Buffinton [Buffington]**	*1 Maple do del'd [delivered] Feb'y 1772 [desk]*	3..6..8	AB; delivered in 02/1772 but billed 1 year later; C 172
335	02 05 1772	**Jonathon Weeb [Webb]**	*Chere't Desk [cherry]*	3..12..0	
336	02 05 1772	**Mr. Francis of Beverly**	*Maple Desk*	3..0..0	
337	03 00 1772	**Israel Dodge**	*1 Large Desk and Casing*	4..13..4	AB; C 173
338	04 00 1772	**Joseph Hilard [Hilliard]**	*Chere't Desk [cherry]*	4..0..0	
339	04 00 1772	**Josiah Orne**	*2 Ceader Desks @ 80/*	8..0..0	C 176
340	04 12 1772	**Jn'o Gardner Jn'r.**	*2 Large Ceader Desks @ 93/4*	9..6..8	AB; C 175
341	06 00 1772	**Nathan Leach**	*1 Large Ceader Desk with draws*	6..0..0	C 174
342	06 00 1772	**Nathan Leach**	*2 Do do @ 93/4 [large desks]*	9..6..8	C 174
343	06 16 1772	**Larkin Dodge**	*2 Large Ceader Desks @ 93/4*	9..6..8	C 177
344	07 03 1772	**Stephan Maskel [Mascol]**	*Cheretree Desk [cherry]*	4..0..0	
345	07 28 1772	**Josiah Bacheldor Jn'r [Batchelder]**	*2 Ceader Desks @ 120/£6*	12..0..0	C 178
346	08 00 1772	**Aasa Dunbar**	*Roughting Desk [writing]*	1..8..0	
347	08 20 1772	**John Gooll**	*Mehogany Desk*	10..0..0	
348	08 20 1772	**George Deblois**	*Desk del'd [delivered] Mr Nichols [walnut or cherry]*	4..13..4	
349	09 11 1772	**Jn'o Gardner jun**	*1 Ceader Desk and Casing*	4..13..4	C 181
350	10 10 1772	**George Deblois**	*1 Wall't Desk [walnut]*	5..0..0	
351	10 10 1772	**Jacob Crowninshield**	*2 Large Ceader Desks @ 93/4*	9..6..8	C 182
352	11 00 1772	**Jn'o Harthorn [Hathorne]**	*1 Mehogany Desk*	10..0..0	D 46
353	11 00 1772	**Nicolas Thorndike**	*Ceader Desk & Casing*	4..0..0	C 183
354	12 19 1772	**Rich'd Nichalls [Nichols]**	*Riteing Desk [writing]*	0..18..0	
355	12 19 1772	**Nath'l Barbor [Barbour]**	*Large Ceader Desk & Casing*	4..13..4	C 184
356	12 19 1772	**Nath'l Barbor [Barbour]**	*Casing do [desk]*	0..6..8	C 184
357	01 22 1773	**Israel Dodge**	*1 Large Ceader Desk*	4..13..4	C 185
358	02 02 1773	**Enoch Colings [Collins]**	*Riteing Desk [writing]*	0..16..0	
359	02 07 1773	**Josiah Batchelder [Jr.]**	*2 Large Ceader Desks with Colt claw feet @ 133/4*	13..6..8	C 186
360	02 07 1773	**Nathan Leach**	*1 Large Ceader Desk*	6..13..4	C 180
361	02 07 1773	**Nathan Leach**	*1 Small do with claw feet glass door [desk]*	6..13..4	C 180
362	03 12 1773	**Jonathon Tucker**	*1 Mehogany Desk*	7..6..8	C 187
363	03 26 1773	**Samel Waters**	*1 Large Ceader Desk*	4..13..4	C 188
364	04 01 1773	**Josiah Batchelder [Jr.]**	*Small Ceader Desk with glass door and claw feet*	2..0..0	C 189
365	04 19 1773	**Elijah Osborn of Danvers**	*Cheretre Desk [cherry]*	3..13..4	
366	06 04 1773	**Ben'n Coats [Coates]**	*Mehogany Desk*	10..0..0	
367	06 26 1773	**Tho's Roxwaiter**	*1 Desk £7..6..8 [mahogany]*	7..6..8*	Order not itemized, total was 9..0..0
368	08 00 1773	**William Putnam**	*Ceader Desk dl'd [delivered] Sam'l Flagg*	4..13..4	AB
369	08 24 1773	**Thomas Huchinson Blacksmith [Hutchinson]**	*1 Cheretree Desk and case d'ld [delivered] Rob't Cook [cherry]*	4..0..0	
370	09 06 1773	**Mary Harthorne [Hathorne]**	*Mehogany Desk*	12..0..0	
371	09 09 1773	**Nathan Leach**	*1 Large Ceader Desk With Claw Feet*	6..13..4	C 195
372	10 07 1773	**William Paine**	*1 Desk*	12..0..0	Shipped in cases; D 81
373	10 07 1773	**Joseph Trask**	*1 Cheretree Desk & cases 80/ [cherry]*	4..0..0	C 192
374	11 03 1773	**Bar'w Putnam**	*2 Ceader Desks & Casing*	13..6..8	C 193
375	01 13 1774	**Edward Allen**	*1 Desk Do [mahogany]*	8..0..0	Price initially listed as 7..0..0, then crossed out and changed to 8..0..0
376	03 00 1774	**Ichabod Nickals [Nichols]**	*1 Mahogany Desk £7:6/8*	7..6..8	D 68
377	04 12 1774	**Nath'n Leach**	*2 Ceader Desk @ 120 @ £6 1/2*	12..0..0	C 195
378	04 12 1774	**Nath'n Leach**	*1 Mehogany do @ 5..6..8 [desk]*	10..13..4	C 195
379	04 12 1774	**Josiah Bacheldor Jn'r [Batchelder]**	*1 Cedar Desk*	6..0..0	
380	04 19 1774	**Thom's Maning [Manning]**	*1 Desk 93/4 [cedar]*	4..13..4	C 194
381	07 06 1774	**Jn'o Bowman**	*Riting Desk*	1..16..0	
382	07 06 1774	**W'm Bartlet [Bartlett]**	*Large Ceader Desk & Casing*	6..0..0	C 197
383	09 15 1774	**Isral Morgan**	*Desk dl'd [delivered] Jam's Stone pr order [walnut]*	4..13..4	
384	10 05 1774	**Jn'o Gardner jun**	*2 Large Ceader Desks @ £6*	12..0..0	AB; C 198

Desks

	LEDGER DATE	CLIENT	LEDGER ENTRY	PRICE	NOTES
385	10 15 1774	**Samuel Grant**	*1 Desk rec'd [received] Feb 8, 1773 to carry for Adventure*	7..0..0	AB; in 1782 when bill was settled, a discount of 10..0..0 was given for all 3 orders; C 199
386	10 15 1774	**Samuel Grant**	*3 Desks @ 93/4*	14..0..0	AB; C 199
387	10 15 1774	**Samuel Grant**	*1 Desk at 140/*	7..0..0	AB; C 199
388	10 15 1774	**Sam'l Grant**	*1 Mehogony Desk*	10..0..0	C 199
389	10 15 1774	**Sam'l Grant**	*1 Ceader Do [desk]*	6..0..0	C 199
390	11 04 1774	**Sam'l Hall**	*Righting Desk frame*	0..10..8	
391	12 31 1774	**Jeremiah Shepard**	*Mahogany Desk*	8..0..0	
392	01 07 1775	**Nathan Leech [Leach]**	*2 Ceader Desks @ £6*	12..0..0	C 200
393	01 07 1775	**Nathan Leech [Leach]**	*1 Mehogany Do [desk]*	8..0..0	Order listed as 1/2 a mahogany desk @ 4..0..0 in AB; C 200
394	03 22 1775	**Jn'o Gardner jun**	*1 Large Ceader Desk*	6..0..0	AB; prob. had cedar drawers; C 201
395	06 24 1775	**John Colston**	*4 Ceader Desk @ 93/4*	18..12..4	Mascol, a Loyalist, fled during war, desk was resold to Colston; C 202
396	06 24 1775	**John Colston**	*Sold to Jn'o Colston by reason of Maskals leaving 4 Desks war*	NOT PRICED	C 202
397	05 00 1776	**Ephrim Ingals [Ingalls]**	*Desk dl'd [delivered] Joshua Convis [prob. walnut]*	4..16..0	
398	03 15 1777	**Nathan Nickals [Nichols]**	*3 tables and a Desk delivered on board sloop*	11..16..0	C 203
399	08 01 1777	**William Goodhue, Jn'r.**	*1 Desk Mehogany*	13..6..8	D 39
400	12 26 1777	**Nathan Brown jun**	*1 Desk*	30..0..0	
401	01 10 1778	**Holton Johnson**	*Large Meh. Desk [mahogany]*	30..0..0	
402	01 10 1778	**John Norice [Norris]**	*1 Desk*	18..0..0	D 71
403	04 28 1778	**John Hartwell**	*1 Desk*	NOT PRICED	Order not itemized
404	07 13 1778	**Sam'l Bickford Ju'r. [Beckford]**	*1 Desk*	48..0..0	
405	10 08 1778	**Mrs White**	*1 Desk- swel'd front [swelled, prob. mahogany]*	70..0..0	
406	02 25 1779	**W'm Brewer**	*1 Desk*	8..0..0	
407	06 09 1779	**Israel Dodge**	*Large Desk & Casing*	4..13..4	AB; C 204
408	11 11 1779	**Peter Sm'otherst [Smothers]**	*Meh'g Desk [mahogany]*	12..0..0	D 95
409	11 13 1779	**Nathan Goodale**	*writing Desk*	NOT PRICED	AB
410	08 00 1780	**Henry Brown**	*1 Mah'y Desk [mahogany]*	1050..0..0	Listed as maple in AB; D 10
411	08 00 1780	**John Danielson [Donaldson]**	*1 Swell'd Desk [prob. mahogany]*	21..0..0	D 26
412	08 22 1780	**Joseph McComb**	*1 Swell'd Desk [prob. mahogany]*	22..10..0	
413	09 23 1780	**Ebenezer Winship**	*1 Mahog'y Desk*	NOT PRICED	
414	09 23 1780	**Mark Lefiiet [Laffite]**	*Meh Riting Desk [mahogany]*	4..10..0	
415	11 00 1780	**Adam Bullard**	*Writing Desk*	NOT PRICED	
416	02 24 1781	**Jonathon Cook Jun'r**	*1 plain Mehog Desk*	1050..0..0	D 19
417	02 24 1781	**Doc'r. [Edward] Barnard**	*1 Desk sweld [swelled]*	NOT PRICED	Order not itemized; D 3
418	03 00 1781	**Jn'o Brooks**	*1 Desk 1500£*	1500..0..0	D 9
419	03 03 1781	**Sam'l Nichols**	*1 Mahogany Desk*	12..0..0	AB; D 70
420	04 00 1781	**Jonathan Horton**	*1 plain Meh'y Desk [mahogany]*	1000..0..0	
421	04 00 1781	**Benjamin Lander**	*1 Desk 1050£*	1050..0..0	
422	05 05 1781	**Thomas Smith**	*1 Desk £14*	14..0..0	
423	05 19 1781	**John Flint**	*1 Desk [mahogany]*	7..6..8	
424	07 12 1781	**Thomas Palfry**	*1 Meh'y Desk [mahogany]*	24..0..0	
425	09 21 1781	**Mary Winning [Vinning]**	*a Mehog'y Desk*	7..10..0	15..0..0
426	03 00 1782	**John Tucker**	*Mahog Desk*	24..0..0	AB
427	04 00 1782	**James Wood Gould**	*1 Mohog Desk*	9..0..0	15..0..0; D 40
428	07 19 1782	**Jacob Clarke**	*1 Meho'g Desk*	12..0..0	
429	05 23 1783	**Israel Hutchinson**	*a Desk without brasses [prob. mahogany]*	5..8..0	AB

Miscellaneous Forms

	LEDGER DATE	CLIENT	LEDGER ENTRY	PRICE	NOTES
1	00 00 1757	John Warding [Wardin]	*Tea board 4/*	0..4..0	AB
2	04 00 1758	Arth'r Jeffry [Jeffrey]	*2 Tea boards 14/*	0..14..0	
3	04 00 1758	Daniel Grant	*Quilting Frame*	NOT PRICED	
4	04 28 1758	John Tasker	*a Server*	0..2..0	0..15..0
5	05 14 1758	The estate of Jefry Lang	*a Coffin*	NOT PRICED	
6	05 20 1758	Francis Grant	*a Gun Stock*	0..1..9 1/2	0..8..0
7	05 24 1758	Francis Coley [Calley]	*a Knife Box*	NOT PRICED	
8	07 01 1758	John Ives	*a Chair body*	2..0..0	15..0..0
9	07 01 1758	John Ives	*painting dito [chair]*	1..12..0	
10	07 01 1758	John Ives	*wing for dito [chair]*	0..8..0	
11	07 01 1758	John Ives	*a [illegible] Trimming*	0..16..0	
12	07 01 1758	John Ives	*Brass nails for chair*	0..8..0	
13	07 01 1758	John Ives	*a pair of Springs*	0..6..0	
14	08 07 1758	Josiah Cheever	*a Chair*	13..6..8	100..0..0
15	08 28 1758	Isral Touer [Tower]	*a Tea board*	0..6..8	2..10..0
16	09 11 1758	Samuel Grant	*a Rideing Chair*	13..6..8	100..0..0
17	01 03 1759	John Giles [Ives]	*Chist [Chest]*	0..10..8	4..0..0
18	01 03 1759	Stephan Higingson [Higginson]	*a Bookcase*	3..6..8	25..0..0
19	02 24 1759	Chrispus Brewer	*a Tea Chist [chest]*	0..16..0	6..0..0
20	06 04 1759	Chrispus Brewer	*Cradle*	0..13..4	5..0..0; E 16
21	06 07 1759	John Ives	*a frame for a Looking Glass*	0..10..8	4..0..0
22	07 12 1759	John Gardnor jn'r [Gardner]	*a Cradle*	0..12..0	4..10..0; E 46
23	10 11 1759	John Gardner [Jr.]	*a Dumbaety [dumbwaiter]*	0..12..0	4..10..0
24	10 24 1759	Daniel Mackey	*5 Picter frames @ 45/ [picture]*	1..10..0	11..5..0
25	10 24 1759	Daniel Mackey	*2 Larger dito @ 80/ [picture frames]*	1..1..4	8..0..0
26	01 23 1760	John Gardnor Jn'r. [Gardner]	*a Meal Chest*	0..18..0	6..15..0
27	02 21 1760	Sam'l Curwin [Curwen]	*a Bookcase*	5..6..8	40..0..0
28	06 17 1760	Sam'l Cauley [Calley]	*a Chair body*	2..18..8	22..0..0
29	11 04 1760	Daniel Grant	*a Coffin for his wife*	0..16..0	6..0..0; his wife died that day
30	12 12 1760	James Cockel Esq	*1 Fyer screen*	0..16..0	6..0..0
31	01 28 1761	James Cockell [Cockle]	*small Box*	0..12..0	4..10..0
32	04 01 1761	Joseph Rolings [Rollings]	*a Cradle*	0..12..0	4..10..0; E 95
33	04 03 1761	Jonathon Cook	*1 Chas [chaise]*	28..13..4	215..0..0
34	04 03 1761	Jon'n Cook	*1 Chair*	16..0..0	120..0..0; may be part of a chaise
35	07 00 1761	Jon'n Mansfield	*Chest for son /18*	0..2..4 3/4	0..18..0; AB
36	07 18 1761	Hasket Darbey [Derby]	*a Frame for umbrilo [umbrella]*	0..12..0	4..10..0
37	07 25 1761	Henry Elkins	*a Cradel*	0..13..4	5..0..0; E 38
38	09 00 1761	Jonathon Gavot [Gavett]	*a Childs cofen [Coffin]*	0..8..0	3..0..0; E 47
39	09 00 1761	John Leach jnr	*a Childs cofen [Coffin]*	0..8..0	3..0..0; E 71
40	01 09 1762	Hasket Darby [Derby]	*a Waiter*	0..12..0	4..10..0; for his new house
41	01 15 1762	Han'h Cabot	*Large Waiter*	0..13..4	5..0..0
42	08 01 1762	Elias Haskett Darby [Derby]	*1 Large Waiter*	0..13..4	5..0..0
43	08 01 1762	Jacob Crowningshield [Crowninshield]	*1 Larg Tea Bord*	0..13..4	5..0..0
44	11 00 1762	William Nickals [Nichols]	*Cradle*	0..12..0*	4..0..0; price incorrect in AB, was 0..10..8; E 78
45	00 00 1763	George Dodge	*Tea board*	0..13..4	5..0..0
46	00 00 1763	Dan'l Chever [Cheever]	*Tea board*	0..13..4*	5..0..0; price incorrect in AB, was 1..1..0
47	01 25 1763	John Prince	*1 Med'n box [medicine]*	0..6..8	2..10..0
48	02 00 1763	James Freeman	*tea board*	0..13..4	5..0..0
49	02 01 1763	Thom's Mason	*Tea bord*	0..13..4	5..0..0
50	02 01 1763	Thom's Mason	*1 cloas hors 12/ [clothes horse]*	0..12..0	4..10..0
51	05 00 1763	Thomas Wood Jr	*Tea board*	1..6..8	10..0..0
52	05 00 1763	Jon'n Cook	*Coffin for boy*	0..16..0	6..0..0

	LEDGER DATE	CLIENT	LEDGER ENTRY	PRICE	NOTES
53	07 00 1763	**W'm Epes Esq'r [Eppes]**	*Coffin for a child*	0..4..0	AB; E 40
54	07 00 1763	**W'm Epes Esq'r [Eppes]**	*Coffin for a negro woman*	0..16..0	AB
55	09 00 1763	**Richard Darby [Derby]**	*1 Waiter*	0..10..8	AB; D 88
56	09 00 1763	**Richard Darby [Derby]**	*1 Server*	0..5..4	AB; D 88
57	09 00 1763	**Daniel Cheever**	*1 Server*	0..6..0	AB
58	12 05 1763	**John Prince**	*Medicine box*	0..3..4	AB
59	12 05 1763	**John Prince**	*6 do' @ 3/4 [medicine boxes]*	1..0..0	AB
60	00 00 1764	**William West**	*1 Server*	0..4..0	AB
61	00 00 1764	**Thomas Poynton**	*Case for Quadrant*	NOT PRICED	
62	03 26 1764	**Jon'n Peale Jr. [Peele]**	*1 Couch*	4..13..4	AB
63	05 22 1764	**William Northey**	*1 Server*	0..3..4	AB; D 73
64	10 29 1764	**Timothy Orne**	*2 umbrilo frames @ 12/ [umbrella]*	1..4..0	AB
65	11 22 1764	**Mark Hu'n Wintworth of ports'th New Ham'r [Wentworth]**	*160 inches of Servers @ 5'd*	3..6..8	AB; D 31
66	01 00 1765	**John Dean**	*Chaney board [china]*	2..8..0	AB
67	04 09 1765	**Sam'l West jn'r**	*Childs Coffin*	0..4..0	AB; E 109
68	06 00 1765	**Billings Bradish**	*1 Teaboard 8/*	0..8..0	AB; D 7
69	06 00 1765	**Billings Bradish**	*1 Server 4/8*	0..4..8	AB; D 7
70	09 24 1765	**Nicholas Bartlet Marblehead [Bartlett]**	*2 Cases for ditto [desk-and-presses]*	0..16..0	AB; C 67
71	10 00 1765	**Benjamin Doland [Daland]**	*Coffin for child*	0..5..4	AB; E 28
72	10 30 1765	**Bartelmy Putnam**	*1 Server*	0..4..6	AB
73	11 21 1765	**Jon'n Gavot [Gavett]**	*Coffin for his father*	0..14..0	AB
74	00 00 1766	**Larkin Dodge**	*1 Chist @ 20 [chest]*	1..0..0	AB
75	00 00 1766	**Is'l Dodge**	*1 4 1/2 foot Chest*	0..13..4	AB; C 82
76	01 00 1766	**Ric'd & Ben'n Pike**	*Cffin for negro child [coffin]*	0..5..0	AB; E 94
77	03 00 1766	**Larkin Dodge**	*Chest 20/*	1..0..0	AB
78	06 00 1766	**Samuel Blyth Jnr**	*Sygn Bord [sign]*	0..2..0	
79	06 00 1766	**John Fisher**	*money Box*	0..4..0	
80	06 04 1766	**Thomas Sumervil [Summerville]**	*Coffin for child*	0..5..0	AB; E 101
81	06 06 1766	**John Fisher, Esq**	*1 Server 4/8*	0..4..8	AB
82	08 00 1766	**Peter Frye [Esq.]**	*Cradle [mending]*	0..5..0	AB; E 43
83	09 00 1766	**Daniel Cheever**	*a Childs Coffin*	0..4..0	AB; E 23
84	10 00 1766	**Joshua Foster**	*1 Tea Board*	0..14..8	AB; D 18
85	10 00 1766	**Joshua Foster**	*1 sett Blaises wallnut*	0..4..0	AB; D 18
86	10 00 1766	**Joshua Foster**	*small Server*	0..5..0	AB; D 18
87	11 00 1766	**Mrs Higingson [Higginson]**	*1 Chaney tra [china tray]*	1..10..0	AB; D 59; shipped in 3 cases
88	11 00 1766	**Mrs Higingson [Higginson]**	*1 Tea bord 9/4*	0..9..4	AB; D 59; shipped in 3 cases
89	12 00 1766	**Jonathon Jackson**	*Sundrie houshold furniture*	12..2..0	AB; D 51
90	01 01 1767	**John Fisher, Esq**	*1 Black Walnut Chist with [chest] 6 Ceader boxes within*	3..6..8	AB
91	06 00 1767	**John Touzel**	*1 teabaord*	0..5..4	AB
92	07 00 1767	**William Burnet Brown [Browne Esq.]**	*2 Dressing Boxes & @ 24/*	2..8..0	AB
93	07 00 1767	**William Burnet Brown [Browne Esq.]**	*Framing 2 glasses for Ditto @ 6/ [for dressing boxes]*	0..12..0	AB
94	07 00 1767	**William Burnet Brown [Browne Esq.]**	*Glass frame*	1..4..0	AB
95	07 00 1767	**John Apleton [Appleton]**	*Frame for umbrilo [umbrella]*	0..12..0	AB
96	08 00 1767	**Jonathon Weeb [Webb]**	*Frame for umbrilo [umbrella]*	0..12..0	AB
97	08 00 1767	**Joseph Cabot**	*1 Chaney tra [china tray]*	1..16..0	AB
98	12 00 1767	**Josiah Orne**	*Tea board 8/*	0..8..0	AB; D 78
99	12 00 1767	**Josiah Orne**	*Candle box*	0..4..0	AB; D 78
100	01 22 1768	**Abijah Northy [Northey]**	*Bread Tray*	0..5..0	
101	02 00 1768	**Tho's Stimson**	*Cradle*	0..13..4	AB; E 104
102	02 07 1768	**Josiah Orne**	*Wall't Cradle 30/ [walnut]*	1..10..0	E 82

Miscellaneous Forms

	LEDGER DATE	CLIENT	LEDGER ENTRY	PRICE	NOTES
103	02 07 1768	**Benjamin Coats**	*Teaboard*	0..10..8	AB
104	03 26 1768	**Abijah Northy [Northey]**	*Childs Coffin 4/*	0..4..0	AB; E 79
105	04 05 1768	**Nehemiah Clough**	*Chaise*	9..0..0	
106	06 01 1768	**Benjamin Coats [Coates]**	*1 teaboard*	0..3..0	
107	06 14 1768	**Israel Dodge**	*a Bread bord*	0..3..0	
108	08 01 1768	**Rebecca Orne**	*1 Chaney Tra [china tray]*	2..0..0	D 16
109	08 03 1768	**Thos Barnard**	*Mak/g [making] map board for shop & mend'g [mending] flame*	0..6..0	
110	09 26 1768	**Alex Walker**	*Draw and Wigg stand*	0..14..0	
111	11 01 1768	**Richard Pike**	*Coffin for his brother*	0..13..4	
112	11 05 1768	**Tho's Stimson**	*Child Coffin*	0..4..8	E 105
113	12 02 1768	**Jn'o Mauskereen Esq [Mascareen]**	*Bok case for Custom House [book]*	2..8..0	
114	01 00 1769	**Stephen Higenson [Higginson]**	*Frame for dresing glass*	0..6..0	
115	01 00 1769	**Stephen Higenson [Higginson]**	*Teaboard*	0..8..8	AB
116	02 16 1769	**Edward Norrice [Norris]**	*Chist [chest]*	0..8..0	
117	03 00 1769	**Daniel Cheever**	*Cupbord for Shoes*	0..5..0	He was a shoemaker
118	03 03 1769	**Henry Williams**	*Chist [chest] 16/*	0..16..0	
119	03 03 1769	**Henry Williams**	*cabin desk 60/*	3..0..0	Installed on schooner *Salem* which sailed to the West Indies before 03/20/1769
120	04 00 1769	**Jonathan Mason**	*Teaboard*	0..10..8	AB
121	05 00 1769	**Jeremiah Newhall**	*Handle for Tea pot*	0..1..0	AB
122	09 00 1769	**Custom House Salem**	*Paper Case*	2..0..0	
123	09 00 1769	**Abj'h Northy [Northey]**	*Childs Coffin*	0..4..8	E 80
124	09 00 1769	**Jn'o Foster**	*Childs Coffin*	0..4..8	E 42
125	10 00 1769	**Benjamin Blyth**	*Sign Board 8/8 [and] 3 Straining frames @ 1/*	0..11..8	
126	11 20 1769	**Ben'n Pickman Esq**	*Large Tea Board*	0..12..0	
127	11 20 1769	**Jn'o Turner Esq**	*Cahaney Tray [china]*	1..16..0	D 36
128	12 11 1769	**Thomas Poynton**	*Reading stand*	0..16..0	Delivered in 10/1769
129	00 00 1770	**Sam'l Waters**	*Chist [chest]*	0..13..4	
130	03 00 1770	**Joseph Lee**	*Cloathes horse & folding Bord*	0..12..0	D 57
131	04 06 1770	**Author Jeffry [Jeffrey]**	*Cradle*	0..13..4	E 61
132	04 30 1770	**Jeremiah Lee [Esq.]**	*2 dressing stools @ 18/*	1..16..0	
133	05 01 1770	**William Pincheon [Pynchon]**	*2 dressing glas frames @ 8/*	0..16..0	Delivered in 04/1770
134	06 00 1770	**John Touzell [Touzel]**	*Feet for Chafein Dishes*	0..2..0	AB
135	06 19 1770	**Jonathon Touzel**	*[2] stools @ 3/*	0..6..0	
136	06 19 1770	**Richard Routh**	*Chist 12/ [chest]*	0..12..0	Listed in DB in 09/1770
137	08 24 1770	**Clark Gat'n Pickman**	*Chaney tra [china tray]*	2..0..0	D 86
138	08 24 1770	**Clark Gat'n Pickman**	*Sundry teaboards & Servers*	1..4..0	D 86
139	08 24 1770	**Clark Gat'n Pickman**	*1 Safe 12/*	0..12..0	D 86
140	08 24 1770	**Clark Gat'n Pickman**	*Meal-Chest*	0..12..0	D 86
141	08 24 1770	**Clark Gat'n Pickman**	*Close horse [clothes]*	0..12..0	D 86
142	08 24 1770	**Clark Gat'n Pickman**	*Folding board*	0..8..0	D 86
143	08 24 1770	**Stephen Cook**	*Chair body & carage*	4..16..0	
144	09 05 1770	**Henry Williams**	*1 bread tray*	0..6..0	D 114
145	11 01 1770	**Nathaniel Whitaker**	*Coffin for Negro woman*	0..16..0	
146	12 05 1770	**Jeremiah Lee [Esq.]**	*Screan Frame 20/ [pole screen]*	1..0..0	
147	02 00 1771	**Josiah Orne**	*Chaney tray [china tray]*	1..16..0	
148	07 00 1771	**Clark G Pickman**	*Cradle made of Ceader*	1..16..0	AB; E 89
149	09 00 1771	**Ben'n Blyth**	*6 stretching frames @ 8*	0..4..0	Price incorrect, was 0..4..4
150	11 12 1771	**Benjamin Cheever**	*Chest, with lock & hinges*	0..16..0	Made by George Deblois for 0..3..6
151	00 00 1772	**Gid'y King**	*Coffin for ye body of Dan Ruck*	0..12..0	
152	01 27 1772	**George Deblois**	*Clothes Horse*	0..8..0	
153	02 00 1772	**Thomas Barnard**	*Glass frame*	0..16..0	AB
154	03 00 1772	**Daniel Hopkins**	*Cradle Chretre [cherry]*	1..6..8	AB; E 58

	LEDGER DATE	CLIENT	LEDGER ENTRY	PRICE	NOTES
155	05 00 1772	Peter Frye, Esq	*Tea Board 10/*	0..10..0	
156	05 03 1772	Richard Routh	*a Chimney Bord*	0..6..8	
157	05 04 1772	David Masury	*a New Chaise*	30..13..4	
158	09 11 1772	Edward Allin [Allen]	*Tea board 6/8d*	0..6..8	Listed in AB after 05/1773
159	10 00 1772	Nathan Goodale	*Wallnut Cradle*	1..10..0	E 51
160	10 10 1772	George Dublois [Deblois]	*Book Case*	4..0..0	
161	10 10 1772	George Dublois [Deblois]	*2 Close Stool @ 16/*	1..12..0	
162	11 00 1772	Josiah Gould	*Tea Board*	0..6..0	
163	11 25 1772	George Deblois	*Close stool*	3..0..0	E 31
164	12 01 1772	Timothy Orne [III]	*Cradle*	1..8..0	E 84
165	05 00 1773	Thomas Barnard Jun.	*60 inches of Teaboard @ 5d*	1..5..0	D 4
166	06 04 1773	Thomas Barnard Jun.	*Clothes Horse*	0..12..0	D 4
167	06 04 1773	Thomas Barnard Jun.	*Bread Trough*	0..6..8	D 4
168	06 04 1773	Thomas Barnard Jun.	*Knife Box*	0..4..0	D 4
169	06 04 1773	Thomas Barnard Jun.	*Folding Board 10*	0..10..6	D 4
170	06 04 1773	Joseph Trask	*Large Chist [chest]*	1..0..0	
171	06 04 1773	George DeBlois [Deblois]	*Childs Crib*	0..9..4	E 34
172	07 01 1773	Timothy Orne [III]	*Cribb for child*	0..9..4	E 85
173	07 17 1773	Edward Allen	*Sideboard 18/*	0..18..0	
174	09 00 1773	Joseph Sprague	*Mohogony Stand for Clock*	1..4..0	AB
175	10 01 1773	Joseph Trask	*Chist painted [chest]*	1..4..0	
176	10 05 1773	Dan'l Hopkins	*Child's Coffin*	0..6..0	E 59
177	10 07 1773	William Paine	*Servers & bottle stands*	NOT PRICED	Complimentary for very large orders; D 81
178	10 20 1773	Arthur Jeffrey	*Bread trough*	0..6..0	
179	11 00 1773	John Appleton	*Cradle*	0..13..4	AB; E 3
180	02 03 1774	Andrew Cabot	*Cradle of B wall't [black walnut]*	1..16..0	E 18
181	03 26 1774	George Cabot	*3 Tea boards 12/*	1..16..0	D 14
182	03 29 1774	W'm Goodhue	*Tea board*	0..8..10	
183	06 24 1774	Tho's Gage Esq	*Mehogany Paper Case*	4..16..0	
184	07 06 1774	Thos Mason jun	*Cloathes horse*	0..12..0	D 63
185	07 13 1774	Andrew Cabot	*Childs crib*	0..13..4	E 19
186	07 25 1774	Nathan Goodale	*Childs crib*	0..13..4	Price listed as 0..13..5 in AB; E 53
187	09 00 1774	Francis Grant	*Coffin*	NOT PRICED	
188	11 02 1774	Richrd Routh	*Cloaths horse*	0..8..0	Delivered after his house fire on 10/06/1774
189	12 00 1774	James Nichols	*Gun stock 1/4*	0..1..4	
190	12 22 1774	Richard Routh	*Chest*	1..6..8	Delivered after his house fire on 10/06/1774
191	01 09 1775	Peter Frye [Esq.]	*Cloaths horse*	0..8..0	D 76
192	06 00 1775	Miles Ward	*12 candle boxes @ 1/*	0..12..0	
193	08 00 1775	William Vans Esq'r	*chany tra [china tray]*	1..16..0	D 105
194	09 00 1775	Miles Ward	*13 candle boxes 1/*	0..13..0	
195	11 00 1775	Josiah Orne	*1 Pine box*	0..6..8	Duplicate entries in AB
196	12 00 1775	Miles Ward	*1 Candle box 1/*	0..2..0	
197	01 00 1776	Ben'n Cheever	*Chist [chest]*	0..16..0	
198	01 01 1776	Joshua Ward [Jr]	*Cradle*	1..10..0	E 107
199	02 00 1776	Joseph Lee [of Beverly]	*Cott*	1..4..0	E 72
200	02 00 1776	Miles Ward	*12 candle boxes @ 1/4*	0..16..0	
201	09 14 1776	Miles Ward	*6 candle boxes*	0..9..0	
202	10 02 1776	Miles Ward	*6 candle boxes*	0..9..0	
203	10 25 1776	Miles Ward	*6 candle boxes*	0..9..0	
204	10 25 1776	Miles Ward	*1/2 dozen candle boxes*	0..9..0	
205	11 00 1776	Samuel Blyth	*Backs for Picture Frames*	0..3..6	
206	11 11 1776	W'm Pickman	*Tea Board 16*	0..16..0	D 87

Miscellaneous Forms

	LEDGER DATE	CLIENT	LEDGER ENTRY	PRICE	NOTES
207	11 25 1776	John Jinks [Jenks]	*1 Tea Board*	0..12..0	D 53
208	11 25 1776	John Jinks [Jenks]	*1 Server*	0..5..0	D 53
209	12 16 1776	Miles Ward	*12 candle boxes @ 2/*	1..4..0	
210	12 31 1776	Edward A Holeoke Esq [Holyoke]	*Coffin for a child*	0..7..0	E 56
211	09 23 1777	Jn'o Lee Esq	*1 teabo'd 1/ [tea board]*	1..0..0	D 77
212	10 01 1777	Israel Thorndike	*Teaboard*	1..0..0	D 103
213	11 01 1777	Dan'l Hopkins	*Teaboard*	0..12..0	Duplicate entries in AB
214	12 00 1777	Sam'l Jones	*Cradle*	0..16..0	E 62
215	02 00 1778	Thomas Mason jun	*8 feet w't for gun stock [walnut]*	0..4..0	
216	02 00 1778	William West	*Teaboard*	0..12..0	
217	02 25 1778	Nath'n Nickals [Nichols]	*Bookcase*	60..0..0	Prob. for the house he shared with his brother and bought from Mark H. Wentworth in 04/1779
218	05 00 1778	Edward A. Holyoke	*Medin Box [medicine]*	0..2..0	
219	04 08 1778	John Hartwell	*Teaboard*	NOT PRICED	Order not itemized, total was 70..0..0
220	04 28 1778	W'm Goodhue, Jn'r.	*Cradle*	6..12..0	E 54
221	09 00 1779	Nathan Nichols	*Coffin for child*	1..10..0	E 77
222	11 00 1778	Nathan Nichols	*Cloaths horse*	NOT PRICED	
223	02 25 1779	George Dodge, Jn'r.	*1 Large tea board*	9..0..0	
224	04 29 1779	Nathan Nichols	*Checker Board*	6..0..0	
225	04 29 1779	Nathan Nichols	*Folding Board*	0..6..0	
226	05 24 1779	Nathan Nickals [Nichols]	*Chist with lock & hinges [chest]*	8..0..0	
227	08 06 1779	Edward Agust's Holoke Es'r [Holyoke]	*Mahogany Cradle*	3..6..8	E 57
228	12 06 1779	Sam'l Flagg	*Mehogany case*	3..0..0	
229	04 00 1780	W'm Safford	*Cloaths horse*	NOT PRICED	D 94
230	07 00 1780	Sam'l Crowel	*1 Cradle*	NOT PRICED	E 27
231	08 00 1780	Paul Dudley Sargent	*Handles for Tea & Coffee Pots*	1..4..0	AB
232	08 00 1780	William Chandler jr.	*Breadtrough*	0..6..0	AB
233	08 00 1780	Josiah Orne	*Making trunk with lock & hinges & handles*	0..1..4	
234	08 00 1780	W'm Chandler jr	*1 Cradle*	1..16..0	E 22
235	10 18 1780	George Cabot	*Shelves for bookcase*	90	
236	11 00 1780	Joshua Dodge	*Cradle 42/*	2..2..0	AB; E 35
237	11 00 1780	Lydia Gowen	*Teaboard*	NOT PRICED	D 21
238	12 01 1780	Francis Cabot Jr	*Mehog'y Cradle 40/*	2..0..0	E 20
239	12 20 1780	George Dodge Jr.	*1 Bookcase*	NOT PRICED	
240	01 00 1781	Joshua Dodge	*Tea tray*	1..10..0	AB
241	02 00 1781	John Norice [Norris]	*1 Teaboard 15 inches 13/4*	0..13..4	AB; duplicate entries in AB
242	08 00 1781	John Danielson [Donaldson]	*Pine Cradle 33/*	1..13..0	E 29
243	08 00 1781	John Danielson [Donaldson]	*1 Tea pot Handle*	0..6..0	AB
244	08 15 1781	Joseph Lee [Esq. of Beverly]	*1 Bookcase*	15..0..0	
245	09 20 1781	John Brooks	*Teaboard 16/*	0..16..0	AB; D 9
246	09 20 1781	David Ashby	*1 Tea board*	0..6..6	
247	11 12 1781	David Ashby	*1 Pine Cradle*	1..13..0	E 4
248	11 15 1781	Henry Gardner	*Small Server*	0..6..0	Ordered after his return from exile
249	01 00 1782	Samuel Blythe [Blyth]	*1 3 foot Chest*	0..12..0	
250	01 00 1782	John Brooks	*Clothes House*	0..18..0	D 9
251	02 00 1782	Jon'o Felt	*Pine Cradle*	1..10..0	E 41
252	02 00 1782	Henry Gardner	*Pine Cradle*	NOT PRICED	E 45
253	02 22 1782	Benj'n Linde Oliver	*40 draws @ 4/6 £9 [drawers]*	27..0..0	Price is total for entire order
254	02 22 1782	Benj'n Linde Oliver	*120 small do @ 3/18 [drawers]*	NOT PRICED	Listed as "nest of drawers" in AB
255	08 00 1782	John Jinkins [Jenkins]	*1 Teaboard 21 inch @ 4 1/2*	0..7..10 1/2	AB
256	11 22 1782	Benj'n L Oliver	*1 medi'n Chest [medicine]*	13..0..0	
257	03 00 1783	James Wood Gould	*1 Tea Tray*	1..4..0	
258	03 20 1783	Peter Landis [Lander]	*Bookcase*	NOT PRICED	

Stands

	LEDGER DATE	CLIENT	LEDGER ENTRY	PRICE	NOTES
1	08 23 1759	Tabytha Skyner [Skinner]	*1 Screen Stand*	1..0..0	7..10..0; D 37
2	01 10 1760	Samuel Magry [Masury]	*1 Stand*	0..18..0	6..15..0
3	01 09 1762	Hasket Darby [Derby]	*a Small Stand*	0..16..0	6..0..0; D 23
4	05 06 1762	John Saundors [Saunders]	*a Scrien Stand [screen]*	1..0..0	7..10..0
5	05 22 1762	William Epes Esq [Eppes]	*1 Stand Table Frame*	1..6..8	10..0..0
6	05 22 1762	William Epes Esq [Eppes]	*1 Stand*	0..18..0	6..15..0
7	05 22 1762	Bez'l Topen [Toppan]	*2 Bottle Stands*	0..6..0	2..5..0; D 85
8	07 00 1762	Bez' l Toppen [Toppan]	*small Stand*	0..16..0	6..0..0; D 85
9	08 00 1762	Elias Hasket Darby [Derby]	*1 pr [pair] of Bottol Stands*	0..6..0	2..5..0; D 23
10	09 00 1763	Richard Darby [Derby]	*1 Ca'o Stand [candle]*	0..18..0	AB; D 88
11	02 00 1765	Billings Bradish	*small Stand*	0..18..0	AB; D 7
12	03 00 1765	George Dodge	*Candlestand*	0..14..8 1/4	AB
13	07 00 1765	Bartelmy Putnam	*1 pair bottle Stands*	0..6..0	AB
14	06 00 1766	Abner Chase	*1 Candle Stand*	0..7..4	AB
15	04 00 1767	George Peale [Peele]	*Screan Stand 18/ [screen]*	0..18..0	AB
16	12 00 1767	Josiah Orne	*small Stand mahogany*	1..0..0	AB; D 78
17	01 14 1768	Gam'l Hodges	*Stand 13/4*	0..13..4	D 109
18	02 25 1768	Gam'l Hodges	*Candle Stand*	0..16..0	D 109
19	03 00 1768	Cap' Skilen [Skillin]	*Candle Stand 16*	0..16..0	0..6..0
20	08 01 1768	Rebeca Orne	*1 Candle Stand*	0..16..0	D 16
21	11 20 1768	Robert Foster	*Candle Stand*	0..16..0	
22	02 18 1769	Isaac Neadham jn'r [Needham]	*Candle Stand 16/*	0..16..0	AB; D 66
23	06 00 1769	John Higinson, Esq [Higginson]	*1 pr [pair] bottle Stands*	0..6..0	AB
24	06 00 1769	John Higinson, Esq [Higginson]	*Glass Stand*	0..10..0	AB
25	10 00 1769	Tho's Poynton	*Reading Stand*	0..16..0	
26	11 11 1769	Jn'o Archer	*Candle Stand*	0..10..0	
27	12 00 1769	W'm Nickals [Nichols]	*Candle Stand*	0..8..0	
28	11 00 1770	Henry Williams	*Candle Stand*	0..6..8	D 115
29	01 07 1771	Henry Gardnor [Gardner]	*Candle Stand*	1..0..0	
30	05 03 1771	Jn'o Maskreen [Mascareen Esq.]	*Reading Stand*	NOT PRICED	
31	07 00 1771	W'm Pinchon, Esq [Pynchon]	*Reading Stand 48/*	2..8..0	
32	08 02 1771	Gideon Foster jn'r of Danvers	*Candlestand*	0..8..0	D 33
33	02 05 1772	Dan'l Hopkins	*Candlestand*	0..12..0	
34	09 18 1772	Thomas Barnard Jun	*Reading Stand*	2..10..8	
35	00 00 1773	Joseph Sprague	*Mehogany Stand for Clock*	1..4..0	AB
36	01 16 1773	Timothy Orne	*1 pr [pair] bottle Stands*	0..4..0	
37	05 09 1773	George Dodge	*1 Candlestand*	0..16..0	D 12
38	04 23 1774	Jon'n Tucker	*Candlestand small Stand 18/*	0..18..0	
39	07 06 1774	Francis Cabot	*Tea kettle Stand*	3..0..0	D 60
40	07 06 1774	Francis Cabot	*1 Kettle Stand*	1..10..0	D 60
41	07 15 1775	Jon'n Paison [Payson]	*Light Stand del'd [delivered] Wadw'th*	0..16..0	
42	11 26 1776	John Jinks [Jenks]	*1 Light Stand @ 18/*	0..18..0	Unit price not included in total; D 53
43	03 16 1777	Nathan Nickals [Nichols]	*Light Stand*	0..16..0	D 69
44	03 22 1777	John Derby	*Candle Stand*	1..6..8	
45	05 02 1777	Joshua Dogue [Dodge]	*Light Stand*	1..0..0	D 25
46	06 25 1777	Elias H Derby	*Stand Candlestand*	1..10..0	
47	09 23 1777	Jn'o Lee Esq	*1 Candlestand*	1..10..0	D 77
48	09 24 1777	W'm West	*Light Stand*	1..10..0	Duplicate entries in AB; D 114
49	10 25 1777	Israel Thorndike	*Light Stand*	1..10..0	D 103
50	11 07 1777	Edmund Putnam	*Light Stand*	$7.10	D 29
51	02 00 1778	George Dodge	*Urn Stand*	4..0..0	
52	08 00 1778	Jn'o Jinkins [Jenkins]	*Stand*	6..0..0	
53	11 09 1778	Jn'o Smith	*Stand*	6..0..0	
54	03 29 1779	Nathan Nichols	*Candle Stand*	7..10..0	Prob. for house Nichols shared with his brother and purchased from Mark Wentworth in 04/1779

Stands

	LEDGER DATE	CLIENT	LEDGER ENTRY	PRICE	NOTES
55	08 27 1781	John Brooks	*Candle Stand 36/*	1..16..0	D 9
56	10 12 1781	Jacob Ashton	*Candlestand*	1..16..0	
57	12 05 1781	W'm Brown	*1 Candlestand*	2..8..0	
58	02 00 1782	Step'n Caldwell	*Candlestand*	0..18..0	
59	02 00 1782	Jn'o Jenkins	*Candlestand*	0..18..0	
60	04 00 1782	James Wood Gould	*1 Candle Stand*	0..18..0	D 40
61	06 00 1782	Jn'o Danielson [Donaldson]	*Candlestand*	1..10..0	
62	12 00 1782	Nath Knight	*Candlestand*	1..4..0	AB

Card Tables

	LEDGER DATE	CLIENT	LEDGER ENTRY	PRICE	NOTES
1	10 29 1759	Jonathan Mansfield	*a Card Table [prob. walnut]*	2..8..0	18..0..0; duplicate entries in DB
2	11 26 1759	Anto'y Lab'm Reyke	*1 Card Table*	2..8..0	18..0..0; C 9
3	03 13 1761	Joseph Grafton	*1 Card Table 80/ [carved knees & border]*	4..0..0	30..0..0; C 19
4	03 13 1761	Joseph Grafton	*Casing Dito 2/8*	0..2..8	1..0..0; C 19
5	09 00 1762	Sam'l Williams	*1 Card Table [w/ carved knees & border, mahogany]*	4..0..0	30..0..0
6	08 00 1764	John Dean	*1 Card Table [w/ carved knees & border, mahogany]*	4..0..0	AB
7	01 09 1768	Jeremiah Lee [Esq.]	*Card Table Carv'd knees & toes*	4..8..0	Prob. charged 1s each for carved knees and feet
8	04 07 1769	Jeremiah Lee, Esq	*1 Card Table*	5..0..0	Prob. had carved knees and feet; delivered 1 year after his house was completed
9	06 00 1771	Dan'l Hopkins	*Card Table [prob. walnut]*	2..8..2	D 49
10	03 00 1772	W'm Pinchon, Esq [Pynchon]	*Card Table with carved knees & border [mahogany]*	4..0..0	
11	06 04 1773	Thomas Barnard Jun.	*1 Card Table, Carved Knees & Border [mahogany]*	4..0..0	D 4
12	10 07 1773	William Paine	*1 Card Do [table, w/ carved knees & border, mahogany]*	4..0..0	D 81
13	10 05 1774	Jn'o Gardner jun	*1 Card Table [mahogany]*	3..10..8	Price listed as 3..0..0 in AB; C 198
14	10 05 1774	Jn'o Gardner jun	*Casing Table*	0..4..0	C 198
15	12 02 1774	Sylveter Gardnor Esq [Gardiner]	*1 Card do [table, w/ carved knees & border, mahogany]*	4..0..0	
16	12 24 1774	Peter Frye esq	*1 Card do [table]*	3..0..0	D 76
17	04 09 1775	Jeremiah Lee [Esq.]	*2 Card Tables @ 80/ [w/ carved knees & border, mahogany]*	8..0..0	D 104
18	08 00 1775	William Vans Esq'r	*1 Card Table lined with green cloath 66/8*	3..6..8	D 105
19	04 05 1777	Andrew Cabot	*1 Card do [table, w/ carved knees & border, mahogany]*	4..0..0	Price corrected in AB, was 4..13..4 in DB
20	02 00 1778	Sam'l Flagg	*Card Table*	6..0..0	16..0..0
21	05 21 1778	George Cabot	*Card Table*	24..0..0	
22	09 22 1778	Paul D Serjant [Sargent]	*2 Card Tables @ £30*	60..0..0	
23	01 27 1780	Francis Cabot jn'r	*1 Card Table 80/ [w/ carved knees & border]*	4..0..0	D 13
24	02 07 1780	Jn'o Cabot	*Card Table*	NOT PRICED	
25	02 00 1781	Doc'r. Barnard	*2 Card Tables*	NOT PRICED	Order not itemized; D 3
26	08 00 1781	Peter Laundor [Lander]	*Card Table*	8..0..0	
27	05 00 1783	Benjamin West	*2 Card tables @ 90/*	9..0..0	

Chamber Tables

	LEDGER DATE	CLIENT	LEDGER ENTRY	PRICE	NOTES
1	09 00 1756	Moses Paine	*a Chamber Table [walnut]*	2..8..0	D 80
2	09 23 1758	John Tasker [Esq.]	*a Chaimb'r Table [walnut]*	2..16..0*	21..0..0; sold w/ case of drawers; delivered to his widow in 1761; D 34
3	11 07 1758	Thomas Elkins	*a Chamber dito [table, walnut]*	2..2..0	16..0..0; AB; sold w/ case of drawers; D 28

	LEDGER DATE	CLIENT	LEDGER ENTRY	PRICE	NOTES
4	07 23 1759	**Richard Stacy [Stacey]**	*1 Chaimber Table [prob. walnut]*	2..2..8	16..0..0; D 98
5	08 18 1759	**Tabytha Skyner [Skinner]**	*1 Chaimber Table [prob. mahogany]*	3..1..4	23..0..0; D 37
6	03 16 1760	**Jonathon Watson**	*1 Chimber Table [prob. walnut]*	2..5..4	17..0..0; D 45
7	01 08 1761	**John Growningsheld [Crowninshield]**	*1 Chaimber dito [table, prob. walnut]*	2..2..8	16..0..0; sold w/ case of drawers; D 23
8	07 00 1761	**Mrs Crowningshield [Crowninshield]**	*1 Chimber Table [prob. mahogany]*	3..4..0	24..0..0
9	04 00 1763	**Jacob Fowle**	*1 Chai'r Table [chamber, mahogany]*	3..6..8	25..0..0; sold w/ walnut case of drawers in 1766
10	03 00 1764	**Zacheus Colins [Collins]**	*Chamber Table [walnut]*	2..8..0	AB; sold w/ case of drawers; D 73
11	04 00 1765	**James Bradish Jn'r.**	*Chaimber Table [walnut]*	2..8..0	AB; sold w/ case of drawers
12	06 00 1765	**John Hodges**	*1 Chamber Table [mahogany]*	3..4..0	AB; mahogany per inventory of 04/02/1800
13	00 00 1766	**Aaron Waite**	*Chamber table*	3..14..1	D 106
14	12 00 1766	**Timothy Pickering**	*Chamber Table [mahogany]*	3..6..8	AB; D 24
15	11 05 1767	**Josiah Orne**	*1 Chamb'r Table [mahogany]*	3..6..8	AB; sold w/ case of drawers; D 78
16	11 00 1770	**Henry Williams**	*1 Chaimber Table [mahogany]*	3..6..8	Sold w/ case of drawers; D 115
17	05 03 1771	**Jonathon Saunders**	*1 Chaimber Table [walnut]*	2..13..4	Sold w/ case of drawers in 1766; D 49
18	08 00 1771	**Roland Savage**	*Bureau Table [walnut]*	2..8..0	Listed as "chamber table" in AB
19	04 28 1774	**Ichabod Nickals [Nichols]**	*Chamber Table 53/4 [prob. mahogany]*	3..0..0	Price listed as 2..13..4 in AB in 03/1774; D 68
20	06 24 1775	**Jon'n Payson**	*Chamber do [table, mahogany]*	3..6..8	Sold w/ case of drawers

China and Tea Tables

	LEDGER DATE	CLIENT	LEDGER ENTRY	PRICE	NOTES
1	04 23 1759	**John Tasker, Esq**	*a Squair Tea Table [mahogany]*	2..0..0	15..0..0; D 34
2	06 04 1759	**John Tasker [Esq.]**	*a Tea Table [mahogany]*	2..2..8	16..0..0; D 34
3	08 23 1759	**Tabytha Skyner [Skinner]**	*1 Tea Table [mahogany]*	2..2..8	16..0..0; D 37
4	03 16 1760	**Jonathon Watson**	*1 Tea dito [table, prob. walnut]*	1..12..0	12..0..0; D 45
5	05 03 1762	**The widow Tasker**	*Tea Dito £16 [table, prob. mahogany]*	2..2..8	16..0..0; D 110
6	01 15 1762	**Hasket Darby [Derby]**	*Tea Table [mahogany]*	2..2..8	16..0..0; D 23
7	12 16 1762	**Ben'n Pickman jn'r**	*Tea table [mahogany]*	5..6..8	40..0..0; D 85
8	00 00 1763	**Joshua Foster**	*1 Tea Table [mahogany]*	2..0..0	AB
9	10 00 1763	**Thomas Poynton**	*2 Tea tables @ 100/*	10..0..0	AB; C 35
10	03 26 1764	**Jon'n Peale Jr. [Peele]**	*1 Tea Table [mahogany]*	2..8..0	AB
11	06 00 1765	**Mssr Francis & Joseph Cabot**	*1 Chaney ditto [china table]*	6..13..4	AB; prob. for their new office building at 229 Essex St., Salem
12	12 02 1774	**Sylveter Gardnor Esq [Gardiner]**	*Chanea Table @ 48 [china]*	2..0..0	Price listed as 0..2..8 in AB
13	01 01 1775	**Peter Frye [Esq.]**	*Chaney Tra & Table [china tray]*	4..0..0	D 76
14	06 24 1775	**Jon'n Payson**	*1 Chaney Table with Border [china]*	3..6..8	

Drop-Leaf Tables

	LEDGER DATE	CLIENT	LEDGER ENTRY	PRICE	NOTES
1	09 01 1756	**Moses Paine**	*a Black Walnut Table [4', sq., pad feet]*	2..2..8	D 80
2	05 01 1758	**Sam'l Archer Jr**	*a Walnut Table [3', round, b&c feet]*	2..0..0	15..0..0
3	08 13 1758	**John Leach Jr**	*a fore feet Table [sq., pad feet, walnut]*	2..2..8	16..0..0; D 56
4	11 07 1758	**Thomas Elkins**	*4 1/2 [foot] Table [mahogany]*	2..18..8	22..0..0; price charged was for a 4' table; D 28
5	11 07 1758	**Thomas Elkins**	*3 1/2 dito [table, sq., pad feet, mahogany]*	2..6..8	17..10..0; D 28

Drop-Leaf Tables

	LEDGER DATE	CLIENT	LEDGER ENTRY	PRICE	NOTES
6	12 26 1758	**Chris Brewer**	*1 Table*	3..1..4	23..0..0; C 2
7	12 26 1758	**Chris Brewer**	*dito [table]*	2..8..0	18..0..0; C 2
8	12 26 1758	**Chris Brewer**	*Casing*	0..10..8	4..0..0; C 2
9	00 00 1759	**Joseph Trask**	*1 Case of Tables Con'g [containing] 7 feet @ 3 £10/*	3..5..4	24..10..0; C 3
10	00 00 1759	**Joseph Trask**	*Casing Dito [table]*	0..6..9 1/2	2..11..0; C 3
11	00 00 1759	**James Gould**	*Table 42/8 [4', sq., pad feet, walnut]*	2..2..8	AB
12	01 02 1759	**John Nutting jn'r**	*3 Cases of Tables Containing 21 feet @ 3 £10/*	9..16..0	73..10..0; C 5
13	01 02 1759	**John Nutting jn'r**	*Casing Dito [table]*	1..4..0	9..0..0; C 5
14	03 29 1759	**Sam Holman**	*a Mahogany Table [3 1/2', sq., pad feet]*	2..6..8	17..10..0
15	04 23 1759	**John Tasker, Esq.**	*a 3 foot Round Table [pad feet, mahogany]*	2..4..0	16..10..0; possibly D 34
16	06 04 1759	**John Tasker [Esq.]**	*1 3 foot Round Table [b&c feet, walnut]*	2..0..0	15..0..0; D 34
17	06 04 1759	**John Tasker [Esq.]**	*1 3 1/2 foot Squair Table [pad feet, mahogany]*	2..6..8	17..10..0; D 34
18	07 23 1759	**Richard Stacy [Stacey]**	*1 3 1/2 feet Table [sq., pad feet, mahogany]*	2..6..8	17..10..0; D 97
19	07 12 1759	**John Gardnor Jr [Gardner]**	*3 feet Table*	2..0..0	15..0..0; round, b&c feet, walnut or sq., pad feet, mahogany; duplicate entries in DB
20	07 30 1759	**Joseph Trask**	*a Black Walnut Table [4 feet, sq., pad feet]*	2..2..8	16..0..0; C 7
21	08 23 1759	**Tabytha Skyner [Skinner]**	*1 4 foot Table [sq., pad feet, mahogany]*	2..13..4	20..0..0
22	08 23 1759	**Tabytha Skyner [Skinner]**	*1 3 feet Dito [table, sq., pad feet, prob. mahogany]*	2..0..0	15..0..0
23	11 26 1759	**Anto'y Lab'm Reyke**	*6 Meh'ny Tables Containing 20 1/2 feet @ 5£ [mahogany]*	13..13..4	102..10..0; C 9
24	11 26 1759	**Anto'y Lab'm Reyke**	*Casing ye above*	1..6..8	10..0..0; C 9
25	11 28 1759	**John Foster Jn'r.**	*1 Case of Tables*	2..14..8*	20..10..0; price corrected, was 4..14..8; C 10
26	11 28 1759	**John Foster Jn'r.**	*Casing of dito [table]*	0..8..0	3..0..0; C 10
27	12 24 1759	**Benjamin Feltt [Felt]**	*1 4 feet Table*	3..0..0	22..10..0
28	03 16 1760	**Jonathon Watson**	*1 four feet Table [sq., pad feet, walnut]*	2..2..8	16..0..0; D 45
29	04 08 1760	**Sam'l White Jn'r**	*a Table of Black Wal't [3 1/2', sq., pad feet, walnut]*	1..17..4	14..0..0
30	04 08 1760	**Joseph Rolings [Rollings]**	*a 4 feet Table Walnut Table [sq., pad feet]*	2..2..8	16..0..0
31	06 00 1760	**Arth'r Jeffry [Jeffrey]**	*3 1/2 fot Wallnut Table d'd [delivered] Rob'o Peal j'n [round, pad feet]*	2..2..0	AB
32	06 03 1760	**Jose'h Grafton**	*2 5 f't Tables @ 55/pr foot*	3..10..8	26..10..0; C 15
33	06 03 1760	**Jose'h Grafton**	*1 3 feet ditto @ 55/ 7/4 [tables]*	1..2..0	8..5..0; C 15
34	06 17 1760	**William Brown Esq.**	*1 Sedar Table [cedar]*	2..13..4	20..0..0
35	07 02 1760	**John Gardnor jn'r. [Gardner]**	*2 Walnut Tables @ £16..0..0/*	4..5..4	32..0..0; C 16
36	07 02 1760	**John Gardnor jn'r. [Gardner]**	*Casing dito [table]*	0..5..4	2..0..0; C 16
37	08 16 1760	**John Gardnor [Gardner, Jr.]**	*4 feet Table [sq., pad feet, mahogany]*	2..13..4	20..0..0
38	09 24 1760	**Robert Millen**	*1 4 feet Table [sq., pad feet, mahogany]*	2..13..4	20..0..0; D 64
39	10 15 1760	**John Dean**	*2 Mehogany Tables @ £17..10/*	4..13..4	35..0..0; C 17
40	10 15 1760	**John Dean**	*Casing Dito @ 25/ [tables]*	0..6..8	2..10..0; C 17
41	12 12 1760	**Mrs [Hannah] Cabot**	*1 Table*	2..8..0*	18..5..0; price corrected, was 2..8..8
42	01 08 1761	**John Growningsheld [Crowninshield]**	*1 4 1/2 feet Table*	3..8..0	25..10..0; D 23
43	01 28 1761	**Jon'n Cook**	*1 Mah'y Table [4', round, pad feet, mahogany]*	2..18..8	22..0..0
44	02 13 1761	**Richard Richards**	*1 Meh'g'y Table [mahogany]*	3..0..0	22..10..0; 4' 6", sq., pad feet or 5'x4', oval, pad feet
45	03 13 1761	**Joseph Grafton**	*3 5 feet Tables @ 55/ per foot @ 7/4*	5..10..0*	41..5..0; price corrected, was 5..18..0; C 19
46	03 13 1761	**Joseph Grafton**	*Casing of Dito 8/ [table]*	0..8..0	3..0..0; C 19
47	04 03 1761	**Jon'n Cook**	*1 Mahogany Table [4', round, pad feet]*	2..18..8	22..0..0; C 20
48	04 10 1761	**Jeremiah Newhall**	*4 feet Table [sq., pad feet, walnut]*	2..2..8	16..0..0; D 67
49	08 28 1761	**Mrs Han'h Cabot**	*1 4 1/2 feet Table [sq., b&c feet, mahogany]*	3..4..0*	24..0..0
50	11 01 1761	**Dan'l Ropes**	*1 4 foot Table [5'x4', oval, pad feet, mahogany]*	3..0..0	22..10..0; D 91
51	11 06 1761	**James Punchard**	*1 Table [3 1/2 feet, sq., b&c feet, mahogany]*	2..10..8	19..0..0?
52	11 18 1761	**James Odel [Odell]**	*1 4 foot dito [table, sq., pad feet, walnut]*	2..2..8	16..0..0; D 75
53	01 02 1762	**Ben'n Bickford [Beckford]**	*1 table 3 feet long [sq., pad feet, walnut]*	1..12..0	12..0..0

	LEDGER DATE	CLIENT	LEDGER ENTRY	PRICE	NOTES
54	01 15 1762	**Hasket Darby [Derby]**	*3 1/2 feet Table*	2..17..0	21..7..6; outside price list; D 23
55	01 26 1762	**John Gardnor Jn'r [Gardner]**	*4 1/2 feet Table [round, b&c feet, mahogany]*	3..10..0	26..5..0; C 25
56	01 26 1762	**John Gardnor Jn'r [Gardner]**	*3 1/2 Dito [table, round, carved feet, mahogany]*	2..15..4	20..15..0; C 25
57	01 26 1762	**John Gardnor Jn'r [Gardner]**	*3 cases for ditos 50/ [tables]*	1..0..0	7..10..0; C 25
58	05 03 1762	**The widow Tasker**	*2 4 feet squ'r Ditos [tables] @ 120/ pr foot*	6..8..0	48..0..0; outside price list; D 110
59	05 03 1762	**The widow Tasker**	*Carving ye Toes of dito [tables]*	0..8..5 1/3	4..0..0; D 110
60	05 03 1762	**The widow Tasker**	*6 Cass [cases] for ye above @ 60/*	2..8..0	18..0..0; D 110
61	06 00 1762	**James Gould**	*1 Walnut Table*	2..8..0	18..0..0; 4' 6" sq., pad feet or 4' round, pad feet
62	06 00 1762	**Dr. Beza'l Topen [Toppan]**	*1 4 feet Table*	3..9..4	26..0..0; outside price list; D 85
63	06 01 1762	**Dr. Beza'l Topen [Toppan]**	*1 3 1/2 feet Table*	3..1..4	23..0..0; outside price list; D 85
64	06 01 1762	**Thomas Mason**	*Mahogany 3' 8" Table [prob. round, carved feet]*	2..19..2 1/3*	22..4..0
65	06 01 1762	**John Bery [Berry]**	*1 Mehugany Table [4 feet, sq., pad feet]*	2..13..4	20..0..0
66	08 00 1762	**Elias Haskett Darby [Derby]**	*2 Mahog'y Tables @ £ 19..10/*	5..4..0	39..0..0; 4 1/2', sq., pad feet, walnut or 4' round, pad feet, walnut; D 23
67	08 01 1762	**Daniel Chever [Cheever]**	*Small Mehogn'y Table [3 feet, sq., pad feet]*	2..0..0	15..0..0
68	11 01 1762	**George Dodge**	*1 4 foot Meh'y Table [mahogany]*	3..8..0	25..10..0; outside price list
69	11 01 1762	**Ben'n Waters**	*1 Mapel Table & casing*	2..2..8	16..0..0
70	11 22 1762	**Eben'r Bickford [Beckford]**	*2 Cheretree Table @ 60/pr foot [cherry]*	8..17..4	66..10..0
71	11 28 1762	**Robert Shilleber [Shillaber]**	*3 1/2 feet Walnut Table [round, pad feet]*	2..2..0	15..15..0
72	01 25 1763	**Sam'l Grant**	*1 3 1/2 feet Table*	2..9..0	18..7..6; D 41
73	03 01 1763	**Sam'l Grant**	*1 3 1/2 feet Mahogany Table [sq., b&c feet]*	2..10..8	19..0..0; D 41
74	04 01 1763	**Jacob Fowle**	*1 3 1/2 foot Table [sq., b&c feet, mahogany]*	2..10..8	19..0..0
75	08 00 1763	**Jeremiah Newhall**	*4 foot Table 42/8 [sq., pad feet, walnut]*	2..2..8	AB; for his new house built in 1763
76	08 00 1763	**Thorndike Procter**	*Walnut Table 3 1/2 feet @ 12/ [round, pad feet]*	2..2..0	AB
77	08 00 1763	**Daniel Cheever**	*Table 4 1/2 Foot long*	3..12..0	AB; outside price list
78	09 00 1763	**Joseph Hood**	*Wallnut Table d'd [delivered] J Teag [4', sq., pad feet]*	2..2..8	AB
79	09 01 1763	**Jacob Fowle**	*Wallnut Table 3 feet long*	1..16..0	AB; sq., b&c feet or round, pad feet
80	10 00 1763	**Jacob Fowle**	*do [table, 3', walnut]*	1..16..0	AB; sq., b&c feet or round, pad feet
81	03 00 1764	**Zacheus Colins [Collins]**	*4 foot Mehogany Table [round, pad feet]*	2..18..8	AB; D 73
82	06 00 1764	**Josiah Orne**	*2 Mehogany Tables*	4..5..4	AB; price charged was for a 4', round, pad foot, walnut table; C 43
83	06 00 1764	**Josiah Orne**	*Casing do [tables]*	0..5..?	AB; C 43
84	12 11 1764	**Ben'n Ober**	*7 feet of maple Tables @ 7/4*	2..11..4	AB; C 51
85	12 11 1764	**Ben'n Ober**	*Casing ditto [tables]*	0..6..8	AB; C 51
86	01 00 1765	**Josiah Gould**	*4 foot walnut Table 12/ p'r foot [round, pad feet]*	2..8..0	AB
87	02 00 1765	**Billings Bradish**	*Mehogany Table 4 foo long [5'x4', oval, pad feet]*	3..4..0	AB; D 7
88	03 00 1765	**Mssr Francis & Joseph Cabot**	*1 Mehogony Table 4 1/2 foot long [round, b&c feet]*	3..10..0	AB; prob. for their new office building at 299 Essex St., Salem
89	03 00 1765	**Elisha Flint**	*4 foot Wallnut Table [sq., pad feet]*	2..2..8	AB
90	04 10 1765	**Josiah Bachelder [Batchelder Jr.]**	*1 Mehogany 4 foot Table [round, b&c feet]*	3..2..8	AB; D 5
91	05 00 1765	**Ebenezer Putnam**	*His part for 4 desks & 3 Tables del'd [delivered] of bord y'e schooner---J Scalley mast'r*	16..13..4	AB; C 60
92	05 00 1765	**Bartelmy Putnam**	*2 Mahogany Tables @ 13/4 p foot*	4..0..0	AB
93	06 00 1765	**John Hodges**	*1 Mehogany Table 4 feet long @ 14.8 per [round, b&c feet]*	2..18..8	AB
94	06 00 1765	**John Hodges**	*1 ditto 3 feet long @ 14/8 [round, b&c feet, mahogany]*	2..4..0	AB; this form in price list @ 2..8..0
95	06 00 1765	**John Hodges**	*Carving 8 feet for ditto @ 1/ [tables]*	0..8..0	AB
96	08 00 1765	**John Warding [Wardin]**	*Mehogany Table 3 1/2 feet long @ 14/8 [round, pad feet]*	2..11..4	AB
97	08 26 1765	**Benjamin Pickman Esq.**	*13 foot of Maple Tables @ 6/8*	4..6..8	AB; C 65
98	08 26 1765	**Benjamin Pickman Esq.**	*2 cases for Do @ 5/4 [tables]*	0..10..8	AB; C 65
99	09 24 1765	**Nicholas Bartlet Marblehead [Bartlett]**	*14 foot of Tables @ 13/4/*	9..6..8	AB; C 67
100	09 24 1765	**Nicholas Bartlet Marblehead [Bartlett]**	*2 cases for ditto @ 8/ [tables]*	0..16..0	AB; C 67

Drop-Leaf Tables

	LEDGER DATE	CLIENT	LEDGER ENTRY	PRICE	NOTES
101	10 17 1765	**Benjamin Pickman Esq.**	*2 Mehagany Tables & casing @ 62/8*	6..5..4	AB; C 68
102	10 17 1765	**Ebenezer Putnam**	*Part for 2 Tables d'd [delivered] Cap'n Scalley*	2..5..4	AB; C 69
103	10 30 1765	**Joshua Foster of Marblehead**	*1 4 feet Table [round, b&c feet, mahogany]*	3..2..8	AB
104	11 00 1765	**Thomas Wood**	*2 Mahogany Tables @ 16/*	5..0..0	AB; prob. 3' 9", sq., pad feet, mahogany table
105	12 00 1765	**Benjamin Lovett**	*3 foot Mehogany Table [round, b&c feet]*	2..8..0	AB
106	00 00 1766	**John White of Marblehead**	*Mehogany Table*	3..0..0	AB; 4' 6", sq., pad feet or 5'x4', oval, pad feet
107	00 00 1766	**William Launder [Lander]**	*Wallnet Table taken from [illegible] Book [4 feet, sq., pad feet]*	2..2..8	AB
108	01 29 1766	**Sam'l Grant**	*1 3 1/2 foot Table [round, pad feet, mahogany]*	2..11..4	AB; C 76
109	05 02 1766	**Jossiah Bachelder [Batchelder Jr.]**	*1 5 foot Mahogany Table [round, pad feet]*	3..13..4	AB; C 81
110	05 02 1766	**Jossiah Bachelder [Batchelder Jr.]**	*1 Case for ditto [table, mahogany]*	0..8..0	AB; C 81
111	06 00 1766	**Thomas Stimson**	*1 4 foot Table [5'x4', oval, pad feet, mahogany]*	3..0..0	AB; D 100
112	06 00 1766	**Sam'l Field**	*1 Mahogany Table [3 1/2', sq., pad feet]*	2..6..8	AB
113	08 09 1766	**Benj'n Molton [Moulton]**	*1 4 foot Table [sq., pad feet, walnut]*	2..2..8	AB
114	08 14 1766	**George Dodge**	*3 1/2 foot Cheretree Table [cherry]*	1..17..4	AB; C 87
115	09 05 1766	**George Dodge**	*3 foot Cheretree do [table, cherry]*	1..12..0	AB; shipped in 3 cases; C 87
116	11 00 1766	**Mrs Higingson [Higginson]**	*2 3 1/2 foot ditto @ 13/4 p'r foot [sq., pad feet, mahogany]*	4..13..4	AB; D 59
117	11 00 1766	**Timothy Pickering**	*1 4 1/2 feet long Table [sq., pad feet, mahogany]*	3..0..0	AB; D 24
118	11 00 1766	**Timothy Pickering**	*1 3 1/2 foot do [table, sq., pad feet, mahogany]*	2..6..8	AB; D 24
119	01 02 1767	**John Fisher, Esq.**	*1 Table 3 1/2 feet long 56/8*	2..16..8	AB; outside price list
120	01 17 1767	**Thomas Colyer 2'd [Collier]**	*2 Mehogany Tables 7 foot @ 14/8 p'r fot [3' & 4', round, pad feet]*	5..2..8	AB; D 18
121	03 03 1767	**Benjamin Nurse**	*Black Wallnut Table d'd [delivered] Jo'h Medcalf [3', round, b&c feet]*	2..0..0	AB
122	03 25 1767	**Benjamin Coats [Coates]**	*Mehgany Table [4', sq., b&c feet]*	2..17..4	AB
123	05 00 1767	**William Nichols**	*four foot Table 60/ [5'x4' oval, pad feet, mahogany]*	3..0..0	AB
124	06 17 1767	**Samuel Masury**	*2 Mehogany Tables 3 1/2 foot long [sq., pad feet]*	4..13..4	AB
125	10 00 1767	**John Apleton [Appleton]**	*1 Dineing Table 3 3/4 feet long [round, pad feet, mahogany]*	2..15..0	AB; D 1
126	11 00 1767	**John Archer Jr.**	*1 4 foot Table [5'x4', oval, pad feet, mahogany]*	3..0..0	AB
127	11 05 1767	**Josiah Orne**	*4 foot Table [5'x4' oval, pad feet, mahogany]*	3..0..0	AB; D 78
128	11 05 1767	**Josiah Orne**	*1 3 1/2 fot Table 51/4 d [round, pad feet, mahogany]*	2..11..4	AB; D 78
129	01 14 1768	**Gamabiel Hodges**	*4 fot Mahogany Table @ 14/8 [@] 58/8 [round, pad feet]*	2..18..8	D 109
130	01 14 1768	**Gamabiel Hodges**	*3 fot do @ do [table, 14/8, round, pad feet, mahogany]*	2..4..0	D 109
131	05 07 1768	**Benjamin Coates**	*3 1/2 Foot Table with carv'd feet 50/8 [sq., mahogany]*	2..10..8	
132	07 07 1768	**Charles Warrin [Worthen]**	*2 Mahogany Tables @ 4 foot long @ 14/8 [round, pad feet]*	5..17..4	C 118
133	07 07 1768	**Charles Warrin [Worthen]**	*1 Case for ditto [table]*	0..6..8	C 118
134	08 01 1768	**Rebeca Orne**	*4 Mehogany Tables containng 13 1/2 foot @ 13/4*	9..0..0	D 16
135	09 16 1768	**Louis Tucker**	*4 foot Wal't Table [sq., pad feet, walnut]*	2..2..8	
136	09 16 1768	**Ms Eliz Lee**	*4 foot Table Mehogany [sq., pad feet]*	2..13..4	
137	09 16 1768	**W'm Launder Jr [Lander]**	*4 foot Mehogany Table w/ carv'd feet [sq.]*	2..17..4	D 55
138	11 11 1768	**Step'n Higgenson [Higginson]**	*Mahogony 3 1/2 foot Table 46/8 [sq., pad feet]*	2..6..8	
139	11 11 1768	**Geo Parrot**	*1 Mahog'y do 46/8 [table, 3 1/2 feet, sq., pad feet]*	2..6..8	
140	11 30 1768	**Jon'h Very**	*4 foot Meh'g Table with carved feet [sq., mahogany]*	2..17..4	D 20
141	12 10 1768	**Jn'o Turner Esq.**	*4 foot Mah'y Table £22 old tenor squair [mahogany]*	2..18..8	22..0..0; price for a round table
142	12 30 1768	**Sam'l Grant**	*Mahog'y Table & cases for Adventure*	4..0..0	C 131
143	00 00 1769	**Edmund Needham**	*4 foot Mehogany Table squair*	2..18..8	AB; price of a round table
144	02 18 1769	**Isaic Neadham [Needham Jr.]**	*1 Mehogany Table 58/8 [4', round, pad feet]*	2..18..8	AB; D 66
145	02 23 1769	**Francis Grant**	*4 foot Table [mahogany]*	2..18..8	AB; price listed as 2..11..6 in AB, 02/1770
146	04 07 1769	**Jn'o Maskeran [Mascareen Esq.]**	*3 foot Table Mehogany [sq., pad feet]*	2..0..0	
147	08 12 1769	**Amos Flint**	*3 1/2 foot Mapple Table*	1..0..0	
148	09 00 1769	**Benj'n Clough**	*Walnut Table 40/ [3', round, b&c feet]*	2..0..0	AB
149	10 00 1769	**Josiah Bacheldor [Batchelder]**	*1 4 1/4 foot Table*	2..17..10	C 146
150	10 00 1769	**Josiah Bacheldor [Batchelder]**	*Casing*	0..4..8	C 146

Drop-Leaf Tables

	LEDGER DATE	CLIENT	LEDGER ENTRY	PRICE	NOTES
151	10 21 1769	Josiah Bacheldor [Batchelder]	2 Tables 4 1/4 foot each @ 13/4 pr foot	6..3..6 1/2	Prob. sq., mahogany; C 144
152	10 21 1769	Josiah Bacheldor [Batchelder]	casing @ 8/ De'd [delivered] Nathan Leach		AB; C 144
153	11 00 1769	Jn'o Turner, Esq.	2 Mehagany Tables 7 3/4 @ 13/4	5..2..4	No combination of 2 tables @ 13/4 per ft gives a total of 5..2..4; D 36
154	01 11 1770	Joseph Lee [Esq. of Beverly]	2 3 1/2 foot ditto @ 13/4 pr foot [tables, sq., pad feet, mahogany]	4..13..4	D 57
155	01 17 1770	Charles Worthen	2 Mehogany Tables 4 1/4 foot each @ 13/4 p foot	5..13..4	C 147
156	01 17 1770	Charles Worthen	Carving the feet @ 1/	0..8..0	C 147
157	01 22 1770	Robert Foster	2 3/4 foot Table @ 13/4 per foot [sq., pad feet, mahogany]	1..16..8	Duplicate entries in AB
158	01 22 1770	Benjamin Blythe [Blyth]	4 1/2 feet Table @ 13/4 [sq., pad feet, mahogany]	3..0..0	
159	02 26 1770	Isarael Dodge	Mahogany 4 foot Table [round, pad feet]	2..18..8	C 147
160	02 26 1770	Isarael Dodge	Casing 2 Tables	0..6..0	AB; C 147
161	03 00 1770	David Bickford jun [Beckford]	4 foot Mehagany Table [5'x4', oval, pad feet]	3..0..0	
162	06 30 1770	Charles Worthen	19 feet of Mehogony Tables @ 13/4	12..13..4	C 149
163	08 24 1770	Clark Gat'n Pickman	2 4 foot Tables @ 13/4 per foot [sq., pad feet, mahogany]	5..6..8	D 86
164	08 24 1770	Clark Gat'n Pickman	1 3 foot Ditto [table, prob. sq., pad feet, mahogany]	2..0..0	D 86
165	09 27 1770	Josiah Batchelder	2 Mehogany Tables 4 foot each @ 13/4/p foot [sq., pad feet]	5..6..8	C 152
166	09 27 1770	Josiah Batchelder	Casing	0..4..0	C 152
167	10 24 1770	Robert H Ives	3 1/2 feet Table @ 13/4 per feet [sq., pad feet, mahogany]	2..6..8	
168	11 00 1770	Henry Williams	2 3 1/2 foot Table [round, pad feet, mahogany]	5..2..8	AB; D 115
169	12 01 1770	Verin Blyth	4 foot Table Mehogany [5'x4', oval, pad feet]	3..0..0	
170	12 21 1770	Ichabod Glover	3 1/2 foot Table with claw feet 46/8 [walnut]	2..6..8	4', b&c feet, walnut or 3 1/2', pad feet, mahogany
171	12 21 1770	Charles Worthen	for 2 Mehogany Tables 8 foot @ 13/4 [sq., pad feet]	5..6..8	
172	12 22 1770	Biling Bradish	1 3 1/2 feet do with carv'd feet [table, walnut]	2..6..8	Either mispriced round, b&c feet, walnut or sq., pad feet, mahogany
173	04 06 1771	Aron Wait [Waite]	1 4 foot Mehogany Table [5'x4', oval, pad feet]	3..0..0	
174	04 27 1771	Jn'o Allcock	3 1/2 foot Mehogany Table [sq., pad feet]	2..6..8	
175	05 00 1771	Charles Worthen	Cheretree Table 3 1/2 foot @ 8/p foot [cherry]	1..8..0	C 158
176	05 03 1771	Nath'l Sparhawk, Jr	1 3 1/2 foot Table [sq., pad feet, mahogany]	2..6..8	
177	05 03 1771	Roland Savage	2 3 Foot Tables @ 42/	4..0..0*	Price listed as @ 40/ in AB; carved feet, walnut, or pad feet, mahogany
178	08 01 1771	Gideon Foster jn'r of Danvers	1 4 foot Table 53/4 [sq., pad feet, mahogany]	2..13..4	D 33
179	08 01 1771	Elizabeth Bell	1 4 foot Table [sq., pad feet, mahogany]	2..13..4	
180	10 08 1771	Elias Haskett Derby	1 Mehogany Table 4 foot 9 inch @ 14/8'd per foot	3..9..9*	
181	10 11 1771	Jon'n Frothingham	4 foot Table round [mahogany]	2..13..4	Price of a 4' sq. table
182	10 12 1771	Jos Phillips Goodwin	4 foot Table [5'x4', oval, pad feet, mahogany]	3..0..0	
183	01 03 1772	W'm Pinchon [Pynchon]	4 foot Mahogany Table @ 53/4 [sq., pad feet, mahogany]	2..13..4	D 79
184	03 00 1772	Israel Dodge	2 four foot Tables & casing [sq., b&c feet, mahogany]	5..14..8	AB; C 172
185	04 00 1772	Nathan Leach	1 Mahogony Table 4 foot 4 inches long @ 13/4	2..18..10	C 173
186	04 00 1772	Nathan Leach	1 Do 4 foot @ 13/4 [table, mahogany]	2..12..4	C 173
187	04 01 1772	Sam'l Grant	1 4 foot Table [sq., pad feet, mahogany]	2..13..4	
188	04 01 1772	Sam'l Grant	1 3 1/2 do [table, sq., pad feet, mahogany]	2..6..8	
189	05 04 1772	George Peale [Peele]	Mehogany 4 foot Table [sq., pad feet]	2..13..4	
190	05 19 1772	Josiah Bachelder [Batchelder Jr.]	4 foot Table [sq., pad feet, mahogany]	2..13..4	
191	06 00 1772	Daniel Jacobs Jr.	2 Mehogany Tables @ 56/8	5..13..4	C 179
192	06 00 1772	Daniel Jacobs Jr.	Casing	0..6..8	C 179
193	07 28 1772	Josiah Bacheldor Jn'r [Batchelder]	2 Tables 4 feet 8 2/3 ft @ 13/4	5..15..6	C 178
194	08 20 1772	Jer'h Lee [Esq.]	2 Mehog'y 4 foot Tables [sq., pad feet]	5..6..8	D 58
195	10 10 1772	George Dublois [Deblois]	4 1/2 foot Tables @ 60/0 per [sq., pad feet, mahogany]	6..0..0	
196	11 06 1772	Ichabod Glover	3 1/2 feet Table claw feet	2..6..8	AB; 3 1/2', pad feet, mahogany or 4', b&c feet, walnut
197	02 07 1773	Josiah Bacheldor [Batchelder]	2 4 foot Tables @ 53/4 13/4 pr feet [sq, pad feet]	5..6..8	C 186
198	03 12 1773	Jonathon Tucker	1 Mehogany 4 foot Table @ 13/4 per foot [sq., pad feet]	2..13..4	
199	05 00 1773	George Dodge	2 Mehogany 4 foot Tables @ 13/4 [sq., pad feet]	5..6..8	D 12
200	05 00 1773	George Dodge	1 do 3 1/2 Do Do @ 13/4 [table, 3 1/2', sq., pad feet, mahogany]	2..6..8	D 12

Drop-Leaf Tables

	LEDGER DATE	CLIENT	LEDGER ENTRY	PRICE	NOTES
201	05 01 1773	**Daniel Adams**	*2 3 1/2 foot Tables & Casing [sq., pad feet, mahogany]*	5..0..0	Casing accounts for extra charge; C 190
202	05 08 1773	**Sam'l Ingersoll**	*3 1/2 foot Table [sq., pad feet, mahogany]*	2..6..8	
203	06 04 1773	**Thomas Barnard Jun.**	*2 4 feet Tables [sq., pad feet, mahogany]*	5..6..8	D 4
204	06 04 1773	**Thomas Barnard Jun.**	*3 foot Table 40/*	2..0..0	Round, b&c feet, walnut or sq., pad feet, mahogany; D 4
205	06 09 1773	**Joseph Hilyard [Hilliard]**	*4 1/2 foot Table [prob. 5'x4 1/2', mahogany]*	3..6..8	
206	06 26 1773	**Tho's Roxwaiter**	*Table £2..6..8*	2..6..8	3' 6", sq., pad feet, mahogany or 4' sq., b&c feet, walnut
207	07 17 1773	**Nathan Leech [Leach]**	*4 foot Table [sq., pad feet, mahogany]*	2..13..4	
208	07 20 1773	**Rich'd Routh**	*1 4 foot Table [sq., pad feet, mahogany]*	2..13..4	
209	09 10 1773	**Nathan Leach [Leach]**	*5 feet Table Mehogany*	4..0..0	
210	10 07 1773	**William Paine**	*2 Tables 4 feet Long @ 13/4 [sq., pad feet, mahogany]*	5..6..8	Shipped in cases; D 81
211	10 07 1773	**William Paine**	*1 Do 3 1/2 Do Do @ 13/4 [table, sq., pad feet, mahogany]*	2..6..8	Shipped in cases; D 81
212	11 03 1773	**Bar'w Putnam**	*2 4 foot Tables @ 53/4 @ 2/8 pr foot [mahogany]*	5..6..8	Unit price of 53/4 is incorrect, total price is correct; C 193
213	11 03 1773	**Bar'w Putnam**	*1 Stand Table & casing 3 1/2 foot do [sq. pad feet, mahogany]*	2..6..8	C 193
214	11 03 1773	**Bar'w Putnam**	*2 cases for do [tables]*	0..8..0	C 193
215	01 11 1774	**Mr Nath'l Webb of Danvers**	*Cheretree Table 2 Tables 65/6 [cherry]*	3..5..6	
216	03 26 1774	**George Cabot**	*2-4 feet Do @ 53/4 [table, sq., pad feet, mahogany]*	5..6..8	D 14
217	03 26 1774	**George Cabot**	*Cheretree do 10/ [table, cherry]*	0..10..0	D 14
218	03 29 1774	**Joseph Southwick**	*4 feet Wall't Table De'd [delivered] his Son Fry [walnut]*	2..2..8*	Price in AB corrected, was 2..8..8; D 35
219	04 01 1774	**Ichabod Nichols**	*4 feet Tables 53/4 [sq., pad feet, mahogany]*	2..13..4	D 68
220	05 27 1774	**Caleb Foster**	*4 feet Table @ 53/4 [sq., pad feet, mahogany]*	2..13..4	
221	07 06 1774	**Francis Cabot**	*2 Dining Tables 4 feet each [sq., pad feet, mahogany]*	5..6..8	D 60
222	07 06 1774	**Francis Cabot**	*Casing of case draws & Tables*	1..0..0	D 60
223	10 01 1774	**Nehemiah Buffinton [Buffington]**	*1 Mehogany Table [4 feet, sq., pad feet]*	2..13..4	D 11
224	10 05 1774	**Edmund Whitemore Jun**	*3 1/2 feet Table [sq., pad feet, mahogany]*	2..6..8	Partially paid by working for Gould for 18 days @ 4/8 per day; D 112
225	12 02 1774	**Sylveter Gardnor Esq. [Gardiner]**	*Tables 5 feet by 4 feet @ 60/ [5'x4', oval, pad feet, mahogany]*	6..0..0	
226	12 02 1774	**Jonathon Symonds [III]**	*1 3 1/2 foot Table 46/8 [sq., pad feet, mahogany]*	2..6..8	D 102
227	12 02 1774	**Jonathon Symonds [III]**	*1 4 foot do @ 53/4 [table, sq., pad feet, mahogany]*	2..13..4	D 102
228	12 22 1774	**Sam'l Luscomb, Jr**	*4 feet Mh'y Table [sq., pad feet, mahogany]*	2..13..4	
229	12 24 1774	**Peter Frye esq.**	*2 4 foot Meh Tables @ 53/4 [mahogany]*	5..6..8	D 76
230	02 03 1775	**Jonathon Symonds [III]**	*1 4 feet Table del'd [delivered] his brother Ben'n Symonds [round, pad feet, walnut]*	2..8..0	D 101
231	02 04 1775	**Jeremiah Page**	*4 feet Table 53/4 [sq., pad feet, mahogany]*	2..13..4	D 90
232	04 09 1775	**Jeremiah Lee [Esq.]**	*4 foot Table [sq., pad feet, mahogany]*	2..13..4	D 103
233	04 09 1775	**Jeremiah Lee [Esq.]**	*1 4 foot Table [sq., pad feet, mahogany]*	2..13..4	D 103
234	06 24 1775	**Jon'n Payson**	*1 4 1/2 foot Table [sq., pad feet, mahogany]*	3..0..0	
235	06 24 1775	**Jon'n Payson**	*1 3 feet Table [prob. sq., pad feet, mahogany]*	2..0..0	
236	07 17 1775	**Jon'n Payson**	*4 cases for goods dl'd [delivered] in May*	1..4..0	
237	12 01 1775	**Jn'o Jenkins, Taylor**	*1 4 foot Table 53/4 [sq., pad feet, mahogany]*	2..13..4	D 52
238	03 01 1776	**Jonathon Nichols**	*4 foot Table [sq., pad feet, mahogany]*	2..13..4	
239	07 01 1776	**Isaac White**	*1 4 feet Table [sq., pad feet, mahogany]*	2..13..4	Duplicate entries in AB; D 112
240	08 14 1776	**Jn'o John Hodges**	*4 foot Table [sq., pad feet, mahogany]*	2..13..4	
241	11 25 1776	**John Jinks [Jenks]**	*1 3 1/4 foot Table Claw feet*	2..9..4	Outside price list; D 53
242	12 31 1776	**Josiah Bacheller [Batchelder Jr.]**	*2 Tables 4', 4 in each @ 16/*	NOT PRICED	
243	01 01 1777	**Isac White**	*4 feet Table*	2..13..4	4..0..0; duplicate entries in AB
244	03 15 1777	**Nathan Nickals [Nichols]**	*1 Mehog'y Table 4 feet*	3..4..0	3..4..0; D 69
245	04 05 1777	**Andrew Cabot**	*1 4 foot Table*	3..4..0	3..4..0
246	05 01 1777	**Joshua Dogue [Dodge]**	*2 Tables 4 feet @ 18 p'r foot*	7..4..0	D 25
247	06 01 1777	**Josiah Bacheldor [Batchelder Jr.]**	*2 Tables 4 feet 4 inches*	NOT PRICED	Poss. duplicate of 1776 entry
248	06 01 1777	**W'm Pickman**	*3 1/2 foot Table*	2..6..8	3..10..0

	LEDGER DATE	CLIENT	LEDGER ENTRY	PRICE	NOTES
249	07 23 1777	**Isaac White**	*3 1/2 feet Table*	2..6..8	3..10..0; duplicate entries in AB
250	07 31 1777	**Daniel Hopkins**	*Small Mehog'y Table 48/*	2..8..0	Duplicate entries in AB
251	08 01 1777	**Nathan Nickals [Nichols]**	*1 3 foot Table*	3..0..0	
252	09 23 1777	**Jn'n Lee Esq.'r**	*2 4 1/2 feet Tables @ 6£*	12..0..0	D 77
253	10 01 1777	**Ichabod Glover**	*1 4 foot Table D' [delivered] @ Benj'n Bacon Jr*	3..0..0	Listed in AB 09/1776
254	10 01 1777	**Ichabod Glover**	*1 4 foot do [table]*	6..0..0	
255	10 24 1777	**Israel Thorndike**	*1 4 foot do [table]*	6..0..0	
256	11 07 1777	**Edmund Putnam**	*1 4 foot Table*	$20?	D 29
257	01 10 1778	**John Novice [Norris]**	*1 Table*	12..0..0	D 71
258	02 04 1778	**Ben'n Goodhue [Jr.]**	*2 4 fet Tables*	24..0..0	D 38
259	04 23 1778	**John Hartwell**	*1 4 foot Table*	NOT PRICED	Order not itemized, total was 70..0..0
260	08 03 1778	**Ichabod Glover**	*1 4 feet Table*	3..0..0	20..0..0
261	09 22 1778	**Paul D Serjant [Sargent]**	*1 Table 5 feet long*	25..0..0	
262	09 22 1778	**Paul D Serjant [Sargent]**	*1 do 3 1/2 do do by 5 do wide [table, 3 1/2' x 5']*	20..0..0	
263	10 08 1778	**Mrs White**	*4 feet Table*	20..0..0	
264	11 09 1778	**W'm Seaford**	*Table*	18..0..0	
265	12 01 1778	**Ben'j Lander**	*4 feet Table*	6..10..0	22..10..0; D 54
266	02 25 1779	**W'm Brewer**	*1 4 Feet Table*	2..13..4	
267	07 24 1779	**Benjamin Deland [Daland]**	*4 Foot Table*	4..0..0	D 27
268	11 00 1779	**Peter Sm'otherst [Smothers]**	*1 4 Feet Table*	6..0..0	D 96
269	01 27 1780	**Francis Cabot jn'r**	*4 foot Tables @ 53/4*	5..6..8	AB; D 13
270	04 06 1780	**Francis Cook**	*1 4 foot Table 60/*	3..0..0	
271	08 01 1780	**Henry Brown**	*1 4 foot Table*	400..0..0	D 10
272	08 22 1780	**Joseph McComb**	*1 4 feet Table 6£*	6..0..0	
273	10 02 1780	**Jerathmail Peirce**	*3 feet Table*	4..16..0	
274	11 00 1780	**W'm Pickering**	*1 4 fot Table*	400..0..0	D 84
275	11 00 1780	**Lidia Gowen**	*1 4 foot Table*	NOT PRICED	D 21
276	01 04 1781	**Jonathon Gavet [Gavett]**	*1 4 fot Table [mahogany]*	3..0..0	
277	02 24 1781	**Jn'o Cook Jun'r**	*1 4 foot Sq Table*	450..0..0	D 19
278	03 00 1781	**Jn'o Brooks**	*1 Table 400£*	400..0..0	AB; D 9
279	03 00 1781	**Jn'o Brooks**	*1 do 300£ [table]*	300	D 9
280	03 03 1781	**Sam'l Nichols**	*1 4 feet Table [mahogany]*	6..0..0	400; AB; D 70
281	03 21 1781	**Adison Richardson**	*1 4 foot Mehog'y Table*	2..13..4	Paid for by Richardson's apprentice working on his house
282	04 00 1781	**Benjamin Launder [Lander]**	*1 4 feet Table 450£*	450	
283	05 00 1781	**John Flint**	*1 4 Table [4' mahogany]*	NOT PRICED	
284	05 05 1781	**Thomas Smith**	*1 Table £5-6-8*	5..6..8	
285	05 16 1781	**Barth'w Putnam**	*1 4 feet Table*	NOT PRICED	D 82
286	06 08 1781	**Jno Jinks [Jenks]**	*3 1/2 feet Table*	NOT PRICED	
287	06 23 1781	**David Ashby**	*1 4 foot Table claw feet*	6..0..0	D 2
288	10 00 1781	**Jerathmeal Pierce**	*1 3 feet Table*	4..16..0	AB
289	11 12 1781	**Henry Gardner**	*1 4 feet do [table]*	NOT PRICED	
290	11 12 1781	**Henry Gardner**	*1 2 feet 10 inch do [table]*	NOT PRICED	Ordered after his return from exile
291	11 22 1781	**Mary Winning [Vinning]**	*1 4 feet Table*	NOT PRICED	
292	12 05 1781	**W'm Brown**	*1 3 1/2 feet Table*	5..6..8	
293	12 05 1781	**Ichabod Glover**	*1 3 1/2 feet Table*	2..6..8	
294	01 00 1782	**Theo Bachelor [Bacheller]**	*4 foot Table*	NOT PRICED	
295	02 07 1782	**Josiah Austin**	*1 4 feet Table [mahogany]*	5..8..0	AB
296	04 00 1782	**James Wood Gould**	*1 4 feet Table*	3..0..0	5..6..8; D 40
297	07 19 1782	**Jacob Clarke**	*1 4 feet Table*	5..8..0	
298	10 15 1782	**Jn'o Frothingham**	*1 4 feet Table £6*	6..0..0	
299	05 23 1783	**Israel Huchinson [Hutchinson]**	*a foure feet Table*	3..0..0	AB
300	03 00 1784	**James Wood Gould**	*2 Tables & Casing*	5..14..0	

Miscellaneous Tables

	LEDGER DATE	CLIENT	LEDGER ENTRY	PRICE	NOTES
1	07 12 1758	John Gardner jr	*Kitching Table*	0..14..6	5..10..0
2	08 13 1758	John Leach Jr.	*a small Table*	1..4..0	9..0..0; D 56
3	11 07 1758	Thomas Elkins	*a Squair Chere dito [table, cherry]*	0..13..4	5..0..0; D 28
4	06 04 1759	John Tasker [Esq.]	*a frame for a Larg Square Table*	2..0..0	15..0..0; D 34
5	07 23 1759	John Gardnor Jr. [Gardner]	*a Kitching Colard Table [colored kitchen]*	0..14..6	5..10..0; duplicate entries in DB
6	11 26 1759	Anto'y Lab'm Reyke	*1 Maple Table*	1..5..8	9..12..6; C 9
7	01 10 1760	Benjamin Feltt [Felt]	*1 Maple Table*	0..9..4	3..10..0
8	01 23 1760	John Gardnor jn'r. [Gardner]	*1 Maple Table*	1..1..4	8..0..0; C 14
9	04 01 1760	Ben'n Felt	*a small Table*	1..0..0	7..10..0; price corrected in AB, was 1..4..1
10	04 24 1760	Jacob Fowle	*1 small Table*	1..6..8	10..0..0
11	07 02 1760	Mary Hix [Hicks]	*1 small mahogany Table*	1..13..4	12..10..0
12	07 02 1760	Mary Hix [Hicks]	*1 side dito [table]*	0..17..4	6..10..0; categorized as "Misc." due to price, most likely a small table
13	11 00 1760	Jn'o Fisher	*1 slabb frame dl'd [delivered] May*	1..16..0	
14	12 12 1760	William Pickering	*a small Table del'd [delivered] his wife*	0..7..4	2..15..0
15	12 23 1760	John Pickering	*small Table delivered his mother*	0..7..4	AB
16	04 00 1761	Ebenezer Bickford [Beckford]	*2 Tables 56/ [prob. 2'9", round, pad ft., walnut]*	2..16..0	
17	04 03 1761	Jon'n Cook	*6 Maple Tables @ 50/*	2..0..0	15..0..0; C 20
18	01 26 1762	John Gardnor Jn'r [Gardner]	*3 Maple Tables*	3..9..4	26..0..0; C 25
19	06 00 1762	John Bery [Berry]	*1 Kichen Table*	0..13..4	5..0..0
20	10 00 1762	Amos Purington	*1 small Table*	0..8..0	3..0..0
21	11 00 1762	Stephan Ozbon [Osborn]	*3 small Tables @ 55/*	1..2..0	8..5..0
22	01 25 1763	Sam'l Grant	*1 Twylight Table [toilet]*	0..4..0	D 41
23	01 25 1763	Sam'l Grant	*1 Breakfast ditto [table]*	0..7..4	2..15..0; D 41
24	10 00 1763	Thomas Poynton	*1 Cabin Table*	1..4..0	AB
25	12 05 1763	John Prince	*1 small Table*	0..3..0	AB
26	08 26 1765	Benjamin Pickman Esq	*13 foot of Maple Tables @ 6/8*	4..6..8	AB; C 63
27	11 00 1765	Stephen Cook	*1 Chere ditto [table, cherry]*	1..8..0	AB
28	07 00 1766	Simon Broadstreet [Bradstreet]	*1 Pine ditto [table] 6/*	0..6..0	AB
29	08 01 1766	Josiah Orne	*Cabin Table*	1..0..0	
30	08 09 1766	Benj'n Molton [Moulton]	*1 Maple Table*	0..8..0	AB
31	11 00 1766	Mrs Higingson [Higginson]	*1 small squair Table*	1..16..0	AB; shipped in cases; D 59
32	10 00 1767	John Apleton [Appleton]	*1 Toy light 4/8 [toilet]*	0..4..0	AB; D 1
33	10 00 1767	John Apleton [Appleton]	*1 Kitcheon Table 12*	0..12..0	AB; D 1
34	11 05 1767	Josiah Orne	*1 Toy light Table 4/8 [toilet]*	0..4..8	AB; D 78
35	12 00 1767	Josiah Orne	*Kitchen Table*	1..3..4	AB; D 78
36	01 21 1768	Amos Flint	*Maple Table @ 23/4*	1..3..4	D 47
37	01 28 1768	Joseph Dowse, Esq	*Toylight Table 6/ [toilet]*	0..6..0	
38	08 09 1768	Jonathan Johnson	*1 Maple Table d'ed [delivered] Orne*	1..3..4	
39	11 11 1768	Step'n Higgenson [Higginson]	*Cheretre ditto 32/8 [table, cherry]*	1..12..8	
40	11 11 1768	Geo Parrot	*1 Maple Table 23/4*	1..3..4	
41	05 16 1769	Jeremiah Newhall	*small Table 6/8*	0..6..8	
42	05 18 1769	Charles Worthen	*small Table*	0..12..0*	Price incorrect in DB, was 0..13..4
43	08 00 1769	Amos Purington	*1 small Table took from day book*	0..8..0	AB
44	09 00 1769	Benj'n Clough	*Cheretree Do 12/ [table, cherry]*	0..12..0	AB
45	01 11 1770	Joseph Lee [of Beverly]	*1 Pine Table*	0..13..4	D 57
46	01 11 1770	Joseph Lee [of Beverly]	*1 Maple do 8/ [table]*	0..8..0	D 57
47	02 03 1770	Jonathan Haridon [Harraden]	*Kitchen Table*	0..12..0	
48	07 05 1770	James Bar [Barr]	*1 Cheretree Table [cherry]*	1..12..8*	Price incorrect in DB, was 1..12..0
49	08 18 1770	Rob't Allcock	*Cabin Table*	1..4..0	
50	08 24 1770	Clark Gat'n Pickman	*1 Chere Do [table, cherry]*	0..8..0	D 86
51	08 24 1770	Clark Gat'n Pickman	*1 Pine Table*	0..12..0	D 86
52	08 29 1770	Roland Savage	*Cheretree Table [cherry]*	1..4..0	
53	11 00 1770	Henry Williams	*1 Kitchen Table*	0..12..0	D 115

	LEDGER DATE	CLIENT	LEDGER ENTRY	PRICE	NOTES
54	11 01 1770	**Bart'w Putnam**	*Cabin Table*	1..6..8	
55	06 00 1771	**Charles Worthen**	*Making 2 3 1/2 foot Tables [Maple] @ 23/*	2..6..0	
56	10 12 1771	**Edmund Neadham [Needham]**	*Cabin Table 16/*	0..16..0	
57	01 00 1772	**W'm Pinchon [Pynchon]**	*Toylight Table 8/ [toilet]*	0..8..0	0..6..0; D 79
58	10 10 1772	**George Dublois [Deblois]**	*2 Toylet do @ 8/ [toilet table]*	0..16..0	
59	10 10 1772	**George Dublois [Deblois]**	*Kitchen Table*	0..16..0	
60	10 10 1772	**Ichabod Glover**	*Breakfast Table*	0..12..0	Poss. for new house built in Salem in 1772
61	11 20 1772	**Joseph Cabot**	*Wall't Cabin Table [walnut]*	2..8..0	
62	02 20 1773	**Abner Chase**	*Table*	0..14..0	
63	03 06 1773	**Jn'o Gooll**	*Large Riting Table [writing]*	1..10..0	AB
64	05 08 1773	**Sam'l Ingersoll**	*1 Breakfast Table*	0..10..0	
65	06 04 1773	**Thomas Barnard Jun.**	*Pine Do 18/ [table]*	0..18..0	D 4
66	06 04 1773	**Thomas Barnard Jun.**	*Chere Do 11 [table, cherry]*	0..11..0	D 4
67	10 07 1773	**Sam'l Flagg**	*Slab frame*	1..16..0	
68	03 26 1774	**George Cabot**	*Toylet do 6/8 [toilet table]*	0..6..8	D 14
69	03 26 1774	**George Cabot**	*1 Pine Kichin Table 16/*	0..16..0	D 14
70	06 18 1774	**Tho's Gage**	*4 deal Tables @ 16/*	3..4..0	
71	07 06 1774	**Thomas Gage**	*1 Large Table and Form*	1..0..0	
72	07 06 1774	**Thomas Gage**	*2 small do @ 12/ [table]*	1..4..0	
73	07 06 1774	**Francis Cabot**	*1 Breakfast Table*	3..0..0	D 60
74	10 00 1774	**Nehemiah Buffinton [Buffington]**	*Breakfast Do [table]*	0..8..0	D 11
75	11 03 1774	**Peter Frye [Esq.]**	*Toylight Table [toilet]*	0..8..8	
76	12 02 1774	**Jonathon Symonds [III]**	*1 Birch do @ 10/ [table]*	0..10..0	D 102
77	12 10 1774	**William Bodin [Boden]**	*1 Cheretree Table [cherry]*	0..8..0	D 6
78	12 24 1774	**Peter Frye esq**	*1 Pine do [table]*	0..16..0	D 76
79	12 31 1774	**Peter Fry [Frye Esq.]**	*Chere'e t Do [table, cherry]*	0..12..0	D 76
80	12 00 1775	**Jn'o Jenkins, Taylor**	*Pine do 10/ [table]*	0..16..0	D 52
81	03 00 1776	**Jonathon Nichols**	*Maple do [table]*	0..10..8	
82	12 16 1776	**Ichabod Glover**	*Table 16/*	0..16..0	
83	01 28 1777	**Bart Putnam**	*Riting Table [writing]*	1..4..0	
84	03 15 1777	**Nathan Nickals [Nichols]**	*1 Breakfast do [table]*	1..0..0	D 69
85	04 05 1777	**Andrew Cabot**	*1 Breakfast Table with 2 drawers & leave*	3..6..8	
86	05 00 1777	**Ichabod Glover**	*Table*	0..18..0	
87	09 23 1777	**Jn'n Lee Esq'r**	*1 Breakfast Do 4.10/ [table]*	4..10..0	D 77
88	09 08 1778	**Joshua Dodge**	*Riting Table [writing]*	7..10..0	
89	11 18 1778	**Peter Lander**	*Toylight Table [toilet]*	3..0..0	
90	12 00 1778	**Charles Wilson**	*1 Table*	6..0..0	
91	01 27 1780	**Francis Cabot jn'r**	*1 Maple do [table]*	1..0..0	D 13
92	08 00 1780	**Henry Brown**	*Breakfast Table*	150..0..0	D 10
93	08 00 1780	**John Danielson [Donaldson]**	*1 small do brea't table 24/ [breakfast]*	1..10..0	AB; D 26
94	08 22 1780	**Joseph McComb**	*Breakfast small do [table] 24/*	1..4..0	
95	11 00 1780	**Lidia Gowen**	*1 small do [table]*	NOT PRICED	D 21
96	11 00 1780	**W'm Pickering**	*1 Breakfast do [table]*	150..0..0	D 84
97	03 03 1781	**Sam'l Nichols**	*1 small do 27/ [table]*	1..7..0	150; D 70
98	05 05 1781	**Thomas Smith**	*Square do 2£ [table]*	2..0..0	
99	05 16 1781	**Barth'w Putnam**	*small do [table]*	NOT PRICED	D 82
100	11 00 1781	**John Brooks**	*Maple kitchen Table 30/*	1..10..0	D 9
101	11 12 1781	**Henry Gardner**	*1 kitchen Table*	NOT PRICED	Ordered after his return from exile
102	11 12 1781	**Henry Gardner**	*1 small do [table]*	NOT PRICED	Ordered after his return from exile
103	02 00 1782	**Jonathon Ireland**	*1 Table*	0..16..0	
104	02 00 1782	**Jonathon Ireland**	*a Squair [table]*	0..8..0	
105	04 05 1782	**James Wood Gould**	*1 Breakfast Table*	0..18..0	D 40
106	06 07 1783	**Sam'l Bickford [Beckford]**	*1 Maple Table*	1..4..0	

Sideboard and Side Tables

	LEDGER DATE	CLIENT	LEDGER ENTRY	PRICE	NOTES
1	08 28 1761	Mrs Han'h Cabot	*1 Side Dito 40/ [table]*	2..0..0	15..0..0
2	01 00 1762	Mrs Hannah Cabot	*1 Side ditto 48/ [table]*	2..8..0	Listed as separate entries in AB but together in DB
3	02 07 1762	Dan'l Maikey [Mackey]	*a Side Table*	2..4..0	16..10..0
4	06 01 1762	Bez'l Toppen [Toppan]	*1 Side Table*	2..6..8	17..10..0; D 85
5	07 01 1762	Peter Fry [Frye Esq.]	*1 Side Table*	2..4..0	16..10..0
6	07 01 1762	Peter Fry [Frye Esq.]	*Carving ye feet of dito [side table]*	0..4..0	1..10..0
7	08 00 1763	John Higgenson Esq [Higginson]	*Side Table*	2..12..0*	AB; price corrected, was 2..8..0
8	09 00 1763	Richard Darby [Derby]	*1 Side Table [mahogany]*	2..8..0	AB; D 88
9	09 00 1763	Richard Darby [Derby]	*Do [side table, prob. walnut]*	1..4..0	AB; D 88
10	04 00 1764	Daniell Mackey	*Side Table 44/*	2..4..0	AB; poss. duplicate of 02/07/1762 order in AB
11	04 10 1764	John Gardner	*2 Meh'y Side Tables @ 42/8 [mahogany]*	[4..5..4]	AB
12	07 00 1764	Ahijah Estes	*1 Side Table with car'd [carved] feet*	2..12..0	AB; charged 1s for foot carving
13	07 00 1766	Simon Broadstreet [Bradstreet]	*Side Table*	1..8..0	AB
14	08 00 1767	Joseph Cabot	*1 Sideboard [table]*	2..8..0	AB
15	10 00 1767	John Apleton [Appleton]	*1 Sideboard*	2..4..0	AB; D 1
16	11 26 1768	Stephen Higenson [Higginson]	*Side Table 40*	2..0..0	
17	08 00 1769	John Higgenson [Higginson]	*Side Table*	2..12..0	AB
18	11 00 1769	Jn'o Turner, Esq	*Side Table*	[2..0..0]	AB; ordered with china tray, total was 3..16..0; D 36
19	11 04 1769	Edmond Neadham [Needham]	*1 Side Table*	2..0..0	
20	11 20 1769	Jn'o Turner, Esq	*Sideboard Table*	2..0..0	
21	11 20 1769	Jn'o Turner, Esq	*3 1/2 fot table dl'd [delivered] W'm Vans*	1..14..8	May be taking this table as credit against Turner's large order and delivering it to William Vans
22	08 24 1770	Clark Gat'n Pickman	*2 Sideboard ditto @ 48/ [tables]*	4..16..0	D 86
23	08 20 1772	Jer'h Lee [Esq.]	*Side Table*	2..8..0	D 58
24	10 07 1773	William Paine	*1 Side Do [table]*	2..0..0	D 81; shipped in cases
25	08 14 1776	Jn'o Hodges	*1 Side do [table]*	2..8..0	
26	11 23 1776	W'm Pickman	*Side board table 3 feet*	2..13..4	D 87
27	05 01 1777	Joshua Dogue [Dodge]	*Side Board Table*	3..8..8	D 25
28	09 23 1777	W'm West	*1 Side b'd do [board, table]*	4..16..0	Duplicate entries in AB; D 114
29	07 24 1779	Benjamin Deland [Daland]	*1 Side do [table]*	3..6..8	D 27
30	08 03 1779	Doc'r Spafford [Beverly]	*Sideboard table*	54..0..0	AB
31	11 11 1779	Nath'n Goodale	*Side Table £4-16*	4..16..0	AB
32	08 22 1780	Miles Greenwood	*1 Side Table*	4..10..0	AB
33	05 16 1781	Barth'w Putnam	*1 Side do [table]*	NOT PRICED	D 82
34	06 08 1781	Mehitable Lawless	*sad Table [side]*	3..12..0	
35	08 00 1782	Miles Greenwood	*1 Side Table*	4..10..0	AB

Stand Tables

	LEDGER DATE	CLIENT	LEDGER ENTRY	PRICE	NOTES
1	04 07 1757	William Lamson	*a Stand Table*	1..12..0	Price is unusual; entry in middle of DB
2	09 23 1758	Chr Brewer	*a Stand Table*	1..17..4	14..0..0; D 8
3	11 07 1758	Thomas Elkins	*a Stand Table [mahogany]*	2..0..0	15..0..0; D 28
4	03 22 1759	Stephen Higginson	*a Standtable [mahogany]*	2..0..0	15..0..0; D 34
5	04 23 1759	John Tasker [Esq]	*a Standtable [mahogany]*	2..0..0	15..0..0; D 34
6	06 04 1759	John Tasker [Esq]	*a Standtable [mahogany]*	2..0..0	15..0..0
7	08 01 1759	William Lamson	*1 Stand Table [mahogany]*	2..0..0	15..0..0
8	08 18 1759	Tabytha Skyner [Skinner]	*1 Stand Table [mahogany]*	2..0..0	15..0..0; D 37

	LEDGER DATE	CLIENT	LEDGER ENTRY	PRICE	NOTES
9	11 20 1759	**Jose'h Grafton**	*3 Stand Tables @ £10 @ 26/8*	4..0..0	30..0..0
10	07 23 1759	**Richard Stacy [Stacey]**	*1 Stand Dito [table, mahogany]*	2..0..0	15..0..0; D 98
11	09 24 1760	**Robert Millen**	*1 Stand dito [table, mahogany]*	2..0..0	15..0..0; D 64
12	01 08 1761	**John Growningsheld [Crowninshield Sr.]**	*1 Stand dito [table, mahogany]*	2..0..0	15..0..0; D 23
13	09 08 1761	**Mrs Han'h Cabot**	*1 Stand Table 48/ [mahogany]*	2..8..0	18..0..0
14	11 18 1761	**James Odel [Odell]**	*1 Standtable [mahogany]*	2..0..0	15..0..0; D 75
15	01 00 1762	**Mrs Hanah Cabot**	*Stand ditto 40/ [table, mahogany]*	2..0..0	These are separate entries in AB but together in DB
16	01 15 1762	**Hasket Darby [Derby]**	*Stand Table [mahogany]*	2..0..0	15..0..0; D 23
17	05 03 1762	**The widow Tasker**	*1 Stand dito £15 [table, mahogany]*	2..0..0	15..0..0; D 110
18	08 01 1762	**William Laundor [Lander]**	*Stand Table [mahogany]*	2..0..0	15..0..0
19	09 01 1762	**Richard Darby [Derby]**	*1 Stand Table [mahogany]*	2..8..0	18..0..0
20	01 25 1763	**William Laundor [Lander]**	*1 Standtable [mahogany]*	2..0..0	15..0..0
21	04 01 1763	**Jacob Fowle**	*1 Stand d'o [table, mahogany]*	2..8..0	18..0..0
22	09 00 1763	**Richard Darby [Derby]**	*1 Standtable [mahogany]*	2..4..0	AB; D 88
23	10 00 1763	**Billings Bradish**	*1 Standtable [mahogany]*	2..0..0	AB; for his new house built in 1764
24	06 16 1764	**Joseph Flint**	*Standtable [mahogany]*	2..0..0	AB
25	11 22 1764	**Mark Hu'n Wintworth of Ports'th New Ham'r [Wentworth]**	*1 Stand Ditto [table, mahogany]*	2..4..0	AB; D 31; delivered following year
26	01 00 1765	**Sam'l Curwin [Curwen Esq.]**	*1 Stand Table [mahogany]*	2..8..0	AB;
27	03 00 1765	**Elisha Flint**	*Stand ditto [table, walnut or cherry]*	1..8..0	AB;
28	06 00 1765	**Benjamin Pickman Esq**	*3 Standtables @ 40/ [mahogany]*	6..0..0	AB; C 58
29	06 09 1765	**John Scalley [Scollay]**	*2 Standtables @ 40/ [mahogany]*	4..0..0	AB;
30	00 00 1766	**Joseph Hopkins**	*Standtable [mahogany]*	2..0..0	AB;
31	00 00 1766	**Aron Wate [Waite]**	*Standtable [mahogany]*	2..0..0	AB; D 106
32	06 00 1766	**Thomas Stimson**	*1 Stand ditto 40/ [table, mahogany]*	2..0..0	AB; D 99
33	08 09 1766	**Jona'n Frothingham**	*1 Standtable [mahogany]*	2..0..0	AB
34	08 09 1766	**Benj'n Molton [Moulton]**	*1 Stand do wolln't [table, walnut]*	1..8..0	AB
35	09 00 1766	**Samuel West Jr**	*Standtable [mahogany]*	2..0..0	AB
36	11 00 1766	**William Launder [Lander]**	*2 Stand Tables @ 40/ [mahogany]*	4..0..0	AB
37	11 00 1766	**Timothy Pickering**	*Stand do [table, mahogany]*	2..0..0	AB; D 24
38	03 00 1767	**Joseph Hood**	*Standtable [mahogany]*	2..8..0	AB
39	03 00 1767	**Thomas Colyer 2'd [Collier II]**	*1 Standtable*	1..17..4	AB; D 18
40	03 00 1767	**William Nickals [Nichols]**	*Stand ditto 40/ [table, mahogany]*	2..0..0	AB
41	08 00 1767	**Samuel Blyth**	*Stand Table [mahogany]*	2..0..0	AB
42	10 00 1767	**John Apleton [Appleton]**	*1 Standtable [mahogany]*	2..0..0	AB; D 1
43	11 05 1767	**Josiah Orne**	*1 Stand ditto 40/ [table, mahogany]*	2..0..0	AB; D 78
44	03 00 1768	**Cap' Skilen [Skillin]**	*Stand Table 20/ [mahogany]*	2..0..0	AB
45	07 25 1768	**M'r Savage**	*Stand Table [mahogany]*	2..0..0	AB
46	08 01 1768	**Rebeca Orne**	*1 ditto Stand Table [mahogany]*	2..0..0	AB; D 16
47	09 03 1768	**Joseph Churchwel [Churchill]**	*Stand Table [mahogany]*	2..0..0	
48	11 26 1768	**Josiah Gould**	*1 Stand Table of cher'e [cherry]*	1..8..0	
49	02 18 1769	**Isaic Neadham [Needham Jr.]**	*1 Stand do 40/ [table, mahogany]*	2..0..0	D 66
50	02 23 1769	**Jonathon Weib [Webb]**	*1 Stand Table [mahogany]*	2..8..0	
51	06 14 1769	**James Bott**	*Stand Table [mahogany]*	2..3..0	Duplicate entries in AB
52	08 12 1769	**David Britton**	*1 Stand Table [mahogany]*	2..0..0	
53	11 01 1769	**Jn'o Turner Esq**	*1 Stand Table [mahogany]*	2..10..8	D 36
54	01 11 1770	**Joseph Lee [of Beverly]**	*1 Standtable [mahogany]*	2..8..0	D 57
55	01 17 1770	**Charles Worthen**	*Standtable 40/*	2..0..0	AB; C 147
56	03 00 1770	**Benjamin Clough**	*1 Stand Table [mahogany]*	2..0..0	
57	03 00 1770	**David Bickford Jr. [Beckford]**	*Stand Table [mahogany]*	2..0..0	AB; duplicate entries in AB
58	03 31 1770	**Nath'l Whitacer [Whitaker]**	*Stand Table [mahogany]*	2..0..0	
59	06 19 1770	**Josiah Batchelder [Jr.]**	*Stand Table [mahogany]*	2..0..0	
60	08 24 1770	**Clark Gat'n Pickman**	*1 Stand Table [mahogany]*	2..13..4	D 86

Stand Tables

	LEDGER DATE	CLIENT	LEDGER ENTRY	PRICE	NOTES
61	08 24 1770	**Clark Gat'n Pickman**	*1 Ditto [stand table, mahogany]*	2..0..0	D 86
62	11 00 1770	**Henry Williams**	*1 Stand ditto [table, mahogany]*	2..0..0	D 114
63	12 21 1770	**Ichabod Glover**	*Stand Do Carved Feet Holo [hollow] Top [table, mahogany]*	2..8..0	
64	02 02 1771	**Edward Norick [Norris]**	*Standtable Del'd [delivered] J Hiller ? [mahogany]*	2..0..0	
65	04 27 1771	**Jn'o Allcock**	*Standtable [mahogany]*	2..0..0	
66	08 01 1771	**Gideon Foster jn'r of Danvers**	*1 Standtable 43/ [mahogany]*	2..13..4	D 33
67	11 13 1771	**Step'n Maskall [Mascoll]**	*Standtable 40/ [mahogany]*	2..0..0	
68	05 04 1772	**W'm Hathorn [Hathorne]**	*Stand Table with Carved feet [mahogany]*	2..3..0	D 46 or 50
69	05 04 1772	**Rich'd Whiteridge of Danvers**	*Stand Table [mahogany]*	2..0..0	
70	05 19 1772	**Nich'l Thorndike**	*1 Stand Table [mahogany]*	2..0..0	
71	08 20 1772	**Israel Hutchinson Danvers**	*Stand Table 40/ [mahogany]*	2..4..0	Price listed as 2..0..0 in AB
72	10 10 1772	**George Deblois**	*Stand Table 40/ [mahogany]*	2..0..0	
73	10 10 1772	**Ichabod Glover**	*1 Stand Table 40/ [mahogany]*	2..0..0	Poss. for his new house built in 1772
74	10 10 1772	**Samuel Flagg**	*Stand Table [mahogany]*	2..3..0	D 32
75	10 10 1772	**Jn'o Harthorn [Hathorne]**	*1 do Stand Table [mahogany]*	2..8..0	D 46
76	05 08 1773	**George Dodge**	*1 Stand Do 40/ [table, mahogany]*	2..0..0	Price listed as 2..3..0 in AB; D 12
77	06 04 1773	**Thomas Barnard Jr.**	*1 Stand Table [mahogany]*	2..0..0	D 4
78	10 07 1773	**William Paine**	*1 Stand Table 48/ [mahogany]*	2..8..0	D 81; shipped in cases
79	10 07 1773	**William Paine**	*1 Do 40/ [stand table, mahogany]*	2..0..0	D 81; shipped in cases
80	11 03 1773	**Bar'w Putnam**	*1 Stand Table mahogany & casing 3 1/2 foot do*	2..6..8	C 193
81	01 11 1774	**Mr [Jonathon] Webb of Danvers**	*Stand Do [table, walnut or cherry]*	1..8..0	
82	01 24 1774	**Jon'n Ireland of Charlestown**	*Stand Table [mahogany]*	2..0..0	
83	03 15 1774	**Ichabod Nickals [Nichols]**	*Stand Do 40/ [table, mahogany]*	2..0..0	D 68
84	04 12 1774	**Nath'n Leach**	*1 Standtable & casing [mahogany]*	2..4..0	C 195
85	04 21 1774	**Tho's Maning [Manning]**	*Standtable 40/ [mahogany]*	2..0..0	
86	06 18 1774	**Roland Savage**	*Cheretree Standtable [cherry]*	1..8..0	
87	07 06 1774	**Ben Nurse**	*Standtable 40/ [mahogany]*	2..0..0	D 74
88	12 02 1774	**Sylveter Gardner Esq [Gardiner]**	*1 Stand do [table, mahogany]*	2..0..0	Order not itemized in AB, listed as "sundrie household furniture"
89	12 31 1774	**Peter Fry [Frye, Esq.]**	*Standtable [mahogany]*	2..0..0	D 76
90	01 07 1775	**Nathan Leech [Leach]**	*1 Stand Table 40/ [mahogany]*	2..0..0	
91	02 02 1775	**Joseph Moses**	*Stand Table [mahogany]*	2..0..0	
92	02 04 1775	**Jeremiah Page**	*2 Stand Do [table, mahogany] @ 40/*	4..0..0	D 90
93	08 01 1775	**William Vans, Esq**	*Stand Table [mahogany]*	2..0..0	D 104
94	08 06 1776	**Ephr'm Ingals [Ingalls]**	*Standtable [walnut or cherry]*	1..8..0	
95	11 25 1776	**John Jinks [Jenks]**	*1 Stand Table [mahogany]*	2..8..0	D 53
96	03 15 1777	**Nathan Nickals [Nichols]**	*1 Stand do*	2..8..0	D 69
97	05 01 1777	**Joshua Dogue [Dodge]**	*1 Stand Table*	3..0..0	D 25
98	06 28 1777	**Jeremiah Page**	*Standtable*	2..0..0	AB
99	07 23 1777	**Isaac White**	*Stand Table*	2..0..0	AB; duplicate entries in AB; D 112
100	09 23 1777	**W'm West**	*1 Stand Table 4£*	4..0..0	Duplicate entries in AB; D 114
101	10 21 1777	**Israel Thorndike**	*1 Stand do [table]*	4..0..0	D 103
102	11 07 1777	**Edmund Putnam**	*1 Stand do [table]*	$15	D 29
103	01 10 1778	**Sam'l Bickfor [Beckford Jr.]**	*Stand Table*	NOT PRICED	
104	01 10 1778	**Rich'd Masury**	*Stand Table*	4..0..0	
105	01 10 1778	**John Novice [Norris]**	*1 Stand do [table]*	6..0..0	D 71
106	02 04 1778	**Ben'n Goodhue Ju'r.**	*1 Stand Table*	8..0..0	D 38
107	04 04 1778	**Joseph Flint Jun'r.**	*1 Stand Table*	8..0..0	
108	04 28 1778	**John Hartwell**	*1 Stand do [table]*	NOT PRICED	Order not itemized, total was 70..0..0
109	08 03 1778	**Josiah Duing [Deering]**	*Stand Table*	2..0..0	12..0..0
110	08 03 1778	**Ichabod Glover**	*Stand Table [mahogany]*	2..0..0	15..0..0
111	08 04 1778	**Jn'o Jinkins [Jenkins]**	*Stand Table 40/ [mahogany]*	2..0..0	12..0..0
112	11 09 1778	**Jn'o Smith**	*Standtable*	15..0..0	
113	12 00 1778	**John Hodges**	*Standtable [mahogany]*	2..0..0	AB

Stand Tables

	LEDGER DATE	CLIENT	LEDGER ENTRY	PRICE	NOTES
114	02 25 1779	W'm Brewer	*1 Stand do [table, mahogany]*	2..0..0	
115	07 24 1779	Benjamin Doland [Daland]	*1 Stand do 3£ [table]*	3..0..0	D 27
116	11 11 1779	Peter Sm'otherst [Smothers]	*Stand Table*	4..10..0	D 96
117	04 06 1780	Francis Cook	*1 Stand Table 40/ [mahogany]*	2..0..0	AB
118	08 01 1780	Henry Brown	*1 St'd Do [stand table]*	300..0..0	D 10
119	08 01 1780	John Danielson [Donaldson]	*1 st'd Table 90/ [stand]*	4..10..0	AB; D 26
120	08 02 1780	Joseph McComb	*1 Stand do 90/ [table]*	4..10..0	AB
121	11 01 1780	W'm Pickering	*1 Stand do [table]*	300..0..0	D 84
122	02 24 1781	Dr. Edward Barnard	*1 Stand Table*	NOT PRICED	D 3
123	02 24 1781	Jn'o Cook Jun'r	*1 Stand do [table]*	300..0..0	D 19
124	05 16 1781	Bartholemew Putnam	*1 Stand do [table]*	NOT PRICED	D 82
125	06 23 1781	David Ashby	*1 Stand do [table]*	4..16..0	D 2
126	11 12 1781	Henry Gardner	*1 Stand Table*	NOT PRICED	Ordered after his return from exile
127	04 00 1782	James Wood Gould	*1 Stand Table [mahogany]*	2..8..0	4..10..0; D 40
128	08 00 1782	Ben'j Lander	*1 Stand Table*	4..16..0	Partially paid for by making a round chair @ 3..0..0
129	10 00 1782	Jn'o Frothingham	*1 Stand Table £4..10*	4..10..0	
130	05 23 1783	Israel Huchinson [Hutchinson]	*a Stand Tabel [mahogany]*	2..8..0	AB

Austin, Josiah | Joiner

LEDGER DATE	LEDGER ENTRY	PRICE	NOTES
11 17 1777	To cash over p'd [paid] on chairs	0..6..0	
02 07 1779	[To] pays 17..8..0 cash first entry for this cabinetmaker	NOT PRICED	
03 04 1779	To cash	30..0..0	
07 00 1779	To cash	24..0..0	
07 00 1779	To cash	48..0..0	
09 00 1779	To cash	24..0..0	
10 02 1779	To cash	60..0..0	
10 09 1779	To cash	72..0..0	
03 00 1780	[To] dr. [debit] to cash	9..0..0	
01 16 1781	[To] 50 feet Mahogany	NOT PRICED	
04 00 1781	To cash	600..0..0	
04 00 1781	To cash	584..8..0	
05 01 1781	To cash	324..0..0	
00 00 1782	By 1 round Chair	2..8..0	AB; prob. for John Donaldson, sold at a loss
00 00 1782	By 1 Easey Chair	2..8..0	AB; prob. for Benjamin West
00 00 1782	By 1 Sett of brasses	2..5..0	AB
08 00 1782	To 8 1/2 feet Walnut	0..3..6	AB

Bacheller, Theophilus | Cabinetmaker

LEDGER DATE	LEDGER ENTRY	PRICE	NOTES
09 07 1773	By 12 month's work @ 42/8	25..12..0	AB
10 00 1773	To board while sick of Measels	0..8..0	AB
10 26 1773	By 1 month & half @ 42/8	3..4..0	AB
11 10 1773	By month work from No'v [November] 10	NOT PRICED	AB
05 26 1774	To board @ 8/8 pr week from ye date 8 week	3..9..4	AB
07 00 1774	To 2 weeks board @ 13/4	1..6..8	AB
10 26 1774	By 2 1/2 months work @ 42/8	5..6..8	AB
01 09 1775	To 6 3/4 feet Mahogony @ 8'd	0..4..6	Pence per foot
01 09 1775	To 30 feet Pine 2@	0..2..0	
01 00 1775	To 26 weeks board @ 8/8	11..18..8	AB
01 18 1775	By his account to Jan 18, 1775	26..19..0	AB
04 06 1775	To 13 weeks board @ 8/8	5..12..8	AB
01 04 1776	By his ac't rend [account rendered] Jan'y 4 1776	11..15..1	AB
04 19 1777	By 4 Months work @ 53/4	10..13..0	
07 28 1777	Began to work		
01 27 1780	To 418 feet Mahogony	NOT PRICED	
03 01 1780	To 27 feet of do [mahogany]	NOT PRICED	
11 12 1781	By making 1 Bureau Table	3..12..0 [TOTAL]	For Henry Gardner
11 12 1781	[By] 1 Sideboard do [table]	NOT PRICED	For Henry Gardner; called side table but crossed out
11 12 1781	[By] 2 4 feet do [table]	NOT PRICED	(1) for Mary Vinning and (1) for Henry Gardner

Barnes, Thomas |Cabinetmaker

LEDGER DATE	LEDGER ENTRY	PRICE	NOTES
05 16 1774	By his account rendered	31..13..8	AB
10 31 1774	To Pine board & nails	0..1..0	
10 31 1774	[To] Board from May 17 to Sept 16 @ 8/8 per week	7..7..2	
12 02 1774	[To] 8 Bed screws @ 4d	0..2..8	
12 02 1774	[To] Stuff for Bedstid	0..4..6	
12 24 1774	By his account	17..18..0	AB

Brown, Nikolas | Upholsterer

LEDGER DATE	LEDGER ENTRY	PRICE	NOTES
02 07 1762	By Bot'ing 6 Chairs @ 15/ [bottoming, 2/]	0..12..0	4..10..0; AB; prob. for Benjamin Stacey
02 07 1762	By 1 Days Work	0..4..8	1..15..0; AB
02 07 1762	By Bot'ing 1 Chair [bottoming]	0..2..0	0..15..0; AB
02 07 1762	By Bot'ing 2 ditto @ 15/ [bottoming, 2/]	0..4..0	1..10..10; AB; prob. for Benjamin Stacey
02 07 1762	By work on a Couch	0..2..8	1..0..0; AB
02 07 1762	To 3 necks of seal skin	0..3..0	1..2..6; AB
02 07 1762	To 8 necks of seal skins @ 9/	3..12..0	AB

Caldwell, John | Joiner

LEDGER DATE	LEDGER ENTRY	PRICE	NOTES
02 22 1768	By six months work @ 42/8	12..16..0	AB; his debits consist of a number of entries for "buying sundries @ Mr Appletons", "shoe buckles of Northey", "reselling shoes of Jno Gray", etc.
02 22 1768	By one ditto omited [month]	2..2..8	
01 06 1775	To 660 feet of Mahogany @ 3/6 old tenor	115	AB

Chandler, John | Ship Carpenter

LEDGER DATE	LEDGER ENTRY	PRICE	NOTES
06 00 1782	By 2 days work @ 12/	5..8..0	AB
08 00 1782	By 8 das work @ 12/ [days]	4..16..0	AB
01 00 1783	By 9 days work @ 12/	5..8..0	AB

Cogswell, John | Cabinetmaker of Boston

LEDGER DATE	LEDGER ENTRY	PRICE	NOTES
00 00 1759	By Making a cham'r tab'l [chamber table]	0..16..0	6..0..0; before 10/11/1759; prob. for Tabitha Skinner
00 00 1759	By 3 feet Dito Cash [chamber table]	0..10..0	3..15..0; before 10/11/1759; prob. for John Gardner Jr.
00 00 1759	By a Mehogony Desk cash	1..13..4	12..0..0; before 10/11/1759; poss. for Ebenezer Beckford
00 00 1759	By 2 Stand Tables Cash	0..18..8	7..0..0; before 10/11/1759; (1) for Richard Stacey and (1) for William Lamson
00 00 1759	By 1 Dito Goods [stand table]	0..9..4	3..10..0; before 10/11/1759; poss. for John Tasker
00 00 1759	By a Case of Draws Cash	3..17..4	29..0..0; before 10/11/1759; prob. for Tabatha Skinner
00 00 1759	By Swelled fr [front] Desk Goods	2..8..0	18..0..0; before 10/11/1759; poss. for Crispus Brewer, then exported
00 00 1759	By 1 Bed Stid cash	0..8..0	3..0..0; before 10/11/1759; prob. for Joseph Dean
00 00 1759	By 2 Tables Goods 1 4 feet 1 3 feet; @ 25/	1..3..4	8..15..0; before 10/11/1759; prob. for Joseph Trask, then exported
00 00 1759	By 1 Desk Cash	1..6..8	10..0..0; before 10/11/1759; prob. for Ebenezer Beckford
00 00 1759	By 1 4 feet, 1 3 feet goods	1..5..0	9..7..6; before 10/11/1759; prob. for Tabitha Skinner
00 00 1759	By 1 Stand Table Goods	0..9..4	3..10..0; before 10/11/1759; prob. for Tabitha Skinner
00 00 1759	By 6 Desks	5..0..0	37..10..0; before 10/11/1759; poss. for (1) Samuel West Jr., (1) Joseph Trask, (2) Joseph Grafton Jr., (2) Benjamin Daland
10 11 1759	Terms of settlement signed by Gould	8..17..8	

Cross, Joshua | Cabinetmaker

LEDGER DATE	LEDGER ENTRY	PRICE	NOTES
05 00 1782	To 8 feet Mahogany @ 1/6	0..12..0	AB
05 00 1782	By 2 1/2 days work @ 12/p	1..10..0	AB
05 00 1782	By 1/2 days work	0..6..0	AB

Doak, William | Chairmaker

LEDGER DATE	LEDGER ENTRY	PRICE	NOTES
00 00 1770	To board from May 25th to November the 20 @ 8/	NOT PRICED	
06 09 1770	By making 6 Chairs @ 7/4	2..4..0	Prob. for Clark Gayton Pickman
07 00 1770	By 12 black W't Chairs @ 6/8 [walnut]	[4..0..0]	Prob. for Clark Gayton Pickman; 6 of the chairs may have been mahogany
09 03 1773	[To] 8 feet Mahogony 6/8	0..6..8	AB
10 31 1773	[To] Burch plank 2/4	0..2..4	AB
09 22 1774	By 6 Chairs @ 8/	2..8..0	Prob. for Nehemiah Buffington

Gavett, Jonathan | Cabinetmaker

LEDGER DATE	LEDGER ENTRY	PRICE	NOTES
01 00 1765	To 2 days time on aprisal [appraisal] of yr estate	0..8..0	AB; for his father Joseph's estate
02 12 1765	By his ac't [account] to y'e [illegible] in margins	8..10..7 1/2	AB
02 12 1765	By his ac't [account] to this day	3..2..2	AB
01 14 1768	To Mahogany 4/	0..4..0	AB
06 01 1770	[To] Cheretree boards & Birch plank	0..3..3	
06 01 1772	To 3 pr [pair] rule joynt hinges @ 7'd	0..1..9	
06 01 1772	3 doz wood screws @ 3 1/2	0..0..10 1/2	
06 01 1772	To 1 Gouge	0..0..8	
06 16 1772	To 1 Set rule joynt hinges & screws	0..1..8	
03 01 1777	To 20 feet of Mahogany	0..16..8	
01 13 1781	To 32 feet of Mahogany @ 1/	1..12..0	AB
11 00 1781	By turning 88 inches of teaboard @ 4d	NOT PRICED	
09 27 1782	To 17 feet of Mahogany @ 1/4	1..2..9	
03 22 1784	By y'e Amount of his accounts	30..5..1	AB; no itemized list of furniture made by Gavett exists, but the total of this order indicates he was supplying Gould with items
03 22 1784	By over charge on 4 feet table	0..6..0	AB

Gavett, Joseph | Joiner

LEDGER DATE	LEDGER ENTRY	PRICE	NOTES
03 28 1764	To survaing [surveying] 6M of boards @ 7 1/4p	0..3..9	AB
04 00 1764	By his accom'p [account] to this day	3..15..4	AB

Giles, Thomas | Cabinetmaker

LEDGER DATE	LEDGER ENTRY	PRICE	NOTES
01 08 1759	By making 2 Desks @ £9 per Desk	2..8..0	18..0..0; prob. for John Nutting, then exported
01 08 1759	To 520 feet of Maple bords @ 6d pr [per] foot	1..14..8	13..0..0
01 08 1759	To 107 feet of Pine @ 4d pr [per] foot	0..4..9	1..15..8
03 10 1759	To 6 3/4 of BlackWalnut @ 4/6	[ILLEGIBLE]	
04 08 1760	To 56 feet of clear boards @ 1/	0..7..5 1/2	2..16..0
04 08 1760	To 21 feet of Cherritree @ 2/ [cherry]	0..5..7 1/4	2..2..0
05 13 1760	[To] sett of brasses	0..6..6	
01 08 1761	To feet of Walnut @ 5/	0..6..9	
01 08 1761	To 17 dito [feet] of Pine @ /9	0..1..8 1/2	
01 02 1762	To 20 feet of Maple bords @ /9	0..2..0	0..15..0; AB

Glover, Ichabod | Chairmaker

LEDGER DATE	LEDGER ENTRY	PRICE	NOTES
02 18 1770	*By 8 chairs @ 4/4 [maple]*	1..14..8	AB; Prob. For Clark Gayton Pickman
11 29 1776	*By his ac't [account] to Nov'r 29 1776*	6..13..1	AB
12 00 1781	*By his acct [account] to Dec'r 1781*	8..8..7	AB

Goodhue, Daniel | Cabinetmaker

LEDGER DATE	LEDGER ENTRY	PRICE	NOTES
07 16 1765	*By work from ye margin date [May 16] to July 16 @ 48/ month*	4..16..0	AB

Graves, Jonathon of Ipswich | Cabinetmaker

LEDGER DATE	LEDGER ENTRY	PRICE	COMMENTS
07 08 1768	*To chist lock [chest]*	0..2..0	
07 08 1768	*By Making 2 Desks @ 24/*	2..8..0	Poss. for Samuel Grant

Gyles, Samuel | Cabinetmaker

LEDGER DATE	LEDGER ENTRY	PRICE	NOTES
06 29 1759	*[To] 6 1/2 feet of Maple plank @ 2/*	0..1..8 3/4	0..13..0
08 18 1759	*To 70 feet of Maple*	0..7..4	2..15..0
08 18 1759	*To 19 feet of Pine*	0..1..9 1/2	0..8..0

Hitchings, William | Cabinetmaker

LEDGER DATE	LEDGER ENTRY	PRICE	NOTES
00 00 1780	*To board from 15th instant*		
02 14 1780	*By balance of act's [accounts]*	383..6..0	
04 09 1782	*By his account*	5..4..4	AB
06 00 1782	*To 13 feet Mahogany @ 2/*	1..6..0	AB
07 19 1782	*By making Desk*	3..0..0	AB; prob. for Jacob Clarke
07 19 1782	*By making Table 4 feet*	1..12..0	AB; prob. for Israel Hutchinson
04 09 1783	*By his account*	5..4..4	AB

Holman, William | Cabinetmaker

LEDGER DATE	LEDGER ENTRY	PRICE	NOTES
06 08 1763	*To 20 feet of Pine*	0..2..?	AB
06 08 1763	*To 208 feet of Maple*	0..8..7	AB
06 08 1763	*[To] 50 feet of Pine*	0..3..4	AB
06 25 1763	*By his acompt [account] June 25th 1763*	11..12..0	AB
07 00 1763	*To 9 feet of Walnut timber @ 2/*	0..18..0	AB
07 00 1763	*To 548 feet of Pine*	1..8..0	AB
07 00 1763	*To 5 1/2 feet of Mahogany @ 1/*	0..5..6	AB
01 03 1764	*To Burch plank 3/*	0..3..0	AB
01 03 1764	*To Black Walnut 8/*	0..8..0	AB

Holman, William | Cabinetmaker

LEDGER DATE	LEDGER ENTRY	PRICE	NOTES
03 00 1764	*To 1 sett of Brasses*	0..9..8	AB
03 00 1764	*To 1 set of lox [locks]*	0..1..8	AB
06 00 1764	*To 10 1/2 feet of Walnut timber @ 1/11d*	1..2..11	AB
06 00 1764	*By making Mahogany Desk*	2..1?..0	AB; poss. for John Gardner Jr., then exported
06 17 1765	*By his acompt [account] from Oc'r [October] 1763*	4..19..4	AB
05 00 1766	*[To] 91 1/2 feet of Cedar baords*	1..10..6	AB
10 00 1767	*[To] 13 1/2 feet Mahogany @ 1/*	0..13..6	AB
10 00 1767	*[By] making 2 Tables [mahogany]*	6..13..4	Prob. chamber table based on unit price
02 00 1768	*[By] making a Stand Table*	0..12..0	Poss. for Captain Joseph Skillin
02 00 1768	*By 32 feet Ceader bord @ 6*	0..16..0	
05 00 1768	*By making Stand Table*	0..13..4	Poss. for Rowland Savage
05 00 1768	*By do [making] Ceadar Desk*	1..6..8	Poss. for Israel Dodge
12 16 1771	*By his ac't [account] to Dec 16th 1771*	2..3..4	

King, Gedney | Cabinetmaker

LEDGER DATE	LEDGER ENTRY	PRICE	NOTES
04 26 1762	*To 4 1/2 feet of Walnut plank @ 7/6*	2..0..6	15..3..9
04 26 1762	*To 2 1/2 ditto @ 10/*	0..3..0	1..2..6
04 26 1762	*To 18 feet of bords @ 4/*	0..9..7 1/4	3..12..0
07 19 1762	*To 20 feet of Mahogany bord @ 10/*	1..6..8	10..0..0, price of 1/4 listed in AB
08 00 1762	*To 15 1/4 feet of Mah'y B @ 1/4 [board, mahogany]*	1..0..4*	AB; incorrect price listed, was 1..1..2
03 00 1765	*By his account in full to March 5 1765*	7..0..0	AB
06 00 1765	*By Making Desk*	1..4..0	AB; prob. for Philip Saunders
04 01 1766	*To 26 feet Wallnut boards @ 4/6 ol'd tinor [old tenor]*	0..15..8	AB; unit price given in old tenor in AB
06 00 1766	*By Making 1 Cheree Desk [cherry]*	1..4..0	AB; poss. for John Gardner Jr.
06 00 1766	*By part of 1 Ceader do [desk]*	1..0..0	AB; poss. for John Gardner Jr.
07 10 1766	*To 100 feet Walnut bord @ 3/6 old tenor*	2..6..8	AB; unit price given in old tenor in AB
06 00 1767	*By Making Ceader ditto [desk]*	1..4..0	Poss. for Josiah Batchelder
09 00 1767	*By Making 1 Maple Desk*	1..0..0	Prob. for Daniel Cheever
04 13 1768	*To 32 feet clear bord @*	0..4..4	
09 16 1768	*To Mehog'y & Wall't & Maple [mahogany, walnut]*	0..19..6	Called "sundries" in AB
09 26 1768	*[To] 7 1/2 feet Mehog'y [mahogany]*	0..6..0	
12 10 1768	*To 26 feet of Birch plank @ 2d*	0..4..4	
01 20 1769	*[To] set brasses*	0..8..8	Price of 8/8 listed in AB
03 09 1769	*To 17 fet of Burch plank @ 2 1/2*	0..3..6	Price of 3/6 listed in AB
03 09 1769	*To 16 feet Burch plank @ 2 1/2/*	0..3..4	Price of 3/4 listed in AB
03 09 1769	*To Wall't plank 3/ pine 1/8 [walnut]*	0..4..8	
05 19 1769	*By his ac't [account] to May 19, 1769*	6..4..8	AB
02 04 1770	*To Mahogany legs for table*	0..2..0	AB
05 09 1770	*[To] 3 1/2 foot Mehog'y 3/*	0..3..0	
01 27 1771	*By his ac't [account] Jan 27,1771*	3..2..8	AB
04 28 1772	*By his ac't [account] rendered*	12..7..4	AB
12 09 1772	*To 5 handles @ 6 1/2*	0..4..6	Unit price given in old tenor in DB
12 09 1772	*[To] 5 escutch's @ 3 1/2 [escutcheons]*	0..1..4 1/2	
12 09 1772	*[To] 1 set lox [locks]*	0..1..2	
12 09 1772	*[To] 1 doz knobs*	0..0..10	
12 09 1772	*[To] 1 pr [pair] hinges*	0..0..7	
12 09 1772	*[To] 1 doz screws*	0..0..3	
01 25 1773	*By 4 3/4 feet oak wood*	0..10..6	
09 01 1773	*[To] sett brasses, locks, knobbs, screws, hinges, etc*	0..10..8	

Knight, Nathaniel | Joiner

LEDGER DATE	LEDGER ENTRY	PRICE	NOTES
12 00 1779	*By making Desk*	21..12..0	Prob. for Peter Smothers
07 00 1782	*By his account*	15..9..3	AB
11 00 1782	*To Maple board*	0..2..0	AB

Lander, Benjamin | Joiner

LEDGER DATE	LEDGER ENTRY	PRICE	NOTES
11 12 1781	*By 6 Black chairs @ 9/*	2..14..0	For John Donaldson
08 00 1782	*By 1 Round Chair*	3..0..0	For Abner Chase, sold at a loss
07 00 1783	*By 8 days work @ 12/*	4..16..0	AB

Lander, William | Chairmaker

LEDGER DATE	LEDGER ENTRY	PRICE	NOTES
04 00 1764	*By discount on 6 Chairs*	0..9..4	AB

Lowater, Stephen

LEDGER DATE	LEDGER ENTRY	PRICE	NOTES
09 08 1761	*By Two Months Work*	1..10..0	Debit side of entry was for cash of 11..5..0 in old tenor
00 00 1763	*By 5 months work @ 48/*	12..0..0	
06 00 1763	*To 11 days bord*	0..15..8	AB; calculates to 0..1..4 per day or 10s. per week
09 00 1764	*To 3 weeks bord @ 9/4*	1..8..0	AB
05 05 1765	*To bord from March 22 1765 To May 5*	2..8..0	AB
11 00 1765	*To 5 weeks bord from Oct 18 to Nov 24 @ 9/4*	2..6..8	AB
04 00 1766	*By 1 day work to Marblehead*	0..3..0	AB
04 00 1766	*By sawing 175 feet of Mehogany*	0..9..8	AB
04 00 1766	*By 544 ditto [sawing mahogany]*	1..11..4	AB
06 01 1766	*To bord from April 28 to June 1 @ 8/8 week*	2..3..4	AB
06 01 1766	*To bord at half price*	0..5..4	AB
01 19 1767	*To 5 weeks & 3 days bord @ 9/4*	2..10..4	
02 19 1767	*By work from Jan'y 19 1767 @ 40/ pr [per] month to Feb'y 19 1 month*	2..0..0	He was charged 2..10..4 for 5 weeks board
01 23 1768	*To month's work*	2..2..8	Listed as "to" but is a credit transaction
02 00 1768	*By work*	2..0..0	
02 00 1768	*By a dumb john [waiter]*	0..6..0	
04 09 1770	*By Making 4 Maple desks @ 20/*	4..0..0	AB; prob. for Captain Robert Alcock, then exported
01 00 1771	*[By] 7 days sawing @ 2/*	0..14..0	AB
11 25 1772	*To sett brasses for Desk*	0..16..8	
10 20 1773	*To 17 feet Mahogony @ 10 1/2/*	0..14..10 1/4	AB
02 07 1775	*To paid Stephan Lowater for sawing ceader 2 1/2 days @ 3/7*	NOT PRICED	
02 15 1775	*To 1 week board*	0..8..0	AB; calculates to 0..8..0 per week
02 16 1775	*By sawing 21 1/2 days @ 18/ old tenor [2/4]*	2..11..7	AB

Martin, Ebenezer | Cabinetmaker

LEDGER DATE	LEDGER ENTRY	PRICE	NOTES
10 00 1763	*By 3 months work @ 48/*	7..4..0	AB
10 12 1763	*To 4 days bord @ 1/4*	0..5..4	AB

Needham, Thomas | Joiner

LEDGER DATE	LEDGER ENTRY	PRICE	NOTES
05 15 1758	*To three posts @ 5/*	0..2..0 1/2	0..15..0; one of the first entries, Gould and Needham are both 24 years old
05 15 1758	*To Black Walnut bord*	0..12..3	4..12..0
06 30 1759	*To 4 Stand table [server or screw]*	NOT PRICED	
08 01 1759	*To a Maple Desk Lent*	2..13..4	20..0..0; price incorrect in AB, was 2..16..4
12 13 1759	*To 1 p'r [pair] of rule joynt hinges*	[ILLEGIBLE]	
01 23 1760	*To 1 p'r [pair] of rule joynr hinges*	0..1..9 3/4	0..8..0
01 28 1761	*By Making 1 Mah'y Table [mahogany]*	0..12..8	4..15..0; for Jonathon Cook @ 2..18..8, sold the same day
02 00 1761	*By making a Chest*	0..6..0	2..5..0
02 19 1761	*To 4 1/4 of wood*	0..9..3	3..9..6
03 13 1761	*By making a Desk & Bokcase*	4..13..4	35..0..0; for Joseph Grafton @ 13..6..8
03 16 1761	*To 1 Sett of Brases 8/8*	0..8..8	1..14..0; price listed as 8/8 in AB
03 16 1761	*To Turning Sett Flam's [finials]*	0..4..0	3..4..10; listed as "blaises" [finials] in AB
03 16 1761	*To cash del [delivered] his son*	0..1..2 1/2	0..9..0
04 10 1761	*To wood*	0..7..0	2..12..6
00 00 1762	*To 6 foot of wood*	0..12..0	4..10..0; AB
05 00 1762	*[By] set hinges*	0..0..2 1/2	0..1..6; AB
03 00 1763	*To 3 1/2 foot of Walnut @ 4/6*	0..2..4	0..16..0
03 00 1763	*To 1 sett of R'g [ring] hinges*	0..1..4	0..10..0
06 03 1768	*[To] 3 feet Mahogony @ 0..2..8*	0..2..8	
06 07 1768	*[To] 3 foot Cheretre [cherry]*	0..1..0	
07 05 1768	*[To] 2 foot Mhogony*	0..1..8	
10 22 1768	*[To] 7 1/2 feet Mahog'y*	0..7..0	
04 27 1770	*To 22 feet Maple @ 3/4 'd*	0..1..5	
05 09 1770	*[To] Chere boards [cherry]*	0..1..4	
09 22 1774	*To 14 feet Oak joists*	0..1..0	
08 09 1779	*To Mahogany plank*	0..12..0	4..10..0

Nurse, Benjamin | Upholsterer

LEDGER DATE	LEDGER ENTRY	PRICE	NOTES
04 12 1762	*By Botoming 21 chairs @ 15 [2/]*	2..2..0	15..15..0; for (6) Joshua Foster, (8) James Cockle, and (7) John Tasker
08 00 1762	*By botoming 18 chairs @ 15/ [2/]*	1..16..0	13..10..0; for Elias Hasket Derby
08 00 1762	*To 6 days bord @ 10/*	3..0..0	AB
12 17 1763	*By his ac't [account] in full*	14..5..0	
01 – 07 1764	*By bottoming 6 chairs @ 9/4 nt*	2..16..0*	Incorrect price, was 2..10..0; prob. for John Peele; much more expensive than usual
01 07 1764	*By ditto @ 2/ [bottoming 6 chairs]*	0..12..0	Prob. for Jacob Fowle
01 26 1765	*By his account to Jan 26, 1765*	17..9..10	AB
01 26 1765	*By bottoming 1 chair*	0..4..0	AB; for Benjamin Pickman Sr.
03 02 1765	*By bottoming 6 chairs with seal skin @ 60/ [8/]*	2..8..0	For Benjamin Pickman Sr.
03 02 1765	*By 2 ditto with needlework @ 4/ [bottoming]*	0..8..0	Poss. for Thomas Poynton
03 02 1765	*By bottoming 6 with calf @ 2/*	0..12..0	For Josiah Batchelder
03 02 1765	*To sundries overpaid for bottoming 1 chair for Col Pickman*	0..2..5	For Benjamin Pickman Sr.
06 00 1766	*To calf skin 20/*	1..0..0	AB
06 00 1766	*[To] Tacks & weben cloth 9/6 [webbing]*	0..9..6	AB
07 00 1766	*By bottoming 6 small chairs del'd [delivered] Broat't [Bradstreet]*	3..5..4	AB; for Simon Bradstreet, order 06/1766; total of 7 chairs
07 00 1766	*By do 1 round del'd do [bottoming 1 small chair, delivered to Bradstreet]*	NOT PRICED	AB; for Simon Bradstreet
07 00 1766	*By ditto 6 small do del'd [delivered] Foster [bottoming chairs]*	2..16..0	AB; for Joshua Foster order 07/1766; cost per chair was 0..9..4
07 00 1766	*By covering easy chair for Cap'n Liley*	1..9..1	AB; for Captain William Lilly, order 10/25/1766
07 00 1766	*By bottoming 6 small chairs @ 10/ for ditto [Captain Lilly]*	3..0..0	AB; for Captain William Lilly, order 10/25/1766
07 00 1766	*By 6 harateen bottoms d'd [delivered] Bradstreet*	1..16..0	AB; for Simon Bradstreet, order 06/1766, cost per chair was 0..6..0
07 00 1766	*By 6 work'd do d'd [delivered] Mrs Freeman [bottoms]*	1..4..0	AB; for Deborah Freeman, order 10/15/1764; cost per chair was 0..6..0

LEDGER DATE	LEDGER ENTRY	PRICE	NOTES
07 00 1766	*By 6 Leather do d'd [delivered] for Mr Ashton [bottoms]*	3..0..0*	AB; price incorrect, was 3..10..0; for Jacob Ashton, order 12/30/1766
07 00 1766	*By 9 Leather do Mrs Higginson [bottoms]*	4..10..0	AB; for Mrs. Higginson, order 11/1766; cost per chair was 0..10..0
07 00 1766	*By 12 Hariteen do Jackson & Higginson [bottoms]*	3..12..0	AB; for Mrs. Higginson, order 11/1766; cost per chair was 0..6..0
07 00 1766	*To 1m [thousand] brass nails*	0..15..0	AB
07 00 1766	*[To] brass nails 15/*	0..15..0	AB
08 00 1766	*To 1m [thousand] brass nails*	0..12..0	AB
09 28 1766	*To 1m [thousand] brass nails 14/8*	0..14..8	AB
11 00 1766	*To 1m [thousand] brass nails 15/*	0..15..0	AB
11 00 1766	*To 1m [thousand] brass nails 15/*	0..15..0	AB
02 18 1767	*By bottoming 6 chairs @ 2*	0..12..0	AB; prob. for Thomas Poynton, order 02/18/1767
02 18 1767	*By bottoming 8 chairs @ 2/*	0..16..0	AB; poss. for John Mascareen Esq. and covered in hair cloth
06 00 1768	*[By] discount for bottoming Sprages chairs*	0..6..5	AB
06 00 1768	*By sundries pr [per] his ac't [account] Not Cr. [credit]*	12..15..4	AB
06 00 1768	*By his ac't [account] for bottoming chairs for Mrs Cabot & salt hay & hair for y'e same*	4..17..7	AB
05 00 1771	*By bottoming 6 chairs @ 6/*	1..16..0	AB; poss. for Ebenezer Swan
05 00 1771 (AFTER)	*[By] Bottoming 1 Chair*	0..6..8	AB; prob. for Nathan Goodale
07 00 1782	*By his Rend July 1782 [account rendered]*	4..14..0	AB

Parker, Philemon | Cabinetmaker

LEDGER DATE	LEDGER ENTRY	PRICE	NOTES
01 15 1763	*By making Desk 26/8*	1..6..8	AB; poss. for John Ropes III
01 15 1763	*By 2 ditto [making desk] @ 26/8*	2..13..4	AB
02 00 1763	*By making Bureau Table 20/*	1..0..0	AB; order placed during time of missing DB, cannot be tied to specific customer
03 00 1763	*By making 2 Candlestands @ 5/4*	0..10..8	AB; order placed during time of missing DB, cannot be tied to specific customer
03 00 1763	*[By] 1 Cheretree Desk 24/ [cherry]*	1..4..0	AB; for Jonathon Webb
03 00 1763	*By making plain Bureau Table*	0..16..0	AB; order placed during time of missing DB, cannot be tied to specific customer
04 20 1763	*By do [making] Case Draws 44/5*	2..4..5	AB; for Jacob Fowle
04 20 1763	*[By] 1 Desk @ 24 [cherry or maple]*	1..4..0	AB; poss. for John Gardner Jr.
04 20 1763	*[By] 1 Table @ 11/8*	0..11..8	AB; prob. for Jacob Fowle
05 09 1763	*By do 1 Desk 26/8*	1..6..8	AB; for Billings Bradish
05 26 1763	*[By] 1 Desk 26/8*	1..6..8	AB; for James Freeman
06 02 1763	*By 2 Desks @ 48/ [cherry or maple]*	2..8..0	AB; for (1) Amos Ramsdall and (1) William Eppes Esq.
06 23 1763	*[By] 3 days work @ 4/*	0..12..0	AB
07 07 1763	*To mak [making] 1 Desk @ 24/*	1..4..0	AB; for Mason and Williams
08 23 1763	*By making 1 Desk 24/*	1..4..0	AB; for Mason and Williams
09 03 1763	*[By] Making 2 Desks @ 24/*	2..6..8	AB; for Mason and Williams
01 04 1768	*To bord @ 65 p'r week old tenor from date in margen @ 8/8*	11..19..1	Per week cost given in old tenor; calculates to 27 1/2 weeks of board at 0..8..9 per week in new tenor
01 15 1768	*By making Desk 26/8*	1..6..8	For John Gardner Jr.
01 15 1768	*[By] 2 ditto @ 26/8 [desks]*	2..13..4	For Josiah Orne
02 07 1768	*[By] mak'g [making] 3 Ceader Desks @ 26/8*	4..0..0	For Josiah Orne
02 07 1768	*By making 1 Bureau Table 20/*	1..0..0	AB; prob. for Samuel Curwen Esq.
03 02 1768	*By making 2 candle stands @ 5/4*	0..10..8	For (1) Captain Joseph Skillin and (1) Captain Gamaliel Hodges
03 02 1768	*By mak'g [making] Cheretree Desk 24/ [cherry]*	1..4..0	Prob. for Rowland Savage
03 23 1768	*By making plain w't Bureau Table [walnut]*	0..16..0	Prob. for Rebecca Orne
04 20 1768	*By mak'g [making] Case drawrs 44/5*	2..4..5	AB; prob. for Rebecca Orne
04 30 1768	*By making Desk 24*	1..4..0	Prob. for Nathan Leach

Parker, Philemon | Cabinetmaker

LEDGER DATE	LEDGER ENTRY	PRICE	NOTES
05 09 1768	*By mak'g [making] Table 11/8*	0..11..8	Poss. for Benjamin Coates
05 09 1768	*[By] making Cherrytree Desk 26/8 [cherry]*	1..6..8	Prob. for Philip Saunders
05 16 1768	*[By] making Cherrytree Desk 26/8 [cherry]*	1..6..8	Prob. for Philip Saunders
06 02 1768	*By mak'g [making] 2 Desks @ 24/*	2..8..0	Prob. for Charles Worthen
06 23 1768	*By making Desk 24*	1..4..0	Prob. for Samuel Shillaber
07 07 1768	*By 3 d's [days] work @ 4*	0..12..0	
07 23 1768	*[By] mak'g Desk 24 [making or mahogany]*	1..4..0	Prob. for Wood and Waters
08 03 1768	*[By] making Desk*	1..4..0	For John Gardner Jr.
09 03 1768	*By M [making] 2 Desks*	2..8..0	Prob. for George Parrot
11 11 1768	*To bord @ 8/ pr [per] week from date in y'e margin*	26..16..0	Calculates to 67 weeks of board backdated to 07/22/1767
11 20 1768	*By M'g 4 fot Table [mahogany]*	0..13..4	Prob. for Samuel Grant
11 20 1768	*By Candlestand*	0..5..4	Prob. for Robert Foster
11 20 1768	*[By] Cr [credit] By 2 days work @ 4/*	0..8..0	
11 26 1768	*[By] Ma'g [making] stand Table*	0..9..4	Prob. for Josiah Gould
12 07 1768	*[By] 5 days work*	1..0..0	
03 01 1770	*To board from date in y'e margins @ 8/ p [per] week*	18..0..0	AB; calculates to 45 weeks of board from approx. 05/1769
03 01 1770	*By making 1 4 foot Table*	0..13..4	AB; for Israel Dodge
03 01 1770	*By his ac't [account]*	54..5..2	AB
01 23 1771	*By his ac't [account] to this day*	35..16..10	AB
05 00 1771	*To bord from Jan'y 23 1771 @ 15 weeks @ 8/*	6..0..0	AB
12 28 1772	*By sundries pr [per] his ac'ts [accounts]*	68..9..11 3/4	AB
01 22 1773	*To 6 3/4 foot Wall't wood @ 2/4 [walnut]*	0..16..0	
01 19 1774	*By sundries pr [per] his ac't [account]*	42..4..6 1/2	AB
11 07 1774	*By his acct [account] to Nov 7 1775*	21..14.	AB
02 07 1778	*By his acct [account] rendered*	76..1..8	AB
02 16 1778	*By Making plain Desk*	NOT PRICED	Prob. for John Norris
02 16 1778	*By d'o [making] 2 4 foot Tables legs & joints made before*	NOT PRICED	Prob. for Benjamin Goodhue, order from 02/1778
02 29 1778	*By Mak'g [making] 3 Stand Tables*	NOT PRICED	Prob. for (1) Benjamin Goodhue, (1) John Norris, and (1) Richard Masury
04 23 1778	*By mak'g [making] Card Table dl'd [delivered] G Cabot*	ILLEGIBLE	Poss. for George Cabot
12 09 1778	*By his account rendered*	164..5..8	AB
03 23 1780	*By Balance Due on Settlement to be p'd [apid] in goods at ye last stated price*	37..3..8	This entry for reference only, not a new charge
02 00 1782	*By work on Olivers draws [drawers]*	27..0..0	For Benjamin Lynde Oliver; 40 drawers @ 4/6 (9..0..0) and 120 small drawers @ 3/ (18..0..0)
03 00 1782	*[To] 17 feet mahogany @ 2./*	1..14..0	AB
03 11 1783	*By his account of March 11, 1783*	47..11..0	Settlement out of Gould's estate

Richards, Joel | Cabinetmaker

LEDGER DATE	LEDGER ENTRY	PRICE	NOTES
09 00 1782	*To 3 weeks board @ 24/*	3..12..0	AB
09 00 1782	*By 13 1/2 days work @ 12/*	8..2..1	AB

Ropes, John Jr. | Cabinetmaker

LEDGER DATE	LEDGER ENTRY	PRICE	NOTES
05 06 1762	*By his acompt [account]*	29..8..9	
00 00 1763	*By Making 3 Maple Desks @ 18/8*	2..16..0	AB; prob. for (1) John Ropes III, order 12/1762 and (2) for Benjamin Pickman, order 01/1763
00 00 1763	*By Mak'g [making] 1 Mahog'y do [desk]*	2..8..0	AB; poss. for James Freeman

LEDGER DATE	LEDGER ENTRY	PRICE	NOTES
00 00 1763	*By 1 do [making desk, mahogany]*	2..8..0	AB; poss. for James Freeman
01 24 1764	*By sundries in his acom't [account] not credited*	10..8..0	AB
01 24 1764	*By Making 2 Waln't desks @ 24/ [walnut]*	2..8..0	AB; prob. (1) for Jonathon Mason and (1) for John Gardner
01 24 1764	*By Making part of a Sedar do [desk, cedar]*	0..13..4	AB; poss. for William West
01 00 1764 (AFTER)	*By Making 2 Wallnt desks @ 24/ [walnut]*	2..8..0	AB; prob. for (1) Thomas Frye and (1) Thomas Aden
01 00 1764 (AFTER)	*By Making part of a Seder Do [desk, cedar]*	0..13..4	AB; prob. for Thomas Aden
01 00 1764 (AFTER)	*By 1 3 1/2 feet Maple Table*	0..12..0	AB; prob. for one half for Benjamin Ober
01 00 1764 (AFTER)	*By 1 Making a Cedar Desk*	1..4..0	AB; prob. for Thomas Aden
02 14 1765	*By Making Ceder Desk*	1..4..0	AB; poss. for William Patterson
05 17 1766	*[To] work Ca'dr Desk 10/8 [cedar]*	0..10..8	Prob. a back charge for rework or a credit for a full desk
05 29 1766	*By sundries not credited*	15..1..4	AB
07 15 1766	*By 2 Ceader Desks @ 24/*	2..8..0	AB; delivered to Josiah Orne in early August
07 22 1766	*By 1 do @ 24/ [desk, cedar]*	1..4..0	AB; delivered to Josiah Orne in early August
01 24 1767	*To 6 feet Walnut wood*	0..14..4	AB
06 08 1767	*[By] for accounts not credited*	16..19..6	AB
06 12 1767	*[By] for accounts not credited*	27..16..6	AB
02 12 1773	*By his account rendered*	26..13..2	AB
08 02 1773	*To 30 feet clear baords*	0..2..6	

Ross, Jonathon | Cabinetmaker

LEDGER DATE	LEDGER ENTRY	PRICE	NOTES
02 08 1770	*To 7 days absence from Jan 1 1770*		
12 00 1770	*By 28 1/2 months work*	71..8..0	AB
05 03 1771	*To 9 foot Wallnuts timber @ 2/6*	1..2..6	
08 01 1771	*To 63 1/4 feet Wall't timber @ 1/8 [walnut]*	5..5..5	
08 01 1771	*To 2m Clear boards @ 53/4 [per thousand]*	5..6..8	
09 14 1771	*To 150 feet Ceader @ 3/3 old tenor*	3..5..0	
10 11 1771	*To 15 feet Mahogony @ 10 p [pence]*	0..12..6	
11 13 1771	*To Maple plank 2/9*	0..2..9	
01 00 1772	*To Sett brasses 11/2 1/2*	0..11..2	AB
03 00 1772	*To 1 sett of brasses & locks 13/8*	0..13..8	
03 00 1772	*[To] Sett brass*	0..7..4	
06 00 1772	*To Birch boards @ 4/6*	0..4..6	
06 02 1772	*To Birch boards @ 4/6*	0..4..6	
08 20 1772	*[To] Mehog'y bords [mahogany]*		Price of 0..4..8 is total for maple planks and mahogany boards
08 20 1772	*[To] Maple planks*	0..4..8 (TOTAL)	
02 19 1773	*To 4 feet Mahogony 3/4*	0..3..4	
03 20 1773	*[To] 39 feet Mahogony @ 10'd*	[1..12..6]	
06 29 1773	*To brasses*	0..8..0	
09 08 1773	*By 6 Chair frames @ 20/*	6..0..0	For Nathan Leach
09 08 1773	*By 2 do Round @ 26/8 [chairs]*	2..13..4	For Nathan Leach
11 00 1773	*By 6 Chair frames @ 18/8*	5..12..0	AB; prob. for Jeremiah Lee's order for his son
11 00 1773	*[By] 2 Round @ 26/8 [chair frames]*	2..3..4	AB; prob. close stool for Rowland Savage and easy chair frame for Edward Allen
11 00 1773	*[By] 2 Elbo Chairs @ 33/8*	3..6..8	AB; price listed as 33/4 in AB; for Daniel Mackey
11 00 1773	*By making 2 4 feet Tables*	1..6..8	AB; prob. for Jeremiah Lee Esq.
11 00 1773	*By carving feet 10/*	0..10..0	AB; prob. for Jeremiah Lee Esq.

Ross, Jonathon | Cabinetmaker

LEDGER DATE	LEDGER ENTRY	PRICE	NOTES
11 00 1773	*[By] making Desk 72/ [mahogany]*	3..12..0	AB; poss. for Jonathon Hathorne
11 00 1773	*By making 3 feet Table*	0..10..0	AB; poss. for Ichabod Glover
06 00 1774	*To 77 feet Pine board*	0..3..8	
06 11 1774	*[To] 79 feet of Pine B [board]*	0..3..9	
07 00 1774	*To brasses for Desk 11/*	0..11..0	
07 18 1774	*To brassing Desk*	0..11..0	
08 05 1774	*To 7 feet of Mahogony 5/10*	0..5..10	
08 05 1774	*To sett brasses omited Jan'y 8*	0..9..0	AB
07 21 1775	*To 5 feet Ceader @ 6'd*	0..2..6	
08 00 1775	*By 1 Case of Draws*	18..13..4	AB; order placed between 03/1774 and 08/1775; prob. for Thomas Mason or Edward Allen @ 18..13..4
08 00 1775	*By 4 feet Wall't Table [walnut]*	2..2..8	AB; order placed between 03/1774 and 08/1775; prob. for Joseph Southwick on 03/29/1775 at 2..2..8
08 00 1775	*By making Desk*	3..0..0	AB; order placed between 03/1774 and 08/1775; prob. for to Samuel Grant then exported
08 00 1775	*By making Bedstid*	1..8..0	AB; order placed between 03/1774 and 08/1775
08 00 1775	*To cash to buy Brasses at Newburyp'r [Newburyport]*	1..10..0	AB
08 00 1775	*To his note hand for £6..6..7 with intrest for 27 mon's [months] bare [bearing] date N'v [November] 23 1773*	7..2..7	AB
06 25 1782	*By 2 days work @ 12/*	1..4..0	AB
06 25 1782	*By 8 days work @ 12/*	4..16..0	AB

Safford, Abraham of Andover | Cabinetmaker

LEDGER DATE	LEDGER ENTRY	PRICE	NOTES
06 17 1767	*By 2 maple desks @ 37/4*	3..14..8	AB; prob. (1) for Ebenezer Hutchinson and (1) for Samuel Masury
06 17 1767	*To 2 pr [pair] rule joint hinges 1/7*	0..1..7	AB
06 17 1767	*[To] 4 pr [pairs] desk do 2/ [joint hinges]*	0..8..0	AB
07 04 1767	*By 1 ditto [desk, maple]*	1..17..4	AB; prob. for Ebenezer Bowditch
07 04 1767	*By making 2 Cheretree ditto @ 33/4 [desks, cherry]*	3..6..8	AB; prob. for Jonathan Mason
07 04 1767	*To 15 feet Cheretree bord @ 3 1/4 [cherry]*	0..4..1	AB
07 25 1767	*To 4 pr [pair] rule joynt hinges @ 1/7*	0..6..4	AB
07 25 1767	*To 3 par [pair] Desk hinges @ 6'd*	0..1..6	AB
08 20 1767	*To 4 pr [pair] hinges @ 7*	0..2..4	AB
08 20 1767	*[To] 6 doz'n screws @ 3 1/2'd*	0..1..9	AB
09 00 1767	*To 30 feet Cheretree bord @ 2/ old tenor [cherry]*	0..8..0	AB
10 00 1767	*[To] 16 feet of Ceader bords 8/8*	0..8..8	AB
07 23 1768	*To 66 foot Cheretree bord 17/8 [cherry]*	0..17..8	
09 26 1768	*[To] 29 feet Chertree bord 8/ [cherry]*	0..8..0	
06 00 1779	*By 1 Mapple desk*	1..6..8	AB; for Israel Dodge

Symonds, Joseph | Cabinetmaker

LEDGER DATE	LEDGER ENTRY	PRICE	NOTES
06 00 1765	*By Making Maple Desk*	1..0..0	AB; poss. for Philip Saunders
06 00 1765	*By Making Cheretree do [desk, cherry]*	1..4..0	AB; poss. for Benjamin Pickman
12 00 1765	*To 18 foot of Wall'nut @ 4/6 old tenor*	0..10..10	AB
06 00 1766	*To 37 feet of Wallnut bords @ 4/6 o'd T [old tenor]*	1..2..2 1/2	AB
01 00 1767	*To 37 feet of Wallnut bord @ 4/6 OT [old tenor]*	1..2..2 1/2	AB

Thaxter, Jonathon | Cabinetmaker

LEDGER DATE	LEDGER ENTRY	PRICE	NOTES
04 00 1782	To 3 weeks board @ 16/	2..8..0	AB
04 00 1782	To 12 1/2 days board @ 18/	1..12..0	AB
05 03 1782	By work from April 16th to ye 3'd of May 16 days @ 6 / p [per] day	4..16..0	AB; he is fined 6s. per day for being absent
06 00 1782	By 1 days work 14 th June	0..8..0	AB; rate increased to 8s.
06 00 1782	To 2 1/2 days absent @ 8/	1..0..0	AB
06 04 1782	By do [work] from May 9 to june 4 17 days @ 6/ 6 do [days] @ 8/ day	7..10..0	AB
07 06 1782	By work from May 20 to July 6 -15 days @ 8/	6..0..0	AB
09 00 1782	To 8 week board @ 18/	7..4..0	AB

Ward, John | Cabinetmaker

LEDGER DATE	LEDGER ENTRY	PRICE	NOTES
04 00 1762	To Black Walnut bords	NOT PRICED	
07 00 1766	[To] 17 1/2 feet ditto [black walnut boards] 6 1/2	0..9..4	AB
05 09 1770	To 17 1/2 feet Mehogony @ 8d	0..11..8	
11 00 1772	To 109 feet Wall't bords @ 5d [walnut]	2..5..5	
05 01 1773	To 29 feet Mahogony @ 1/	1..9..0	
05 01 1773	To Stand pillar	0..2..0	Prob. turning or carving post of a stand table

Ward, Miles | Cabinetmaker

LEDGER DATE	LEDGER ENTRY	PRICE	NOTES
02 00 1782	By his Acct rend'r [account rendered]	2..16..6	AB; entry probably the result of Gould's attorney Nathan Dane reviewing ledgers for omissions or for creditors making claims against the estate

West, Thomas Britnal | Cabinetmaker

LEDGER DATE	LEDGER ENTRY	PRICE	NOTES
11 00 1758	By making a Desk	2..18..8	22..0..0; prob. for Captain Crispus Brewer
11 00 1758	By Making 3 Tables	1..15..0	13..2..6; prob. for Thomas Elkins
11 18 1758	By Making part of a Case Draw & Table	2..6..8	17..0..0; for Thomas Elkins
11 21 1758	By Making a Stand Tabel	0..9..4	3..10..0; for Thomas Elkins
03 00 1759	By 7 days work @ 22/6	1..1..0	7..17..6
05 18 1759	"This day sett all acomptt with Nath Gould & find Deu to me ye sum of 28..15 4 1/4 old tenor"	3..16..8	28..15..4 1/4

Whitemore, Edmund Jr. | Cabinetmaker

LEDGER DATE	LEDGER ENTRY	PRICE	NOTES
03 14 1782	By his acct rend'd [account rendered]	5..5..0	AB
03 14 1782	By 18 days work @ 4/8	4..3..8	AB
11 19 1782	By his Acct rend [account rendered]	3..18..0	AB

Wood, Thomas of Charlestown | Cabinetmaker

LEDGER DATE	LEDGER ENTRY	PRICE	NOTES
06 01 1761	*To 87 1/2 feet Walnut plank @ 5/*	2..18..4	28..15..0; price listed in DB does not reflect quantity
11 06 1761	*To Lock and Hinges for a Chest*	0..2..2 1/2	0..16..6
05 00 1762	*To 1 Sett of Blaises [finials]*	0..0..7 1/2	0..4..8; AB
05 00 1762	*To sundry peases of Mehogany*	0..0..9 1/2	0..6..0; AB
06 00 1762	*To 145 feet of Mehog'y @ /9d [mahogany]*	5..5..9	AB
08 21 1762	*By his acompt [account]*	4..10..8	34..0..0
00 00 1763	*By 200 feet Ceadar Timber @ 1/ in posts @ 8'd*	1..7..11	10..9..4; AB
00 00 1763	*By 150 foot of Ceader bords @ 4'd*	2..10..0	AB
00 00 1763	*By Charges on y'e Ceader*	0..1..3	0..9..4; AB
05 00 1763	*To 1 Cet [set] of blazes [finials]*	0..4..8	1..15..0
06 00 1763	*By 3 Ceader desks without brasses @ 60/*	9..0..0	AB; prob. (1) for Benjamin Pickman and (2) for James Freeman
06 00 1763	*By cash short pd on 3 other Desks*	0..11..7 1/2	AB
09 00 1763	*To 1 Doz'n Locks*	0..6..4	AB
09 00 1763	*To 20 pr [pairs] of Hinges @ 2 1/2d*	0..4..2	AB
11 00 1763	*To 1 set of brasses for Desk*	0..16..0	AB
11 00 1763	*To 5 Do [set] @ 16/ [brasses for desk]*	4..0..0	AB
07 00 1764	*To Maple bords & carting surveying*	7..10..0	AB
04 00 1765	*To 408 feet Mehogany @ 5/6 old tenor*	14..19..2 *	Price incorrect in AB, was 15..6..2 1/2
03 23 1766	*To 1 Doz rule joynt hinges*	0..6..0	
03 23 1766	*By 16 Ceader Desks [@ 3/]*	48..0..0	Possible customers all @ 4..0..0 resale: (5) Jonathan Mason, (3) Israel Dodge, (1) Israel Lovett, (2) Richard Manning, (2) Larkin Dodge, (1) John Gardner Jr., (1) Henry Williams, (1) Bartholomew Putnam
12 00 1766	*By 2 Ditto [cedar desks @ 3/]*	6..0..0	AB; poss. for (1) Ebenezer Bowditch and (1) William Lander
12 00 1766	*[By] 1 cheritree ditto @ 66/8 [desk, cherry]*	3..6..8	AB; for John Archer
06 00 1767	*By 1 Ceader desk 88/2*	4..8..2	AB; prob. for John Hodges
06 00 1767	*[By] 2 ditto @ 66/8 [desk]*	6..13..4	AB; prob. for John Hodges
06 00 1768	*By 3 Ceader Desks without brasses @ 60/*	9..0..0	AB; prob. (2) for Josiah Batchelder and (1) for John Gardner
07 21 1768	*To 33 feet Mahogony @ 1/*	1..13..0	
12 26 1768	*By 2 large Ceader Desks @ 88/ brds & cas'd [brassed and cased]*	8..16..0	Prob. for Ezekiel Fowler; AB states "brassed & cased," extra charge of 0..10..0
08 01 1769	*By 3 Large Cedar Desks bras'd & cas'd [brassed and cased]*	14..0..0	Prob. (1) for Israel Dodge, (1) for Charles Worthen, and (1) for Samuel Grant
10 00 1769	*By bast'd Mahogany Desk [brassed]*	4..13..4	AB; prob. for Daniel Cheever, then exported; only mahogany desk sold in 1769
12 00 1769	*By 2 large Ceader Desks bras'd & case [brassed and cased]*	9..6..8	AB; (1) for Nathan Leach and (1) for Josiah Batchelder
06 00 1770	*To charges on 7 Desks*	1..4..0	AB; this amounts to a backcharge on all 7 desks made by Wood in 1769
10 04 1770	*By 2 Ceader Desks @ 93/4*	9..6..8	For Jonathan Gardner
10 00 1770	*[To] Charges on 2 desks 9/*	0..9..0	AB; he is backcharged 0..9..0 presumably for repairs or adding hardware
00 00 1771	*By 3 Ceadar Desks without brasses @ 60/*	9..0..0	AB; prob. for Josiah Orne
02 00 1771	*To discount on Desks sold to Nath'l Leach*	0..13..4	For Nathaniel Leach, order 10/1769; evidently smaller desk than the charge indicates
03 28 1771	*By Cash Short Paid on 3 Desk[s]*	0..11..4	
05 00 1771	*By 4 Large Cedar desks @ 93/4*	18..13..4	AB; for Larkin Dodge
05 00 1771	*By cash short p'd [paid] on 3 other Desks*	0..11..7 1/2	AB
07 14 1772	*To 4 doz handles No. 1 @ 7/*	1..8..0	"No. 1" refers to English brass catalogue number
07 14 1772	*To 2 1/2 do [dozen] Escutcheons @ 3/6*	0..8..9	
07 14 1772	*To 4 Do [dozen] Handles No. 2 @ 8/*	1..12..0	"No. 2" refers to English brass catalogue number
07 14 1772	*To 2 1/2 do [dozen] Escutcheons @ 4/*	0..10..0	
07 14 1772	*To 2 Do [dozen] Handles No. 3 @ 10/6*	1..1..0	"No. 3" refers to English brass catalogue number
07 14 1772	*To 1 1/4 do [dozen] Escutcheons*	0..6..6	
07 14 1772	*To 1 Groce Knobbs No.12 [gross]*	0..5..4	AB
07 14 1772	*To 1 Do Do No. 13 [gross knobbs]*	0..8..8	"No. 13" refers to English brass catalogue number
07 14 1772	*To 1 Doz Do N 14 [gross knobbs]*	0..1..4	"N 14" refers to English brass catalogue number
07 14 1772	*To 1 Do Do No.15 [gross knobbs]*	0..1..8	"No. 15" refers to English brass catalogue number
07 14 1772	*To 4 Groce Wood Screws @ 2/6 [gross]*	0..10..0	
08 04 1772	*To 1/2 doz brass hinges @ 6/6*	1..19..0	

Wood, Thomas of Charlestown | Cabinetmaker

LEDGER DATE	LEDGER ENTRY	PRICE	NOTES
08 04 1772	*To 2 doz rule joynt hings @ 45/*	4..10..0	
08 04 1772	*To 2 do [doz rule joint] do [hinges] @ 40/*	4..0..0	
08 04 1772	*To 1 do [dozen] till locks 39/*	1..19..0	
08 04 1772	*To 2 do [dozen] do 39/ [till locks]*	3..18..0*	Price incorrect in DB, was 1..19..0
08 04 1772	*To 4 Groc screws @ 19/ [gross]*	3..16..0	
08 04 1772	*To 1 doz stand Ketches 7/ [catches]*	3..18..0	Total indicates unit price of 0..6..0 not 0..7..0
08 04 1772	*To 4 3 [dozen] in batens @ 24/ [battens]*	4..16..0	
08 04 1772	*To 4 2 [dozen] in do [battens] @ 17/*	3..8..0	
08 04 1772	*To 1 1 [dozen] in do [battens] 14/*	0..14..0	
08 04 1772	*To 2 doz handles @ 65/ 1 [illegible] 32/6*	8..2..6	
08 04 1772	*To 4 do [dozen] do [handles] @ 58/6*	11..14..0	
08 04 1772	*To 2 do [dozen] escutch @ 29/3 [escutcheons]*	2..18..6	
08 04 1772	*To 2 do [dozen] handles @ 32/6*	3..5..0	
08 04 1772	*To 1 1/3 do [dozen] escuth's @ 16/3 [escutcheons]*	1..4..6	
08 04 1772	*To 4 plain form @ 4/4*	0..17..4	
08 04 1772	*To 1 doz firmen [illegible] & gouges 45/*	2..5..0	
08 04 1772	*To 1 fish skin*	3..0..0	Total invoice for hardware was 64..5..10
08 04 1772	*To 155 feet of Mahogony @ 4/3*	32..18..9	Price reflects the very large increase in the cost of mahogany
05 01 1773	*By 1 Mehogony Desk*	7..6..8	For Thomas Roxwaiter, 06/26/1773
06 16 1773	*By Mahogony board*	1..0..0	
06 24 1775	*To Brasses for 4 Desks*	3..4..0	

	DEPARTURE DATE	CLIENT	ORDER	LEDGER DATE	VESSEL AND TONNAGE	MASTER	FIRST KNOWN DESTINATION	FINAL KNOWN DESTINATION
1	07 00 1758	Robert Shillaber	2 [cedar] desks	07 00 1758				
2	12 18 1758	Crispus Brewer	2 tables with cases	12 26 1758	Sch. *Two Brothers* (42 tons)	Crispus Brewer	West Indies	Monte Christo
3	01 00 1759	Joseph Trask	1 walnut desk, 1 table with cases	00 00 1759				
4	02 00 1759	Crispus Brewer	1 [mahogany] desk	02 24 1759	Sch. *Two Brothers* (42 tons)	Crispus Brewer		
5	02 03 1759	John Nutting Jr.	3 [maple] desks, 3 tables with cases	01 02 1759	Sch. *Dolphin* (56 tons)	John Hathorne	West Indies	
6	06 00 1759	Joseph Trask	1 maple desk	06 29 1759				
7	06 00 1759	Joseph Trask	1 black walnut table	06 30 1759				
8	08 00 1759	Crispus Brewer	1 [mahogany] desk	08 00 1759				
9	11 00 1759	Antony Reyke	1 mahogany desk with cases, 1 maple desk with cases, 6 mahogany tables, 1 maple table, and 1 card table, all with cases	11 26 1759				
10	11 00 1759	John Foster Jr.	1 case of tables	11 28 1759				
11	11 27 1759	Joseph Grafton Sr.	1 walnut desk with case, 2 maple desks with cases, 3 stand tables, 1 close stool	11 20 1759	Sch. *Wolf* (24 tons)	Joseph Grafton Jr.	West Indies	Guadaloupe
12	12 18 1759	Samuel Masury	1 maple desk with case	12 18 1759	Sch. *Eagle* (20 tons)	Samuel Masury	West Indies	
13	02 26 1760	Thomas Mason	1 maple desk	02 26 1760	Bgtne. *Salem* (96 tons)	Thomas Mason	West Indies	Guadaloupe
14	03 31 1760	John Gardner Jr.	1 [mahogany] desk with case, 1 maple table with case	01 23 1760	Sch. *Dolphin* (56 tons)	John Gardner Jr.	Virgin Islands	Tortola
15	06 23 1760	Joseph Grafton Jr.	1 cedar desk-and-bookcase with case, 2 cherry desks with cases, 3 tables with cases	06 03 1760	Sch. *Wolf* (24 tons)	Joseph Grafton Jr.	West Indies	
16	07 07 1760	John Gardner Jr.	2 walnut tables with cases	07 02 1760	Slp. *Dolphin* (45 tons)	John Gardner Jr.	Maryland	Maryland
17	10 26 1760	John Dean	4 cherry desks with cases, 2 mahogany tables with cases, 8 chairs	10 15 1760	Slp. *Windsor* (48 tons)	Mattis Whitworth	Jamaica	
18	01 00 1761	Ebenezer Beckford	2 desks	01 13 1761				
19	03 27 1761	Joseph Grafton Jr.	2 desk-and-bookcases with cases, 3 desk-and-presses with cases, 1 card table, 4 cedar desks with cases, 3 tables with cases	03 13 1761	Sch. *Apollo* (32 tons)	Joseph Grafton Sr.	Guadaloupe	
20	04 07 1761	Jonathan Cook	2 cherry desks, 1 walnut desk, 1 mahogany table, 6 maple tables	04 03 1761	Sch. *Neptune* (40 tons)	Samuel Grant	Maryland	
21	05 00 1761	Ebenezer Beckford	1 desk with case	05 07 1761				
22	08 18 1761	Samuel Grant	2 cherry desks	09 00 1761	Sch. *Neptune* (40 tons)	Samuel Grant	Maryland	Maryland
23	08 18 1761	Jonathan Cook	12 chairs, 1 cherry desk	09 00 1761	Sch. *Neptune* (40 tons)	Samuel Grant	Maryland	
24	10 17 1761	Joseph Dean Jr.	1 cherry desk, 1 black walnut desk	09 00 1761	Slp. *Windsor* (48 tons)	Joseph Dean Jr.	Jamaica	Jamaica
25	01 29 1762	John Gardner Jr.	1 table, 3 maple tables with cases, 1 veneered desk with case, 1 walnut desk with case, 1 cedar desk with case	01 26 1761	Bgtne. *Cicero* (82 tons)	John Gardner Jr.	West Indies	Guadaloupe
26	04 19 1762	David Masury	1 mahogany desk, 1 cedar desk, 1 maple desk all with cases	04 01 1762	Bgtne. *Sally* (78 tons)	David Masury	West Indies	Guadaloupe
27	10 06 1762	Jonathan Cook	1 mahogany desk with case	10 12 1762	Sch. *Neptune* (50 tons)	Jonathan Cook	Virginia	
28	10 23 1762	Mason and Williams	42 chairs, 3 convenient chairs, 2 settees	10 23 1762	Sch. *Volant* (70 tons)	Samuel Williams	West Indies	St. Martin's
29	11 04 1762	John Gardner Jr.	2 walnut desks, 1 maple desk	11 00 1762	Bgtne. *Cicero* (82 tons)	John Gardner Jr.	Martinico	Guadaloupe
30	11 23 1762	Philip Saunders Jr.	1 maple desk with case	11 00 1762	Sch. *Dolphin* (50 tons)	Philip Saunders Jr.	St. Kitts	Guadaloupe

	DEPARTURE DATE	CLIENT	ORDER	LEDGER DATE	VESSEL AND TONNAGE	MASTER	FIRST KNOWN DESTINATION	FINAL KNOWN DESTINATION
31	12 22 1762	**John Ropes III**	*1 walnut desk, 1 maple desk*	12 12 1762	Sch. *Molly* (70 tons)	John Ropes III	**Guadaloupe**	
32	03 23 1763	**Benjamin Pickman Esq.**	*1 cedar desk, 2 maple desks all with cases*	03 01 1763	Bgtne. *Bradford* (78 tons)	William Patterson	**Martinico**	**Grenada**
33	04 30 1763	**James Freeman**	*3 mahogany desks, 2 cedar desks all with cases, 14 chairs*	05 01 1763	Sch. *Margaret*	Samuel Freeman	**Louisbourg**	
34	08 06 1763	**John Gardner Jr.**	*1 maple desk, 2 mahogany side tables*	07 00 1763	Sch. *Industry* (70 tons)	John Gardner Jr.	**St. Kitts**	
35	11 19 1763	**Thomas Poynton**	*2 tea tables, 1 reading stand*	10 00 1763	Bgtne. *Salem* (90 tons)	Thomas Poynton	**Barbadoes**	**St. Martin's**
36	11 26 1763	**Ebenezer Beckford**	*half of 4 desks*	11 05 1763	Sch. *Hampton* (30 tons)	John Beckford	**North Carolina**	
37	12 00 1763	**William West**	*1 cedar desk and 3 cherry desks*	12 00 1763	Sch. *Lucretia* (50 tons)	George West	**North Carolina**	**North Carolina**
38	12 13 1763	**Mason and Williams**	*3 cedar desks, 3 maple desks*	11 00 1763	Sch. *Union* (50 tons)	Jonathan Mason	**Dominica**	**Guadaloupe**
39	12 13 1763	**Jonathan Mason**	*1 walnut desk, 1 maple desk*	12 00 1763	Sch. *Union* (50 tons)	Jonathan Mason	**Dominica**	**Guadaloupe**
40	00 00 1764	**Stephen Cook**	*1 maple desk*	00 00 1764				
41	04 14 1764	**John Gardner Jr.**	*1 mahogany desk, 1 walnut desk, 1 cedar desk, all with cases*	04 10 1764	Sch. *Industry* (70 tons)	John Gardner Jr.	**St. Vincent**	**Philadelphia**
42	06 00 1764	**Thomas Frye**	*1 walnut desk with case*	06 00 1764				
43	06 18 1764	**Josiah Orne**	*1 cedar desk, 2 mahogany tables, all with cases*	06 00 1764	Slp. *Hunter* (70 tons)	Josiah Orne	**Barbadoes**	**Surinam**
44	06 23 1764	**Thomas Aden**	*3 cedar desks, 1 walnut desk*	06 00 1764	Bgtne. *Mary* (90 tons)	Thomas Aden	**Dominica**	**Dominica**
45	06 23 1764	**Joseph Flint**	*1 maple desk*	06 16 1764	Bgtne. *Mary* (90 tons)	Joseph Flint	**Dominica**	**Dominica**
46	07 08 1764	**Israel Dodge**	*4 cedar desks*	07 00 1764	Sch. *Brittania* (90 tons)	Israel Dodge	**Dominica**	**Guadaloupe**
47	08 08 1764	**Philip Saunders Jr.**	*1 maple desk*	08 00 1764	Sch. *Neptune* (90 tons)	Philip Saunders Jr.	**St. Kitts**	**St. Croix**
48	11 00 1764	**Peter Frye Esq.**	*1 [cherry] desk with case*	11 00 1764		Peter Frye Esq.		
49	11 24 1764	**John Ropes III**	*1 walnut desk with case*	11 16 1764	Bgtne. *Brittania* (80 tons)	John Ropes III	**Barbados**	**Tortugas**
50	11 30 1764	**Samuel Grant**	*1 walnut desk with case*	11 30 1764	Slp. *Dove* (50 tons)	Samuel Grant	**Virginia**	**Maryland**
51	12 07 1764	**Benjamin Ober**	*7 ft of maple tables with casing*	12 11 1764	Sch. *Molly* (40 tons)	Benjamin Ober	**Maryland**	**Maryland**
52	01 09 1765	**Benjamin Pickman Esq.**	*1 walnut desk*	01 01 1765	Slp. *Love* (36 tons)	Samuel Chipman	**Barbadoes**	
53	03 09 1765	**William Patterson**	*2 cedar desks with cases*	03 07 1765	Bgtne. *Salem* (96 tons)	William Patterson	**Surinam**	**Surinam**
54	04 01 1765	**Jonathan Mason**	*3 cedar desks*	04 01 1765	Sch. *Union* (50 tons)	George Williams	**Dominica**	**Martinico**
55	05 10 1765	**Israel Dodge**	*2 cedar desks*	05 00 1765	Sch. *Brittania* (90 tons)	Israel Dodge	**West Indies**	**Guadaloupe**
56	05 16 1765	**Philip Saunders Jr.**	*1 walnut desk, 1 maple desk*	05 00 1765	Sch. *Neptune* (90 tons)	Philip Saunders Jr.	**Barbadoes**	**Guadaloupe**
57	05 25 1765	**John Gardner Jr.**	*3 cedar desks*	05 00 1765	Sch. *Industry* (70 tons)	John Gardner Jr.	**Dominica**	
58	06 00 1765	**Benjamin Pickman Esq.**	*4 mahogany desks, 1 cherry desk, 3 stand tables, all with cases*	06 00 1765				
59	06 05 1765	**Samuel Grant**	*1 cedar desk*	05 00 1765	Sch. *Industry* (25 tons)	Samuel Grant	**Dominica**	
60	06 07 1765	**Ebenezer Putnam**	*4 desks, 3 tables*	05 00 1765	Sch. *Porter* (70 tons)	John Scollay	**Maryland**	**Maryland**
61	06 07 1765	**Bartholomew Putnam Jr.**	*1 desk on separate account*	05 00 1765	Sch. *Porter* (70 tons)	John Scollay	**Maryland**	**Maryland**
62	08 12 1765	**Bartholomew Putnam Jr.**	*1/4 part for 4 desks, 2 mahogany tables*	08 00 1765	Sch. *Leopard* (60 tons)	Thomas Bufton	**West Indies**	
63	08 12 1765	**Gamaliel Hodges**	*1/2 for 4 cedar desks*	08 00 1765	Sch. *Leopard* (60 tons)	Thomas Bufton	**West Indies**	
64	08 12 1765	**John Hodges**	*1/4 part for 4 cedar desks*	08 00 1765	Sch. *Leopard* (60 tons)	Thomas Bufton	**West Indies**	
65	09 04 1765	**Benjamin Pickman Esq.**	*2 cherry desks with cases, 13 ft of maple tables, all with cases*	08 26 1765	Bgtne. *Bradford* (60 tons)	John Hathorne	**West Indies**	**Grenada**
66	09 10 1765	**John Ropes III**	*2 cherry desks with cases*	09 11 1765	Bgtne. *Brittania* (100 tons)	John Ropes III	**Barbados**	
67	09 26 1765	**Nicholas Bartlett**	*1 desk-and-bookcase, 1 mahogany desk, 1 chest of drawers, 14 ft of table, all with cases, 6 chairs*	09 24 1765	Sch. *Dove* (40 tons)	Nicholas Bartlett	**West Indies**	**St. Eustatius**
68	10 00 1765	**Benjamin Pickman Esq.**	*2 mahogany tables with cases*	10 17 1765		Benjamin Pickman		

	DEPARTURE DATE	CLIENT	ORDER	LEDGER DATE	VESSEL AND TONNAGE	MASTER	FIRST KNOWN DESTINATION	FINAL KNOWN DESTINATION
69	10 15 1765	Ebenezer Putnam	*"His part for 2 tables"*	10 00 1765	Sch. *Porter* (70 tons)	John Scollay Jr.	Maryland	Maryland
70	10 25 1765	Samuel Shillaber	*1 cherry desk*	11 02 1765	Sch. *Benjamin* (90 tons)	William Shillaber	West Indies	Guadaloupe
71	10 29 1765	John Gardner Jr.	*1 cedar desk*	10 00 1765	Sch. *Industry* (75 tons)	John Gardner Jr.	West Indies	Guadaloupe
72	10 29 1765	Israel Dodge	*1 cedar desk, 1 cherry desk*	11 20 1765	Sch. *Brittania* (75 tons)	Israel Dodge	West Indies	
73	11 00 1765	Henry Williams	*1 cedar desk*	09 05 1765	Sch. *Volant* (65 tons)	Henry Williams		
74	11 00 1765	Stephen Cook	*1 walnut table, 1 cherry table, 1 walnut desk*	11 00 1765				
75	11 01 1765	Philip Saunders Jr.	*1 chest, 1 cherry desk*	11 29 1765	Sch. *Neptune?* (90 tons)	Philip Saunders Jr.	Barbados	Guadaloupe
76	02 00 1766	Samuel Grant	*1 half of case of drawers, 1 table, 1 mahogany bedstead all with cases*	01 29 1766	Slp. *Harpswell* (70 tons)	Samuel Grant		St. Eustatius
77	03 19 1766	Larkin Dodge	*2 cedar desks, 1 cherry desk*	03 04 1766	Sch. *Neptune* (72 tons)	Larkin Dodge	West Indies	Guadaloupe
78	04 02 1766	Richard Manning	*2 cedar desks with cases*	03 00 1766	Bgtne. *Union* (115 tons)	Thomas Bowditch	West Indies	Martinico
79	04 15 1766	Bartholomew Putnam Jr.	*2 maple desks with cases*	04 00 1766	Sch. *Leopard* (60 tons)	Bartholomew Putnam	West Indies	St. Martin's
80	04 30 1766	Israel Lovett	*1 cedar desk, 1 cherry desk*	04 16 1766	Sch. *Cicero* (80 tons)	Israel Lovett		Guadaloupe
81	05 03 1766	Josiah Batchelder Jr.	*1 mahogany desk-and-bookcase, 1 cedar desk, 1 mahogany table, all with cases*	05 02 1766	Sch. *Dolphin* (80 tons)	Josiah Batchelder	West Indies	St. Croix
82	05 21 1766	Bartholomew Putnam Jr.	*2 maple desks with cases*	04 00 1766	Sch. *Porter* (70 tons)	John Scollay Jr.		Grenada
83	05 31 1766	Henry Williams	*1 cherry desk, 4 desks, all with cases*	05 31 1766	Sch. *Volant* (65 tons)	Henry Williams	West Indies	
84	06 24 1766	Israel Dodge	*1 maple desk, 2 cedar desks, 1 chest*	06 00 1766	Sch. *Brittania* (75 tons)	Israel Dodge	West Indies	Guadaloupe
85	07 00 1766	Jonathan Mason	*5 cedar desks, 1 cherry desk*	07 03 1766	Sch. *Union* (50 tons)	Jonathan Mason		
86	07 23 1766	John Gardner Jr.	*1 cherry desk, 1 cedar desk*	07 03 1766	Sch. *Industry* (75 tons)	John Gardner Jr.	West Indies	West Indies
87	08 00 1766	George Dodge	*2 cherry tables*	08 14 1766				
88	08 09 1766	Josiah Orne	*3 cedar desks, 2 with cases*	08 01 1766	Bgtne. *Caesar* (80 tons)	Josiah Orne	Barbados	
89	10 00 1766	Ebenezer Bowditch	*1 cedar desk with case*	10 15 1766				
90	11 26 1766	John Archer Jr.	*1 cherry desk with case*	12 00 1766	Sch. *Patty* (72 tons)	John Archer Jr.	South Carolina	Guadaloupe
91	11 28 1766	William Lander	*1 cedar desk with case*	11 29 1766	Slp. *Ranger* (65 tons)	John Lander	West Indies	Grenada
92	12 13 1766	Thomas Frye	*"cedar desk sold for me in the West Indies"*	06 00 1767	Sch. *Mercury* (55 tons)	Thomas Frye	West Indies	Turk's Island
93	02 14 1767	Benjamin Lovett	*2 cedar desks with cases*	01 00 1767	Slp. *Hannah* (60 tons)	Benjamin Lovett	West Indies	Martinico
94	02 18 1767	Israel Dodge	*1 cedar desk with case, 1 meal chest*	02 20 1767	Sch. *Brittania* (75 tons)	Israel Dodge	West Indies	Guadaloupe
95	03 30 1767	John Gardner Jr.	*2 cedar desks*	03 04 1767	Sch. *Industry* (75 tons)	John Gardner Jr.	West Indies	West Indies
96	05 00 1767	Robert Shillaber	*Payment for "part of sundries"*	11 00 1767	Bgtne. *Greyhound* (100 tons)	David Masury	West Indies	Alicant
97	05 08 1767	Jonathan Mason	*5 cherry desks*	05 11 1767	Sch. *Union* (50 tons)	Jonathan Mason	West Indies	Monte Christo
98	05 26 1767	George Smith	*1 mahogany desk with case, 1 cedar desk, 1 walnut desk, 1 small cedar desk, 1 small cedar desk with maple ends, 1 cherry desk*	05 28 1767	Sch. *Molly* (70 tons)	George Smith	Barbados	St. Eustatius
99	06 00 1767	David Britton	*1 cedar desk with case*	05 26 1767				
100	06 19 1767	Samuel Masury	*1 maple desk*	06 17 1767	Sch. *Anna/Anne* (45 tons)	Samuel Masury	Turk's Island	Turk's Island
101	06 22 1767	John Hodges Jr.	*3 cedar desks with cases*	06 16 1767	Sch. *General Wolfe* (80 tons)	John Hodges Jr.	Dominica	Monte Christo
102	06 26 1767	Josiah Batchelder Jr.	*1 cedar desk, 1 cedar desk with pine drawers, all with cases*	06 25 1767	Sch. *True Briton* (80 tons)	Josiah Batchelder	West Indies	Jamaica
103	08 00 1767	Ebenezer Bowditch	*1 maple desk with case*	08 00 1767	Slp. *Mary* (80 tons)	John Bowditch		Martinico

	DEPARTURE DATE	CLIENT	ORDER	LEDGER DATE	VESSEL AND TONNAGE	MASTER	FIRST KNOWN DESTINATION	FINAL KNOWN DESTINATION
104	09 14 1767	**Larkin Dodge**	*2 cedar desks with cases*	09 06 1767	Sch. *Neptune* (72 tons)	Larkin Dodge	**West Indies**	
105	10 08 1767	**John Gardner Jr.**	*6 cedar desks*	10 00 1767	Sch. *Industry* (75 tons)	John Gardner Jr.	**West Indies**	
106	10 20 1767	**Israel Dodge**	*1 [maple] desk*	10 00 1767	Sch. *Brittania* (75 tons)	Israel Dodge	**Dominica**	
107	11 07 1767	**Daniel Cheever**	*1 maple desk*	11 00 1767	Slp. *Weymouth* (40 tons)	Samuel Cheever	**North Carolina**	
108	12 01 1767	**Samuel Shillaber**	*1 cherry desk with case*	12 24 1767	Sch. *Benjamin* (80 tons)	John Berry	**Dominica**	
109	01 27 1768	**Josiah Orne**	*5 cedar desks with cases, 1 chest*	01 28 1768	Sch. *Tryal* (75 tons)	Josiah Orne	**West Indies**	**Monte Christo**
110	02 25 1768	**Israel Lovett**	*1 cedar desk with case*	02 25 1768	Sch. *Cicero* (80 tons)	Mark Lovett	**West Indies**	
111	02 12 1768	**Philip Saunders Jr.**	*2 cherry desks with cases*	04 13 1768	Sch. *Neptune* (90 tons)	Philip Saunders Jr.	**West Indies**	
112	03 03 1768	**Samuel Grant**	*1 casing for case of drawers, 2 cedar desks with cases*	02 25 1768	Brig *Union* (115 tons)	Samuel Grant	**Dominica**	
113	06 00 1768	**Jonathan Gardner Jr.**	*1 cedar desk with case*	06 02 1768	Sch. *Industry* (78 tons)	Jonathan Gardner Jr.		
114	06 00 1768	**David Britton**	*"His part of sundries"*	11 00 1768	Bgtne. *Greyhound* (100 tons)	David Britton	**West Indies**	
115	06 07 1768	**Israel Dodge**	*2 cedar desks, 1 cherry desk, with cases*	06 06 1768	Sch. *Brittania* (75 tons)	Israel Dodge	**West Indies**	**St. Eustatius**
116	06 23 1768	**Josiah Batchelder Jr.**	*2 cedar desks with cases*	06 23 1768	Sch. *True Briton* or *Hawk*	Nathan Leach	**Dominica**	
117	06 23 1768	**Nathaniel Leach**	*2 cedar desks with cases*	06 23 1768	Sch. *True Briton* or *Hawk*	Nathan Leach	**Dominica**	
118	07 00 1768	**Charles Worthen**	*2 cedar desks, 2 mahogany tables, all with cases*	07 07 1768	Sch. *Sally* (78 tons)	Charles Worthen		
119	07 00 1768	**Woods & Waters**	*1 cedar desk*	07 15 1768				
120	09 27 1768	**Israel Lovett**	*2 cedar desks*	09 26 1768	Sch. *Cicero* (80 tons)	Mark Lovett		
121	10 10 1768	**Josiah Batchelder Jr.**	*1 cedar desk*	10 05 1768	Sch. *Hawk*	Josiah Batchelder	**Dominica**	
122	10 17 1768	**Samuel Saunders**	*4 cedar desks with cases*	10 14 1768	Brig *Conway* (90 tons)	Samuel Saunders	**Dominica**	
123	10 31 1768	**John Gardner Jr.**	*1 cedar desk, 1 cherry desk*	10 22 1768	Sch. *Industry* (75 tons)	John Gardner Jr.	**Dominica**	
124	12 28 1768	**Robert Shillaber**	*part of 4 desks*	12 00 1768	Sch. *Speedwell* (50 tons)	John Tucker	**West Indies**	
125	12 28 1768	**Charles Worthen**	*part of 4 desks*	12 23 1768	Sch. *Speedwell* (50 tons)	John Tucker	**West Indies**	
126	12 28 1768	**Thorndick Procter**	*part of 4 desks*	12 00 1768	Sch. *Speedwell* (50 tons)	John Tucker	**West Indies**	
127	12 28 1768	**Ezekiel Fowler & Co**	*2 cedar desks; part of 4 desks*	12 30 1768	Sch. *Speedwell* (50 tons)	John Tucker	**West Indies**	
128	01 00 1769	**Henry Higginson**	*1 cedar desk*	01 12 1769	Sch. *Two Brothers*? (66 tons)	Stephen Higginson		
129	01 00 1769	**Thomas Frye**	*1 cedar desk*	06 14 1769	Sch. *Molly* (70 tons)	Thomas Frye	**West Indies**	
130	01 01 1769	**Charles Worthen**	*1 large desk*	12 23 1768	Sch. *Sally* (78 tons)	Charles Worthen	**West Indies**	
131	01 09 1769	**Samuel Grant**	*1 cedar desk, 1 mahogany table with case, 1/2 case of drawers*	12 30 1768	Brig *Union* (115 tons)	Samuel Grant	**West Indies**	
132	02 00 1769	**Daniel Cheever**	*1 mahogany desk with case, 1 cedar desk, 1 cherry desk*	02 02 1769	Slp. *Weymouth* (40 tons)	Samuel Cheever	**North Carolina**	
133	02 00 1769	**Wyer & Turner**	*3 cedar desks with cases, 1 cedar desk with maple ends with case*	02 02 1769				
134	03 00 1769	**George Osborn**	*2 cedar desks*	03 17 1769				
135	03 02 1769	**Henry Williams**	*2 cedar desks*	03 09 1769	Sch. *Salem*	Henry Williams	**West Indies**	
136	05 19 1769	**Stephen Higginson**	*1 cherry desk with case*	05 18 1769	Sch. *Two Brothers* (66 tons)	Stephen Higginson	**West Indies**	
137	05 22 1769	**John Gardner Jr.**	*2 cedar desks, 2 cherry desks*	05 16 1769	Sch. *Lydia*	John Gardner Jr.	**West Indies**	
138	06 00 1769	**Israel Lovett**	*1 cedar desk*	06 00 1769				
139	06 20 1769	**John Archer Jr.**	*1 cedar desk with case*	06 20 1769	Sch. *Patty* (72 tons)	John Archer Jr.	**West Indies**	
140	07 00 1769	**Samuel Shillaber**	*1 cedar desk with case*	07 08 1768				
141	07 10 1769	**Samuel Grant**	*1 cedar desk*	07 01 1769	Brig *Union* (115 tons)	Samuel Grant	**West Indies**	
142	08 08 1769	**Israel Dodge**	*1 cedar desk, 1 cherry desk, 1 maple desk*	08 00 1769	Sch. *Brittania* (75 tons)	Israel Dodge	**West Indies**	
143	08 14 1769	**Charles Worthen**	*1 cedar desk, 1 small desk*	08 12 1769	Sch. *Sally* (78 tons)	Charles Worthen	**West Indies**	
144	10 00 1769	**Jonathan Turner Jr.**	*2 maple desks with cases*	10 00 1769				
145	10 30 1769	**Nathaniel Leach**	*1 cedar desk*	10 21 1769	Sch. *Hawk*	Nathaniel Leach	**Dominica**	

	DEPARTURE DATE	CLIENT	ORDER	LEDGER DATE	VESSEL AND TONNAGE	MASTER	FIRST KNOWN DESTINATION	FINAL KNOWN DESTINATION
146	10 30 1769	Josiah Batchelder Jr.	*1 cedar desk, 3 tables, all with cases*	10 00 1769	Sch. *Hawk*	Josiah Batchelder	**Dominica**	
147	01 22 1770	Charles Worthen	*1 cherry desk, 2 mahogany desks with cases, 1 stand table with case*	01 17 1770	Sch. *Sally*	Charles Worthen	**West Indies**	
148	03 19 1770	Israel Dodge	*1 cedar desk, 1 mahogany table, all with cases*	02 26 1770	Sch. *Brittania* (75 tons)	Israel Dodge	**West Indies**	
149	05 07 1770	Henry Williams	*1 cherry desk with case*	05 00 1770	Sch. *Salem* (80 tons)	Henry Williams	**West Indies**	
150	07 09 1770	Charles Worthen	*1 mahogany table, cherry tables with cases, 1 maple desk with case*	06 30 1770	Sch. *Sally*	Charles Worthen	**West Indies**	
151	08 00 1770	Israel Dodge	*1 maple desk*	08 05 1770				
152	08 27 1770	Robert Alock	*4 maple desks with cases*	08 18 1770	Sch. *Betsey*	Robert Alcock	**Newfoundland**	**[Barbadoes]**
153	09 10 1770	Josiah Batchelder Jr.	*2 mahogany tables with cases*	09 27 1770	Sch. *Volante*	Josiah Batchelder	**West Indies**	
154	10 15 1770	Jonathan Gardner Jr.	*2 cedar desks*	10 04 1770	Sch. *Lydia*	Jonathan Gardner Jr.	**West Indies**	
155	01 00 1771	David Masury	*3 maple desks*	01 10 1771	[Brig Greyhound]	David Masury		
156	02 29 1771	Israel Dodge	*1 maple desk with case, 2 cherry desks, 2 tables with cases, 1 bedstead*	02 02 1771	Sch. *Brittania* (75 tons)	Israel Dodge	**West Indies**	
157	04 15 1771	John Gardner Jr.	*2 cherry desks, 1 maple desk*	04 06 1771	Sch. *Lydia*	John Gardner Jr.	**West Indies**	
158	05 27 1771	Charles Worthen	*1 desk, 1 table, 8 drawers with locks*	05 00 1771	Sch. *Sally*	Charles Worthen	**West Indies**	
159	06 00 1771	Peter Frye Esq.	*1 cherry desk with case*	06 00 1771				
160	06 17 1771	Josiah Orne	*3 cedar desks*	06 00 1771	Brig *Essex*	Josiah Orne	**West Indies**	
161	06 17 1771	Larkin Dodge	*4 cedar desks*	06 00 1771	Sch. *Neptune* (72 tons)	Dodge Larkin	**West Indies**	
162	07 23 1771	Israel Dodge	*3 cedar desks*	08 00 1771	Sch. *Brittania* (75 tons)	Israel Dodge	**West Indies**	
163	08 26 1771	William Lander	*1 cherry desk with case*	08 00 1771	*Magna Charta*	William Lander	**West Indies**	
164	09 00 1771	Jonathan Gardner Jr.	*2 cedar desks*	09 28 1771	Sch. *Lydia*	Jonathan Gardner Jr.		
165	10 00 1771	Josiah Batchelder Jr.	*1 cedar desk*	10 12 1771	*Hawk* or *True Briton*	Josiah Batchelder		
166	10 00 1771	Henry Higginson	*1 cedar desk*	10 12 1771	Sch. *Two Brothers* (66 tons)	Stephen Higginson		
167	10 10 1771	Jonathan Gardner Jr.	*1 cedar desk*	10 10 1771	Sch. *Lydia*	Jonathan Gardner Jr.		
168	11 00 1771	Jonathan Tucker	*1 cedar desk with case*	09 14 1771	Sch. *Speedwell*	Jonathan Tucker		
169	11 00 1771	Peter Frye, Esq.	*1 cherry desk with case*	11 18 1771				
170	11 19 1771	Nathaniel Leach	*2 cedar desks, 1 desk*	12 02 1771	Sch. *True Briton*	Nathaniel Leach	**West Indies**	
171	12 02 1771	Larkin Dodge	*1 cedar desk*	11 25 1771	Sch. *Neptune*	Larkin Dodge	**West Indies**	
172	02 00 1772	John Buffington	*1 maple desk*	02 00 1772	Sch. *Tryal*	John Buffington		
173	03 30 1772	Israel Dodge	*1 desk, 2 tables all with cases*	03 00 1772	Sch. *Brittania* (75 tons)	Israel Dodge	**West Indies**	
174	04 00 1772	Nathaniel Leach	*3 cedar desks, 2 mahogany tables*	04 01 1772	[Sch. *True Briton*]	Nathaniel Leach		
175	04 00 1772	Jonathan Gardner Jr.	*1 cedar desk*	04 12 1772	[Sch. *Lydia*]	Jonathan Gardner Jr.		
176	04 27 1772	Josiah Orne	*2 cedar desks*	04 01 1772	Brig *Essex*	Josiah Orne	**West Indies**	
177	06 00 1772	Larkin Dodge	*2 cedar desks*	06 16 1772				
178	07 00 1772	Josiah Batchelder Jr.	*2 cedar desks, 2 tables*	07 28 1772	*Hawk* or *True Briton*	Josiah Batchelder		
179	07 13 1772	Daniel Jacobs	*2 mahogany tables with cases*	06 00 1772	Sch. *True Briton*	Daniel Jacobs	**West Indies**	
180	07 13 1772	Nathaniel Leach	*payment for 1 cedar desk, 1 cedar desk with glass door and claw feet, 12 chairs, 3 large chairs*	02 07 1773	Sch. *True Briton*	Nathaniel Leach	**West Indies**	
181	09 21 1772	Jonathan Gardner Jr.	*1 cedar desk with case*	09 11 1772	Sch. *Lydia*	Jonathan Gardner Jr.	**West Indies**	
182	10 00 1772	Jacob Crowninshield	*2 cedar desks with cases*	10 10 1772				
183	11 00 1772	Nicolas Thorndike	*1 cedar desk with case*	11 01 1772				
184	12 00 1772	Nathaniel Barbour	*1 cedar desk with case*	12 19 1772				
185	01 00 1773	Israel Dodge	*1 cedar desk*	01 22 1773	Sch. *Brittania* (90 tons)	Israel Dodge		
186	02 00 1773	Josiah Batchelder Jr.	*2 cedar desks with claw feet, 2 tables*	02 07 1773	Sch. *Volante* or *True Briton*	Josiah Batchelder Jr.		

	DEPARTURE DATE	CLIENT	ORDER	LEDGER DATE	VESSEL AND TONNAGE	MASTER	FIRST KNOWN DESTINATION	FINAL KNOWN DESTINATION
187	03 23 1773	**Jonathan Tucker**	*1 mahogany desk*	03 12 1773	Sch. *Betsey*	Jonathan Tucker	**West Indies**	
188	03 29 1773	**Samuel Waters**	*1 cedar desk*	03 26 1773	Sch. *Benjamin*	Samuel Waters	**West Indies**	
189	04 00 1773	**Josiah Batchelder Jr.**	*1 cedar desk with glass door and claw feet*	04 01 1773	Sch. *Volante* or *True Briton*	Josiah Batchelder		
190	05 10 1773	**Daniel Adams**	*2 tables with cases*	05 00 1773	Sch. *Hephzibah*	Daniel Adams	**West Indies**	
191	09 09 1773	**Nathaniel Leach**	*1 cedar desk with claw feet*	09 09 1773	Sch. *Volante*	Nathaniel Leach	**West Indies**	
192	10 00 1773	**Joseph Trask**	*1 cherry desk with case*	10 07 1773				
193	11 08 1773	**Bartholomew Putnam Jr.**	*2 cedar desks with cases, 2 [mahogany] tables with cases, 1 stand table*	11 03 1773	Sch. *General Wolfe*	John Hodges Jr.	**West Indies**	
194	04 00 1774	**Thomas Manning**	*1 [cedar] desk*	04 19 1774				
195	04 12 1774	**Nathaniel Leach**	*2 cedar desks, 1 mahogany desk, 1 stand table*	04 12 1774	Sch. *Volante*	Nathaniel Leach	**West Indies**	
196	04 12 1774	**Josiah Batchelder Jr.**	*1 cedar desk*	04 12 1774	Sch. *Volante*	Nathaniel Leach	**West Indies**	
197	07 00 1774	**William Bartlett**	*1 cedar desk and case*	07 06 1774				
198	10 00 1774	**Jonathan Gardner Jr.**	*1 card table with case, 2 cedar desks*	10 05 1774	[Sch. *Lydia*]			
199	10 00 1774	**Samuel Grant**	*4 desks*	10 15 1774	[Sch. *Industry*]	Samuel Grant		
200	01 08 1775	**Nathaniel Leach**	*2 cedar desks, 1 mahogany desk*	01 07 1775	Sch. *Volante*	Nathaniel Leach	**[West Indies]**	
201	04 03 1775	**Jonathan Gardner Jr.**	*1 cedar desk*	03 22 1775	Sch. *Lydia*	Jonathan Gardner Jr.	**West Indies**	
202	06 00 1775	**John Colston**	*4 cedar desks*	06 24 1775				
203	03 00 1777	**Nathan Nichols**	*3 tables, 1 desk*	03 15 1777	Slp. [unnamed]			
204	01 00 1779	**Israel Dodge**	*1 desk with case*	01 09 1779	Sch. *Brittania* [(90 tons)]	Israel Dodge		

APPENDIX D: Furniture Orders Associated with Weddings

	NAME / AGE OF GROOM	NAME / AGE OF BRIDE	DATE AND PLACE OF WEDDING	LEDGER DATE	ORDER TOTAL	PURCHASER
1	Appleton, John / 28	Jane Sparhawk / 19	10 06 1767 Boston	10 00 1767		Groom
2	Ashby, David / 24	Mary Field / 23	06 03 1781 (int.) Salem	06 23 1781		Groom
3	Barnard, Dr. Edward / 25	Judith Herbert / approx. 25	01 07 1781 Wenham	02 00 1781	47..10..8*	Groom
4	Barnard, Thomas Jr. / 25	Lois Gardner / 31	05 31 1773 Salem	06 04 1773	68..18..6	Groom
5	Batchelder, Josiah / 22	Hannah Dodge / 20	02 17 1760 Beverly	04 10 1765		Groom
6	Boden, William	Experience Downing	07 18 1774 (cert.) Salem	12 10 1774		Groom
7	Bradish, Billings / 23	Sarah Austin / 19	02 10 1765 Charlestown	02 00 1765		Groom
8	Brewer, Crispus / 24	Anna Gardner / 19	09 19 1758 Salem	09 23 1758		Groom
				10 04 1758		Groom
				09 23 1758		Bride's father, Daniel Gardner
9	Brooks, Captain John / 31	Sally Hathorne	01 02 1781 Salem	03 00 1781 (BEGINNING)		Groom
10	Brown, Henry	Mary Williams	07 30 1780 Salem	08 01 1780	2414*	Groom
11	Buffington, Nehemiah / 29	Elizabeth Proctor	09 14 1774 Danvers	10 01 1774	11..6..8	Groom
12	Cabot, Andrew / 22	Lydia Dodge / 24	03 28 1773 Beverly	05 00 1773		Bride's father, George Dodge
				05 18 1773	24..0..0	Groom
13	Cabot, Francis Jr. / 22	Nancy Clarke / 18	01 28 1780 Salem	01 27 1780		Groom
14	Cabot, George / 21	Elizabeth Higginson / 17	02 22 1774 Salem	03 26 1774		Groom
15	Cabot, John / 34	Hannah Dodge	05 09 1779 (int.) Beverly	10 09 1779	26..13..4	Groom
				05 00 1779		Bride's father or brother, George Dodge
16	Cabot, Joseph / 22	Rebecca Orne / 20	08 04 1768 Salem	08 01 1768	111..13..4	Bride
17	Cabot, Stephen / 22	Deborah Higginson / 23	03 29 1777 (cert.) Salem	02 25 1777		Groom
				05 06 1777		Groom
18	Collier, Thomas / 23	Jane Foster	10 26 1766 Marblehead	07 00 1766		Bride's father, Joshua Foster
				10 00 1766		Bride's father, Joshua Foster
				01 17 1767		Groom
				03 00 1767		Groom
19	Cook, Jonathan Jr.	Love Heron	09 18 1781 (cert.) Salem	02 00 1781	2712*	Groom
20	Cox, Benjamin Jr.	Elizabeth Very / 21	12 01 1768 Salem	11 30 1768	2..17..4	Bride's father, Jonathan Very
21	Dasccerrotte, John	Lydia Gowen	11 27 1780 (int.) Salem	11 00 1780		Bride or (possibly) bride's mother
22	Deblois, George / 31	Sarah Deblois / approx. 18	12 25 1771 Boston	12 14 1771		Groom
				01 00 1772		Groom
23	Derby, Elias Hasket / 22	Elizabeth Crowninshield / 25	04 23 1761 Salem	01 08 1761		Bride's father, John Crowninshield
				05 07 1761		Bride's father, John Crowninshield
				01 00 1762		Groom
				08 00 1762		Groom
24	Dodge, Israel / 27	Lucia Pickering / 18	06 17 1766 Salem	06 00 1766		Groom
				11 00 1766	11..18..8	Bride's father, Timothy Pickering
25	Dodge, Joshua / 23	Elizabeth Crowninshield / 19	04 05 1777 (cert.) Salem	05 01 1777	62..5..4	Groom
26	Donaldson, John	Sarah Hecleton	07 19 1780 Salem	08 00 1780	34..19..0	Groom
27	Dunham, Benjamin	Hannah Daland / 18	07 25 1779 (int.) Salem	07 24 1779		Bride's father, Benjamin Daland
28	Elkins, Thomas / 21	Elizabeth White / 21	11 07 1758 Salem	11 07 1758		Groom
29	Endicott, Samuel	Sally Putnam / 20	10 07 1777 Danvers	11 07 1777	92..10..0*	Bride's father, Edmund Putnam
30	Estes, Nathaniel / approx. 23	Elizabeth Knight	08 00 1764 Salem	07 00 1764	2..12..0	Groom's father, Abijah Estes
31	Fisher, John / approx. 27	Anna Wentworth	06 10 1763 Portsmouth, NH	11 22 1764	67..4..4	Bride's father, Mark Hunking Wentworth
32	Flagg, Samuel / 35	Dorothy Drowne / 33	08 30 1772	10 00 1772		Bride's father, Thomas Drowne
				10 00 1772		Groom
33	Foster, Gideon / 22	Mercy Jacobs / approx. 22	06 18 1771 Danvers	08 01 1771		Groom
34	Freeman, James / approx. 29	Deborah Tasker / 26	10 01 1758 Marblehead	09 23 1758		Bride's father, John Tasker
				04 23 1759		Bride's father, John Tasker
				06 04 1759		Bride's father, John Tasker
35	Frye, William / approx. 24	Tamson Southwick / 22	11 02 1773 Salem	03 29 1774	2..2..8	Bride's father, Joseph Southwick
36	Gardner, Henry / 22	Sarah Turner / approx. 21	10 19 1769 Salem	10 00 1769	20..0..0	Groom

#	NAME / AGE OF GROOM	NAME / AGE OF BRIDE	DATE AND PLACE OF WEDDING	LEDGER DATE	ORDER TOTAL	PURCHASER
				11 00 1769	76..0..8	Bride's father, Jonathan Turner
37	Gerry, Thomas / 24	Tabitha Skinner / 17	09 27 1759 Marblehead	08 18 1759	44..5..4	Bride
38	Goodhue, Benjamin / 30	Frances Richie / 26	01 06 1778 (ca.) Philadelphia	02 00 1778		Groom
39	Goodhue, William Jr. / 29	Elizabeth Davis / 18	04 23 1777 Boston	08 00 1777	19..1..6*	Groom
40	Gould, James Wood / approx. 21	Mary Watts / approx. 18	04 07 1782 (cert.) Salem	04 00 1782		Groom
41	Grant, Samuel / 22	Elizabeth Dolhonde/ 20	12 28 1762 (int.) Salem	01 25 1763		Groom
42	Gray, William / 31	Elizabeth Chipman / 25	03 28 1782 Salem	05 18 1782	8..8..0*	Groom
43	Gray, Winthrop	Mary Gray / 21	10 11 1764 (int.) Salem	11 01 1764	7..5..4	Bride's father, Abraham Gray
44	Hacker, Jeremiah	Anne Southwick / 21	04 07 1765 Salem	04 15 1765	4..4..0	Bride's father, Joseph Southwick
45	Hall, Captain James / 27	Mary Watson / 23	03 27 1760 Medford	03 16 1760		Bride's father or brother, Jonathan Watson
46	Hathorne, John / 23	Susannah Herbert,	10 18 1772 Salem	11 00 1772		Groom
47	Herrick, Samuel	Elizabeth Flint / approx. 20	11 19 1767 Reading	01 21 1768		Bride's father, Amos Flint
48	Hibbert, Jeremiah	Martha Lee / approx. 23	10 03 1776 Manchester	12 04 1776	8..13..4	Bride's father, John Lee
49	Hopkins, Daniel / approx. 36	Susannah Saunders / approx. 17	03 07 1771 Salem	05 03 1771	10..0..0	Bride's father, Jonathan Saunders
				06 00 1771	2..8..2	Groom
50	Ingersoll, Samuel / 28	Susannah Hathorne / approx. 26	10 00 1772 Hampton, NH	11 00 1772		Bride or Bride's mother, Susannah Touzel Hathorne
				05 08 1773		Groom
51	Jackson, Jonathan / 24	Sarah Barnard / 25	01 03 1767 Salem	12 00 1766	12..2..0	Groom
52	Jenkins, John / 23	Elizabeth Davis / approx. 23	09 23 1775 (int.) Salem	12 00 1775	3..3..4	Groom
53	Jenks, John / 24	Hannah Andrew / approx. 27	11 03 1776 Salem	11 00 1776	8..2..4	Groom
54	Lander, Benjamin	Abigail Gould	11 07 1778 (int.) Salem	12 00 1778		Groom
55	Lander, Peter / 25	Rebecca Brown	06 01 1768 Salem	09 03 1768		Groom's father, William Lander
				09 16 1768		Groom's father, William Lander
56	Leach, John Jr. / approx. 20	Elizabeth Hacker	07 30 1758 (int.) Salem	08 18 1758		Groom
57	Lee, Joseph of Beverly / 25	Elizabeth Cabot / approx. 22	06 09 1769	01 11 1770	45..4..3	Groom
58	Lee, Joseph of Marblehead / 22	Hannah Hinckley / 20	10 09 1771 Barnstable	08 20 1772	81..18..0	Groom's father, Jeremiah Lee
59	Lowell, John / 23	Sarah Higginson / 21	01 03 1767 Salem	11 00 1766		Bride's mother, widow Elizabeth Cabot Higginson
60	Lowell, John / 30	Susanna Cabot / approx. 20	05 31 1774 Salem	07 06 1774		Bride's father, Francis Cabot
61	Mackintire, David	Gartrude Flint / approx. 26	01 08 1770 Reading	05 00 1770		Bride's father, Amos Flint
62	McIntire, Archelaus / 32	Abigail Felton / approx. 31	02 05 1761 Danvers	01 00 1761	30..0..0	Groom
				02 00 1761	15..0..0	Groom
63	Mason, Thomas Jr. / approx. 24	Eunice Diman / 22	04 12 1774 (int.) Salem	01 17 1774		Groom
				05 00 1774		Groom
				07 00 1774		Groom
64	Millen, Robert / 23	Mercy Mansfield	10 16 1760 Salem	09 24 1760		Groom
65	Mugford, John / approx. 24	Judith Reeves / approx. 24	11 15 1759 Salem	08 00 1759		Groom
66	Needham, Isaac / 22	Betty Pope / approx. 21	01 12 1769 Danvers	02 18 1769	17..6..0	Groom
67	Newhall, Jeremiah / 23	Elizabeth Grant / approx. 24	04 07 1761 Salem	04 10 1761		Groom or groom's father with same name
68	Nichols, Ichabod / 24	Lydia Ropes / 19	04 12 1774 (cert.) Salem	03 15 1774		Groom
69	Nichols, Nathan	Abigail Kempton / 20	10 05 1776 (int.) Salem	03 15 1777		Groom
70	Nichols, Samuel	Sara Cane	05 10 1781 Salem	03 03 1781	1850*	Groom
71	Norris, John / approx. 27	Mary Herbert / approx. 21	02 22 1778 Salem	01 00 1778	36..0..0*	Groom
72	Northey, Abijah / 24	Abigail Wood	10 31 1765 Charlestown	09 00 1765		Groom
73	Northey, William / approx. 28	Rebecca Collins / approx. 25	01 25 1764 Lynn	03 00 1764	12..15..4	Bride's father, Zaccheus Collins
				04 16 1764		Groom
				05 22 1764		Groom
74	Nurse, Benjamin Jr.	Margaret Welcomb	04 16 1774 (int.) Salem	07 06 1774		Groom's father, Benjamin Nurse

	NAME / AGE OF GROOM	NAME / AGE OF BRIDE	DATE AND PLACE OF WEDDING	LEDGER DATE	ORDER TOTAL	PURCHASER
75	Odell, James	Sarah Frye	07 09 1761 Salem	11 18 1761		Groom or groom's father with same name
76	Oliver, Dr. Peter	Love Pickman Frye / 20	12 04 1774 Salem	12 24 1774		Bride's father, Peter Frye Esq.
				12 31 1774		Bride's father, Peter Frye Esq.
				01 00 1775		Bride's father, Peter Frye Esq.
				01 09 1775	48..14..8 (TOTAL)	Bride's father, Peter Frye Esq.
77	Orne, Joshua / approx. 30	Mary Lee / 35	11 20 1777 Marblehead	09 23 1777		Bride's father, John Lee
78	Orne, Josiah / approx. 22	Alice Palmer / approx. 20	05 16 1767 Salem	11 05 1767		Groom
				12 00 1767		Groom
79	Orne, Timothy III / approx. 21	Elizabeth Pynchon / 19	11 28 1771 Plaistow, NH	12 00 1771		Bride's father, William Pynchon
				01 00 1772		Bride's father, William Pynchon
80	Paine, Moses / approx. 24	Esther Gould	06 17 1756 Boston	09 01 1756		Groom
81	Paine, William / approx. 23	Lois Orne / 17	09 23 1773 Salem	10 00 1773	99..7..0	Groom
82	Palfry, Thomas	Sally Putnam / approx. 18	11 30 1780 Salem	05 00 1781		Bride's father, Bartholomew Putnam
				07 00 1781	22..18..10*	Groom
83	Pickering, John / 25	Hannah Ingersoll / approx. 19	08 06 1763 Salem	09 03 1763	7..6..8	Groom
84	Pickering, William / approx. 43	Elizabeth Gray	05 18 1780 (cert.) Salem	11 00 1780		Groom
85	Pickman, Benjamin Jr. / 21	Mary Toppan / 18	04 22 1762 Salem	05 00 1762		Bride's father, Dr. Bezaleel Toppan
				06 00 1762		Bride's father, Dr. Bezaleel Toppan
				07 00 1762		Bride's father, Dr. Bezaleel Toppan
				12 16 1762	5..6..8	Groom
86	Pickman, Clark Gayton / 23	Sara Orne / 18	07 24 1770 Salem	08 24 1770	120..8..0	Groom
87	Pickman, William / 28	Elizabeth Leavitt / 17	10 10 1776 (int.) Haverhill	10 00 1776		Groom
				11 23 1776		Groom
88	Prince, John / 28	Martha Derby / 18	09 16 1762 (int.) Salem	09 00 1763	41..6..8	Bride's father, Richard Derby
89	Procter, Thorndike Jr. / 45	Mary Goodhue / 33	02 21 1771 Salem	02 00 1771	13..6..8	Bride's father, William Goodhue
90	Putnam, Andrew / 24	Mary Page / 18	08 13 1774 (int.) Danvers	02 04 1775	14..0..0	Bride's father, Jeremiah Page
91	Ropes, Daniel / 23	Priscilla Lambert / approx. 22	11 19 1761 Salem	11 01 1761		Groom
92	Ropes, David Jr. / approx. 20	Priscilla Webb / approx. 20	10 09 1760 Salem	12 00 1760	1..1..4	Groom
93	Routh, Richard / 21	Abigail Eppes Jr. / 20	07 02 1771 Salem	06 00 1771	16..0..0	Groom
				07 00 1771		Bride's mother, widow Abigail Eppes
94	Safford, William	Thankful Goodale / approx. 23	12 25 1779 Salem	04 00 1780		Groom
95	Shillaber, Robert / 22	Elizabeth Proctor	11 30 1758 Salem or Danvers	07 00 1758		Groom
96	Smothers, Peter / approx. 22	Hannah Mugford / approx. 18	11 04 1779 (int.) Salem	11 00 1779	24..0..0*	Groom
97	Stacey, Benjamin	Sarah King / approx. 19	10 22 1758 Salem	01 16 1759		Groom
98	Stacey, Richard / approx. 27	Penelope Hazard / approx. 26	07 12 1759 Marblehead	07 23 1759	15..5..4	Groom
99	Stimson, Thomas / approx. 30	Rebeckah Browne	10 12 1765 (int.) Salem	06 00 1766		Groom
100	Sweetser, Samuel / approx. 25	Elizabeth Wells / approx. 18	01 20 1776 (int.) Salem	03 00 1776		Groom
101	Symonds, Benjamin	Abigail Buffum	01 07 1775 (int.) Salem	02 03 1775	2..8..0	Groom
102	Symonds, Jonathan III	Susanna Silver / approx. 20	12 03 1774 (int.) Salem	12 00 1774		Groom
103	Thorndike, Israel / 22	Mercy Trask / 20	10 09 1777 Beverly	10 24 1777		Groom
104	Tracy, Nathaniel / 23	Mary Lee / 21	02 28 1775 Marblehead	04 09 1775	135..3..4	Bride's father, Jeremiah Lee
105	Vans, William	Eunice (Nutting) Crowninshield	07 00 1775 (ca.)	08 00 1775	36..16..0	Groom
106	Waite, Aaron / approx. 24	Elisabeth Call	03 10 1766 Charlestown	00 00 1766		Groom
107	Walker, Alexander	Martha West / approx. 17	04 16 1770 Salem	04 00 1770		Groom
				05 00 1770		Bride's father, Samuel West Jr.
				11 00 1770		Groom
108	Walter, William	Lydia Lynde / 24	09 30 1766	08 00 1766	22..0..6	Bride's father, Benjamin Lynde

	NAME / AGE OF GROOM	NAME / AGE OF BRIDE	DATE AND PLACE OF WEDDING	LEDGER DATE	ORDER TOTAL	PURCHASER
109	Ward, Samuel / 27	Priscilla Hodges / approx. 18	01 02 1768 Salem	01 14 1768		Bride's father, Gamaliel Hodges
				02 00 1768	26..2..8 (TOTAL)	Bride's father, Gamaliel Hodges
110	Wentworth, Thomas / approx. 21	Ann Tasker / approx. 21	11 14 1761 Marblehead	11 03 1761		Bride's father, John Tasker
				05 03 1762		Bride's mother, widow Deborah Tasker
111	Wetmore, William / approx. 32	Sarah Waldo / 19	10 08 1782 Boston	10 18 1782		Groom
112	White, Isaac / 22	Sarah Leavitt / approx. 18	06 09 1776 Haverhill	07 00 1776		Groom
113	Whitemore, Edmund Jr. / approx. 24	Hannah Pierce	10 20 1774 Salem	01 18 1774		Groom
				10 00 1774	9..13..4 (TOTAL)	Groom
114	Williams, George Jr. / approx. 23	Mehitable West / 23	09 14 1777 (cert.) Salem	09 23 1777	29..14..0	Bride's father, William West
115	Williams, Henry / 26	Abigail Russell / approx. 20	11 01 1770 Andover	11 00 1770	37..6..4	Groom

APPENDIX E: Furniture Orders Associated with Children and Childbirth

	CLIENT	LEDGER ENTRY	PRICE	DATE OF BIRTH/BAPTISM	LEDGER DATE
1	**Appleton, John**	*oltering frame for Glass & putting up Beds*	0..4..0	John, 09 13 1773	07 00 1773
2		*paled [pallet] Bedstid*	0..20..0	John, 09 13 1773	09 00 1773
3		*Cradle*	0..13..4	John, 09 13 1773	11 00 1773
4	**Ashby, David**	*Pine cradle*	1..13..0*	Samuel, bp after 06 1781	11 00 1781
5	**Ashton, Jacob**	*Bedstead with fluted posts*	10..0..0*	Sarah, bp 07 1781	06 00 1781
6		*1 Chair Frame [easy]*	4..0..0*	Sarah, bp 07 1781	06 00 1781
7		*Set of bed rails*	0..12..0*	Sarah, bp 07 1781	06 00 1781
8		*Candlestand*	1..16..0*	Sarah, bp 07 1781	06 00 1781
9	**Barnard, Edward**	*Bed cornice*		Edward, 11 06 1781	09 00 1781
10	**Bartlett, Walter P.**	*1 Easey Chair Frame*	2..8..0*	Betsy, bp 02 16 1783	10 00 1782
11		*1 Bed Cornice*	1..16..0*	Betsy, bp 02 16 1783	11 00 1782
12		*Cot Bedstead*	0..18..0*	Betsy, bp 02 16 1783	11 14 1782
13		*Polishing bureau*	0..12..0*	Betsy, bp 02 16 1783	11 22 1782
14		*1 Sett Bed Rails*	0..10..0*	Betsy, bp 02 16 1783	11 22 1782
15		*1 Head posts*	0..6..0*	Betsy, bp 02 16 1783	11 22 1782
16	**Brewer, Crispus**	*Cradle*	0..13..4		06 00 1759
17	**Cabot, Andrew**	*To takeing Down & Seting up beds*	0..18..0	Sebastian, bp 01 16 1774	02 00 1774
18		*Cradle of B Wallt [walnut]*	1..16..0	Sebastian, bp 01 16 1774	02 00 1774
19		*Childs Crib*	0..13..4	Sebastian, bp 01 16 1774	07 00 1774
20	**Cabot, Francis Jr.**	*Mehog Cradle [mahogany]*		Francis, bp 11 12 1780	12 00 1780
21		*Bedstid High Posts*		Francis, bp 11 12 1780	12 00 1780
22	**Chandler, William Jr.**	*1 Cradle*	1..16..0		08 00 1780
23	**Cheever, Daniel**	*Child's coffin*	0..4..0	Joseph, bp 12 30 1764	09 00 1766
24	**Churchill, Joseph**	*2 low chairs*	0..6..8		08 00 1760
25		*Rockers for a cradle*	0..2..0		08 00 1760
26	**Collins, Enoch**	*Trundle Bed Stid*	0..12..0		07 00 1773
27	**Crowel, Samuel**	*1 Cradle*			07 00 1780
28	**Daland, Benjamin**	*Coffin for Child*	0..5..4		10 00 1765
29	**Deblois, George**	*Low chair*	0..12..0	Betsy, bp 11 22 1772	09 17 1772
30		*1 Bed Stid*	3..10..0	Betsy, bp 11 22 1772	11 00 1772
31		*1 Close stool*	0..6..0	Betsy, bp 11 22 1772	11 25 1772
32		*Rockers for chair*	0..2..0	Betsy, bp 11 22 1772	09 00 1772
33		*Childs Crib*	0..9..4	Betsy, bp 11 22 1772	06 04 1773
34	**Dodge, Joshua**	*1 Cot Bedsted*	0..10..0		11 00 1780
35		*1 Mohog Cradle [mahogany]*	0..42..0		11 00 1780
36		*Bedsted with High Posts*			01 00 1781
37	**Donaldson, John**	*1 pine Cradle*	0..33..0		08 16 1781
38	**Elkins, Captain Henry**	*a Cradle*	0..13..4	Henry, 07 04 1761	07 25 1761
39		*1 Bedstid*	0..13..4	Henry, 07 04 1761	07 25 1761
40	**Eppes, William Esq.**	*Cofin for Child*	0..4..8		07 00 1763
41	**Felt, John**	*Pine cradle*	1..10..0*	Mary, 11 26 1780; John 10 07 1782	02 00 1782
42	**Foster, John Jr.**	*Child Coffin*	0..4..8		09 00 1769
43	**Frye, Peter Esq.**	*[mending] Cradle*	0..5..0	Benjamin, 04 21 1765	08 00 1766
44		*Mending Cradle*	0..4..0	John, bp 07 16 1769	02 00 1771
45	**Gardner, Henry**	*Pine cradle*		Sally, 03 30 1782	05 00 1782
46	**Gardner, John, Jr.**	*a Cradle*	0..12..0	Elizabeth, 02 09 1759	07 12 1759
47	**Gavet, Jonathan**	*a Childs Cofen*	0..8..0		09 00 1761
48	**Glover, John**	*6 Small Mehogany Chairs*	8..8..0	Tabitha, bp 12 08 1765	12 00 1765
49		*1 Large Ditto [chair]*	1..17..4	Tabitha, bp 12 08 1765	12 00 1765
50	**Goodale, Nathan**	*maple bedstid*	0..16..0	Francis Cabbot, bp 09 27 1772	09 17 1772
51		*wallnut Cradle*	1..10..0	Francis Cabbot, bp 09 27 1772	10 00 1772
52		*Trundle Bed Stid*	0..16..0	Francis Cabbot, bp 09 27 1772	02 00 1774
53		*Childs Cribb*	0..13..4	Francis Cabbot, bp 09 27 1772	07 13 1774
54	**Goodhue, William Jr.**	*Cradle*	6..12..0	William, 03 08 1778	04 28 1778
55	**Hood, Joseph**	*frame of Easy Chair*	1..6..8	Elisabeth, bp 06 18 1769	03 00 1769
56	**Holyoke, Edward Augustus**	*Coffin for a Child*	0..7..0	Henrietta, 12 05 1776 − 12 27 1776	12 31 1776
57		*Mehog Cradle*	3..6..8*	Susanna, 04 21 1779	08 00 1779

	CLIENT	LEDGER ENTRY	PRICE	DATE OF BIRTH/BAPTISM	LEDGER DATE
58	Hopkins, Daniel	Cheretree Cradle [cherry]	1..6..8	Nathaniel, bp 02 16 1772	03 00 1772
59		Child's coffin	0..6..0	Nathaniel, bp 02 16 1772	10 00 1773
60	Ives, Robert Hale	Easey Chair	3..0..0	Charlotte, bp 01 27 1771	10 24 1770
61	Jeffery, Arthur	1 Cradle	0..13..4	Rebecca, 04 03 1768	04 00 1770
62	Jones, Samuel	1 Cradle	0..16..0	Polly & William, bp 08 24 1777	11 00 1777
63	Kast, Philip Godfried	bed Stid	1..0..0	Sarah, 04 03 1772	02 05 1772
64	King, James Jr.	1 Bed Stid Mehog Posts		Polly, 07 22 1781	02 00 1781
65	Lander, Peter	High posts for Bedstid Set Bed Rails & Putting up Bed	4..0..0	William, 10 05 1778	09 18 1778
66		Toylet Table	3..0..0	William, 10 05 1778	09 22 1778
67		Mendg Cradle [mending]	1..10..0*	Polley, bp 01 13 1780	11 00 1779
68		Putting up 2 Beds and mendg Looking Glass Frame [mending]	0..7..0*	Lydia, 10 14 1781	09 00 1781
69		6 chair frames	16..16..0*	Lydia, 10 14 1781	09 22 1781
70		Mending Cradle	0..8..0*	Lydia, 10 14 1781	00 00 1781
71	Leach, John	Child's coffin	0..8..0		09 00 1761
72	Lee, Joseph	Cott	1..4..0	George, bp 01 14 1776	02 00 1776
73	Lilly, Captain William	6 Mehogany Chairs	10..16..0	Ann Lorn, bp 10 25 1767	10 25 1766
74		1 Easey chair	2..16..0	Ann Lorn, bp 10 25 1767	12 00 1766
75	Mascareen, John	mending Cradle	0..1..4		09 00 1769
76	Mascol, Stephen	Trundle BedStid	0..13..4	Mary, 1770; Stephen 03 31 1773	12 02 1772
77	Nichols, Nathan	Cofin for Child	1..10..0		09 00 1778
78	Nichols, William	Cradle	0..12..0		11 00 1762
79	Northey, Abijah	Child's coffin	0..4..0		03 00 1768
80		Child's coffin	0..4..8		09 00 1769
81	Orne, Josiah	1 Low Chair	1..0..4	Josiah, bp 04 03 1768	12 00 1767
82		Wallnut Cradle	1..10..0	Josiah, bp 04 03 1768	02 00 1768
83		Cot Bedsted	0..18..0*	John, 11 06 1779	08 00 1780
84	Orne, Timothy III	Cradle	1..8..0	child, 09 23 1772	12 02 1772
85		Cribb for Child	0..9..4	Elisabeth, 1773	07 00 1773
86		1 chair childs	0..4..8		07 17 1773
87	Peirce, Nathan	1 high Post Bedsted		George, bp 10 00 1783	05 00 1783
88	Pickman, Benjamin Jr.	mending Cradle	0..2..0	Mary, bp 09 29 1765	08 00 1766
89	Pickman, Clark Gayton	Cradle made of Ceader [cedar]	1..16..0	Sally Orne, 06 07 1771	07 00 1771
90		Rockers for cradle	0..6..0		12 00 1773
91	Pickman, William	Putting up beds		William, 10 18 1777	09 23 1777
92		Bureau table	8..0..0	William, 10 18 1777	11 00 1777
93		Sett Bedrails & Putting up Bed	1..0..0*	Dudley Leavit, 05 01 1779	05 00 1779
94	Pike, Richard & Benjamin	Coffin for Negro Child	0..5..0		01 00 1766
95	Rollings, Joseph	Cradle	0..12..0	Hannah, 02 17 1761	00 00 1761
96	Routh, Richard	Making Rockers to a Cradle	0..3..0	Abigail, 06 21 1772	06 30 1772
97	Sargent, Paul Dudley	4 chair frames		child, 03 13 1779	03 19 1779
98		1 Do [chair] Do [frame] [easy]		child, 03 13 1779	03 19 1779
99	Savage, Roland	Easy chair frame and covering	3..2..8	Philip, 05 29 1770	05 00 1770
100		Close Stool Chair	1..8..0	Richard, bp 03 08 1772	03 00 1772
101	Somerville, Thomas	Coffin for Child	0..5..0		06 04 1766
102	Sprague, Joseph	Bed-Stid Mehogany posts	3..12..0	Joseph, 11 23 1771	09 28 1771
103		Easy chair frame	1..10..0	Joseph, 11 23 1771	09 28 1771
104	Stimson, Thomas	Cradle	0..13..4		02 00 1768
105		Child's coffin	0..4..8		11 00 1768
106	Tracey, Nathaniel	Easey chair frame	1..16..0	Hannah, 01 25 1776	12 00 1775
107	Ward, Joshua	Cradle	1..10..0	Joshua, 05 11 1776	06 00 1776
108	Ward, Samuel	mending Cot Bedsted		Polly, bp 01 02 1780; Gamaliel Hodges, 01 24 1782	09 00 1781
109	West, Samuel Jr.	Child's coffin	0..4..0		04 09 1765
110	West, William	Easey Chair frame	8..0..0*	George Williams (grandson), bp 06 14 1778	07 00 1778
111	White, Isaac	puting up Bed	0..6..8	Sally, bp 08 1777	07 09 1777
112		1 Bedstid	5..0..0	Sally, bp 08 1777	08 00 1777

BIBLIOGRAPHY

Adamson 2013
Adamson, Glenn. "The Labor of Division: Cabinetmaking and the Production of Knowledge." In *Ways of Making and Knowing: The Material Culture of Empirical Knowledge*, edited by Harold J. Cook, Pamela H. Smith, and Amy R. W. Meyers. New York: Bard Graduate Center, 2013.

Anderson 2011
Anderson, Judy. *Glorious Splendor: The 18th-Century Wallpapers in the Jeremiah Lee Mansion Salem, Massachusetts*. Virginia Beach, Virginia: Donning Co. Publishers, 2011.

Appleton 1773
Appleton, John. *Imported in the last ships from London, by John Appleton a fine assortment of English and India goods, which he will sell at his store in Salem, as low as can be bought at Boston, by wholesale and retail: Among which are the following articles, viz.* Salem, Massachusetts: Samuel and Ebenezer Hall, 1773.

Baarsen 2000
Baarsen, Reinier. *The Splendour of the Dutch Interior 1600 – 1800*. Amsterdam: Salomon Stodel, 2000.

Barquist 1992
Barquist, David L. *American Tables and Looking Glasses in the Mabel Brady Garvan and Other Collections at Yale University*. New Haven: Yale University Press, 1992.

Beard 1986
Beard, Geoffrey. *Craftsmen and Interior Decoration in England 1660 – 1820*. London: Bloomsbury Books, 1986.

Benes 1982
Benes, Peter. *Two Towns, Concord & Wethersfield: A Comparative Exhibition of Regional Culture, 1635 – 1850*. Vol. 1 of 2. Concord, Massachusetts: Concord Antiquarian Museum, 1982.

Bentley 1962
Bentley, William. *The Diary of William Bentley, D.D., Pastor of the East Church Salem, Massachusetts*. 4 vols. 1905 – 1914. Reprint, Gloucester, Massachusetts: Peter Smith, 1962.

Bolton and Coe 1973
Bolton, Ethel Stanwood, and Eva Johnston Coe. *American Samplers*. 1921. Reprint, New York: Dover, 1973.

Bowen 1973
Bowen, Ashley. *The Journals of Ashley Bowen (1728 – 1813) of Marblehead*. Edited by Philip Chadwick Foster Smith. Vol. 1 of 2. Salem, Massachusetts: Peabody Museum of Salem and the Colonial Society of Massachusetts, 1973.

Briggs 1927
Briggs, L. Vernon. *History and Genealogy of the Cabot Family*. Vol 1 of 2. Boston: Charles E. Goodspeed & Co., 1927.

Brockway and Cavanagh 2004
Brockway, Lucinda A., and Lindsay H. Cavanagh. *Gardens of the New Republic: Fashioning the Landscapes of High Street Newburyport, Massachusetts*. Albany, Texas: Bright Sky Press, 2004.

Browne 1914
Browne, Benjamin F. "Youthful Recollections of Salem." *Essex Institute Historical Collections* 50 (1914), pp. 8 – 9.

Buhler 1931
Buhler, Kathryn C. "Pickman Family Silver." *Bulletin of the Museum of Fine Arts, Boston* 29, no. 173 (June 1931), pp. 43 – 51.

Buhler 1936
Buhler, Kathryn C. "The Ledgers of Paul Revere." *Bulletin of the Museum of Fine Arts, Boston* 34, no. 203 (June 1936), pp. 38 – 45.

Buhler 1961
Buhler, Kathryn C. "The Pickman Silver," *Ellis Memorial Antiques Show Catalogue*. Boston: Ellis Memorial, 1961.

Buhler 1972
Buhler, Kathryn C. *American Silver, 1655 – 1825, in the Museum of Fine Arts, Boston*. 2 vols. Boston: Museum of Fine Arts, 1972.

Buhler 1979
Buhler, Kathryn C. *American Silver from the Colonial Period through the Early Republic in the Worcester Art Museum*. Worcester, Massachusetts: Worcester Art Museum, 1979.

Bushman 1993
Bushman, Richard L. *The Refinement of America: Persons, Houses, Cities*. New York: Vintage Books, 1993.

Bushman and Bushman 1988
Bushman, Richard L., and Claudia L. Bushman. "The Early History of Cleanliness in America." *The Journal of American History* 74, no. 4 (March 1988), pp. 1213 – 38.

Butterfield et al. 1963
Butterfield, L. H., Marc Friedlaender, Richard Alan Ryerson, and Margaret A. Hogan, eds. *Adams Family Correspondence, June 1776 – March 1778*. Vol. 2 of 11. Cambridge, Massachusetts: The Belknap Press, 1963.

Cabot 1997
Cabot, John G. L. *The Vermont Descendants of George Cabot (1678–1717) of Salem and Boston*. Manchester, Massachusetts: New England Historical Genealogical Society, 1997.

Carlisle and Harholdt 2003
Carlisle, Nancy Camilla, and Peter Harholdt. *Cherished Possessions: A New England Legacy*. Boston: Society for the Preservation of New England Antiquities, in association with Antique Collectors' Club Ltd., 2003.

Chamberlain and Holahan 1950
Chamberlain, Samuel, and Elizabeth Gibson Holahan. *Salem Interiors: Two Centuries of New England Taste and Decoration*. New York: Hastings House, 1950.

Chapelle 1935
Chapelle, Howard Irving. *The History of American Sailing Ships*. New York: W. W. Norton & Co., 1935.

Chippendale 1762
Chippendale, Thomas. *The Gentleman and Cabinetmakers Director*. 3rd ed. London: Printed privately, 1762.

Clarke 1763
Clarke, Edward. *Letters Concerning the Spanish Nation Written at Madrid During the Years 1760 and 1761*. London: Printed for T. Becket and P. A. De Hondt, 1763.

Cummings 1964
Cummings, Abbott Lowell. "The Foster-Hutchinson House." *Old-Time New England* 54, no. 195 (Winter 1964), pp. 52, 65–67.

Cummings 1983
Cummings, Abbott Lowell. "The Beginnings of Provincial Renaissance Architecture in Boston, 1690–1725: Current Observations and Suggestions for Further Study." *The Journal of the Society of Architectural Historians* 42, no. 1 (March 1983), pp. 43–53.

Currier 1896
Currier, John J. *"Ould Newbury": Historical and Biographical Sketches*. Boston: Damrell Upham, 1896.

Curwen 1890
Curwen, James Barr. "Reminiscences of Capt. James Barr of Salem, Mass." *Essex Institute Historical Collections* 27, nos., 7–9 (July, August, September, 1890), pp. 123–24.

Derby 1861
Derby, Perley. "Genealogy of the Derby Family." *Essex Institute Historical Collections* 3, no. 4 (August 1861), pp. 163–64.

Downs 1939
Downs, Joseph. "A Pair of Chairs." *Metropolitan Museum of Art Bulletin* 34, no. 10 (October 1939), pp. 227–29.

EIHC 1860
"Market prices for Salem commodities in 1775." *Essex Institute Historical Collections* 2 (October 1860), pp. 259.

EIHC 1862
"Materials for a History of the Ropes Family." *Essex Institute Historical Collections* 7 (1862), pp. 162.

EIHC 1895
"A Stately Pleasure House." *Essex Institute Historical Collection* 31 (1894–95), pp. 205–12.

EIHC 1903
"Pickman Silver." *Essex Institute Historical Collection* 39, no. 2 (April 1903: 97–120.

EIHC 1907
"Extracts from the Interleaved Almanacs of William Wetmore of Salem 1774–1778." *Essex Institute Historical Collections* 63, no. 2 (April 1907), pp. 115–20.

EIHC 1922
"List of Houses Built in Salem from 1750–1773." *Essex Institute Historical Collection* 58 (1922), pp. 290–96.

EIHC 1936
"Col. William Browne House." *Essex Institute Historical Collections* 72 (1936), pp. 283–84.

The English Pilot **1765**
The English Pilot. The fourth book, describing the West India navigation from Hudson's Bay to the river Amazones. Also a new description of Newfoundland, New-England, &c. 1765. London: Printed for J. Mount and T. Page, 1765.

English Shipping Records **1931**
Abstracts of English shipping records relating to Massachusetts ports: from original records in the Public Record Office, London / compiled for the Essex Institute [by English research workers] n.d. Extracts from CO5: 848–85, National Archives (of the UK), p. 1348.

Essex Gazette **1769**
Essex Gazette 1, no. 25 (January 10–17, 1769), 101.

Essex Gazette **1773**
Essex Gazette 6, no. 270 (September 21–28, 1773), 35.

Fales 1965
Fales, Dean A. Jr. *Essex County Furniture: Documented Treasures from Local Collections, 1680 – 1860.* Salem, Massachusetts: Essex Institute, 1965.

Fales 1976
Fales, Dean A. Jr. *The Furniture of Historic Deerfield.* New York: E. P. Dutton, 1976.

Felt 1845
Felt, Joseph B. *Annals of Salem.* 2 vols. Salem, Massachusetts: W. & S. B. Ives, 1845.

Finamore 2008
Finamore, Daniel. "Furnishing the Craftsman: Slaves and Sailors in the Mahogany Trade." In *American Furniture 2008,* edited by Luke Beckerdite. Milwaukee: Chipstone Foundation, 2008.

Foote 1959
Foote, Henry Wilder. "Benjamin Blythe, of Salem: Eighteenth-Century Artist." *Proceedings of the Massachusetts Historical Society* 71 (October 1953 – May 1957), pp. 64 – 107.

Forman 1971
Forman, Benno M. "Salem Tradesmen and Craftsmen Circa 1762: A Contemporary Document." *Essex Institute Historical Collections* 107 (January 1971), pp. 62 – 81.

Gardner 1913
Gardner, Samuel. "Diary for the Year 1759 Kept by Samuel Gardner of Salem." *Essex Institute Historical Collections* 49, no. 1 (January 1913), p. 9.

Garrett 1985
Garrett, Elisabeth Donaghy. *The Arts of Independence.* Washington, DC: National Society of Daughters of the American Revolution, 1985.

Garrett 1990
Garrett, Elisabeth Donaghy. *At Home: The American Family 1750 – 1870.* New York: Harry N. Abrams, 1990.

Goodwin 1999
Goodwin, Lorinda B. R. *An Archaeology of Manners: The Polite World of the Merchant Elite of Colonial Massachusetts.* New York: Kluwer Academic/Plenum Publishers, 1999.

Greenlaw 1974
Greenlaw, Barry A. *New England Furniture at Williamsburg.* Williamsburg: Colonial Williamsburg Foundation, 1974.

Haase 1983
Haase, Gisela. *Dresdener Möbel des 18. Jahrhunderts.* Leipzig: E. A. Seemann, 1983.

Hardy 1911
Hardy, Stella Pickett. *Colonial Families of the Southern States.* New York: Tobias A. Wright, 1911.

Hecksher 1985
Hecksher, Morrison H. *American Furniture in the Metropolitan Museum of Art II, Late Colonial Period: Queen Anne and Chippendale Styles.* New York: Random House, 1985.

Hecksher 1994
Hecksher, Morrison H. "English Furniture Pattern Books in Eighteenth-Century America." In *American Furniture 1994,* edited by Luke Beckerdite. Milwaukee: Chipstone Foundation, 1994.

Higginson 1907
Higginson, Thomas Wentworth. *Life and Times of Stephen Higginson.* Boston: Houghton Mifflin Company, 1907.

Hines 1896
Hines, Ezra D. "Browne Hill and Some History Connected with It." *Essex Institute Historical Collections* 32 (1896), pp. 201 – 38.

Hipkiss 1941
Hipkiss, Edwin J. *Eighteenth-Century American Arts: The M. and M. Karolik Collection.* Cambridge: Harvard University Press, 1941.

Hogarth 1753
Hogarth, William. *The Analysis of Beauty.* London: Printed by J. Reeves for the author, 1753.

Holyoke 1911
Holyoke, Edward. *The Holyoke Diaries 1709 – 1856.* Edited by George Francis Dow. Salem, Massachusetts: Essex Institute, 1911.

Hunter 2001
Hunter, Phyllis Whitman. *Purchasing Identity in the Atlantic World, Massachusetts Merchants, 1670 – 1780.* Ithaca, New York: Cornell University Press, 2001.

Jenison 1976
Jenison, Paul B. "The Availability of Lime and Masonry Construction in New England: 1630 – 1733." *Old-Time New England* 67, no. 245 (Summer – Fall 1976), pp. 21 – 26.

Jobe 1992
Jobe, Brock. *Portsmouth Furniture: Masterworks from the New Hampshire Seacoast.* Boston: Society for the Preservation of New England Antiquities, 1992.

Jobe and Kaye 1984
Jobe, Brock, and Myrna Kaye. *New England Furniture: The Colonial Era. Selections from the Society for the Preservation of New England Antiquities.* Boston: Houghton Mifflin Company, 1984.

Kane et al. 1998
Kane, Patricia E., Francis Hill Bigelow, John Marshall Phillips, and Jeannine J. Falino. *Colonial Massachusetts Silversmiths and Jewelers: A Biographical Dictionary Based on the Notes of Francis Hill Bigelow & John Marshall Phillips.* New Haven: Yale University Art Gallery, 1998.

Karras 2007
Karras, Alan L. "Transgressive Exchange: Circumventing Eighteenth-Century Atlantic Commercial Restrictions, or The Discount of Monte Christi." In *Seascapes: Maritime Histories, Littoral Cultures, and Transoceanic Exchanges,* edited by Jerry H. Bentley, Renate Bridenthal, and Kären Wigen. Honolulu: University of Hawai'i Press, 2007.

Kelly 2006
Kelly, Margaret Whyte. *Sarah: Her Story: The Life Story of Sarah Parker Rice Goodwin, Wife of Ichabod Goodwin, New Hampshire's Civil War Governor.* Portsmouth, New Hampshire: Back Channel Press, 2006.

Kenny 2011
Kenny, Peter. *Duncan Phyfe: Master Cabinetmaker in New York.* New York: The Metropolitan Museum of Art, 2011.

Kimball 1966
Kimball, Fiske. *Mr. Samuel McIntire, Carver: The Architect of Salem.* 1940. Reprint, Gloucester, Massachusetts: Peter Smith, 1966.

Kirkham 1989
Kirkham, Pat. *The London Furniture Trade, 1700–1870.* London: Furniture History Society, 1989.

Kornwolf 2002
Kornwolf, James D. *Architecture and Town Planning in Colonial North America.* Vol. 2 of 3. Baltimore: Johns Hopkins University Press, 2002.

Lahikainen 2008
Lahikainen, Dean T. *Samuel McIntire: Carving an American Style.* Salem: Peabody Essex Museum, 2008.

Lasser 2012
Lasser, Ethan. "Selling Silver: The Business of Copley's Paul Revere." *American Art* 26, no. 3 (Fall 2012), pp. 26–43.

Little 1972a
Little, Nina Fletcher. "The Blyths of Salem." *Essex Institute Historical Collections* 108, no. 1 (January 1972), pp. 49–57.

Little 1972b
Little, Nina Fletcher. "Cornè, McIntire and the Hersey Derby Farm." *Antiques* 101, no. 1 (January 1972), pp. 226–29.

Little 1984
Little, Nina Fletcher. *Little by Little: Six Decades of Collecting American Decorative Arts.* New York: E. P. Dutton, 1984.

Loring 1864
Loring, George B. "Some Account of Houses and Other Buildings in Salem from a Manuscript of the late Col. Benj. Pickman." *Essex Institute Historical Collections* 6 (1864), p. 102.

Lovell 1974
Lovell, Margaretta. "Boston Blockfront Furniture." In *Boston Furniture of the Eighteenth Century,* edited by Walter M. Whitehill. Charlottesville: University of Virginia Press, 1974.

Lovell 2005
Lovell, Margaretta. *Art in a Season of Revolution: Painters, Artisans, and Patrons in Early America.* Philadelphia: University of Pennsylvania Press, 2005.

Lynde 1880
Lynde, Benjamin. *The Diaries of Benjamin Lynde and of Benjamin Lynde, Jr. with an appendix.* Edited by F. E. Oliver. Cambridge, Massachusetts: Riverside Press, 1880.

Manwaring 1765
Manwaring, Robert. *The Cabinet and Chairmaker's Real Friend and Companion, Or the Whole System of Chair-making Made Plain and Easy.* London: Printed for Henry Webley, 1765; reprinted for I. Taylor, 1775.

Massachusetts Spy 1773
Massachusetts Spy 3, no. 122 (June 3, 1773), p. 2.

Massachusetts Spy 1779
Massachusetts Spy 9, no. 419 (May 13, 1779), p. 4.

McCracken 1990
McCracken, Grant. *Culture and Consumption: New Approaches to the Symbolic Character of Consumer Goods and Activities.* Bloomington: Indiana University Press, 1990.

McCusker 1978

McCusker, John J. *Money and Exchange in Europe and America, 1600 – 1775: A Handbook.* Chapel Hill: University of North Carolina Press, 1978.

McCusker 1992

McCusker, John J. *How Much Is That in Real Money? A Historical Price Index for Use as a Deflator of Money Values in the Economy of the United States.* Worcester, Massachusetts: American Antiquarian Society, 1992.

Morris 2000

Morris, Richard J. "Redefining the Economic Elite in Salem, Massachusetts, 1759 – 1799: A Tale of Evolution, Not Revolution." *The New England Quarterly* 73, no. 4 (December 2000), pp. 603 – 24.

Morse 1970

Morse, John D., ed. *Country Cabinetwork and Simple City Furniture.* Charlottesville: University of Virginia Press, 1970.

Murphy 2008

Murphy, Emily A. "To Keep Our Trading for Our Livelihood—The Derby Family of Salem, Massachusetts and Their Rise to Power in the British Atlantic World." PhD diss., Boston University, 2008.

Murphy 2012

Murphy, Kevin D. "Buildings, Landscapes, and the Representation of Authority on the Eastern Frontier." In *New Views of New England Studies in Material and Visual Culture, 1680 – 1830,* edited by Martha J. McNamara and Georgia B. Barnhill. Boston: Colonial Society of Massachusetts, 2012.

Museu Nacional de Arte Antiga 2000.

Museu Nacional de Arte Antiga. *Portuguese Furniture Collection Guide.* Lisbon: Museu Nacional de Arte Antiga, 2000.

Mussey and Haley 1994

Mussey, Robert and Anne Rogers Haley. "John Cogswell and Boston Bombé Furniture: Thirty-Five Years of Revolution in Politics and Design." In *American Furniture 1994,* edited by Luke Beckerdite. Hanover, New Hampshire: University of New England Press, 1994.

NEHGR 1900

"Richard Skinner of Marblehead." *New England Historic and Genealogical Register* 54 (October 1900), pp. 419 – 20.

Nelson 2000

Nelson, Susan S. "Capt. Abraham Knowlton, Joiner, and the Seminal Woodworkers of Ipswich, Massachusetts." In *Rural New England Furniture: People, Place, and Production. Dublin Seminar for New England Folklife Annual Proceedings 1998,* edited by Peter Benes and Jane Montague Benes. Boston: Boston University Press, 2000.

New Hampshire Loyalists 1783 – 90

"New Hampshire Loyalists; Transcripts from the Records of the Commission for Enquiring into the Losses and Services of American Loyalists, 1783 – 1790, Preserved in the Public Record Office, London, England." 5 vols., Concord, New Hampshire: New Hampshire State Library, n.d.

New Hampshire Historical Society 1979

New Hampshire Historical Society. *Plain & Elegant, Rich & Common: Documented New Hampshire Furniture, 1750 – 1850 : A Loan Exhibition, 29 September through 3 November 1978.* Concord, New Hampshire : New Hampshire Historical Society, 1979.

Nichols 1861

Nichols, Andrew. "Genealogy of the Holyoke Family." *Essex Institute Historical Collections* 3, no. 2 (April 1861), pp. 57 – 61.

Norton 1988

Norton, Paul F., ed. *Samuel McIntire of Salem: The Drawings and Papers of the Architect / Carver and His Family.* Salem, Massachusetts: Peabody Essex Museum, 1988.

Nylander 1993

Nylander, Jane C. *Our Own Snug Fireside: Images of the New England Home 1760 – 1860.* New York: Alfred A. Knopf, 1993.

Parmal 2012

Parmal, Pamela A. *Women's Work: Embroidery in Colonial Boston.* Boston: Museum of Fine Arts, 2012.

Perley 1924 – 28

Perley, Sidney. *History of Salem, Massachusetts, 1670 – 1716.* 3 vols. Salem, Massachusetts: Sidney Perley, 1924 – 28.

Phillips 1937

Phillips, James Duncan. *Salem in the Eighteenth-Century.* Boston: Houghton Mifflin Company, 1937.

Pickman 1928

Pickman, Benjamin, and George Francis Dow. *The Diary and Letters of Benjamin Pickman (1740 – 1819) of Salem, Massachusetts. With a biographical sketch and genealogy of the Pickman family.* Newport, Rhode Island: Printed privately, 1928.

Pierson 1976

Pierson, William H. Jr. *American Buildings and Their Architects: The Colonial and Neo-Classical Styles.* Garden City, New York: Anchor Books, 1976.

Prickett 2008

C. L. Prickett. "The Important Cabot – Paine – Metcalf Chippendale Mahogany Bonnet-Top Bombé Desk-and-Bookcase." Yardley, Pennsylvania: C. L. Prickett, 2008.

Prown 1966

Prown, Jules. *John Singleton Copley*. Vol. 1 of 2. Cambridge: Harvard University Press, 1966.

Puetz 1999

Puetz, Anne. "Design Instructions for Artisans in Eighteenth-Century Britain." *Journal of Design History* 12, no. 3 (1999), pp. 217 – 39.

Pynchon 1890

Pynchon, William. *The Diary of William Pynchon of Salem: A Picture of Salem Life, Social and Political, a Century Ago*, edited by Fitch Edward Oliver. Boston: Houghton Mifflin Company, 1890.

Randall 1965

Randall, Richard H, Jr. *American Furniture in the Museum of Fine Arts, Boston*. Boston: Museum of Fine Arts, 1965.

Rebora et al. 1995

Rebora, Carrie, et al. *John Singleton Copley in America*. New York: The Metropolitan Museum of Art, 1995.

Richards and Evans 1997

Richards, Nancy E., and Nancy Goyne Evans. *New England Furniture at Winterthur: Queen Anne and Chippendale Periods*. Winterthur, Delaware: Winterthur Museum, 1997.

Richter 2000

Richter, Paula Bradstreet. "Samplers from Mistress Sarah Stivours School, Salem, Massachusetts." *Piecework* 8, no. 6 (November/December 2000), pp. 28 – 33.

Ring 1993

Ring, Betty. *Girlhood Embroidery: American Samplers and Pictorial Needlework, 1650 – 1850*. Vol. 1 of 2. New York: Alfred A. Knopf, 1993.

Rorabaugh 1986

Rorabaugh, W. J. *The Craft Apprentice from Franklin to the Machine Age in America*. New York: Oxford University Press, 1986.

Ruffin 2007

Ruffin, J. Rixey. *A Paradise of Reason: William Bentley and the Struggle for an Enlightened and Christian Republic in America, 1783 – 1805*. New York: Oxford University Press, 2007.

Sack 1957–91

Sack, Israel. *American Antiques from the Israel Sack Collection*. Vols 1 – 10. Alexandria, Virginia: Highland Press Publishers, 1957 – 91.

Sack 1987

Sack, Albert. "Regionalism in Early American Tea Tables." *Antiques* 131, no. 1 (January 1987), pp. 248 – 52.

Sargentson 1996

Sargentson, Carolyn. *Merchants and Luxury Markets: The Marchands Merciers of Eighteenth-Century Paris*. London: V&A Publications, in association with the J. Paul Getty Museum, 1996.

Shepard 1978

Shepard, Lewis A. *American Art at Amherst: A Summary Catalogue of the Collection at the Mead Art Gallery, Amherst College*. Middletown, Connecticut: Wesleyan University Press, 1978.

Shipton and Sibley 1972

Shipton, Clifford Kenyon, and John Langdon Sibley. *Biographical Sketches of Those Who Attended Harvard College in the Classes 1764 – 1767*. Vol. 16 of 18. Boston: Massachusetts Historical Society, 1972.

Shipton and Sibley 1975

Shipton, Clifford Kenyon, and John Langdon Sibley. *Biographical Sketches of Those Who Attended Harvard College in the Classes 1768 – 1771*. Vol. 17 of 18. Boston: Massachusetts Historical Society, 1975.

Silsbee 1887

Silsbee, M. C. D. *A Half Century in Salem*. Boston: Houghton Mifflin Company, 1887.

Small 1957

Small, Edwin W. "The Derby House: Part of Salem Maritime National Historic Site, Derby Street, Salem, Massachusetts." *Old-Time New England* 47, no. 168 (Spring 1957), pp. 101 – 107.

Smith 1998

Smith, Philip Chadwick Foster. *A History of the Marine Society at Salem, Established 1766: Incorporated 1772. Together with the Laws of the Society, the Acts of Incorporation and a List of Members, 1766 – 1966*. Salem, Massachusetts: The Marine Society at Salem, 1998.

Snell 1976

Snell, Charles W. *Historic Structure Report Derby/Prince/Ropes House Historical Data Salem Maritime National Historic Site Massachusetts*. Denver: National Park Service, U.S. Department of the Interior, 1976.

Streeter 1896
Streeter, Gilbert L. "Salem before the Revolution." *Essex Institute Historical Collections* 32, nos. 1–6 (January–June 1896), pp. 47–98.

Stuart 2008
Stuart, Susan E. *Gillows of Lancaster and London, 1730–1840: Cabinetmakers and International Merchants: A Furniture and Business History.* Woodbridge, UK: Antique Collector's Club, 2008.

Sturgis 1907
Sturgis, Mrs. E. O. P. "A Description of the Dr. Paine House at Worcester, Called 'The Oaks,' as It Was in His Day." *Proceedings of the Worcester Society of Antiquity for the Year 1905.* Vol. 21. Worcester, Massachusetts: Worcester Society for Antiquity, 1907.

Styles and Vickery 2006
Styles, John, and Amanda Vickery, eds. *Gender, Taste, and Material Culture in Britain and North American 1700–1830.* New Haven: The Yale Center for British Art, 2006.

Sweeney, K. 1984
Sweeney, Kevin M. "Mansion People Kinship, Class and Architecture in Western Massachusetts in the Mid Eighteenth Century." *Winterthur Portfolio* 19, no. 4 (Winter 1984), pp. 231–55.

Sweeney, J. and Du Pont 1963
Sweeney, John A. H., and Henry Francis Du Pont. *The Treasure House of Early American Rooms.* New York: Viking Press, 1963.

Tagney 1989
Tagney, Ronald N. *The World Turned Upside Down, Essex County during America's Turbulent Years, 1763–1790.* West Newbury, Massachusetts: Essex County History, 1989.

Tapley 1934
Tapley, Harriet Silvester. *Early Coastwise and Foreign Shipping of Salem: A Record of the Entrances and Clearances of the Port of Salem.* Salem, Massachusetts: The Essex Institute, 1934.

Thornton 1989
Thornton, Tamara Plakins. *Cultivating Gentlemen: The Meaning of Country Life among the Boston Elite, 1785–1860.* New Haven: Yale University Press, 1989.

Ulrich 2001
Ulrich, Laurel Thatcher. *Age of Homespun: Objects and Stories in the Creation of an American Myth.* New York: Alfred A. Knopf, 2001.

Upham 1865
Upham, William P. "Letter of Samuel Sewall Jan. 27, 1789." *Essex Institute Historical Collections* 5–7 (October/December 1865), pp. 196–97.

Upham 1876
Upham, William P. "Extract from Letters Written at the Time of the Occupation of Boston by the British 1775–6." *Essex Institute Historical Collections* 13, no. 3 (July 1876), pp. 153–236.

Venable 1989
Venable, Charles L. and the Dallas Museum of Art. *American Furniture in the Bybee Collection.* Austin: University of Texas Press, 1989.

Vickers and Walsh 2005
Vickers, Daniel, and Vince Walsh. *Young Men and the Sea: Yankee Seafarers in the Age of Sail.* New Haven: Yale University Press, 2005.

Vincent, G. 1974
Vincent, Gilbert T. "The Bombé Furniture of Boston." In *Boston Furniture of the Eighteenth Century*, edited by Walter M. Whitehill. Charlottesville: University Press of Virginia, 1974.

Vincent, J. A. 1864
Vincent, John Adams. *The Giles Memorial.* Boston: Dutton & Son, 1864.

Ward 1988
Ward, Gerald W. R. *American Case Furniture in the Mabel Brady Garvan and Other Collections at Yale University.* New Haven: Yale University Press, 1988.

Ward et al. 2008
Ward, Gerald W. R., Kelly H. L'Ecuyer and Nonie Gadsden. *MFA Highlights: American Decorative Arts and Sculpture.* Boston: Museum of Fine Arts Publications, 2008.

Warren et al. 1998
Warren, David B., Michael K. Brown, Elizabeth Ann Coleman, and Emily Bellew Neff. *American Decorative Arts and Paintings in the Bayou Bend Collection.* Houston: Museum of Fine Arts, Houston, in association with Princeton University Press, 1998.

Waters 1879
Waters, Henry Fitzgilbert, comp. "The Gedney and Clarke Families of Salem, Mass." *Essex Institute Historical Collection* 16, no. 4 (October 1879), pp. 241–90.

Watson 1873
Watson, John Lee. *Memories of the Marston Family of Salem.* Boston: Press of David Clapp and Son, 1873.

Whitehill 1974

Whitehill, Walter M., et. al. *Boston Furniture of the Eighteenth Century. A Conference Held by the Colonial Society of Massachusetts, 11 and 12 May 1972*. Boston: Colonial Society of Massachusetts, 1974.

Widmer 2009

Widmer, Kemble. "Sleuthing a Masterwork." *Historic New England* 10, no. 2 (Fall 2009), pp. 22 – 24.

Widmer 2013

Widmer, Kemble. "A Scotsman, Thomas Chippendale, and the Green Dragon Inn." In *Perspectives on Boston Furniture*, edited by Brock Jobe and Gerald W. R. Ward. Boston: Colonial Society of Massachusetts, forthcoming.

Widmer and King 2008

Widmer Kemble, and Joyce King. "The Documentary and Artistic Legacy of Nathaniel Gould." In *American Furniture 2008*, edited by Luke Beckerdite. Milwaukee: Chipstone Foundation, 2008.

Widmer and King 2010

Widmer, Kemble, and Joyce King. "The Cabots of Salem and Beverly: A Fondness for the Bombé Form." *Antiques and Fine Art* (Spring 2010), pp. 166 – 74.

Wood 1994

Wood, Lucy. *Catalogue of Commodes: Lady Lever Art Gallery*. London: Her Majesty's Stationary Office, 1994.

INDEX

tables, 47, 97 n.5, 123 n.2, 160, 161, 164, 166, 170 n.2, 171 n.10, 172

Walter, William (Reverend), 49

Ward, Anna Mansfield, 42, **43**

Ward, John, 19, 22 n.10, 144 n.1

Ward, Samuel, 123 n.11

Ware, Benjamin P., 43

Waters, Samuel, 123 n.18

Watson, Abraham, 21, 23 n.21, 94, 138

Webb, Jonathan, 65 n.29, 123 n.4

Webster, Peletiah, 123 n.18

wedding orders, 21, 47–49, 54–55, 65 n.27, 97, 102, 134, 165

wedding orders (Gould), 19, 21, 22 n.11, 47–49, 50, 52, **52**, 54, 58–59, 64 n.7, 64 n.9, 64 n.19, 71, 85, 88, 89 n.21, 96, 143 n.1 *see also under* types of furniture

Wentworth, Anna (Mrs. John Fisher), 48, 100 n.3, 110, 110 n.2

Wentworth, John, 110

Wentworth, Mark Hunking, 19, 48, 100, 100 n.3, 110, 158, 158 n.1, 167

Wentworth, Thomas, 96

West, Thomas Brintnal, 16, 22 n.8, 79, 80, 81

West, William, 123 n.11

West Indies, 11, 19, 21, 67–68, 71, 73, 75–76, 82, 85, 95, 121, 163

 charts, **66**, **68**

 see also named places

Wetmore, William, 64 n.11

Whipple, Jobe, 123 n.4

Whitaker, Nathaniel, 65 n.39

White, Abigail, 64 n.12

White, Rebeckah, 64 n.12

Whitemore, Edmund Jr., 109 n.7, 171 n.10

wig boxes, 58, 65 n.39

Williams, Samuel, 123 n.11

William and Mary–style furniture, 148, 160

William Hunt House, Salem, Massachusetts, 33

Williams, Benjamin, 123 n.4

Williams, Henry, 123 n.11, 171 n.10

Women Dancing in an Arcadian Landscape (needlework picture by S. Derby after Le Pautre), 42

Wood, Thomas (father-in-law), 16, 19, 22 n.5, **69**, 81, 83, 85, 121

Wood, Thomas Jr. (brother-in-law), 19, 22 n.5

woods, 48, 82, 85, 97, 123 n.2, 141, 165, 181 *see also* types of wood

Worcester, Massachusetts, 47, 52, 112

workshop (Gould), 16, 19, 20–21, 34, 49, 52, 54, 79, 83, 85

 case furniture construction, 93, 94, 95

 chairs, 95, 138, 139, 141, 144, 152

 chests of drawers, 96, 97 n.2, 102

 chests-on-chests, 106, 107, 112

 desk-and-bookcases, 85, 121, 122, 130, 134

 desks, 118, 121, 123 n.13

 staff, 80, 81–82, 83, 85, 95

 tables, 22 n.18, 123 n.2, 160, 161, 162–63, 164–65, 167, 169, 172, 178

workshops, 21, 22 n.12, 76, 81, 89 n.10, 92, 137 n.6

Worthen, Charles, 121

Y

Yell, Moses, 123 n.4

IMAGE CREDITS